P9-CDW-111

DADA AND SURREALIST ART

DADA AND SU

RREALIST ART

WILLIAM S. RUBIN

Chief Curator of the Painting and Sculpture Collection, The Museum of Modern Art, New York

HARRY N. ABRAMS, INC., PUBLISHERS, NEW YORK

To James Thrall Soby
Pioneer scholar and connoisseur in the work of these movements

Frontispiece Joan Miró *Painting.* 1930

Nai Y. Chang, *Book Designer*

Standard Book Number 8109–0060–2
Library of Congress Catalog Card Number: 68–13064
All rights reserved. No part of the contents of this book may be
reproduced without the written permission of the publishers
Harry N. Abrams, Incorporated, New York
Printed and bound in Japan
Reproduction rights reserved by S.P.A.D.E.M. and A.D.A.G.P. where relevant

CONTENTS

PREFACE AND ACKNOWLEDGMENTS

Dada and Surrealism were pan-cultural movements; this book focuses upon the plastic art they encouraged. Literary, philosophical, and political considerations are summoned when they can throw particular light on the context and, hence, content of the art, or when, conversely, the art can especially illuminate them. The extensive chronology includes events, publications, and other activities important in the general history of Dada and Surrealism but not essential to a discussion of their art.

Most contemporary writing about this art was the work of poets whose virtually exclusive concern was with its imagery. I have tried to balance these iconographic interests with the needs of stylistic analysis. In so doing, I have had to bring into play such judgments as that of quality. These determinations were not simply outside the concerns of the Surrealist poet-critics, they were utterly alien to their beliefs. Yet despite the Dada posture (accepted by most Surrealists) that rejected the possibilities of inherent esthetic value, the ultimate survival of the objects in question depends on the fact that they *are* art and not mere cultural artifacts. I have proceeded from the assumption, therefore, that the works can be described in terms that make sense for art history in general and for the discussion of modernist painting and sculpture in particular.

All the Dada and Surrealist artists alive during the years this book was researched and written were exceedingly generous with their time. Among them, I owe very special thanks to Alberto Giacometti, Jean Arp, Joan Miró, André Masson, and Marcel Jean. Man Ray, Marcel Duchamp, Matta, and Hans Richter were also especially helpful. I should like to thank James Thrall Soby, pioneer monog-

rapher of many of the Surrealist painters, for reading the manuscript and making valuable suggestions. Lucy Lippard also read the manuscript and was of special help in problems of dating certain works of Max Ernst. William Camfield was of considerable assistance in regard to problems in the work of Picabia, and David Sylvester provided special information for dating Giacometti's Surrealist sculpture. My special thanks go to Marion Kuhn for her patience in typing the first version and corrections of the manuscript, to Annette Allwardt for working so hard to locate certain works of art and assembling the photographs of them, and especially to Irene Gordon for her many fine suggestions and her superb chronology. The chronology grew out of the remarkable editing job which she did on my catalogue *Dada, Surrealism, and Their Heritage* for the 1968 exhibition of the same name at The Museum of Modern Art. Although that catalogue was written while this book was in galley proofs, it has been possible to make additions (some of them verbatim) and changes which reflect not only the help I received on that project from Miss Gordon, Christie Kaiser, and many others, but also the changes in my thinking that followed from the experience of the exhibition. Barbara Adler directed the protean task of gathering photographs for this book, and Margaret Kaplan, patient and comforting, saw it through the last stages. Nai Y. Chang did marvels in getting the signatures arranged so that the colorplates would coordinate with the text and designed what I, for one, consider a most beautiful layout. Finally, my thanks to Milton S. Fox and Harry N. Abrams for their understanding and generosity in agreeing to my many special requests regarding this book.

7

PART I: DADA

The Dadaist is fighting against the agony of the times and against inebriation with death....

—HUGO BALL, DIARY FOR JUNE 18, 1916

THE DADA SPIRIT

Dada was born, though not baptized, on the eve of the First World War; Surrealism died, but was not interred, in the wake of the Second. Without the violence that bracketed their consecutive span of years and the uneasiness of the peace between the wars, the "creative anarchy" of Dada and the visionary inventions of Surrealism would be difficult to conceive. World War I seemed to have demonstrated the long-suspected bankruptcy of nineteenth-century rationalism and of the bourgeois culture it had animated. That logic could be used to justify the killing and mutilation of millions revolted some men of sensibility. "The beginnings of Dada," Tristan Tzara recalled, "were not the beginnings of art, but of disgust."[1]

At the same time that it brought about a crisis of values, World War I caused physical displacements which themselves contributed to the radical nature of the conclusions Dada was to draw. In America, for example, Marcel Duchamp was better insulated against the esthetic tradition (Manet to Cubism) from which he had just "liberated" himself. The unorthodox, iconoclastic mood in America at that time, its youth and energy (all of which had contributed to make the "American" boxer-poet Arthur Cravan a proto-Dada culture hero in France), created an ideal environment. A few months after Duchamp's arrival in New York in 1915, Francis Picabia visited him and found "another man."

Switzerland, however, offered a more convenient refuge from the war. There pacifists, poets, painters, and revolutionaries from all over Europe lived side by side in an atmosphere of intellectual ferment. Among those who organized the Dada Cabaret Voltaire were Hugo Ball, who had come from Germany; Tristan Tzara and Marcel Janco, both from Romania; and Jean Arp, who had come from Alsace via Paris. This cross-fertilization led rapidly to the germination of ideas that transcended national mentalities and traditions. Yet contact among the members of this international intelligentsia was far from universal. A few steps down Old Zurich's Spiegelgasse from the Cabaret Voltaire lived Lenin, meditating a revolution quite different from that of the Dadaists, in whose activities he took no interest whatever.

The word "Dada" was first used in what has since become its historical sense in Zurich in April, 1916, having most probably been discovered in a Larousse dictionary. It first appeared in print the following month in the preface to the initial number of the review *Cabaret Voltaire*. The identity of its discoverer remains unclear, and as we shall see later, almost everyone present at the founding of the Cabaret claimed the discovery. This dispute has led to great animosities over the four decades since the end of Dada, but it is rather beside the point, since the movement existed before its name did. That name itself owed its subsequent popularity to the fact that it seemed perfectly to denote, or connote, a state of mind and a kind of creative activity already in the air—in fact, in the air since 1912, if we are to judge from the cases of Duchamp, Jacques Vaché, and others.

"A child's hobbyhorse" in French, and simply "an infantile sound" according to the *Concise Oxford English Dictionary*, the childish, analphabetic, nonsensical character of the word Dada suggested willful rejection of the inherited world of adult values and adoption of a pose of absolute naïveté. ("What is beautiful?" wrote Georges Ribemont-Dessaignes. "What is ugly? What is great, strong, weak? What is Carpentier, Renan, Foch? Don't know. What am I? Don't know, don't know, don't know, don't know.") The collective regression to a simulacrum of childhood, with its "justification" of elemental and asocial impulses, is interpreted by the psychologist Hans Kreitler as a reaction to the intense disappointments that young men of the

wartime generation experienced in their efforts to come to terms with external reality.[2] But while a psychotic neither controls nor is aware of his regression to infancy, the Dadaists made it a calculated act of the will. By participating in Dada the individual shed responsibility for the horror of a world that considered war something natural.

Dada never had a consistent set of principles and was never coherently organized; even less did it stand for a particular style in art. As it emerged in New York and Zurich, and later in Berlin, Cologne, and Paris, all that Dada manifested as its common denominator was the aim of subverting modern bourgeois society. This is why Dada has often been called a purely negative movement. Nothing could be further from the truth. Dada fostered real contributions to art, poetry, music, and even politics. But while the character of these contributions tended to vary from center to center, its nihilism remained substantially the same wherever Dada appeared.

The destructive *élan* of Dada derived from the conviction that bourgeois society in Europe was irremediably corrupt. "Corrective" operations on the bodies politic and social had continued throughout the nineteenth century, only to end like the experiments of Dr. Frankenstein. Before the "new man" could be made, the old one would have to be destroyed. Dadaists everywhere called for a *tabula rasa*. "Honor, Country, Morality, Family, Art, Religion, Liberty, Fraternity," wrote Tzara, "had once answered to human needs. Now nothing [remains] of them but a skeleton of conventions. . . ."[3] "... there is a great negative work of destruction to be accomplished. We must sweep and clean."[4]

What was to follow this purification remained vague. Only in Germany, where Richard Huelsenbeck, J. T. Baargeld, and others became active Communists, did Dada associate itself with a political program. Accomplishments in painting and poetry in different Dada centers remained individual and often isolated gestures. Systematization was itself rejected as un-Dada. But positive anarchy could be sustained just so long, and the need for something binding was certainly a main motive in the formation of the Surrealist movement which succeeded Dada in Paris in the early twenties. Though Dada lacked a specific set of aims, the general tenor of the changes in life it wished to bring about was clear: man was no longer to be measured to the Procrustean bed of bourgeois morality and rationalism. "Dada," wrote Arp, "wished to destroy the hoaxes of reason and to discover an unreasoned order [*ordre déraisonnable*]."[5]

In some respects the call for a new order that would accommodate the expression and acting-out of irrational and unconscious impulses harked back to Rousseau and Romanticism. The notion that the

human being was stunted or deformed by social conventions that failed to allow for his irrational side never seemed so plausible as it did to the generation that came of age with World War I. But Dada's "unreasoned order" was more radical than the dualism proposed by the Romantic-Symbolist tradition in that it envisioned not a gradual assimilation and attunement of irrational drives to rational controls but an abrupt and utter rejection of the latter in favor of anarchic spontaneity.

Awareness of the unconscious, of man's irrational mechanisms, was in the air as a result of the great strides taken around the turn of the century in psychological theory. But though Zurich was the home of Freud's follower Egon Bleuler, as well as of Carl Gustav Jung, there is no evidence to suggest any direct influence of psychoanalysis on Dada except in Berlin. Dada rejected psychoanalytic theory as it rejected everything systematic, even though the systematic in this case comprehended the irrational. That psychoanalytic ideas were acceptable to Dadaists in Berlin was consistent with their adherence to systematic politics, which Dadaists in France, Switzerland, and America rejected. Even so, it was not Freudian psychoanalysis that interested Dada in Berlin but a psychotypology that was based on the researches of Otto Gross as systematized in 1916 by Franz Jung (not to be confused with the Zurich Jung), who, the following year, founded the review *Die freie Strasse* to propagate these views. It became the first voice of Dada in Berlin.

It was Surrealism rather than Dada that was to embrace Freud's own ideas and assimilate his insights into philosophy, art, and poetry. André Breton had become interested in psychoanalysis while serving as an orderly in an army mental clinic during the war, and he later visited Freud in Vienna. He tells of having tried, during his wartime leaves, successively to interest Apollinaire, Valéry, and Gide in Freud, but they all turned him down "with indulgent smiles and a friendly pat on the back." Later, with Philippe Soupault, Paul Eluard, Robert Desnos, and Louis Aragon, Breton carried out experiments in hypnotic sleep in hope of confirming and extending Freud's ideas. These ideas became a central pillar of Surrealist theory, and the nature of most Surrealist art presupposes some familiarity with them.

Though its works of art remain the most durable contribution of the Dada movement, at the time of their origin they were considered of marginal importance by most of their creators. Dada was fundamentally a "life" movement; its ideal expression was through social rather than esthetic activity, through personalities rather than pictures. The realizations of major Dada artists like Duchamp and Picabia are inseparable from their biographies, and their lives often

transcend in interest their esthetic concerns. The pure Dadaist was not a painter at all, or even a poet, but someone whose essence was expressed equally in all his acts. "Dada," Tzara insisted, "shows its truth in action."[6] These acts may take any form as long as they remain *gratuitous*. According to Huelsenbeck,

Everyone can be a Dadaist. . . . The bartender in the Manhattan Bar, who pours out Curaçao with one hand and gathers up his gonorrhea with the other, is a Dadaist. The gentleman in the raincoat, who is about to start his seventh trip around the world, is a Dadaist. The Dadaist should be a man who has fully understood that one is entitled to have ideas only if one can transform them into life—the completely active type, who lives only through action because it holds the possibility of his achieving knowledge.[7]

The Dadaist did not act on behalf of anything; the notion of *engagement*—or man acting in the service of some belief—was alien to him. In Berlin, where Dada "went down into the streets" to make propaganda for Communism, it was soon absorbed by politics. The ideal Dada act was a paradoxical, spontaneous gesture aimed at revealing the inconsistency and inanity of conventional beliefs. Its core was criticism, and the more radical the gesture, the more critical its impact; thus the constant recourse to scandal. But with repetition people get used to anything, even scandal; in time, Dadaist scandal ceased to shock and began to entertain the public, who enjoyed it for itself, apart from its intentions. When Dada action stopped seeming really subversive, when Dadaists ceased being considered dangerous radicals and began to be thought of as naughty boys, the end of the movement was at hand.

THE DADA PERSONALITY

The legendary Arthur Cravan and Jacques Vaché (figs. D-42, D-43) stand out as prototypes of pure Dada behavior. Both functioned outside, though on different sides, of respectable society. Cravan was the "primitive"; his pose as a boxer, his exaggerated vulgarity, and the elemental nature of his public provocations all threatened, at times even physically, the *politesse* that protect bourgeois convention. Vaché was the dandy, a supersophisticate who gave the impression of having evolved, by dint of pure clairvoyance, above and beyond the limits of the society which became the butt of his "*umour*."

Little is known of Cravan (whose real name was Fabian Avenarius Lloyd) before his emergence in Paris in 1912 as the publisher of a

polemical little review called *Maintenant*. Nothing has been heard of him since the day in 1918 when he disappeared from a small town on the Mexican coast. He was known to many in Paris as an American, a fact insisted upon by Ribemont-Dessaignes and others, but he was actually born in Lausanne of British parents. He spoke excellent English, French, and German, affected the manners of an English aristocrat (he claimed to be the nephew of Oscar Wilde) as well as of an American tough guy, and during the war he boasted of being a "deserter sought by seventeen nations."

Maintenant, printed on wrapping paper, was sometimes hawked by Cravan himself. It appeared irregularly from 1912 to 1915 and published bits of poetry and a good deal of outspoken, often insolent and scurrilous "criticism." Its aggressive tone foretold that of the Dada magazines a few years later. In a notable issue devoted to the Salon des Indépendants of 1914, Cravan's anti-esthetic tendencies came to the fore in a violent attack on a number of leading avant-garde painters and poets. The *brio* of his writing did little to soften the violence of his views; these led to a brawl with a number of the insulted artists and to a challenge to a duel from Guillaume Apollinaire. Cravan worried little about threats to his person, however, for he was immensely tall and heavy and prided himself on his prowess as a boxer. (He had the distinction of being knocked out two years later in Madrid by the first Negro heavyweight champion, Jack Johnson, in an exhibition match; fig. D-41.)

More important in the development of Cravan's myth were the proto-Dada soirées or "manifestations" in which he starred in Paris in 1914 and in New York three years later. The first took place in the Salle des Sociétés Savantes on the rue Danton. A handbill announced that Cravan, "THE BRUTAL CRITIC," would "SPEAK–BOX –DANCE" and perform the new "boxing dance" and "other eccentric numbers" with the aid of "NEGROES–BOXERS–DANCERS." Cravan opened the "performance" by firing a few random pistol shots and then, "alternately laughing and serious, mouthed the most enormous insanities against art and life. He eulogized athletes (whom he considered superior to artists) homosexuals, robbers of the Louvre, and madmen,"[8] all the while shouting insults at the spectators.

With the start of the war, Cravan claimed Swiss citizenship (he boasted widely of having carried out the "perfect burglary" against a jewelry store in Switzerland), and, after leaving Paris in 1915, traveled through Central Europe, demonstrating an uncanny ability to slip across the frontiers of the belligerents. A stay in Spain in 1916 was followed by a trip to America. There, under the joint sponsorship of Picabia and Duchamp, a lecture was arranged for Cravan in New

York's Grand Central Palace, where the First Annual Exhibition of the Society of Independent Artists was taking place in April, 1917. The crowd included many smartly dressed people anxious to hear the latest about European avant-garde activities. Cravan came in, visibly drunk, and after roundly cursing his audience, began, to its consternation, to take off his clothes. He was interrupted by two policemen, who handcuffed him and dragged him to the station house, where only collector Walter Arensberg's intervention saved him from jail. Duchamp, beaming, considered it a "wonderful lecture."

André Breton, the most potent myth maker of twentieth-century culture, is our main source of information regarding Jacques Vaché. It comes to us in the form of personal reminiscences by the "pohète," as Vaché, who never forgave Breton his estheticism, called him, and in Vaché's own letters, addressed principally to Breton, which the latter published in 1919, *Lettres de guerre de Jacques Vaché.* The two had met in Nantes early in 1916 at the Neurological Center where Breton was an orderly and Vaché was being treated for a wound in the calf (figs. D-44, D-45). The "very elegant, red-haired young man" immediately intrigued Breton, and, though circumstances prevented their meeting often, they remained close friends until Vaché's death shortly after the Armistice. Through Breton ("It is to Jacques Vaché that I owe most") and his colleagues of the review *Littérature,* the Vaché myth had immense influence on Parisian Dada and later on Surrealism ("Jacques Vaché," wrote the author of the Surrealist manifestoes, "lives on as a Surrealist in me"). A measure of his impact was Picabia's assertion late in life that in the "fabrication" of his personality he had been "very much influenced" by that of Vaché, whom he had known briefly through Apollinaire.

An inveterate *poseur,* Vaché changed costumes like an actor, masquerading as an English gentleman (he often signed his letters "Harry James"), a lieutenant of the Hussars, a pilot, and a doctor, among others. In one letter he writes of being attached to the English army as an interpreter, but which branch of service he actually served in was never clear. "One of his uniforms," according to Breton, "was most elegantly cut and, for that matter, cut in two—a synthetic uniform which was on one side that of the Allied armies and on the other side that of the enemy." But if Vaché did not take the same joy in war that the Futurists did, neither was he anything so positive as a deserter or a defeatist; his attitude was, rather, one of total indifference. Since "everything we look at is false," the outcome of events is "no more important than the choice between cake and cherries after dinner."

This indifference was consistent with the more obvious aspects of Vaché's dandyism, such as his obsession with fashions in men's clothes. Vaché took the role of a dandy with a seriousness equal to that of Barbey d'Aurevilly and Baudelaire. The latter had called dandyism the "last flash of heroism in an era of decadence." Unwilling to accept the values of the society in which he lives, the dandy creates his own world and chooses his morality, like his clothes, to suit his style. As a man of displaced sensibility, he is an outsider and to some extent, therefore, a prototype of the modern artist. Dandyism was a widespread phenomenon in Dada. In Zurich, Arp often wore English clothes, and shoes designed by himself. George Grosz, in Berlin, "preferred to conceal his sensitivity beneath the brittle and provocative appearance of a dandy," while Hans Herzfelde wore Savile Row clothes and changed his name to its English equivalent, John Heartfield. Monocles were fashionable, and Tzara, Grosz, Hausmann, Breton, and Arp were among those who sometimes wore them. "The very sight of a monocle in those days," recalls Hannah Höch, "offended the stuffed shirts who claimed to be progressive." All of them came from well-to-do middle-class families, but the modes of their reaction were parodies of the aristocratic.

The dandy remains, however, just one in the gallery of types which Dadaists created in their pursuit of the *displacement of the self,* which was to be a realization on the plane of action of Rimbaud's "I is another." The most baroque Dadaist was certainly Baroness Elsa von Freytag-Loringhoven, whose photos, bare-bosomed and wearing an Easter bonnet, were published by Man Ray and Duchamp in *New York Dada* (fig. D-46). "Dressed in rags picked up here and there, decked out with impossible objects suspended from chains . . . her head ornamented with sardine tins, indifferent to the legitimate curiosity of the passers-by, the Baroness promenaded down the avenues like a wild apparition, liberated from all constraint." The most complex and subtle displacements of personality, however, were perhaps those affected by Duchamp, who, as R. Mutt, had sent a urinal (Readymade) titled *Fountain* (fig. 20) to the Society of Independent Artists exhibition in 1917 (of which he himself was a juror), and who, by 1920, professed to have reincarnated himself as a woman named Rrose Sélavy (see "her" photos by Man Ray; figs. D-48, D-59), who lived at 14 rue de la Paix, where, among other activities, "she" edited books and signed Readymades.

Vaché's most crucial contribution to the formation of the Dada mentality was the propagation of a kind of ironic, paradoxical, and sometimes violent "black humor," which he called *umour* (the dropped *h* giving a hint of burlesque). The kind of outrageous and hyperbolic wit that it betokens is an old tradition in French letters

Alfred Jarry. *Père Ubu*

that goes back, in some ways, to Rabelais. It was injected into modern literature by the turn-of-the-century playwright and novelist Alfred Jarry (fig. D-47), whose writings, particularly *Ubu Roi* and the Rabelaisian *Gestes et opinions du Docteur Faustroll*, had great influence on both Dada and Surrealism. Vaché loved Jarry and insisted that there was a large dose of the *ubique* in his own *umour*. An extraordinary example of literary mimesis, Jarry's life ended in an hallucinatory confusion with the characters he had created. Vaché went even further. Abandoning the literary entirely, he catapulted Jarry's brand of humor into a form of proto-Dada by making it a principle of action. In thus abstracting *humour noir* from literature,

Vaché anticipated Ball's Dada ideal of life as a tragicomic "harlequinade" and Tzara's Dada definition of life as "a pun." Among the first to insist on the importance of the act, Vaché was admittedly influenced by the "*geste gratuit*" of Lafcadio in Gide's *Les Caves du Vatican*, a book he greatly admired and for which he had done some sketches. *Umour*, he wrote to Breton, means keeping the world "in astonished half-ignorance" until the sparking of some "scandalous manifestation."

One such manifestation took place at the 1917 premiere of Apollinaire's *Les Mamelles de Tirésias* (itself a play to *épater le bourgeois*), which bore the subtitle "Surrealist Drama." (This was one of the first appearances in print of the term "Surrealist," which had been coined shortly before by Apollinaire and was to be canonized seven years later by Breton.) Breton himself was there: "The first act had just finished. An English officer was creating a huge racket in the orchestra; it could be none other than he [Vaché]. The scandal of the performance had enormously excited him. He had entered the hall, revolver in hand, and was now talking of firing into the crowd."[16] This example (recall that random shooting had accompanied Cravan's 1914 soirée) was not lost on Breton, who in the second Surrealist manifesto (1929) was to write: "The most simple surrealist act consists of going down into the street, revolvers in hand, and shooting at random, as much as one can, into the crowd."[17] Vaché's threat of random firing was a "critical provocation" par excellence, as it implicitly questioned the central adventure in which the world was then engaged: if it was "realism" to shoot a human being because he wore a German uniform, it would be "superrealism" to apply the principle more broadly. Not all Dadaist acts were so threatening, but each constituted, Tzara proclaimed, "a cerebral revolver shot."

The capital act of Vaché's life was his leaving of it. His suicide, in 1919, from an overdose of opium (he was an experienced addict) at once fulfilled the nihilistic implications of his posture and assured his myth. Dead with him was another young man, but a third member of their party survived his overdose. It is very possible, as Breton notes, that Vaché's unhappy companions were new to the drug and that "in disappearing, [Vaché] wished to commit, at their expense, a last practical joke."[18] The notion of suicide continued, in any case, to pursue the wartime generation. Jacques Rigaut's papers, published after his suicide, contained the reproach: "You are all poets; I, myself, am on the side of death." His death prompted a Surrealist inquiry titled "Is Suicide a Solution?"[19] Among the replies was that of the poet René Crevel, who found it "seemingly the most just and defini-

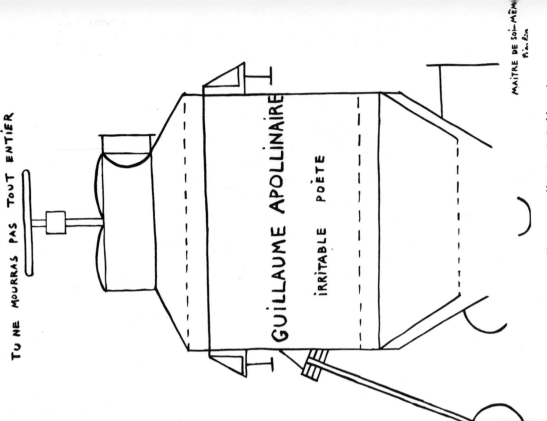

TU NE MOURRAS PAS TOUT ENTIER

GUILLAUME APOLLINAIRE

IRRITABLE POÈTE

MAITRE DE SOI-MÊME
Picabia

Francis Picabia. *Guillaume Apollinaire, irritable poète*

tive one." Crevel later acted upon this sentiment; his body was discovered with a piece of paper pinned to his jacket containing the single word: "Disgusted."

DADA AND ART

The plastic arts played only an ancillary role in Dada and Surrealism; they were held useful as means of communicating ideas, but not worthy of delectation in themselves. The more pressing concern of these movements with philosophy, psychology, poetry, and politics stamped the art they encouraged with a character much in contrast to that of prevailing avant-garde ideals. At a time when modernist abstraction seemed to be claiming autonomy for painting, the Dadaist reaction was to "humiliate" art, as Tzara advocated, by assigning it "a subordinate place in the supreme movement measured only in terms of life."[20] Later, Breton would call painting "a lamentable expedient."

Dada and Surrealism proposed life attitudes that, particularly in the case of the latter, coalesced into comprehensible philosophies. But they fostered activities in the plastic arts so variegated as almost to preclude the use of the terms as definitions of style. "Impressionism" and "Cubism" designated particular painting styles that already existed; the terms "Dada" and "Surrealism" pre-existed the art to which they were applied. Obviously, a definition of style that, for Dada, must comprehend the work of Duchamp and Arp and, for Surrealism, that of Miró and Dali will be problematic. Yet the alternative is not simply to accept confusion. We can distinguish in Dada and Surrealist art some common properties of style and many common denominators of character, iconography, and intent.

The literary hero of the Cubists in the five years before the outbreak of World War I had been Wilhelm de Kostrowitzki, better known as Guillaume Apollinaire. Apart from being a poet, Apollinaire also acted as critic, propagandist, and *agent provocateur* of the plastic arts. His taste was broad, and he was as receptive to the painting of Giorgio de Chirico, whose work he was the first to champion, as he was to the Cubists. Yet despite the quasi-Dada nature of some of his own work (*Les Mamelles de Tirésias*, for example), a real gulf separated him from nascent Dadaism. Vaché was right in insisting that Apollinaire "marks an epoch," an epoch that ended when the Dadaists denied the value and efficacy of art, which, even in its most advanced contemporary forms, they considered just another aspect of a corrupt culture. Vaché, for whom art was *une sottise*,

suspected Apollinaire of "patching up Romanticism with telephone wire." Apollinaire insisted: "I have no fear of art."

Dada initiated a shift in attitude toward modern art, at least in certain vanguard circles, a shift which determined not only Dada's own course but, with modifications, that of Surrealism. In view of the reaffirmation of "pure painting" which the years following World War II have seen in America and Europe, and despite the more recent renewed interest in Dada in an estheticized form, it is now evident that the *programs* of Dada and Surrealism constituted, historically, a major interlude (about 1913–47) of reaction against the main premise of modern art, which was in the direction of the *increasing autonomy of art* as such. Recent so-called Neo-Dada and even more recent Pop art, like that of the earlier Symbolist and Expressionist movements, are plastically oriented despite their involvement with subject matter, and to that extent are at odds with the anti-art men-

tality fostered by Dada. The bronze *Light Bulb* of Jasper Johns (fig. D-295) strikes us in its refined estheticism, in the sensibility of its surface modeling. It is precisely what a Readymade bulb of Duchamp would not have been: a real piece of sculpture.

Before 1860, painting had almost always been in the service of something—religion, ethics, history, government. And in order to celebrate such relatively specific ends and institutions, it had to have a recognizable imagery. In this older art the image content was generally considered more important than the style; with few exceptions, the artists were *imagiers* first, *peintres* afterwards. The disengagement of painting from the service of collective and institutional values—in other words, the advent of modern art—was signaled by Manet and the Impressionists. Descriptive content began to decline in favor of the communication of feeling through color, form, texture, and other purely formal values, in the direct manner of music. Such communication, while less particularized than that of older art, was felt, at least by the painters, to be just as intense. Painting, to use Meyer Schapiro's formula, increasingly came to be about the *possibilities of painting*. And as an activity in its own right, it assumed greater moral and social significance. Not that descriptive subject matter disappeared, of course; it simply ceased to maintain its central role.

Since subject matter has always been that part of painting which appealed directly to the intellect, its demise left the field open to an art based more and more on sensations. Even such subjects as did survive in Impressionist, Post-Impressionist, and Fauve pictures were directed not to the mind but to the pleasure of the senses. Despite some success on the part of the Symbolists and pre-World War I Expressionists in creating meaningful, viable subjects for modern art, the main tendency of European painting was poised, by 1910, for the triumph of "pure painting": the creation of nonfigurative art. This latter appeared, literally, in the three years preceding the war in the work of Kandinsky and the Orphists, and to all outward appearances in the 1911–12 works of the Cubists.

It was in the context of the euphoria produced by this plastic breakthrough, so strongly reflected in Apollinaire's book *The Cubist Painters* (1913), that the pioneers of what was later called Dada began their reaction. "I was interested in ideas—not merely in visual products," Duchamp recalled.

I wanted to put painting once again at the service of the mind. And my painting was, of course, at once regarded as "intellectual," "literary" painting. It was true I was endeavoring to establish myself as far as possible from "pleasing" and "attractive" physical paintings. . . . The more

sensual appeal a painting provided—the more animal it became—the more highly it was regarded.[21]

The Dada attack upon art was two-pronged: the purgative and "reactionary" extremes of Dada came to be called "anti-art," but its less absolutist explorations led indeed to a revival of "poetic painting" (*peinture-poésie* as opposed to *peinture-peinture*, or "pure painting" as it is spoken of in the modern French tradition). It is not surprising that the new attention paid to subject matter, even if only in an indirect and allusive way, should have subjected Dadaist painting, as in the case of Duchamp, to the reproach of being "literary," which same criticism was leveled even more frequently (and with somewhat more justification) at the Surrealists, who continued the tradition of *peinture-poésie*. It is necessary, however, to keep clear the distinction—not always made in writing on modern painting—between the "poetic" and the "literary." There is no limit to the poetic, dramatic, psychological, or historical charge a picture may carry without becoming "literature" so long as the point of departure for these values lies in qualities proper to painting. The suprapainterly insights thus communicated remain, however, inseparable from the nature of painting and are untranslatable into any other medium. It is only where the plastic qualities of a picture are wholly submerged by extraplastic concerns, only where painting is thought of as a vehicle separate from the content conveyed, where it becomes wholly descriptive in a narrative rather than a metaphoric sense, that it can be called "literary." Figuration in itself no more prevents plastic richness than the absence of figuration guarantees it.

Anti-art stood first for a rejection of what Dada considered the hermetic estheticism and escapism of pre-1914 modern painting. "The Dadaist," said Huelsenbeck, "considers it necessary to come out against art because he has seen through its fraud as a moral safety valve."[22] The problems facing the world had never been more serious, but the advanced art of the time seemed further than ever from being able to act, even indirectly, upon them. It was evident, according to Breton, that "the more and more necessary transformation of the world is *other* than that which can be achieved on canvas."[23] It is in this context that Vaché, who had originally intended to become an artist (he studied with Luc-Olivier Merson), was to turn from art to "disgorge a little acid."

Anti-painting implied principally anti-Cubism, the rejection of art deriving from Cézanne, whose "portrait" by Picabia consisted of the montage of a stuffed monkey (fig. D-49). But despite the endless disparagement of art in Dadaist manifestoes, it was not so much art

itself as "the idea that had been made of it" (that is, the autonomy of "pure painting") which Dada wanted to destroy.

Anti-painting meant the rejection of techniques as well as attitudes traditionally associated with picture making. Between 1912 and 1914, Duchamp, who was not only the inventor of anti-art but also the only artist to see its implications through to their speculative end, progressively gave up brush, oil paints, and canvas. In 1914, by fiat, he conferred upon a production-line bottle rack the status of a "sculpture" (fig. 16), one of the earliest of his Readymade art objects. In Robert Motherwell has observed that the bottle rack Duchamp chose appears in retrospect more beautiful in form than almost anything made, in the year 1914, in the line of deliberate sculpture (an ironic fate, since "beauty" was the last thing Duchamp was after). "It is also," Motherwell continues, *"a subtle solution to an essential Dada dilemma, how to express oneself without art when all means of expression are potentially artistic."*[24] The Dada collage created by Max Ernst, the Dada photomontage of the Berlin group, and the textbook-like "anti-drawings" of Picabia were all "solutions" to this same problem. Picabia became, after Duchamp, the greatest master of anti-painting. "He found in it," writes Gabrielle Buffet-Picabia, "a formula of black humor which gave him free rein to express his rancor against men and events, an inexhaustible vein of plastic and poetic sarcasms." Whatever the label given it, anti-painting [was] a general crisis which transcended individual experiences."[25]

Dada refused to consider itself the successor of Futurism and Cubism; as that, it would have constituted no more than the latest in a long parade of literary and artistic movements. It insisted, instead, on its ahistoricism. Dada could exist only in the present, and its creations could have efficacy only in the present; these creations neither updated values of the past nor provided models for the future. Since a work of art becomes history the moment it is completed, there was logic as well as wit in the Dada "manifestation" in which Picabia made drawings that Breton erased as he went along. Duchamp discovered another way to keep an art work open-ended when he purposely left his *Large Glass* unfinished, so that it required, he has implied, repeated creative acts on the part of spectators for its completion.[26]

Dadaists felt that all older art was useless for present purposes, and nothing struck them as more ridiculous than the homage paid to the old masters, to art with a capital A. Duchamp "improved" a reproduction of the *Mona Lisa* with beard and moustache (fig. D-50), and Otto Schmalhausen doctored a plaster bust of Beethoven. Yet their repudiation of past cultures differed in motive from the attack on

history by the Italian Futurists. For the latter, the problem had been that of getting out from under the dead weight of the museums in a country which seemed, on the eve of World War I, to have been by-passed by modern times. While the Futurist, in his excitement over contemporary technology, might find a motorcar more beautiful than the *Nike of Samothrace*,[27] he never doubted the latter's esthetic value. Dada's ridicule, on the other hand, was an assertion of the meaninglessness of the values themselves.

The efficacy of art, to the extent that Dada admitted it at all, lay in the purposeful *act* of making it. The object created was not an end in itself and consequently nothing to be prized.[28] This suggested the resurrection of that "millennial" view according to which art justifies itself only as the herald and agent of a more advanced historical state, and the implication is that when this millennium is achieved, art will disappear or become vestigial. While Breton could not personally accept the extreme of the Dada position as advanced by Duchamp, for whom the usefulness of even anti-art was already at an end by 1920 (at which time he became an "engineer"), participation in Dada helped determine the many restricting conditions hemming in his allowance of art in Surrealism. Prior to the formulation of the first Surrealist manifesto, he was to write in *Les Pas perdus:*

It would be an error to consider art as an end. The doctrine of art for art's sake . . . seems senseless to me. We know that poetry must lead somewhere . . . painting, for example, should not have for its end the pleasure of the eyes. . . . I persist in believing that a picture or sculpture . . . is justifiable only insofar as it is capable of advancing our abstract knowledge properly so called [*nôtre connaissance proprement dite*].[29]

But art cannot be made from life alone, even less from particular psychological methodologies; more than anything else it is made from art. No matter what the radicality of an artist's *démarche*, or his commitment to extrapictorial concerns, he sets out from some definition of art. Hence, despite the postures assumed by some of the Dada and Surrealist artists, they were all in an enforced dialogue with the art that preceded them. The "anti-art" created by Dada pioneers such as Duchamp and Picabia seemed to reject out of hand the premises of modern painting as they stood on the eve of World War I. But "anti-art" depended from the first on the very presence of the "pure painting" against which it reacted, and it incorporated more of that "art-art" than its authors knew. While the Dadaists used the term "anti-art" to deny the tradition of modern art, in retrospect their work takes its place in that tradition, enriching more than denying it.

While the term anti-art might be applied to most Dada plastic creations, at least in the sense that their authors aspired to produce something "beyond painting" (to use Max Ernst's phrase), its use as a descriptive common denominator goes no further. If such terms as Impressionism, Futurism, and Analytic Cubism conjure up relatively specific and definable styles, the term anti-art does not. It denotes rather an anarchy of images striking out in different directions, whose sole common denominator is their dialectical relationship—direct or indirect—to earlier phases of the modernist tradition.

The history of Dada art from its proto-Dada phase of 1912 until its fading after 1922 is that of the gradual attrition of the original anti-esthetic ideal. The way "beyond painting" was first proposed by Duchamp, who, if "unquestionably the first to assert himself as a Dada," as Robert Lebel observes, "was one of the few who have remained so all their lives."[30] His departure from the Cubist-Futurist formulations of 1912, a redirection we shall study in detail a little later, led in the period 1913–18 to what is often called the "machine style": the creation of ambiguous "being-machines" realized with forms of a pseudomechanical nature. This early Dada style, which existed before the name Dada was coined, was elaborated by Duchamp first in Paris and later in New York. Picabia developed his own version of it, which, after stays in Paris and New York, he introduced to Spain and Switzerland, where the Zurich group of the Cabaret Voltaire became acquainted with it.

Paradoxically, the Zurich group, which was the first to call itself "Dada," was much more reluctant to accept the extremes of anti-art than the denigrations of art contained in its manifestoes would suggest. While Huelsenbeck may be exaggerating when he recalls that "an art for art's sake mood lay over the Galerie Dada,"[31] there was no question in Zurich of anything so radical as Duchamp and Picabia's *démarche*. Most of the anti-art talk there came from the poets and philosophers, not from the artists themselves. Arp and Janco remained, for the most part, discreetly silent. And the contribution that Zurich Dada made to modern art, almost entirely identified with the pioneering works of Arp, was one of greater plastic possibilities, if few philosophical challenges, than that of Duchamp and Picabia.

Late in 1915, Arp established a vocabulary of ambiguous biomorphic forms which, while never literally describing anything, evoked associations with plant, animal, and human forms. An attempt to probe and poetically express the internal organic and psychological processes behind the surfaces of things, it constituted in some ways a continuation of the *plastic representation of an internal event*

attempted by Duchamp in the paintings of 1912. But it contained none of the allusions to mechanical movements which led Duchamp to the machine style.

Max Ernst came of age artistically at the end of the war, and his collages of 1919–20 represent the next important phase of Dada art. By the very nature of the collage elements he liked, Ernst was drawn toward more descriptive images. He was influenced, moreover, by the three-dimensional perspective space and oneiric illusionism of de Chirico, the adaptation of whose practices set Ernst at some distance from Arp's flat designs and provided a bridge to what later became the illusionistic branch of Surrealist painting. The attempts of Arp and Ernst to go "beyond painting"—Arp with his flat-painted, machine-sawn reliefs and Ernst with his collages—represented not so much a Duchampesque attempt at anti-art as a response to the feeling that the nature of prewar painting had been excessively hermetic and esthetic. What they produced formed the basis (along with the painting of de Chirico) for the tradition of *peinture-poésie* which was to survive in Dada and animate a quarter century of Surrealism.

By the end of the war, shortly before Ernst began working in Cologne, Dada art appeared elsewhere in Germany. Aside from George Grosz's incisive caricatural paintings, Berlin's main artistic contribution was the typo-photocollage, the most important practitioners of which were Raoul Hausmann and Hannah Höch. But plastically Berlin Dada, which was torn between literal political propaganda and Futurist, Constructivist-Suprematist tendencies, made no contribution comparable in importance to those already mentioned.

Also at the end of 1918, Kurt Schwitters, in Hanover, founded a tangential branch of Dada, which he distinguished by calling it **Merz,** a neologism adopted from a torn advertisement containing the word *Kommerz* that he had used in one of his collages. Schwitters' productions, including sound poems, the *Merzbau* (he turned his home into a cathedral of selected junk and refuse; figs. 98, 99), and plans for a *Gesamtkunstmerz* (a synthetic "Happening" combining simultaneous appeals to sight, smell, touch, and hearing), certainly deserve to be characterized as Dada. But if we confine ourselves to his collages, we discover works in most ways closer to Cubism (and sometimes Futurism). They have always been considered Dada because of the "anti-materials" from which they are constructed—trash-basket waste, odds and ends picked up by Schwitters in the street and countryside. But many of these materials had already figured in Cubist *papiers collés* and constructions; although Schwitters broadened their range, systematized their use, and extracted a special poetry from

them, his collages remained plastically within the framework of the Cubist grid and the radiating patterns of the Futurists. From what has been said, it is not surprising that in his attitude toward art, Schwitters stood diametrically opposed to earlier Dada anti-artists. "Art," he insisted, "is a primordial concept, exalted as the godhead. . . . Merz stands for freedom from all fetters, for the sake of artistic creation. . . . As a matter of principle, merz aims only at art. . . ."[32]

By 1920, the magnetic center of Dada had shifted to Paris, where for two years its "manifestations" had an extraordinary *succès de scandale.* In the four years after the war, Duchamp, Picabia, Man Ray (who had joined Dada in New York under Duchamp's tutelage), Arp, and Ernst all sojourned at one time or another in Paris. But while Parisian Dada was to be the glory of the poets, largely under the impetus of Breton, Tzara (who had been "awaited like a Messiah" in 1919), and Picabia (in his capacity as Dada poet and activist rather than as a painter), it contributed nothing new to modern art but witnessed, rather, the elaboration of earlier discoveries.

A POST-CUBIST MORPHOLOGY

It is only as we follow the development of Dada artists into the Surrealist decades that the apparent anarchy of Dada styles begins in retrospect to resolve itself into several basic directions. Though the Surrealists strove to distinguish their work from Dada, the evolutionary continuity could not be disguised. This continuity was particularly apparent in painting, if only because of the continuity of the personalities involved. Arp and Ernst were to become pioneer Surrealists, and Picabia, while formally rejecting association with the movement, produced work not unrelated to it. Duchamp, though he had long since given up painting, was active in the Surrealist movement in other ways.

The tradition of *peinture-poésie* in the years between the world wars depended on two main sources, both of which were established in the second decade of the century: the biomorphism vaguely anticipated by Duchamp and realized by Arp, and the poetic spatial illusionism of de Chirico. The de Chirico style, which lent itself to the surreal dream image, was much discussed by the Surrealists, as we shall see later. The biomorphic or organic form, perhaps too plastic an element to appeal to the Surrealist poet-critics, was passed over in silence. And yet it represents a major common denominator—perhaps the only one—which allows us to draw together the stylistic innovations of the Surrealist years. If there is a characteristic formal

element that runs like a leitmotif through the stylistic innovations of 1915–47, it is surely this biomorphology. Studying the period in these terms allows us more clearly to set off its styles against the Cubism that preceded it and the new American painting—or, less accurately named, Abstract Expressionism—(and its counterparts in Europe) which succeeded it.

While de Chirico's influence on Surrealism was broad, it left much of the best Surrealist painting untouched. Miró, Arp, and André Masson, all charter Surrealists of the twenties, explored the possibilities of biomorphism but rejected the three-dimensional scaffolding of de Chirico. Nevertheless, such Surrealist painters as Dali and Yves Tanguy, whose space, light, and (to a lesser extent) modeling derived from de Chirico, made constant use of the biomorphic shape. Among the Surrealist painters, only certain illusionist extremists— Magritte and Delvaux, for example—abstained from biomorphism (and in the early works of Magritte there are exceptions like *The Acrobat's Ideas* of 1928; fig. 179). So far as the *plastic* development of (non-Cubist) Dada and, more particularly, Surrealist art is concerned, I venture the thesis that it is, above all other determinants, the saga of biomorphism. It is a measure of their immersion in iconography and their lack of concern with the forms of art that Breton and the other Surrealist writers never even raised this question.

The curvilinear style of *fin-de-siècle* painting (Lautrec and the Nabis) had provided some vague anticipations of the organic morphology but pointed more directly to the arabesqued lyricism of Matisse and the Fauves than to Arp or Miró. The art of Redon played a certain role (his forms were limited by their literalness) but it is in the decorative arts rather than in painting that the most significant adumbrations of biomorphism are to be found. Art Nouveau, particularly the work of Henry van de Velde, Victor Horta, and Hector Guimard, was rich in convoluted organic shapes of botanical derivation (figs. D-19–21). But as an essentially linear style, Art Nouveau provided few instances of the large, solid, and massed biomorphic forms that we find later in Arp, while the insistently floral connotations of most Art Nouveau shapes precluded the anthropomorphic allusions which were central to the poetry of the painters who later explored biomorphism. Nonetheless, the indirect influence of Art Nouveau was widely felt; it was the style of the childhood years of the Dada and first Surrealist generations, and echoes of it are scattered through their works, particularly in those of draftsmen like Miró, on whom the work of Gaudí (fig. D-16) had an unquestionable influence. Dada and Surrealist criticism was for the most part silent on Art Nouveau; only Dali championed it, though his article in

Minotaure[33] in 1933 dealt with its fantasy rather than its forms.

The first adumbration in painting of the new counter-Cubist morphology is found in Duchamp's canvases of 1912. It accompanied his shift from an external (and essentially Futurist) view of the human mechanism (*Nude Descending a Staircase, No. 2*; fig. 5) to his suggestion of an *internal event* expressed in ambiguous psychological and physiological terms (*The Passage from Virgin to Bride*; colorplate 1). In such pictures Duchamp overcame the Cubist-Futurist insistence on locking the arabesque in the vertical-horizontal grid, but only a few of his curvilinear shapes really approached the organic; the forms hung ambivalently between the images of the body as machine and as organism. By 1913, the machine idea had triumphed in Duchamp's art. Two years later the new biomorphism was clearly and firmly established by Arp.

The Stag of 1914 (fig. 56) and subsequent Dada reliefs and woodcuts constitute Arp's point of departure and represent the high-water mark of Zurich Dada. Although sometimes influenced by de Chirico (as in *Fiat Modes*) and the machine scaffolding of Picabia (as in *Glacial Landscapes*), Ernst's Dada works only occasionally display biomorphic forms (*The Gramineous Bicycle*; fig. 88) while introducing a taste for ornamental richness, elaborately whimsical iconography, and more literal detail than we see in Arp. In later years, Ernst was to return to this morphology from time to time, but in his exceedingly rich catalogue of styles the organic form is to be found less than in the work of any other pioneer Surrealist.

The adoption of biomorphism marked the transition of Miró and Masson from Cubism to Surrealism in the early twenties. From *The Harlequin's Carnival* (begun in 1924; colorplate 15) to Miró's work of the present day, it has been the fundamental constituent in the vocabulary of his pictures, and from the point of view of both quality and quantity, no painter has put it to better service. Miró retained Arp's flatness and rejected Ernst's illusionistic modeling and spatial tricks. He endowed biomorphism with far greater variety and richness than we find in Arp, and put it at the service of a sense of color second only to Matisse's and Bonnard's. Masson used the new morphology less consistently, abandoning it almost completely at times and pressing it too far toward the literally visceral at others. It is nevertheless common to his best work: the extraordinary sand paintings of 1927 and the dark pictures of his American period.

Starting in 1927 and using an increasingly academic dry technique, Tanguy turned the biomorphic shape into an illusion of a three-dimensional object of crystalline hardness, and set it within a Chiricoesque space. Not long after Tanguy began thus depicting sculp-tural forms, Arp endowed the biomorphic form with an actual concreteness by producing his first sculptures in the round. Dali's earliest Surrealist pictures of the very late twenties are indebted to Tanguy, whose biomorphism he transmuted by grafting it to a style of Pre-Raphaelite literalness. Then, in 1938, Matta (Sebastian Antonio Matta Echaurren) put the biomorphic shape in motion, metamorphosing it endlessly through what appeared to be vaporous, liquid, and crystalline states, to create what Meyer Schapiro has aptly called "the futurism of the organic."

The last Surrealist painter in whose work biomorphism played a crucial part is Arshile Gorky, who kept it close to the world of nature and endowed it with an unexpected pathos and urgency. Strictly within the Surrealist line in most of his forms (in his mature, post-1940 works), Gorky's love for paint set him apart from the Dada-Surrealist tradition, which disdained the medium as such. While he was thought for a time to have been the initiator of the new American painting—or Abstract Expressionism, if you will—Gorky appears in retrospect much more tied to the European tradition and, plastically, to Surrealism. And it is with him that the adventure of the biomorphic form comes to a virtual end. Its final appearance as a formal device in painting of quality (apart from the *surréalisant* early works of such painters as Rothko, Stamos, Pollock, Gottlieb—and its extension in Baziotes) is in the late forties works of de Kooning, who at the time was somewhat influenced—morphologically—by Gorky. De Kooning further "agonized" the biomorphic form, tearing it open to give it an angular, expressionist character. In making it his own he obliterated it; not long after, its remaining fragments were absorbed into the Cubist-derived grid which has since provided the underpinning for de Kooning's compositions.

While most founders of the new American painting thus used organic forms in one way or another during the transitional years of the early forties, they dropped these in their later and more independent work. In Europe, Picasso alone among the pre-World War I masters (and Kandinsky in a very limited way) exploited this new form-language. Matisse and Bonnard spent the years between the wars cultivating their own gardens, disdaining the new art and being largely disdained in return by the young painters of the avant-garde. At the very end of their careers, they were resurrected as models by the first post-Surrealist generation, which matured just after World War II. With this reinstatement of their reputations, fostered not a little by the fact that in their old age they produced some of their most glorious works, came what appeared, at first glance, to be a wholesale return to the principles of *peinture-peinture* by that

younger generation both in Europe and in America. But, as we shall see later, this new abstraction was markedly different from that to which Cubism and Fauvism alone might have been expected to lead. And this difference depended on the artists' experience with the forms and poetic content of Surrealist painting.

That biomorphism is a formal common denominator of a variety of styles still leaves open the question of its particular expressive character. Some light may be thrown here by contrasting biomorphism with the form-language or morphology of Analytic Cubist painting, its historical predecessor. The Analytic Cubist picture in its most developed state (for example, Picasso's *Ma Jolie*, 1911–12, fig. D-30; and Braque's *Man with a Guitar*, 1911) consists of an architectural (that is, vertical and horizontal) scaffolding seen through a sprinkle of Neo-Impressionist brushstrokes. Emerging and submerging in the myriad touches of pigment that provide the painting's luminosity, the fragmentary shapes tend to align themselves with the verticals and horizontals of the frame as if by magnetism. Diagonals are not infrequent but are subordinated to the prevailing grid, while arabesques are rarer and almost invariably enclosed within straight lines. The result is a composition whose stability is continuously reinforced by our perception of the smaller and more subtle aspects of the grid.

Jean Arp. Woodcut

The main anti-architectural element in the composition—the dissolution of the scaffolding toward the edges of the canvas—is a vestige of the figure-ground relationship in older center-dominated illusionistic pictures; but this "weakness" was soon to be overcome by the Cubists in their so-called "synthetic" phase, and by the later Mondrian, who carried certain implications of Cubism to what seems retrospectively an inevitable conclusion. The subject which was the artist's starting point (a woman with a guitar in the case of *Ma Jolie*) makes little difference in the advanced Cubist picture of 1911-12 owing to the extreme to which the process of abstraction and reorganization is carried. All subjects, whether inherently architectural or not, end as architecture.

Verticality and horizontality are not so much the properties of man as of the manmade world, the environment that man creates in order to function with maximum stability. The Cubist picture speaks of this external world—one that man constructs and upon which he meditates—abstractly, from a position once removed. To the Dada and Surrealist generations this attitude of reserve seemed too detached, too disengaged from a man's psyche and passions, from his need for movement and change. In creating an art that would "return to man" it is not surprising that the Dadaists and Surrealists should have developed a form-language with properties evoking the inwardness—both physiological and psychological—of man. The very terms "organic" and "biomorphic" testify to the new humanism. Compare the Picasso and Arp prints on these pages. The former is balanced and stabilized and unfolds with a pictorial logic, though not predictability, which makes its stasis seem classically definitive; the latter might be turned any way—its contours unwind in a free and meandering manner implying growth and change. In the Arp we no longer have the sober, classical scaffolding of the collective external world of architecture but a unique and ambiguous shape which, while describing nothing specifically, multiplies associations to the physiological processes, to sexuality, and, through its very ambiguity, to humor. It is a shape that turns man's speculation in on himself and away from the transcendent and impersonal order of Cubism.

Although biomorphism opened the way to a new vocabulary of forms, it did not in itself constitute a style (in the sense that Impressionism or Cubism did). Nor did it help determine or generate any new comprehensive principle of design or distribution of the

Pablo Picasso. Drypoint

21

total surface—or of the illusion of space—in pictures. Rather it provided constituent shapes for paintings in a variety of styles. When more than one or two such shapes are used by the "abstract" Surrealists, we almost always find them disposed in relation to one another and to the frame in what is ultimately a Cubist manner. Thus, while we may speak of the form-language or morphology of Arp, Masson, and Miró as anti-Cubist, this does not apply to the overall structure of their compositions, since these painters cling on *that* level to organizational principles assimilated from Cubism (which all had practiced earlier). This is most easily illustrated by an extreme example, Miró's *The Harlequin's Carnival* (1924-25; colorplate 15), which should be compared with his "Cubistic" pictures of the early twenties. *The Harlequin's Carnival* is a full-blown Surrealist work, its iconography related to (Miró's own) poetry (see below, p. 154) and its forms almost entirely biomorphic. But despite the suppression of straight lines and vertical and horizontal accents, the multitude of little organic forms are distributed over an underlying Cubist grid —the picture's infrastructure—as if constrained by some rectilinear magnetism. We see the distillation of this particular design principle in Miró's late "Constellations" (fig. 359). With the Mondrians of 1913-14 (figs. D-31, D-32) and certain Surrealist works of 1925-27, they constitute a bridge from Analytic Cubism to the "all-over" patterning of Pollock, Tomlin, and others in the late forties.

THE PAINTINGS OF MARCEL DUCHAMP

The very beginnings of the Dada movement are to be found in Marcel Duchamp, and in this regard it is symptomatic that he is perhaps the only painter to have impressed the world of art as much by what he did not do as by what he did. But it took an age in which painting had become an autonomous ideal, a way of life, and even, in Malraux's terms, a quasi religion for his inaction to be meaningful. After "incompleting" the *Large Glass* in 1923 (fig. 19), and retiring to a life of chess, punctuated occasionally by the creation of ironic "machines" and by other forms of Dada activity, Duchamp became a living myth, the personification of Dada's refusal to distinguish between art and life. His insistence that painting was but "one means of expression among others, and not a goal destined to fill an entire lifetime," remained a permanent challenge to artists. For an age in which painting has been identified with freedom, his own greatest freedom, paradoxically, became the freedom to abstain from painting.

The persistence of a myth depends, however, not on the authen-

ticity of the facts or events that it derives from but on its viability for the age that uses it. The sense of crisis that pervaded art between the wars lent great prestige to Duchamp's nihilism. In this regard, the wholehearted reaffirmation of pure painting that followed World War II took some of the urgency out of the Duchamp myth. Though his personal prestige with the immediate postwar generation was great, the extra-artistic implications of his work and of his retreat from it were overlooked. This attitude was then reversed by the younger generation of New York artists such as Robert Rauschenberg and Jasper Johns, sometimes wrongly labeled Neo-Dadaists, and by their counterparts, the *nouveaux réalistes*, in Paris. Yet if the first command of an artist is to be true to that in himself which he must express, then Duchamp's abandonment of painting was the ineluctable consequence of his particular genius.

This is not to imply that the work Duchamp *did* produce is of secondary interest. On the contrary, among his handful of pictures are a few masterpieces. Moreover, his work of 1911-13 provided the basis of Picabia's imagery in the years following and gave Matta some plastic and iconographic ideas he used in the early forties. There, however, the direct influence of his *painting* ceases. His Readymades, on the other hand, anticipated if they did not engender the entire Dada and Surrealist cult of objects—to say nothing of their more recent influence—and his final rejection of art gave force to the "millennial" ideal that dominated Surrealist art attitudes.

Nothing in Duchamp's work before his emergence as a mature painter in 1911 prepares us for the rapidity of his development during the subsequent four years. By 1915, when he began the *Large Glass*, all that was essential in his contribution as an artist had been established. No four years in the work of any other modern painter demonstrate such rapid stylistic development or witness so many radical departures in method and idea. Remarkably, the different stages of this progress are seldom represented by more than one picture. In fact, between *Sad Young Man in a Train* of 1911 (fig. 3) and his last painting, *Tu m'* of 1918 (colorplate 2), Duchamp executed only seven other oil paintings, two oil sketches, three works on glass, some thirteen Readymades and other objects, and some twenty small works in pencil, watercolor, and mixed media. Yet these works embody an evolution more extended and more varied in certain important respects than do the four years spanning the beginning and the end of Analytic Cubism, the stages of which are marked, in Picasso's oeuvre alone, by thousands of paintings and drawings. This testifies to a great difference in procedure between the two artists. Picasso finds his way through Cubism *in the act of painting*. The

development is by accretion and subtraction, slight changes taking place from work to work. Duchamp advances speculatively, not by painting but *by cerebration*; the finished work representing the plastic re-creation of a reality which had grown to maturity in the mind.

Most of Duchamp's early work has been lost; typical of his extant painting done prior to 1907 is a portrait in the Arensberg collection that is run-of-the-mill student work with a touch of *fin-de-siècle* self-consciousness. From 1907 through 1910, he assimilated some of the influence of Cézanne, which was very much in the air, but produced work that was in general much closer to Fauvism. The color of his Fauve canvases seems to Lebel "unusually bold and unexpected," with an "acid stridency," perhaps closer to German Expressionism than to the Fauves."[34] But his was not the real acidulousness of a Kirchner, for example, in whose works the prevailing offshades create an aura of *Platzangst* that contrasts with the *joie de vivre* expressed by the primaries of the Fauves. The stridency of the early Duchamp's color springs not from a desire to project Expressionist anxiety but from the inability to control color in the manner of mature Fauve painting. Since, moreover, his later painting is monochromatic, there is no basis for attributing to Duchamp any special gift as a colorist—the sensibility, in any case, of a painter in the "retinal-sensation" tradition. Rather, his forte, like that of "intellectual" painters in all ages, was his draftsmanship.

Portrait (*Dulcinea*; fig. D-51) and *The Sonata* (fig. 1), painted early in 1911, mark the start of Duchamp's real advance. Until that time, he had been occupied by Fauvist techniques that were already abandoned by the leading Fauve masters. Now, with his brother Jacques Villon's canvases as steppingstones, Duchamp caught up with the avant-garde. From Villon he adopted a tenderly colored, transparent kind of Cubism that leaned more on the washlike over-lapping of translucent facets found in some late Cézannes than on the contemporary work of Picasso and Braque. Though the color facets of Duchamp's pictures are flat, and traditional modeling, still abundant in some of his "Fauve" canvases, has been minimized, the remains of a perspective space, especially in *The Sonata*, suggest that he had not responded to the need to affirm the picture plane which was leading the pioneer Cubists toward an increasingly flat image. In fact, we may distinguish even the mature paintings of Duchamp in 1912 from the Cubism contemporaneous with them by the fact that, while Picasso and Braque had virtually dissolved tactility and set their forms floating in a shallow frontal space, Duchamp never entirely renounced perspective vistas or the chiaroscuro modeling concomitant with such illusionism.

Though *The Sonata* and *Portrait* cluster toward the center of the canvas and dissolve toward the edges in a manner typical of Analytic Cubism, they differ significantly from Picasso's and Braque's com-positions in their inverted scaffolding. This is less evident in *The Sonata*, which is a top-heavy X composition, than in *Portrait*, where the five different positions of the same figure fan upward to form a V shape. We will see this anti-Cubist arrangement, which hangs from the top of the canvas, in *Sad Young Man in a Train* (fig. 3) and the first version of *Nude Descending a Staircase* (fig. 4), both of 1911, and (somewhat less explicitly) in *The Passage from Virgin to Bride* (colorplate 1) and *The Bride* of 1912 (fig. 7). Even when the V arrangement is not present (as in *The King and Queen Sur-rounded by Swift Nudes*; fig. 6), the forms are generally suspended from the upper part of the composition rather than planted below. The culmination of this fondness for suspension was the *Large Glass*, in which the forms seem to hang in the air against the background of the room which we see through it.

December, 1911, was crucial for Duchamp; during that month, he executed *Portrait of Chess Players* (fig. 2), which summarized what he had assimilated from Cubism up to that moment, and *Sad Young Man in a Train* (fig. 3), which marks the beginning of his independent imagery. *Portrait of Chess Players*, representing Duchamp's brothers Jacques Villon and Raymond Duchamp-Villon facing each other across a chessboard, is richer than the work of early 1911 in the variety and subtlety of its muted browns, greens, and yellows, and in the great complexity of its division of the surface. More important here, however, is the substitution of shapes of color for the Cézannesque facets or patches used previously in *Portrait*. The overlapping and interpenetrating planes of *Sad Young Man* (influ-enced, according to Apollinaire, by Robert Delaunay's Eiffel Tower series) are, on the one hand, less firmly shaped than those in *Portrait of Chess Players*; on the other hand, the picture interests us as Duchamp's first attempt to portray motion—that is, as a prototype for *Nude Descending a Staircase*.

Cubism had been for Duchamp a clue to the decomposition of forms; now he was to put them together again in a manner related to Futurism. In *Portrait* he had shown simultaneously five different positions of the same figure, but these did not constitute a *series*; that, exactly, is what the different positional phases do in *Sad Young Man in a Train*, which picks up an idea that had been in the air since 1910. At that time, the *Futurist Painting Technical Manifesto* had spoken of retinal afterimages and proposed a kind of art that would suggest motion by superimposing images of the same figure at slightly

different stages of action, as is demonstrated to academic perfection in such works as Giacomo Balla's *Leash in Motion* (fig. D-52). It is unlikely that Duchamp's innovation was directly influenced by Futurism, for although he knew Gino Severini, his ideas on motion had been developing well before the first Futurist Exhibition was held in Paris, in January, 1912, at the Galerie Bernheim-Jeune. It is probable that both Duchamp and the Futurists were influenced by common sources: the cinema and the chronophotographs of Muybridge (fig. D-53) and Marey. "Chronophotography was at the time in vogue," Duchamp recalls. "Studies of horses in movement and of fencers in different positions as in Muybridge's albums were well known to me."[35]

December, 1911, also saw the first version of *Nude Descending a Staircase* (fig. 4), curiously a less advanced and much less personal work than *Sad Young Man.* The forms of this first *Nude* are largely cylindrical and may reflect the momentary influence of Léger, while the closely juxtaposed linear splinters of *Sad Young Man* more directly anticipate the effects of the definitive *Nude, No. 2* (fig. 5). *Nude, No. 1* is realized, moreover, with a pasty, viscous pigment, reminiscent of Roger de la Fresnaye and other conservative Cubists, which in no way anticipates the fragile grace, transparency, and articulateness of the definitive version.

The second, and definitive version of *Nude Descending a Staircase* was painted in January, 1912, in slightly inflected but essentially monochromatic shades of brown virtually identical with the palette of Analytic Cubism, but with a diluted paint that harks back to the Villonesque works of 1910. The articulation is effected by the subtle play of light and dark (as is borne out in the success of the third version [1916], which is a black-and-white photograph of the second tinted with watercolor, ink, and pastel). The elements of the nude's body have been generalized into ciphers. "The reduction of a head in movement to a bare line," says Duchamp, "seemed to me defensible. A form passing through space would traverse a line; and as the form moved, the line it traversed would be replaced by another line—and another and another."[36] Amid the shuffled lines and planes one shape distinguishes itself especially: the semielliptical device of the hips. It alone adumbrates (but only slightly) the half-mechanical, half-organic forms of the subsequent oils.

The nude descends along a diagonal running from the left to the right side of the canvas, the action stopped at various points in a manner foretelling the effects of stroboscopic photography (see Eliot Elisofon's photo of Duchamp descending a staircase; fig. D-54). The picture hangs together better than the first version or *Sad Young Man*

because Duchamp extended the composition to fill the areas near the edges of the canvas, which had remained empty in the earlier pictures. But though the staircase fills the lower left and upper right of the canvas, the lessened density of the shapes, the darker tones, and above all the perspective devices in these areas deny that sense of surface continuity which was at that time being achieved in different ways by both Matisse and the Analytic Cubists. It is symptomatic that the spatial perspective in the upper right of the *Nude* should influence only one later artist, Matta; in such pictures as *Splitting the Ergo* (fig. 369), *The Onyx of Electra* (colorplate 48) and *Being With* (fig. 371). Matta became the only painter after Duchamp to explore wholly new possibilities in illusionistic space.

According to Apollinaire, Duchamp is "the only painter of the modern school who . . . concerns himself with the nude."[37] Duchamp's *Nude* is not the nude of tradition, however, but an impersonal occasion for speculation on the body in motion. Duchamp had always preferred figures to landscapes or still lifes, even in his student paintings, and the nude, as opposed to a clothed figure, might have been suggested by the fact that most of the Chronophotographs of figures in motion showed them nude—besides which, Duchamp, like Leonardo, probably wanted to study motion in terms of the body as an unencumbered machine. His subsequent internalizing of the body image has led some critics to view *Nude Descending a Staircase* as a "subjective" picture, even a private metaphor for the sexual act. This is not out of keeping with the fact that Duchamp thinks of himself as the *Nude* as well as the *Sad Young Man in a Train* (to Rouen). But whereas such readings follow automatically from the situations and plastic elements of the later painting, there is nothing *in* the *Nude Descending a Staircase* to prompt, not to say compel, notions of "subjectivism" or sex. "My aim [in *Nude*]," Duchamp himself has said, "was a static representation of movement."[38]

The furor caused by *Nude Descending a Staircase, No. 2,* when it was shown in Paris in 1912—and even more at the Armory show in New York—has exaggerated its importance in the development of modern painting and in Duchamp's own oeuvre. It is not his masterpiece. Among the paintings, *The King and Queen Surrounded by Swift Nudes* (fig. 6), the *Network of Stoppages* (fig. 15), *Tu m',* and especially *The Passage from Virgin to Bride* are superior to it in both plastic and iconographic inventiveness, as is, of course, the *Large Glass* (fig. 19). In his profoundly sensitive if rather uncritical monograph on Duchamp, Lebel attributes the commotion over the *Nude* to the fact that with it Duchamp "had moved to the farthest limits of painting."[39] I disagree. Only in his subsequent work does

1

3

4

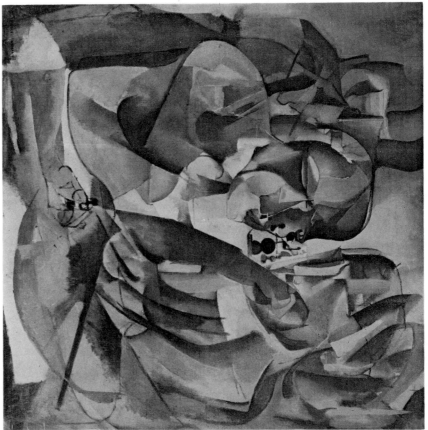

2

5

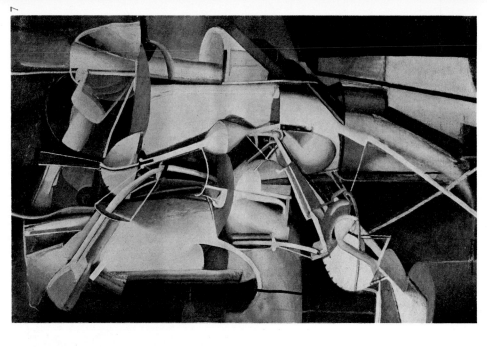

7

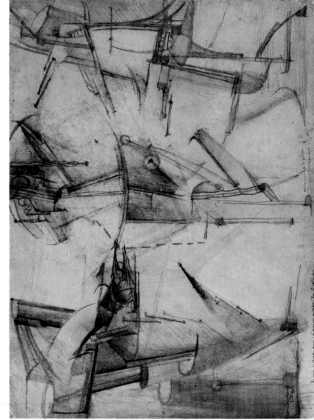

9

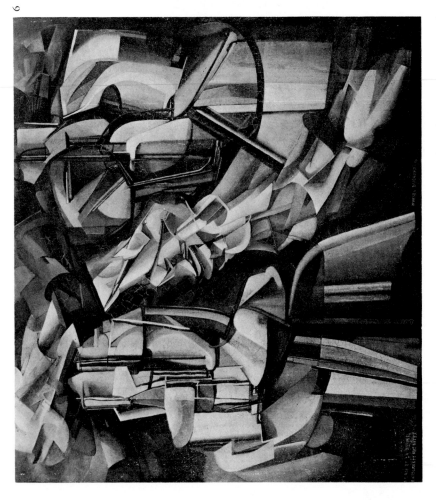

6

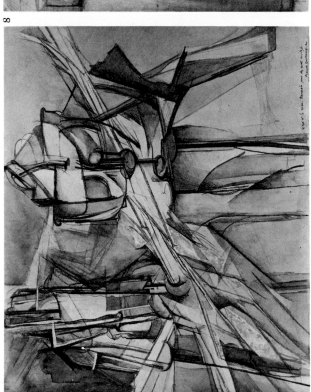

8

6 MARCEL DUCHAMP *The King and Queen Surrounded by Swift Nudes.* 1912

7 MARCEL DUCHAMP *The Bride.* 1912

8 MARCEL DUCHAMP Study for *The King and Queen Surrounded by Swift Nudes.* 1912

9 MARCEL DUCHAMP *The Bride Stripped Bare by Her Bachelors.* 1912

10 MARCEL DUCHAMP *Chocolate Grinder, No. I.* 1913

11 MARCEL DUCHAMP *Bicycle Wheel.* Readymade. 3rd version, 1951
(original, 1913, and 2nd version, 1916, lost)

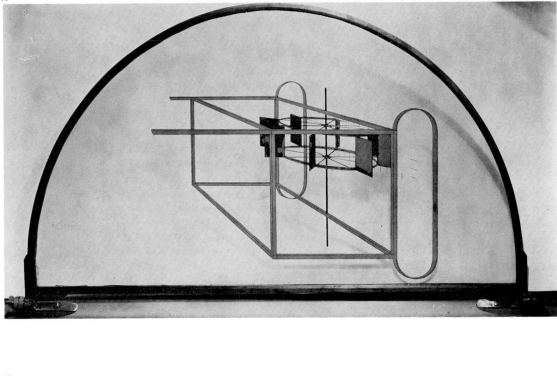

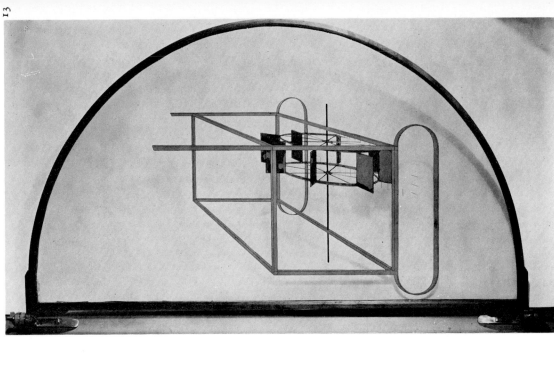

12 MARCEL DUCHAMP *Three Standard Stoppages.* 1913–14

13 MARCEL DUCHAMP *Water Mill Within Glider (in Neighboring Metals).* 1913–15

14 MARCEL DUCHAMP *Chocolate Grinder, No. II.* 1914

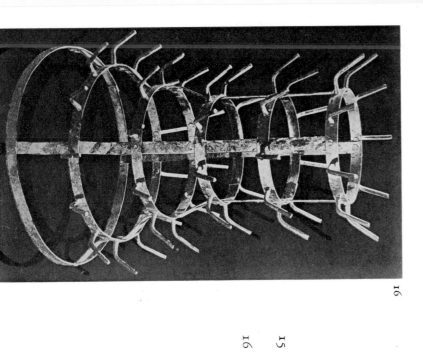

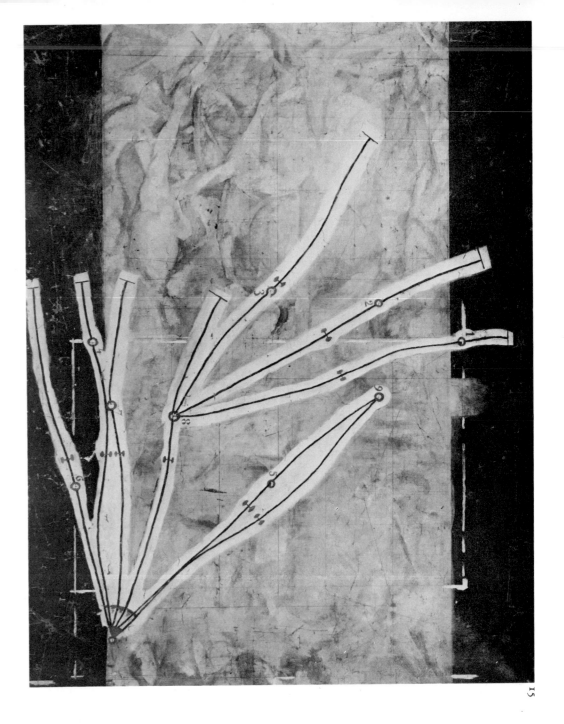

15 MARCEL DUCHAMP *Network of Stoppages.* 1914

16 MARCEL DUCHAMP *Bottlerack.* Readymade. 2nd version, 1961
 (original, 1914, lost)

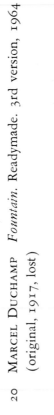

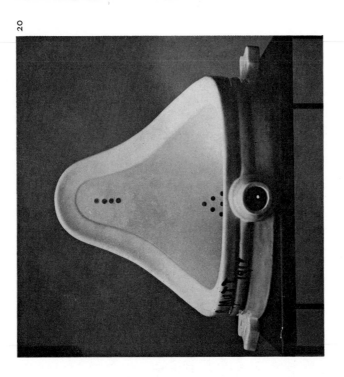

20 MARCEL DUCHAMP *Fountain*. Readymade. 3rd version, 1964
 (original, 1917, lost)

21 MARCEL DUCHAMP *Fresh Widow*. 1920

22 MARCEL DUCHAMP *Why Not Sneeze Rose Sélavy?* 1921

23 RAYMOND DUCHAMP-VILLON *Horse*. 1914

Duchamp break entirely new ground; with regard to formal structure, the *Nude* hardly compares in adventurousness with the great Analytic Cubist paintings of the same year. Lebel's assertion that Duchamp had "overtaken Picasso and Braque in a few months by simultaneously liquidating objective form and color" is incomprehensible to me. Of "objective" form, a great deal is quite evidently left in the *Nude*, as compared with the mere hints of such form in the Cubist paintings of 1912, where for all practical purposes the subject has disappeared. Moreover, precisely those monochromatic tonalities of the *Nude* had already been used for years by the Cubists. One reason why public interest centered on the *Nude*, I suspect, is that while obviously avant-garde, it was, paradoxically, *less advanced*, more gimmicky, than the Analytic Cubist pictures of the same date. With the aid of its title, spectators could make out the cinematic action of the painting and, grasping it by that handle, could compare it in turn with their presumptive notions of what a nude descending a staircase should look like. Such possibilities are obviated by the greater abstractness of a Picasso or Braque of 1912. The *Nude's* place in modern painting is not far from that of Futurist painting. Its novel element—the "representation" of movement by the depiction, in one picture, of successive phases of an object in movement—was a *narrative*, not a *plastic*, innovation, and it did not open a new direction for painting.

Yet if the "mechanism" of *Nude Descending a Staircase* is like that of Futurism, its spirit is quite different. Looking not to its manifestoes but at the paintings themselves, particularly those of Umberto Boccioni, we become aware that Futurism frequently appeals to nostalgia and mystery (see Boccioni's *Farewells* or *The Forces of a Street;* fig. D-28). Duchamp's *Nude*, on the other hand, is unsentimental and ironic, and has an undercurrent of mordant wit. This last is rarely found in Futurism. We may laugh at Balla's *Leash in Motion,* but humor was not the painter's aim. Duchamp had grasped Bergson's insight that humor is inherent to the image of man momentarily deprived of his human status and reduced to the state of an automaton or machine (for example, a man slipping on a banana peel). This kind of humor, as well as its converse, the humanization of the machine, was to be more deliberately explored in Duchamp's later creations.

It is with *The King and Queen Surrounded by Swift Nudes* (fig. 6) that we pass from the form-language of Futurism into a world of organo-mechanical beings that is entirely Duchamp's own; at the same time, we pass from the external, retinal appearances of events to what Gabrielle Buffet has called the "capturing of the nonpercep-

tible." The enigmatic title is hybrid: the king and queen are taken from chess, though they more closely resemble fantastic mechanical analogues of human beings. It is as if, in the dreamlike confusion of different levels of reality, the images of chessmen (chess had for long been a favorite field of Duchamp's, and later it became his major preoccupation) had been fused with the images of machines (rapidly becoming the central metaphor of his imagery) and of human beings (Duchamp's parents, within the framework of a psychological reading). Iconographically, the "swift nudes" can be interpreted as the Duchamp children, "turbulent offspring," according to Lebel, who threaten the "totemic stability" of the "Father and Mother machines."

The new form-language is based upon a principle of reduction rather than abstraction. Duchamp's interest in man—his psychology and physiology—leads him into a path quite different from Cubism's. "Reduce, reduce, reduce was my thought," he recalls. "But at the same time my aim was turning inward, rather than toward externals. . . . I came to feel an artist might use anything—a dot, a line, the most conventional or unconventional symbol—to say what he wanted to say. . . . [In *The King and Queen*] there are no human forms or indications of anatomy. But in it one can see where the forms [would be] placed; and for all this reduction I would never call it an 'abstract' painting."[40] *The King and Queen* leaves behind the predominantly straightedged forms of the *Nude* in favor of fragmentary cylindrical and conical shapes which stand midway between Léger's 1912–14 manner and Duchamp's own more organic vocabulary firmly established two months later in *The Passage from Virgin to Bride* (coloplate 1). Certain echoes in Raymond Duchamp-Villon's *Horse* of 1914 (fig. 23) suggest the influence exerted by this picture, as does the similarity of the hybrid morphology used by Picabia in his giant canvases of 1913–14. The overlapping forms of the swift nudes moving diagonally upward from the lower right recall the Futurist kind of "representation" of motion in the *Nude*, a visual trick which Duchamp would shortly leave behind in favor of an *implication* of movement in his machine pictures. The execution of *The King and Queen* is rather dry, the forms are modeled in a metallic way, and the picture lacks the refinement and lightness of its watercolor study (fig. 8). Over the years, its surface has developed a marked crackle which pleased Duchamp, who enjoyed this participation of chance and time in the work.

Two pencil drawings (one heightened with wash and watercolor), both titled *Virgin* (fig. D-55), were executed in the summer of 1912 during Duchamp's stay in Germany. They constitute the bridge from *The King and Queen* to *The Passage from Virgin to Bride* and

The Bride (fig. 7), both completed that August in Munich. These drawings pile up irregular, somewhat visceral forms in constructions that foreshadow de Chirico's scaffolded mannequins of 1917 (which are also anticipated by what appear to be seams on some depicted surfaces in *The Passage from Virgin to Bride*). Here we have the nucleus of what will become the "Bride Machine" of the *Large Glass* and the model for the machine style of Picabia in ensuing years. With Futurism the machine had entered the history of art as a thing appreciated on its own terms; for Duchamp it was of interest primarily as a metaphor for human beings. Gabrielle Buffet-Picabia recalled:

It seems incomprehensible to the present generation that the machines which populate the visual world with surprising and spectacular forms, hitherto unknown, could for a long time have remained the victims of a frenzied ostracism in the official world of the arts, and that they could have been looked upon as essentially antiplastic, both in substance and in function. I remember a time when their rapid proliferation passed as a calamity. . . . The discovery and rehabilitation of these strange personages of iron and steel, which radically distinguished themselves from the familiar aspects of nature, both by their construction and by the dynamism inherent in the automatic movements they engendered, was in itself a bold, revolutionary act; but one which, if it had not gone beyond descriptive representation, would have remained very close to the landscape and the still-life. Yet, first enthroned for their own sake, the machines soon generated propositions which evaded all tradition, above all a mobile, extra-human plasticity which was absolutely new. . . . The multiple possibilities which this unexplored field offered to the imagination seem to have shown Duchamp his true mission. Or perhaps he created for his own personal use an imaginary mechanical world, which became the place, the climate, the substance of his works.[41]

The Passage from Virgin to Bride is in every sense the masterpiece of Duchamp as far as traditional oil painting is concerned. Its structure is more tenuous, less obviously mechanical, than the tighter, more descriptive earlier paintings or *The Bride*, with which it is contemporary. Its greater painterliness is owed to its forms being modeled in low relief rather than in the round, with a delicacy that suggests that the paint had been applied with fingers rather than brush. Though the coloring is still essentially the monochrome of Analytic Cubism, we cannot escape the allusion to human flesh in the pink tones. The complex of forms, spreading to cover most of the surface, seems in motion and suggests an oneiric counterpart of the objective sensory experience of motion given in *Nude*

Descending a Staircase. Iconographic interest has shifted from the family group (*The King and Queen*) to the sexual act—here the deflowering—and only the "Bachelor" remains to round out the cast. He makes his appearance in a drawing of the following year.

The structure of these oil paintings, and of the *Large Glass*, which summarizes their elements, constitutes an attempt on Duchamp's part to find a plastic equivalent for internal, irrational, and even extrasensory experience. It presupposes the existence of another "dimension," one of which man becomes aware only in moments of revelation—a "meta-world" which Duchamp has described as "fourth-dimensional" and posited in his works as the "unknown quantity." We need not consult Einstein to grasp it; Duchamp explains very simply that if a shadow is a two-dimensional projection of a three-dimensional form, then a three-dimensional object must itself be the projection of a four-dimensional form. The most ordinary object thus holds the possibility of an epiphany; given the right insight into its nature, one need only single out the object and detach it from its ordinary context to make manifest its meanings. Duchamp performed this magical act for the first time in 1913 when, by the sole act of selection, he endowed a common bicycle wheel with the properties of a revelation.

Duchamp says that the sexual act is the "ideal fourth-dimensional situation," and it is therefore not surprising that it is the central theme of his iconography. He thus provides an ironic and cerebral prototype for the more sensuous Surrealist pictorial eroticism. The Surrealists, paraphrasing and reinterpreting Freud, situated all consciousness between Eros and Thanatos—the life force and its antithesis—in the moment of *The Vertigo of Eros* (as Matta was to title one of his pictures; colorplate 47). Duchamp's own view of the possibility of enlightenment through sex is essentially pessimistic, however, if we accept the implications of the iconography of the *Large Glass*: sexual communication and unity are never achieved; the Bachelors remain bachelors and the Bride a virgin.

DUCHAMP BEYOND PAINTING

During his stay in Munich in the summer of 1912, Duchamp had executed a pencil sketch titled *The Bride Stripped Bare by Her Bachelors* (fig. 9); this announced the next in his series of oil paintings. In a morphology markedly less organic than the two oils with which it was contemporaneous, the drawing shows a "Bride Machine" flanked by mechanical "Bachelors." Before advancing this

1 MARCEL DUCHAMP *The Passage from Virgin to Bride.* 1912

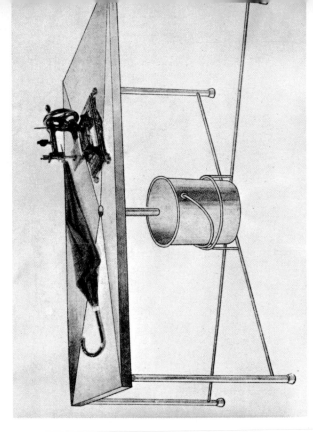

Man Ray. *The Image of Isidore Ducasse*

image further, however, Duchamp underwent a profound intellectual crisis, which resulted in his renunciation of oil painting and his adoption at the same time of a more mechanistic, pseudoscientific, verbally inspired imagery. The new direction culminated in *The Bride Stripped Bare by Her Bachelors, Even* (the *Large Glass*; fig. 19), which, despite the similarity of its title to that of the drawing of 1912, is radically different in structure and iconography.

On his return to Paris from Germany, Duchamp had found himself increasingly dissatisfied by the emphasis in avant-garde circles on "pure painting," and by the fact that even his own admirers tended to regard his painting from a primarily esthetic point of view, overlooking the "metaphysical" implications that, for him, lay at its core. "More and more," writes Breton,

the practice of drawing and painting appeared to him a kind of trickery that tended toward the senseless glorification of the *hand* and nothing else. . . . Why consent to being the slave of one's own hand? It is unacceptable that drawing and painting should today still stand where writing stood before Gutenberg. . . . The only solution, under such conditions, was to unlearn painting and drawing. And Duchamp has never abandoned this purpose since that date.[42]

The decisive break in Duchamp's oeuvre is marked by *Chocolate Grinder*, the two versions of which—date from the spring of 1913 and February, 1914, respectively. "One day, in a shop window," Duchamp recounts, "I saw a real chocolate grinder in action and this spectacle so fascinated me that I took this machine as a point of departure." The first version of *Chocolate Grinder* (fig. 10) was executed in oil on canvas but differed from Duchamp's earlier imaginative compositions in being simply a dry, almost academic perspective study of a real object. But though this kind of handling amounts in the twentieth century to a form of anti-art, as the case of Dali would later show, it still was not sufficiently "unplastic" to suit Duchamp, and in the second version of *Chocolate Grinder* (fig. 14) he eliminated shading and traced the forms with lengths of thread glued to the canvas in most places with paint and varnish, but sewn to it at all intersections.

Duchamp was dissatisfied with his image of the chocolate grinder, for it was still too freighted with the baggage of esthetic convention that inevitably informs any three-dimensional illusion on a flat, regular field. There seemed to be no escape from esthetics within the minimal conditions, or definition, of the art of painting. The solution lay in taking the logical step from the *trompe-l'oeil* replica

of an object to the object itself. Hence the origin by fiat of the Readymades: man-designed, commercially produced utilitarian objects endowed with the status of anti-art by Duchamp's selection and titling of them. In 1913 he placed a bicycle wheel upside down on a stool (fig. 11); singled out for contemplation in isolation from its normal context and purpose, it seemed strangely enigmatic, especially when the wheel turned pointlessly. What Duchamp had done was subject the wheel to the same kind of *dépaysement*—dissociation or displacement—as that to which the Symbolist poets had subjected words in an attempt to liberate their hidden meanings. The poet Isidore Ducasse ("The Count of Lautréamont"), who had died in 1870 at the age of twenty-four and was later hailed as a precursor by the Surrealists, had provided the classic example in describing the "chance encounter of a sewing machine and an umbrella on a dissection table."

Duchamp himself was quite taken up at this time with experiments in language paralleling the Readymades. Not that he tried to write poetry—that for him would have meant just another form of estheticism. But he took words out of their normal contexts and joined them together in lapidary illogical phrases to produce what were in effect verbal Readymades. He let himself be guided by internal rhymes, puns, and anagrammatic, alliterative, and rhythmic resemblances, as in the film title *Anemic Cinema*, the *moustiques domestiques demistock* of his Monte Carlo "bonds," and the monumental legend of the Rotary Demisphere: *Rrose Sélavy et moi estimons les écchymoses des Esquimaux aux mots esquis.* Sometimes the pun or play on words was in English ("Oh! Douche it again"). The ambiguous, multilevel meanings of Duchamp's verbal *trouvailles* were inextricably linked to the Readymades and the *Large Glass*, not simply as disconcerting titles (*In Advance of a Broken Arm* for a Ready-

made snow shovel, *Fresh Widow* for a French window; fig. 21) but as sources for the images themselves. "It was a question," writes Michel Sanouillet, "of *exhausting* the sense of words, of playing with them to the point of violating their most secret attributes, and so totally divorcing a word from the expressive content we habitually recognize in it. Once empty and available, the words would deliver themselves, be it by the suddenly visible strangeness of their internal structure or by their baroque association with other words, of a treasury of unexpected images and ideas."[43]

Readymades resulted from Duchamp's almost predestined confrontations with manufactured objects ("it is a kind of rendezvous"), but they could also be conceived in advance ("Buy a pair of ice-tongs as a Rdymde" goes a note from *The Green Box*) or made by proxy, for example, the *Unhappy Readymade*, constructed by Duchamp's sister in Paris according to instructions he sent from New York). There even exists a project for a *Reciprocal Readymade*: "Use a Rembrandt as an ironing-board." As the Readymades proliferated, they created an environment of their own, which is attested by photographs of Duchamp's West 67th Street apartment (1917–18; fig. D-56); Gabrielle Buffet-Picabia remembers Duchamp living "in a kind of Capernaum surrounded by chosen objects."

Duchamp also began to "assist" and join objects together on principles analogous to those he used to join words, producing hybrid Readymades like *Why Not Sneeze Rose Sélavy?* (1921; fig. 22), a birdcage filled with cubes of sugar, into which a thermometer and cuttlebone have been thrust. The spectator, having gotten over this unexpected juxtaposition, lifts the cage and discovers by its great weight that the "sugar lumps" are really cubes of white marble. Duchamp went illusionistic art one better by creating illusionistic anti-art: the *trompe-l'oeil* object.

The relation of the Readymades to their titles varied. *Bottlerack* (fig. 16) was a simple description of that object. *In Advance of a Broken Arm* gave a dimension of black humor to a common snow shovel. Sometimes, however, as in *Why Not Sneeze?*, the dissociation of object and title rendered the latter enigmatic. *L.H.O.O.Q.*, the title of Duchamp's famous bearded and mustached reproduction of the *Mona Lisa* (fig. D-50), is a puzzle whose scurrilous solution is perhaps meant to explain the mysterious smile of the lady. (When the letters of the title are pronounced quickly in French they form the sentence, "Elle a chaud au cul"—She has hot pants.) In adding the beard and mustache Duchamp was engaging in more than just a Dada attack on high art, or indulging in the popular type of defilement to which public images are subjected. He was drawing attention to a sexual ambiguity in Leonardo's life and work, noteworthy in relation to the quite different dualism reflected in his own creation of a female alter ego, Rrose Sélavy.

Readymades were intended by Duchamp to be devoid of esthetic interest. "A point that I want very much to establish is, that the choice of these Readymades was never dictated by an esthetic delectation. The choice was based on a reaction of visual *indifference*, with at the same time a total absence of good or bad taste, in fact, a complete anesthesia."[44] But though Motherwell exaggerates when he says that the *Bottlerack* of 1914 (fig. 16) appears in retrospect to have a more beautiful form than almost any deliberate sculpture made that year, there is no question that after years of the assimilation of real objects into sculptures of all sorts, many of the Readymades have taken on an inescapably "arty" look. The fact is that sculpture does not separate itself as clearly as does painting from the world of objects. Almost any three-dimensional form can be *seen as sculpture*, if not necessarily as good sculpture. The determination is largely based on the observer's expectations or mental set. The answer as to whether the Readymades were art or not lay in the eye of the beholder. This equivocal hovering was part of their enigma. But if they had—and still have—the value of throwing received definitions of art into doubt, they also failed to satisfy Duchamp in his search for an expressive activity wholly beyond esthetics, which may be why he ceased making Readymades.

Readymades like *Bicycle Wheel* are, however, essentially different from what appear at first to be related objects: for example, Picasso's *Bull's Head* (fig. 309), which was created by joining together the seat and handlebars of a bicycle. The Picasso work has to do not primarily with a new revelation of meaning in the object but with the metamorphosis of its shape. The transformation from bicycle to bull's head is in the interest of *plasticity*, and though the result has a kind of surreal poetic quality (which it lost when later cast in bronze), it attests rather to the activity of the artist as manipulator than to the passive though incantatory insight of the "Seer."

Duchamp's abandonment of painting as a profession in 1913 forced him to look for a means of support; he found it for a while as an assistant in the Bibliothèque Ste.-Geneviève in Paris. There, in an atmosphere conducive to reflection and study, Duchamp created the "new physics" without which, he was convinced, future art would be anachronistic. Notions of a relation between abstract painting and the latest science had been in the air since the advent of Cubism. Not that Picasso or Braque had any interest in science; but to those unable to understand and accept Cubism on its own esthetic terms, its asso-

ciation with science (about which they were generally just as much in the dark) seemed to justify and legitimize it as an aspect of technological civilization. An insurance clerk named Princet, who was a friend of many of the advanced painters and an amateur mathematician, did not a little to put these ideas into circulation, and they continue to plague every popular history of modern art. The weaker, more conservative Cubists like Jean Metzinger were particularly attracted by such notions, which allowed them to "reason" the need of the new abstract art. Severini was to use the same pseudoscientific, mathematical jargon to reason himself out of Cubism (and Futurism) and into Neo-Classicism.[45] "There were discussions at the time of the fourth dimension and non-Euclidian geometry," recalls Duchamp, "but most views of it were amateurish. . . . And for all our misunderstandings, through these new ideas we were helped to get away from the conventional way of speaking [about art,] . . . from our cafe and studio platitudes."[46] Duchamp, alone among the painters, devoted himself seriously to the study of the new science and mathematics, reading Lobachevski and Riemann and attempting to assimilate to art such ideas as he gleaned from them, yet even his science remained, at best, pseudoscience.

In his conviction that art must derive its underpinning from the artist's knowledge of the physical world, Duchamp reminds us of Leonardo. But the world of Renaissance science, as Meyer Schapiro observes,[47] was one that could be seen with the naked eye, and the mathematics of Leonardo's day was on today's high-school level. A knowledge of these fields proportionate to what Leonardo's was is inconceivable in an age of advanced science and professional specialization. For Leonardo scientific knowledge not only guaranteed a more "correct" image of the real world but enabled the picture to recapitulate and thereby symbolize the great advances in science which engendered the optimistic outlook of the Renaissance. Practically, the modern painter can use science only in a more limited way. Seurat, for example, might avail himself of it in connection with his use of color, but even there it was more the idea of scientific method, more the spirit of science than its actual data, that affected the work. Yet the desire to use science in order to join the spirit of one's age was no less legitimate for Duchamp—and later on for Matta—than it had been for Renaissance artists (or than the preoccupation with technology had been for the Futurists). There being no question of using science in the direct way of Leonardo, Duchamp arrived in the end at a parody of science, an "amusing physics," as he called it, which from one angle appeared a serious if puzzling apotheosis of quantitative knowledge, but from another, an ironic and comic critique.

(Duchamp's notes, Lebel remarks, are full of such phrases as "matter of oscillating density," "emancipated metals," and "divergence of molecules," all embedded in formulas which strain the laws of physics "just a little.")

The first thing Duchamp needed to establish the mathematical foundations of his "new science" was a unit of measure. According to a note from The Green Box: "a straight horizontal thread one meter in length falls from a height of one meter onto a horizontal plane while twisting at will and gives a new form to the unit of length." Three such threads were fixed to strips of cloth mounted on glass to make the Three Standard Stoppages (fig. 12). Together with wooden forms cut in the profile of the fallen threads they were enclosed in a specially prepared croquet box ("canned chance"). Drawings made for the Bachelor Machine at this time began to resemble engineers' designs filled with what appear to be serious, if highly cryptic, indications of length. Since everything that pertained to the artistic execution of a picture was now rejected, the "new art" was to be based entirely upon mathematical computations as expressed in mechanical drawings; the entire work was to be determined in advance of its execution: "I wanted to return to an absolutely dry drawing, to the creation of a dry art, and what better example of this new art than mechanical drawing. I began to appreciate the value of exactitude, of precision. . . ."[48]

It was in New York, where Duchamp settled in 1915, that these interests in language and science, along with virtually the whole spectrum of his previous artistic speculations, were summarized in The Bride Stripped Bare by Her Bachelors, Even (the Large Glass; fig. 19), begun shortly after his arrival and left definitively incomplete in 1923. It consists of two large panes of glass in metal frames forming together a field a little under nine feet tall and slightly under six feet wide. On one side of the glass a series of forms covering roughly a third of its surface have been applied with lead wire and paint. A spectator unfamiliar with Duchamp's iconography would not immediately divine that he was in the presence of "a mechanistic and cynical interpretation of the phenomena of love" (Breton); he would tend rather to respond to it as a perspective study for some strange and humorous machine of unclear purpose. He would note that, although the parts were connected mechanically, they are non sequiturs in terms of individual identity. A water wheel, a chocolate grinder, a cloud, and what appear to be dry cleaners' blocking and pressing forms seem to function together like a very serious and scrupulously tooled counterpart of a Rube Goldberg apparatus (one of which was published by Duchamp in New York Dada; fig. D-57).

Since an account of the integration of the *Large Glass* or a full exploration of its many-leveled iconography would require a book in itself, I shall have to content myself here with a thumbnail sketch, referring the reader wishing further information to the classic description by Breton in "Phare de la Mariée," the monograph of Robert Lebel, and texts by Katherine Dreier and Matta, Harriet and Sidney Janis, Jean Reboul, Arturo Schwarz, and the unpublished Ph.D. dissertation by Lawrence Steefel (see Bibliography). Interesting speculations on the psychological implications of the work are contained in the chapter on Franz Kafka and Marcel Duchamp in Michel Carrouges' *Les Machines célibataires*. However, an approach to an interpretation of the *Large Glass* necessarily depends on the notes and drawings covering the years 1911–15 which Duchamp published in facsimile in a limited edition (*The Green Box*). Unless otherwise attributed, all citations in my discussion are from this source. Duchamp wrote of planning "to reduce the Glass to as succinct an illustration as possible of all the ideas in the Green Box," and while these texts are contradictory in some respects, they do cohere sufficiently to make possible a general exposition of his intended iconography.

The upper and lower parts of the *Large Glass* differ somewhat in both the style and character of their imagery, drawing as they do upon different moments of Duchamp's evolution between 1911 and 1915. The upper part is dominated by a Bride Machine very closely resembling the apparatus of *The Bride* of 1912 (fig. 7), and realized with chiaroscuro modeling and monochromatic tonalities comparable to the painting. To the right of the Bride (referred to as the "Breast Cylinder" in the early notes and later generally as the "*Pendu femelle*" —literally, "hanging female thing") is a large cloud or "milky way," modeled in low relief around the edges, out of which three almost square shapes or "draught pistons" have been cut. Little is said in *The Green Box* about this cloud, which, according to Breton, contains "the original mystery," but its presence above the Bride reinforces her interpretation as an "apotheosis of virginity" and suggests, as the Janises have observed, a kind of ironic Assumption of the Virgin. The lower section is more complicated and recapitulates a number of images, beginning with the *Chocolate Grinder*, that are realized in a linear style.

The synthetic way in which the *Large Glass* was created, preceded as it was by numerous calculations, speculations, drawings, and paintings complete in themselves, recalls the way in which Seurat went about *La Grande Jatte* (fig. D-15). Yet though both these works reflect pseudolaboratory procedures, they convey, perhaps for this very reason, a strange and enigmatic air (the result of that "poetic science" which Baudelaire foresaw?)[49] that has had much to do with the great appreciation they have received from the Surrealists.

Though the upper (Bride) section of the *Large Glass* derives from earlier sources and was, in fact, put in place first, the iconographic drama begins with the Bachelor section below and more particularly with the chocolate grinder in the center. Here, in what is virtually a duplication of the *Chocolate Grinder* of 1914 (fig. 14), we have the elemental procreative organ of the Bachelor ("the Bachelor grinds his own chocolate"). The axial pole of the grinder is joined by an X-shaped horizontal metal "scissors" to a metallic glider on its left containing a small water wheel, the "cooler" of the Bachelor Motor. This is a reproduction of the *Water Mill Within Glider* (in *Neighboring Metals*) of 1913–15 (fig. 13), which was executed in oil and lead wire on glass—Duchamp's first such composition. In a to-and-fro motion along its gutter, the glider furnishes the "Carriage" of the Bachelor Motor and orients the nine "malic molds" (fig. 18) in red lead which are the cylinders of this "internal-combustion machine." Eight of these molds appear in a perspective drawing of 1913, and the series is completed in a watercolor of the following year where they are joined through a "network of stoppages" (derived from *Three Standard Stoppages*, fig. 12) that reappear with them in the *Large Glass* as "capillary tubes" leading from the tops of the "malic" cylinders to a semicircular series of cones identified in the notes as "sieves" and "drainage levels." The *Network of Stoppages* was itself studied in isolation in one of Duchamp's largest and most impressive canvases, a painting of 1914 (fig. 15) executed over the traces of earlier pictures and giving the impression of a palimpsest.

The "malic molds" are among the most interesting shapes in the *Large Glass*, standing midway between the more rigidly geometrical forms that otherwise belong to the Bachelor apparatus and the visceral, organic forms of the Bride. Reboul and Lebel agree that the sources of these forms may be tailors' or dry cleaners' dummies (suggested also by the title of the original pencil version of the molds: *Cemetery of Uniforms and Liveries*; fig. 17). If this is so, it is another instance where Duchamp anticipated de Chirico, who was to use such dummies as models for the mannequins which first appear in his paintings in 1914.[50]

The remaining salient iconographic elements of the lower section of the *Glass* are four circular radiating devices on the right called the "oculist witnesses" and based upon opticians' charts; these introduce a note of voyeurism into the ensemble—an interpretation supported by the fact that the prototype for this element, the small glass

in The Museum of Modern Art, is titled *To Be Looked at with One Eye, Close to, for Almost an Hour*, and contains a small magnifying glass for the "Peeping Tom" to use while watching the "disrobing."

If the *Large Glass*, and thus the "love operation" of the two machines, had been completed, the Bachelor Machine, "all grease and lubricity," would have received "love gasoline secreted by the Bride's sexual glands" in its "malic" cylinders for ignition by the "electrical sparks of the undressing," and, mixing with the secretions of the ever-turning Grinder, would have produced the ultimate union. In its "incomplete" state the *Large Glass* constitutes, rather, an assertion of the impossibility of union—of the sexual alienation of man and woman in a situation that Lebel describes as "onanism for two." This depressing interpretation is confirmed by the "litanies" endlessly recited by the Glider in its to-and-fro movement: "Slow life. Vicious circle. Onanism. Horizontal. Return trips of the buffer. The trash of life. Cheap construction. Tin, ropes, wire. Eccentric wooden pulleys. Monotonous flywheel. Beer professor." A suspended state of activity is further alluded to in the subtitle of the work—*A Delay in Glass*—to be thought of, Duchamp tells us, as you would a "poem in prose" or a "silver spittoon."

The iconography of older art was largely drawn from a store of familiar symbols—religious, mythological, historical—that were ready at hand for the artists. Even a cursory glance at the art of the last century reveals that these symbols have no longer seemed viable; while the modern artist has moved toward abstraction he has largely eschewed iconographic schemes and narrative situations. The Dadaist and Surrealist attempts to reinvest painting with these symbols and stories led paradoxically not to greater illumination but greater mystification. Seen apart from Duchamp's explanatory notes in *The Green Box*, the *Large Glass* is surely one of the most obscure and hermetic works ever produced. This, despite the fact that its sexual subject matter would seem to be a most universal one, especially in an age when the myths that informed the art of the past are no longer tenable. Indeed, the myth of sexuality would become the only iconographic common denominator in all Dada and Surrealist art and literature.

Though knowledge of the iconographic program adds a dimension —and for Duchamp, the crucial one—to our experience of the *Large Glass*, the work makes a remarkable impression on purely visual grounds. Suzi Bloch observes that the transparent glass field literally became the "window" that the picture plane of illusionistic painting had been posited to be. Duchamp's method of suspending the shapes in isolation against transparent glass created an unusual and poten-

tially infinite series of effects. With the aid of a photograph of Katherine Dreier's library in 1937 (fig. D-58), we can conjure an image of the *Large Glass* in the normal living environment of human beings rather than in the neutral context of the museum chamber in which it now rests. Against a background of people and everyday objects, "a Readymade continually in motion" (Lebel), the images *on the Glass*, thrust by perspective drawing *into* the space of the room, materialized as if some giant X-ray plate had suddenly revealed the extraretinal aspects of reality.

As we see it today, the *Large Glass* has been enriched by the patterns of cracks caused accidentally during transportation in 1931. Duchamp was rather pleased by the effect (not unlike the long linear splinters representing the Swift Nudes in the watercolor of 1912), which denoted a further incursion of *chance*, already "canned" in the work by use of the Standard Stoppages.

In 1918, five years after finishing his last oil painting and five years before the "incompletion" of the *Large Glass*, Duchamp returned to painting, in a manner of speaking, for a definitive farewell to that art, creating a large (slightly over ten feet long) freize-shaped picture to "decorate" the library of Katherine Dreier's Connecticut home.[51] Duchamp had called *Tu m'* (colorplate 2) a dictionary of his main ideas prior to 1918, and the title (suggesting "*tu m'emmerdes*" or "*tu m'ennuies*") might well be taken as a summary of his attitude toward painting at the moment of his farewell to it. Just as the nineteenth-century academicians created giant "machines" in which to demonstrate their command of the mechanics of representational painting, so Duchamp, in what literally appears to be a horizontal machine (in the Duchampesque sense of the word), demonstrates his mastery of what is now his own considerably expanded "mechanics."

The elements splay out over the surface from left to right, appearing to hang together like a Duchampesque mobile (it was Duchamp who later so named Calder's sculptures). The superimposed color samples in the upper left not only allude to color theory but in their overlapping and diminution demonstrate two ways of representing space. The cast shadow is introduced in the form of pencil tracings of the actual shadows projected by three Readymades (left to right: *Bicycle Wheel, Corkscrew,* and *Hat Rack*), which also show the shadows as direct projection (wheel), distorted projection (corkscrew), and vague or diffused projection (hat rack). In the lower left the *Three Standard Stoppages* provide a module for the work. From the handle of the corkscrew emerges a carefully painted little *trompe-l'oeil* hand, its index finger pointing in the manner of old-

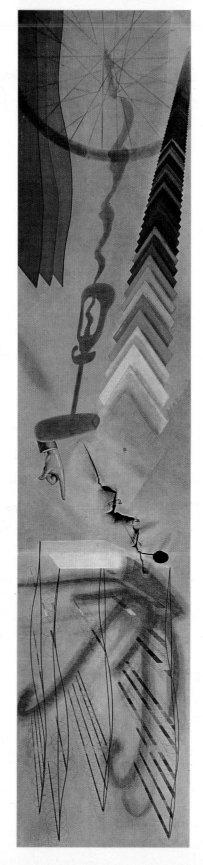

II MARCEL DUCHAMP *Tu m'*. 1918

fashioned direction signs. It was, in fact, executed by a sign painter, one A. Klang, whose minuscule signature is visible on the right. Above and to the right of the hand the canvas appears torn, but we soon discover this to be a *trompe-l'oeil* illusion; however, the false tear is held together by real safety pins and has a real bottle brush inserted in it. Thus Duchamp recapitulates the span from the shadow of an object to the illusion of an object itself.

The right side of the picture is dominated by wavy lines, recalling the *Stoppages*, which are attached to brightly colored diagonals (themselves often surrounded by coils of compass-drawn circles). The diagonals give the illusion of projecting the wavy lines outward like the edges of shelves. The small circles bear the same cross relation to the wheel on the left as the wavy lines do to the *Stoppages*, and the colored lines to the sample squares. It is as if all were offshoots of elements on the left side of the picture but had become confused and less clearly identified, perhaps as a result of the "accident" represented by the rent canvas. The little sign painter's hand seems to be pointing out a lesson in it, in much the same way that didactic points are literally indicated in old religious paintings.

What seems in retrospect to have been an ineluctable progression away from art reached its final phase around 1920, when Duchamp ceased making images of machines and began constructing actual ones. This transition from "anti-artist" to "engineer" found him still true, nevertheless, to his ironic view of experience, for his machines denied their own premises by their absolute uselessness. The two most significant of these are *Rotary Glass Plate* (*Precision Optics*; fig. D-60), painted segments of glass that give the illusion of a circle

while rotating on a metal axis (constructed in New York in 1920 with the aid of Man Ray) and the *Rotoreliefs* (made in Paris in 1935), a series of cardboard disks covered with patterns of colored lines that create three-dimensional illusions of objects when spinning at a rate of around thirty-three revolutions a minute (a kind of visual phonograph record). In another extension of his earlier concerns as a painter, Duchamp now began to develop the possibilities of these disks in terms of the motion picture (this was, again, a logical extension of the cinematic effects of such paintings of his as the *Nude*), and in 1926 he created *Anemic Cinema* in collaboration with Man Ray and Marc Allégret.

Duchamp's machines were thus involved with optical as well as mechanical questions, but optical questions outside the framework of the plastic arts. Though these pioneering activities reveal him as a prophet of the concerns of recent artists, his basic anti-esthetic commitment distinguishes him. The younger artists' aim has been to reintegrate the kinetic and optical effects—and even those of accident —*into an experience of art*. Thus, Rauschenberg's *Revolvers* differs from the *Rotary Glass Plate* by virtue of the same estheticism that separates Jasper Johns' *Light Bulb* (fig. D-295), with its sensitive sculptural surface, from a Readymade. Jean Tinguely's machines have realized other implications of Duchamp's posture. In destroying itself, his *Homage to New York* (demonstration in the sculpture garden of The Museum of Modern Art, New York, March 17, 1960) fused the machine concept and the idea of Dada action in a single nihilistic event. Tinguely's machines for making pictures appeared to bring the wheel of Duchamp's logic full circle. But these "méta-

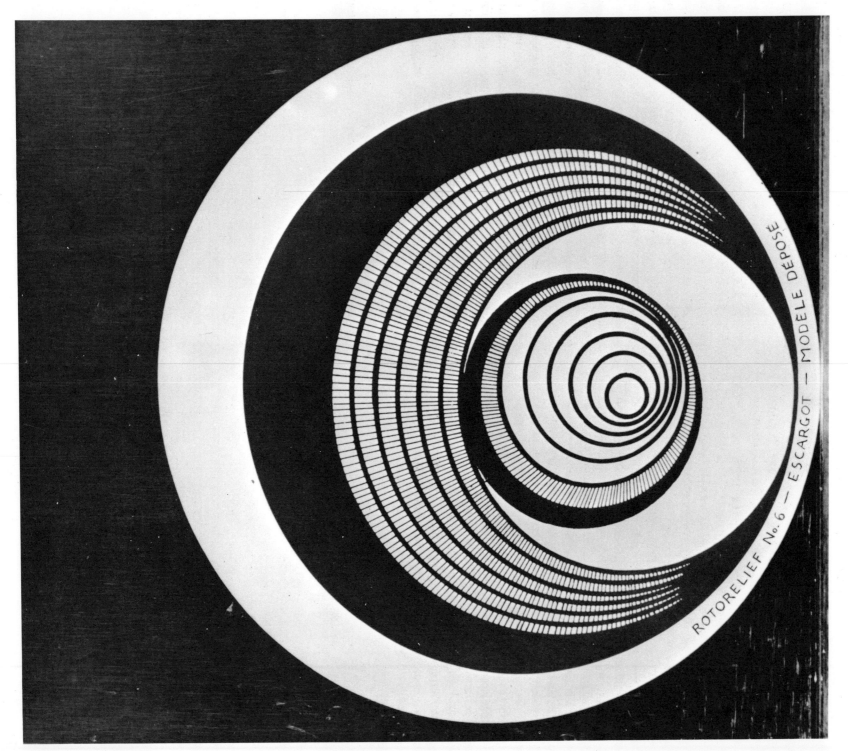

Marcel Duchamp. *Rotorelief No. 6*

"matics" did not really make art; they only provided a kinetic instrumentality. The extent to which the images they produced were art depended upon the choices—settings controlling distance, color, contour, etc.—made in the construction and operation of the machines. Their perhaps unintentional revelation—one buried somewhere in the implication of Duchamp's reduction of "creation" to a matter of selection—was to confirm that painting is almost entirely a matter of decisions following from conception, as distinct from facility in the techniques of execution.

In the years between the wars, Duchamp now and then produced some further Readymades, invented ironic pranks, and collaborated with the Surrealists in the staging of their most important exhibitions as well as in other projects. But this kind of activity was infrequent; he devoted far more time to playing and studying chess. Like Leonardo, Duchamp had always been more interested in processes than in results. Chess seemed to make possible a constant renewal of the formative process ("the game itself is very, very plastic"), involving as it does a combination of mathematics and space, logic and imagination, in which the result is zero in the sense that the board is swept clean. Thus, as a form of mathematic-esthetic speculation, the preoccupation with chess reconfirmed Duchamp's renunciation of painting and recapitulated the Dada belief that the value of creative activity lies in the doing, in the act of making, rather than in the esthetic significance of the thing made.

In Les Fleurs du mal Baudelaire called certain old masters phares ("beacons") of art, an image adopted by Breton for the title of his essay on Duchamp, "Phare de la Mariée" (usually translated "Lighthouse of the Bride"). Indeed, for the Dada-Surrealist generations of the interwar period, Duchamp was the ultimate example of that anti-esthetic ideal which, to varying degrees, the avant-garde art of that time upheld. Duchamp is still a fixed point for navigation; he remains constantly in the corner of our eye. His Readymades have become monuments of the enigma of seeing: reminders that visual meaning cannot be defined in plastic terms alone or within the cumulative conventions of any art. In a world of competing artistic programs, he argues the transcendence of creative seeing—that genius lies in the eye and mind, and not in the hand, of the artist.

THE PAINTINGS OF FRANCIS PICABIA

The Dada movement is usually described as having arisen in Zurich and New York during World War I, thence spreading to Germany and finding its denouement in Paris in the immediate postwar years. If Dadaism is considered inseparable from the word "Dada," such an account is acceptable. But, as we have observed, Dada had already made itself essentially present some years earlier in the activities of Duchamp, Vaché, and Picabia in Paris; consequently, that city might qualify as the scene of Dada's birth as well as of its death. Only in the context of this expanded view can we fully appreciate the cycle of Dada activities initiated by Francis Picabia, who set out from Paris in 1913 to become the roving ambassador to the world of a new outlook. Though lacking Duchamp's intransigence and consistency, the ubiquitous Picabia, with his anti-esthetic scatter shooting, his tireless "provocations," and his privately published magazines, actually did more to spread the gospel of Dada, even if in a somewhat diffused form.

Don Francisco Martinez Picabia della Torre was born in Paris in 1879. His mother came from a distinguished upper-middle-class family; his father was a wealthy Cuban businessman. From the first, Picabia enjoyed the advantages of considerable wealth, and he affected the role of a dandy. For him art was but one of the pleasures of life ("all my life I've smoked painting"), and he regarded it from the posture of the amateur (in the French sense of the word). There were other pleasures, too—cars, women, travel, and poetry; these often took precedence, a fact that accounts, though only in part, for his uneven career as a painter. Picabia was the first and probably all-time champion among artists in the sport of buying and driving fancy automobiles (fig. D-61). He bought his first one in 1898, and thereafter maintained an ever-changing stable that included the fastest racing cars and the most luxurious Rolls-Royce touring sedans. By 1953, the year of his death, he had owned at one time or another seven yachts and 127 cars. "And that," declared his friend H. P. Roché, "was nothing beside his women."[52] In true Dada spirit, Picabia put "life" above "art." He refused to make a career of painting and disdained those who did, for to his mind this cut them off from living. He considered art a byproduct of his passion for life and spoke of his pictures as "the shadows of my adventures."

Picabia enjoyed early success as a painter. In 1899, while still a student (he worked in the studios of Humbert, Wallet, and possibly Cormon, which van Gogh and Toulouse-Lautrec had attended a few years before), one of his pictures was exhibited in the Salon des Artistes Français and drew very favorable notices. At that time, he was painting in a purely academic manner, but in 1903 he adopted what is generally referred to as his "Impressionist" style. Picabia was given a contract by the dealer Danthon, director of the Galerie Hauss-

mann, around 1905, and the pictures from this period were avidly purchased by collectors for whom the more radical forms of modern painting were too *outré*.

Yet calling this work Impressionist (or Post-Impressionist, as did Picabia's wife, Gabrielle Buffet) is a mistake; stylistically and chronologically it has about the same relation to the real Impressionism of Monet and Renoir as Severini's late painting does to Cubism. These are pictures by a confident draftsman working in a post-Barbizon manner, essentially within the formula of Jongkind but with brighter colors. Although his heightened palette was unquestionably suggested by Impressionist and Post-Impressionist painting, Picabia handled it in an academic way, superimposing the color on a chiaroscuro layout of forms still descriptive in their realism. Had these pictures in fact demonstrated real understanding of the revolutionary color principles of Impressionism and Post-Impressionist art, they would still have been decades late historically, for by 1908, when Picabia finally put this style behind him, Fauvism had already had its day and was beginning to give ground to the rising influence of Cubism.

In the first months of 1908, dissatisfied with the kind of painting he had been doing, Picabia began to work in a true Impressionist style which, toward the end of the year, developed into a Signac-like Neo-Impressionism that carried him (in 1909) into Fauvism. Though he experimented with Cubism briefly in the spring of 1909, Fauvism dominated Picabia's painting until he moved definitively into Cubism in 1912. But even as he advanced to his more personal, historically important work, Picabia remained an oddly dependent painter, relying on cues from other artists, mainly Picasso, Léger, Delaunay, and Duchamp. His youthful pictures remained completely conventional, for all the bravura of their execution. Duchamp's early work, in contrast, was frequently unsure and often unsuccessful, but it revealed a more probing mentality.

The progression toward Cubism is marked by *Landscape at Creuse* (fig. 24), probably painted early in 1912. In this painting Picabia stylizes his forms into simple flat shapes, bounded by straight edges and uncomplicated curves, that fit together like a jigsaw puzzle. *Landscape at Creuse* stands midway between Fauvism and Cubism It is reminiscent of the former in its flatness and bold coloring, of the latter in the rendering of the motif by simple, generally geometrical forms. It marked the beginning of a phase of Picabia's art that reached its climax later in 1912, in *Dances at the Spring* (fig. 25) and *Procession, Seville* (fig. 26), pictures that reveal a sculpturesque, three-dimensional kind of handling closer to the Cubism of 1908-09

than to that of 1911-12. In moving, during those years, from a context of flatness to one of relief, Picabia reversed the evolution undergone by Picasso's and Braque's art, in which solid forms had increasingly dissolved into an increasingly luminous and pictorial frontal space. Thus, when *Dances at the Spring* was exhibited at the New York Armory Show in 1913, the New York *Times* could refer to Picabia as "the Cuban who outcubed the Cubists."

If Picabia's paintings of 1911-12 have a real affinity with Cubism, it is with Léger's rather than Picasso's or Braque's kind. Paintings like *Dances at the Spring* and *Procession, Seville* approach Léger's *Nude in the Forest* (1910) in dynamism of subject and the crowded juxtaposition of planes. In both Léger and Picabia, shapes pre-exist as vocabulary elements, rather than being discovered in the "analysis" of the visual field; human figures become part of the same order of shapes as their landscape settings, so that the eye hardly disengages one from the other. The boldness and dynamism of Léger's and Picabia's pictures at this time also reflect their affinity with the Futurists, and the Futurist celebration of the machine was soon to be echoed, in quite different ways, by both of them.

Up to this point, there had been nothing in Picabia's painting to suggest that he would ever turn to an art of fantasy. The change began early in 1913, its immediate cause being Picabia's trip to New York for the opening of the Armory Show in February of that year (although ultimately his friendship with Duchamp—dating from 1910—and his familiarity with Duchamp's paintings of 1912 were more important influences). Travel always stimulated Picabia's imagination. He probably derived the idea for *Dances at the Spring* from a peasant celebration he had seen near Naples, for the *Procession, Seville* from a parade of flagellants he had watched in that Spanish city. Now, on the liner carrying him to New York, he was fascinated by two passengers: a Dominican friar and a young dance star whom he observed every day rehearsing with her troupe. From his recollections of this trip gradually emerged a private iconography dominated by figures called "Udnie" and "Edtaonisl."

The names Udnie and Edtaonisl were invented by Picabia and are cryptic, representing a juggling of letters of key words or clues to the iconography. Picabia never revealed their meanings, even to Gabrielle Buffet. But Philip Pearlstein[53] has convincingly interpreted "Edtaonisl" as an alternation of the letters *e-t-o-i-l* and *d-a-n-s*, which words, given their terminal *e*'s, would refer to the star dancer; he speculates that *Udnie* may be an anagram for *Nudie*, a reading supported by the fact that Udnie appears in a drawing of 1915 as a *Young American Girl in the State of Nudity*. Picabia had been struck by the youth,

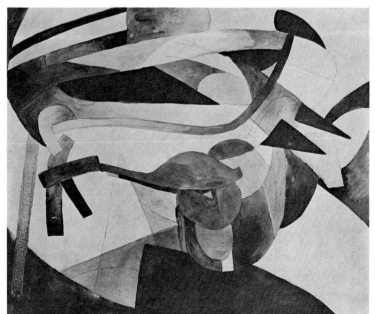

24

26

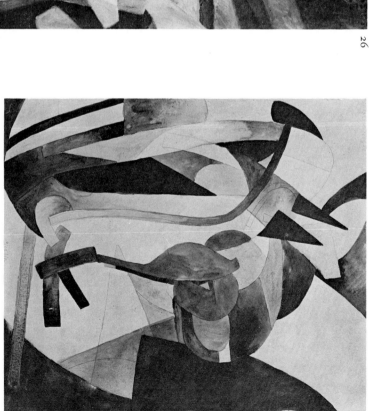

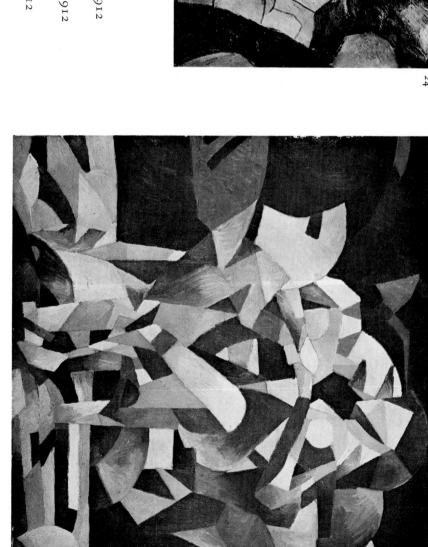

27

25

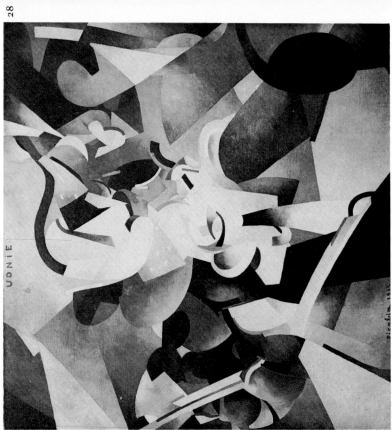

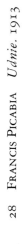

29

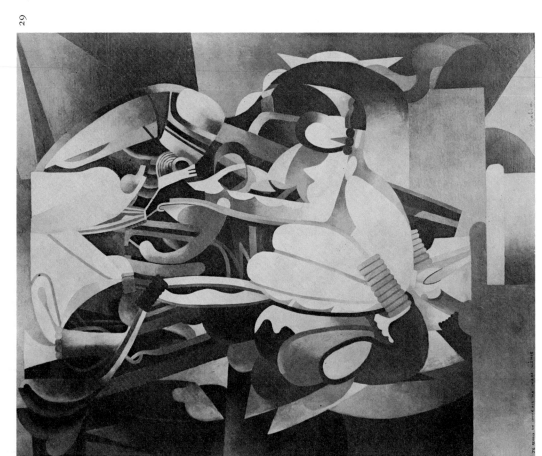

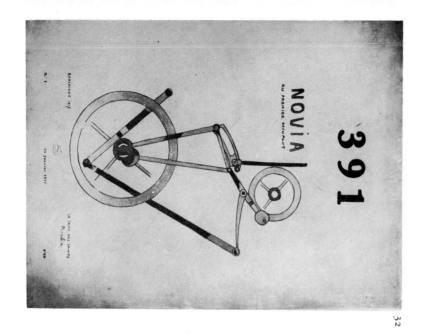

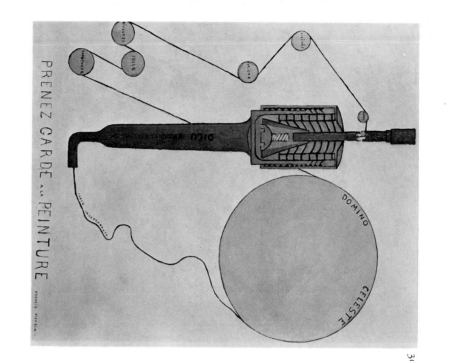

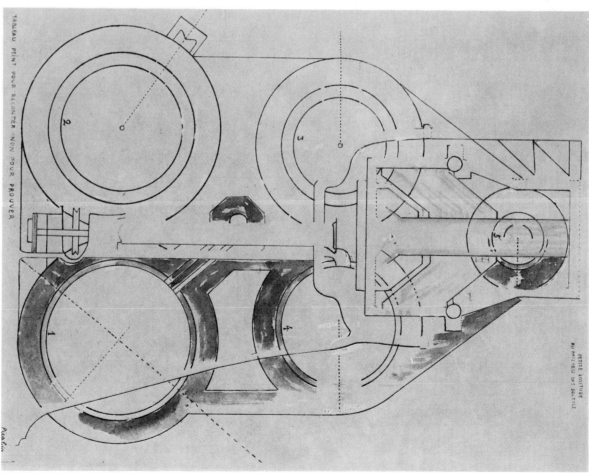

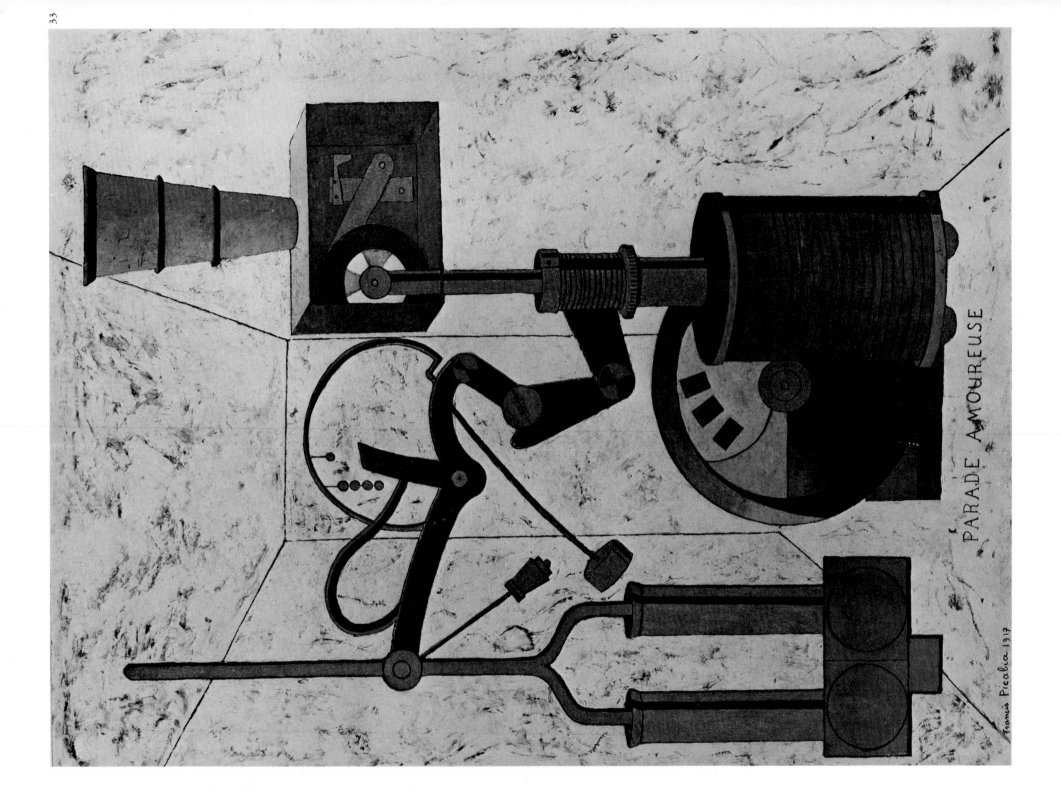

PARADE AMOUREUSE

Francis Picabia 1917

LA NUIT ESPAGNOLE

36

34

CONVERSATION II

35

CULOTTE TOURNANTE

37

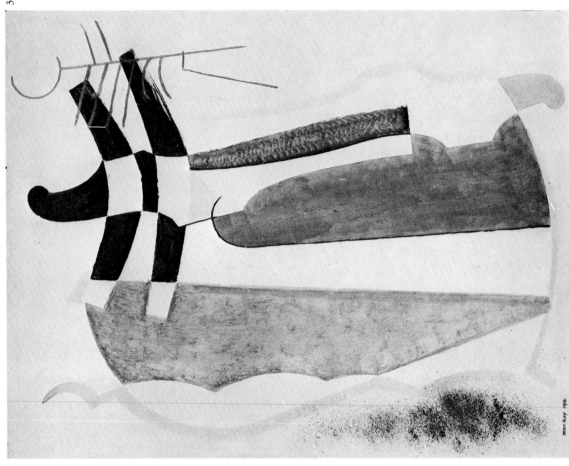

38 MAN RAY *Revolving Doors: Dragonfly.* 1916–17

39 MAN RAY *Legend.* 1916

40 MAN RAY *Boardwalk.* 1917

41 MAN RAY Untitled Aerograph. 1919

42 MAN RAY *Preconception of Violetta.* 1919

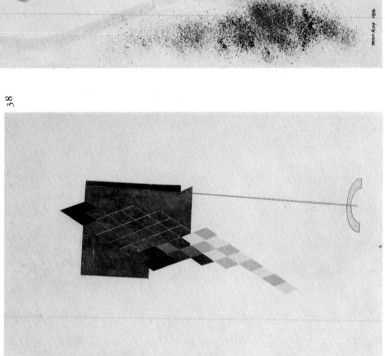

42

41

43 MAN RAY *The Impossibility*. 1920

44 MAN RAY *The Enigma of Isidore Ducasse*. 1920

45 MAN RAY *Coat Stand*. 1920

46 MAN RAY *Gift*. Replica (original, 1921, lost)

energy, and allure of the dancer on the steamer, and he was to associate all these qualities with young American women during his stay in New York. Though the dancer was actually a Russian named Napierkowska, her image soon became assimilated to that of the "American Girl."

If, indeed, it dates from Picabia's first voyage to America, the earliest work containing this new proto-Dada iconography would be a drawing made on stationery of the former Hotel Brevoort on lower Fifth Avenue, where Picabia stayed during the Armory Show. The title, *Girl Born Without a Mother*, suggests the mythological nature of Napierkowska-American Girl-Udnie, and if we study the drawing (fig. D-64) in relation to Picabia's previous work, we discover two new and prophetic elements: the upper part of the drawing shows a series of curvilinear, proto-organic forms, while the lower part shows coil springs and other indications of machine parts. This drawing was to provide the nucleus of the very large canvas titled *Udnie* (fig. 28), painted by Picabia after his return to Paris and now in the Musée National d'Art Moderne, Paris.

The Picabias were delighted by their reception in New York. Contrary to their expectations, they found a group of amateurs thoroughly familiar with the intellectual life of Europe and very much interested in modern art. There is no need here to rehearse the excitement created by the Armory Show; along with Duchamp's *Nude Descending a Staircase, No. 2*, Picabia's paintings were the *succès de scandale* of the event. Picabia received tremendous publicity —in part because he was alone among the major painters shown was actually on the scene—and he was treated with great respect and admiration. Picabia, in his turn, was taken with New York. Gabrielle Buffet recalls that the architecture and machinery astonished him; he was especially impressed by the Queensboro Bridge. This fascination with American machinery, which Duchamp also felt two years later, undoubtedly affected the new proto-Dada direction of Picabia's painting and helped lead him ultimately to the machine style.

At the center of avant-garde art circles in New York was Alfred Stieglitz, whose Photo-Secession Gallery at 291 Fifth Avenue exhibited photographs and modern paintings. He published a review called *Camera Work* and, in 1915, began to publish *291* (for the gallery's street address). This provided Picabia with the idea for his review, *391*, which saw the light two years later. Invited to exhibit at Stieglitz's gallery, Picabia bought paper and watercolors and immediately began working in his apartment at the Brevoort. While some of the watercolors he produced there simply repeat the plastic conventions of his paintings of 1912, others break away

in the direction signaled by *Girl Born Without a Mother*. One of these latter, *Negro Song* (fig. 27), which Stieglitz kept for his own collection, is marked by arabesques and contains at least incipient suggestions of the kind of organic forms that were to appear in the large oils which Picabia did later that same year. Some of the contours of the female nightclub singer who is the subject are almost literal (the breasts are readily identifiable), but other shapes of *Negro Song* are imaginative and do not relate to external appearances. Picabia was leaving the optical tradition, to which his Cubist-influenced work had still been committed, and following Duchamp into a world of ambiguous symbolic forms.

Color, too, became symbolic. In such pictures as *Procession, Seville* the browns and blues can be immediately identified as the flagellants' cloaks and the sky. But although *Negro Song* is ordered generally with the same kind of light-dark patterns as the paintings of 1912, the dominant purple tonality superimposed on the chiaroscuro belongs to the realm of imagination and poetic association rather than perception. Picabia chose it because it was the color that always sprang to his mind when he heard "Negro music." Later, he was delighted when Stieglitz asserted that purple was the favorite color of most Negroes in America.

Elated by his stay in America, and bursting with ideas, Picabia returned to Paris and at once began a series of huge paintings (the largest about eight feet square), in which he developed further the proto-Dada motifs of the Stieglitz watercolors. The first two of these big pictures, *Edtaonisl* (colorplate 3) and *Udnie* (fig. 28), were shown in the Salon d'Automne of that year (1913) and were reproduced in color by Apollinaire in the November issue of *Les Soirées de Paris*. Apollinaire described them as "Orphic" pictures, "worthy of Poussin's motto that painting has no other goal but the delectation and joy of the eye." It is apparent that Apollinaire had not registered the transformation that had taken place between these pictures and those of the previous year, for by now Picabia had certainly begun to move from a context of sensation-oriented abstraction to a Duchampesque proto-Dada ideal of painting addressed to the mind.

Apollinaire and Picabia had become very friendly in 1912 (fig. D-62); at the time, the former was writing his *Cubist Painter*, the publication of which in the following year Picabia financed. In this book Apollinaire defined the two main tendencies of Cubism as "scientific" (Picasso, Braque, Gris) and "Orphic" (Delaunay, Picabia, Léger, and Duchamp). By "scientific" Apollinaire meant what has come to be known as Analytic Cubism; but Orphic Cubism

was a confused concept, suggesting at first glance what might be called nonfigurative painting. Orphic artists, according to Apollinaire, paint "new structures out of elements which have not been borrowed from the visual sphere, but have been created entirely by the artist himself. . . . This is true art." Confusion arises only when we turn to the paintings Apollinaire had in mind: such pictures as Picabia's *Dances at the Spring* (fig. 25) and Duchamp's *The King and Queen Surrounded by Swift Nudes* (fig. 6). It immediately becomes clear that Orphism, at least in 1912, did not mean nonfigurative painting but at most a disposition toward it. Apollinaire understood that "scientific" (Analytic) Cubism proceeded from a visual motif, while "Orphic" Cubism, though retaining subject matter (that is, the dancers in Picabia's picture), tended to use forms that derived not from analysis of the motif but from imagination, forms that existed prior to the choice of "subject" for the painting. The Orphists seemed to Apollinaire to be creating a basically musical art (thus the term "Orphism"), and he wrote specifically of Picabia's canvases that they were "close to music" and "would like to stand, with respect to past painting, as music stands to literature."

The analogy to music was one to which Picabia himself was much addicted even earlier. Though the "subject" is much in evidence in his paintings of 1912, he was thinking of these pictures as free compositions. "We must devote ourselves," said Picabia, echoing Mallarmé, "to setting down on canvas, not things, but emotions produced in us by things." But, by the time of the Armory Show, these views were given a new twist when he wrote that the properties of things "can no longer be expressed in a purely visual or optical manner," and that a language had to be created to express "the objectivity of a subjectivity." On his return to Europe, he moved further from Orphism and closer to the new proto-Dada path being explored by Duchamp, asserting that this new language must be capable not only of arousing emotions but of *conveying subtleties of thought*. "With this language he wished to state ideas," Pearlstein observes, and he "expressed belief in the ability of his subconscious to invent the symbols of this new pictorial language."

Picabia's three outsize canvases of 1913–14 hover between two poles: colored planes in purely formal arrangements (the inheritance from Orphism) and the definition of symbols addressed to the mind of the spectator. The most impressive of the three fantasies is *Edtaonisl*; it is also the most formal, with all references to the mechanical or organic being submerged in the "musicality" of the composition. *I See Again in Memory My Dear Udnie* (fig. 29), last of the three to be executed, is the most literal and contains very clear references to mechano-organic elements which Picabia, following Duchamp, went on to explore in the machine style. Hoses, coiled springs, suggestions of spark plugs, and sexual organs are among the salient shapes.

In the painting *Edtaonisl* the forms are concentrated in the lower center of the canvas, fanning out toward the edges, the planes nearer the center overlapping those farther away. The result is not, however, the creation of a deep space, for the planes themselves are mostly unmodeled and adjusted parallel to the picture plane. The shapes are among Picabia's most inventive, and while certain passages (concentric arabesques) are obviously borrowed from Delaunay, others anticipate as much as they parallel the work of Léger from then on. The title relates, as we have noted, to the star dancer he had seen on the transatlantic crossing, but as the forms are highly generalized and abstract, an iconographic reading must be conjectural. On the basis of Gabrielle Buffet's recollections,[54] the intended theme of the picture is probably the palpitating heart of the clergyman as he watches the dancer and her troupe rehearse on the deck of the liner.

Edtaonisl is carried off with tremendous bravura and decorative power; had Picabia continued in this direction, he might well have become a bold "architectural" painter on the order of *Léger*. But the transition to *I See Again in Memory My Dear Udnie*, painted in the year 1914, indicates that his interest clearly had shifted from direct plastic expression to symbolic iconographies requiring more literal forms. Those of *I See Again in Memory My Dear Udnie* are concretely sculpturesque—that is, modeled in high relief—and they cluster, as objects before a background, in space that is much deeper and more illusionistic than that of *Edtaonisl*. The theme is quite clearly sexual intercourse, presented ideographically by the confrontation and interpenetration of forms akin to the external organs of the male and the internal organs of the female. To use the language of painting so descriptively was to risk an almost academic dryness, no matter how fantastic or unrealistic the manifest subject of the picture. Picabia resolved this dilemma soon afterward in the manner of Duchamp, by renouncing oil painting (at least as the term is generally understood) and creating an anti-art based on collage, montage, and the techniques of commercial illustration. Picabia thought of this anti-art as a rejection of the whole tradition of modern painting and particularly of the Cubism that had most recently influenced him. Cubism was, after all, an extension of the Post-Impressionist styles, which still accepted nature as a starting point. The stuffed monkey in Picabia's *Portrait of Cézanne* was not merely an insult; it was an allusion to the fact that Cézanne's painting from a

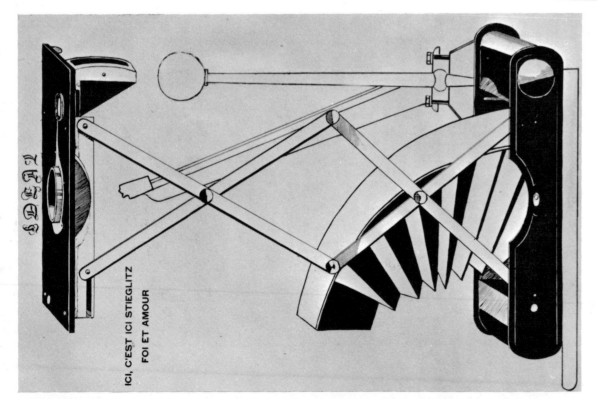

Francis Picabia. *Ici, c'est ici Stieglitz*

model made him a descendant of those naturalistic old-master painters who had been satirized as *simiae naturae*. Picabia wanted an art that would proceed wholly from fantasy. "We wanted to make something new," he later recounted, "something that nobody had ever seen before."

DADA IN NEW YORK: PICABIA, DUCHAMP, AND MAN RAY

With the outbreak of war in Europe in 1914, Picabia stopped work on the series of large paintings he had begun the year before and,

choosing not to assert his Cuban nationality, let himself be drafted into the French army. Because of Picabia's knowledge of cars, General de Boissons, an old friend of his wife's family, was able to have him appointed his chauffeur. Then, in 1915, when a mission was being sent to Cuba to purchase sugar for army stores, somebody remembered Picabia's Cuban background, whereupon the War Office named him its emissary and ordered him to proceed to Havana via New York. In New York, in June, 1915, Picabia rejoined Marcel Duchamp (who had himself recently arrived), renewed his acquaintance with Stieglitz, and again found himself at the center of a community of amateurs animated by Walter Arensberg, Marius de Zayas, Mrs. Ernest Meyer (wife of the publisher of the *Washington Post*), and Paul Haviland (American representative of the Limoges porcelain manufacturers). His mission to Cuba was soon forgotten, and he resumed his art, this time in a manner totally different from his oil paintings and very much influenced by Duchamp, who was then at work on the *Large Glass* and the Readymades.

The first phase of Picabia's anti-art consisted of a series of "Object-Portraits," drawings of isolated technological objects given new meaning by titles (often included in the drawings as legends) that identified them with particular personalities. Stieglitz was represented by a folding camera, Picabia himself by an automobile horn, and the *Young American Girl in the State of Nudity* by a spark plug (because she is a "kindler of flame"). Compared with the sophisticated leap of the imagination demanded by the works of Duchamp, the relation of title and image in these Picabias is obvious. The symbols themselves are so exaggeratedly prosaic as to suggest that it was Picabia's intention to telescope the process of association which might give them richness, and thus arrive at the greatest commonplace. If so, this intention reinforces the anti-art approach of the drawings themselves, based as they are, as William Camfield has demonstrated, on mail-order catalogue illustrations and newspaper ads of the day. (The "For-Ever" on the spark plug recalls the brand names associated with such commercial illustration.) But on closer inspection we realize that the drawings are as different from their commercial models as are Roy Lichtenstein's paintings from the cartoons that inspired them. Their layout, distribution of accents, and firm contouring reflect a hand and eye still informed by the taste and discipline of Cubism.

This plastic dimension is even more apparent in a series of "machine paintings" that Picabia made shortly after. Like Duchamp's *Large Glass* and Picabia's own Object-Portraits, these were nominally held to be "anti-esthetic." Yet the best of them—*Very Rare Picture on the Earth* (colorplate 4), for example—reveal a bold handling of essen-

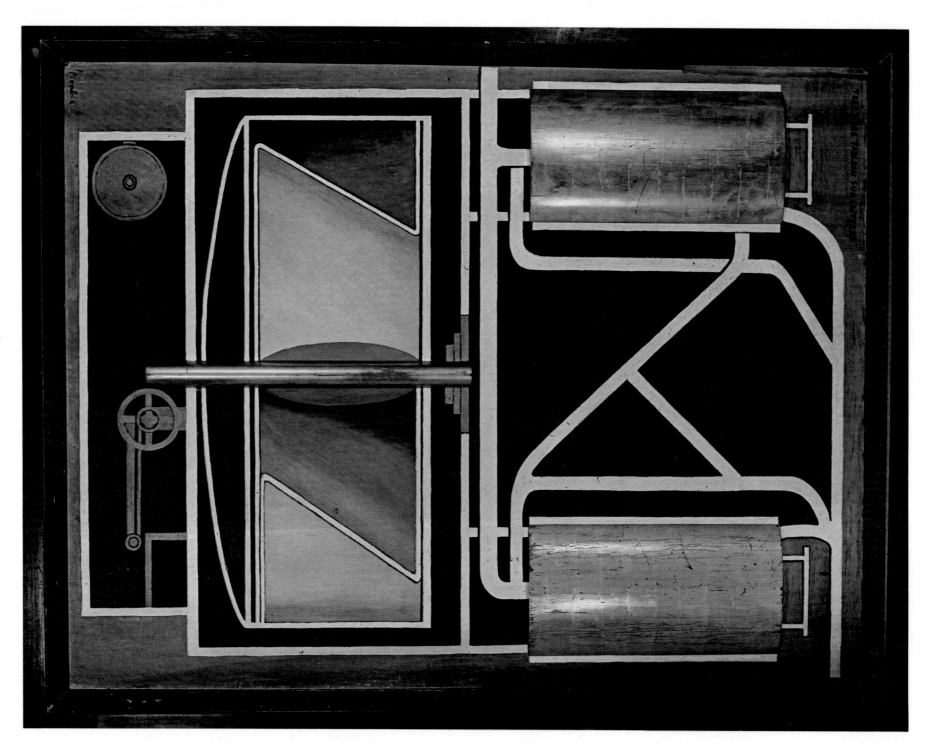

tially Cubist design, and are free from the prolixity of shape that mars many of Picabia's 1913 paintings. It was as if the sudden decision to eliminate "esthetics" freed Picabia—at least momentarily—of some inhibiting art-school habits and gave him the courage to jettison a great many inherited pictorial mannerisms. As powerful as is a work like *Edtaonisl*, it strikes us as somewhat overelaborated and synthetic, by contrast with the "machines" of 1915, which have the freshness and directness that usually mark modern painting in the moments when it discards expendable conventions.

Very Rare Picture on the Earth presents us with a strange, pointless machine made of cylindrical tanks joined by pipes in a system apparently run by little wheels at the bottom. Unlike the work of Duchamp, in which notes by the painter permit specific iconographic interpretation, Picabia's machine remains a total enigma. The spirit of anti-painting makes itself felt, first, through the avoidance of color: only black, gray, silver (pipes), and gold (tanks) are used. Then, instead of representing the cylindrical form of the tanks by light-dark modeling, Picabia gives us actual cylinders that stand out in relief from the surface, creating a light-dark play in the way they catch the light. Yet, as with all other attempts at anti-art, the device here depends on the very tradition it would deny, for just as the plan of the composition derived from Cubism (and the cylinders perhaps directly from Léger's *Contrastes de Formes*), so the idea of attaching three-dimensional cylinders to the surface was rendered conceivable by the precedent of Picasso's constructions of 1912–14. The spatial effect of *Very Rare Picture on the Earth* is entirely Cubist, the forms projecting forward into the space of the spectator rather than receding illusionistically back from the picture plane.

This picture and the related "machine" pictures of 1915 show Picabia at his best; from that time on, his pictorial and other plastic productions become more infrequent and less dense esthetically as he devotes his time increasingly to poetry, travel, and the publication of *391*. Restless and impatient with anything that might tie him to a studio, Picabia left New York and by August, 1916, was in Barcelona. There he encountered a new set of exiles from the war, Albert Gleizes, Max Goth, and Marie Laurencin among them. They collaborated with him on *391*, a review which he conceived toward the end of the year and first published in January, 1917. Typical of the subsequent numbers in format and content, No. 1 contained only four pages, including the cover, a watercolor titled *Novia* ("sweetheart" in Spanish and possibly a play on the word *avion*; fig. 32), which resembled locomotive wheels and their connecting rods turned vertically. The second page contained poems by Picabia, Goth, and

Laurencin, and the third a timid watercolor of two girls by Laurencin. The back cover, titled "Odeurs de Partout," was devoted to witty gossip (some of it fabricated) about friends and enemies of Picabia in New York, Paris, and elsewhere.

Having published four issues of *391* in Barcelona, Picabia returned to New York, in April, 1917. In addition to continuing the review (Nos. 5, 6, and 7 appeared monthly beginning in June), he returned briefly to painting for another series of machine pictures. The best of these—*Amorous Parade* (fig. 33)—is a bold confrontation of mechanical male and female apparatuses inspired by Duchamp. Early the following winter, Picabia left New York again, this time for Lausanne, Switzerland, where he published "Poems and Drawings by the Young Girl Born Without a Mother." Later he met Tzara and Arp, and contributed to *Dada, No. 3*, though he did not actually visit Zurich until January, 1919, following a short stay in Paris. In Zurich, after a hiatus of eighteen months, *391* reappeared in an issue that contained texts by Tzara and reproductions of work by Arp.

Between 1918 and 1922 Picabia's painting was in an equivocal state. His style was no longer developing coherently and real successes had become less frequent. Among the latter is the striking *M'Amenez-y*, its title based on a "verbal Readymade" by Duchamp, and the handsomely abstract *Culotte Tournante* (fig. 37), the visual simplicity of which reflects Picabia's interest during the early twenties in arresting optical devices, for example, the target that makes up *Optophone*.

The war over, New York ceased to be a magnetic center for Dada, and, instead of returning there, Picabia went again to Paris, where Duchamp joined him as a house guest in July, 1919. They soon established contact with the French Dada poets, who met regularly at the Café Certá. The New York branch of the movement did not come to an end immediately, however. Morton Schamberg (fig. 50) continued to make machine pictures, and even Joseph Stella was momentarily influenced by Duchampesque imagery (fig. 51). The most active American Dada, however, was the painter-photographer Man Ray. In 1920 Katherine Dreier, Marcel Duchamp, and Man Ray founded the Société Anonyme, which was in effect the first museum of modern art in New York; Man Ray gave the new museum its name. In 1921 Man Ray and Duchamp collaborated on *New York Dada*. Man Ray's departure later that year for Paris marked the definitive close of Dada activities in New York.

Man Ray was twenty-three and studying painting in New York when the Armory Show took place. As a child, he had been brought

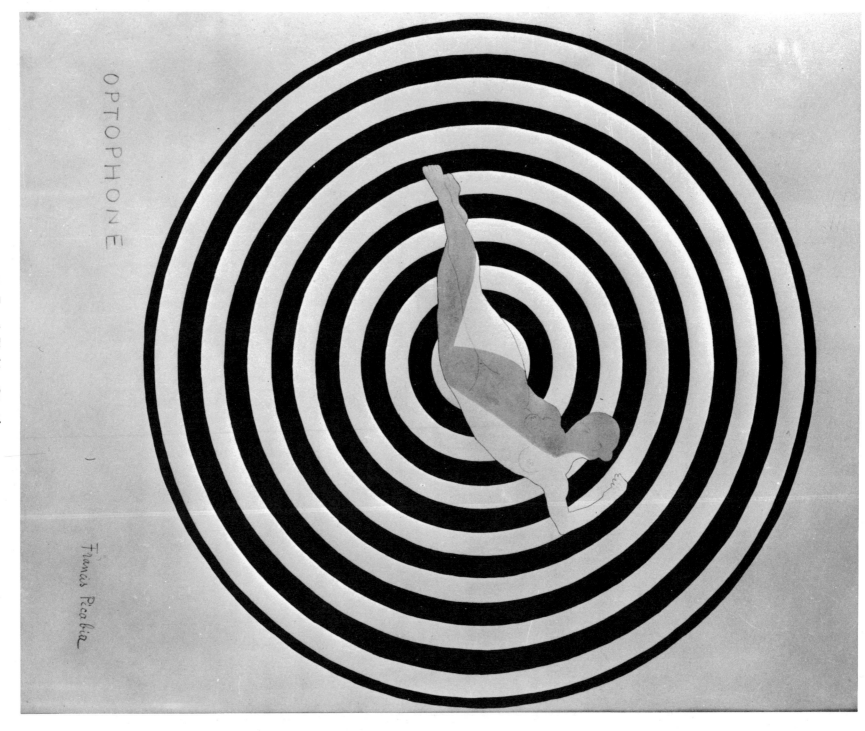

Francis Picabia. *Optophone*

to the city from Philadelphia; now his early training in architecture and engineering enabled him to support himself by doing odd jobs for commercial designers. There is no question that what Man Ray saw at the Armory largely determined the nature of his paintings of 1913–15, but these were still apprentice efforts. Only after the arrival of Duchamp in 1915 does his maturity begin.

The influence of the Armory Show may be measured by comparing the loosely painted *Dream* of 1912 with the *Woman Asleep* executed just after the show. The latter not only contains manneristic elongations recalling Picasso's Blue Period but displays a handling of color in flat planes particularly reminiscent of "conservative" Cubists like Roger de la Fresnaye. *Five Figures* (fig. D-66), painted the following year, is less affected but more obviously schematic. The coloring in both is somewhat awkward, and the touch relatively insensitive. At no time has Man Ray worked particularly successfully in a painterly manner (nor does he consider himself a painter); his best efforts have usually involved some short cut in technique.

More important for Man Ray's subsequent development than the Armory Show or his studies with George Bellows and Robert Henri was a stay at an artists' and intellectuals' colony in Ridgefield, New Jersey, which he helped found in 1913. There, in an environment animated by discussions of anarchism and socialism, he came in close contact with people like Max Eastman, founder of *The Masses*, and the poets Alfred Kreymborg and William Carlos Williams. Sharing in this adventure in living under the stars of Whitman, Thoreau, and Veblen served to prepare Man Ray spiritually for the American phase of Dada. To this extent the Dada "revolt" in New York was not an alien transplantation but a mutation, entirely understandable in terms of the thinking of the American intellectual avant-garde. John Baur[55] has called attention to the figures who prepared the ground for Dada in New York; one of the most prophetic of them was the Jewish poet and critic Benjamin De Casseres, who, as early as 1913, had written what might pass for a Dada manifesto:

Sanity and simplicity are the prime curses of civilization ... a kind of lunacy wherein a fixed idea blankets the brain and smooths the admirable incoherence of life to a smug symmetry and proportion. ... We should mock existence at each moment, mock ourselves, mock others, mock everything by the perpetual creation of fantastic and grotesque attitudes, gestures and attributes....

To this native anarchistic pre-Dada heritage Man Ray soon added a familiarity with European culture. During his second year at Ridge-

field, he met a young French girl, Adon Lacour, whom he subsequently married, and who introduced him to the work of Rimbaud and Mallarmé. He was thus prepared—indeed predisposed—to profit from contact with Duchamp, who visited Ridgefield shortly after his arrival in America in 1915. From that time, the two remained fast friends, working together on most of the projects that constituted New York Dada, and later participating together in the "manifestations" of the Surrealists. Though deeply influenced by Duchamp's ideas, Man Ray never, however, adopted the imagery of the machine style as did, briefly, Schamberg and Stella.

During the winter of 1916–17, Man Ray executed his first works of importance, and it is not surprising that these were done in collage rather than painting. Influenced by Synthetic Cubism, but less obviously figurative, Man Ray's collages are inventive designs in arabesques and straight edges cut out of commercial colored papers and isolated in the center of the ground sheet without that concern for rapport with the frame that characterizes Synthetic Cubism itself. In some cases there are elliptical references to figures and objects, and these suggest a continuity with such of Man Ray's figure paintings of 1915 as *Dance* and *Promenade*, in which, despite the remains of painterly textural variations, the flattening out of the planes had advanced quite far. Ten of these collages, more distilled than the paintings to which they relate, were published a decade later in Paris under the title *Revolving Doors* (fig. 38). They suggest that though Man Ray lacked a sensibility for paint substance as such, he was nevertheless an inventive designer and composer.

The best and most ambitious of Man Ray's New York period paintings is *The Rope Dancer Accompanies Herself with Her Shadows* (1916; colorplate 5). Though executed entirely in oils, it is in reality simply a transposition of ideas from *Revolving Doors* into the *trompe-l'oeil* of a collage. The dancer herself is a small, very schematic figure at the top of the canvas, with legs and skirt shown simultaneously in many different positions. The same Duchampesque principle allows the rope to be represented six times, forming lariat-like arabesques that swing out to enclose the "shadows," large, flat, abstract shapes of orange, green, rose, blue, yellow, and purple. This painting had been preceded by work on a collage based on the same subject, in which the contours of the dancer in various positions were cut from pieces of variously colored paper. When the artist's eyes lighted on the remains of the colored sheets on the floor, he was struck by them, and the "shadows" in the painting are enlarged transpositions of the shapes left in the original colored paper when the representations of the dancer had been cut out.

V MAN RAY *The Rope Dancer Accompanies Herself with Her Shadows*, 1916

Cover of *The Blind Man*

Having retreated from painting via the collage and its *trompe-l'oeil* equivalent, Man Ray took the next step in the suppression of facture by entirely eliminating brush and traditional pigment. From 1917 until the end of Dada in the early twenties, he worked primarily as a maker of objects and an explorer of new technological methods of image making: his "Aerographs" were made with a spray gun (air gun) and his "Rayographs" by direct exposure of sensitized photographic paper (figs. 41, 47).

The earliest of Man Ray's objects was *Boardwalk* (fig. 40), a curious painted checkerboard pattern with knobs and cords attached in relief. It is much less a Readymade than an extension into fantasy sculpture of the checkerboard-like collage *Dragonfly* (fig. 38), from *Revolving Doors* (the only one of that series which is organized according to perspective illusion). *By Itself* (fig. D-67) was simply the three-dimensional wooden template he had made to facilitate his Aerographs. *The Enigma of Isidore Ducasse* (fig. 44) was a mysterious object entirely wrapped in sackcloth (actually a sewing machine suggested by the famous Ducasse-Lautréamont image) and bound with cord. It anticipates by almost half a century the comparable objects of Christo. The original paper spiral *Lampshade* of 1920 was destroyed by the janitor of the Société Anonyme the day before the gallery opened (he thought it was a piece of wrapping), but like the Readymades of Duchamp, it is—and was—easily replaced (in painted metal). Man Ray continued to make objects in Paris, where he settled in 1921, and his *Gift* of that year (fig. 46), an anti-functional affirmation in the form of a flatiron with a row of nails on its sole, became one of the most celebrated of Dada works.

The Aerographs, or "pistol paintings," begun in 1918, were made by spraying color with an air gun. The image was outlined by stencils and templates, and, depending on their proximity to the surface, on the angle of spraying, and other variables, a considerable variety of effect could be obtained. The *Preconception of Violetta*, an Aerograph of 1919 (fig. 42), suggests three female torsos, the contoured modeling of which was achieved by varying the distances of the templates. Another Aerograph (fig. 41), untitled, the template of which subsequently became *By Itself*, is based on patterns from *Revolving Doors*. In its interpenetration of planes, its delicately graduated monochromy, and in the way it fades toward the sides of the field, it immediately reminds us of the Analytic Cubist pictures of 1911–12, whose influence may also be seen in its oval format; it is a paradigmatic example of the persistence of Cubist syntax even in the teeth of an anti-art technique. *The Impossibility* (1920; fig. 43), executed on glass, is quite different in its virtually flat patterns and

strong contrasts. Though at first reminiscent of Picabian "flywheel machines," and no doubt influenced by them, the arrangement here is far more rationally mechanical, the teeth of the wheel actually interlocking. The word "Dancer" is printed on the surface in such a way as to read, alternatively, *Danger*.

Man Ray had long been experimenting with photography, and with his move to Paris (where painters turned to him for records of their work) it became his main support. In addition to this commercial work and a variety of nudes, studies from nature, and other subjects handled according to the conventions of "art photography," we owe to this period a series of extraordinary camera portraits of leading avant-garde painters, writers, and composers (fig. D-150). Earlier he had created a "Dadaphoto" of a live nude whose anatomy

Inside the cover illustration:

THE BLINDMAN

INDEPENDENTS' NUMBER

APRIL–10TH–1917 No. 1. PRICE 10 CTS

The second number of The Blind Man will appear as soon as YOU have sent sufficient material for it.

The Blind Man
33 West 67th Street,
New York.

is partially replaced by collage construction, and portraits of the Dadaist Baroness von Freytag-Loringhoven, for *New York Dada*, on which he had collaborated with Duchamp. Also in 1920, Duchamp had adopted the pseudonym Rrose Sélavy, and Man Ray commemorated the change in a series of photographs of a transvestite Duchamp.

Among the experimental photographic techniques Man Ray explored was solarization, by then known to photographers for some time: by exposing the negative to strong light in the process of development, a blanched, cameolike effect was obtained. In portrait photographs, such as the one of André Breton, the outer contours became in effect wide, dark lines, reducing the image to a low-relief illusion. Man Ray's own (accidental) discovery—though not unrelated to the less interesting but earlier experiments of Christian Schad (fig. 49) which were little known—was a method of recording images by exposing sensitized paper, masked by objects placed flat against it or close to it, directly to the light. By controlling the period of exposure and by reexposing with the masking objects shifted or removed, he was able to get a number of fugitive effects, as well as a full range of values from black to white (missing in Schad's work) in this instantaneous, "automatic" process. The best of these Rayographs (fig. 47) were those in which a Symbolist-inspired juxtaposition of silhouetted figures and objects was reinforced by the dreamlike, negative, dark-light relationship and the ambiguities caused by the technique's elimination of detail. Some of these were later published in a limited edition under the title *Les Champs délicieux*, for which Tzara wrote the preface.

Man Ray's most intensely creative period coincided with the rise and fall of Dada; later he became an active member of the Surrealist group. Since the late 1920s he has painted sporadically in an illusionist vein inspired by de Chirico and Magritte, many of his pictures growing out of ideas derived from photographs.

Some of Man Ray's most arresting photographs were outsize magnifications of a detail of a face or body (an idea present in de Chirico but not pressed to an extreme). "One of these enlargements of a pair of lips haunted me like a dream remembered," he recalls. "I decided to paint the subject on a scale of superhuman proportions." After two years of intermittent work, *Observation Time—The Lovers* (fig. 48) was finished in 1934. The title reflects the way the disembodied and enormous pair of lips suggests two figures embracing. Man Ray worked in this simplified illusionistic manner on and off between photographic commitments through the following decades, sometimes synthesizing ideas from other artists into the Chiricoesque mode, as in *End Game* (1946; fig. D-169), where Léger's mechanical

figures are surrealized and amalgamated with de Chirico's mannequins in a picture showing the artist's original designs for chess pieces.

THE CABARET VOLTAIRE AND ZURICH DADA

Poet, Catholic mystic, and pacifist, Hugo Ball had fled Germany for Switzerland in 1914, taking with him his wife, Emmy Hennings (fig. D-74). Shortly afterward, in Zurich, he decided to establish a gathering place for like-minded young artists and intellectuals, and to this end he enlisted the help of certain new acquaintances, Marcel Janco, Tristan Tzara, and Jean Arp. With them as the nucleus of his group (Richard Huelsenbeck joined a little later), Ball convinced the owner of a restaurant at No. 1 Spiegelgasse (fig. D-68), in the Old City, to rent him a part of the premises: a small hall with a stage of about one hundred square feet and space for tables to seat forty to fifty guests.

The hall was baptized the Cabaret Voltaire, "out of veneration," according to Huelsenbeck, "for a man who had fought all his life for the liberation of the creative forces from the tutelage of the advocates of power."[56] However, in view of the subsequent Dada denunciations of "reason," the choice of the name seems most ironic. Opening night, February 5, 1916, there was standing room only, and so it continued for almost every soirée in the Cabaret's career. Janco recalled "painters, students, revolutionaries, tourists, international crooks, psychiatrists, the demimonde, sculptors, and polite (sic) spies . . . all hobnobbed with one another."[57]

The entertainment consisted of skits, lectures, recitations of poetry, and music and dance recitals. Each evening provided a diversified program; often the numbers were created specifically for the occasion. Visiting poets, musicians, and dancers regularly added impromptu bits. Certain soirées were devoted less to poetry and music than to Dada pranks of a type more humorous and less vitriolic or ironic than the *gestes* of Cravan and Vaché. Arp wrote:

On a platform in an overcrowded room are seated several fantastic characters who are supposed to represent Tzara, Janco, Ball, Huelsenbeck, Madame Hennings, and your humble servant. We are putting on one of our big Sabbaths. The people around us are shouting, laughing, gesticulating. We reply with sighs of love, salvos of hiccups, poems, and the bowwows and meows of medieval bruitists. Tzara makes his bottom jump like the belly of an oriental dancer. Janco plays an invisible violin and bows

down to the ground. Madame Hennings, with a face like a madonna, attempts a split. Huelsenbeck keeps pounding on a big drum, while Ball, pale as a plaster dummy, accompanies him on the piano."[58]

At its founding, nobody at the Cabaret Voltaire thought in terms of a movement, programmatic or otherwise. But during its first few months, a collective social and artistic outlook began to take hold, and on April 11, 1916, about eight weeks after the opening of the Cabaret, Hugo Ball noted in his diary[59] that a "Voltaire Society" was being planned to coordinate the increasingly varied activities sponsored by the Cabaret's founders. An entry one week later indicates that Ball's suggestion to use the word "Dada" in connection with the forthcoming issue of the Cabaret's projected magazine had been accepted by the group. These two entries provide us with our most accurate limits for the discovery of the word Dada. Its first appearance in any public document was in the issue of the review Cabaret Voltaire that appeared the following June.

Tzara has always claimed to have found the word ("I found Dada by accident in the Larousse dictionary"), and he is widely credited with the discovery by writers on the subject. Georges Hugnet states that Tzara "gave a name to this delicious malaise: DADA."[60] Georges Ribemont-Dessaignes,[61] himself a Parisian Dadaist, and art historian Jean Cassou[62] both support this attribution. Unfortunately, these critics lean heavily on a statement by Arp in the last number of Dada titled Dada Intirol Augrandair (open-air Dada), published in the Tyrol, where Tzara, Arp, Ernst, and Breton were vacationing during the summer of 1921 (fig. D-105). Breton and Picabia had raised the question of whether Tzara was really the one who had discovered the magic name, and word had been spreading in Paris that it was Arp, not Tzara. Under pressure from Tzara, Arp wrote a disavowal, which began: "I hereby declare that Tristan Tzara discovered the word Dada on February 8, 1916, at six o'clock in the afternoon; I was present with my twelve children when Tzara for the first time uttered this word which filled us so justifiably with enthusiasm. This took place at the Café de la Terrasse in Zurich, and I was wearing a brioche in my left nostril. . ." Ribemont-Dessaignes[63] reports that "someone" (most likely Breton, who was anxious to discredit Tzara) told him that afterward, in the corridor outside the room in which he had made his "deposition," Arp remarked: "I found myself under an obligation to make this declaration, but in reality it is I who. . ." In 1949, Arp affirmed to Robert Motherwell that his account was, of course, a Dada joke, as he "would have supposed it sufficiently evident from its fantastic tone."[64] Its humorous nature notwithstanding, Arp's

declaration has not only supported Tzara's claim to having found the word but also provided historians with an erroneous date for the event, February 8, 1916, weeks before Huelsenbeck's arrival in Zurich, and (as we have deduced from Ball's diary) more than two months before the actual discovery of the word. This error was unfortunately perpetuated in David Gascoyne's A Short Survey of Surrealism (1935), as well as by Georges Hugnet in his essay in The Museum of Modern Art's Fantastic Art, Dada, Surrealism (1937), long the standard work on the movement.

Although Eugene Jolas attributed the discovery of the word Dada to Hugo Ball, the latter never made such a claim. On the contrary, a letter he wrote to Richard Huelsenbeck in November, 1926, strongly points to the latter as the discoverer ("You would then have the last word on the matter, as you had the first"). Huelsenbeck has long insisted on this distinction, and on numerous occasions has recounted his version of the finding of Dada. In En Avant Dada: A History of Dadaism (1920), Huelsenbeck describes the word as "accidentally discovered by Hugo Ball and myself in a German-French dictionary as we were looking for a name for Madame Le Roy, the chanteuse at our Cabaret." In "Dada Lives" (1936), he recounts the details:

I was standing behind Ball looking into the dictionary. Ball's finger pointed to the first letter of each word descending the page. Suddenly I cried halt. I was struck by a word I had never heard before, the word dada.

"Dada," Ball read, and added: "It's a children's word meaning hobby-horse." At that moment I understood what advantages the word held for us.

"Let's take the word dada," I said. "It's just made for our purpose. The child's first sound expresses the primitiveness, the beginning at zero, the new in our art. We could not find a better word."[65]

The contradictory accounts I have been describing—typical of the confusion surrounding the whole history of Dada—will probably never be resolved, and, to be sure, the problem is interesting only as a matter of historical record. Yet we can only be amused by the retrospective historical ambitions animating men who in their Dada days had done their best to reject and damn the notion of history.

Poetry, not painting, was the pervasive and characteristic interest of most of the group gathered around Hugo Ball. He himself was the inventor of the Lautgedicht, the pure phonetic, or sound, poem. Though similar experiments were widespread after World War I in the work of poets quite unaware of Ball (Raoul Hausmann thought he had invented the form later in Berlin), he was unquestionably the first to use phoneticism systematically. Dressed in a special card-

47 MAN RAY *Rayograph, 1922*

48 MAN RAY *Observation Time—The Lovers, 1932–34*

47

48

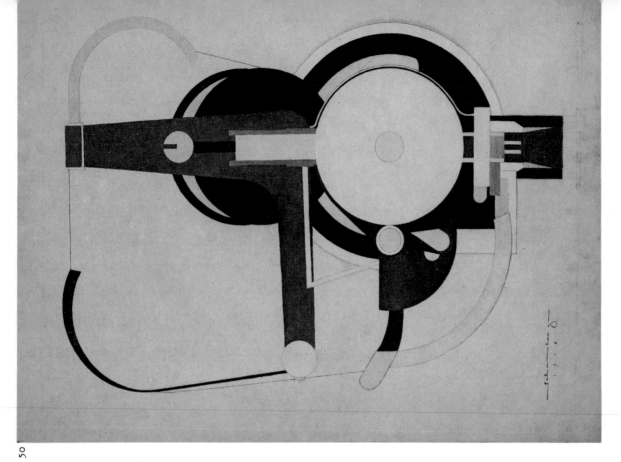

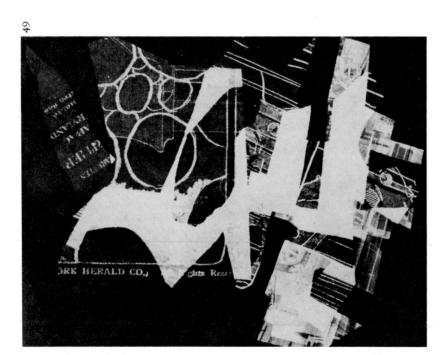

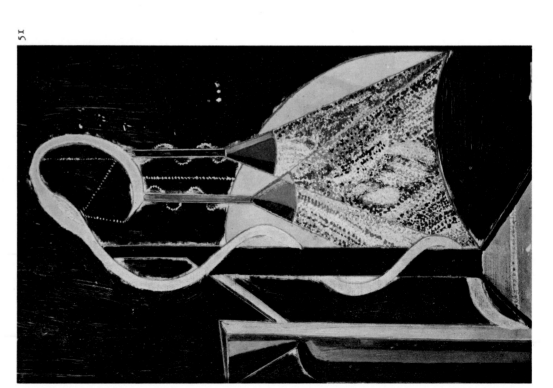

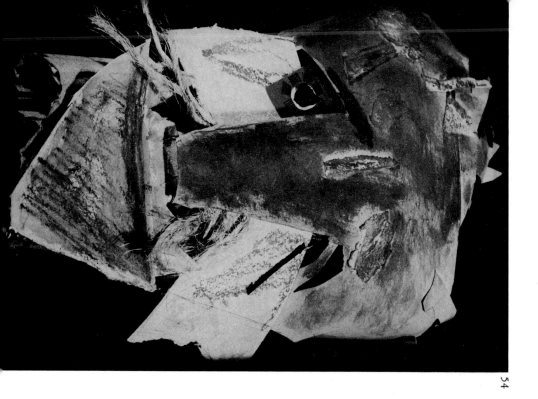

54

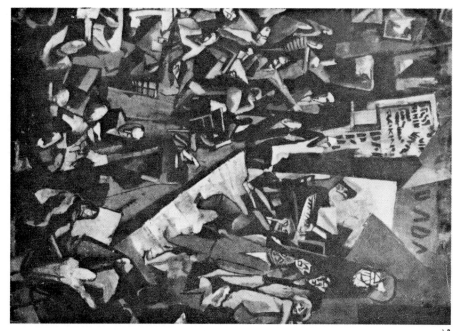

52

67

55

53

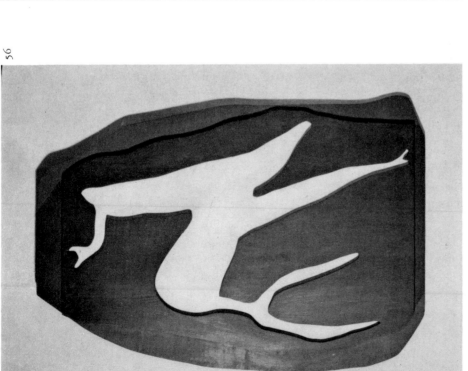

57

58

56

61

59

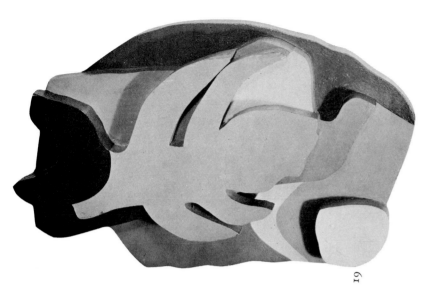

62

60

69

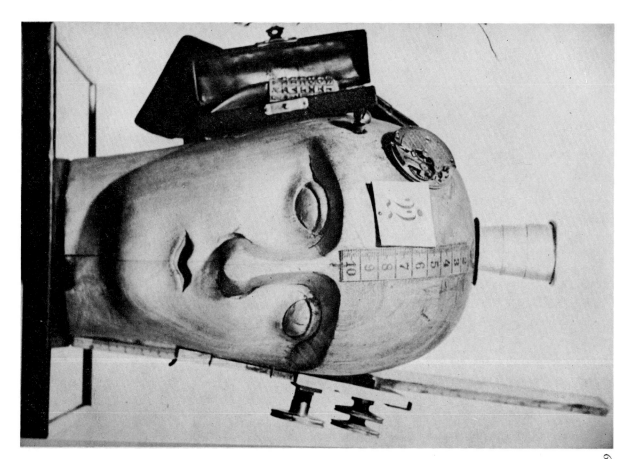

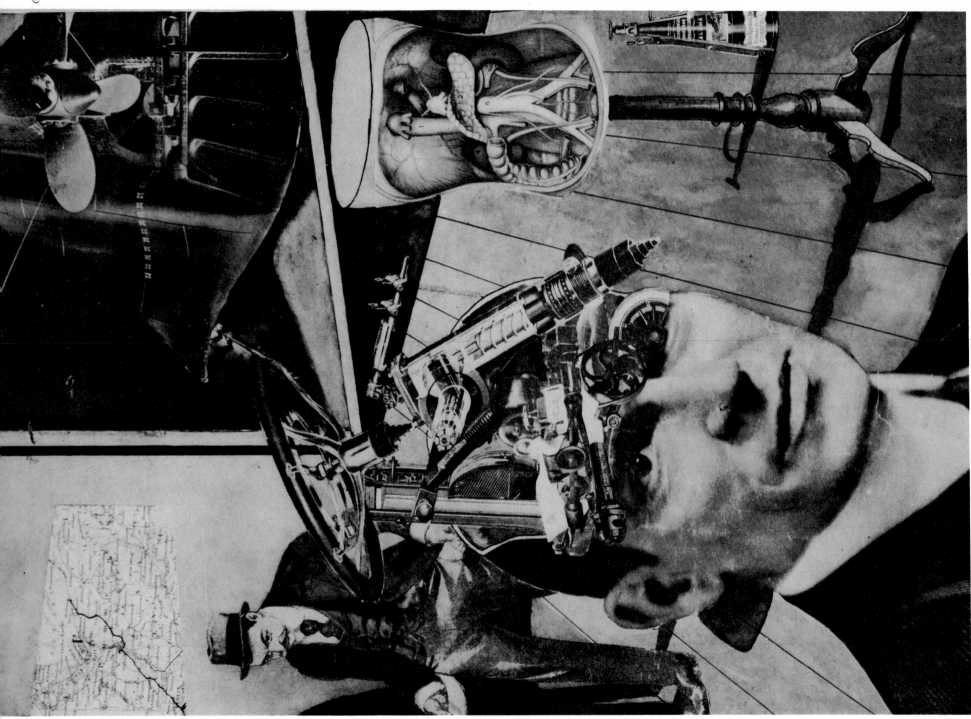

68 RAOUL HAUSMANN *Tatlin at Home.* 1920

board costume (fig. D-70) that turned him into a kind of geometrical abstract sculpture, he recited such poems as:

KARAWANE

jolifanto bambla ô falli bambla
grossiga m'pfa habla horem
égiga goramen
higo bloiko russula huju
hollaka hollala
anlogo bung
blago bung
blago bung
bosso fataka
ü üü ü
schampa wulla wussa ólobo
hej tatta gôrem
eschige zunhada
wulubu ssubudu uluw ssubudu
tumba ba- umf
kusagauma
ba - umf

The "Simultaneous Poem" was a Dada extension of the experiments by the Futurist "bruitists" and the poets Henri Barzun and Fernand Divoire in France. I have reproduced the "scoring" of one, *Admiral Seeks a House for Rent* (fig. D-71), as it appeared in the magazine *Cabaret Voltaire*. It opened with Huelsenbeck intoning, "*Aboi, aboi! Des Admirals gwirktes* [sic] *Beinkleid schnell zerfällt,*" while Janco sang, "Where the honny [sic] suckle wine [sic] twines Itself arround [sic] . . . ," and Tzara shouted, "*Boum boum boum il déshabilla sa chair quand les grenouilles humides commencèrent à brûler*" After each stanza came a rhythmic interlude during which Huelsenbeck pounded a bass drum as he chanted the words "hihi Yabonm," and Tzara repeated endlessly the words "*rouge bleu*" in rhythm with his castanets while Janco played a counterrhythm on a

whistle. The text is accompanied by Tzara's "Note for the Bourgeois," in which we are told that "the attempts at transmutation of objects and colors by the first Cubists . . . aroused the desire to apply the same principles of simultaneity to poetry."

Tzara was the animating force behind the experiments with new types of poetry. His "static poem" consisted of a group of words printed on separate placards placed on a row of chairs; with each raising and lowering of the curtain their order was rearranged. More interesting, and related to techniques being explored by Arp in the creation of certain collages, was the "accidental poem." Here are Tzara's instructions:

To make a dadaist poem
Take a newspaper.
Take a pair of scissors.
Choose an article as long as you are planning to make your poem.
Cut out the article.
Then cut out each of the words that make up this article and put them in a bag.
Shake it gently.
Then take out the scraps one after the other in the order in which they left the bag.
Copy conscientiously.
The poem will be like you.
And here you are a writer, infinitely original and endowed with a sensibility that is charming though beyond the understanding of the vulgar.
Example:
when the dogs cross the air in a diamond like the ideas and the appendix of the meninx shows the hour of awakening a program. . . .

Only in mid-March, 1917, a year after the opening of the Cabaret, did the Dada leaders direct their attention to the plastic arts. It was then that Tzara and Ball established the Galerie Dada in what had previously been the Galerie Corray, in Zurich's Bahnhofstrasse. Two of the first exhibitions were organized in cooperation with Herwarth Walden's Sturm gallery in Berlin, and leaned heavily toward German Expressionism. Ball was a friend of Kandinsky's and Klee's, and although he showed some works representing other tendencies in Expressionism (and a good many French painters as well), he shared Arp's reservations about the *Brücke* phases of that movement and even suspected the spirit of Franz Marc's animal pictures (discovering in them a metaphorical projection of the pure-race mythology, which he found characteristically Germanic and unpleasant).

Since the ideals of Dada were from the start supranational ("Dada has no relation to the German mentality," Ball insisted), its gallery eventually showed every kind of avant-garde art. But Ball and Tzara were personally convinced that abstract art was the only genuinely international modern painting. The art movements immediately before World War I had been generally national in character; in consciously fostering a supranational artistic endeavor, Dada became the first *programmatically* international movement in the plastic arts.

To accompany its one-man and group shows, the Galerie Dada offered a regular program of lectures and soirées. A typical program of one of the latter (April 14, 1917) included an introductory talk by Tzara; recitations of the poetry of Marinetti, Kandinsky, Apollinaire, and Cendrars; jazz music and choreographed "Negro" dancing (masks by Janco); piano music composed and played by Hans Heusser; recitations by Emmy Hennings of poetry by Jacob van Hoddis; and a playlet by Oscar Kokoschka, *Sphinx und Strohman* (decor by Janco), in which Ball and his wife played two of the four roles. In his diaries Ball described as follows the multiple purposes of the gallery: "During the day it served as a kind of teaching situation for boarding school students and high-born ladies. At night a philosophy club met by candlelight in the Kandinsky room to discuss the most esoteric matters, and the soirées saw celebrations of a splendor and frenzy never seen before in Zurich."

In view of the exhibitions and other art activities of the Galerie Dada, we cannot take too seriously Tzara's disclaimers of estheticism in the Dada manifestoes:

ART NEEDS AN OPERATION

Art is a PRETENSION warmed by the TIMIDITY of the urinary basin, the *hysteria* born in THE STUDIO.[67]

When he conceived this, Tzara was probably the leading promoter of avant-garde painting in Switzerland. Huelsenbeck describes the Galerie Dada as dominated by an "art-for-art's-sake" attitude, dismissing it as a "manicure salon of the fine arts, characterized by tea-drinking old ladies trying to revive their vanishing sexual powers with the help of 'something mad.'"[68] But Huelsenbeck's testimony is qualified by the fact that he had already left Zurich for Berlin, where, he insists, the "true meaning of Dada" was being discovered.

If we wish to distinguish the plastic art *produced* by the Zurich Dadaists from that which they simply *exhibited*, there are few artists of significance. The contribution of Zurich Dada was associated primarily with the pioneering work of Arp, though Marcel Janco made a contribution and Augusto Giacometti was briefly connected with the movement. Hans Richter, who with Viking Eggeling developed abstract motifs sequentially in long "scroll paintings" (fig. 64), was later to realize these aims of visual motion in his pioneer films such as *Rhythmus 21* and *Rhythmus 23*.

Marcel Janco was just twenty years of age when he arrived in Zurich with his brother one year before the founding of the Cabaret Voltaire. After that event, in which he participated, he was charged with making the posters and other decor for the Cabaret, and he also created the semiabstract masks (fig. 54) used in many of the skits. "What altogether fascinates us about [these] masks," Ball notes, "is that they personify beings and embody passions larger than life. The dread of our times, the paralyzing background of things, is made visible." Apart from his work at the Cabaret, Janco did a number of wood and plaster reliefs, occasional paintings and objects. His oil, *Cabaret Voltaire* (1916; fig. 52), deserves the description—"naturalism in zigzag"—that Arp gave all Janco's paintings. Here the planes of the figures are flattened and juxtaposed in an angular manner to harmonize with the posters shown on the wall. Janco's wood reliefs, an excellent example of which is in the collection of Jean Arp's brother François (fig. 53), were less literal in their shapes and were composed within an architectural framework of rectangles which suggests their antecedents in Cubism and the rectilinear collages of Arp done in 1915–16.

Augusto Giacometti, uncle of the sculptor Alberto, was close to forty when he returned to Zurich, after years of teaching in Florence, just before the founding of the Cabaret Voltaire. A successful and prosperous painter, he sympathized with the Dadaists and often took part in their demonstrations. Arp tells of his going from restaurant to restaurant, carefully opening the door at each place, shouting "Vive Dada!" and then closing the door just as carefully. "The diners gaped, dropping their sausages. What could be the meaning of this mysterious cry from the mouth of a mature, respectable-looking man who didn't at all resemble a charlatan or foreigner."[69] Giacometti's painting developed along lines not unrelated to Kandinsky's. Like Kandinsky, he was deeply influenced by Art Nouveau, and his decorative mosaics of 1903–06, indebted to Klimt, parallel the folkloristic and romantic tempera paintings executed by Kandinsky between 1902 and 1905. But whereas Kandinsky passed into

a lyrical form of nonfigurative painting in the years just before World War I, the corresponding development in the work of Giacometti—aside from some small irregularly shaped patternly images around 1900—was confirmed only on his return to Zurich in 1915. Giacometti never did abandon representational painting, but continued to practice it simultaneously with his nonfigurative work. Among the last are some items that, like Kandinsky's pictures of the same years, show elliptical relations to motifs in nature (*Fantasy on a Potato Flower*, 1917); others, like the exquisitely colored *Chromatic Fantasy* (1914; fig. 55), are purely nonfigurative and have a kind of improvised configuration which somewhat anticipates certain aspects of recent "informal" lyrical abstractions, or *l'informel*.

While Augusto Giacometti's brief personal association with Dada encouraged the radicality of his explorations, it had no distinctive effect on his style. His most Dadaist invention was a machine, inspired perhaps by those in Picabia's paintings and drawings. In 1917 he took the mechanism of a large clock, painted it, and attached colored forms to some of the moving parts, which functioned in a manner that foreshadowed the 1954 mobile reliefs of his compatriot Jean Tinguely (fig. D-242). The machine was accidently destroyed, but in a comical playlet by Arp, Giacometti gives us a fanciful description of it: "Yesterday I finished my kinetic Dadaist work of art. I don't believe anybody has ever created anything comparable to it. My kinetic work of art resembles a square cloud with a pendulum of blue smoke."

JEAN ARP: THE DADA YEARS

The role of Marcel Duchamp had been to disorient and confound; through the use of paradox he cast a pall of doubt over the basic assumptions of abstract painting, thereby provoking what Breton later called *la crise de l'objet*, the birth trauma of Dada and Surrealism. But if Duchamp thus originated the *mentalité* and much of the iconography of Dada and Surrealism, Jean Arp was the first major contributor to its specifically formal vocabulary. He confirmed the possibility of a *peinture-poésie* by charging his work with allusive subject matter and at the same time preserving a nonillusionist formal purity uncompromised by the forced and self-conscious literary complications that vitiate some Dada and Surrealist art. His work seemed equally at home with the Surrealists and with the Abstraction-Création group; it was alone in appealing equally to Mondrian (who saw Arp's reliefs as "neutral," "pure plastic forms" "against a neutral

background") and Ernst (who spoke of Arp's "hypnotic language" that "takes us back to a lost paradise" and reveals "cosmic secrets").

Born in Strasbourg, Arp was fluent not only in German and French but also in Alsatian, a Germanic dialect almost constituting a language in itself. His name first appeared publicly in 1905, when, at the age of eighteen, his poetry was included in Karl Gruber's anthology of contemporary Alsatian poetry. As a boy, his loves included German Romantics like Brentano and Novalis, and the French Symbolists—he was particularly fond of Rimbaud. It is not surprising that he later felt comfortable among the Surrealists, whose poetic tradition derived primarily from such sources.

Though many Dadaist and Surrealist artists were practicing poets, Arp is one of the very few whose poetry stands in both quality and quantity as an important contribution in its own right. The involvement of the painters of these movements with poetry produced a variety of rapports between the two arts, some of which endowed their *peinture-poésie* with new and unexpected dimensions, but others of which tended to vitiate their painting through a dilution of esthetic modes. Arp's collages, reliefs, and sculpture share with his poetry an iconography—e.g., navels, mustaches, and clouds—a gentle whimsy, and a feeling of naturalness, but nowhere is their plasticity compromised.

Arp's definitive pictorial language did not emerge until 1915, and it is difficult to study its earlier phases because very little work of his youth is extant. His disdain for this early work led him to destroy much of it and allow the rest to be lost, so that the only evidence we possess of his style in the immediately prewar years are some small portrait drawings and nudes reproduced in *Der Blaue Reiter* (1912) and in various spring and fall numbers of *Der Sturm* for 1913. These drawings are all naturalistic; the contours are loose and sketchy and the spotting of darks unsure. Those reproduced in the

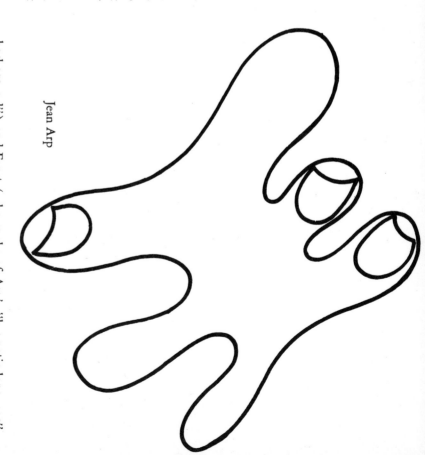

Jean Arp

autumn of 1913 are completely linear and more open in their sketchiness, identical in style with engravings of horses done the following year and later used as illustrations for a book by Huelsenbeck. From this it is evident that both the rectilinear and biomorphic styles of Arp's Zurich period were the result of a radical conversion during the winter of 1914–15 rather than of a long process of gestation.

Arp's first art studies were at the School of Applied Arts in Strasbourg, which he attended in 1904; that same year, he visited relatives in Paris, where he had his first contact with modern painting. Then followed two years at the Weimar Art School and a year at the Académie Julian in Paris. Between 1903 and 1912, his family sojourned frequently in Weggis, Switzerland, where he worked in the studio of Franz Huf. There he made the only sculptures he was to do before the age of forty-three, when, already a major figure in modern art, he began again to work in the round. On his return to Switzerland in 1915, Arp carefully sought out and destroyed all these early sculptures—or at least he thought he destroyed them all. One very small portrait has recently come to light, and was in his atelier during the years before his death. It shows him working, as in his drawings, in a figurative vein, with a slight flattening of the planes and a tendency to exaggerate and twist the features in a manner related to the early *Brücke* phase of German Expressionism.

In his crucial formative years just before World War I, Arp was deeply impressed by the painting of the Cubists and Kandinsky—which somewhat explains the bipolarization of his work during 1915 and 1916, just after he had relinquished Expressionist naturalism. He had been a student in Paris when the first Analytic Cubist pictures were being painted, and in subsequent years he continued to follow the development of Cubism closely. His rectilinear collages and paintings of 1915–16 suggest that the Cubists (particularly Picasso) gave him the idea of an architectural grid pattern and encouraged him to press forward radically in the direction of greater abstraction (his meeting with Apollinaire in 1914 was important in this regard). Analytic Cubism contained much that Arp felt constrained to reject: vestiges of luminous illusionistic space, suavity of brushwork, and refined "cuisine." Synthetic Cubism, which began to emerge in the wake of the collage late in 1912, was more to his liking, for it flattened the space of the picture, carried it evenly to the edges (in contrast to the dissolving or "fadeout" in earlier Cubism), and suppressed niceties of brushwork and impasto. Collage, however, interested him even more, providing as it did a still better means of eliminating "cuisine" and rendering execution more impersonal. But

by the outbreak of World War I, Arp was searching for something still more anonymous and collective, still more ascetic and even antiseptic than anything he could find in Cubism.

In the catalogue of an exhibition of his geometrical *papiers collés* and tapestries (and works by his friend Otto van Rees) held at the Tanner Gallery shortly after his arrival in Zurich in 1915, Arp describes his work in terms of simple constructions of "lines, surfaces, forms, and colors." They strive, he continues, to "surpass the human and attain the infinite and eternal. They are a negation of man's egotism." It was natural that this desire for an impersonal, communal art should have led Arp to collaborate with other artists (among them Sophie Täuber, his future wife; fig. D-77) and to media more associated with artisanship than with fine art. Throughout his Zurich period, and for many years after, he abstained not only from sculpture but from easel painting. His wood reliefs, tapestries, and collages required, if not the mediation of another party (the weaver or the carpenter), at least that of a mechanical operation:

We searched for new materials which were not weighted down with tradition. . . . We embroidered, wove, painted and pasted static geometric pictures. Impersonal severe structures of surfaces arose. All accident was excluded. No spots, tears, fibres, imprecisions, should disturb the clarity of our work. For our paper pictures we even discarded the scissors with which we had first cut them out since they too readily betrayed the life of the hand. From this time on, we used a paper-cutting machine.[70]

But even as Arp was cutting these rectilinear collages, he had begun to explore another, less geometrical, more organic language of forms, the antecedents of which were to be found not in Cubism but in Kandinsky and, to a lesser extent, in Art Nouveau. By the end of 1916, biomorphism had triumphed in Arp's work, and rectilinear forms, associated with his collaboration with Sophie Täuber, disappeared except as framing devices.

Except for the work of Henry van de Velde (figs. D-19, D-21), Arp has had nothing but disdain for Art Nouveau. It was the plastic language of his parents' generation, and he found its fluency abhorrent, wanting for himself something simpler and more abstract. Arp's own position notwithstanding, we cannot overlook a certain affinity of forms. And it is unquestionable that Arp digested certain elements of Art Nouveau, if only unconsciously; a young artist who was thirteen at the turn of the century and who traveled widely in the next decade could not have escaped being exposed to Art Nouveau in a variety of forms. Moreover, it is probable that a visit during his student days in Weimar to an exhibition of works by van de Velde

Wassily Kandinsky. *Klänge*

had a special effect on him. No other artist connected with Art Nouveau used its stylistic resources in a manner so like that biomorphism which crystallized in Arp's work some eight years later. Arp's mature work bears the same elliptical relationship to the uncomplicated, highly abstract organic language of van de Velde as Miró's painting does to the more prolix and ornamented Art Nouveau of his Spanish compatriot Antoni Gaudí (fig. D-16).

The impact of Kandinsky on Arp, and the way in which the latter converted the former's discoveries to his own purposes, can be studied by comparing the woodcuts illustrated here from Kandinsky's *Klänge* (1913) and Arp's *Zeltweg* (1919). The Kandinsky has more motor character, greater tension and excitement. What is linear in Kandinsky, Arp converts into flat shapes; what is fragmented, he assimilates into larger masses; what is angular he blunts or rounds (this

is particularly noticeable when we compare the pointed black element in the center of the Kandinsky with the very similar motif in the lower left of the Arp). The result is a work of a more meditative and detached character, of greater simplicity and stability. And while both works are highly abstract, the associations to landscape evoked by Kandinsky are transformed by Arp into suggestions of the human and organic.

Jean Arp. *Der Zeltweg*

The first appearance in Arp's work of the formal language so beautifully illustrated by this woodcut from *Der Zeltweg* dates from 1914–15, when its vocabulary still contained specific, easily identifiable references to nature. His earliest extant relief, *The Stag* (fig. 56), defines quite clearly the major parts of the animal's body, including its antlers. However, the contours have been transformed and the masses assimilated in a manner that is very abstract and wholly in

Jean Arp. *Vegetation*

character with Arp's subsequent Zurich work. Markedly biomorphic shapes make their first appearance in *Forest* of 1916 (fig. 61), but here they are still specifically identifiable as the moon and its halo. Only in the reliefs that follow does the biomorphic shape become ambiguous and the motif indeterminate and allusive.

The Stag and *Forest* are good examples of the two ways Arp has handled the wood relief throughout his career. In *The Stag* the animal's shape is an empty space *cut out* of the wood panel, while in *Forest* the moon and trees are independent shapes of wood, *on top* of the rear plane, that advance toward the spectator. The outside contours of both these reliefs, like most of those done in Zurich, are irregular and meandering. This rejection of the conventional rectangular field gives them a fresher, more unexpected air than most of the reliefs of the 1920s, and at the same time brings them closer to sculptural objects than to paintings.

Arp's first relief free of the pointed naturalistic references still manifest in *Forest* is *Portrait of Tzara* (fig. 57), which he did late in 1916. In this work only parts of the outer contour and the shape on the right (perhaps derived from an eyebrow) have even an elliptical relationship to identifiable subject matter. The same is true of *Plant Hammer* (1917; colorplate 7), which is built on an opposition of blunt, straightedged forms (vaguely recalling hammers) and meandering plantlike contours. All these reliefs were painted in bright flat colors taken from Synthetic Cubism, in a technique that, except for occasional stippling, displays no nuances and leaves no trace of the brush.

One of the earliest unpainted reliefs is the haunting *Bird Mask* of 1918 (fig. 62), which contains a macabre element rare in Arp's work. He might have developed this element had he so wished, for, as Robert Melville observes, "he was on terms of intimacy with Dadas and Surrealists who were practising various kinds of pictorial terrorism and he must have been tempted at every turn. As a northern artist, he would have been following the line of least resistance if he had allowed the scarifying image to flourish in his work."[71] But it was not to be, and the macabre has remained for him something marginal.

Simultaneously with the reliefs, Arp executed a series of "automatic drawings" that are among the most prophetic works of his Dada years (fig. 58). Their starting point was the notion of vitality, the movement of the creative hand. There were no preconceived subjects, but as the patterns formed on the surface, they provoked poetic associations. Intimations of plant life, animal forms, human physiognomies and organs began to emerge but were never brought to a

literal level, the artist preferring always the ambiguous form which suggested much but identified nothing. The pencil outlines once drawn, he filled in the contours with black ink, often changing and adjusting them, and even eliminating shapes as he brought the drawing to completion. Arp has given us an insight into this associational and improvisational methodology as it functioned in connection with the work reproduced on this page:

The black grows deeper and deeper, darker and darker before me. It menaces me like a black gullet. I can bear it no longer. It is monstrous. It is unfathomable. As the thought comes to me to exorcise and transform this black with a white drawing, it has already become a surface. Now I have lost all fear and begin to draw on the black surface. I draw and dance at once, twining and winding, twining, soft, white flowery round. A snakelike wreath . . . turns and grows. White shoots dart this way and that. Three of them begin to form snakes' heads. Cautiously the two lower ones approach one another.[72]

Many of these drawings appear nonfigurative to us, but for Arp they always implied some relation, however tenuous, to the world of recognizable things. In their uncompromising flatness they are comparable to Mondrian's works of that time, and they represent a more complete rejection of illusionistic pictorial space than either Picasso or Kandinsky had yet considered.

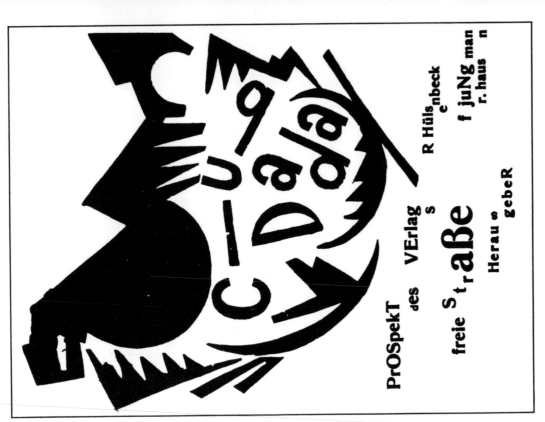

Cover of *Club Dada*

That Arp titled many of these works "automatic drawings" has caused some confusion as to their character and the manner in which they were made. When we compare them with the "automatic" sketches done by Masson or Miró in the following decade, we become aware that Arp's have a less casual, less accidental character; their contours are quite firmly drawn, and the blacks are quite evenly brushed in. It is clear that for Arp the data of automatism could be neither accepted as freely nor employed as spontaneously as it later was by Surrealists and, more heroically, by Jackson Pollock. For Arp it was a starting point, but the image underwent considerable transformation and was always given a scrupulous "finish."

Something of the same problem exists with respect to a series of collages from the Zurich period that in their titles incorporate the phrase "according to the laws of chance" (fig. 59). Hugnet, among other historians of Dada, has taken those titles at face value and mistakenly described Arp as shaking up the scraps of colored paper and then "pasting them to the cardboard [ground] *just as they had fallen*."[73] One glance at these collages is enough to suggest the unlikelihood of this procedure, and Arp himself affirmed that he used "chance" in these works (letting elements fall where they would) only as he used automatism in the drawings: as a way of stimulating the imagination and as a starting point for images that were afterward consciously rearranged. Later, in such techniques as decalcomania, the Surrealists were to give chance and accident a greater role in the finished product.

The emergence of Dada in Zurich had resulted directly from that city's having been such an accessible refuge from war. With peace, the movement dissolved there as its members scattered, for the most part to France and Germany. In January, 1917, Huelsenbeck had left for Berlin; a year after the end of the war, Tzara left for Paris, and Arp joined Ernst in Cologne, where the two collaborated on a series of collages with poetic titles.

BERLIN DADA AND THE BEGINNINGS OF THE MOVEMENT IN GERMANY

When Huelsenbeck (fig. D-85) returned to Berlin from Zurich in 1917, he found the city in a state of crisis. Food was scarce, despair was spreading, and the established authorities seemed unable to cope with the situation. Here was a place ripe for a more aggressive and more politically motivated Dadaism than well-fed Zurich would have tolerated, and Huelsenbeck was quick to take advantage of the

situation. The groundwork had already been laid by Franz Jung, a politically and psychologically oriented critic and editor. His review, *Die freie Strasse* (founded in February, 1916, in collaboration with Richard Oehrins), had been arguing for an activist type of psychoanalysis based on studies I have already referred to by the psychiatrist Otto Gross; according to Gross, fulfillment of the self would be achieved by making or encouraging changes in the environment. Huelsenbeck has at various times been identified as a cofounder of *Die freie Strasse*, but in fact the review got under way while he was still in Zurich, and he contributed personally only to No. 8, a special issue titled *Club Dada*. Later numbers of *Die freie Strasse* appeared under the direction of the Czech émigré Raoul Hausmann.

Huelsenbeck found no lack of kindred spirits in Berlin. A lecture he gave in February, 1918, in the New Secession Hall brought the

message of Zurich Dada and, above all, a name around which the Berlin movement could crystallize; the word Dada pleased everyone. In April, Franz Jung himself signed a Dada manifesto along with Huelsenbeck, Hausmann, George Grosz, Walter Mehring, and a number of Zurich Dadas. In June, 1919, Hausmann founded *Der Dada;* its three issues record the adherence of Johannes Baader and Hannah Höch to the movement, and they surpass in the riotous zigzag of printed characters of every description—including Hebrew— the liberated format of the Zurich Dada publications.

The Berlin manifestations were more resolutely collectivistic than those of Zurich, and, led by Huelsenbeck and John Heartfield (who later became a member of the Communist Party), the group veered sharply to the political left. Not content with vilifying revered values ("What is German culture? Answer: Shit"), Berlin Dada called for their eradication by "all the instruments of satire, bluff, irony and, finally, violence" in a "great common action." "Dada," came the final conclusion, "is German Bolshevism."[74] However, despite such violent language, there seems to be considerable truth in Hannah Höch's memories of Dada's association with Communism as "innocent and truly unpolitical." "Communism itself, in those days," she recalls, "appeared to be much more liberal and freedom-loving than it does today. . . . We were living in a social order that had approved the declaration of a disastrous war, which even the Socialist Party had failed to condemn."[75]

A good deal less has survived of the work of the Berlin Dadaists than of that of Ernst, Schwitters, and Dadaists outside Germany. Much of what the Berlin Dadaists produced was intentionally ephemeral: posters, *pièces d'occasion,* propagandist creations manufactured for particular manifestations. What remains cannot be said to define a style, though it is characterized by a particular technique— the so-called photomontage (actually photo-collage and not made by photographic process), the creation of which is Berlin Dada's artistic contribution to the movement. To be sure, Max Ernst arrived at the wholly photographic collage in 1919 largely through his own efforts to extend the possibilities of collage, but Raoul Hausmann had been making mixed typographic and photographic montages almost a year earlier, and precedents exist in both Futurist and Suprematist art.

Late in 1918, Hausmann hit upon the idea of the photographic collage, which was partly suggested by a trick of the German army photographers, who had made oleolithographed mounts, from which the faces were cut out, showing groups of soldiers in idealized settings. In these mounts they inserted the photographed faces of their clients, often unifying the whole by tinting it. Hausmann was to make a much more complex thing of it (figs. 68, 69), and in 1919 it became central in the work of Hannah Höch (fig. 70), Johannes Baader (figs. 72, 73), John Heartfield, Paul Citroen, and familiar in that of George Grosz. Many of these collages combined photographs with other printed materials and sometimes even drawing and painting. Others, like Citroen's superb *Metropolis* (1923; fig. 74), were purely photographic.

In its pure form, photomontage entirely eliminated any need to paint or draw; the mass media could provide all the material. One could attack the bourgeoisie with distortions of its own communica-

George Grosz. *Man in a Restaurant*

George Grosz. *Fit for Active Service*

tions imagery. The man in the street would be shocked to see the components of familiar realistic photography used to turn his world topsy-turvy, and the familiar lettering of his newspapers and posters running amuck.

More allied to Expressionism and Futurism, yet placed in the service of Dada "provocation," was George Grosz's savagely anti-militaristic, anti-bourgeois satire (he paraded through Berlin streets wearing a death's-head and carrying a placard emblazoned "*Dada über Alles*"). By exaggerating the distortions introduced by the

Brücke painters, Grosz arrived at caricature, always preserving, however, an Expressionist angularity. Like Meidner and, to a certain extent, Ernst Ludwig Kirchner (after 1912), he incorporated in his painting angular pattern-devices derived from Cubism and Futurism; but unlike the more formal Franz Marc and August Macke, he kept these clearly subordinated to expressive distortions of space and object. If Grosz's paintings of this period (such works, for instance, as *The Lovesick One;* fig. 75) are insufficiently known and appreciated, it is because his genius expressed itself best on the whole in drawing,

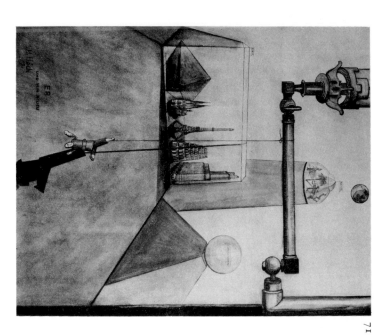

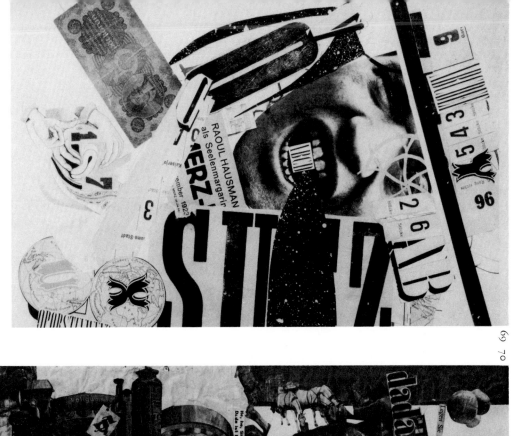

69 RAOUL HAUSMANN *Head*. 1923

70 HANNAH HÖCH *Cut with the Kitchen Knife*. 1919

71 HANNAH HÖCH *He and His Milieu*. 1919

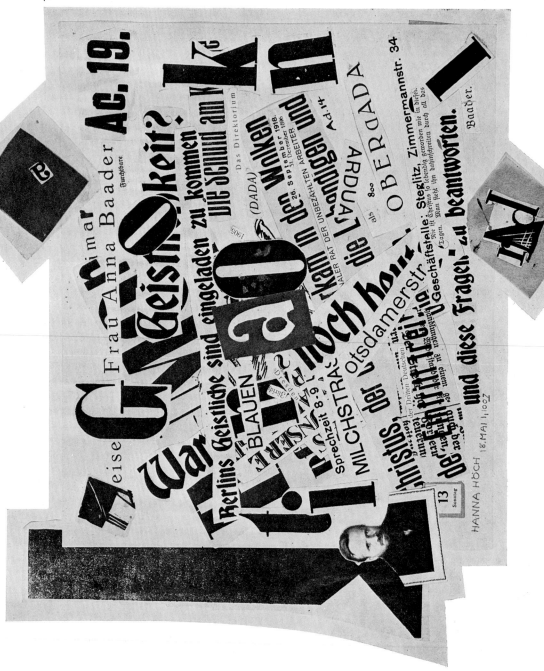

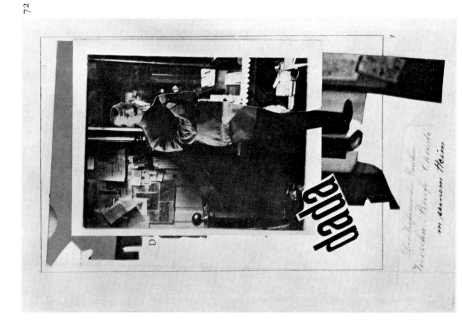

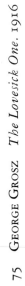

75 GEORGE GROSZ *The Lovesick One.* 1916

76 GEORGE GROSZ *Student*
 (Study for Goll's *Methusalem*). 1916

77 GEORGE GROSZ *The Engineer Heartfield.* 1920

where his sharp linear focus achieved a mordancy he was seldom able to match in paint.

His drawings, mostly satires of Berlin society and its demimonde, were aimed particularly at the Prussian military caste. Both Grosz (who spelled his first name with a terminal *e*, in the English manner, out of sheer anti-nationalist feeling) and John Heartfield (who anglicized his name, Hans Herzfelde, for the same reason) had been soldiers.[76] At the end of the war, the latter continued to wear his uniform in protest; in order to "dis-honor" it, he wore a particularly dirty and disgusting one. On the pretext of suffering from a skin disease, he shaved only one cheek, and this, together with his uniform, made him a living counterpart of the grotesque caricatures in Grosz's drawings.

Grosz's art was not limited to drawing and painting. In such collages as *The Dadaists Mount a Pudding* he was able to wed Dada techniques to his own brand of satire: the heads he glued to his comical *bonshommes* were those of his fellow Dadaists; *The Engineer Heartfield* (fig. 77) wears a mechanical heart glued to the watercolor figure like a medal. Still, Dada was only a passing phase in Grosz's career, and his separation from the Dadaist milieu after 1920 was accompanied by a shift to a more conventional representational style.

The climax of Berlin Dada, as far as art was concerned, was the *Erste Internationale Dada-Messe*, which opened at the Kunsthandlung Otto Burchard in June, 1920 (figs. D-79, 80). The exhibit contained 174 items, virtually all of them—despite the title of the show—contributed by Germans. Among the exceptions were a few works each by Picabia, Arp, and Chicago's Ben Hecht (*America's Greeting to George Grosz* and a Dada poster). The broadside catalogue-announcement (figs. D-81–83) reproduced collages done jointly by Grosz and Heartfield in which, through insertion of extraneous photographic elements, a Cubist picture by Picasso and a *Self-Portrait* by the Douanier Rousseau became "corrected masterpieces" (fig. D-82). Placed helter-skelter in the gallery were paintings, photomontages, reliefs, objects, and Dada posters and placards ("Dilettantes Arise"), and along the ceiling was hung a dummy of a German officer fitted with the head of a pig. There was no entry from Kurt Schwitters, whose exclusion was the result of personal animosity on the part of Huelsenbeck; there were, however, five works by Max Ernst, including the lost sculpture, *Phallustrade* (*Falustrada*), which must have stood out among the Berlin works by their quality. Indeed, during the previous year, Ernst, working in Cologne, had created a series of collages richer and more inventive than anything in the entire output of the Berlin group.

DADAMAX ERNST IN COLOGNE

No painter more completely personified the interwar avant-garde than Max Ernst. In retrospect he appears to have been almost predestined for a leading role in the particular poetic, intellectual, and anti-esthetic climate that prevailed after 1918 in the plastic arts, and his work is characterized by the anti-art inventions—and concomitant pictorial problems—of that era. An important figure in the history of Dada, he was a pioneer of Surrealist painting, which, as Ribemont-Dessaignes argues, "would not have existed without him." In the extraordinary range of his styles and techniques he is to Dada and Surrealism what Picasso is to twentieth-century art as a whole. Gifted with the temperament of both explorer and philosopher, his restless

Baargeld. *Beetles*

invention is sustained by a demanding intellect; as Matta remarks, "though he has invented many things, he has never bothered to exploit any of them."77 Nevertheless, there is a difference between exploitation and exploration, and certain moments in the art of Ernst promised more profound results than his impatient quest for change permitted. Just as the single-mindedness of Matisse and Bonnard produced work of higher average intensity than the eclecticism of Picasso, so among the Surrealists Miró emerges as a more profound, if narrower, painter than Ernst. To put it another way, the greatness of Ernst is horizontal rather than vertical; it is to be found less in the depth of single works than in the range of qualities offered by a selection of paintings from various moments in his career.

Ernst was born in 1891 in Brühl, six miles south of Cologne. "The geographic, political and climatic conditions of Cologne," he notes, ". . . are perhaps propitious to the creation of fertile conflicts in a sensitive child's mind. Many of the important crossroads of European culture meet: influences of the early Mediterranean, Western rationalism, Eastern inclination toward the occult, myths of the French North, the Prussian categorical imperative, the ideals of the French Revolution, and so forth."78 His father, who taught at a school for the deaf, was also a painter of academic persuasion and bourgeois temperament. He provided his son with an artistic environment from earliest childhood (Ernst was drawing avidly at the age of five), and with an ideal style and mentality against which to react.

Ernst's childhood was particularly rich in fantasy life and private adventure; he recounts memorable events in "An Informal Life of M.E. (as told by himself to a young friend.)" Such experiences played a larger or more manifest role in his art than in that of any other twentieth-century painter, except possibly Klee. It is a truism that psychological makeup is determined in the first years of life, and that all painters, for the most part unconsciously, are to some extent preoccupied with recapturing the naiveté and freshness of their vision in those years. With Ernst, however, the contribution of childhood is much greater; it provides not only the inspiration but the substance and subject of most of his work. He has a remarkable recollection of childhood events, some of which he first recalled in the very process of making pictures. His art is thus dialectically an analytical and autobiographical process, and the "automatic" techniques favored by Dada and Surrealism provided an excellent means of self-discovery through images, not unlike the method of free association in psychoanalysis. Ernst has described himself, when using these techniques, as a spectator at the birth of his own paintings, an instrument recording *"ce qui se voyait en moi"* [what was

visible within me]. He considers his painting less an esthetic statement oriented toward a spectator than the diary of a philosopher striving for maximum consciousness.

Though he had drawn and painted throughout his youth (an oil sketch, *Ice Skaters*, executed when he was twelve shows surprising authority), it was only in 1912, when he was twenty-one, that Ernst finally decided to become a painter. Earlier, intellectual curiosity reinforced by family pressure had led him to study at the University of Bonn for a degree in philosophy with emphasis on abnormal psychology. At that time, he visited frequently a nearby insane asylum and was particularly touched by the art of madmen, about which he planned a book ("I tried to recognize streaks of genius in it and decided to explore fully those vague and dangerous lands bounded by madness"). While these studies provided ideas for Ernst's later independent work, they were not immediately viable. Before he could use them as a modern painter, he would have to absorb a great deal of contemporary art, with which he had as yet little or no contact. His period of assimilation began when he joined an artistic circle called Das Junge Rheinland, led by the painter August Macke. In the Sonderbund exhibition of 1912 in Cologne and then in Berlin (*Der erste deutsche Herbstsalon*, 1913), Ernst was able to study paintings by Cézanne, van Gogh, Munch, Picasso, Kandinsky, Chagall, Delaunay, and Klee. His art education was also furthered by a short trip to Paris in the summer of 1913; a small still life in Cubist style painted at that time (fig. D-92) demonstrates his control of the multiple viewpoint, shuffled planes, stenciled letters, and boxy Neo-Impressionist brushstrokes familiar in Picasso's and Braque's Analytic Cubist pictures of the previous year.

Ernst had hardly begun his career as a painter when the war broke out; he was drafted and served as an artillery engineer, often at the front. He nevertheless managed to produce occasional oils and watercolors, and these give us an idea of what led to his emergence as a Dada collagist in 1919. *Flowers and Fish* (fig. 79), an oil of 1916, might be described as prismatic Cubism; it recalls the work of Marc, Macke, and other German painters influenced by Orphism. Like them, Ernst infused his world of vegetal and animal forms with a mythical, metaphysical quality that immediately distinguished it from its French sources. Some watercolors of the following year (*The Battle of Fish*, for example) are more related to Klee and foreshadow the hybrid monsters that appear later in Ernst's work. A very curious oil titled *Submarine Still Life* (fig. 80), dated 1917, might have been made late in that year when Ernst, on leave from the front, was able to catch up with the art magazines, for it contains

references to the flywheel type of machinery that dominated Picabia's pictures of 1915–17. Ernst, however, diluted the machine image by rendering it with the paint quality and tonal nuancing of Cubism. Two years later, he would incorporate the same machine elements in a more direct way in such "collages" as *The Roaring of Ferocious Soldiers* (fig. 81) and *Glacial Landscapes*.

When the war ended, and Ernst had returned to full-time painting, an event occurred that was to lead him to the creation of a new type of collage and, with it, his maturity as an artist.

One rainy day in 1919 in a town on the Rhine, my excited gaze is provoked by the pages of a printed catalogue. The advertisements illustrate objects relating to anthropological, microscopical, psychological, mineralogical and paleontological research. Here I discover the elements of a figuration so remote that its very absurdity provokes in me a sudden intensification of my faculties of sight—a hallucinatory succession of contradictory images, double, triple, multiple, superimposed upon each other with the persistence and rapidity characteristic of amorous memories and visions of somnolescence. These images, in turn, provoke new planes of understanding. They encounter an unknown—new and non-conformist. By simply painting or drawing, it suffices to add to the illustrations a color, a line, a landscape foreign to the objects represented—a desert, a sky, a geological section, a floor, a single straight horizontal expressing the horizon, and so forth. These changes, no more than docile reproductions of *what is visible within me*, record a faithful and fixed image of my hallucination. They transform the banal pages of advertisement into dramas which reveal my most secret desires.[79]

The collage, as Max Ernst re-created it, had little in common, technically or plastically, with that of the Cubists. For them collage elements were a counterpoint to the painted lines and forms in a whole oriented toward formal values. To Ernst plasticity was of secondary interest; he used the borrowed elements primarily for their *image value*, joining them in irrational, unexpected ways, thereby, as E. L. T. Mesens puts it, turning plastic revolution into mental subversion. "Collage, as it is now understood," wrote Louis Aragon of Ernst's work in *A Challenge to Painting*, "is something entirely different from the *papiers collés* of the Cubists. . . . Glue is not even an essential feature of the operation." In conceiving of the collage as "a meeting of two distant realities on a plane foreign to them both," or as a "culture of systematic displacement and its effects," Ernst was putting into visual form the type of verbal hybrids explored by the Symbolist poets (the most famous being Lautréa-

mont's already mentioned "chance meeting of a sewing machine and an umbrella on a dissection table"). Thus Ernst's collages had less to do with Cubist *papiers collés* than with Duchamp's compound objects, such as *Why Not Sneeze?* (fig. 22), and with de Chirico paintings like *The Faithful Servant* (1916; fig. 118) and *Evangelical Still Life* (1916; fig. 119), where candies and biscuits painted in *trompe-l'oeil* are inserted into completely alien contexts. In the instantaneous presentation of apparently contradictory data, the Dada collage might be considered the visual counterpart of the Simultaneous Poem, and, like that earlier invention, it sought to make its point through paradox.

As his own account suggests, Ernst's collages were often made without actually gluing elements together. Of the fifty-six collages he showed in Paris in 1921, only ten deserved the name technically (in the announcement all the works exhibited were identified as "peintopeintures" rather than "collages"). According to his own definition of collage as a superimposition of *images*, Ernst is right when he observes that "it's not glue that makes a collage" ("Si ce sont les plumes qui font le plumage, ce n'est pas la colle qui fait le collage"). One is struck by the inventiveness of their technique, which combines elements from many sources into a vocabulary even more heterogeneous than that of most of Schwitters. Photoengravings (*Here Everything Is Still Floating*; fig. 82), printers' proofs (*Trophy Hypertrophied*), and all sorts of photographic sources were used in

Max Ernst. *Trophy Hypertrophied*

addition to more conventional collage materials such as wallpaper and printed matter, to say nothing of the superimposition of painted images.

Titles are important elements in Ernst's collages. Almost all of them are very long and written in awkward print above and below—and sometimes on—the collage. The introduction of language to give added dimension to the image was fundamental throughout to the tradition of *peinture-poésie*; it had been used by Redon, who often employed poetic fragments—some borrowed, some invented—as titles for his lithographs, in much the same spirit as Debussy used them for his *Préludes*. In Redon, however, the metaphorical title (*The Eye Like a Strange Balloon Moves toward Infinity*; fig. D-11) is often directly related to the visual image and to that extent remains basically descriptive. In the years just prior to World War I, de Chirico began applying to his work enigmatic, poetic titles that recalled French Symbolist poetry and evoked the spiritual ambiance of his compatriot poet Giacomo Leopardi. On occasion de Chirico widened the distance between image and title in order to provoke, through abrupt juxtaposition, the kind of mental leap also exploited by Duchamp and Picabia. A painting of 1913, which brings together factory chimneys, plaster casts of feet, an egg, and a St. Andrew's cross, is titled *Self-Portrait* (fig. 104), anticipating (in a more Freudian manner) the mechanism of Picabia's Object-Portraits of 1915. Though Apollinaire made much of the fact that Duchamp printed his titles on the surface of his paintings, these titles themselves remained, within the framework of his imagery, substantially descriptive. Only later, in connection with the Readymades, did Duchamp detach his titles from narrative logic. From 1915 on, Picabia was likewise engaged in making commonplace images with inventive titles. "In my work," he explained, "the subjective expression lies in the title; the painting is an object."

Ernst's Dada titles range from scraps of poetry to lunatic recipes. A 1920 collage of photoengravings (fig. 86) bears this title:

Au-dessus des nuages *plane l'oiseau invisible du jour.*
marche la minuit. *Un peu plus haut que l'oiseau l'éther pousse*
Au-dessus de la minuit *et les murs et les toits flottent.*

Another (fig. 83), executed in pencil and rubbing from assembled printers' plates, is labeled (in German): *Self-constructed small machine in which he mixes sea salad, editorial, mourner, and iron sperm into cylinders of the best ergot so that the development can be seen in front and the anatomy in back.* Some titles combine various lan-

guages, as, for example, the legend on a technical engraving heightened with watercolor: *Le limaçon de chambre fusible et le coeur de la moissoneuse légère à la course. Stubenschnecke 5 nummern wandervogel 8 nummern summa 13 nummern sursum corda.* Others are themselves verbal collages constructed in a manner recapitulating the composition of the collage itself. One such is the *Phallustrade*, an "alchemistic product," according to Ernst, "composed of the following elements: the *autostrade* [express highway], the balustrade, and a certain quantity of phallus." Occasionally the title seems to precede the image, which, in its turn, may become a visual translation of the proverbial, or pseudoproverbial, phrase or metaphor. *The Hat Makes the Man* (fig. 87) thus consists of a series of engraved illustrations of men's hats from a hat catalogue slightly rearranged and then joined by columns of watercolor and ink to form *bonshommes*.

The plastic character of Ernst's Dada collages varies with the elements they comprise. Unlike Arp's, they affirm no dominant morphology; only *The Gramineous Bicycle* (fig. 88), a botanical chart out of which Ernst developed a series of amorphic echinoderms at play, attests to an interest in biomorphism. Ernst's borrowed collage elements often carry illusionistic, three-dimensional relief with them from their origins as conventional illustrations, but this is sometimes minimized by placing the modeled forms in a predominantly flat context, as is the case with *The Hat Makes the Man*. Here the collage hats are three-dimensional, the painted areas of watercolor connecting them slightly relieved, the background flat; as in *The Gramineous Bicycle*, the overall impression is of a laterally unfolding design. Another group of collages, including *Glacial Landscapes* and *Undulating Catherine* (fig. 90), have landscape backgrounds, but the shapes in them are usually ranged parallel to the picture plane, with the result that the sketchy vistas of hills and sky rarely establish a deep perspective illusion.

Taken as they are from photographs, the elements of the photocollages are tightly illusionistic and therefore tend to read in depth, as, for example, the cloudscape of *Au-dessus des nuages marche la minuit* (Ernst's Dada collages are generally known by the first lines of their long titles). In other cases, exaggerated perspective orthogonals reminiscent of de Chirico are collaged from photographs (*The Massacre of the Innocents*; fig. 89) or drawn in (*Dada in Usum Delphini*). Ernst had been much impressed by a booklet of de Chirico reproductions (1919) and by those of Carlo Carrà published in the magazine *Valori Plastici*, and the effects are noticeable in the diving perspective of some of his collages as well as in the curious transparent heads of *Two Ambiguous Figures* (colorplate 8), which are re-

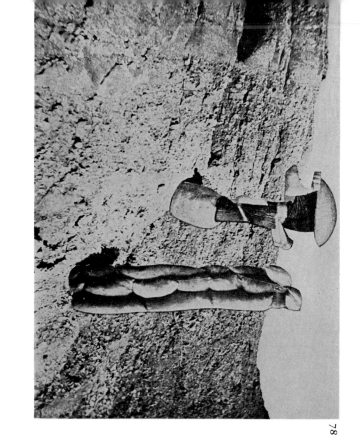

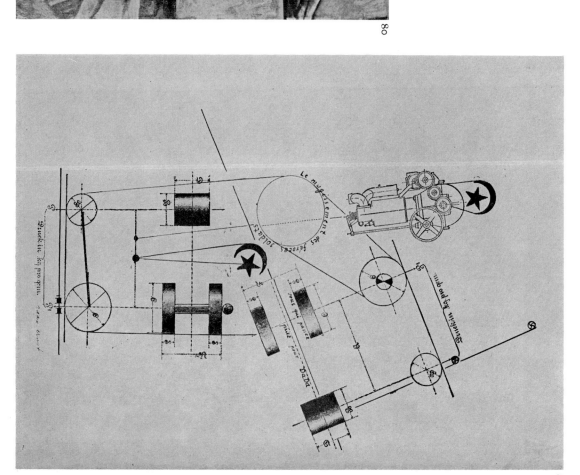

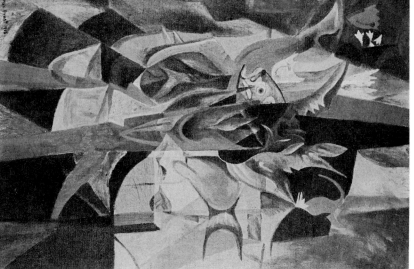

78 MAX ERNST *Untitled*. 1920

79 MAX ERNST *Flowers and Fish*. 1916

80 MAX ERNST *Submarine Still Life*. 1917

81 MAX ERNST *The Roaring of Ferocious Soldiers*
 (*You Who Pass—Pray for Dada*). 1919

80

78

79

81

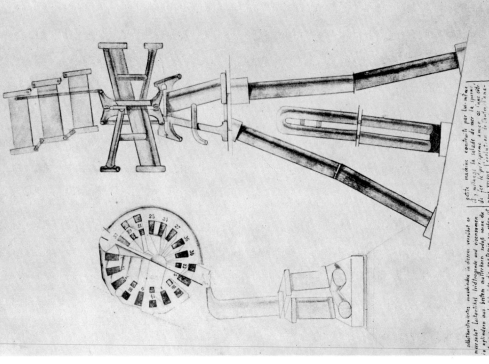

83

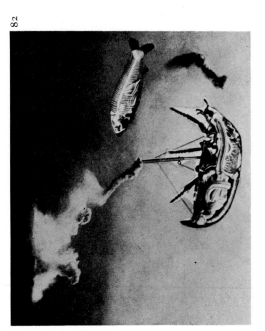

82

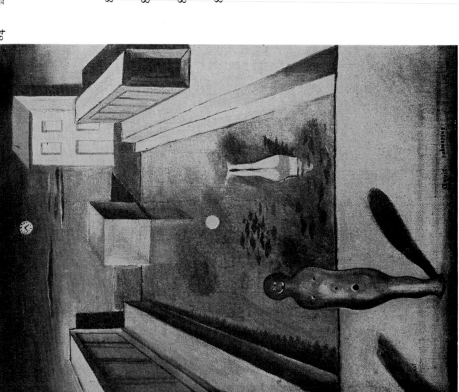

84

82 MAX ERNST *Here Everything Is Still Floating.* 1920

83 MAX ERNST *Self-Constructed Small Machine.* 1919

84 MAX ERNST *Aquis Submersus.* 1919

85 MAX ERNST *Fruit of a Long Experience.* 1919

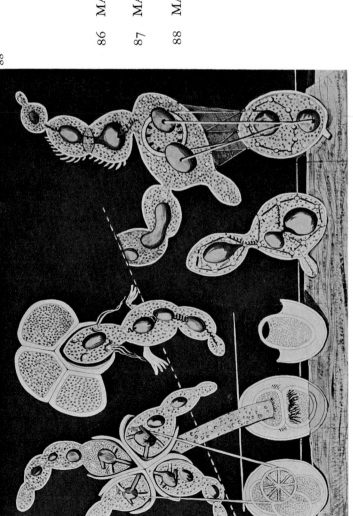

87

86

88

86 MAX ERNST *Above the Clouds Midnight Passes.* 1920

87 MAX ERNST *The Hat Makes the Man.* 1920

88 MAX ERNST *The Gramineous Bicycle.* c. 1920–21

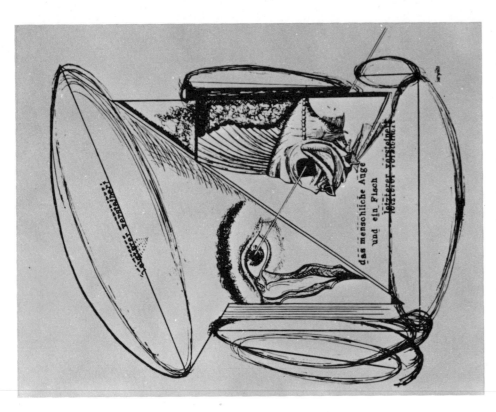

Baargeld. *The Human Eye and a Fish, the Later Petrified*

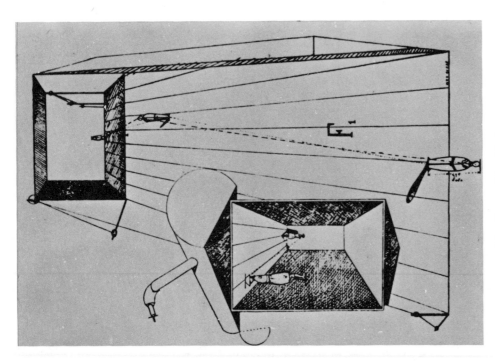

Max Ernst. *Fiat Modes*

lated, at least indirectly, to such de Chirico pictures as *The Two Sisters* (fig. 114) and *The Inconsistencies of the Thinker* (both 1915). Even more obviously close to de Chirico and Carrà is the portfolio of eight lithographs published in 1919 and titled *Fiat Modes: Pereat Ars*, which contains—along with the juggled perspectives—tailors' dummies of the type used by the Italian painters for their mannequins. These influences, however, had but a secondary role in Ernst's Dada collages; it was only late in 1921 that he accepted de Chirico's entire illusionist framework in a series of canvases (1921–23) that, despite their early date, might be considered, as we shall see, the beginning of Surrealist painting.

While collages make up the bulk of Ernst's earlier work in Cologne, he also executed a few eclectic paintings (for example, *Aquis Submersus*; fig. 84), Dada objects, and excellent wood reliefs. *Fruit of a Long Experience* (1919; fig. 85) is a collection of wooden templates and dowels comparable to such "machines" as *Undulating Catherine* and paralleling certain collage-reliefs of Schwitters (such as *The "Worker" Picture*, colorplate 9), whom he met the following year. Ernst was also busy with other Dada activities. Together with Baargeld ("Ready Money": a pseudonym for a banker's son and one-

time Oxford student, Alfred Grünewald) he founded the Dada conspiracy of the Rhineland. Baargeld was a talented collagist and poet (fig. D-91), but his primary interest was social revolution, and *Der Ventilator*, which he published in collaboration with Ernst, took an extreme political position. Directed largely to the working classes, *Der Ventilator* reached a circulation of twenty thousand copies (extraordinary for such a review), many of which were sold at factory gates. It was banned, finally, by the British army of occupation in the Rhineland and was succeeded first by *Bulletin D* and then, in 1920, by *Die Schammade* (fig. D-94), to which Arp, whom Ernst had met in 1914, also contributed. Ernst collaborated with Arp, and also with Baargeld on a number of collages titled "Fatagaga" (FAbrication de TAbleaux GArantis GAzométriques). One of these is *Here Everything Is Still Floating* (fig. 82), in which Arp's contribution is the title.[80]

The climax of Cologne Dada was a scandalous exhibition (Brauhaus Winter, *Dada-Vorfrühling*) held in April, 1920, in the glassenclosed courtyard of a café in the center of the city. To enter the courtyard, visitors had to walk through a public urinal; then farther on, they passed a little girl, in a white first-communion dress,

reciting obscene poems. On the walls were collages, and spotted around the court were various objects, including Baargeld's *Fluidoskeptrik*, a glass aquarium filled with blood-red water with women's hair floating on the surface and the ubiquitous Dada alarm clock at the bottom. Needless to say, most of the visitors were shocked; as an outlet for their anger a wooden object by Ernst was provided, to which a hatchet was attached by a chain. The public was invited to destroy the object, and did so. Following a complaint of obscenity, the police closed the exhibition, but it reopened when it turned out that the picture of a nude taken as evidence was an engraving by Dürer.

In May, 1921, the Au Sans Pareil gallery in Paris mounted a large exhibition of Ernst's Dada collages, and the antics of Breton, Soupault, and other members of the *Littérature* circle made the opening one of the most successful "manifestations" of Parisian Dada. But even as this was taking place, Ernst was beginning to concentrate on more illusionistic, Chiricoesque paintings; marking a beginning of Surrealist art, they will be studied in that context. Ernst stayed on in Cologne until the late summer of 1922, when he at last succumbed to the magnetism of Paris, which became from then on his base of operations. Dada was by that time as moribund in Cologne as it was in Berlin. It survived in Germany (though in greatly modified form) only in the work of Kurt Schwitters, who was to make Hanover the center of his Merz activity.

KURT SCHWITTERS IN HANOVER

The amalgam of life and art created by Kurt Schwitters has so much poetry and charm about it that critics have often been seduced into describing the way he lived and worked instead of analyzing and evaluating the artistic results he achieved. "Too many anecdotic, propagandistic and dated elements attached to his person," Werner Schmalenbach observes, "prevented him from being readily available for history's clarificatory process."[81] As a consequence, Schwitters is often pictured more as one of modern art's eccentric innovators than as the synthesist he really was. Concerned with fusing the viable elements of Dada with the dominant formal tradition of Cubism, Schwitters' role coincides with the denouement of the artistic developments that filled the second decade of the century; he played no part in any important beginning. In retrospect—and this is one reason why his work has been so celebrated in recent years—he seems to have functioned as a bridge between the pioneer wave of Cubists and Dadaists and certain members of the latest generation of post-World War II painters. Like Schwitters, many of these younger artists—Rauschenberg, for example—want to combine the *matériel* of Dada with formal structures descendent from late Cubism.

By 1919, when Schwitters devised the personal form of Dada he called Merz, the essential contributions of Dada had already been made. In the early 1920s, as Dada veered off into Surrealism and as many Cubists joined a Neo-Classical reaction (counterpart of the Catholic revival of that period), it fell to Schwitters to extend Cubism by enriching its vocabulary with certain *trouvés* of Dada. He contributed nothing crucial to the structural vocabulary of modern painting; the plastic organization of his collages is anticipated in the work of the Cubists and, to a lesser extent, the Futurists (except for a period in the late twenties when he is influenced by the De Stijl group and the Constructivists). The use of trash (bus tickets, advertisements, letterheads, bottle labels, etc.) had been foreshadowed, at least in principle, by the Cubists; even the Merz objects, and the *Merzbau* itself (figs. 98, 99), would have been unthinkable without Picasso's constructions of 1913–15 and the work of the Russian Constructivists.

This is not to say, however, that Schwitters' work is devoid of freshness. His large collage constructions (fig. 93) went beyond anything proposed by Picasso, and as Clement Greenberg observes, he brought to the Cubist collage an intensity of color not present in the pioneer collages of the Cubists themselves. And if the Cubist collages opened the way to the new materials, Schwitters broadened the range of its vocabulary and conjured from it, as I have already observed, a unique and nostalgic poetry. At the same time, the *Merzbau*, as an auto-biographical and improvisational *esthetic environment*, contained the germs of important ideas explored by artists after World War II, particularly in America.

Schwitters' Merz sounded the death knell of Dada. With it the anti-esthetic posture proposed by Duchamp and Picabia, largely accepted by Ernst and to some extent even by Arp, was jettisoned in both theory and practice. (Arp, while uncompromising in his plastic integrity, nevertheless sometimes sided in theory and word with the "literary" critics, and his position remained equivocal as far as their attacks on art were concerned.) Unlike the pioneer Dadaists, Schwitters objected to the art of the past, Robert Motherwell observes, not because it was art but because it was past.[82] "Merz," Schwitters insisted, always strives toward art."[83]

Chronologically, too, Schwitters is largely a post-Dada phenomenon, for although the first Merz collages date from 1919, many of them, the *Merzbau*, and his activities as poet and editor (the review

Merz first appeared in 1923; fig. D-96) belong to a time when Dada was dead everywhere else. Precisely because of his opposition to the basic anti-esthetic principles of Dada, Schwitters was able to survive it while appearing, at least in the public eye, still to be Dada.

Schwitters was born in 1887 in Hanover, Germany, where he lived until 1937, when he emigrated from his Nazified homeland. His artistic development was not rapid; he was thirty before he cautiously approached abstract painting. No sudden peripety marked his evolution as a painter, and Schwitters himself spoke of the "unbroken line of development" from his naturalistic painting to the Merz abstractions. In fact, throughout his career he continued to make realistic portraits and landscapes, which, since they sold more easily than his avant-garde work, provided him with a livelihood. At the same time, his constant recourse to nature, Schwitters maintained, stimulated pictorial ideas that kept his abstract work from becoming stale. The two years preceding the Merz collages of 1919, during which time he met Herwarth Walden and became associated with his Sturm gallery in Berlin, saw Schwitters' assimilation of advanced European painting. The transitional works of this period, varying markedly in character, contain a mélange of the styles of the painters favored by Walden; the general context is that of Cubism (fig. D-97), Orphism, and Expressionism, within which the particular influences of Delaunay, Chagall, and Klee are discernible.

Schwitters might well have figured in the history of Berlin Dada, for in 1918 he introduced himself to Hausmann, presented examples of his poetry, and asked to be allowed to join Berlin's Club Dada. But his "bourgeois" idealization of art and, above all, his indifference to radical politics repelled Huelsenbeck, who saw to it that his application for membership was rejected. Schwitters lived, Huelsenbeck later wrote, "like a lower middle class Victorian. He had nothing of the audacity, the love for adventure . . . the keenness, the personal thrust, and the will born of conviction, that, to me, made up most of the dadaist philosophy. . . . To me . . . he was a genius in a frock coat. We called him the abstract Spitzweg, the Kaspar David Friedrich of the dadaist revolution."[84]

For the next two years, Schwitters continued to be in disfavor with Hausmann and Huelsenbeck; he was pointedly not invited to the big Berlin Dada exhibition of 1920. Hausmann later changed his attitude, and in the fall of 1921 he and Schwitters went to Prague, where they joined in an evening of "Anti-Dada and Merz." The hostility between Schwitters and Huelsenbeck continued, however, though Schwitters' remarks about Huelsenbeck were characteristically restrained ("Merz energetically and as a matter of principle rejects Herr Richard Huel-senbeck's inconsequential and dilettantish views on art"). Schwitters was destined never to have close associations with the Berlin Dadaists, or, for that matter, with the Cologne ones either. But he did collaborate with the Zurich Dadaists, whose moderate ideas—particularly regarding politics—were more congenial to him.

Hausmann considers Schwitters' rejection by the Berlin Club Dada the reason for his having established Merz. Actually, Schwitters coined the term in order to distinguish the collages he had begun early in 1919 from other types of modern painting. He recounts:

For I could not see the reason why old tickets, driftwood, cloak-room tabs, wires and wheel parts, buttons and old rubbish found in the attic and in refuse dumps should not be a material for painting just as good as the colours made in factories. This was, as it were, a social attitude and, artistically speaking, a private hobby, but particularly the last. . . . I called my new works that employed any such materials "MERZ." This is the second syllable of "Kommerz." It arose in the MERZ Picture, a work which showed, underneath abstract shapes, the word MERZ, cut from an advertisement of KOMMERZ- UND PRIVAT-BANK and pasted on. This word MERZ had itself become part of the picture by adjustment to the other parts, and so it had to be there. You will understand I called a picture with the word MERZ the MERZ Picture just as I named a picture with the word "and" the "And" Picture and a picture with a worker, the "Worker" Picture. And now, as I exhibited these pasted and nailed pictures at the Berlin Sturm for the first time, I was looking for a collective term covering this new style since I was unable to expand old terms such as expressionism, cubism, futurism and the like to cover my work. So I named all my work as a species after the characteristic picture—MERZ pictures. Later I extended the use of the word MERZ, first to my poetry, for I have written poetry since 1917, and then to all my related activities. Now I call myself MERZ.[85]

While some Merz collages are organized in radiating patterns borrowed from Futurism (for example, *Merz Picture 25 A*, 1920; fig. 93), the greater number betray the underlying presence of the Cubist grid, even when, as in the case of 0-9 (fig. 94), the rectilinear substructure is a slanting one. As in Analytic Cubist paintings, there are numerous diagonal and occasional curvilinear elements, all of which are subordinated to the vertical-horizontal accents holding them in place. This axiality is emphasized by the fact that printed matter, the largest source of material for the Merz collages, is by its nature rectilinear. Schwitters only rarely isolated a single large letter or number (as in 0-9) to exploit its curvilinear forms. In the main,

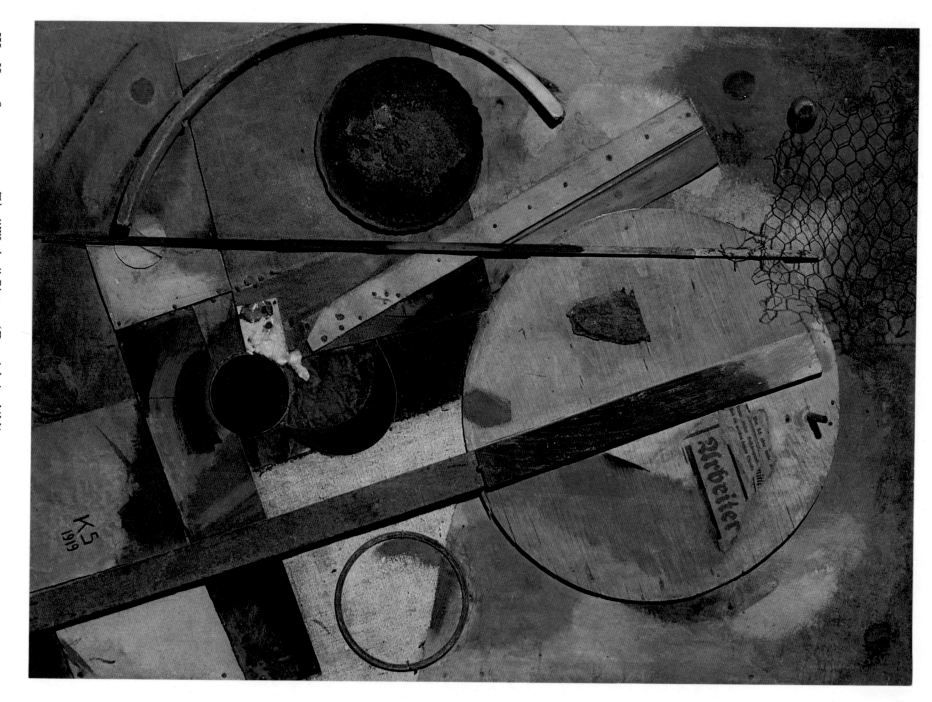

letters and numbers were kept in words and short sequences (as in *Blue Bird*, 1922; colorplate 10); in all such cases, the curvilinear character of any single letter or number is subordinated to the rectilinear or vertical-horizontal axial character of the composition as a whole. Moreover, many of the small elements, like tramway tickets, that appear intact in the collages are by nature rectangular, and in the majority of cases where a naturally curvilinear object has been cut before insertion in the collage, Schwitters gave it a straight edge.

Schwitters rarely tore his papers, preferring to cut them with scissors in a very straightforward manner. Thus, except in infrequent collages like *Unicos Importadores* (fig. 96), the sense of facture, or "handwriting," was eliminated. Here Schwitters was more Dadaist than Cubist, though less extreme than Arp, for whom, in 1915, even the scissors were suspect. Cubist collages contain a great many torn papers, which, aside from having edges with a very particular profile and character, manifest directly the activity of the painter's hand. Not that the use of the scissors necessarily diminishes the evidence of facture; Matisse's late cutout pictures and passages in some Cubist collages bear witness to the "sense of the hand" that can be retained even while using the scissors. But we find nothing of this in Schwitters.

The pieces of which the Merz collages are composed are rarely interesting in themselves from a plastic viewpoint; Schwitters was concerned not with shaping or creating forms but with making ensembles. His concept of picture making was not one of contouring or modeling the surface but of arranging and adjusting it. He proceeded by improvisation in an additive manner, and thus there are few evident *pentimenti*: elements are not reshaped but covered over. The results always have an orderly character and an air of almost classical isolation, because Schwitters' feeling is never for a particular form but solely for the totality of the picture. We never feel any struggle in Schwitters to give character to the components of the work in themselves; perhaps this was out of fear of what he called "the striving for expression," which he considered to be "injurious to art." Yet such an approach inevitably limited his form-language, and as a consequence he tended to repeat himself. Seeing forty or fifty small Merz collages together is not impressive; unless very carefully selected, a whole exhibition of Schwitters is likely to be boring.

Love of poetry and the attempt to fuse it with painting are the main bonds between Schwitters and the Dada-Surrealists in their reaction against "pure painting." Arp had consummated this union by inventing forms that functioned abstractly but nevertheless evoked poetic analogies. Ernst had actually reincorporated descriptive images and let them prevail. Schwitters created a synthesis in which poetry of a very specific order, in both word and image, was subordinated to a plastic whole of Cubist derivation. This he did by reducing the size of words and images and multiplying them in number, so that they could be assimilated more easily into the abstract pattern governing the composition as a whole. Such a solution, however, obviated some possibilities of exploring imagery in ways left open to both Ernst and Arp.

For Schwitters the union of painting and poetry could start from either pole. "First I combined individual categories of art. I pasted words and sentences into poems in such a way as to produce a rhythmic design. Reversing the process, I pasted up pictures and drawings so that sentences could be read in them."[86] Observe how this interaction works in a typical Merz collage, *Blue Bird* (colorplate 10), which contains words (entire and fragmentary) and a truncated image (an engraving of soubrettes at a masked ball). The words *er und sie* ("he and she"), in large print (lower case) and cut from different sources, are located roughly in the upper left, the center, and the lower right of the field, respectively. Immediately they establish an ambiance of "romance." The *er* and *sie* are then repeated in smaller print in the upper right center and lower left center. The large male *er* is in solid heavy lettering, and the female *sie* is by comparison narrower, taller, and more elegant. The small *er* is in simple capitals, while the small *sie*, followed now by a provocative question mark, is considerably smaller than the *er* and is in delicate gothic print. The general theme having been established, the spectator may then relate to it other elements of the composition. The engraving of flirtatious women on the lower left is counterbalanced by a broad (phallic?) arrow coming down the upper right and pointed directly at the dot of the letter *i* in *sie*. In the bottom-right margin is the title *Blue Bird*, and to the left of it part of a page from a desk calendar marked "Sunday, 23rd." A train ticket, a theater stub, and the fragment of a letterhead containing the name of the city of Hanover fill out the novelistic "iconography" of the ensemble. Among the other elements we might relate to the theme are the letters *a-c-b* cut from a larger word, forming the German word for "Ah!," and the word *Sturm* ("storm"), which has a particularly romantic meaning in German (and alludes also to Walden's gallery).

In the recent major exhibitions of Schwitters' work, particularly the Hanover retrospective and that of the 30th Venice Biennale, critics and painters were most impressed by the ten or so very large and prophetic Merz collages of 1919–20, most of which had not been seen publicly since their original showing at the Sturm Gallery.

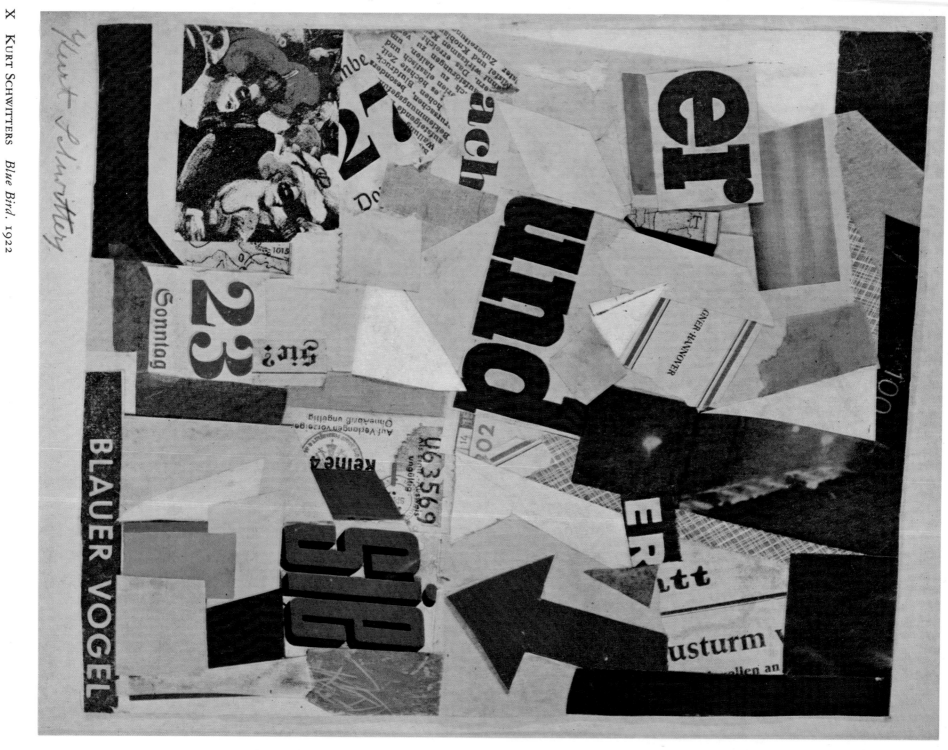

Kurt Schwitters. *Memoiren Anna Blumes in Bleie*

Kurt Schwitters. *Fec. 1920*

These, however, are not wholly typical Merz collages, for much of Schwitters' favorite trash was too small to lend itself to large-scale compositions, which forced him to use other materials. In the large *"Worker" Picture* (colorplate 9), for example, the wood slats, wire mesh, and other objects produce a bold geometrical effect, close to Picasso's relief constructions and very different from the intimate poetry of Schwitters' smaller collages. That these larger works should appeal to today's audience is understandable. But there is good reason why by far most of Schwitters' collages are small—besides the fact that his favorite materials required this scale: he wanted to create the same intimacy between the spectator and the work of art that existed between himself and his materials. This kind of intimacy can be produced only by very small pictures which force the spectator's eye very close to the surface or, on the other hand, by a certain type of large non-illusionist picture (Mark Rothko, for example, says that he paints large pictures in order to be intimate).

Smallness is, therefore, as in Klee, a fundamental element of Schwitters' style. Which is not to say that it was an unalloyed asset for Schwitters. He was never able to match the variety that kept Klee's miniaturist art from becoming monotonous in its smallness. By his scale, and by his materials, Schwitters opposed everything that con-

noted grand-manner painting, whether it was Poussin's or Matisse's. Repelled as much by the "noble" as by the "official," he sought his humble poetry in forgotten things, in the leftovers of modern life and industrial society in particular. He wanted an art that was as homely as it was honest, an art that acknowledged the petit-bourgeois love of *conserving* (and its idealization in the form of *collecting*). We might think of Schwitters' crowded compositions as modern expressions of an essentially Victorian taste, but it is an expression in which Victorian sentimentality has been purified into sentiment and detached from its pecuniary scale of values if not from its fetishism. At the same time, Schwitters' love for refuse is his badge as an outsider.

Schwitters' position remains ambivalent: if, in a sense, he stands outside bourgeois society, rejected by it as a revolutionary artist, he nevertheless evinces a marked nostalgia for things bourgeois. This same ambivalence appears in his poetry. *Anna Blume* is a conventional bourgeois declaration of love interspersed with sarcastic nonsense, meant, according to Schwitters' son Ernst, "to force us to smile at our own futility." Like today's Pop artists, Schwitters does not consider himself one apart from the bourgeois world; he *is* Anna Blume, even as he makes fun of her, just as he is the *Blue Bird* (a title that might well derive from a sentimental cabaret song of the twenties). *Anna*

89 MAX ERNST *The Massacre of the Innocents.* 1920

90 MAX ERNST *Undulating Catherine* 1920

91 JOHN HEARTFIELD *Cover for Der Dada #3* (Berlin), 1920

92 KURT SCHWITTERS *The "And" Picture (Das Undbild),* 1919

90

89

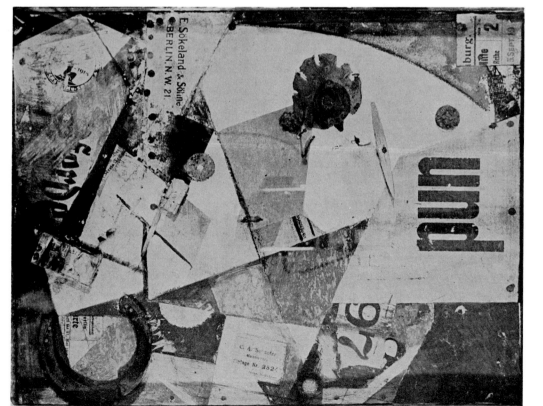

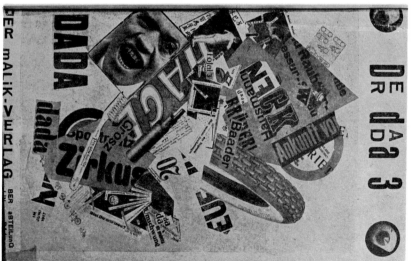

92

91

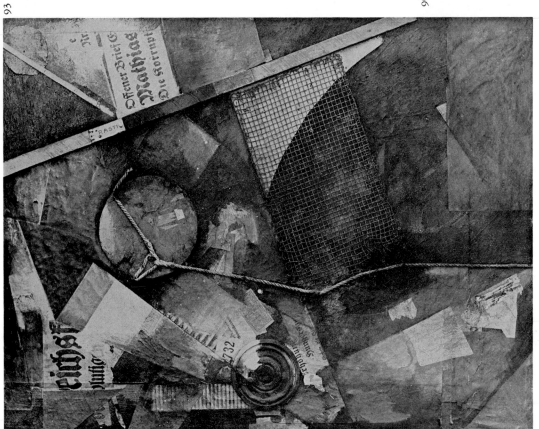

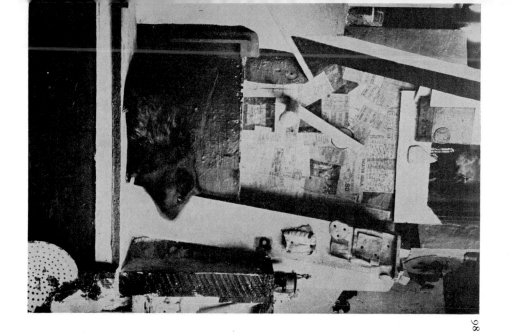

98

99

97

100 KURT SCHWITTERS Untitled. 1925

101 KURT SCHWITTERS *Cathedral.* 1926

102 KURT SCHWITTERS *Merzbild.* 1930

101

Blume, however, holds a secondary place in his poetry, next to the *Ursonate*, or *Sonate in Urlauten*, on which he worked continuously from the early 1920s until his death, proceeding by accretion in a manner comparable to the creation of the *Merzbau* (figs. 98, 99). The general precedents for this long and ambitious poem were the sound poems of the Zurich Dadaists, suggested in turn by Henri Barzun, Fernand Divoire, and Paul Dermée in France, and by the Italian Futurist bruitists. (F. T. Marinetti had called for the use of language "not as a means of communication, not as an instrument of thinking, but as behavior.") The immediate germ, however, was Hausmann's "letterist" sound poem *f m s b w*, which Schwitters got to know when he and Hausmann went on their anti-Dada and Merz lecture tour to Prague in 1921. Schwitters became obsessed with Hausmann's poem and repeated it everywhere. At a soirée of Der Sturm he recited it under the title *Portrait of Raoul Hausmann*. Gradually he added and extended the sounds until the poem bore little or no relation to the original. The "ur-sounds" or primary vocables, *f m s b w*, had become "fumma bowotas zaauu pogiff kwiee. In his endless reciting of the poem (a recording was made by Lord's Gallery in London), Schwitters often improvised and sometimes retained the improvisations in successive "definitive" versions. And in the same way that the collages and the *Merzbau* had moved, in the later twenties, in the direction of plastic formalism, so the *Ursonate* became an increasingly formal arrangement of pure sounds suggested by musical forms (hence its title). The last major section is the scherzo, "lanke trr gll," which dates from around 1932; one "definitive" form of the poem was published by Schwitters in No. 24 of his review *Merz*. He had long since ceased calling it *Portrait of Raoul Hausmann*; in fact, Hausmann reproached him roundly "for having made of my four-part invention a classical sonata entirely contrary to the phonetic meaning of the letters I had chosen."[87]

Schwitters' reputation amongst collectors rests primarily on his collages, despite the fact that they connect him with Dada less than do his other activities. He never surpassed those of the classical Merz period (1919–23), though many collages from the middle thirties until his death in 1948 compare favorably with these in quality. Least interesting are the rigidly geometrical, virtually purist collages that appeared in 1924 and continued into the early thirties. The colored reliefs and collages of these years (figs. 100–102) contain direct suggestions of Theo van Doesburg, El Lissitzky, László Moholy-Nagy, and Arp, and they show Schwitters choosing the path of the later Abstraction-Création group, rather than Surrealism, to fill the vacuum left by Dada. In the early 1930s, he returned to his more personal

Merz style, which he subsequently carried on in virtual isolation from the changing currents of European painting, first in Norway, where he fled from the Nazis in 1937, and later in England.

The same progression from collage to relief and then to free-standing constructions that had marked Picasso's development took place in Schwitters'. But if his reliefs often had a compositional tautness like that of his collages, his free-standing "object-sculptures," at least the few I have been able to see, are by and large unsuccessful. Here the problem was not one of adjusting and manipulating shapes in a field but of creating them out of whole cloth. Schwitters seems not to have had a gift for this; he was unable to replace the figure-ground dialogue of his collages and reliefs with the different but equivalent kind of play of space demanded by sculpture.

In part an outgrowth of Schwitters' sculptural constructions, but in the end *sui generis*, was the *Merzbau* ("Merz structure"), of which the interior elements date from the 1920s and the architectural elements from 1925–35. Unfortunately, the *Merzbau* was destroyed during a bombing of Hanover in 1943, and since the extant photographs show mostly the larger architectural shell, we are largely dependent on verbal descriptions for a sense of its interior. The *Merzbau* developed out of the familiar Dada ideal of abolishing the distinction between "art" and "life." In the deepest sense, however, it transcended Dada and became the expression of an aim animating modern art as a whole: the physical and spiritual reintegration of plastic art—as something more than a salon object designed to decorate apartments—with the daily process of living.

Beginning in 1919, Schwitters' walls had begun to overflow with collages and reliefs, and shortly afterward his floors became crowded with free-standing objects. The result was what Lawrence Alloway has called his "personal museum." The distinction between the reliefs as independent entities and the walls as backdrops for any interesting junk that Schwitters happened to find soon disappeared. At the same time, the piles of free-standing junk grew constantly, refreshed with every new *trouvé* of the painter. This improvised environment gradually obliterated the architectonic sense of Schwitters' house. Then, toward 1925, the Merz walls and concretions in the center of the house began to be surrounded by a stalactite-like growth of wood and plaster—"a sculpture built from inside around you," Ernst Schwitters called it—which in time extended through two floors of the building and down into a cistern. As this shell developed, it became more and more Constructivist in aspect, in keeping with the general reorientation of Schwitters' art in the later twenties. It is this more purely plastic apparatus which the photographs best preserve for us; the

inner core, formed of Merz agglomerations, amounted to a kind of Dada grotto, part of which was accessible only through "doors" and "windows" in the surrounding timber structure. Among the names Schwitters gave to sections of the *Merzbau* were Nibelungen Treasure, Cathedral of Erotic Misery, Goethe Grotto, Great Grotto of Love, Lavatory Attendant of Life; there was also a Sex-Murder Cave, which contained a red-stained broken plaster cast of a female nude.[88]

The labyrinthine *Merzbau*, "half cathedral, and half Dr. Caligari's Cabinet," opened up whole series of possibilities, both plastic and ideational, which neither Schwitters nor the other painters of his generation had time to explore fully. Apart from being a prototype for recent Environments (fig. D-302), the *Merzbau* and Schwitters' other work anticipated such experiments in "environmental" sculpture as that of Henri Etienne-Martin in France and Herbert Ferber in America, to say nothing of providing a point of departure for the reliefs and free-standing objects of Rauschenberg and others. But Schwitters had had a vision, which he never realized, of a far more radical, hallucinatory Merz experience than the *Merzbau*, one that foreshadowed the Happenings (fig. D-301). This was the Merz total work of art, or what I shall call the *Gesamtkunstmerz*, which would, in Schwitters' words, "embrace all branches of art in a single unit." It differed from the Wagnerian *Gesamtkunstwerk* by being not a synthesis of genres but a confusion of them: "Take gigantic surfaces, conceived as infinite," Schwitters instructs,

cloak them in color, shift them menacingly. . . . Paste smoothing surfaces over one another. . . . Make lines fight together and caress one another in generous tenderness. . . . Bend the lines, crack and smash angles . . . let a line rush by, tangible in wire. . . . Then take wheels and axles, hurl them up and make them sing (mighty erections of aquatic giants). Axles dance mid-wheel roll globes barrel. Cogs flair teeth, find a sewing machine that yawns. . . . Take a dentist's drill, a meat-grinder, a car-track scraper, take buses and pleasure cars, bicycles, tandems and their tires, also war-time ersatz tires and deform them. . . . Take petticoats and other kindred articles, shoes and false hair, also ice-skates and throw them into place where they belong, and always at the right time. . . . Inner tubes are highly recommended. Take in short everything from the hairnet of the high class lady to the propeller of the S.S. *Leviathan*, always bearing in mind the dimensions required by the work.

Even people can be used. . . .

Now begin to wed your materials to one another. For example, you marry the oilcloth table cover to the home owners' loan association, you bring the lamp cleaner into a relationship with the marriage between

Anna Blume and A-natural, concert pitch. . . . You make a human walk on his (her) hands and wear a hat on his (her) feet. . . . A splashing of foam.

And now begins the fire of musical saturation. Organs backstage sing and say "Futt, futt." The sewing machine rattles along in the lead. A man in the wings says: "Bah." Another suddenly enters and says: "I am stupid." (All rights reserved.) Between them a clergyman kneels upside down, cries out, and prays in a loud voice: "Oh mercy seethe and swarm disintegration of amazement Halleluia boy, boy marry drop of water." A water pipe drips with uninhibited monotony. Eight.[89]

Schwitters' ideas for a Merz-stage remained in the realm of theory. Although they represent his urge to erase the boundaries that exist among the arts, he himself felt that they were unrealizable. In 1923 he began to develop his ideas for a *Normalbühne Merz*, which lacked the radicality of the Merz-stage but for which he conceived a space stage in which the machinery constituted part of the visible esthetic of the event.

The history of modern art, from its inception with the generation of Manet and the Impressionists, has moved in a direction opposite to the *Gesamtkunstwerk*; it was only with Dada that theater influenced it. Clement Greenberg has observed that the informing dialectic of modern painting, indeed, of all the modern arts, has been the search for those qualities that are both indispensable and peculiar to them. It is no accident that Dada, reacting to the implied autonomy of painting at the very moment that it was going over into total abstraction, should have wanted "to dissolve the rigid frontiers" of the various arts even as it wanted "to put them once again under the dependency of man." Nor does it seem to be an accident that the reaffirmation of abstract painting by the "first generation" of post-World War II artists should in turn have engendered a reaction in the form of Environments, Happenings, and other mixtures of the arts which are still under way.

The relationship of the Dadaist conception of the gratuitous or spontaneous act to the theory of Action Painting and the relationship of this, in turn, to the vogue of Happenings is too complicated to be treated here, but there is no question that historical consciousness of Dada and Surrealism in New York during and after World War II had an important role in these developments. The fact that most of the artists and critics involved in our recent history had no firsthand knowledge of the earlier experiments proved to be a virtue, since the

distance made them freer to judge and to develop what was still viable in them.

Schwitters' Merz collages of 1919–20 (and those of Max Ernst of the same time) represent, as far as painting is concerned, the last important Dada innovations. Were we concerned here with all phases of the movement, it would be necessary to conclude this account with a chapter on Paris Dada in the years following the war, a chapter rightly treated in all general histories of Dada as the culmination of the movement. But while Paris saw Dada painters elaborate and extend their ideas, this period was more interesting for the work of its poets and for the new ideals animating the "manifestations," which gave Paris Dada a notoriety—and a sociological importance—it had never achieved before. From the point of view of the plastic arts, the main function of Paris Dada was the establishing of the point of departure for Surrealism, and it is within this context that we shall study it.

AVRIL 1922

LE CŒUR À BARBE

JOURNAL TRANSPARENT

1 Fr.

Administration: AU SANS PAREIL
37, Avenue Kléber - PARIS (XVIᵉ)

Ont Collaboré à ce 1ᵉʳ numéro:

Paul ELUARD, Th. FRAENKEL, Vincent HUIDOBRO, Mathew JOSEPHSON, Benjamin PÉRET, Georges RIBEMONT-DESSAIGNES, Erik SATIE, SERNER, Rrose SÉLAVY, Philippe SOUPAULT, Tristan TZARA.

PART II:
THE BACKGROUND OF SURREALIST PAINTING

FROM DADA TO SURREALISM IN PARIS

Though the earliest collective manifestations of Dada took place in Zurich and New York, most of the movement's founders, inside the sphere of the plastic arts (Duchamp and Picabia) as well as outside it (Cravan and Vaché), were formed by Paris. The war had made organized activity like that in Zurich and New York impossible in France. This was the reason, as we have seen, for the presence in Switzerland and the United States of the expatriate painters and poets who did most to crystallize the Dada idea. With the end of the war, Paris saw a great homecoming. Picabia and Duchamp returned to Paris in 1917 and 1919; Tzara moved there from Zurich in 1920; in the same year Arp came to visit; Man Ray arrived in 1921, and Ernst in 1922.

Apart from Tzara and Picabia, however, the principal moving spirits of Dada in Paris were the young French poets who wrote for the avant-garde magazine *Littérature*, which had been founded in 1919 by André Breton, Louis Aragon, and Philippe Soupault. This group created a very distinctive philosophical and literary ambiance for Dada in Paris—one in which, as we view it retrospectively, the seeds of Surrealism become apparent. These poets had all been in the service, so that it was not until 1919 that they—along with their friends Jean Paulhan, Paul Eluard, and Georges Ribemont-Dessaignes —were able to catch up with wartime Dada. Only then did they see the Zurich periodicals (Breton alone had seen a single number of *Dada I* at Apollinaire's home in 1917).

The anarchic nature of Dada shortened its existence in Paris in the same way as elsewhere. Essentially a reaction against war and the drift to war before 1914, Dada could not long survive the *détente* after the Armistice. Picabia has said that genuine Dada activity had come to an end by 1919. Vaché's suicide in that year and Duchamp's

disavowal of anti-art in favor of "engineering" in 1920 were clearly symbolic acts on the part of two individuals who had taken most seriously the nihilism that constituted Dada's point of departure. After ceasing to exist as a movement (which it did by 1921), Dada persisted here and there, on an individual basis, as a state of mind. But even on this level it did not survive for long, and such later Dada creations as Picabia's ballet *Relâche* (fig. D-103), of 1924, were isolated experiments, coming as they did when the viable elements of Dada had already been assimilated in the synthesis that was Surrealism.

Despite Breton's praise of Jacques Vaché, the latter's truly Dada rejection of the whole avant-garde literary tradition (he detested Rimbaud and dismissed Apollinaire) was unacceptable to the founder of Surrealism. Neither Breton nor the other poets around *Littérature* accepted Dada's *tabula rasa*; they insisted on the importance of certain writers (largely of Romantic or Symbolist persuasion), as they were shortly to insist on the importance of certain painters, whom they "rehabilitated" as Surrealist precursors. The contents of the earliest numbers of *Littérature*, even more than its restrained format, indicate the distance which at first separated its editors from the pioneer Dadaists. It was in *Littérature* that, after twenty years of silence, Paul Valéry (who had suggested the magazine's title as an ironic play on Verlaine's famous passage "*tout le reste est littérature*") returned to poetry with *Le Jeune Parc*. André Gide, whose relevance to Dada I pointed out earlier, enjoyed great prestige with the editors of *Littérature*. Rimbaud was their model (though Mallarmé was given equal emphasis), and Isidore Ducasse (the "Count of Lautréamont") was their "discovery." The review immediately undertook to reissue Lautréamont's *Poésies*, of which but a single copy was then known to exist, buried in the stacks of the Bibliothèque Nationale.

Besides the work of its own founders, *Littérature* welcomed con-

tributions from Pierre Reverdy, Blaise Cendrars, Raymond Radiguet, Max Jacob, André Salmon, and Raymond Roussel (whose *Impressions of Africa* deeply affected Marcel Duchamp). Some of these writers had already appeared in Pierre Albert-Birot's periodical *Sic* (founded in 1916 and vaguely Dadaist in tendency). Others, particularly Breton's immediate circle, had contributed in 1917 to Reverdy's review *Nord-Sud*. In France, during the year that followed the war, Dada was an undigested, exciting, foreign phenomenon, and while from the first *Littérature* was referred to now and then as *dadaïsante*, it remained independent of Dada in its first twelve numbers.

Though they took part in the "manifestations" that Paris Dada put on in the very first months of 1920, it was only a little later on, in the spring of that year, that Breton and his friends of *Littérature* fully committed themselves to the movement. The entire May issue of *Littérature*—which accompanied the notable Salle Gaveau soirée (fig. D-101)—was devoted to twenty-three Dada manifestoes by twelve different hands, among them Breton, Aragon, Soupault, Eluard, Ribemont-Dessaignes, and several Zurich and New York Dadaists. In August, an article by Breton, titled "Pour dada," spelled out the gospel for the wider literary public of the *Nouvelle Revue Française*. And, in the following year, Parisian Dada saw a seemingly endless succession of manifestations (largely satirical playlets, music, and poetry), publications, and "happenings" (like the visit to the church of St. Julien le Pauvre, the first—and last—of a projected series of derisive visits to popular or sentimental tourist sites; fig. D-113).

But even as the movement seemed to be provoking its greatest—or at least most scandalized—reactions, it began to dissolve. In the spring of 1921, Picabia signaled his disaffection with Dada in a "communiqué" to the newspapers in which he insisted stubbornly that

the Dada spirit really existed only from 1913 to 1918, during which time it never ceased evolving and transforming itself, and after which time it became as uninteresting as the productions of the Beaux-Arts or the static lucubrations offered by the *Nouvelle Revue Française* and certain members of the Institute. In wishing to prolong itself, Dada became enclosed within itself. . . .

The following year Picabia's repudiation led to his breaking with Tzara, whom he attacked—along with Cocteau, the Cubists, and a number of minor Dadaists—in a pamphlet titled *La Pomme de Pins* which bears the date February 25.

At the very time that Picabia was walking out on Dada, Breton organized two "manifestations" in which a tendency foreign to Dada

emerged. The first of these, which Breton had obviously pondered for some time, was the mock trial of the writer (and Deputy) Maurice Barrès for "crimes against the security of the spirit" in May, 1921 (fig. D-102), in the Salle des Sociétés Savantes (earlier the site of Cravan's manifestation). The once liberal author of *Le Culte du moi*, Barrès had become increasingly chauvinist (president of the League of Patriots) and "bourgeois," while committing himself to academicism in matters of literature and art. (As Annette Michelson has pointed out,[90] Barrès' conversion in many ways anticipated and paralleled André Malraux's metamorphosis from radical novelist to Gaullist cabinet minister.) Breton was judge at the trial and Ribemont-Dessaignes the public prosecutor, while Jacques Rigaud and the "Unknown Soldier" (Benjamin Péret dressed in a German uniform) were the witnesses. Louis Aragon, the defense attorney, did little to save the name of his absent "client," who was represented by a life-size mannequin.

Despite all this, the "trial" of Barrès was deadly serious—too serious, in fact, for Tzara, who on the witness stand reviled himself and the Dadaists, as well as Barrès, as *salauds* and *cochons*. This was a genuinely Dada attempt to divert into anarchy what, in Breton's hands, had become un-Dada by its programmatic seriousness. It was the idea of collective and purposeful action that made the Barrès "trial" distasteful to Tzara, and completely antagonized Picabia, who would have no part of it. Reasserting the essentially anarchic spirit of Dada against Breton's systematizing approach, Tzara's behavior on the witness stand heralded the inevitable break between Breton and Dada.

What completed this break as far as Tzara was concerned was Breton's attempt to organize the Congrès International pour la Détermination des Directives de la Défense de l'Esprit Moderne, later known simply as the Congress of Paris. This proposal, made seriously, was well received outside specifically Dada circles; Delaunay, Léger, Amédée Ozenfant, and the composer Georges Auric were among those who accepted places on the Organizing Committee. But this glorification of "modernism" (a term long abhorrent to Dadaists) and the attempt it involved to conciliate various avant-garde groups ("to satisfy every tendency," as Tzara critically put it) offended many pioneer Dadaists. In *La Pomme de Pins* Picabia, who had rejected the idea out of hand, wrote paradoxically: "The Congress of Paris is fucked because Picabia belongs to it." Tzara put out a pamphlet titled *Le Coeur à barbe* attacking the proposed Congress; the signatories of its foreword included Eluard, Satie, Soupault, and Ribemont-Dessaignes. Two months earlier, the last-named had invited

the avant-garde to a protest meeting at the Closerie des Lilas, where "the ridiculous bureaucratic preparations" for a "Congress for the Delimitation of Modern Art" were attacked and Breton was called to account for certain uncomplimentary references he was alleged to have made about Tzara ("an impostor avid for personal publicity"). In a unanimous resolution, the forty-five people present (including such diverse personalities as Cocteau, Arp, Radiguet, Man Ray, Metzinger, and Eluard) "withdrew confidence" from the Organizing Committee of the Congress of Paris. This succeeded in scuttling the Congress, and Breton, seeing himself deserted by so many of his former associates, gave up the project and with it any hope of achieving his aims within the framework of Dada.

Breton later described the spring of 1921 as the period of "the obsequies of Dada." Speaking early in 1922, he insisted that "for a long time now, the *risk* has been elsewhere. . . . If there is to be an attempt at subversion, it will have to be sought on other terrain than that of Dada."[91] The "other terrain" had not yet been mapped, but certain coordinates of its geography were already clear to Breton. Dada had postulated the total destruction of the prevailing order, speculating that out of the resultant void, "in which nothing exists any longer," a new and better world would emerge; almost completely engrossed in its "enterprise of total subversion and destruction," it gave only the barest hints of what might later come forth. To Breton this future reconstruction was the central problem, and as far as he was concerned, the moment for it had now arrived. "Dadaism," he wrote, "cannot be said to have served any other purpose than to keep us in the perfect state of availability in which we are at present, and from which we shall now in all lucidity depart toward that which calls us."[92]

What Hugnet aptly calls Breton's "dialectical transformation" of Dada into Surrealism[93] took place during the three years preceding the publication of his first Surrealist manifesto in 1924. This interregnum was a period of particular confusion and realignment in both the ideals and the groupings within the Parisian avant-garde. For this reason it is sometimes called the *époque flone*—the uncrystallized period. Long before he defined Surrealism formally, Breton was drawing attention to the works of poets, philosophers, psychologists, artists, and others that contained, to a greater or lesser degree, the features which would later be called Surrealist. In fact, the somewhat elusive general definition of Surrealism in the first manifesto depended very much on the names of precursors.

For Breton not much of the pre-Dada world deserved saving, but some of it did. What was still viable—ideas, works, reputations (that is, myths)—would have to be rehabilitated, and incorporated in Surrealist theory. In literature this meant, broadly speaking, the Romantic-Symbolist tradition, particularly the writers of *romans noirs* and all the others who celebrated the marvelous and bizarre. Baudelaire, Gérard de Nerval, Aloysius Bertrand were "resurrected," and Rimbaud (who had been rejected by Dada) became, with Jarry (who had not been) and Lautréamont ("discovered" earlier by Breton in the pre-Dada stage of *Littérature*), the immediate literary progenitors of the movement. The German Romantics attracted special interest, and the poets in the circle around Breton all read Novalis' *Hymns to the Night* and the "Bizarre Tales" of Achim von Arnim, both of which left traces on later Surrealist literature and the imagery of Surrealist paintings.

The "last of the great poets" in the literary tradition that Breton was bent on resuscitating was Guillaume Apollinaire, and it was no accident that the term "surrealist" was his invention. It will be recalled that the genuinely Dada Jacques Vaché had dismissed Apollinaire, suspecting him of "patching up Romanticism with telephone wire." To Vaché, for whom all art was "foolishness," Apollinaire's esthetics were clearly no more than the most recent phase of a vestigial kind of poetry that traced its development back to Baudelaire. Despite his great admiration for Vaché, Breton could reject neither Apollinaire nor the tradition that lay behind him. In accepting Apollinaire (who had "no fear of art"), Breton marked his fundamental break with the nihilism to which Dada had at least paid lip service.

Breton gave Surrealism its first formal definition in the manifesto of 1924, but the term had been in frequent use in avant-garde circles since 1920 and actually dates from 1917. Its first appearance in print, according to Breton, was as the subtitle ("a surrealist drama") of Apollinaire's *Les Mamelles de Tirésias*, which had its premiere on June 24, 1917, under the sponsorship of Pierre Albert-Birot and his review *Sic*. Actually, the word had appeared in print a month earlier—as William Lieberman[94] and Wallace Fowlie[95] have pointed out—in a short text written by Apollinaire for the program of Diaghilev's production of Erik Satie's ballet *Parade*. Cocteau had called *Parade* a "realist ballet," implying that the primarily Cubist decor and costumes by Picasso (fig. D-98), his own disjointed scenario, and the unexpected character of Satie's music and Massine's choreography had combined to illuminate an artistic truth more "real" than that conveyed by conventional realism. In his brief program text Apollinaire went further, seeing in the product of this unique collaboration "a kind of *sur-réalisme*" which would become

the point of departure for a series of manifestations of [the] New Spirit that, finding today an occasion to show itself, shall not fail to captivate the elite, and promises to transform arts and manners into universal joy. For common sense wants them to be at least on a level with scientific and industrial progress.[96]

It is evident that for Apollinaire the neologism had none of the psychological implications which later, during the *mouvement flou*, came to pervade the term Surrealism. Rather, his references to scientific and industrial progress suggest an attempt to rationalize the novelty of the art in question in the manner of the Futurists and of the misguided popularizers of Cubism.

Despite its more exaggerated fantasy, *Les Mamelles de Tirésias* was a stage piece in the general spirit of *Parade*, and it is very unlikely that Apollinaire attributed any more specific meaning to the word Surrealism in June, 1917, than he had in May of that year. Most critics passed over the subtitle of his play, preferring to call it a "Cubist play." The review *Sic* used the term Surrealist interchangeably with "supernaturalist." Critics seemed generally confused. Victor Basch explained in *Le Pays* that "sur-realist drama . . ," in French [means] symbolic drama," but clouded his definition by using "Surrealist," "Cubist," and "Simultaneist" as though they were synonymous. "Surrealist" might have soon acquired general acceptance as a blanket term for avant-garde art but for the fact that "Dada," which entered France the year after the war, served the purpose better. It was only around 1921—by which time the meaning of Dada had become highly particularized and the movement it identified was dissolving—that the term Surrealism gained real currency. Since its meaning had been vague at the time of its invention in 1917, it proved an ideal instrument for Breton and the *Littérature* group at a time when their own ideas were still uncrystallized and their direction unsure. In 1921, nobody quite knew what Surrealism meant, but during the next three years its circulation in avant-garde writing and talk attached to it a variety of more specific meanings. In the first Surrealist manifesto (1924), Breton made an attempt to codify and clarify these.

Perhaps the most significant new interest of the *Littérature* group during the years of the *époque floue* was Freudian psychology. Dada had promoted a kind of activity intended to "liberate the irrational," but the "unreasoned order" anticipated by its pioneers had never emerged from the anarchy it produced. ("How Dada Failed to Save the World" was a chapter heading in Aragon's projected "History of Contemporary Literature.") If unconscious forces were really to be understood and profited by, argued Breton, their nature

would have to be systematically probed and appropriate conclusions drawn. This scientific, rational approach to the irrational was entirely uncongenial to most of the pioneer Dadaists; when Breton visited Freud in Vienna late in 1921, it was a sign that Surrealism would worship at at least one shrine never dreamed of by Dada.

Breton had first become interested in Freud's ideas while serving during the war as an orderly in a mental clinic. But it was difficult for him to learn much more about them, since very few of Freud's writings had been translated into French. Breton's interview with him proved rather disappointing. Freud seemed ill at ease with this foreigner who was not a professional but tossed around names like Charcot and Babinski in an attempt to engage him in a serious discussion. All Breton got from him were such generalities as "We are counting heavily on youth" and "Your letter was the most touching I ever received." Nevertheless, on his return to Paris, Breton decided to experiment with ways of laicizing Freud's methods of free association in order to produce a body of material that might confirm (and even extend) Freud's ideas. This data, Breton thought, would in turn open up new possibilities for poetry.

The free flow of associations had, of course, been one of the standard techniques of Dada, and a large body of automatic and semiautomatic writing was already in existence. Breton and Soupault had collaborated on such texts in 1919, publishing them in *Littérature* under the title *Les Champs magnétiques* ("Magnetic Fields"). As published, the texts of *Les Champs magnétiques* indicate that the raw material of free association was subjected to no small amount of editing to arrange the flow of images in normal grammar and syntax: "*Les gares merveilleuses ne nous abritent plus jamais: les longs couloirs nous effraient. Il faut donc étouffer encore pour vivre ces minutes plates, ces siècles en lambeaux.*" Breton later identified these texts as "incontestably the first Surrealist works (in no way Dada), since they were the fruit of the first systematic applications of automatic writing." It is significant that Breton emphasized *systemization* as the properly Surrealist element in the work; Ribemont-Dessaignes, who never made the transition from Dada to Surrealism, has insisted that systemization was the *only* contribution of Surrealism.[97] While this is an exaggeration, it is unquestionable that Surrealist literature and art were, in some measure, an ordering and systemization of the chaotic inventions of Dada.

Among the techniques of free association explored by Breton were a variety of word games. The April, 1922, number of *Littérature* contained responses by Breton, Eluard, Aragon, Rigaud, Soupault, and others to "stimulus" words and phrases, such as "part of the

103

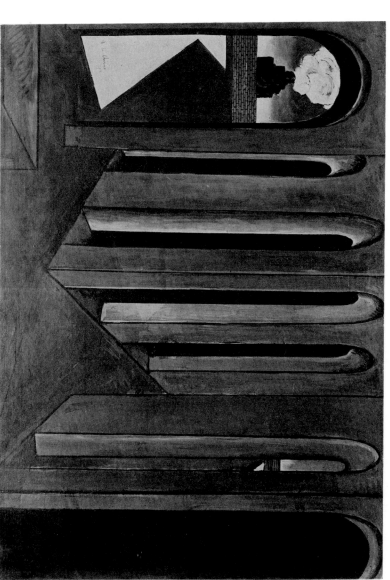

105

104

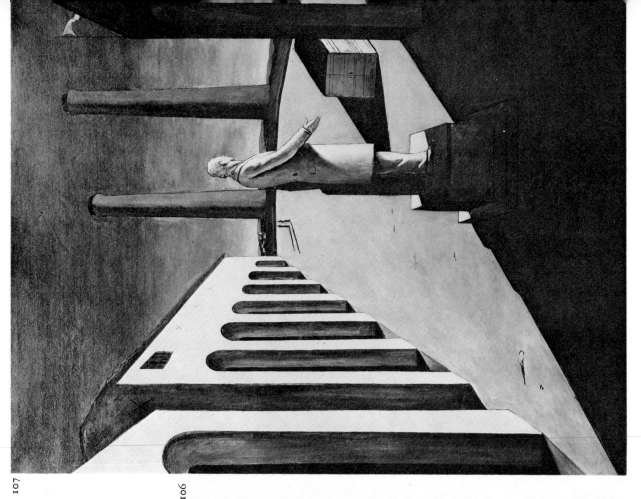

107

106

106 GIORGIO DE CHIRICO *The Child's Brain*. 1914

107 GIORGIO DE CHIRICO *The Enigma of a Day*. 1914

108 GIORGIO DE CHIRICO *Gare Montparnasse (The Melancholy of Departure).*
1914

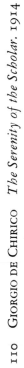

109 GIORGIO DE CHIRICO *The Mystery and Melancholy of a Street.*
 1914

110 GIORGIO DE CHIRICO *The Serenity of the Scholar.* 1914

body." But in order to liberate the flow of thought more effectively, it was decided to explore the possibilities of hypnotic trances, during which the babbled reveries of the subjects were recorded. More and more, *Littérature* became devoted to *récits de rêves* and transcriptions of things spoken, written, and drawn under hypnosis. Afterward, the years 1922–23 were regarded as the *époque des sommeils* ("period of trances"); the experiments conducted then were summarized in Aragon's *Une Vague de rêves*, published in 1924.

The various forms of automatism that were explored and the data thereby obtained gradually fleshed out the definition which the word Surrealism had lacked. "Up to a certain point," wrote Breton in November, 1922, "one knows what my friends and I mean by Surrealism. This word, which is not our invention and which we could have abandoned to the most vague critical vocabulary, is used by us in a precise sense. By it, we mean to designate a certain psychic automatism that corresponds rather closely to the state of dreaming, a state that is today extremely difficult to delimit."[98]

For a while, however, the word Surrealism continued to be used by Paul Dermée and by Ivan Goll, an Alsatian author, in a manner more consistent with the intentions of Apollinaire, from whom they, too, had borrowed it. Dermée's earlier experiments in poetry, which I have already mentioned, had grown out of Futurism. By 1920, Futurism as such was dead, but the more inclusive term *esprit nouveau*, under which Apollinaire had grouped all avant-garde tendencies, hung on. Dermée contributed to a magazine called *Esprit Nouveau* that Ozenfant and Le Corbusier published from 1920 to 1925. It had been in the course of a discussion of the *esprit nouveau* that Apollinaire had first mentioned "sur-réalisme," and Dermée and Goll, who also wrote for Ozenfant's review, felt that they were closer to the real meaning of the word than Breton. In 1924, Goll founded a short-lived review called *Surréalisme*, to which Dermée, Albert-Birot, Delaunay, and others of the old Apollinaire circle contributed. Apollinaire himself was annexed retroactively, and the definition of Surrealism that appeared in the sole issue—"the transposition of reality on to a higher [artistic] plane"—was entirely consistent with his original use of the word.

By the end of 1924, the controversy over the meaning of Surrealism was settled in favor of Breton, who remarked, not without justification, in the first Surrealist manifesto (published that autumn) that it was "very petty" for anyone "to contest our right to use this word surrealism in the particular sense in which we understand it, because it is clear that before us this word had not made its fortune. I [shall]] now define it once and for all:

"SURREALISM. noun, masculine. Pure psychic automatism by which one intends to express verbally, in writing or by other method, the real functioning of the mind. Dictation by thought, in the absence of any control exercised by reason, and beyond any esthetic or moral preoccupation.

ENCYCL. *Philos.* Surrealism is based on the belief in the superior reality of certain forms of association heretofore neglected, in the omnipotence of dreams, in the undirected play of thought. . . ."

"I believe," Breton proclaimed, "in the future resolution of the states of dream and reality—in appearance so contradictory—in a sort of absolute reality, or *surréalité*, if I may so call it."

THE PROBLEM OF FANTASY ART

"Surrealist painting" is to some extent a contradiction in terms, for, as defined in the first manifesto, Surrealist activity is ideally

Max Ernst. *Portrait of André Breton.* 1924

"beyond any esthetic . . . preoccupation." Since all art—whatever nonformal or iconographic charge it may carry—necessarily involves some degree of esthetic structuring, there can be no such thing as Surrealist painting if we take the manifesto's statement at face value. This is precisely what Pierre Naville did in 1925 when, in the movement's pioneer magazine, *La Révolution surréaliste*, he insisted that "everybody knows" there is "no such thing as Surrealist painting: neither pencil lines made as a result of accidental gesturing, nor images tracing dream figures, nor imaginative fantasies can qualify as such." André Breton and most other leaders of the movement were unwilling to take their own manifesto so literally; esthetic values were in themselves beside the point, yet they existed and might possibly be useful. Painting was a "lamentable expedient" but an expedient nevertheless. The automatic drawings of André Masson, reproduced in the first numbers of *La Révolution surréaliste*, were Surrealist in inspiration yet unquestionably art; the same was true of Miró's fantasies and Ernst's disturbing oneiric images of that period. Though at the time of the manifesto Surrealist art was more a possibility than an actuality, four years later, in *Le Surréalisme et la peinture*, Breton was able to describe it if not define it by its entelechy.

Despite the "Naville crisis," it was generally agreed that the mere presence of form did not prevent paintings from being Surrealist. Art would be a *means* of expression, an instrument of self-discovery, not an *end* to be savored. *Surrealist identity would binge on the methodological and iconographic relevance of the picture to the main ideas of the movement—that is, automatism and the "dream image."* It also depended on Breton's personal attitude toward the painter in question. Such painters as Masson, Ernst, and Matta were at times dropped from the ranks of Surrealism not because of any real changes in their art but simply because they had fallen out with Breton.

Inasmuch as Surrealism was devoted primarily to literary, psychological, and philosophical problems, it was not destined to foster a "school" of painters sharing a common style. We cannot formulate a definition of Surrealist painting comparable in clarity with the meanings of Impressionism and Cubism (which began, and remained, movements in the plastic arts). During the twenties, thirties, and early forties, however, there came into being a body of painting and sculpture which was in varying degrees related to the concerns of the Surrealist group, and which was exhibited under their auspices. Though stylistically heterogeneous (Miró and Magritte, for example), the works involved did have certain common denominators in aims, character, and iconography. And it is only on the basis of this historical body of work, at first glance so diverse

and contradictory in character, that one can attempt—as I shall later —to formulate a comprehensive *intrinsic* definition of Surrealist painting.

For the moment, let us return to the problem of painting as it appeared to Breton during the time of the *époque floue*. Surrealism had not yet been launched as a movement; there was no Surrealist art as yet, and therefore no problem of finding antecedents for it or of placing it in history. But the time had arrived, Breton felt, to question Dada's peremptory rejection of the tradition of modern painting. Just as the *Littérature* circle had insisted on the viability of certain poets in the Symbolist tradition, despite their dismissal by Dada, so, in "Distances," (reprinted in *Les Pas perdus*), Breton sought to "rehabilitate" various painters—Moreau, Gauguin, Seurat, Redon, and Picasso in particular. With the exception of Moreau, none of these, of course, needed rehabilitation beyond the very narrow circles of the Parisian Dadaists. Breton also stressed the importance of de Chirico (largely overlooked by Dada) and Ernst. Not long after, in the first Surrealist manifesto, he added a footnote on painters of interest to Surrealism in which we find the above list extended to include one old master (Uccello) as well as Matisse ("in the *Music Lesson*, for example"), André Derain, Braque, Duchamp, Picabia, Klee, Man Ray, and ("so close to us") Masson.

Obviously, at the time of the first Surrealist manifesto Breton had only the vaguest ideas about the relation of Surrealism to the plastic arts. His list of names (he presented them with no comment or elaboration) is curious even as a general list of fantasy painters. If the presence of Picasso and Braque can be justified by their invention of collage, the same cannot be said for Derain (who happened at that moment to be very friendly with Breton) or for Matisse (who, four years later, was to be dismissed as "an old lion, discouraged and discouraging"). If we can attribute the omission of nineteenth-century forerunners like Charles Meryon, Rodolphe Bresdin, or J. J. Grandville to ignorance, how can we explain the absence of Henri Rousseau, so celebrated by Apollinaire (and only much later admitted into Breton's pantheon)? Even at the end of the 1920s, when Breton's ideas on painting were elaborated and published, it was still impossible to derive from them any comprehensive view of painting or a definition of Surrealist art. And this although Breton was identified more than any other critic with new developments in European painting between the world wars.

Probably no other art critic has made a reputation on the basis of as little critical writing as Breton. His articles on painting were infrequent, and usually focused more on literature and mysticism than

on the pictures themselves. When he confronted the latter directly, he was anything but critical. Almost without exception, Breton wrote about painters he loved ("criticism can exist only as a form of love"), and his identification with them was so complete that he rarely found it possible to speak of their shortcomings (if and when he was at all aware of them). His writing deals more with painters than with painting and is so personal, so lyrically effusive, that his occasional remarks about the works themselves remain obscure.

Breton rarely addressed himself to the formal aspects of painting; he remained almost totally involved with the *subject* of the picture. He admits to being incapable of considering a painting "except as a window, about which [my] first concern is to know what it looks out on."[99] This single-mindedness tended to make him write about all image makers with almost equal conviction, regardless of their paintings' pictorial qualities proper.

In any case, only a small part of Breton's critical writing is devoted to painting and sculpture. The two Surrealist manifestoes barely mention painting either. His remarks on painting that appeared in magazines are buried among lengthier texts dealing with literature, psychoanalysis, and politics. To collate his art criticism, therefore, one must rely largely on the booklet *Le Surréalisme et la peinture* (1928) and on an even shorter essay, "Genesis and Perspective of Surrealism," that first appeared in English in 1942, as a preface to Peggy Guggenheim's catalogue *Art of This Century*. To these may be added a number of eulogistic catalogue prefaces and random remarks made in interviews or in the course of writing on other subjects.

There emerges no fully defined view of painting, no clearly predictable taste from this material, but rather a remarkable intuition for quality, especially when it comes to fantasy painting. Despite the praise Breton accorded many painters now rightfully forgotten, there was not a single new contributor to the artistic adventure of the interwar period whose art did not immediately move him. He championed Miró, Masson, Ernst, Tanguy, Arp, and Giacometti long before they achieved public recognition. Later, he was one of the first to appreciate developments among the younger painters in wartime America, where he wrote pioneer articles on Matta and Gorky.

As we have seen, Breton's lists of Surrealist precursors leave much to be desired, and the art historian finds he must develop the prehistory of the movement without relying on documentation by the Surrealists themselves. One approach, adopted by Marcel Jean in his *History of Surrealist Painting*, takes the form of short expository discussions of all "imaginative" painting of the late nineteenth

and early twentieth centuries. The first section of Jean's book, titled 'Surrealist Painting before Surrealism,' is in effect a capsule history of modern painting, with special emphasis on the Pre-Raphaelites, Moreau, Böcklin, Redon, photography, "Negro art," Rousseau, de Chirico, and Cubism. The difficulty here is that while Jean's discussion offers valuable insights into the works of these various artists, some of them had no influence at all on Surrealist painting. And in the case of others, such as Redon, the author does not distinguish, in his general description, the particular aspects that were assimilated by one or another of the Surrealist painters. At the same time, the effort to appropriate primarily formal painters, like Cézanne, as iconographic precursors of Surrealism leads to distorted emphases. For example, Jean accepts Breton's ill-advised description of Cézanne's *The House of the Hanged Man* as expressing specifically the relation between "the sudden fall of a human body, a cord around its neck, and the very spot where the fall takes place."

Nevertheless, Jean's treating of modern fantasy art within the context of modern painting as a whole is quite correct. Though he never states it this way, the implication is that fantastic art must be analyzed within the context of the particular cultural outlook and plastic conventions of its time. A different position is taken by such writers as Claude Roy[100] and Marcel Brion,[101] who treat Surrealism as a late phase of a continuous (that is, "vertical") historical tradition of fantasy art that goes back to medieval times and even earlier. But fantasy art, in its sporadic appearances, *created no history of its own;* it always depended for its very definition as fantasy *on what was considered unusual or unbelievable* at the time it was created.

Meyer Schapiro has observed that what we—on the basis of our experience—would now call the fantasy art of previous periods is of a piece with the other art of its time and unlike modern fantasy. The imaging of a fantastic scene was based on a text or tradition that was the *collective* property of the culture in question. The image thus had a *directly given quality* and in this respect was analogous to a street scene or landscape. The contemporary artist—fantasist or abstractionist—paints what he alone feels, without taking his image from what everybody around him recognizes as the immediately visible, or from material offered by history, religion, or myth. Insofar as he invents images that are personal and unique, the Surrealist is closer to the Cubist than to the older fantasy painters.

If the medieval world believed in the reality of the winged lion of St. Mark as firmly as it did in that of its streets and houses, the winged lion cannot really be called a fantasy. The same is true of the Greek centaurs, the Babylonian Zoë,

the monsters of the bestiaries, and countless other visions. Accepting Schapiro's formulation forces us to go further and ask what if any older art may truly be called fantastic in the context of its own period. The answer was provided by Alfred Barr when he organized The Museum of Modern Art's *Fantastic Art, Dada, Surrealism* in 1936: something outside the limits of collective belief—unique inventions by artists with a special bent. These might include, for example, certain pictures by Giovanni di Paolo, Hans Baldung Grien, Giovanni Battista Bracelli, Guiseppe Arcimboldo, and Nicolas I de Larmessin (figs. D-2, D-3, D-5, D-6). The bounds of such a definition cannot be sharply drawn, of course, for if the illustrators of the medieval bestiaries should not in our sense be called fantasy painters, they did, from time to time, add details—or even whole conceptions—that derived from their own imagination rather than from the text or some related folkloristic tradition. The matter is one of degree: One might still call Hieronymus Bosch a fantasy painter even if, as Wilhelm Fraenger has tried to prove, the general structure and many details of his iconography depend upon the program of the heretical Adamite sect; it remains that the majority of his pictorial ideas (in such works as *The Garden of Earthly Delights*) are without precedent even among the Adamites.

While it is possible to speak of a more or less continuous unfolding of Western art as a whole, there is no comparable historical dialectic for fantasy painting, the coordinates of which are horizontal (that is, dependent on their relation to their moment in history) and form no continuum. The history of style is cumulative; at any given moment (at least in relatively modern times), the artist has available to him the sum of the discoveries of the past. But such similarity as exists in the imagery of fantasy painters, who were separated chronologically and geographically, derives from constants in human psychology, from the commonly shared symbols of reverie and dreams, rather than from contact with a body of specifically fantastic art.

The inventiveness of the fantasy artist operates on the iconographic rather than on the plastic level. He is a creator of new images; but whether Renaissance or medieval, Italian or Flemish, he uses the same formal structures as his more conventional colleagues. With the advent of modern art, however, the distinction between plastic structure and iconography becomes more difficult to maintain. We have seen how the iconographies of Ernst's collages grew from the collage materials themselves; the same is true of a sand painting by Masson or an object-sculpture by Miró. Yet even in these cases,

where a personal iconography issues from a plastic device, it is still a plastic device common to the painter's own period. However, with Dali and—to a lesser extent—Magritte, in whose work plastic structure is only marginally influenced by modern painting, we have a situation that *never existed* in older art: fantasy artists who dissociate themselves stylistically from their age.

MOREAU

The fact of the matter is that most of the nineteenth-century "precursors" in Breton's early lists have had very little influence on what has come to be called Surrealist painting. Such similarities as do obtain derive primarily from related aims rather than from historical cause and effect.

Gustave Moreau, who heads Breton's list in "Distances," is a case in point. His particular form of academicism (in contrast to that of Meissonier and the Pre-Raphaelites, who influenced Dali) had no effect on the stylistic evolution of Surrealist painting. His mythological subject matter, dominated by *femmes fatales* (Salome, Delilah, Helen) and androgynous heroes, is strictly in the spirit of *fin-de-siècle* Symbolism and far more closely related to the literature of that spirit (see the examples cited by Mario Praz in *The Romantic Agony*) than to either the painting or literature of Surrealism. Classical mythology became important to the Surrealists only in the late phase of the movement (about 1937–45), and the painter most concerned with it, André Masson, put it in the service of a robust eroticism completely opposed to the epicene spirit of Moreau's work. Only in the painting of Max Ernst during World War II (such pictures as *Napoleon in the Wilderness*) do we approach a style having affinities with Moreau's. Here the illusion of exotic spongy flora and telluric gems, generated by Ernst's adaptation of the decalcomania technique, reminds one of the accumulation of lapidary detail in Moreau's paintings (the central aspect of his "Byzantinism" and the demonstration of the "principle" he called *la richesse nécessaire*). But though Ernst's eroticism in this period also bears an affinity to Moreau (the emphasis on voyeurism), all the aspects of his style developed out of his own oeuvre or in response to contemporary influences independent of Moreau.

In recent years, Moreau's work has enjoyed one of its periodic "rediscoveries" (Breton "discovered" the Moreau museum in 1914), but interest now centers on his more loosely painted watercolors and a handful of "abstract" oil sketches (figs. D-9, D-10) According to Masson, these oil sketches played no part in the revival of interest in

Moreau during the pioneer years of Surrealism; now they are sometimes heralded by Surrealist critics and others as adumbrations of recent Abstract Expressionist painting. In the catalogue for the 1961 Moreau exhibition at The Museum of Modern Art, Dore Ashton speaks of the "textures, hectic linear interlaces and strange concordances of color" as appealing to Abstract Expressionist artists, who find them "so close to their own."[102] But this has not been taken seriously in most quarters. Moreau's small oil "abstractions" are patently initial drafts of color layouts of the kind many artists make in the course of working on larger pictures. If we had the studio scraps and casual layout notations of a Rubens or a Delacroix, these painters, too, could be resurrected as prophets of Abstract Expressionism. Perhaps the significant difference in the case of Moreau is that, as was consistent with his marked narcissism, he kept them, and made them part of the studio-home he bequeathed to posterity.

Even so, Moreau's intention was probably not to call attention to these sketches as "audacious and unprecedented means toward an increasingly abstract end,"[103] but, as Ragnar von Holten[104] maintains, to make visible every phase of his procedure. In any case, the oil sketches are far more illusionistic than Abstract Expressionist painting despite the absence of recognizable subject matter (in this regard, one could extract any number of passages from Impressionist and Post-Impressionist paintings that are far more pertinent). Moreau's tendency even here to work his pigment into lapidary clusters is closer rather to the Surrealists' "alchemistic" notions of painting (the gemlike and molten passages in Matta between 1939 and 1944). With the partial exception of Miró and Masson, the Surrealists tended to disdain the quality of paint substance as such, wanting always, like Moreau, to discover in it some "otherness" related to their poetic concerns.

REDON

Surrealist writers have never considered Odilon Redon especially important to the art of their movement. Breton, to be sure, included him in his list of "precursors" in the first manifesto and occasionally mentioned him in later texts, but accorded him scant attention in comparison with that given Moreau. Marcel Jean's *History of Surrealist Painting*, written from the point of view of an active participant in the later phases of Surrealism, typically devotes but one paragraph to Redon as against several pages to Moreau. This is surprising treatment for the first artist in history who explicitly affirmed the significance of the "unconscious," and whose work not only directly influenced at least one important Surrealist painter (Masson) but also found echoes and affinities in the work of a number of others.

There seem to be two reasons for this unexpected lack of interest in Redon on the part of the Surrealist critics. The first has to do with Redon's insistence on the primacy of plastic structure in determining the quality of a painting; it is this, as Masson observes, that "makes Redon a modern." Despite Redon's devaluation of "will" in favor of "docilely submitting to the arrival of the unconscious," he never accepted the data of the unconscious as by their very nature worthwhile, as did Breton (at least theoretically, in his insistence on "pure automatism"). Redon saw in these data only raw material that had to be re-ordered by what he called "pictorial logic." It is precisely in the presence of unconscious forces, he wrote, "that one must retain the greatest lucidity; without this, the art of painting would be like that of lunatics, children, and fools." Consistent with his Surrealist posture, Breton has devoted far more attention to the para-art of psychotics and children than to the art of Redon.

A second reason for the alienation of the Surrealists (at least the Surrealist *imagiers*) from Redon lies in the differences between their fantastic imagery. Redon's, even when he creates his most incredible hybrids, might be described as having evolved through *organic metamorphosis*. His minutely realistic studies from nature were useful, as he put it, "in bringing to life, in a human way, improbable beings and making them live according to the laws of probability, by putting—as far as possible—the logic of the visible at the service of the invisible." The great number of images Redon devoted to such biological processes as *eclosion* (hatching) and *germination*—his close friendship with the botanist Armand Clavaud was an important source of ideas in this regard—bear witness to his fascination with nature. Later, images of germination and hatching were very frequent in the work of Masson, Miró, and Matta, painters whom we may call "organic" or "biomorphic". Surrealists, and who applied to these themes the new vocabulary of shapes discussed earlier in this book.

Though Redon may be said to have an affinity with the biomorphic branch of Surrealist painting, his creative procedure was quite different from that employed by Magritte, Dali, Ernst, and the minor Surrealists of the 1930s. These painters were not concerned with creating *organic*, pararational beings but with forming disconcerting yet coherent images by *juxtaposing disparate elements in the manner of collage*. It is this commitment to the collage principle, whether used in visual imagery or poetry (we have seen how Max Ernst used both), that constitutes the major distinction between much of Surrealist art and Redon.

Nonetheless, Redon's art does anticipate various aspects of later Surrealist painting. Central to his subject matter are the fantasies of the microscopic and telescopic, often handled ambiguously to suggest both simultaneously. His lithograph . . . et que les yeux sans têtes flottait comme des mollusques (Mellerio No. 146) evokes a microbiological undersea world in which strange amoeboid shapes are metamorphosed into eyes and hints of quasi-human faces. Germination (Mellerio No. 28; fig. D-12) describes an astral world where embryonic stars and planets have anxious, guilt-ridden faces. While the "random" anti-geometrical distribution of shapes in such compositions echoes Impressionism, and the psychological content of the heads anticipates twentieth-century Expressionism, the microscopic-telescopic fantasy that binds the whole is found frequently in Surrealism (and also in Klee). We see it marginally in the works of Miró (The Birth of the World, colorplate 16; "The Poetess," colorplate 44), more commonly in Ernst (The Gramineous Bicycle, fig. 88; The Blind Swimmer, fig. 339), and constantly in the painting of Matta (The Earth Is a Man, colorplate 46; To Cover the Earth with a New Dew, fig. 374) and Masson (Constellations; Meditation on an Oak Leaf, colorplate 52; Germination). For Ernst the sources of this microbiology were often actual scientific diagrams, which played a role for him comparable to Redon's studies with Clavaud.

Redon's cosmic and botanical imagery, particularly in his drawings and lithographs, anticipated Ernst's brilliant series of frottage drawings of 1925, collectively titled Histoire Naturelle (figs. D-125, D-126); these resemble Redon's work also in the refinement of their gray values and in the delicate granular character of their surfaces. Redon's dream-inspired art was predominantly black and white (psychologists identify these as the "colors" of dreams), as was Ernst's Histoire Naturelle; the Surrealist dream world was otherwise almost always bodied forth in color. Redon's influence on Ernst's Histoire Naturelle may be judged by comparing such items in it as The Earthquake (fig. 155), The Ego and His Own (fig. 160), and When the Light Makes the Wheel (fig. 157) with Redon's The Eye Like a Strange Balloon Moves toward Infinity (Mellerio No. 38; fig. D-11) and The Spider (Mellerio No. 72; fig. D-13). It is also possible that Redon's marine fantasies suggested ideas for Tanguy's early paintings, particularly such "undersea" images as The Storm (1926; fig. 171), With My Shadow (1928), and The Mood of Now (1928).

Redon's Light (Mellerio No. 123; fig. D-14) anticipates Surrealist techniques in its "irrational" scale, showing a colossal head viewed by tiny figures (compare it with Max Ernst's Oedipus Rex; colorplate 13). This sudden wrenching of scale is even more marked in Vision (Mellerio No. 34), where the scale established by the human figures is disrupted by the immense columns of the temple in which they stand, and again by the giant eye floating like a planet between the columns. It is probable, however, that the myriad examples of such incongruities of scale in Surrealist painting were more directly owed to de Chirico's exploitation of the same device (as in The Serenity of the Scholar, fig. 110; and The Double Dream of Spring, fig. 113) and to the results of "collaging" illustrations from diverse sources.

The isolation of the eye, one of Redon's most frequent themes, was also explored, though more in the spirit of a trompe-l'oeil collage, by de Chirico in such paintings as The Jewish Angel (fig. 117); it was common in Miró's early Surrealist pictures (The Tilled Field, colorplate 14; The Harlequin's Carnival, colorplate 15; and Catalan Landscape, fig. 133) and recurs throughout his work; in Masson it is less frequent, appearing primarily in pictures of his American period (Meditation on an Oak Leaf, colorplate 52; and The Auguring Sibyl, fig. 384). If in Miró and Masson the process by which parts of the anatomy become disassociated from one another is related to some extent to the methods of Cubist abstraction and displacement, the isolated eye in Max Ernst's Histoire Naturelle (The Wheel of Light, fig. 158; The Fugitive, fig. 159; System of Solar Money, fig. D-125) is purely visionary (as it is in Magritte's The False Mirror; fig. 180) and remarkably close in character and arrangement to the work of Redon.

Redon also anticipated Surrealism in the use of poetic titles for his pictures. These were often fragments of poetry (his friend Mallarmé professed to be jealous of them), much like the titles of Debussy's Préludes. And while it is true that some of them are little more than literal, verbal counterparts of the metaphoric images, many of them have a Mallarméan indirection, as befits images that, in Redon's words, were meant to "inspire and never define . . . to put us—like music—in the ambiguous world of the indeterminate."

A final affinity between Redon and Surrealism is reflected in their conceptions of their own positions in art history. Redon saw the situation of painting in the 1870s and 1880s in much the same light as Baudelaire had regarded the early work of Manet and the Impressionists a decade before. Baudelaire argued that "the great tradition [the old masters] had been lost and the new one not yet made." His objection to the emerging Impressionist movement (and, to be fair, we must note that he lived long enough to see only its earliest phase) arose from its attachment to naturalism, in the form of fidelity to visual sensations, and its elimination of subjective, imaginative

images. He saw the Impressionists as artists who painted "not what they dream but what they see." Asserting, three decades later, that "great art no longer exists," Redon found the reason for this state of affairs in "the right that has been lost and which we must reconquer: the right to fantasy." Sixty years later, in *Le Surréalisme et la peinture*, Breton, defining the post-Cubist crisis in painting, suggested much the same solution for the "limitations" of Cubism and Neo-Classicism as Baudelaire had offered for Impressionism. "It is a cheap use of the magic power of figuration," Breton wrote, "to make it serve the conservation and reinforcement of that which would exist even if men did not have this power.... The plastic work, in order to respond to the necessity of an absolute revision of values ... must therefore refer to a *purely interior model*, or it will not be able to exist." "The model of yesterday, taken from the external world, no longer existed and could no longer exist. The model that was to succeed it, taken from the internal world, had not yet been discovered."[105]

HENRI ROUSSEAU

Henri Rousseau, too, must be counted among the small group of late nineteenth- and early twentieth-century painters who prepared the way for Surrealism, though, to be sure, he never exerted a marked influence on the movement. Some of Rousseau's contributions were made only through de Chirico; in other cases, the affinities we observe between him and Surrealism are probably not related causally. Yet in so many ways did Rousseau anticipate Surrealism that we are surprised not to find his name among those mentioned by Breton in "Distances" or in the list of "precursors" in the first manifesto. Nevertheless, considerable interest in Rousseau was shown in Surrealist circles during the twenties; this was intensified in 1926 by the reappearance, after many years in obscurity, of *The Sleeping Gypsy*, shown in the exhibition of the John Quinn collection in Paris. Daniel Catton Rich[106] considers that this trancelike painting "foretells Surrealism" and was "especially influential" for the Surrealist milieu; Jean Cocteau wrote a poem about it; and, in the year following the Quinn exhibition, the Surrealist poet Philippe Soupault published one of the earliest critical biographies of the painter. Breton himself continued to vacillate on the importance of Rousseau, virtually ignoring him in print until after World War II, when he observed that "it is with Rousseau that we can speak for the first time of Magic Realism ... of the intervention of magic causality."[107]

In the light of Breton's assertion that Rousseau's "simplicity" was a "defense against conventions," we can understand why the Rousseau "myth" should have appealed to the Dada-Surrealist generations. Rousseau's disengagement from "a world which was not strictly his" brought about, according to Tzara, "the formation of a personality distinctive enough to give birth to a style which is not only of a pictorial or theatrical order [Rousseau was a playwright], but which is *a style of life*."[108] This was, of course, the Dada ideal, and it was not without significance that Rousseau was "discovered" and first championed by Alfred Jarry, who, as we have seen, was himself one of the prototypes of Dada.

Legend—enhanced, as Soupault observes,[109] by a paucity of biographical facts—has it that Rousseau's inability to conform to conventional ways of acting, thinking, and painting resulted from an almost absolute naïveté. While it hardly seems possible that he was quite as guileless, as unconscious of his program, as some of his biographers would have us believe, Rousseau's own recorded comments rarely suggest otherwise. And to the extent that he was a true *naïf*, his attitude was vastly different from the acute self-awareness of the Dadas and Surrealists, for all the similarities in their approach to "the conventional." Certainly, Rousseau's myth was not nearly so consciously and programmatically cultivated and nurtured as those of Duchamp and Dali. (Some years after Rousseau's death, his friend Guilhermet, a lawyer and criminal psychologist, reported: "Rousseau always remained an enigma for me. Was he a man mystified by everything, or was there something of the mystifier in him?")

Rousseau appealed to the Surrealists because he was a poet-painter outside the "professional" tradition of art, a man unwilling to separate art and life. Moreover, much was made—mistakenly, I believe—of Rousseau's comment "It is not I who paint [my] pictures, but another who guides my hand." This seemed to suggest some form of psychic automatism, anticipating Ernst's assertion that he was a "spectator at the birth" of his own paintings in which "the importance of the 'author' was reduced to a minimum." Of course, this Surrealist view of Rousseau overlooks some of the available biographical material, which reveals Rousseau's professionalism and his desire to maintain the posture of "artiste-peintre" despite the ridicule with which his work was received.

The Surrealists were also interested by Rousseau's passion for necromancy. Their preoccupation with spirits and mediums, already evident in the earliest days of *Littérature*, became very marked at the time of the second Surrealist manifesto (1929), a large part of which was devoted to alchemy and the black arts. There was also Rousseau's belief in apparitions. "Those who knew Rousseau," wrote Apollinaire, "remember his decided taste for phantoms. He met them everywhere,"

and one of them tormented him for more than a year when he worked for the customs."[110] This sense of supernatural reality spilled over into his work; if we are to credit Apollinaire, Rousseau "sometimes took fright and, trembling all over, had to open the window" while working on a fantastic subject. We shall see how important *de Chirico's* belief in specters was for Breton, and, in turn, how much of the subject matter of Surrealist painting became involved with the apparitional.

Rousseau clearly belonged to the tradition of *peinture-poésie* for, as Tzara observes, he "considered the imaginative *subject* as the very center of his preoccupations." No wonder that among his earliest admirers were Redon and Gauguin, both of whom were concerned with oneiric and exotic subject matter. (Gauguin particularly admired Rousseau's "mysterious" use of black at a time when that color had been banished from the avant-garde palette by the Impressionists, Cézanne, and Seurat.)

Rousseau's particular handling of imaginative subjects, at least after 1891, provided precedents for Surrealism. *The Sleeping Gypsy*, for example, depicts a dream world in which rational expectations are suspended: the lion does not attack or even disturb the gypsy. Cocteau's poem celebrating this painting suggests that the lion and the landscape are a dream projection of the gypsy herself. *The Dream* (fig. D-23) was the apotheosis of this aspect of Rousseau's imagery. Like all his forest pictures, it depicts a world with a spell on it. What was implicit in *The Sleeping Gypsy* is explicit here. The curious situation of the red sofa (photographs show that it was a piece of furniture in Rousseau's studio) in the middle of an exotic jungle was much derided, but the painter's explanation was simple: "The sleeping woman on the sofa dreams that she is transplanted into the forest, listening to the music of the snake charmer. This explains why the sofa is in the picture."[111] Tzara, noting this and other instances in which different moments in time were telescoped, compares this technique with the devices Rousseau used in his play *The Revenge of a Russian Orphan*, and goes on to suggest that the juxtaposition of elements in *The Sleeping Gypsy* "anticipates what Ernst meant by the collage."

Rousseau's exotic pictures derive their dreamlike quality from the simplification and conventionalization of forms, which are often rendered with the frontality and strict profile common to primitive, archaic, and other "conceptual" styles. The dream process, being selective, suppresses in a similar way much of the kind of detail associated with perceptual experience. Although, for example, the starting point for most of Rousseau's flowers was sketches made in the Jardin des Plantes, botanists have indicated that the process of

reduction and simplification has made it impossible to identify most of them (some appear to be pure inventions).

The peculiar character of his light likewise imparts to Rousseau's forest pictures a dreamlike clarity; it is not atmospheric like real light, and does not modulate form. Foliage in background planes is lit, like the foreground, with a flat, shadowless light that tends to bring the entire composition toward the picture plane and create an impression of shallowness. Moreover, it is often not possible to say whether the light is daylight or moonlight. This strange "timeless" light is unquestionably one of the aspects of Rousseau that interested de Chirico, whose enigmatic "white light" is likewise important in creating the dreamlike ambiance of his Piazza pictures. That de Chirico knew Rousseau's work well during his crucial formative years, when both painters were being championed by Apollinaire, is certain, and Robert Melville has observed that one of de Chirico's most important works, *The Child's Brain* (fig. 106; long a focal point of Surrealist curiosity and formerly in Breton's private collection), was modeled in part on Rousseau's *Portrait of Pierre Loti* (fig. D-24).[112]

What relates Rousseau most to the *imagiers* of Surrealist painting is a common opposition to the exploitation of the esthetic possibilities of the paint substance. Rousseau suppressed brushwork and texture in favor of a smooth "finish" not unrelated to that of academic painting. In this connection it is important to recall his admiration for such painters as Jean Léon Gérôme (to whom he went for advice) and Adolphe William Bouguereau (later also much admired by Dalí). "You know," Rousseau once said during a visit to the Cézanne Memorial Exhibition in 1907, "I could finish all these pictures." (*Cézanne had characterized academic* "finish" as "*le fini des imbéciles*.") It was, indeed, Rousseau's insistence on finish that led Herbert Read to deny him a role in the modern movement.[113] Among the Surrealists, those painters whom I call "*imagiers*" (Tanguy, Magritte, Dalí), and who have been called simply the "academic Surrealists,"[114] shared this dislike of the medium because, as they believed, it took away from the clarity of the artist's vision. Of them all, Magritte and Delvaux painted most like Rousseau. The Pre-Raphaelite fussiness of Dalí, on the other hand, recalls the academicians Rousseau admired more than it does Rousseau's own work.

Ever since Apollinaire called him "the Uccello of our century," Rousseau's name has been coupled with that of the Italian painter. This is particularly interesting in view of the fact that the first Surrealist manifesto, while omitting Rousseau from its list of "precursors," includes Uccello *alone* among the old masters. We cannot be sure what Apollinaire had in mind when he described Rousseau

this way, but the extreme simplification of Rousseau's forms, their "naïve" conception and posturing, seems to recall the ambiance of the Italian Primitives, and certain figures (the "hobbyhorse" recalling *The Cart of Père Junot*) directly suggest Uccello. In addition, as did Uccello, Rousseau often treated a background plane in the same clarity as those of the foreground. It is doubtful, however, that Apollinaire had anything so specific in mind. The net effect with both painters is the enigmatic quality we have already remarked. This is what especially interested the Surrealists in Uccello, though it is improbable that Uccello sought this quality; his style derived from an obsession with linear perspective carried to the point where it bordered on fantasy. De Chirico and, later, Dali would show how linear perspective could be used as an expression of the irrational, as an instrument for subverting that rationalist order which the systematic perspective of the Renaissance was originally devised to express.

SEURAT AND GAUGUIN

Among Post-Impressionist painters, Seurat and Gauguin have always been characterized by Breton as important for Surrealism. With the "unclassifiable Seurat," listed as a precursor in the first manifesto, "we approach the borderline of the end of art." Beyond this rather uninstructive comment, Breton's writings touch only briefly on particulars of Seurat's painting. In "Genesis and Perspective of Surrealism" he remarks on "the troubling *insinuations* of Seurat" that are produced by the echoing of certain foreground forms in background figures, and "the magic of certain disorganizing lighting systems."

Art criticism, largely adopting Seurat's own attitude toward painting, has tended to regard his work almost entirely from the formalist point of view, overlooking the enigmatic poetry it unquestionably possesses. Breton may be said to sin in the opposite direction, for the echoing patterns in background figures to which he refers were undoubtedly, in the first instance, a formal device, whatever the resultant mystery. Seurat's charm for certain Surrealists, and the reasons for such influence as his work has exerted upon them, lie beyond the factors to which Breton has drawn attention. In *Sunday Afternoon on the Island of La Grande Jatte* (fig. D-15), for example, the sources of the enigmatic poetry are not hard to identify. The scene itself is drawn wholly from the world of Impressionism, but whereas Renoir would have represented the figures at different angles, as we normally confront them, Seurat shows them, with few minor excep-

tions, virtually parallel with, or else at right angles to, the picture plane, in a state of suspended animation, as in a dream. True, this device was prompted by the desire to reinforce the "architectural" feeling of the composition, but it also produced a stasis and quietude disconcertingly alien to the subject of the painting. In the midst of this hieratic immobility, the lone figure of a little girl running toward the trees (in the right middle ground) seems most enigmatic. Indeed, it is not surprising that de Chirico should have borrowed it (as James Thrall Soby was the first to point out) for the little girl running with a hoop in *The Mystery and Melancholy of a Street* (fig. 109), where the stillness and emptiness of the piazza provide a foil comparable to the stasis of figures in *La Grande Jatte*.

A world with figures fixed in front view or profile (in this connection we know the influence of Seurat on Munch) constitutes a denial of systematic focus perspective: we do not see the scene from a single point of view but as if we were standing successively before each figure. This manner of representation—first noted by Meyer Schapiro, who has called it the "collective perspective"—derives in part from the synthetic way in which the picture was constructed, each part having first been studied in isolation and then set within the composition. But though it was not part of Seurat's intent, this rejection of traditional perspective—still informally present in the more naturalistic works of the Impressionists—was one step in the *reversal of the role and meaning of perspective*, which was to culminate in de Chirico's early work and that of the Surrealists influenced by him. The inconsistent lighting in Seurat, which is the logical concomitant of this new perspective, is probably what Breton had in mind when he referred to "the magic of certain disorganizing lighting systems." This, also, adumbrates discoveries of de Chirico.

Breton alone among Surrealist critics and poets has insisted on the importance of Gauguin. Mentioned in "Distances" and then inconsistently omitted from the list of "precursors" in the first manifesto, Gauguin re-emerged, in Breton's last writing, as comparable in importance (for Surrealism) with Moreau and of greater interest than Seurat. "The work of Gauguin, and particularly the Polynesian pictures," he writes, "witness a perpetual transcendence of *plastic ends*, which are but *means*, entirely inspired by the true end of artistic activity—poetry. Coming before the immediate precursors of Surrealism, Gauguin was the only painter who perceived that he carried a magician within himself." Admiring Gauguin's "quest for a myth"—an overriding concern of late Surrealism—Breton summarizes his role by stating that he replaced the Impressionist *physique* (sensorial painting) with a *métaphysique*.[115]

But Breton's appreciation of Gauguin is not penetrating. He seems unable to perceive the confusion behind the pseudoprofundities of Gauguin's images and titles. He is quite literally awestruck by the title *Where do we come from? Who are we? Where are we going?* Moreover, the poetry of which he speaks (thus the presence of such symbols as the raven in *Nevermore*) was not original but wholly within the framework of *fin-de-siècle* Symbolism, and was grafted onto Gauguin's imagery in a generally inorganic way. In his evaluation of Gauguin, Breton never gets beyond the shallow iconography, despite the fact that this painter's real contribution to modern art derived primarily from his great gifts as a composer in flat color. Surrealist art was not in the least affected by Gauguin; his true heirs are not the Surrealists but the Nabis and Fauves.

DE CHIRICO

Giorgio de Chirico's painting exercised the strongest single formative influence on Surrealist art, and was so prophetic in character that de Chirico has often been mistakenly labeled a Surrealist himself. But except for copies—which amounted to self-made forgeries—de Chirico had ceased working in his inventive early style at least five years before the emergence of the Surrealists, and despite the myriad ways in which he anticipated them, his painting is clearly distinguishable, iconographically and stylistically, from theirs. De Chirico's mature style appeared *sui generis* in the context of modern painting. It seemed no more related to Cubism than it did to Dada, which was working its way out of formal abstraction in the same years. Seemingly neither modernist art, nor anti-art, it appeared to revert to the illusionism of the Renaissance from which it derived the spatial "theater" it bequeathed to Surrealism. The idealized architecture of de Chirico's streets and piazzas recalled—in Leopardian silence and nostalgia—the Italy of another epoch.

De Chirico's enigmatic juxtaposition of objects, his diving perspectives and hallucinatory lights and shadows, laid down precedents for Surrealist iconography and established, pictorially, the theater in which the drama of much Surrealist imagery was to unfold. It was not, however, the drama of all Surrealist imagery, nor was it the drama of the very best of it. De Chirico's theater of dreams, with its illusionist spatial scaffolding, proved to be of interest primarily to the *imagiers* of the movement: Magritte, Dali, Tanguy, Delvaux, and, in certain periods, Ernst. The concerns of Arp, Miró, Masson,

and, later, Matta and Gorky lay elsewhere. De Chirico's essentially inorganic world recommended itself to painters who, following Ernst's lead, had diverted the collage from its original, primarily plastic purposes to those of "poetry"; that world was of limited interest to the more improvisational painters, the ones who chose to explore the possibilities of automatism. One irony of the situation is that de Chirico's art remains so obviously superior to that of the painters deeply influenced by him.

De Chirico's important painting (1911–17) emerged at the moment when advanced Analytic Cubism had practically obliterated recognizable subject matter and opened the way to nonfigurative art. That de Chirico's emergence coincided with this point in the development of Analytic Cubism is crucial, for it made him react all the more strongly in an endeavor to "rehabilitate the object." A year later, Cubism also turned away from abstractness and entered its Synthetic phase, which Meyer Schapiro has called "the Cubism of rehabilitation." De Chirico himself, though rejecting Cubism's attitude toward nature, was influenced by the Cubist collage and by the emphasis on planar structure of Synthetic Cubism (a fact that has been overlooked in Surrealist criticism of his work, though accounted significant by James Thrall Soby in his definitive monograph on the painter).[116]

The years just before World War I saw a crisis in the role of subject matter. "The model of yesterday," we have seen Breton observe, "taken from the external world, no longer existed and could no longer exist. The model that was to succeed it, taken from the internal world, had not yet been discovered." His first sight of a de Chirico painting, *The Child's Brain* (fig. 106), in the window of the Parisian art dealer Paul Guillaume, was a turning point for Breton. After seeing more of the painter's work, he became convinced that "it is to Giorgio de Chirico that credit must go for preserving for eternity the memory of the true modern mythology which is in formation."[117]

The first step in the direction of the "purely interior model" seemed to be to reconsider familiar objects in the light of their subjectively poetic and metaphysical implications, which are generally obscured by their everyday contexts and uses. Objects had to be wrested from their familiar "horizontal," rational contexts and juxtaposed in novel, imaginative, "vertical" (that is, poetic and psychological) arrangements. This began to be done more or less simultaneously by de Chirico and Duchamp, but the lesson was more direct and assimilable in the work of the former. De Chirico had written of the "second identity" of the objects in his pictures in terms not unlike Duchamp's:

Every object has two appearances: one, the current one, which we nearly always see and which is seen by people in general; the other a spectral or metaphysical appearance beheld only by some rare individuals in moments of clairvoyance and metaphysical abstraction, as in the case of certain bodies concealed by substances impenetrable by sunlight yet discernible, for instance, by X-ray or other powerful artificial means.[118]

Objects in de Chirico's paintings were not fantastical as they subsequently became in Surrealist painting, but, as Breton observes, "even if . . . the exterior aspect of the object is respected, it is evident that this object is no longer cherished for itself, but solely as a function of the signal which it releases. From the sensorial world of Post-Impressionism and Cubism . . . we pass, with Chirico, into the *purely emblematic* . . . [he] retains only such exterior aspects [of reality] as propose enigmas or permit the disengagement of omens and tend toward the creation of a purely divinatory art."[119] In the middle twenties, Breton looked back on de Chirico as a "great sentinel" on the route to be traversed by Surrealism. "In times of great uncertainty about the mission which had been confided to us," he wrote later, "we often turned back to this fixed point [de Chirico] as to the fixed point of Lautréamont, who with Chirico sufficed to determine our straight line."[120]

When Breton wrote of Surrealism in general that it had "one foot in automatism and the other in the dream," he had de Chirico mainly in mind as far as the painting of the dreamlike was concerned: none of the Surrealist artists came nearly as close as he did to the true images of dreams. The word "dream" and such terms as "dream world" have been used indiscriminately and without qualification by critics in writing of such diverse artists as Arp, Masson, Tanguy, Matta, and Ernst. But it should be borne in mind that the imagery of dreams is not abstract, nor does it take radical liberties with the configurations of things. At most, an object might be dreamed of as distorted, its perspective wrenched, but it is always an object familiar to us in our waking life. No matter how strange the juxtapositions and relationships of things in dreams, these things must all have been seen with the waking eye before they can become part of dreams. It is, strictly speaking, incorrect to call the morphologically "abstract" visions of a Matta or a Tanguy dream images. No one ever dreamed such things, or at least not until after seeing pictures by Matta or Tanguy.

To refer, as is so commonly done, to the whole of Surrealist art as involved with dream imagery is a way of dodging the relevant issues. At the same time, it is unfair to the imaginative powers of the artists in question, for it implies that their inventions—often symbols cut from whole cloth—are primarily transpositions of dreams. It is highly doubtful whether even Dali's Surrealist pictures were in large part really the "hand-painted dream photographs" that he claimed—and the extent to which they were partly accounts for his weakness as a painter. After all, the separate items which go to make up dreams—even nightmares—are in themselves entirely prosaic. Allowing for the exaggerations attributable to Dali's professedly self-induced "paranoia," the images of his dreams, if they could somehow be photographed, would constitute art in about the same measure that an ordinary snapshot of the real world does. The dream has no art in its imagery as such; the painter must use dream data selectively and put them into an esthetic framework before they can become pictorial art, just as Breton had to edit his automatic writing before it could become poetry.

The images in de Chirico's paintings are more like those we actually see in dreams than are the images in the paintings of the Surrealists who were influenced by him. De Chirico shuns the fantastical almost entirely. (His mannequins are an exception, but even these probably derive from storewindow figures and tailors' dummies.) The mysterious white light in his pictures is less like that "interior light" (even Mediterranean sunlight) than it is like that "interior light" already noticed in Henri Rousseau's paintings, and its absolute clarity, combined with the simplification and generalization of the shapes it illuminates, produces an apparitional effect closer to dream experience than to anything else. (In his notebooks Leonardo mentions that we see things with much greater clarity in dreams than in waking life.)[121]

Sensations of sound, psychiatrists observe, are extremely rare in dreams, and in this connection the Leopardian silence that prevails in de Chirico's pictures is noteworthy. It is, however, a pregnant rather than a calm silence, charged with elusive, nightmarish foreboding. (Writing, in *Sur le Silence*, of the nature of great cataclysms, de Chirico makes a point of warning us to "beware of the silence" that precedes them.)

The most literally dreamlike aspect of all in de Chirico's art consists of the *extraordinary juxtapositions of ordinary objects* in his paintings. As we know, different contexts and levels of reality constantly mingle in dreams. What makes these minglings striking in de Chirico's art is not so much their presence per se as the *quality* of the poetry evoked by his *particular* confrontations—a quality often intensified by exaggerated foreshortenings that bring the objects into hallucinatory proximity with the spectator. The juxtaposition, in *The*

Song of Love (colorplate 11), of the head from an ancient Greek sculpture (*Apollo Belvedere*) with a surgeon's glove, a ball, and a distant locomotive, all set amid arcaded buildings, has the telling simplicity, force, and directness of Lautréamont's classic evocation. As with the latter's sewing machine, umbrella, and dissection table, each of de Chirico's objects calls forth associations that are rationally quite unrelated to the associations of the other objects. But cross-fertilized, as they are in this painting, all these associations create a poetry in which a heretofore unsuspected metaphysic is revealed.

The models and objects the Cubists painted were assimilated to esthetic structures that seemed to come into being autonomously. In de Chirico the model is primary, and to a considerable extent it determines the structure of the picture. They are not *things seen* around the studio but *things remembered* from childhood. Together they constitute a symbolic autobiography. However, since we cannot psychoanalyze paintings, we can be sure only of the manifest implications of the objects: in *Song of Love*, for example, the themes of travel, nostalgia for Italy (from which de Chirico had been away for three years), and the painter's equivocal relationship to Renaissance and Antique traditions. But the difficulty, or even impossibility, of verbalizing latent meanings in no way denies their presence or blocks our visual response to the particular psychological overtones which give de Chirico's poetry its ring of authenticity. De Chirico's favorite objects—trains, towers, artichokes, Antique sculpture, toys, cannons, eggs, gloves, and anatomical charts—recur frequently, and in various contexts, and the viewer is able, in time, to intuit some of their more elusive aspects just as one sees the symbols in dreams acquire meaning from their contexts.

To be sure, symbols like the tower and the artichoke can be interpreted as phallic and vaginal in the light of modern psychological theory. It is undeniable, in this regard, that de Chirico's pictures of 1911–17 are charged with subliminal (and largely passive) sexuality. But far too much criticism of de Chirico has been devoted—rather embarrassedly—to defining the degree of that sexuality. Opinion has ranged, as Soby observes, from those who refuse to see the least sign of erotic meaning in the paintings to those who see vaginas in virtually every arcade. However, critics agree that none of de Chirico's icons were consciously *intended by him* as sexual symbols. In this sense de Chirico's poetry is naïve and inspirational, and because it is, it derives from deeper wellsprings than the sophisticated and self-conscious sexual iconography of Surrealists like Dali.

Establishing the presence of sexual implications in de Chirico's imagery was important to the Surrealist critics, for in their view it

was proof, to the unbelieving, of the Freudian revelation, which was still largely unknown in the French intellectual community or, where known, generally unaccepted. Sexual liberation became an important aspect of the Surrealists' program for the "total liberation of the individual," and led to their manifesto, *Hands Off Love*, in support of Charlie Chaplin during his prosecution in a paternity case. Curiously, however, the biographies of most of the Surrealists reveal no more flouting of sexual conventions than obtained among other groups of modern artists (the Cubists, for example); Breton was known for his almost puritanical prejudices in actual life (particularly regarding homosexuality; he considered Rimbaud's relationship with Verlaine "inadmissible").

Perhaps the most remarkable aspect of de Chirico's art—plastically as well as iconographically—is its equivocal relation to the art of Renaissance Italy and ancient Greece. His use of iconographic motifs drawn from these traditions has often been noted, as has also his adaptation of linear perspective and other devices of fifteenth-century illusionism. But while critics have noticed that he transformed these elements in appropriating them, the consistency and completeness with which he turned classical traditions upside down has never been sufficiently remarked.

We must remember that de Chirico emerged along with the Futurists in the resurgence of Italian painting in the second decade of this century. There had been no really important Italian painting for well over a century before, at the most generous estimate. The glorious past seemed to weigh on painters in Italy with a weight reinforced by a conjunction of social, economic, and cultural circumstances. Up until at least World War I, this past was something every Italian artist had to face up to. There is no better testimony to its oppressiveness and to the inertia for which it was responsible than the Futurist manifestoes, with their attacks on museums, archeologists, tourist guides, professors, and the like, and their affirmations that a motor car is more beautiful than the *Winged Victory of Samothrace*.

From the French Revolution until World War I, most Italian artists had bowed to the past by practicing one form or another of Neo-Classical or academic painting. The Futurists rejected this heritage vociferously and tried to create an ultramodern art. But, ironically, the results they achieved contained much more of the past than they realized, as witness the Baroque aspect of Umberto Boccioni's painting *The City Rises*, and the affinity of his sculptured striding figure, *Unique Forms of Continuity in Space*, with the much maligned *Winged Victory*. Moreover, the prevailing nostalgia and reverie of

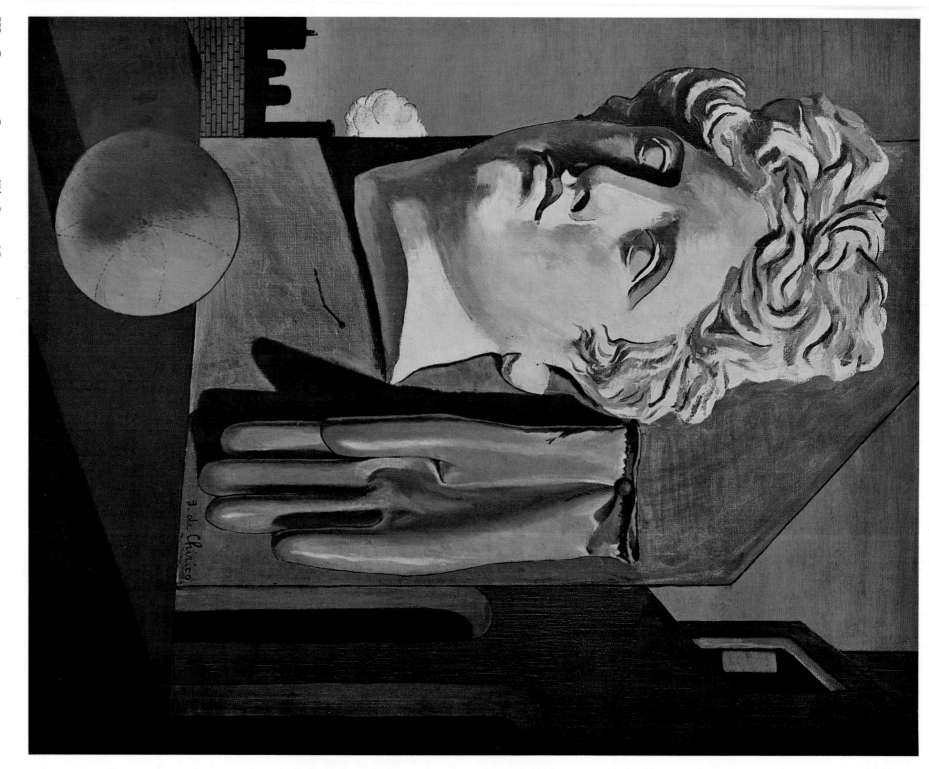

XI GIORGIO DE CHIRICO *The Song of Love*. 1914

Boccioni paintings like *The Forces of a Street* (fig. D-28), with its disembodied shadows, suggest an affinity with the metaphysics of de Chirico.

While the Futurists built on a foundation of Cubism, de Chirico appeared to be taking the opposite course, and opting plastically, as well as iconographically, for the Renaissance. But de Chirico's classical world was not recollected in tranquility. The pervasive malaise of his vision ended by denying the ordered, rational structure of experience proposed by fifteenth-century art. And this denial was even more a matter of formal than of literary content. In a style that constitutes as much a parody as an adaptation of Renaissance art, de Chirico revealed, at least by 1913, a more subtle insight into Cubism than did his Futurist compatriots, while his imagery, by "irrationalizing" the cosmos of the *quattrocento*, reflected the unstable mood of the early twentieth century with a vividness equal to theirs.

The purged, transparent manner of de Chirico's best work begins to manifest itself in 1910 and is consolidated over the next two years (fig. 103). In 1909, his painting had still been rather academic, deeply influenced by the Swiss-German post-Romantic Böcklin, as Soby has demonstrated (figs. D-36, D-37). Albert Elsen observes that de Chirico was a mature poet before he was a mature painter: the poetry of his early Böcklinesque works survived the *quattrocento* influences that he used in 1910 and 1911 to clear his art of nineteenth-century academicism.

It was with the *quattrocento* that de Chirico then came to feel his closest affinity. His foreground figures stand, like Uccello's and Piero's, in a frontal space that is felt as separate from the background, which is treated as a foil or backdrop; the High Renaissance continuity of realistic spatial feeling through the middle ground (as in the mature Raphael) is foreign to him, as is its aerial or atmospheric perspective.

As a branch of projective geometry, fifteenth-century perspective endowed the imaged world with a coherent, measurable order. The *quattrocento's* characteristic perspective arrangements, unlike those, for example, of Mannerist art, suggested a stable visual reality whose unity of purpose was expressed by the perfect—and usually symmetrical—convergence of all the picture's orthogonals on a single vanishing point. In de Chirico there are multiple vanishing points. In *The Anxious Journey* (fig. 105) and *The Evil Genius of a King* (fig. 112), for example, conflicting spatial schemes create a sense of frustration and disorder; in *The Mystery and Melancholy of a Street* (fig. 109) the dominant note is of malaise. Pictorial space no

longer evokes real space but recalls, rather, space that one has dreamed or imagined. And though de Chirico's orthogonals read as indications of retreating space, the bland, unmodeled surfaces of the planes they delineate remain paradoxically flat on the surface of the picture, as on a screen. This ambiguity is spelled out in *The Double Dream of Spring* (fig. 113), where the retreating orthogonals of the center ground connect with those of the picture-within-a-picture in the foreground plane, rendering the reading entirely equivocal.

Since the verisimilitude of de Chirico's space is only schematic, we should not be surprised that the representation of the figures that people this space is equally schematic. In Renaissance art the mass of the figure is seen quantitatively, with the modeling giving the illusion of a continuous turning that completes the cylinder of the whole mass, while empty space acts as a foil to the relief of the figures, enhancing their tangibility by contrast. De Chirico's modeling is based on simple—and frequently rather crude—hatching, supported intermittently by shading in very low relief; his figures never have bulk, and their weightlessness—often like that of a flat silhouette—intensifies their spectral quality.

But perhaps the most extraordinary reversal of *quattrocento* style may be seen in de Chirico's use of cast shadows. In Renaissance art, cast shadows speak of the logic and reality of the world by attesting to the concreteness of solids as forms blocking the passage of light, by confirming the ground as a solid entity supporting the figures, and by palpably measuring the intervals between solids. In de Chirico, cast shadows have a life of their own, free from the demands of a consistent light source. Sometimes their contours are so unrelated to the objects by which they seem to be thrown as to suggest hidden presences. Or the reality of an object is called into doubt by the conspicuous absence of cast shadows. And frequently, as in *The Mystery and Melancholy of a Street*, we see haunting shadows that are cast by objects outside the field of vision. The disembodied shadow, its source often mysterious, is perhaps the most startling of de Chirico's poetic devices (and one which highly recommended itself to the illusionistic Surrealists).

De Chirico's patchwork shading and his shallow, virtually ungraduated modeling constitute an almost autonomous decorative convention, and his linear perspective inverts that of the Renaissance in such a way as to destroy it. (It was the resultant flat effect in de Chirico's pictures that led Clement Greenberg to see them as "announcing the absolute flatness of Mondrian.") Such pictures as the boldly designed *Gare Montparnasse* (fig. 108) reveal a greater affinity with Synthetic Cubism than with old-master illusionism. The

illusionistic Surrealists most influenced by the "poetic theater" proposed by de Chirico did not grasp its essential plastic character. While Magritte, though sacrificing de Chirico's fluency of touch and semi-transparent *matière*, retained a somewhat comparable standard of abstraction, Tanguy and Dali altered the de Chirico style in a way that put them at a much greater remove from the mainstream of modern painting. Their crystalline surfaces, in which all traces of brushwork and impasto have been suppressed, their modeling in the round, and their atmospheric perspective recall Meissonier more than Piero. Despite de Chirico's parentage of Surrealist illusionism, his own work is finally closer stylistically, though not poetically, to Matisse and Mondrian than to Tanguy and Dali. It was precisely the reintroduction of atmosphere, modeling, and abundant detail that in the 1920s profoundly changed the nature of de Chirico's own art once again, and made such later pictures of his as *The Departure of the Knight Errant* (1923; fig. D-39) and the "Roman Villa" series (1920–22; fig. 122) seem unmodern.

While the illusionistic structure that de Chirico adapted from the Classical past was a crucial influence for many Surrealist artists, his references to the iconography of the past were handled in such a way as not to be assimilable. Citations from Classical sculpture (the recurrent *Ariadne*, the *Apollo Belvedere*, and other fragments) or Classical literature (Hector and Andromache and the Muses) do not appear in his paintings in contexts appropriate to their sources but are juxtaposed with trains, toys, and other paraphernalia of de Chirico's private iconography, so that their significance becomes more directly personal than cultural. But if the substance of his iconography could not be transmitted to others, the general method of it—that is, the denaturing and reinterpreting of objects by putting them in unexpected juxtapositions—could. To be sure, this method was derived from Lautréamont's and Rimbaud's poetry, and we have already noted the beginning of its pictorial application in such painters as Redon and Rousseau. But it was only with de Chirico that it received its full application in painting.

By 1918, de Chirico's inspiration had more or less deserted him, but this was not immediately apparent to the *Littérature* group, which was not able to follow his work on a year-to-year basis. In 1922, when Max Ernst portrayed the members of the incipient Surrealist circle in a painting, *The Meeting of Friends* (fig. D-106), the absent de Chirico was represented by a statue. In 1924, in the first Surrealist manifesto, Breton spoke of him as "for so long admirable." That same year, Paul Eluard, who greatly admired *The Disquieting Muses* of 1917 (fig. 120) but was unable to obtain it, consented to de

Chirico's suggestion that he—de Chirico—make a replica of it, which, he said, "will have no other fault than that of being executed in a more beautiful medium and with a more knowledgeable technique." By then de Chirico had already embarked on the series of forgeries of himself which he was to create with increasing cynicism (regardless of the stylistic direction of his new work), and which were to cause a major scandal in the end (the problem is treated at length in the Soby monograph). It was only in 1928, when Breton published *Le Surréalisme et la peinture*, that his gradually cooling relations with de Chirico culminated in a final break. "Inspiration," Breton said, "had abandoned Chirico. Having abused his supernatural powers since 1918, Chirico is astonished that one cannot go along with his paltry conclusions, images about which the least one can say is that the spirit is absent and in its place presides a shameless contempt."

Though surreal illusionism of the twenties and thirties derived from de Chirico's early painting, no comparable influence existed in the second decade of the century for subsequent automatic Surrealism, except insofar as Cubist space and articulation would be retained as the infrastructures of pictures. Though he had no causal role in Surrealist automatism, Paul Klee had, nevertheless, arrived at a somewhat comparable position as early as 1914 when he began using "doodling" to get pictures started. The process is beautifully depicted in the remarkable 1919 self-portrait (fig. D-34) which shows Klee drawing with virtually closed eyes, plumbing the recesses of his mind for an image, the conjuration of which is whimsically encouraged by scratching his head; meantime his right hand—as if it had a life of its own—mediumistically traces lines on the drawing paper. The Surrealists recognized Klee's affinities with them (Breton mentioned him in the Manifesto of 1924) and invited him to participate in the first collective Surrealist exhibition held in 1925 at the Galerie Pierre; for a long time they were his lone champions (except for the dealer D. H. Kahnweiler) in France. Though surreal automatism did not derive from Klee, there were moments in the unfolding of Miró's, and to a lesser extent, Masson's and Ernst's, art that were directly touched by the magic of Klee's inventions (his direct influence would prove greater on the first post-Surrealist generations: Wols and Dubuffet in France and the early work of the new American painters).

Kandinsky's improvisational painting of circa 1912–14 (figs. D-26, D-27) was virtually unknown to the Surrealists until later in their history. When Kandinsky came to Paris in 1933 he was already working in his more precise style. The Surrealists received him

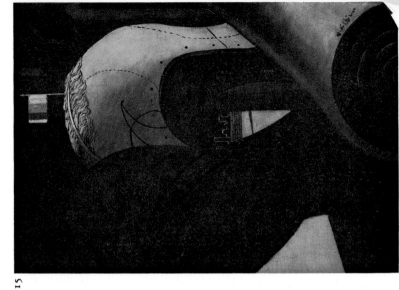

115

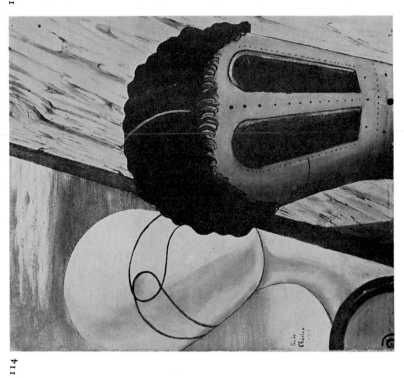

114

113

116

117

119

118

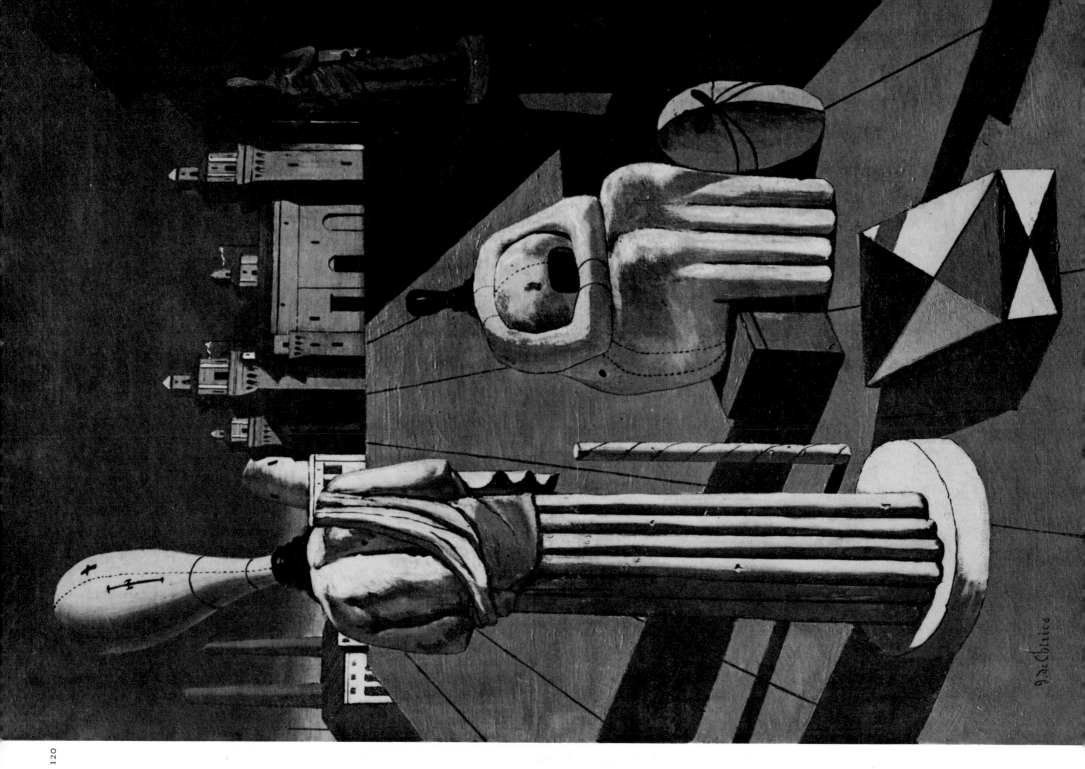

121

122

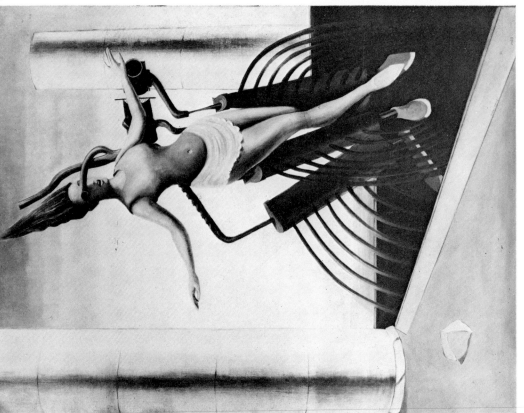

125

123

124

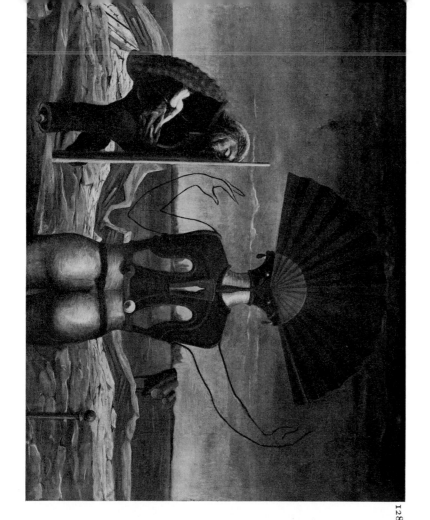

128

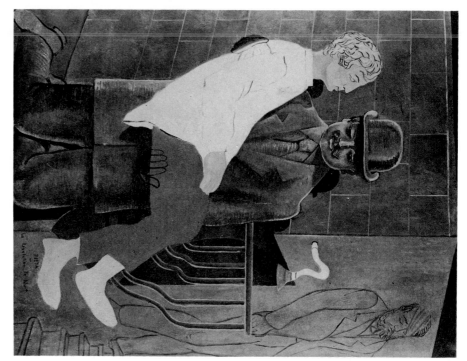

126

129

127

130 MAX ERNST *Picture-Poem.* 1924

131 MAX ERNST *La Belle Saison.* 1925

warmly, however, and in keeping with their internationalist, anti-chauvinist ideals, invited him to exhibit with them. In any case, the more spontaneous appearing Kandinskys of the second decade were all based upon sketches of a relatively studied type as compared to the automatism of Klee. These pictures would influence Surrealist painting only near the very end of its history—around 1943—when, as we shall see, they played an important role in the work of Arshile Gorky.

Though in his early work unquestionably one of the great fantasy artists of the century, Marc Chagall proved of no interest to the Surrealists. Despite the fact that his work provided a prototype for a fantasy art built upon a Cubist underpinning (fig. D-33), neither the Surrealist writers nor painters took note of it until their mutual "exile" in America during World War II. At that time Breton wrote curiously that it is "with Chagall alone," that "metaphor makes its triumphant entry into modern painting". ("Genesis and Perspective of Surrealism"). The statement is patently false, Redon among others having "pictured" linguistic metaphors decades earlier. It is clear, in any event, that the Surrealists found Chagall's folkloristic type of fantasy absolutely alien to them; some years later Breton indicated that his wartime mention of Chagall had been prompted by the expediencies—social and political—of communal life among the European artists and intellectuals then in New York.

THE PROTO-SURREALISM OF MAX ERNST (1921–24)

The years of the *époque floue* found Breton and his friends attempting to flesh out a definition of Surrealism that would satisfactorily differentiate it from Dada. Many of the essentials of Surrealism—the experimentation with automatism, accident, biomorphism, and found objects within the framework of an overriding commitment to social revolution—had been present in Dada to some degree, but in a chaotic state. These would be systematized within the Freud-inspired dialectic of Surrealism. What had been a therapy for Freud would become a philosophy and a literary point of departure for Breton. During these same years, Max Ernst created a synthesis of Dada collage and Chiricoesque spatial structure that provided, for a whole generation of illusionist Surrealists, a more inclusive prototype than did de Chirico's art alone.

Ernst began the series of oil paintings in which this synthesis is embodied, and which constitutes the sole direct link between Dada and Surrealism, late in 1921, and continued it until the summer of 1924, when he traveled to the Far East. I have already noted, in discussing Ernst's Dada collages, the peripheral intrusion of de Chirico's and Carrà's influence. This occurred after Ernst had seen, in 1919 and 1920, reproductions of their work. But except for the patent allusions in the diving perspectives and the tailor's dummies of the lithographs titled *Fiat Modes: Pereat Ars*, the Italian artists' influence on Ernst was at that time secondary.

However, Ernst had long been an admirer of the German painters Böcklin and Klinger (figs. D-36, D-37, D-40), both of whom had had a formative influence on de Chirico, and the affinity between Ernst and de Chirico to which this testified was to make itself more markedly felt. Ernst adopted de Chirico's total spatial theater only in the winter of 1921–22, but this step may have been anticipated by at least one earlier oil painting, which Lucy Lippard, now engaged in clarifying Ernst's chronology, has dated late 1919 or early 1920.[122] The foreground of this clumsy, patently experimental picture, *The Last Judgment* (fig. D-38), shows a male nude running into a tilted perspective which is articulated by an architectural background. The would-be arcane poetry here misses fire, and the low-relief modeling and the perspective vista, while manifestly inspired by de Chirico, are crude and forced. Both iconographically and stylistically, this work is quite different from the collages which constituted Ernst's main production at that time. (Its execution and conception are so awkward that even if the date of 1919–20 were too early, the picture would still suggest a date before the end of 1921.) Translated into illusionistic painting and enlarged in size under the star of de Chirico, the hybrid monsters and machines of Ernst's Dada collages took on a more intense reality in his paintings of 1921–24.

Ernst's proto-Surrealist amalgam of de Chirico and the Dada collage is well illustrated by *The Teetering Woman* (fig. 125), a large canvas of 1923. The style is generally realistic, but with the elimination of detail, the low-relief modeling, and the transparency of *matière* that characterize the early de Chirico. The space is deep and stagelike, articulated by two columns that remind us of de Chirico's Classical architecture and his factory chimneys. An orthogonal cuts across the foreground, and the front space is measured by a lonely stone, a device reminiscent of de Chirico's *The Evil Genius of a King* (fig. 112) and *The Song of Love* (colorplate 11). However, into this setting is injected an un-Chiricoesque female, who is quite literally being "shook up" by a hallucinatory, Kafkaesque machine. Iconographically, this female figure is descended from Duchamp, while some details of the oscillator are closer to the Duchamp-inspired machines of Picabia. But other aspects of the machinery, and particu-

Max Ernst. *The Invention*

in Cubism the words were isolated, more important for their function as elements of design than for their meaning. In Ernst's "Picture-Poems" the words are syntactically related and, like the images they replace, are primary rather than secondary in determining the design of the picture. In one fifty-word "Picture-Poem" most of the lines of poetry are arranged, like the walls of a building, in a Chiricoesque perspective, while the rest of the lines filter through a semitransparent still life in the foreground. The town square formed by the letters of the opening lines illustrates what these lines say ("*Dams*

larly the way the figure is grafted to it, depend on Ernst's own Dada collages.

Ernst's indebtedness to de Chirico is revealed in the iconography of some other pictures of this series. In the *Pietà or Revolution by Night* (fig. 126) the frontal male figure holding the young boy in his arms is a quotation from de Chirico's *The Child's Brain*. The hollows in the metallic armature of the foreground figure in *Woman, Old Man, and Flower* (fig. 128) were no doubt suggested by such de Chiricos as *The Astronomer* (fig. 116) and *The Fatal Light* (fig. 115).

Yet despite their plastic and iconographic derivations from de Chirico, the originality of Ernst's proto-Surrealist pictures is unmistakable, and depends essentially on the impact of his extremely individual oneiric iconography. This is best seen in *Oedipus Rex* (colorplate 13), one of a few masterpieces in the series. From a window emerges a giant hand holding a walnut; the fingers are pierced by a horrifying pointed instrument derived from a collage (*The Invention*) that Ernst had made some months before and then published in 1922 as an illustration for Paul Eluard's *Répétitions*. To the right are fantastic birds' heads, one with horns, of a type that would become familiar, and in the distant sky a balloon with a gondola hovers.

The extraordinary *Two Children Are Threatened by a Nightingale* (1924; fig. 129) was the final form taken by Ernst's synthesis of de Chirico and Dada. Here the figures and landscape, receding rapidly into deep space, are complemented by wood constructions of a small house and a gate that project from the canvas surface, the gate folding out over the raised frame of the picture. Picabia had used such Dada constructions in paintings like *Very Rare Picture on the Earth* (colorplate 4), but had relieved them from a flat background, re-enacting the bas-relief spatial arrangement of early Analytic Cubism. But because in Ernst the forms in relief constitute the obverse of those receding into illusionist space, they relate less to Cubism than to de Chirico.

More than his very painterly works of the years immediately following (1925–27), Ernst's proto-Surrealist pictures rely on the poetry of the image rather than on plastic structure. It is therefore not surprising that in 1924, the culminating year of this series, Ernst should have given the literary character of these paintings more actual form. His "Picture-Poems" (fig. 130) bring into focus the underlying verbal premises of the series in the same way that *Two Children Are Threatened by a Nightingale* had made concrete his synthesis of Chiricoesque illusionism and Dada collage. The insertion of words in the field of the picture was unquestionably suggested to Ernst by Analytic Cubism (he had put stenciled letters, though not whole words, in an Analytic Cubist exercise dated 1913). But

une ville pleine de mystère et de poésies . . .''); and the still life is spectrally inhabited by the reference to "*la nature morte se dressant au centre.*" In the "Picture-Poems" the letters cast shadows attesting to their concrete actuality in a way not unlike those in certain medieval manuscripts, where the illuminators wished to illustrate the primacy of the word.[123]

Ernst returned to Paris from the Far East in the fall of 1924, at which time Breton published the first Surrealist manifesto. Ernst's trip had caused a break in the continuity of his painting; when he resumed work, it was in a quite different manner, akin to the automatic techniques of Miró and Masson, and reflecting the definition of Surrealism in Breton's manifesto. Like the more abstract art of Miró and Masson, Ernst's began to be either flat or very shallow spatially, with reminiscences of the Chiricoesque theater entirely eliminated. In fact, de Chirico's kind of illusionist fantasy disappeared momentarily from the history of painting—to be revived shortly in different form by Magritte, Tanguy, and Dali. And Ernst himself eventually returned to a modified form of it.

PART III: THE HEROIC PERIOD OF SURREALIST PAINTING (1924-29)

THE AFFILIATION OF THE PAINTERS

One day in the winter of 1922–23, two young, unknown painters met at a party in Paris and discovered that they had adjoining studios in a building (now demolished) at 45 rue Blomet. Joan Miró and André Masson were soon *copains.* "Masson was always a great reader and full of ideas," Miró recalls. "Among his friends were practically all the young poets of the day. Through Masson I met them. . . . [They] interested me more than the painters I had met in Paris. I was carried away by the new ideas they brought and especially the poetry they discussed. I gorged myself on it all night long."[124]

Some months later, Miró poked his head through the hole in the wall which he and Masson had made to facilitate communication. "Should one go to see Picabia or Breton?" he asked.

"Picabia is already the past," Masson replied. "Breton is the future."

The answer proved correct, and within a year the circle of the rue Blomet, which included Antonin Artaud, Robert Desnos, and Georges Limbour, had entered the Surrealist orbit, itself now widening far beyond the initial *Littérature* group. Masson's intellectual curiosity and erudition particularly recommended him to Breton. They met when the latter was piecing together the first Surrealist manifesto, destined to be published in the fall of 1924.

In Ernst's documentary group portrait, *The Meeting of Friends* (1922; fig. D-106), the only artists depicted, aside from the painter himself, were Jean Arp and the absent de Chirico. Soon the circle included not only Miró and Masson but, a year later, Yves Tanguy, whose chance discovery in 1923 of an early de Chirico had crystallized his desire to become a painter. The "official" *apéritif*-time meeting place for the Surrealists was the inelegant Café Cyrano (still standing) on the Place Blanche at the head of the rue Fontaine, in which street Breton had his studio-apartment. Located a few blocks from Place Pigalle, the milieu of the Cyrano differed considerably from that of the artists' cafés on the Montmartre hill and the Left Bank, frequented as it was by pimps, prostitutes, money-changers, and drug peddlers, who, like the Surrealists, often crossed the street to attend a performance at the Grand Guignol. Most evening meetings were held in Breton's atelier, sometimes in Miró's or Masson's studio on the rue Blomet, and later, in 1925, at the quarters of Tanguy, Marcel Duhamel, and Jacques Prévert on the rue du Château.

Miró and Masson's participation in the Surrealist group was to be decisive in determining the early painting of the movement. Both had gone through a prolonged Cubist phase, and, despite the subsequent transformation of their art, they never entirely relinquished the grid-influenced disposition of the compositional field and the shallow or flat space of Analytic or Synthetic Cubism. Above all, they remained committed to the substance of painting in a way that kept them both (except for a lapse by Masson in the late thirties) from adopting the academic realism and deep spatial illusionism favored by other Surrealists. Their influence had a part in drawing Ernst away from his proto-Surrealist style and to the more abstract, flatter, semiautomatic pictures of 1925–29, which remain unquestionably his finest.

But while Miró and Masson brought to Surrealism a new and more "abstract" kind of painting, they got from it in return the idea of automatism (which, it will be remembered, was central to the definition of Surrealism in the first manifesto), and this idea emboldened them in breaking away from the rigorous architecture of Cubism in the direction of a more improvisational art. Moreover, the Surrealist

interest in dreams and oneiric images was to suggest to them a new type of poetic iconography—and its vehicle, biomorphism—very foreign to Cubism but capable of satisfying the poetic inclinations of both artists.

From 1924 until 1928, "abstract"-automatist art was dominant among Surrealist painters. Its ascendancy was heralded by the first and most important group exhibition of Surrealist painting, held in 1925 at the Galerie Pierre. In addition to works by Ernst, Miró, Arp, Masson, and Man Ray (who had joined the movement after the demise of Dada), there were exhibited paintings by three artists never formally affiliated with Surrealism: de Chirico, Picasso, and Klee. The two de Chiricos dated before 1918 were logical inclusions in view of his role as a precursor. But Picasso's presence is more difficult to account for, since the works of his included were all Cubist. Breton was drawn to these Cubist pictures by their revolutionary character and, probably, by their purely artistic quality; in any case, the latter could not be said aloud, as it contradicted the anti-estheticism to which Surrealism was theoretically committed. When, a few years later, in *Le Surréalisme et la peinture* Breton wrote about Picasso and Braque, he "justified" their Cubist work principally by a metaphysic that he professed to see in the treatment of motifs. Picasso was credited with "sweeping open" the "mysterious road" to the new art by his awareness of the "betrayal" involved in "the facile, customary appearance of objects." Breton meditated upon the mystery of the incomplete words and phrases in the Analytic Cubist pictures: "the immemorial newspaper, LE JOUR . . ." and the truncated inscription "VIVE LA" on a still life. Braque was described as a "master of *rapports*" between objects, and the "fascination" of his work was said to lie in discoveries like the "delicate thread which links a blue package of tobacco to an empty glass." Unmentioned by the Surrealist writers at the time, but historically most relevant, was the fact that the stylistic essence of many paintings in the Galerie Pierre exhibition (of the Mirós, of some of the Ernsts, and especially of the Massons) was derived from Picassos like those present.

The presence of Paul Klee in the 1925 exhibition was, as we have noted (p. 136), a recognition not only of this painter's entirely independent contribution to fantasy art but, more particularly, of the importance of automatic drawing in the formation of his images. Klee's automatism developed entirely apart from the influence of Dada or Surrealism (and together with the latter was important in the genesis of the spontaneous art which was to emerge on both sides of the Atlantic in the 1940s).

As Surrealist painting emerged in its heroic period—between the first (1924) and the second (1929) manifestoes—it bipolarized stylistically in accordance with the two Freudian essentials of its definition. Automatism (the draftsmanly counterpart of verbal free association) led to the "abstract" Surrealism of Miró and Masson, who worked improvisationally with primarily biomorphic shapes in a shallow, Cubist-derived space. The "fixing" of dream-inspired images influenced the more academic illusionism of Magritte, Tanguy, and Dali. We tend to think of Miró and Masson primarily as painters (*peintres*), in the sense that the modernist tradition has defined painting; we think of the latter artists more as image makers (*imagiers*). The styles of all Surrealist painters are situated on the continuum defined by these two poles. Those of Max Ernst—the "compleat Surrealist"—oscillated between them. Both kinds of painting were done virtually throughout the history of the movement, though the "abstract"-automatic vein dominated the pioneer years and the period of World War II. In between, oneiric illusionism held sway.

The common denominator of all this painting was a commitment to subjects of a visionary, poetic, and hence metaphoric order, thus the collective appellation *peinture-poésie*, or poetic painting, as opposed to *peinture-pure*, or *peinture-peinture* (by which advanced abstraction was sometimes known in France). Surrealists never made nonfigurative pictures. No matter how abstract certain works by Miró, Masson, or Arp might appear, they always allude, however elliptically, to a subject. The Cubists and Fauvists selected motifs in the real world but worked *away* from them. The Surrealists eschewed perceptual starting points and worked *toward* an interior image, whether this was conjured improvisationally through automatism or recorded illusionistically from the screen of the mind's eye.

This visionary iconography, which was intended to reveal unconsicous truths that were heretofore assumed to be inaccessible, was sometimes inspired by the literature that interested Surrealism, but was more often of an entirely personal order, though certain psychological constants in human nature—and their concomitant symbols—naturally tended to manifest themselves. However "abstract" its figuration, the Surrealist picture almost always contained those irrational juxtapositions of images common in free association and dreams.

The first phase of Surrealist painting was improvisational and "abstract." Both Miró and Masson made the transition from Cubism to fantasy art in 1924, and the following year Ernst, under the direct influence of the text of the manifesto, began the *frottage* drawings that redirected his art into a non-illusionist vein.

JOAN MIRÓ (1917–29)

Miró is unquestionably the finest painter to have participated in Surrealism. Already friendly in 1923 with the poets and painters who formed the nucleus of the movement, his formal adherence to Surrealism dates from its official launching with the first manifesto of 1924. The five years between the first and second manifestoes—I have called these the "heroic years" of Surrealist painting—saw his closest participation in the movement. Hilton Kramer writes:

Surrealism did for Miró what neither Cubism nor any other purely plastic doctrine could have done. It encouraged him to go back to his own childhood for the materials of his mature vision, and allowed him to make of these materials a pictorial statement which is at the same time a species of poetry. It provided a rationale for the whole conjunction of folk art, primitivism, native wit and Spanish grotesquerie with the mystique of eroticism which was Surrealism's special metaphysical interest and Miró's personal obsession.[125]

The change in direction of Surrealist art at the end of the twenties, marked by the new departures of the second manifesto and the rise of Dali, created an ambiance which Miró found less congenial. He had never had any interest in the quasi-theological arguments regarding philosophy and action (particularly political) which had long agitated Surrealist circles and were then becoming paramount. Aside from his adoption of automatism, his relation to the movement was very general, growing out of his love for poetry ("je ne fais aucune différence entre peinture et poésie"). When, after 1929, "abstract" Surrealism was overshadowed by the return to illusionism, Miró found himself being wooed by the "Abstraction-Création" group, whose gods were Mondrian and Kandinsky; unlike Arp, however, he refused to join it. And unlike Masson, who broke with Breton at that time, Miró never formally disengaged himself from Surrealism; he simply drifted away from its milieu. Nor did this estrangement prevent his occasional collaboration in Surrealist projects, for he remained on good terms with Breton until the latter's death. (Shortly before he died, Breton wrote the introduction to the publication of Miró's "Constellations.")

Since it was only in his first Surrealist paintings of 1923–24 that Miró fully achieved his artistic identity, there has been a tendency to minimize his accomplishments of the six preceding years. Yet many of the works of that time show him already in full command of his powers as a painter, if not as an originator of forms, and a few, such

as The Table (Still Life with Rabbit; fig. D-122), have a structural grandeur and a sumptuousness as pure painting that are only occasionally matched later on. In these earliest paintings we can observe, too, the germs of ideas that were later to flower under Surrealism. In the light of this youthful work we can understand how Miró was able to maintain such unwavering fidelity to his own sense of art in the face of all the contrary blandishments, literary and technical, which Surrealism offered, and which could divert, at least for a time, the course of a painter like Masson.

From its very beginnings in 1915 until a climax was reached in 1917, Miró's painting was more Fauve than anything else. "Matisse," he recalls, "taught us that autonomous color, with or without modeling, could carry structure through contrasts and subtle juxtapositions." Miró knew Matisse's painting even before the big wartime exhibition of French painting that was held in Barcelona by Ambroise Vollard at the request of the French cultural attaché there. The unmodeled pure tones and transparent quality of Miró's Nord-Sud (1917; fig. D-120) are inconceivable without Matisse. Miró himself readily accepts the label "Fauve" for his art of this period, but except for such pictures as Nord-Sud, the canvases of this time are really very personal in style. The formalized patterning of The Path, Ciurana (fig. D-118) hangs somewhere between Orphism and Fauvism, and the romantic offshades of the Village and Street, Ciurana (fig. D-119) evoke a poetry completely foreign to the emphatic primary hues of the Fauves.

Miró's Standing Nude (1918; fig. D-121) testifies to his assimilation of lessons from both Cubism (the fan-shaped, modeled planes of the nude's midsection) and Matisse (the patterned backdrop and the sumptuously decorative rug). But in fusing these two influences he produced a work that bears the stamp of his own genius and contains in germ much that would be realized in later years. One has only to compare this picture with the works of the thirties and forties (Woman's Head, 1938, colorplate 42 is a good example) to see how the shades of blue, green, and red used in Standing Nude became the characteristic color chord of Miró's carefully limited palette. Also, the plumes and beaks of the birds in the Majorcan-patterned backdrop reappear frequently in more abstract and fantastic guise, as do the curved black lines of the plant stems on the right (which remind us of the armpit hair in Woman's Head). There is, moreover, in the undulating design of the rug on which the nude stands, a hint of those organic forms which, liberated in flat silhouette, become the morphological basis of Miró's later art.

One of the most important works of Miró's early period is The

Table (Still Life with Rabbit; 1920). Here the genius of the Catalan decorator merges perfectly with that of the Cubist architect. The arabesques of the table legs are set against fan-shaped Cubist planes modeled by a kind of brushwork that bears a greater resemblance to Juan Gris' of 1912 than to that in the Analytic Cubist pictures of Picasso and Braque. With the latter two artists brushwork tends to dissolve rather than to affirm the expanse of a plane, and this militates against the decorative effects obtained by Gris and later adopted by Miró. Miró's Cubism is of a personal order. He never accepted Cubism completely, but took from it—as from Matisse—only what he considered viable for himself. He would not allow himself to be "detoured" by Cubism, to use his own word. But if there was much in Cubism that he did not sympathize with or even understand, certain of its basic ideals were to remain with him to constitute the infrastructure, if not the superstructure, of his art. In this sense Miró kept Cubism alive long after its more direct imitators had run aground.

The Farm (fig. 132), which Miró began in Spain in 1921 and completed the following year on the rue Blomet, is generally regarded, with much justification, as "the masterpiece of his first manner . . . [its] end product and synthesis."[126] But I must admit to certain reservations with respect to the overly anecdotal character of the composition and almost microscopically tight facture. The pale color, which lacks the richness of the best early works, does not create or define shapes but merely tints them. A large part of the surface is ornamented with small forms based on barnyard motifs and unified by parallelism of shape, but they do not entirely meld into the rhythmic patterns as characteristically in Miró's mature work.

With *Tilled Field* (colorplate 14), begun in 1923 and finished the following year, we come to Miró's first important breakthrough, his first venture toward a pictorial language that was not only new but wholly consonant with his own artistic identity. Here the perspective space and modeling of *The Farm* have been virtually eliminated. The flat surface is bisected by a straight horizon line (an emphasis Miró retained from the work of his teacher Modesto Urgell y Inglada) and then further subdivided by diagonals, with the geometrical units locked together by a few salient forms (like the tree trunk on the right) that intersect the various fields. Against this bold backdrop are dispersed a profusion of small ornamental shapes still clearly legible as farmyard iconography: a dog, horse, and farmhouse read vertically upward in the center, and a snail, rooster, rabbit, and ox on the right. These forms are more fantastic in conception and more stylized in drawing than the forms in *The Farm*, and

they are distributed over the surface with considerably greater freedom.

This freedom came, in part, as the result of a break with rational illustration, a daring step owed to Miró's association with the Surrealists. A tree trunk sprouts a giant ear, and an eye blossoms in its foliage; below, a lizard in a dunce cap anxiously scans a newspaper. Motifs such as these introduce a note of drollery that is typical of Miró from this point on. Nothing of this humor is apparent in the earlier works, but by the same token this gentle whimsey has little to do with the sardonic *humour noir* that the Surrealists inherited from Dada. It depended on the rediscovery and preservation of the childlike in his own mentality. Far from being a regression, this was a triumph; unlike the child, who is an involuntary humorist, Miró is master of his effects. The absence of political and social implications in Miró's whimsey—compared with the subversive *humour noir*— was no doubt one reason for Breton's complaint of "a certain arrest of [Miró's] personality at the infantile level."[127]

At the same time that it made possible his realization of himself as a painter of fantasy and wit, Surrealism's "liberation of the irrational" impelled Miró to discard the vestigial plastic conventions he had inherited from representational painting and retained throughout his "Cubist" works. Regarding the new pictorial superstructure that he was introducing into his art, *Tilled Field* is of particular importance; it is the first of his works in which biomorphic forms are clearly delineated. Though the salient forms and the geometrical scaffolding of the composition are Cubist, such shapes as the eye and the ear in the tree announce the form-language which, by the end of 1925, was to dominate Miró's painting and serve as the vehicle of his fantasy.

Tilled Field was the first giant step in Miró's plan to "go beyond the *plastique cubiste* to attain poetry." But while his iconographic fantasy was clearly set free, the geometry of Cubism was still dominant compositionally, despite the emphasis on flat silhouettes that declared his almost permanent rejection of the texture and mass also associated with that style. It remained for *Catalan Landscape* (fig. 133), painted slightly later in the winter of 1923–24, to confirm the new decorative style. Here the large "architectural," rectilinear shapes disappear in favor of freer, more meandering linear devices that have all the airiness and fragility of the mature Miró. The various motifs hang weightlessly and are strung together by linear tracery, like the mobiles Calder made after being inspired by Miró. Miró himself had probably been influenced here by the fantastic "machine" drawings which Picabia made during his stay in

152

Joan Miró. *Automaton*

Barcelona in 1917. A drawing titled *Automaton* (1924) shows how he was able to assimilate suggestions from Picabia—and also from Klee—in a blend that remained, nevertheless, profoundly personal.

Catalan Landscape's subtitle, *The Hunter*, identifies the main motif of the iconography, a stick figure in the upper left, mustached, bearded, and smoking a pipe. He holds a gun in one hand and a rabbit in the other. Like the other rustic motifs in the iconography, these are not simply abstractions, as are the shapes in *Tilled Field*, but schemata so far removed from their sources in nature that, as Jacques Dupin insists, they should be called symbols. This reduction of things to calligraphic motifs and small geometrical symbols renders the picture much less illustrative; in order to "read" it, we must search out and speculate on the cues that Miró gives us—but failure to do so does not detract from our appreciation of the picture.

Catalan Landscape is also notable for what James Thrall Soby has called its "soft, fresco-like" colors;[128] the terracotta earth and the yellow sky form an absolutely flat foil devoid of every trace of linear or atmospheric perspective. Like *Tilled Field* and much of Miró's later work, the flat, decorative character of this painting was partly inspired by the Romanesque frescoes of Catalonia—an influence the painter himself sets great store by—and it also has affinities with the Beatus manuscripts and Catalonian folk art.

The first phase of Miró's Surrealist painting ended with *The Harlequin's Carnival* (colorplate 15), painted in the winter of 1924-25. The nature of its iconography is perhaps best evoked by the poem Miró later wrote about its inception:

The ball of yarn unraveled by the cats dressed up as Harlequins of smoke twisting about my entrails and stabbing them during the period of famine which gave birth to the hallucinations registered in this picture beautiful flowering of fish in a poppy field noted on the snow of a paper throbbing like the throat of a bird at the contact of a woman's sex in the form of a spider with aluminum legs returning in the evening to my home at 45 rue Blomet a figure which as far as I know has nothing to do with the figure 13 which has always exerted an enormous influence on my life by the light of an oil lamp fine haunches of a woman between the tuft of the guts and the stem with a flame which throws new images on the whitewashed wall at this period I plucked a knob from a safety passage which I put in my eye like a monocled gentleman whose foodless ears are fascinated by the flutter of butterflies musical rainbow eyes falling like a rain of lyres ladder to escape the disgust of life ball thumping against a board loathsome drama of reality guitar music falling stars crossing the blue space to pin themselves on the body of my mist which dives into the phosphorescent ocean after describing a luminous circle.[129]

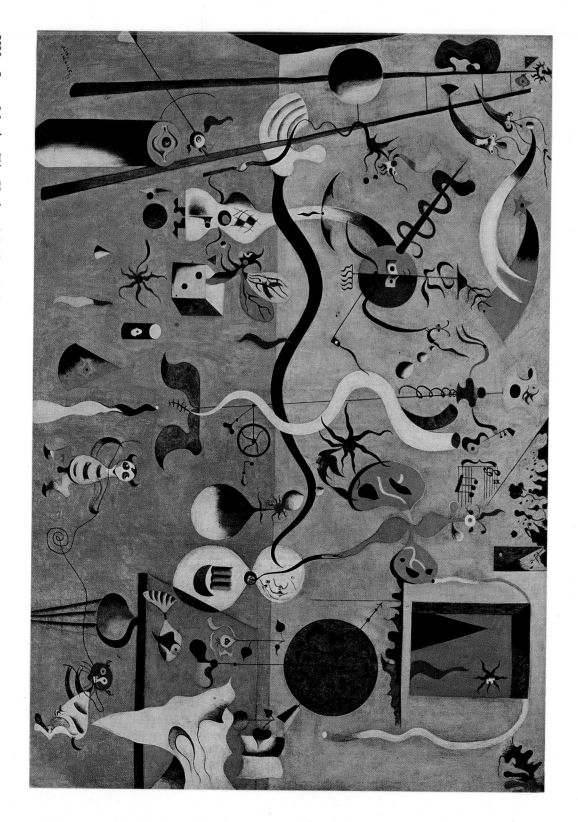

Drawing upon a repertory of fanciful personages, stylized animals, and props, Miró has crammed this picture with an extraordinary variety of shapes, all of which are more or less of a size, so that no one form or group of forms dominates the composition or sets up a hierarchy that would alter its generally uniform accenting. Each of the small forms is very carefully wrought and fairly tightly painted; modeling is eschewed, except for a few local accents which in no way diminish the effect of bright flat color. This type of painting—Dupin calls it "detail-istic"—harks back in its crowdedness to *The Farm*, but now the details, while complex, are less fussy, and the myriad shapes all resolve into an overall rhythmic pattern, allowing us to take in the entire composition as a unity.

The Harlequin's Carnival incorporated a number of advances that Miró had made since *The Farm*. Most conspicuous was his commit-

ment to meandering contours, in an ornamental manner deeply influenced by Art Nouveau. This accompanied the multiplication of biomorphic shapes, marginally present in *Tilled Field* and more evident in *Catalan Landscape*, but now dominating the composition. In this connection, it is significant that 1924 was the year, Miró tells us, in which he got to know the work of Jean Arp.

What is new in *The Harlequin's Carnival* is the orchestration of the biomorphic forms in rhythmic chains which, linking up with one another, extend over the *whole surface* of the field from top to bottom and into the corners, though never touching the frame. (In *The Farm* the details of the lower part of the picture had been set against the foil of the sky.) This type of composition, despite its biomorphism, distributed its motifs in a way similar to that of the Mondrians of 1913–14 (figs. D-31, D-32); and, like these, it may be

said to take certain implications of Analytic Cubism beyond the point where Picasso and Braque had left them in 1912. But Miró did not return to this "allover" design until the beginning of World War II, when his "Constellations" revived it in a more abstract manner.

Of the "poetic ambiguities" generated by the use of biomorphic shapes, none was better served than the erotic, which Surrealist theory had liberated as a subject, and which was to dominate Miró's painting from then on. Robert Motherwell has written an extraordinary appreciation of it:

Miró is filled with sexuality, warm, abandoned, clean-cut, beautiful and above all intense—his pictures breathe eroticism, but with the freedom and grace of the India love-manuals. His greatness as a man lies in true sexual liberation and true heterosexuality; he has no guilt, no shame, no fear of sex; nothing sexual is repressed or described circumspectly—penises are as big as clubs, or as small as peanuts, teeth are hack-saw blades, fangs, bones, milk breasts are round and big, small and pear-shaped, absent, double, quadruple, mountainous and lavish, hanging or flying, full or empty, vaginas exist in every size and shape in profusion, and hair!—hair is everywhere, pubic hair, underarm hair, hair on nipples, hair around the mouth, hair on the head, on the chin, in the ears, hair made of hairs that are separate, each hair waving in the wind as sensitive to touch as an insect's antenna, hairs in every hollow that grows them, hairs wanting to be caressed, erect with kisses, dancing with ecstasy. They have a life of their own, like that Divine hair God left behind in the vomit of the whore-house in Lautréamont. Miró's torsos are mainly simplified shapes, covered with openings and protuberances—no creatures ever had so many openings to get into, or so many organs with which to do it. It is a coupling art, an art of couples, watched over by sundry suns, moons, stars, skies, seas and terrains, constantly varied and displaced.[130]

During the summers of 1926 and 1927, which he spent in Montroig, Miró completed fourteen large canvases in the controlled, deliberate manner of 1924. But the winters of 1925–27, which were spent in Paris, were devoted to a new, more spontaneous, and abstract kind of painting that, in its radicalness if not always in its quality, marked one of Miró's greatest challenges to the history of style. The fantasy that had transformed nature in Tilled Field and Catalan Landscape bore a general relation to the poetry of Surrealism; the Paris works of 1925–27 drew more specifically on Surrealism for their automatism and their exploitation of accident. Although he still preceded most of his paintings with some sort of sketch, Miró

now began to work on his canvases by allowing his brush to wander freely, only later picking up cues for the composition from its traces and locking the picture together formally. In one case the starting point was some blackberry jam that had accidentally spilled on the canvas. Miró drew around the stains, making them the center of his composition. "Rather than setting out to paint something," Miró explains, "I begin painting and as I paint, the picture begins to assert itself, or suggest itself under my brush. The form becomes a sign for a woman or a bird as I work. . . . The first stage is free, unconscious."[131] These paintings prompted Breton to observe that it was "by such pure psychic automatism that Miró might pass for the most Surrealist of us all."[132] Of course, the automatism was not "pure," nor even as rapid or little edited as some of Masson's. Pure automatism, like pure accident, is inimical to art, and it is noteworthy that Miró qualified the description of his procedures cited above by adding that "the second stage is carefully calculated."

Many of the "automatic" pictures are painted in large, irregular patches of pure color, sometimes linked by meandering lines, against loosely brushed brown grounds free of any trace of a horizon line. It is not surprising that these pictures should have found a much narrower public than the more tightly painted storytelling works. But they have had greater actualité for abstract painters in the last two decades than almost anything else in Miró's oeuvre. For the painter himself they became the prototypes of a loose abstraction to which he returned—with differences—in 1959–60 (when he was unjustly criticized as having "taken over wholesale" the methods of tachisme and Abstract Expressionism). In the monumental The Birth of the World (1925; colorplate 16), for example, Miró poured a blue wash over lightly primed burlap and then, using rags and a sponge, spread it rapidly in a "random" manner. Within the pictorial chaos of these patches, which suggested iconographically a primordial sea, he began to improvise with painted lines that in turn led to flat percussive shapes of black and primary colors. Together these suggested an incipient iconography of living creatures. Amour (1926; colorplate 17) consists of an irregular boulder-shaped patch of white impasto covering most of the burlap brown ground. Over this a transparent veil of liquid blue has been poured, the excess spilling off on the right-hand side of the cradled canvas. Only at this point did the painter add a few specifically metaphoric details, like the stick figure of a woman, which identify as a Miró a picture that might otherwise have passed for one of the more advanced abstractions of the 1940s. The schematic woman, in conjunction with the telluric texture of the impasto biomorph and the earthen color of the

XVI Joan Miró *The Birth of the World. 1925*

XVII JOAN MIRÓ *Amour*. 1926

ground, triggers a train of poetic associations which begin with the academic woman as *tellus mater* and develop into a *maternité* made specific by the flat color patterns of a "child" nursing at her breast. The configuration of the child is so disposed that it constitutes the letter *A* of *Amour*, the other letters of which spring from the womb opening of the Earth Mother, thus defining the nature of the love referred to in the title.

The year 1927, during which Miró executed a number of very abstract paintings in crisp shapes of pure flat color against white grounds, also saw a series of extraordinary linear pictures based on the motif of the circus horse. In the most daring of these (fig. 137) the image is reduced to a single meandering black line of varying thickness that is suggested by the ringmaster's whip. The line is more spare and angular than is customary in Miró and echoes the drawing of Masson, who that same year was converting his automatic drawing into painting.

The interest in rapid execution to which Miró's automatic paintings attest inevitably led him to collage. In 1928 and 1929, the spirit that had prevailed earlier in his automatic paintings on brown grounds made itself felt in a series of *papiers collés* and object-collages (fig. 139). These grew out of the most abstract tendencies in Miró's art and, except for their vocabulary of shapes, are closer to the Cubist than to the Surrealist conception of collage. It was another five years before Miró turned to the latter, in a series inspired by the "Loplop Introduces" collages of Max Ernst from 1931; and whereas these later works included picture postcards and conventional engravings, the collages of 1928–29 have little illustrative content.

The collage-objects of 1928, of which the *Spanish Dancer* in the Neumann collection is the best example (fig. 139), involve a substitution of materials. For his meandering brush line Miró substituted string; for the right triangle, familiar since *Catalan Landscape*, we find a real draftsman's triangle; and for the minor textural variations that often distinguish different shapes in the paintings we have the contrast of sandpaper against plain paper.

The use of sandpaper, tar paper, and papers with glazed surfaces in the collages of 1929 marks one of the few moments when texture seems to have been of great interest to Miró. By and large, as Clement Greenberg observed, he has not felt the need that many of his contemporaries have to call attention to the physical presence of the picture surface. He eschews not only heavy impastos but also any kind of brushwork that would make the image's character as a painted surface unmistakable. Not that he does not at times allow traces of the brush to be seen, nor that when he suppresses these in the interest of

a smooth surface, the result is like the hard, enameled, academic surfaces of Tanguy and Dali. Yet the evidences of facture visible in a Miró are always local accents and never run through the work as a whole.

During the four years that separated his first automatic painting from the collages which evolved from these, Miró also continued to work in his more deliberate manner. He did not, however, attempt both manners simultaneously; rather he alternated between them for groups or series of pictures—an alternation that reflected winters in Paris and summers in Spain. The fourteen landscape-type pictures that Miró executed in his deliberate manner in the summers of 1926 and 1927 (including the famous *Dog Barking at the Moon* and *Animated Landscape*; fig. 136) were followed in 1928 by the extraordinary "Dutch Interiors" and, in the year after, by the "Imaginary Portraits." These works are, in both character and technique, entirely opposed to more spontaneous, improvisational paintings that were executed in the same years. In the "Dutch Interiors" and "Imaginary Portraits" Miró worked slowly, developing the pictures after many detailed preliminary drawings and executing them painstakingly. Whereas he had only a few "cues" in mind when he started an automatic picture, in his more deliberate paintings he would use works of art by other hands as his starting point; and as radically as he transformed the Dutch genre paintings and old-master portraits which he took for "pretexts," he was compelled to refer to them as he worked.

In the spring of 1928, Miró had visited Holland, and returned with new enthusiasm for the seventeenth-century genre painters. Their anecdotal situations, their crowded settings, their intimate scale and facture—all these struck a responsive chord in the painter of *The Farm* and *The Harlequin's Carnival*. The most elaborate picture Miró made in response to his trip was *Dutch Interior I* (fig. 140), which is a transposition, as Jacques Dupin points out,[133] of H. M. Sorgh's *Lute Player*, a postcard reproduction of which Miró had acquired. This is one of the most intricate of his compositions, and the execution is very tight and precise. Even such traces of facture as remained in *The Harlequin's Carnival* are suppressed, and the entire surface is covered with areas of flat, unbroken color. The absence of modeling eliminates such hardness as these surfaces might otherwise have (as, for example, in *The Farm*) and helps to avoid any appearance of academic "finish." The composition is dominated by the X formed by the figure of the singer, an extended biomorphic shape of white, and his schematized orange lute. Around this central motif circulate a swarm of subordinate motifs: a cat and dog below;

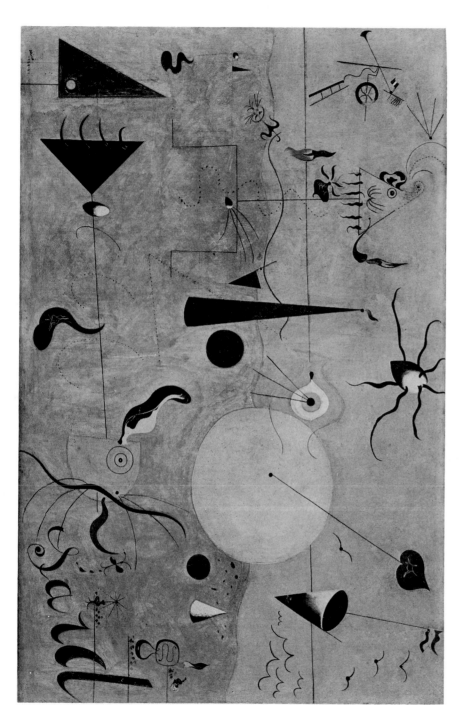

132 JOAN MIRÓ *The Farm.* 1921–22

133 JOAN MIRÓ *Catalan Landscape (The Hunter),* 1923–24

132

133

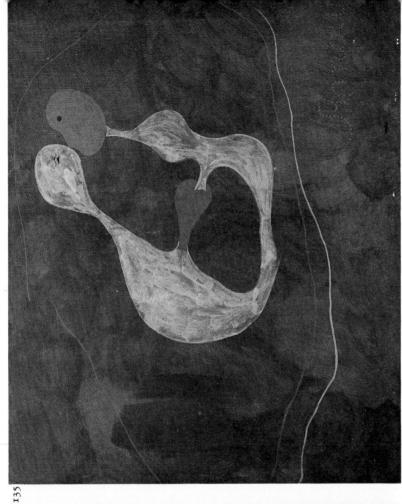

le corps de ma brune

j'aime je j'aime ma chatte habillée en vent salade

comme de la

grêle s'pareil

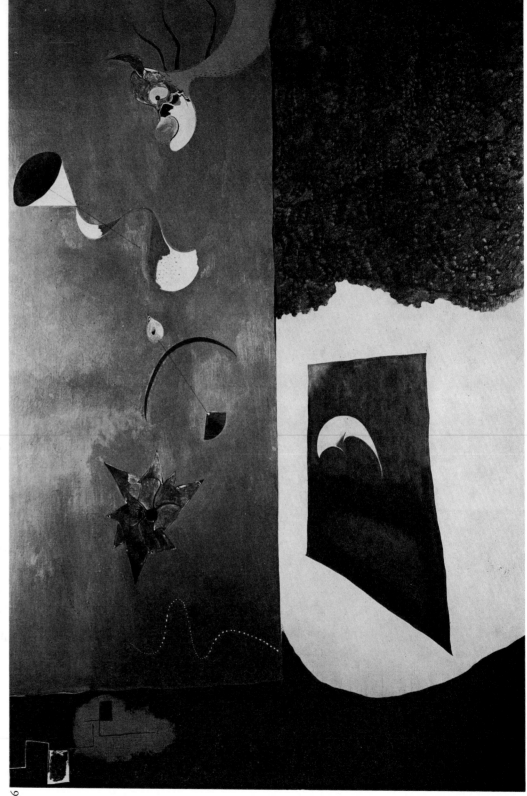

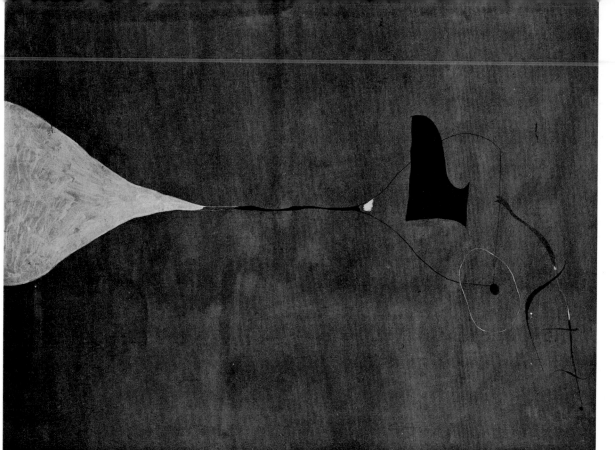

137

138

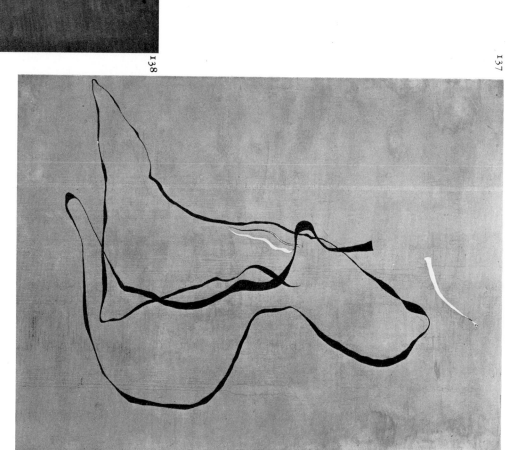

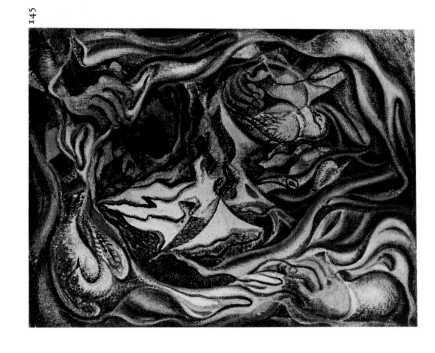

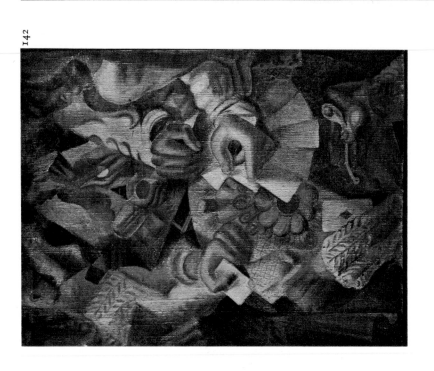

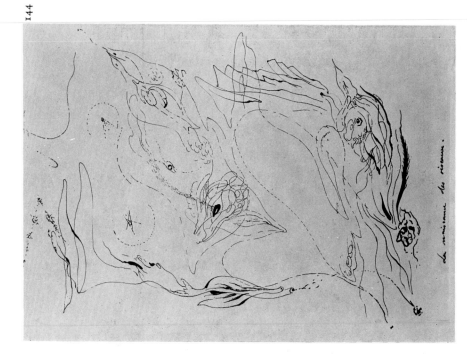

142 ANDRÉ MASSON *Card Players*. 1923

143 ANDRÉ MASSON *The Constellations*. 1925

144 ANDRÉ MASSON *Birth of Birds*. 1925

145 ANDRÉ MASSON *The Dead Bird*. 1925

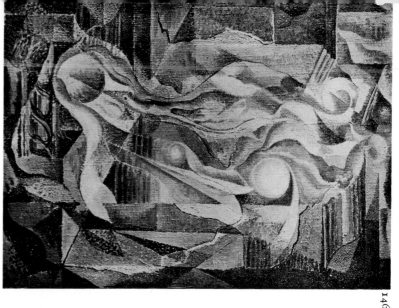

146

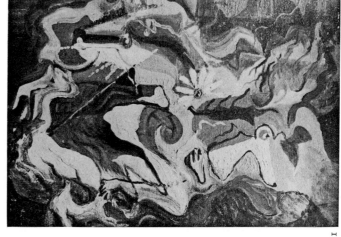

147

148

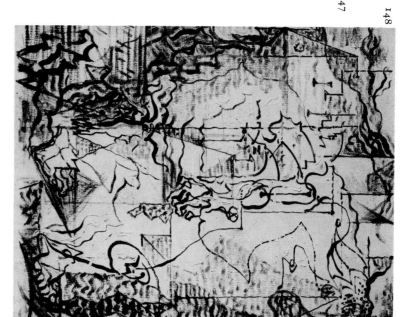

149

151 152

150

150 André Masson *Two Death's-Heads*. 1927

151 André Masson *Fish Drawn on the Sand*. 1927

152 André Masson *Metamorphosis*. 1928

a footprint, bat, and painting within a painting on the right; a view of Amsterdam with a canal, bridge, and other details on the left.

In Miró's earliest Surrealist works, like *The Harlequin's Carnival*, the forms seem clearly suspended *in front of* the ground, from which they are differentiated by slight variations of touch and marginal traces of modeling. In *Dutch Interior I* the omission of these allows the space of the picture to be squeezed flat, so that the intricate figures and the ground, like pieces of a jigsaw puzzle. This flatness is even more evident in *Dutch Interior III* (colorplate 19), a less anecdotal composition that leads directly into the "Imaginary Portraits."

James Thrall Soby has identified the source of the *Portrait of Mrs. Mills in 1750* (colorplate 20) as a portrait by George Engleheart (fig. D-7), a student of Joshua Reynolds.[134] The original shows the subject half-length, seated and reading a letter. Miró has converted her undulating broad-brimmed hat into a large biomorphic shape, the green color of which continues downward to form the upper torso. The ribbon bow of Mrs. Mills's hat has been schematized into black and red circles and its plumes reduced to a single black curlicue. Miró has retained, in much simplified form, the contouring of the upper torso and has added a wide skirt at the bottom, thus converting the seated figure into a standing one.

Of the four "Imaginary Portraits"—among the others are *Portrait*

of a Lady in 1820 (fig. 141), after Constable, and *La Fornarina*, after Raphael—*Portrait of Mrs. Mills in 1750* is certainly the best, and it is one of Miró's masterpieces. Here he achieved a compactness of design that he rarely equaled in his later work—a compactness that depended on eliminating, again, the differentiation between figure and ground. In the "Dutch Interiors" Miró had squeezed both figure and ground into a single plane, but only the figure had had real definition as a shape. In the *Portrait of Mrs. Mills in 1750* the reserve shapes of red on the left and ocher on the right have an interest comparable to that of the contiguous green and brown shapes of the upper torso and the skirt. As if to symbolize this equalization of figure and ground, Miró included in the lower-right corner of the canvas a passage of interpenetrating brown and yellow abstract shapes any one of which may be read as figure or ground. Such contouring of the surface as we have here was to prove very rare in Miró's later works, which are usually composed of figure-shapes of interesting profile against a ground that functions only as that, often in a shallow depth created by "atmospheric" textural differences, with or without traces of low-relief modeling.

The "Dutch Interiors" and, especially, the "Imaginary Portraits" signal Miró's maturity as a colorist. In the earlier pictures, prismatic colors are often muted, and when not, they are used only as accents, while blacks tend to work as local modeling as much as they do as

Joan Miró. *The Writer*

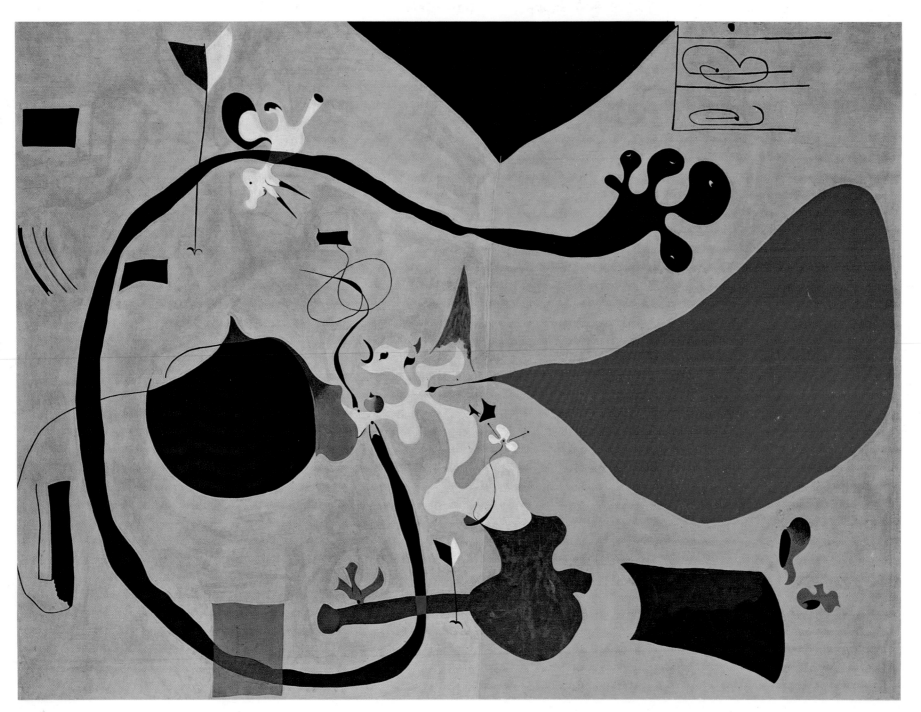

XIX JOAN MIRÓ *Dutch Interior III.* 1928

color. But in pictures such as *Portrait of Mrs. Mills in 1750*, the large areas of prismatic color sing out brilliantly, and the blacks provide the foil for their brilliance. Except in the thirties, when Miró added greater saturation (chroma) to his hues, he was never richer as a colorist than here. Clement Greenberg wrote:

[Miró's] ability to use color structurally, that is, to build the picture on the oppositions and intervals of pure hue as apart from those of dark and light, surpasses Picasso's and perhaps any other painter's of his time except Matisse's. Every painter knows how difficult it is to compose in flat colors without employing modulations of dark and light or a single over-all tone to unify the surface; Miró, along with Matisse and Mondrian, belongs among the few artists in the Western tradition who have done this with consistent success.[135]

ANDRÉ MASSON (1923–29)

For two years after the end of World War I, André Masson wandered about France, mostly in the Pyrenees. His doctors had advised him to stay away from urban centers to alleviate a nervous condition brought on by battle wounds. But memories of the hallucinatory nature of trench warfare—the horror and exaltation—were to stay in his consciousness as an artist, manifesting themselves not only in his series of "Combats" and "Massacres" but also in his depictions of the vicious primordial struggles of fantastic marine and plant creatures. Despite the trauma left by the violence and horror of war, Masson had found "enormous compensations":

There were moments of true happiness even on the line of fire. That is astonishing, perhaps. . . . The odor of the battlefield was intoxicating. "The air was filled with a terrible alcohol." Yes, Apollinaire saw all of that. There was only one poet to say it. . . . The shock of the dead in strange positions, like those I saw one day seated on a bank of earth, their heads having been blown away by an Austrian 85. . . . Others in very beautiful poses, like the one who had the appearance of a wounded lioness. At first I thought he was still alive and crying out for help.[136]

As a sixteen-year-old, before the war, Masson had studied fresco techniques for a year at the Ecole des Beaux-Arts in Paris, and he was continuing these studies in Tuscany when the war broke out. His first contact with Cubism took place only after his demobilization in 1919. In 1921, when he finally settled in Paris, Masson did

odd jobs and relatively little painting. His first professional pictures were a series of "Forests" executed during the winter of 1922–23 at the rue Blomet in a semi-Cubist manner adapted from the "hard" style of André Derain, with whom Masson was very friendly at that time. By the end of 1923, he had adopted a form of late Analytic Cubism, and that year saw an admirable suite of generally monochromatic *Portraits, Still Lifes*, and *Card Players* (fig. 142), which, while not original in conception, were beautifully painted and more deeply felt than the works of those minor Cubists, like Albert Gleizes, who were then in vogue in France. A frequenter of Max Jacob's salons, Masson was soon on familiar terms with most of the Parisian avant-garde, and his work impressed D. H. Kahnweiler, the pioneer dealer of the Cubists, who gave him his first one-man show, early in 1924.

In those years, Masson was working nights as a proofreader for the *Journal officiel*, and sleeping and painting during the day. The pressures of this existence whetted his desire to put into practice Rimbaud's "systematic derangement of the senses." (Miró tells how hunger alone intensified his own "hallucinatory faculties" in the years on the rue Blomet.) Masson's disordered life, marked by heavy drinking and experiments with drugs, was considerably animated by friendships in anarchist circles and with young poets and critics like Armand Salacrou, Antonin Artaud, Robert Desnos, Michel Leiris, and Georges Limbour. He met the last through Dubuffet, who had not yet deserted artistic and literary activity for the wine business.

The circle of the rue Blomet, which began by overlapping that of *Littérature* and then that of the rue du Château, ended by more or less fusing with them as part of the larger grouping that, from 1924 on, would be called Surrealism. Masson was reading furiously at the time, particularly Rimbaud, Lautréamont, Nietzsche, Dostoevski, Sade, the English and German Romantics, and the Elizabethans. Partly as a result of his extraordinary (and largely autodidactic) culture, he became an intimate friend of Breton's immediately on their meeting in the winter of 1923–24. His contacts with the world of nascent Surrealism provoked—among other things—an extraordinary series of automatic drawings that Masson was to continue sporadically for almost six years. One of these drawings was reproduced in the first number of the Surrealist movement's pioneer review *La Révolution surréaliste*.

Masson's oil painting, still under the discipline of Cubism, could not admit the immediacy and spontaneity of expression he wanted. Nor could he translate his powerful, aggressive, destructive, and

André Masson. *Automatic Drawing.* 1924

André Masson. *Furious Suns*

erotic impulses into anything like the vocabulary of Cubism. The technique of painting itself thwarted him, and for three years Masson explored automatism exclusively in drawings. These were begun with no subject or composition in mind: letting his pen travel quickly across the paper in mediumist fashion, he might find fragments of images and suggestions of compositional arrangements emerging from the "abstract" web. As the drawings progressed, conscious artistic decisions were increasingly made, but without reflection, without halting the rapid movement of the pen. The automatic drawing of 1924 reproduced here began as a small arabesque in the center of the paper, gradually expanding until the top lines touched the edge of the paper. Masson did not feel compelled to organize these drawings according to the size and shape of the paper; occasionally, partway through, he would attach another piece of paper as the drawing grew as though endowed with a life of its own. Yet such is the hold of Cubism on those who have once submitted to its discipline that quite unconsciously many of these drawings—like *Furious Suns*, reproduced here—have a Cubist distribution of accents, despite the un-Cubist character of their forms. (Something similar is to be seen in such Mirós as *The Harlequin's Carnival*.) As Masson worked on these drawings, the lines that suggested objects or fragments of anatomy might be emphasized somewhat, but they were never allowed to become literal.

Masson's line quickly took on a very particular character. In contrast to Miró's relaxed and sensuous lyricism, Masson's sudden redirections and frequently convoluted and angular contours, which admitted no revisions, conveyed a sense of overwhelming urgency and conflicting impulses. The seismographic nature of the markings suggested a hand responsive to the most minute variations within the psyche.

Notwithstanding the influence of Analytic Cubism, Masson's painting was opposed to Cubism insofar as it was committed to "poetry." Already in the works of 1924, the style that had at first been used to explore still life and portrait as simple motifs was being turned to subjects of obscure and symbolic character (like *The Four Elements*, the first of Masson's paintings bought by Breton). "For Masson," wrote Leiris, "the figures [in these paintings] became, essentially, magicians, and the objects they manipulated became signs and talismans in which the obscure forces of change and chance were condensed."[137] Hybrids and metamorphoses were common: disembodied horses grew into *The Constellations* (fig. 143), which, along with *The Cardinal Points* and *The Meteors* (fig. 146)—all 1925—became the point of departure of a personal cosmogony; a new

and personal bestiary was born in *Bear-Leaf* and *Rooster-Fig* (1924). Other, more violent themes manifested themselves, such as birds that are transfigured as they are pierced by arrows. "We were all caught up," Masson relates, "in the desire to get beyond the 'plastic integrity' of Cubism. The knife immobilized on the Cubist table would be seized at last. I remember Miró's remark to me at the time: 'I will break their guitar.'"[138]

It was inevitable that these new subjects should engender changes in the formal structure of Masson's painting; the calm architectural scaffolding of Analytic Cubism could not contain them. Gradually, beginning with the paintings of late 1924 and becoming more pronounced the following year, new, meandering linear devices and organic shapes appear in Masson's oils. These motifs, which represent a translation into painting of the oneiric discoveries made in his automatic drawings, are seen first in the center of the picture (*The Meteors*, *The Constellations*, for example), the margins of the composition still containing and framing them with rectilinear Cubist motifs. On seeing these pictures one day at Kahnweiler's, Picasso jokingly chided Masson for "setting us [the Cubists] up only to tear us apart."

By the end of 1925, only vestiges of Cubist scaffolding remained, as *Woman* (colorplate 21) demonstrates. The torso here is not re-

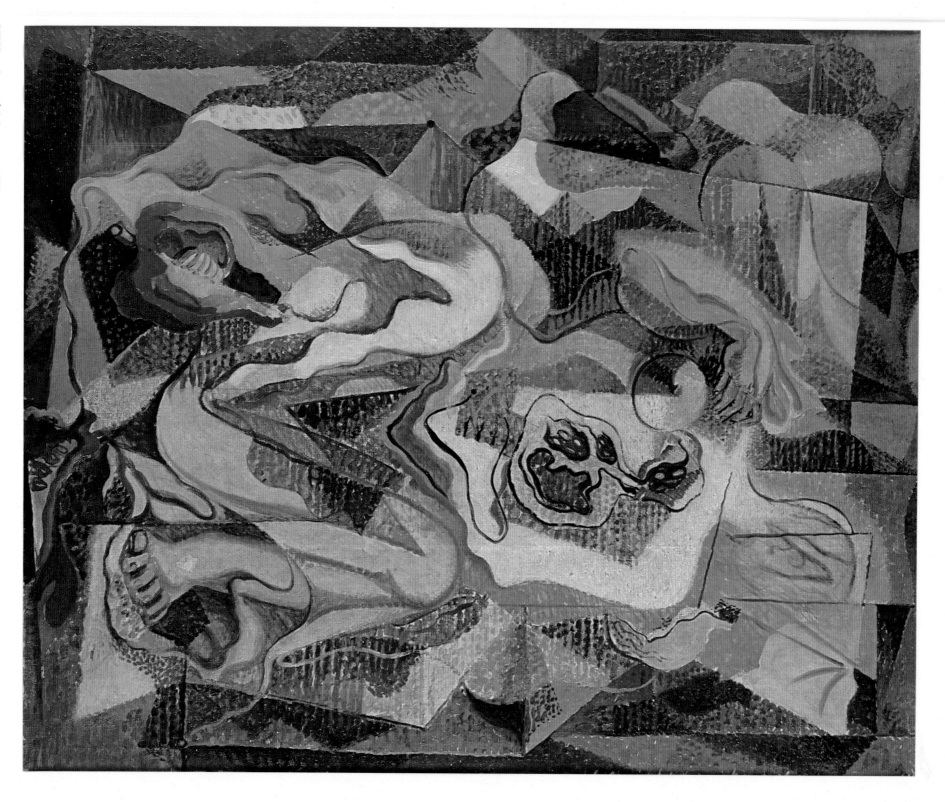

solved in a scaffolding of rectilinear accents but reconstitutes itself as an Earth Mother whose botanical "organs" have become universal symbols of generation. Metamorphosis thus became the informing principle of Masson's new iconography, which fused the image of man with that of the earth, the animal world, and the heavens.

As *The Haunted Castle* illustrates (fig. 148), the winter of 1926–27 found Masson striving for a way to endow his paintings with the discoveries of automatic drawing. In the center of this picture the Cubist scaffolding has dissolved under the pressure of the meandering line, though it persists in the margins. But painting was unalterably resistant to the rapid and extended linear automatism Masson wanted. Constant reloading of the brush broke the continuity of the line as well as the sequence of psychic impulses, while the drag of the brush prevented the rapid execution that was possible with pen or pencil.

The sand paintings were Masson's answer to the problem. Not that sand was a novelty: the Cubists had used it to create textural effects. In those of his sand pictures in which the subject was marine, Masson's use of the substance was a form of collage realism; but its truly radical purpose was to permit an automatism impossible with paints. *Battle of Fish* (1927; fig. 149), one of the earliest of the sand paintings, was begun when Masson, without any intention as to subject, spontaneously spilled glue in irregular patches over a prepared ground. Sand was then sprinkled over the entire surface, which, when the stretcher was tilted, remained on the glue patches and ran off elsewhere. Masson studied the results and began drawing around the patches (for the most part with charcoal or a pen so as not to have to lift his hand). Gradually, an undersea environment emerged, and the linear meanderings were made to look more like fish. Meanwhile, blotches of paint were assimilated to the imagery as wounds (on one occasion the blotches were made by blood from a cut in his finger, adding an element of "collage").

The imagery of *Battle of Fish* and other sand pictures, like *Fish Drawn on the Sand* (fig. 151), is manifestly violent and implicitly erotic in character; the ambiguous contouring suggests human anatomies of a kind that emerged more clearly in the later pictures of the series. Here Masson's graphic metaphors of the struggle between the forces of life and death recall the great shipwreck scene from Canto II of Lautréamont's *Chants de Maldoror*, with its battle of humans and sharks that ends in the hideous coupling of Maldoror and a shark. It was the spirit of the sand paintings, in particular, that inspired Kahnweiler to write:

... the universe of Masson is not a world of forms, like that of the Cubists,

but one of forces... [His is] an art in which the pulse—the "pneuma"—breathes life into the forms, influencing and twisting them. The Cubists lived in an Eden from which unhappiness and death were banished. Masson's world of forces is shaken by frenzied passions. It is a world where people are born and die, where they are hungry and thirsty, where they love and kill... This tragic art, which remains a stranger to nothing that is human, is truly the art of a generation which, even as it aspires to the Dionysian exaltation of Nietzsche, trembles before the prevailing *Weltangst*.[139]

As the sand paintings continued, their surfaces became denser (sometimes four or five layers of differently textured and colored sand were used), and the forms were left more and more abstract (as in *Two Death's Heads*; fig. 150). One of the most extraordinary pictures of the series, containing a prophetic solution to the problem of spontaneous drawing with paint, was *Painting* (colorplate 22).[140] the title of which was intended ironically, for it no more fitted hitherto accepted definitions of painting than the writings which the Surrealists published in the ironically christened *Littérature* fitted those of literature. Here the spontaneity of the meandering lines, added after two layers of sand, was preserved by *drawing directly from the tube*, the physical quality of the picture now expressing a release from conventions comparable to that of the imagery which arose from it. Unlike such Surrealist techniques as decalcomania and *frottage*, drawing from the tube was not a trick discovered accidentally and subsequently exploited for its artistic possibilities; it represented, rather, a solution called forth by an urgent formal problem. A similar problem was to lead Pollock to his "drip" method.

Painting, *Two Death's Heads*, and some others of the late 1927 sand paintings can strike the viewer, at first glance, as nonfigurative, so minimal and vague are the representational cues. But despite the abstractness in which Masson left his automatic pictures, he never aspired to pure abstractness of a kind which Mondrian or Pollock reached. Even in *Painting* we discern, in the polyphony of lines, the contours of a striding figure, as well as the suggestions of a bird and fish into which the top and bottom of the personage metamorphose.

The fundamental distinction between Surrealist techniques and those of abstract painting was illuminated in a memorable exchange that took place between Masson and Matisse (at whose home in Grasse Masson was spending a few weeks in 1932). Masson was explaining his manner of working:

"I begin without an image or plan in mind, but just draw or paint rapidly according to my impulses. Gradually, in the marks I make,

XXII ANDRÉ MASSON *Painting (Figure)*. 1927

I see suggestions of figures or objects. I encourage these to emerge, trying to bring out their implications even as I now consciously try to give order to the composition."

"That's curious," Matisse replied. "With me it's just the reverse. I always start with something—a chair, a table—but as the work proceeds, I become less conscious of it. By the end, I am hardly aware of the subject with which I started."

Thus, even when it appears most "abstract," Surrealist *peinture-poésie* moves, to use Breton's phrase, "in favor of the subject." Although automatist Massons such as *Painting* appear less figurative and hence apparently more abstract than typical Matisses, the picture evolves in a way that tends to clarify an image and is thus opposed to the abstracting process that functions in Matisse.

The sand and tube-painted pictures represented the high point of Masson's *élan*. But unlike Miró, he seemed not to know where his best possibilities lay, and instead of developing the sand style, he relaxed into a more familiar curvilinear Cubist manner during the final years of the decade.

MAX ERNST (1925–29)

Max Ernst tends to make his pictures in series that are tied together by subject, technique, or both. *Two Children Are Threatened by a Nightingale* (fig. 129) had fittingly summarized his proto-Surrealist explorations. When he arrived in Paris in the fall of 1924, after his voyage to the Far East, he found himself without inspiration for a new departure. The year 1925 marks a relative gap in Ernst's painted output. In the summer of that year, however, he discovered *frottage* ("rubbing"). There is no doubt that the automatic Mirós and Massons of that time and the text of the first Surrealist manifesto had provoked his interest. He himself records that the discovery of *frottage* was made "under the direct influence of the information concerning the mechanism of inspiration" that he found there.[141]

The immediate occasion of the discovery was Ernst's reading of Leonardo's *Treatise on Painting*, in particular the celebrated passages where Leonardo recommends stimulating the imagination by "looking at a wall spotted with stains or with a mixture of stones," in which "you will be able to see various landscapes, ... battles and figures in action, strange faces and costumes and an infinite number of things. ..." Not long afterward, at a seaside inn, Ernst found himself recalling how in his childhood an imitation-mahogany panel opposite his bed had provoked somnolent visions.

... I was struck by the obsession imposed upon my excited gaze by the wooden floor, the grain of which had been deepened and exposed by countless scrubbings. I decided to explore the hidden symbolism of this obsession, and to aid my meditative and hallucinatory powers, I derived from the floorboards a series of drawings by dropping pieces of paper on them at random and then rubbing them with black lead. ... The drawings thus obtained steadily lost the character ... of the wood, thanks to a series of suggestions and transmutations that occurred to me spontaneously (as in hypnagogic visions), and assumed the aspect of unbelievably clear images probably revealing the original causes of my obsession. ...

I marveled at the results and, my curiosity awakened, I was led to examine in the same way all sorts of materials that I happened upon: leaves and their veins, the ragged edges of sackcloth, the palette knife markings on a "modern" painting, and so forth. ...[142]

Rubbings are, of course, an old form of copying, familiar both as a child's game and as a technique for reproducing low-relief sculpture. (Rubbings of Far Eastern bas-reliefs were widely sold in Germany until World War I, when photographic reproductions tended to displace them.) Ernst himself had already used rubbings in a few collages of 1919 made from assembled printers' plates and in the ground of the collage-painting *Perturbation, My Sister* (1921; fig. 124). But in these works rubbing had been only a device for creating textured grounds and had in no way stimulated Ernst's imagination.

Frottage may be compared with automatic drawing insofar as it is a method of rapid improvisation in which the image gradually emerges from what appears at first to be a field of meaningless or unrelated cues. But there is this important difference: in automatic drawing, the initial marks derive from impulses of the artist, no matter how unconsciously dictated or uncontrolled the artist may feel them to be. Since *every* mark the artist makes bears some relation, however elliptical, to his being, automatic drawing is revelatory from the outset. The first stages of *frottage*, however, are swayed by chance or accident. To be sure, the general contours of a *frottage* can be predicted from the object over which the drawing paper is placed, but it was from the unpredictable, more delicate, inner patternings, for the most part, that Ernst evolved his images. By using only part of an object or surface and by mixing and overlapping different surfaces in the same drawing Ernst could obliterate, if he chose, the illusion of wood, stone, or leaves.

The exploitation of chance—what the Surrealists referred to as *objective hazard*—was a practice and a mystique in no way related

Max Ernst. *Stallion and Bride of the Wind*

to modern probability theory. Citing Hume, they defined hazard as "the equivalent of the ignorance in which we find ourselves in relation to the real causes of events." The chance patterns of *frottage* were therefore felt to contain, in spectral form, meanings which might be divined by Ernst's visionary faculties as he studied the markings—by *hineinsehen* ("overreading" or "reading into").

The hundreds of *frottage* drawings that Ernst made during the last six months of 1925, thirty-four of which were published a year later in portfolio form under the title *Histoire Naturelle* (figs. 155, 156, 158, 159, D-125, D-126), constitute one of the most beautiful groups of drawings in all modern art. Their great variety was due partly to the variety of surfaces on which the drawing paper was placed. In addition to the things mentioned by Ernst above, pebbles, dirt, shells, a crushed straw hat, watch parts, bricks, cheese graters, buttons, and chair caning were used—and these formed only part of the battery. Such textures in turn often produced what Waldberg[143] calls *formes mères*, which were to reappear in Ernst's paintings long after he had given up *frottage*.

Occasionally, the titles of the *Histoire Naturelle* drawings are descriptive as well as poetic (*The Pampas, The Fascinating Cypress*), but most of them are enigmatic (*The Vaccinated Bread, System of Solar Money, The Palette of Caesar*), and are intended to give an added dimension to the experience of the image. Jean Arp's introduction to *Histoire Naturelle* took the form of a long automatic prose poem inspired by the drawings:

. . . alarm clocks replaced by earthquakes showers of jordan almonds by showers of hail. the shadow of a man encountering the shadow of a fly causes a flood. thus it is a man who has taught horses to embrace one another like presidents kings or emperors sucking each other's beards licking each other's snouts plunging their tongues into patriotic profundities. . . . scarecrows with volcanoes and geysers in their buttonhole show cases of eruptions displays of lava string systems of solar currency labeled abdomens walls razed by poets the palettes of the caesars. . . .

Though many of the *frottages* cover the entire surface of a sheet

arrived at by rubbing alone. The light-and-dark scaffolding and grid elements, combined with the way the fragmented forms in shallow space articulate the entire surface even as they retreat from its edge, carry the image plastically into the world of late Analytic Cubism (p. 20), and put Ernst's art at that moment relatively close to the contemporaneous work of Masson.

The subject of birds, which at that time played a central role in Masson's iconography, had been familiar in Ernst's imagery all along, but from this point on birds were to become an absolute obsession with him. Ernst's hallucinatory identification with them led, around 1930, to his creating an alter ego, an avian *Doppelgänger*, named Loplop—Superior of the Birds, whose elongated, anthropomorphic appearance bears a curious resemblance to Ernst himself. In "An Informal Life of M. E. (as told by himself to a young friend)," the artist recounts (in the third person) how, when he was fifteen, "one of his best friends, a most intelligent and affectionate pink cockatoo, died in the night . . .":

It was an awful shock to Max when he found the corpse in the morning and when, at the same moment, his father announced to him the birth of his sister Loni. The *perturbation* of the youth was so enormous that he fainted. In his imagination he connected both events and charged the baby with the extinction of the bird's life. A series of mystical crises, fits of hysteria, exaltations and depressions followed. A dangerous confusion between birds and humans became encrusted in his mind and asserted itself in his drawings and paintings.[144]

So rich was Ernst's output in the four years following the discovery of *frottage* that I can do no more than describe several of the outstanding series. From the cosmological and landscape images of the *Histoire Naturelle* emerged a series of primeval "Forests" (fig. 163), usually night scenes showing strange, disc- or doughnut-shaped moons, as well as a corollary group of landscapes and seascapes, of which *The Gulf Stream* (1927; fig. 162) is the most impressive. Another series, known as "Hordes," is crowded with fierce monsters.

The "Forests" of 1925–27 (colorplate 25) derive from *frottages* (and *grattages*–scraping rather than rubbing the surface) of wood planks. These are "read" as trees, and in some cases crags, with additional small "foliage" often provided near the roots by *frottages* of shells and leaves. These elements are generally dark brown, gray, green, and black, their rough *frottage* texture set against the liquid surface of the sky, which is brushed in. Usually the sky is dark, with an effect of moonlight; in some cases, however (for example, *Forest;*

of drawing paper, often revealing as many as five or six different textural sources, some are very fragmentary and cover only part of the sheet. The images themselves are all in the nature of vegetal, animal, or cosmological fantasies (the latter in particular resembling the drawings and lithographs of Redon, pp. 125–27). In most cases the source objects are metamorphosed, as in *The Fugitive* (fig. 159), where buttons and leaves (among other textures) coalesce with a strange flying monster. Sometimes, however, the source remains recognizable, as does a leaf in *The Idol* (fig. D-126).

Rubbings done over slightly uneven objects produced delicate gradations of grays as in low-relief modeling. But despite the occasional horizon line or hint of perspective, the *frottage* drawings remain spatially shallow in the manner of the 1919–21 collages. When Ernst used *frottage* in painting, as he did a short time later, the Chiricoesque structure of his 1921–24 pictures disappeared, and the results came much closer, plastically, to the non-illusionist images of Miró and Masson. However, the first paintings that he made after his discovery of *frottage*, those of the fall of 1925, did not fully employ that technique; they were primarily painted variants of images discovered in the *Histoire Naturelle* drawings. The equine protagonist of *La Belle Saison*, for example, is a fusion of images taken from such *frottages* as *The Repast of the Dead* (fig. 156) with those in a collage of around 1920, *The Horse, He's Sick* (fig. 123).

The exquisite *To 100,000 Doves* (it has been dated both late 1925 and early 1926) is one of the earliest oil paintings in which Ernst employed a modified form of *frottage* (colorplate 23). He first covered his canvas with layers of paint, then held it over a roughly textured surface and rubbed part of the paint away. An alternative method involved putting paint on a rag which was then passed over the canvas so that the raised areas in the texture of the source object underneath caught the paint in saturations varying according to the degree of relief of the raised areas. The pale blue, rose, and white of *To 100,000 Doves* fuse, as the result of the *frottage* technique, in what we may call a *painterly* surface, in the Wölfflinian sense of the term. The loosely handled, creamy, and seductively textured surface was something entirely new for Ernst—the polar opposite of the execution in his proto-Surrealist pictures (though this new concern with texture had already been presaged in a set of small pictures of birds Ernst painted on sandpaper in 1924). In the mass of cues which the rubbing provided, Ernst discerned myriad birds' heads and bodies, which he then "clarified" by brushing in wider contours and details of the heads, but without making any attempt to model the forms; he preferred to retain solely the delicate value gradations

XXV Max Ernst *The Great Forest.* 1927

Max Ernst. *The Young Prince*

fig. 163, in the Slifka collection), the night landscape enigmatically includes a bright, daylight sky. (Magritte was to explore this same conjunction later in *The Empire of Light, II*; fig. 188.)

The "Hordes" (1927) are stronger and more varied in design than the "Forests." The title of the first "Horde," *Vision Provoked by a String Found on My Table* (fig. 164), heralds the new variant of the *frottage* technique that distinguishes this series. Bemused by the accidental coil and meander patterns of some heavy twine on his table, Ernst placed canvas over the twine and rubbed the surface of the canvas with paint. Into the linear patterns that emerged he began to read "hordes" of vaguely anthropomorphic monsters. He clarified the contours of these by brushing in a ground that identified not only the spaces between the crowded monsters but also such details as their eyes. These areas were brushed in with particular concern for their character as reserve, or negative, shapes, and for this reason, in part, these pictures are formally among Ernst's very best.

Ernst's use of the accidental string patterns to invent shapes was not without precedent. Besides Arp's well-known string reliefs of 1924 the reader will recall that Duchamp had dropped meter lengths of thread on a wood panel, which he had then cut on the pattern of the thread to create *Three Standard Stoppages* (fig. 12). He called these "canned chance," and they subsequently figured as motifs and measuring devices in others of his works, notably *Tu m'* (colorplate 2).

As Ernst progressed with the "Hordes," his canvases became larger and tended to incorporate other *frottage* textures, as well as passages of false *frottage*, or *frottage in trompe-l'oeil*, which was used where necessary to overcome accidental gaps in pattern continuity. These pictures reached their climax in *The Horde* in the Stedelijk Museum, Amsterdam (fig. 165). However, the "Hordes" were not the only pictures in which string *frottage* was used; other paintings, of a less massed, more open design, were devoted to nightmarish horses and to birds; the best of these latter is the exquisite *Blue and Rose Doves* (fig. 161).

In a variation on the string-*frottage* technique, Ernst made a few pictures by soaking twine of different thicknesses in liquid paint and then dropping it in labyrinthine patterns on the surface of the canvas. The lines remaining when the cord was removed would form the starting point of the composition. *One Night of Love* (1927; colorplate 26), which I consider Ernst's greatest painting, was created in this fashion. By means of linear patterns the artist conjured the upper torso of a horned male creature rising from a kind of

table top, against which are seen the curvilinear outlines of a spectral female figure, a bird, and animals that change shape in the grip of the horned figure. Eighteen years later, this horned monster was to reappear in Ernst's sculpture as *The King Playing with the Queen* (fig. 252). In *One Night of Love*, the broad, flat areas of the ocher table and the dark-blue background with which the blue-black figure merges give the picture—which is large—a bolder, simpler appearance than is usual in Ernst; and at the same time the sand mixed in the paint endows the surface with an assertive physical presence.

The extraordinary year 1927 saw Ernst producing not only a work like *One Night of Love*, and the "Forests" and the "Hordes," but also pictures done in low plaster relief and with paint surfaces patterned with combs and plasterers' tools (for example, *The Gulf Stream*; fig. 162). That same year saw him produce, further, a brilliant set of highly abstract pictures known as "Shell-Flowers." Creating through *grattage* an effect of blossoms and shells, Ernst painted flat, schematic backgrounds in saturated, brilliantly contrasting colors around them. Although these works included *grattage* and *frottage*, the best of them (like *Snow Flowers*, colorplate 24, and *Flower and Animal Head*, fig. 167) are much closer esthetically to *One Night of Love* than to the more intricate "Forests" and "Hordes."

Some flagging of Ernst's inspiration became apparent in the years

153

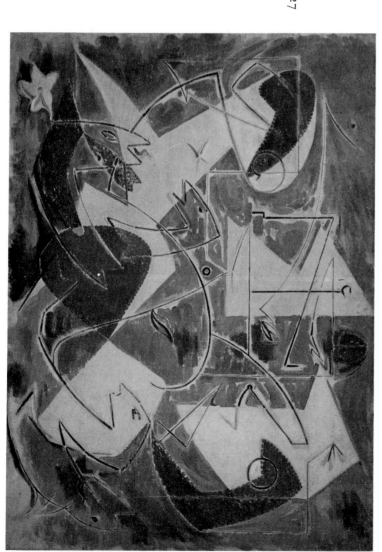

154

156

155 MAX ERNST *The Earthquake* (Plate V from *Histoire Naturelle*) · 1926

156 MAX ERNST *The Repast of the Dead* (Plate XXVIII from *Histoire Naturelle*) · 1926

157 MAX ERNST *When the Light Makes the Wheel* (Plate III from *Histoire Naturelle*, II) · 1925

158 MAX ERNST *The Wheel of Light* (Plate XXIX from *Histoire Naturelle*) · 1926

157

158

159

160

161

YVES TANGUY

YVES TANGUY

YVES TANGUY

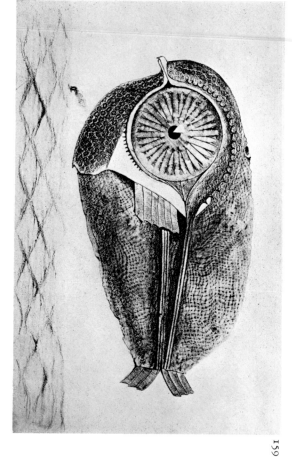

164

162

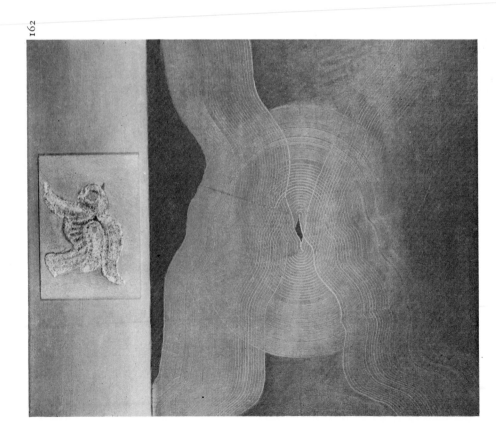

163

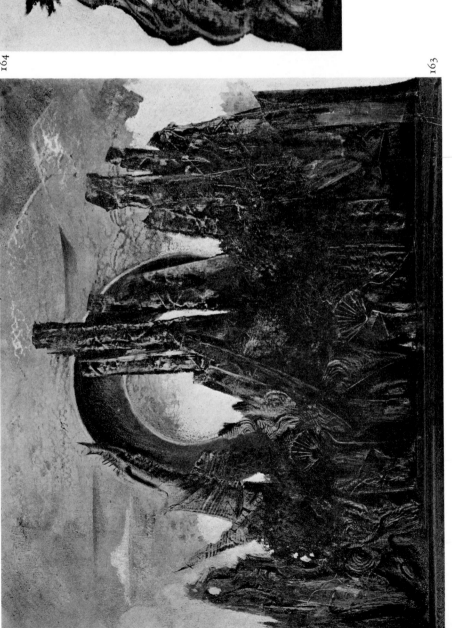

166

167

168

165

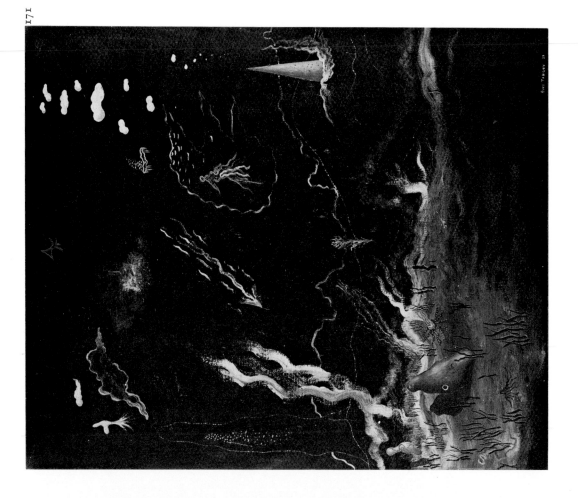

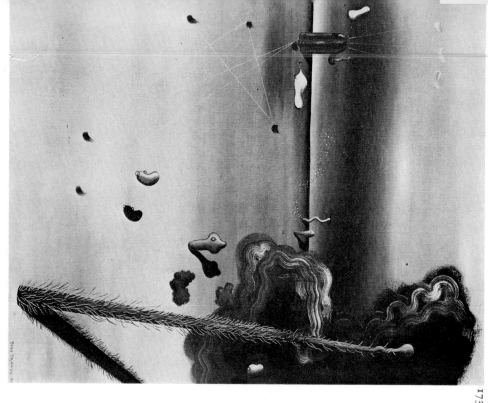

173

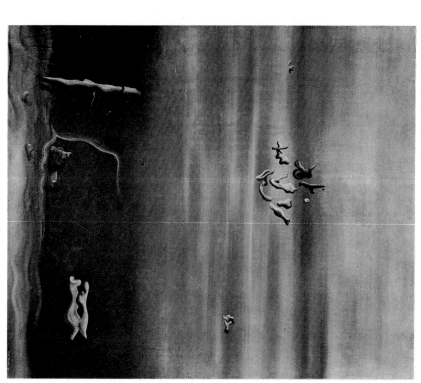

174

175

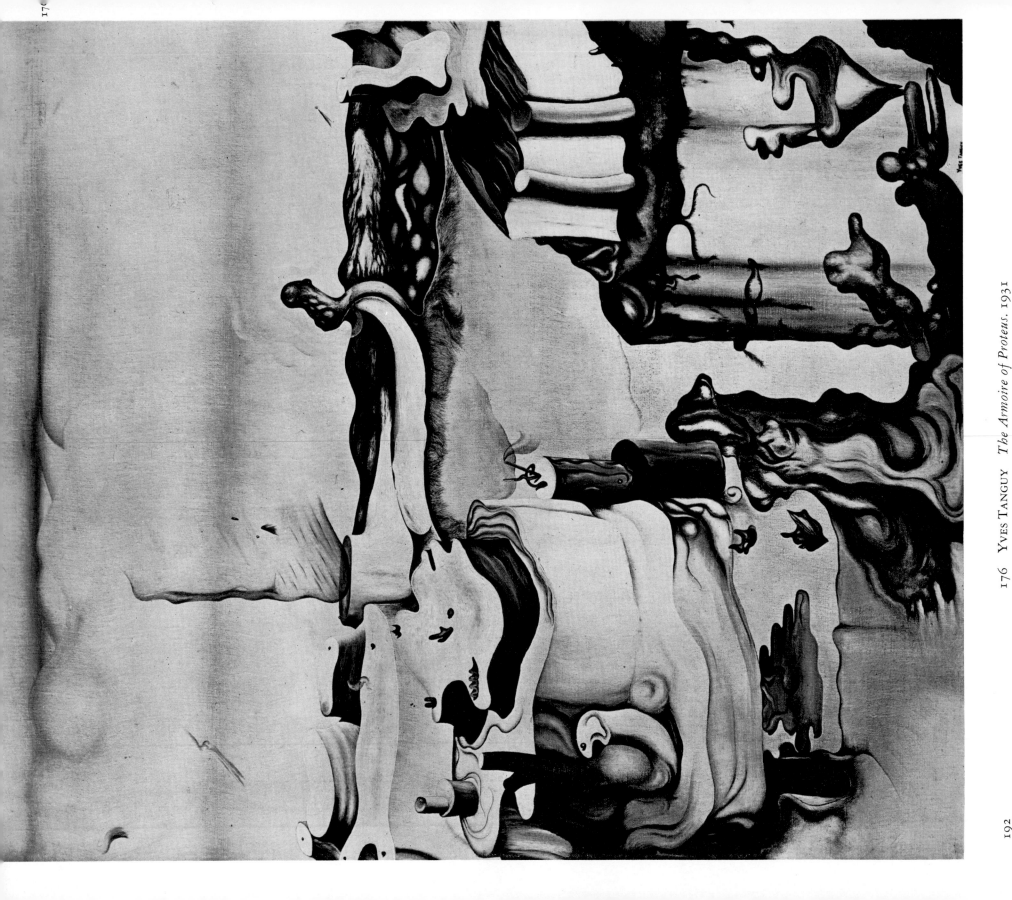

176 YVES TANGUY *The Armoire of Proteus.* 1931

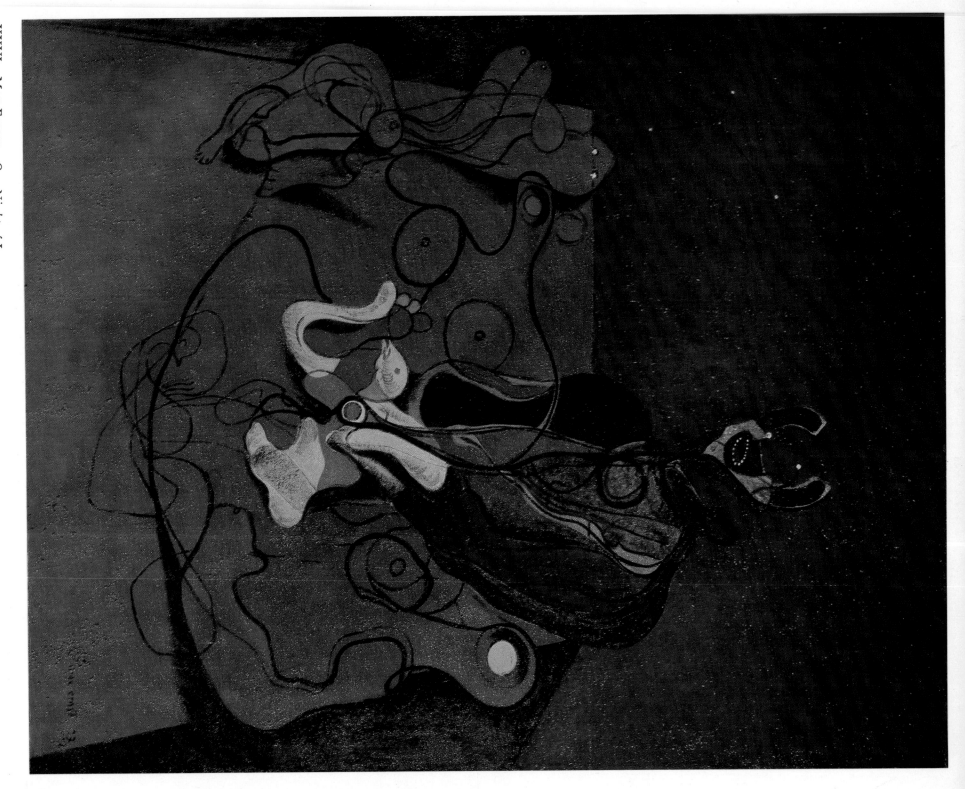

1928-30. "Forests" continued to be made, but now they were often less dependent on *frottage* and more deliberately modeled with the brush in a manner foreshadowing the way Ernst was to treat the forest theme in the following decade. In a very large and, for 1927, relatively uncharacteristic painting, *Monument to Birds* (fig. 166), Ernst had returned to something like the dryer, more sculptural modeling of his proto-Surrealist works. This more illusionistic style, which is also to be seen in smaller variants of the *Monument* and in works like *Two Anthropomorphic Figures* (1930; fig. 168), was now reasserting itself, and it was to dominate Ernst's paintings in the middle and later thirties, when Surrealist taste as a whole tended toward illusionism.

THE RESURGENCE OF ILLUSIONISM: TANGUY AND MAGRITTE

Max Ernst's temporary conversion to automatism, shallow space, and more marked abstraction in his paintings of 1925-28 seemed to repudiate the illusionistic style that had been established by de Chirico and further developed in Ernst's own proto-Surrealist pictures. But even as the new, more abstract phase of Surrealism was moving, with Miró and Masson, toward the climactic year of 1927, two young painters—Yves Tanguy and René Magritte—working under the influence of de Chirico, were in the process of forming styles that would shortly declare the resurgence of the illusionistic "dream" image.

Not that this kind of painting had been forgotten by the Surrealists during 1925 and 1926. From its first issue in December, 1924, until its twelfth and last in December, 1929, *La Révolution surréaliste* constantly reproduced early works of de Chirico and pre-1925 Ernsts. Moreover, in 1926, before either Tanguy's or Magritte's art appeared in its pages, the review carried illustrations of the illusionistic "magic realism" of Pierre Roy (fig. D-117), and before that, in 1924, a prophetic—for Magritte—"realistic" painting by Robert Desnos (who provided the idea) and Pierre Naville (who executed it; fig. D-115). This curious painting showed a table with a bottle in whose highlight was reflected the distant image of the drinker of the bottle leaping from a balcony; the right side of the table top was a sea on which rode a schooner so tiny as to suggest that it might have escaped from the bottle.

It was, to be sure, a measure of Surrealism's tendency toward abstraction during 1925 and 1926 that Masson was the artist most reproduced in *La Révolution surréaliste*, with Picasso next, though for every two Massons there was still one de Chirico; it was only in 1928 that reproductions of illusionistic Surrealist painting became very frequent. In the last number of the magazine, which contained Breton's second manifesto of Surrealism, they dominated. The discontinuance at this point of *La Révolution surréaliste* and the founding of a new review called *Le Surréalisme au service de la révolution* was, as we shall see later, further evidence of the change of attitude signaled in the second manifesto.

Of the illusionistic Surrealist painters whose art came to dominate the movement in the thirties, Yves Tanguy was in many ways the most remarkable. What sets him apart from the modern tradition even more than his deep spatial illusionism is his tight modeling, in which all traces of brushwork disappear into a smooth, crystalline surface that has a tendency, especially after 1930, to appear somewhat dry and metallic. This facture—even tighter than that of the Flemish Primitives—when applied in shading and combined with aerial perspective, obviates that planar, more corporeal paint surface which makes de Chirico's pictures cling to the picture plane despite their linear perspective, and endows even Magritte's illusionism with a distinctly modern air.

Tanguy's disengagement from twentieth-century styles makes for a unity of oeuvre that is virtually without parallel in modern art. Even Magritte went through a crisis toward the end of World War II, when he abandoned his earlier descriptive style—to which, however, he subsequently returned—in favor of saturated, pure color and a looser, brushier execution. And among contemporary non-Surrealists, no painter, however single-mindedly he pursued a personal style, failed to betray, at least tangentially, the impact of the major developments of his time. But from 1927, the year in which his manner crystallized, until his death in 1955, Tanguy's style—except for slight differences in color dosage and a more marked tightness after 1930—underwent no change.

The consistency of Tanguy's style reflects that of his imagery, to which this style was ineluctably bound and for which it had been devised. This vision of a semiabstract undersea wasteland, this "mindscape," remained from first to last. It appears first in 1927, sparsely populated with biomorphic forms; through the 1930s, these proliferate, filling more of the foreground space; in the forties, the forms themselves become larger, making the effect of a kind of architectural grandeur. Around 1950, the biomorphic shapes become much more crowded and dense, until, in his last works—the halluci-

natory *Multiplication of Arcs*, for example (fig. 400)—they fill entirely what originally had been a largely empty landscape.

The poetry of Tanguy's imagery differs from that of the other illusionistic Surrealists, and even from that of many of the "abstract" Surrealists like Miró, Arp, and Masson, by being less specifically literary. Though on occasion his biomorphic constructions are vaguely anthropomorphic, they are never—after 1927—particularized with features or anatomical details; nor can his forms ever be identified as recognizable objects, as can the shapes of Miró and Ernst, to say nothing of those of Dalí and Magritte. If Tanguy's style is realistic, his poetry is abstract.

Tanguy was born in 1900 in Paris, son of a retired sea captain employed in the naval office. His childhood summers were spent at the family home in Locronan in the Finistère province of Brittany, the extraordinary landscape of which made a deep impression on him. "The fields near Locronan," writes James Thrall Soby, "are peopled with menhirs and dolmens from prehistoric times and these, subjectively transformed, are frequent properties in the dream world Tanguy celebrated as an adult painter. Moreover, he never forgot the vast plateaus of the Brittany midland nor the submarine landscape of its rocky shore, where objects float hesitantly in the underwater light, shifting with the depth and tide."[145]

Nothing could have been further from the mind of young Tanguy than a career in art. At eighteen, he followed family tradition by shipping out as an officer-trainee in the merchant marine. This apprenticeship was abruptly terminated when, two years later, he was drafted into the French army. He found life in the infantry barracks in provincial Lunéville a trial and overcame a period of severe mental depression only with the help of a fellow draftee, Jacques Prévert, who was later to become well known as a poet and motion-picture director.

After their discharge, Tanguy and Prévert lodged together in Paris in 1922, managing to live by odd jobs. Even at that time, neither of them considered careers in art or writing, though both were deeply interested in poetry and, according to Marcel Jean, "spent their time visiting bookstores specializing in modern literature." Their discovery of Lautréamont's *Les Chants de Maldoror* and, later, of *La Révolution surréaliste* drew their attention to Surrealism. During that time, Tanguy began to draw, and the imaginary scenes with which he covered the paper napkins of Montparnasse cafés attracted the attention of Maurice Vlaminck, who thought enough of them to show them to the critic Florent Fels. One day in 1923, Tanguy saw from a bus platform an early work by de Chirico in the window of the art dealer Paul Guillaume. He got off to examine it and was so impressed that he was moved to a decision regarding a possibility that had been increasingly on his mind: he would make painting his life's work. Later he learned that André Breton had come upon de Chirico's painting in precisely the same way.

The question of a livelihood, which had to be resolved first, was answered in 1925, when the well-to-do young Marcel Duhamel invited Tanguy and Prévert to join him in a spacious house he had rented at 54 rue du Château. This house became, with Breton's quarters on the rue Fontaine and those of Miró and Masson on the rue Blomet, an important meeting place for the new avant-garde. Duhamel not only paid the rent, he also provided an unstinted supply of paints and canvases. Tanguy, though he had never had any formal instruction in painting, began to work like a man possessed. He burned most of the pictures of 1924–26 out of dissatisfaction. Those that survive from 1925 and early 1926 exhibit many of the qualities of naïve, Sunday painting. *Rue de la Santé* (1925) is awkwardly drawn and has a very high horizon line which makes the vista of the street reminiscent of de Chirico. *At the Fair* (fig. 169), done early in 1926, shows two acrobats in tights standing in front of a nude female, who floats horizontally in the air, while a fourth figure gestures in the background; the murky space here is shallower than in *Rue de la Santé*, and the oversized heads and insistent frontality of the figures have a primitive flavor not unlike that of the Dubuffets of the early forties.

Some time toward the spring of 1926—to judge from the untitled painting reproduced in the June, 1926, issue of *La Révolution surréaliste*, from such other paintings as *Lost Animals* (reproduced in the October issue), and from the still partly primitive *Girl with Red Hair* (fig. D-127)—Tanguy began to thin out his paint and loosen his brushwork so as to create airy, atmospheric landscape backgrounds. His composition came at the same time to be organized around fragmentary images juxtaposed in irrational combinations. This scheme was borrowed directly from the proto-Surrealist oils of Ernst, whose *Landscape* of 1923, with its painted simulation of a geometrical collage element, prefigures such works as *Genesis* (fig. 170), perhaps the best of Tanguy's pictures of this transitional period.

Against a vague, atmospheric background, in which the horizon line surrenders to that gradual and undefined merging of earth and sky later typical of Tanguy, *Genesis* depicts a geometrical tower supporting a tightrope and a balancing woman whose long hair is treated in a manner recalling Ernst's *The Teetering Woman* (1923; fig. 125). In the foreground a serpent approaches a high mound that

work of Arp, and adopted by Miró in 1924. Tanguy was to take these forms out of the pristine, flat environment of Arp's reliefs and construct a whole landscape world with them. Unlike Miró, he modeled them in the round and inserted them in deep space, where they became, in effect, illusions of sculpture. Two years later, Arp would shift from flat relief and collage to an analogous roundedness in his first three-dimensional sculptures.

If *He Did What He Wanted* seems closely related to the paintings of the previous year, Tanguy's other works of 1927, particularly *A Large Painting Which Is a Landscape* (colorplate 27) and *Mama, Papa Is Wounded!* (fig. 173), reveal his mature style at its earliest—and best. Never again would the manner seem so graceful and pellucid, or the images so unforced. *A Large Painting Which Is a Landscape* depicts a desert-sea floor, striated with patterns of light and shadow and dotted with what resemble clusters of seaweed. Here and there are simple biomorphs, like primordial one- or two-celled creatures; also a form clearly resembling a tailed quadruped that but for its modeling might have been found in Miró. Rising steeply from the gray floor and silhouetted against the pale blue-gray "sky," is a plateau on the far side of which loom the "head" and upper torso of an anthropomorph whose posture and position in the composition bring de Chirico to mind. *A Large Painting Which Is a Landscape* clearly establishes most of the features that will henceforth dominate in Tanguy's art: space is deep and atmospheric; forms, primarily biomorphic, are modeled in the round and cast shadows (lighted from a more or less consistent source); color is subdued and, except for small isolated accents, blends into an allover monochromy.

These same features are also found in the famous *Mama, Papa Is Wounded!*, the title of which is taken from a psychiatric case history.[146] This picture also contains a kind of cat's-cradle symbol that Tanguy would frequently use as a linear perspective device to reinforce and measure more dramatically space otherwise suggested by atmospheric, tonal means. Though without the grace and lyricism of *A Large Painting Which Is a Landscape*, the painting *Mama, Papa Is Wounded!* offers a more affecting, disturbing image, whose hallucinatory intensity is not matched again until Tanguy's very last works. To the right, the "wound" in a hairy, phallic pole—a kind of father totem—spurts a cloud of inky liquid. In the left rear is the "mother," resembling a cutting from a succulent cactus; and spread through the intervening space are the biomorphs that complete the "family."

In the three or four years after 1927, Tanguy's works alternate between "sea-bottom" and "desert" settings, with occasionally a

Yves Tanguy. 1926

has a tropical plant or tree emerging from its top and a hand holding a strange instrument projecting from its flanks. The drawing of the serpent, hand, tree, and woman is strictly literal, and nowhere in this picture do we find those unidentifiable biomorphic forms which were shortly to become the essential feature of Tanguy's imagery. The articulation and juxtaposition of the elements is reminiscent of the images obtained in the game of "Exquisite Corpse" (p. 278), which was very popular at the rue du Château at that moment and which may have been the immediate source of this painting.

The Storm (fig. 171), in the Arensberg collection, must have been painted at the very end of 1926, for it has moved very far in the direction of Tanguy's definitive style. Indeed, *The Storm* in many ways goes further in that direction than *He Did What He Wanted* (fig. 172), painted early in 1927, with its collagelike letters and numbers, and its geometrical toy, rightly identified by Soby with de Chirico's Ferrarese period. The black ground of *The Storm*, lit up as if by flashes of lightning, seems at once undersea and terrestrial, and though one of the forms is still anthropomorphic, the picture shows, in its lower left, the first of those freely contoured biomorphs which multiplied so rapidly in the following year. Here we see Tanguy absorbing a morphology well established since 1916 in the

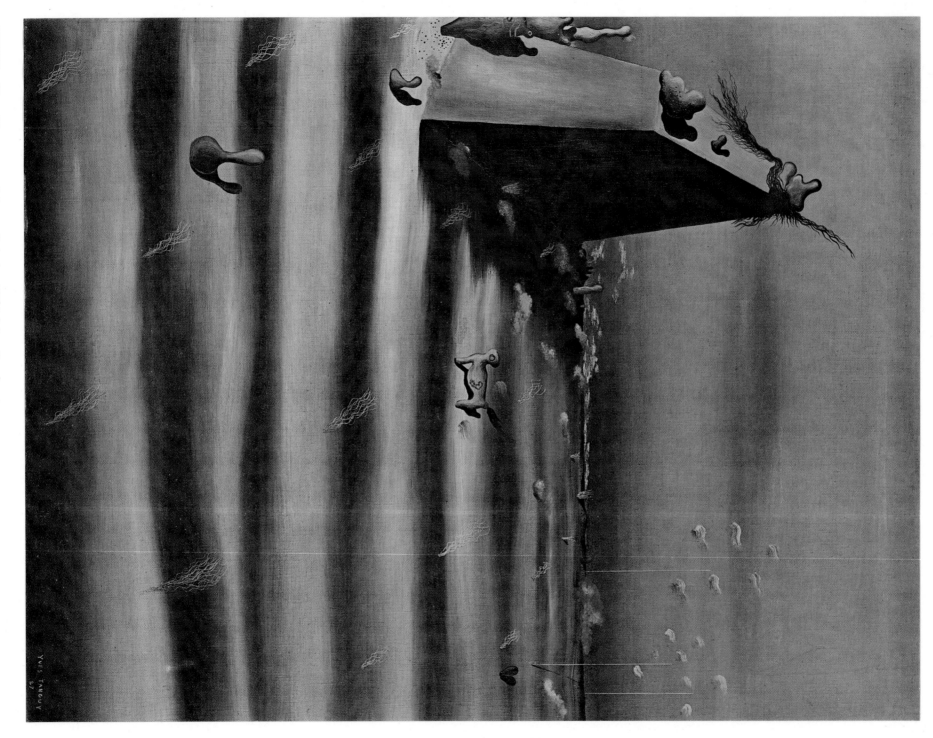

seem more malleable than elsewhere in Tanguy. They give the impression of beginning to melt, as if made of candle wax or soft plastic, though they never dissolve to the nonsculpturesque state as they do later in Matta, for whom the landscapes of Tanguy were a starting point.

The crowding of motifs in this series—so different from Tanguy elsewhere except in the last pictures before his death—was occasioned in part by the fact that the pictures were sketched on the canvas before being painted. This method, as James Thrall Soby has observed, is contrary to the improvisational manner—a form of automatic doodling—by which Tanguy usually arrived at his images (a morphological and iconographic open-endedness entirely at odds with his tight execution). The remainder of the thirties saw little change in Tanguy's art, the structures of which began altering only after his immigration to the United States.

During the year 1926, while Tanguy was distilling his characteristic style in as yet somewhat eclectic paintings like *Genesis*, René Magritte had already confirmed a style in an illusionistic manner derived largely from de Chirico. This was the manner that with but minor changes became characteristic of his art. Magritte undertook to define both the nature and the limits of *peinture-poésie*, or "poetic painting," and to distinguish it, if possible, from that which it is often criticized for being: painted literature. More than the other illusionist Surrealists, he wished to be purely an *imagier*. And he insisted that, far from leading him to adulterate painting, being an image maker put him squarely in the art of painting—at least as he was to define that art.

Magritte took as his starting point the descriptive style and spatial scaffolding of de Chirico, but he rejected such "inventions" as the latter's mannequins. He sought an almost total prosaism in the things he represented. In his art there are none of the bizarre and marvelous objects or beings of Ernst, none of the "paranoid" fantasies of Dali, and—except marginally in his pictures of 1926–27— none of Tanguy's biomorphic forms. He rejected "invention" as much in the thing represented as in the manner of representing it. The originality of his pictures lay rather in the revelation of affinities and relations between otherwise conventional elements, a revelation effected by displacements, juxtapositions, fusions, ambiguities, transparencies, and disparities of scale—in short, by the whole battery of techniques we have already seen employed for the creation of "hybrid" images. Magritte added nothing to these techniques. He distinguished himself from Ernst, Tanguy, and Dali by the technical

Yves Tanguy. Letter to Paul Eluard

fusion of the two. The objects depicted are generally small, never large enough to dominate the composition, and are sparsely distributed. The well-defined horizon line in the paintings of 1927 and early 1928 fades out later in 1928, and in such pictures as *The Lovers* (fig. 174) of 1929 we are confronted with a space that reads as much vertically as it does recessionally. The mood in all these pictures is one of silence; the same can be said of almost everything done by Tanguy, but in these early pictures the silence is that of a penetrating loneliness which Tanguy later sacrifices when the numerousness of the shapes in his paintings puts them inevitably into more "sociable" relations with one another.

Unique among Tanguy's work of the 1930s is a group of canvases executed in the first years of the decade, following a trip to Africa. Based on certain curious rock formations he saw there, the pictures are built up in plateaulike strata. In *The Armoire of Proteus* (1931; fig. 176), probably the finest of the group, the biomorphic forms

devices (*frottage*, for example) and the esthetic formulations (bio-morphism) that he eschewed rather than by those he incorporated; he eliminated anything that would dilute the "poetic purity" of his image. This made an important difference, especially in view of the direction Surrealist painting was to take in the 1930s. By 1938, it was possible for Herbert Read, then at the center of the British Surrealist circle, to write: "Magritte is quickly assuming a pivotal position in the modern movement"—this because he had dared to go beyond Picasso, Klee, Miró, "and even Ernst" in asserting "*the self-sufficiency of the poetic idea in painting.*"[147]

René Magritte. *Perspective*

René-François-Ghislain Magritte was born in 1898 in Lessines, Belgium, a small town in the province of Hainaut. Two events pro-foundly affected his otherwise quiet childhood and were to exercise, he recalled, a continuous influence on his introspective art. When he was fourteen, his mother, a neurasthenic, drowned herself; a year later, while walking in a forest near Charleroi, he met a young girl, Georgette, who, almost a decade later, was to become his wife. From eighteen till twenty, Magritte studied at the Académie des Beaux-Arts in Brussels. In 1920, two years after leaving the Académie, he exhibited publicly for the first time, in a two-man show in Brussels at Le Centre de l'Art.

The early 1920s, when he supported himself by designing wall-paper and doing advertising posters, were difficult years for Magritte. It was in the wallpaper factory that he met the painter Victor Ser-vranckx and with him practiced, in his spare time, a kind of abstraction closely related to Orphic Cubism. Despite what critics and Magritte himself take to be a total about-face owing to the influence of de Chirico, the bold, simple, and generalized abstraction of the Orphist tradition left its mark in the purged, handsome surfaces of Magritte's later illusionistic painting (so different from Dali's Victorian fussi-ness) and in its very generalized modeling (much less precise than Tanguy's).

By 1925, Magritte was well acquainted with the poets and artists of the Belgian avant-garde. He was particularly close to the then composer E. L. T. Mesens, with whom he brought out in 1925 the first and only number of a magazine called *Oesophage*. It was *dadaïsante* in character and reproduced works by Picabia and Ernst as well as by Magritte himself. Mesens was a bridge to the French avant-garde; in 1921, he had been in Paris, where he met such Dada personalities as Tzara, Soupault, and Ribemont-Dessaignes.

In 1922 Magritte and Mesens were shown a reproduction of de Chirico's *The Song of Love* (colorplate 11) in *Les Cahiers libres*. The picture so moved them that they sought out copies of *Valori Plastici*, in which they were able to see many more of de Chirico's paintings. This experience, and that of Ernst's proto-Surrealist imagery of 1922, not only subsequently changed the course of Magritte's art, it also led Mesens to abandon music for painting. It is of special interest that *The Song of Love*, the first de Chirico these Belgian artists saw, was particularly distinguished by the simplicity of its juxtapositions, which created an image I described earlier as having the force of Lautréamont's evocation of the sewing machine and umbrella on a dissection table. Magritte would later allude to this de Chirico in a picture titled *Memory*), which in a like manner isolates the head of

E. L. T. Mesens. *The Complete Completed Score for Marcel Duchamp's Band*

an antique sculpture in an architectural setting (fig. 186). In the painting, the white-marble head bears a bleeding wound, possibly a reference to Lautréamont's famous *"tache de sangue intellectuel."*

Paintings in this new Chiricoesque style were exhibited in 1927 in Magritte's first one-man show, at the Galerie Le Centaur in Brussels. Neither the public nor the critics took much notice, but the show did serve to bring Magritte close to a small Surrealist group (fig. D-131) that had already been formed in Belgium under the leadership of Paul Nougé and Camille Goemans (later the founder of a Surrealist-oriented gallery). That August, Magritte moved to Perreux-sur-Marne just outside Paris and came in touch with Eluard and Breton. During the three years he lived in France, his work was exhibited by the Surrealists, and "from that time on," Breton observed, "he was a main prop of Surrealism."

From the earliest of his de Chirico-influenced pictures, executed during the winter of 1925–26, through the paintings of 1928,

Magritte's mood, expressed in dominants of gray, brown, and black, is more somber than in his later work. *The Conqueror* (1925; fig. 177) incipiently establishes the perspective space and modeled forms out of which his illusionism is to be created, along with the use of *trompe-l'oeil* collage. Here we confront the upper torso of a man in evening dress, whose head has been replaced by a wood panel; behind this figure is a landscape of dunes above which floats an uprooted tree trunk.

This "levitation" of objects, one of Magritte's most familiar themes, is also present in *The Great Voyages* (1926; fig. 178), where the torso of a woman floats above a mountainous landscape. Inside the outlines of her legs, as though on a screen, appears the precise image of a factory town. To this "transparency," destined to remain another recurrent Magritte theme, *The Great Voyages* added a third motif (purged from his art by 1928): the biomorphic, or free, form. The arm of the floating woman in *The Great Voyages* ceases to be asso-

200

177 RENÉ MAGRITTE *The Conqueror.* 1925

178 RENÉ MAGRITTE *The Great Voyages.* 1926

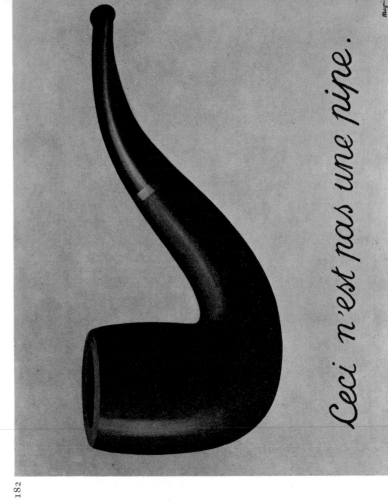

Ceci n'est pas une pipe.

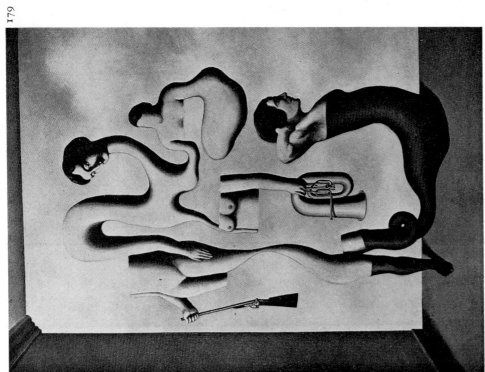

185

183

186

184

189

190

187	RENÉ MAGRITTE	*Delusion of Grandeur.* 1948
188	RENÉ MAGRITTE	*The Empire of Light, II.* 1950
189	RENÉ MAGRITTE	*The Explanation.* 1952
190	RENÉ MAGRITTE	*Hegel's Holiday.* 1958

187

188

ciated with human anatomy and becomes ambiguous and indeterminate, changing at its extremity into a tree. Such "fusion" of images will also be seen later in Magritte, but as in *The Red Model* (1935; fig. 185), where boots fuse into feet, and *The Explanation* (1952; fig. 189), which witnesses a Freudian fusion of a carrot and a bottle, the later mergings take place without the agency of ambiguous, abstract, or invented shapes.

Another characteristic Magritte motif, the picture-within-a-picture, is already established in 1926 in *Wife of the Phantom*. This device (which would influence Dali) derives from de Chirico, not from the motif as we see it in *Grand Metaphysical Interior* but rather from *The Double Dream of Spring*, where the illusion of the picture within the picture is shown ambiguously as being continuous with the illusion of the painting's space as a whole. Magritte's *Wife of the Phantom* shows an easel supporting a picture frame (whose biomorphic "bone style" is a mark of its early date), but we cannot be sure whether or not the frame contains a separate picture, since the landscape vista inside it is continuous with the whole landscape background of the painting. This same kind of ambiguity is sharpened in such later pictures as *The Beautiful Captive* (1931) and *The Human Condition, I* (1934; fig. 184).

Another device of enigmatic description anticipated by Redon, de Chirico, and Ernst is the unexpected disparity of scale by which the horse and rider of *The Lost Jockey* (1937) shrink to minuscule size, while the toilet articles of *Personal Values* (1952; colorplate 29) expand to gargantuan proportions. Though also inspired by outdoor advertising, Claes Oldenburg's gigantic *Hamburger* (fig. D-296) and, above all, his projected city monuments, mark a recent development of this idea. His outsize *Soft Typewriter* gives a Pop art brashness to the sexual connotations which are usually more veiled in Surrealist symbols like Dali's limp watches.

Using the ambiguous picture-within-a-picture, Magritte drew attention to his definition of painting as something other than the objective reality it represents. A realistically descriptive style like his runs the risk of having the painted image understood merely as a substitute for the object itself. Magritte rightly insisted, however, that his art goes beyond the creation of illusions of objects in combinations that might in principle exist on the same plane of reality as combined Readymades (like Duchamp's *Why Not Sneeze?*). For Magritte the art of painting consisted in representing images. But though the image is made up of illusions of objects (or even of a single object), the conversion of these *objects* into the state of *images* transforms their meaning. "An object," Magritte asserted,

"never serves the same function as its image—or its name." The painted image of a hat releases signals of far different meaning than the hat itself or the word *hat*; "there is little relation between an object and that which it represents."

The transformation results from representing the object on a flat, delimited surface—that is, *as an image*; and this must be entirely independent, Magritte insisted, from the enhancements of color, impasto, or other painterly devices. Indeed, all displays of pure painting can only harm the purity of the image, "the precision and charm of which depends upon the resemblance—and not on the imaginative manner of depicting it.... 'How to Paint' depends solely on spreading the colors over the surface in such a way that their actual aspect recedes and lets the 'image of resemblance' emerge." Magritte's picture-within-a-picture reminds us that we are looking not at reality but at painting, and it does so by equating the two pictures. Were we really to see the landscape image in *The Human Condition, I* (fig. 184) against its real "life" source, there would be no confusion.

Nowhere has Magritte made the enigma of the image clearer than in his famous *The Wind and the Song* (1928–29; fig. 182), which is a straightforward image of a smoker's pipe under which is written (in French): "This is not a pipe." The first thing understood here is that this is not a real pipe, because it is an image of a pipe; the next is that this is not a *pipe*, because that word has a nature foreign to the image of a pipe. But if the image of a pipe is not to be associated with the word *pipe*, it may, nevertheless, give off signals leading to other words. Therefore, in *Key of Dreams* (fig. 183) the isolated objects have written titles below them which bear no rational relation to the image: a drinking glass is "the storm," a hammer "the desert," a man's hat "the snow." For Magritte these names go with the images in the sense that they respond to the image signals. In *Key of Dreams*, which is consciously arranged to suggest the illustrations of a grade-school primer, we are made to feel that our accepted and cherished sense of the relation between words and images has been undermined.

Like the written legends of *Key of Dreams*, which constitute titles for the imaged objects, the titles for the pictures as a whole were arrived at through association after the finishing of the painting, usually by Magritte himself but not infrequently, according to Paul Nougé, by friends in sympathy with his art. "The titles of my paintings accompany them," said Magritte, "in the same way that names correspond to objects, without illustrating or explaining them."

What distinguishes Magritte's painting from "literature" is the

XXVIII René Magritte *On the Threshold of Liberty.* 1929

essential estrangement of his images from the language that would ordinarily be used to identify the objects that are images; *what his pictures present cannot be verbalized.* His painting is not "literature"; what it is, Magritte assures us, is a form of poetry, his images being metaphors, not constituents of narration. But while their processes are analogous to poetry, Magritte's images are not translations of verbal configurations. On the contrary, Magritte insisted that to understand "poetry-in-painting" is to perceive that an inspired image is "an idea capable of becoming visible only through painting" and is in its nature as inseparable from a visual image as the idea of a poem is from a verbal one. The art of painting thus becomes "the art of describing thought that lends itself to being made visible, thus to evoke the mystery of the experience."

Magritte conceived of the affective image as "inspired visual thought." Sometimes such images present themselves to the artist complete in all their parts and relationships. But often he has to explore and experiment before all the elements fall into satisfactory relations with one another to form the *image juste.* This exploration may occur in the mind, but more frequently it takes place in a series of sketches, a kind of free-associational iconographic improvisation in which objects absent from the original conception may force their way into the image. An interesting insight into this aspect of Magritte's procedure is revealed in a letter he wrote to a friend, the young American art writer Suzi Gablik, describing the origins of his recent painting *Hegel's Holiday* (fig. 190). This picture began with speculation on a glass of water: how to show it in a revelatory manner "with genius." "I began by drawing many glasses of water," Magritte wrote, "always with a linear mark on the glass." After a great many drawings, "this mark widened out and finally took the form of an umbrella. The umbrella was then placed inside the glass and, finally, underneath it. Which is the exact solution to the initial question: how to paint a glass of water with genius. I then thought that Hegel (another genius) would be very sensitive to this object. . . . He would have been delighted, I think, or amused (as on vacation) and I called the painting *Hegel's Holiday.*"[148]

Critics of Magritte's art, following the painter's own lead, have been content to locate his genius solely in the power of his images, without reference to his compositional structures or his style. But I believe this does him some injustice. For, more than most other "precisionist" styles, Magritte's maintains a considerable *standard of abstraction,* and the degree to which this obtains is easily measured by comparing Magritte's manner with that of Dali, the abundance of whose closely modeled detail reveals a style like that of the fussiest Pre-Raphaelite. A good deal of Magritte's appeal lies, therefore, in the area of the purely esthetic: the compositional breadth, the massive contrasts of solids and voids, the economy of means. Even his most poetically compelling images would be considerably less satisfactory pictorially if treated in Dali's much tighter style. This is implicitly recognized by that sector of art opinion devoted to abstract art insofar as it accords Magritte a tolerance not shown to Dali, or even to Tanguy. Moreover, the effect of compositional—as distinguished from iconographic—factors on the quality of Magritte's art can be gauged by comparing different versions he has made of the same iconographic idea. I refer here to his variants, not his replicas. In these variants, despite little or no change in iconography, we find a considerable range in the impact of the pictures resulting from purely compositional differences. The various versions of *Memory*

(figs. 186, D-130) and *Delusion of Grandeur* (figs. 187, D-132) are cases in point.

Magritte's stay in Paris coincided with the end of what I have called the "heroic period" of Surrealist painting. In 1929, conflicts within the movement led to wholesale disaffection and a realignment which I describe below. By 1930, when he left France for England (in 1931, he returned to Brussels, remaining until his death in 1967), Magritte had witnessed the redefinition of Surrealism in Breton's

second manifesto and the apotheosis of the young Dali as the paragon of Surrealist artists. Except for the years of World War II during which he executed his personal imagery in bright colors and with Impressionistic brushwork (fig. D-133)—he soon renounced this—his painting did not alter stylistically, though he constantly enlarged the range of his iconography, usually within the framework of the conventions developed in the paintings of the late twenties and thirties described above.

René Magritte. *The Thought Which Sees*

PART IV:
THE SURREALISM OF
THE THIRTIES

CRISIS AND REDIRECTION
IN THE MOVEMENT

The crisis that overtook Surrealism in the winter of 1929–30 was the culmination of a series of personal, intellectual, and political conflicts that had begun five years earlier with the inception of the movement. No sooner had Surrealism emerged triumphant from the *époque flone* and asserted its basic principles than the familiar syndrome of revolutionary symptoms emerged: dissension developed among leaders whose solidarity was no longer compelled by external pressures, and "heresies," were met by "excommunications."

I have suggested (p. 121) that the term "Surrealist painting" is somewhat contradictory; so is "Surrealist movement." Breton had defined Surrealism as a state of the creative mind and/or spirit which had existed in various individuals throughout history, and which he and his friends were consciously and systematically exploring. According to Breton, the movement was intended to function as the spontaneous expression of affinities between independent collaborators. But a group that conducted psychological and literary experiments, produced manifestoes on current issues, published books and magazines, organized "manifestations," and held art exhibitions could not function with total spontaneity. Organization and authority were needed, and Breton provided these to a degree that many considered excessive, with the result that as issues multiplied so did disagreement and conflict. One after another, the experimenters in this "*collective* experience of *individualism*"[149] were forced to choose between the polar terms of the formula.

Difficulties first arose at the Surrealist *centrale* in connection with *La Révolution surréaliste*, the first organ of the movement, which was published there. The *centrale* headquarters (figs. D-111, D-112), located at 15 rue de Grenelle, was formally known as the Bureau of

Surrealist Research (in Aragon's words, "a Romantic hostel for unclassifiable ideas"). It was from there that the famous Surrealist "butterflies" were distributed: small rectangles of colored paper bearing such slogans as "Parents! tell your dreams to your children," and "If you like love, you'll like Surrealism." These began turning up all over Paris.

At the outset, *La Révolution surréaliste* was edited by Pierre Naville and Benjamin Péret. Naville wanted the review to look like a scientific journal, hence layout and typography were severe and relatively unimaginative, making for a sober appearance that was only slightly relieved by reproductions of drawings and paintings. This dour format was a "subtle camouflage," as Maurice Nadeau observed, for a publication that claimed to be "the most scandalous in the world."

It was understood that, while all members of the movement shared the avant-garde's general approbation of Marxism or at the very least were in strong sympathy with the political left, the "revolution" in the title of the review referred to something clearly different from—and in many ways opposed to—the Russian Revolution. In a dispute with Jean Bernier, editor of the Communist review *Clarté*, Aragon characterized the Russian Revolution as "the miserable little revolutionary fuss produced to our east," and insisted that "only by a veritable abuse of language could it be described as revolutionary." But by 1930, when the defunct *La Révolution surréaliste* was replaced by *Le Surréalisme au service de la révolution* (*Le Surréalisme A.S.D.L.R.*), the "revolution" in the new title had clearly become the Russian one. The same Aragon now delivered a *mea culpa* before the Second International Congress of Revolutionary Writers at Kharkov in which he denounced many of his previous Surrealist views.

These events of 1930 had been preceded by a long period of vacil-

lation on the part of Surrealism regarding radical politics, a vacillation that inevitably became involved with personal and artistic differences. The source of the trouble lay in the paradoxical ideal of Surrealism as a community of individualists steering a course between the Dadaists, who scorned the community, and the Communists, who sacrificed the individual.

The problem of Surrealism's relation to Communism, in the former's initial phase at least, was crystallized in a dispute between Breton and Naville. Differences had first arisen in connection with Naville's denial of the possibility of a Surrealist art and Breton's reply that the possibility was indeed being realized (see p. 122). Breton personally took over direction of *La Révolution surréaliste*, and what came to be called the Naville crisis expanded to include the larger question of the limits of Surrealism, particularly with respect to concrete political situations. The event that ignited this phase of the quarrel was the war in Morocco, which reached a climax in 1925. The Surrealists, with the horrors of World War I fresh in their minds, could not sympathize with the suppression of a colonial people whose chief, Abd-el-Krim, insisted that the Riffs wanted nothing more than to live on an equal footing with Frenchmen. Since the majority of the French literary and academic world sided with the government (their manifesto was titled *Les Intellectuelles aux côtés de la Patrie*), the Surrealists found themselves left with only the Communists for company.

A "crisis of conscience" ensued among the Surrealists. Could one remain aloof from political action, isolated in the world of ideas? A *rapprochement* with the Communists seemed inevitable, and the Surrealists began to collaborate openly with the Communist intellectuals of *Clarté*, whose position they had earlier belittled. Surrealism admitted that social revolution was essential and that its own revolution, of the mind and spirit, offered no way of coping directly with that question—hence the need for cooperation. This admission did not necessarily require the dissolution of the movement and its merger with Communism, however. On the contrary, in a first article he wrote for *Clarté*, Breton emphasized that, though conceding that any work of the spirit had value only insofar as it contributed to "the changing of the condition of the entire world," Surrealism did not regard the material level as of primary importance to itself. Surrealism, Breton insisted, transcended specialized economic and social approaches to experience, and consequently had to continue to exist and function in its own right, albeit side by side with the "other revolution."

But Naville was not satisfied. He maintained that Surrealism did not constitute a real threat to the bourgeoisie precisely because it functioned on the *plan moral*; the bourgeoisie was glad to forgive it its "manifestations" because they were sure that moral scandal could never suffice to overthrow social—or even intellectual—values. In *La Révolution et les intellectuels. Que peuvent faire les Surréalistes?* Naville stated the problem in terms of two alternatives. One was to "persevere in a negative and anarchical attitude"; the other, Naville's own choice, was to "engage resolutely to follow the revolutionary path, the only revolutionary path, the path of Marxism."

Breton's reply, in the form of a pamphlet titled *Légitime Défense* (September, 1926), rejected Naville's alternatives as a basis for discussion. While reiterating his adherence to the Communist program *par principe enthousiaste*, he castigated the Communist paper in France, *L'Humanité*, as "puerile, declamatory, cretinizing, and unreadable," and found fault with the Communist leadership, whose inadequacies, he explained, derived from the fact that they were motivated solely by material interests, concerns "that have never been able to inspire revolutionaries." Communist psychology failed because it tried to arouse people by promising them a better existence. "None of us," concluded Breton, presuming to speak for all Surrealism, "is lacking in the wish that power would pass from the hands of the bourgeoisie into those of the proletariat. In the meantime, it is no less necessary, as far as we are concerned, that the experiments of the inner life continue, and without, to be sure, any external control, even Marxist." Now there was nothing more for Naville to do but leave. He became coeditor of *Clarté*. But despite his *de facto* break with Surrealism, he continued to be a nominal adherent for a while, and continued to see his Surrealist friends, many of whose poems and essays he published in the Communist review.

At the same time that Breton was equivocating with regard to formal liaison with the Communists, in an effort to protect Surrealism from being swallowed up politically, he was busy defending it against the opposite tendency, the purely artistic one, into which he felt it might be absorbed and disappear. Despite occasional Dada-style statements to the contrary ("all writing is crap"), the pioneer Surrealist Antonin Artaud had been insisting on the value of literature as an end in itself. He was joined by Philippe Soupault, who broadened the argument to include painting and the other arts. This view was opposed to that of Breton, Aragon, and Eluard, and in November, 1926, the exclusion of Artaud and Soupault from the Surrealist circle was publicly announced. Breton had defied Naville by upholding the usefulness of art as a *means* of expression. Now he challenged Artaud and Soupault by rejecting art as an *end* in itself

and questioning its autonomy. His position was delicately balanced, and in subsequent years the tightrope he walked would be shaken by many different hands.

The immediate cause of the crisis of 1929 was a reunion of intellectuals convoked by Breton to examine "the recent fate of Leon Trotsky," who, displaced by Stalin, had just been sent into exile. No one in Surrealist circles doubted Trotsky's revolutionary faith, and it seemed nothing less than one's duty to concern oneself with the situation of Lenin's former comrade. Breton envisioned a gathering, not only of Surrealists, but of other intellectuals and artists of the avant-garde, all of whom would unite in a "common action." The nature of the latter was to form the basis of the projected discussion. Breton began by sending to all the persons invited a request for a statement of their ideological position and their views on the possibilities and advisability of either individual or collective action. The text of the letter containing this request was provocative. A passage asking the recipient to specify what sort of people he would like to be associated with in collective action brought to a head some of the private disputes that had been simmering around Breton.

His letter was sent to all the Surrealists of the moment (including, among painters, Arp, Ernst, Magritte, Masson, Mesens, Miró, Man Ray, and Tanguy), to the Clarté circle, to the editors of Grand Jeu and Esprit, to such intellectuals of the left as Georges Bataille (who had recently founded the review Documents, for which Desnos, Leiris, Prévert, and others were writing), and to former Dadaists, including Duchamp, Picabia, Tzara, and Ribemont-Dessaignes. A number of recipients did not reply at all; some did so in jesting, scathing, and even abusive ways. Those who wrote generally serious replies were invited to a meeting on March 11, 1929, in the Bar du Château at the corner of the rue du Château and the rue Bourgeois. Among the invited were a few whose ideas were "challenged" (by Breton) and who were "excused" from taking part in the discussion "in view of their occupations or their character." (These included Tanguy, Man Ray, Prévert, and Duhamel.)

The meeting began with the reading of the letters that had been received in answer to Breton's. Among those against the common action proposed by Breton were Miró and Masson. Ernst's letter demanded the undeviating pursuit of Surrealist activity. The discussion, under Breton's direction, soon strayed from Trotsky and became an inquiry into the personalities and motivations of those who were not present—as well as of a few dissenters, like Ribemont-Dessaignes, who were. Needless to say, the meeting ended inconclusively, and no action regarding Trotsky was undertaken.

Just as the failure of his much earlier proposed Congress of Paris had caused Breton to lose faith in Dada and inspired him to the statement of his own aims that became the nucleus of the first Surrealist manifesto, so now the collapse at the Bar du Château provoked a new crise de conscience. (As Ribemont-Dessaignes later observed tartly, these had become "the speciality of the house.") [150] The rejection of Breton's leadership by many Surrealists, as well as by virtually all non-Surrealists, called for a new definition of his position and a "purification" of the movement that would permit "a new departure." This new definition took form in the second Surrealist manifesto, which Breton published in La Révolution surréaliste in what proved to be the last issue of that review, that of December 15, 1929. "Whatever may have been the controversial issues raised by former or present followers of Surrealism," Breton wrote, "all will admit that the tendency of Surrealism has been always and primarily in the direction of a general and emphatic crisis in consciousness, and it is only when this is happening or shown to be impossible that the success or historical eclipse of the movement will be decided."

The second Surrealist manifesto said virtually nothing about the technique of automatism that had constituted the heart of the definition of Surrealism in the first manifesto. Breton conceded that automatic writing and, above all, the recital of dreams could still be useful, but he deplored the fact that the possibilities of these techniques had increasingly led their practitioners into art. These practices now had to be restored to their original experimental, scientific basis, the purpose of which was the discovery of the nature of man (and hence his liberation), free from the need of "the artistic alibi."

Surrealism is not interested in paying much attention to that which is produced on its margins under the pretext of art, even anti-art, of philosophy or anti-philosophy, in one word, of all which has not for its end the resolution of the being into a dazzling interior gem that will be no less the spirit of ice than that of fire.

Surrealism is redefined as the resolution of apparent contradictions; its locus operandi is the "plane of convergences."

Everything leads to the belief that there exists a certain spiritual point where life and death, the real and imaginary, the past and future, the communicable and incommunicable, the high and low, cease to be perceived contradictorily. Now, it is vain to seek in Surrealist activity another motivation than the determination of this point.

The "dazzling gem" of which Breton speaks and the "supreme point" which he uses as an alternative to the "spiritual point" mentioned above have the flavor of alchemists' language. Indeed, the second manifesto has such a mystical and speculative tone that we are not surprised to find part of its text devoted to alchemy, Breton envisioning himself as heir to the tradition of Nicolas Flamel and the fourteenth-century alchemists. Surrealism was now searching for the "philosopher's stone" which would allow the imagination of man "to take a dazzling revenge on the inanimate." "I proclaim," Breton concluded, "the profound and veritable occultation of Surrealism."

This new orientation inspired the mystique of inanimate objects that became so central to the later phases of Surrealism and was already being explored in the paintings of Magritte. From "uncovering the strange symbolic life of the most ordinary and clearly defined objects"—which Breton called for in the second manifesto—it was only a short step to the creation of Surrealist objects themselves. These concrete realizations of the irrational or the oneiric were to proliferate in the 1930s, created as much by poets as by painters.

In view of its historical context, it is not surprising that a part of the second Surrealist manifesto was devoted to attacks on personalities. Many dead, who had been resurrected in the first manifesto as precursors of the movement, were once again interred, including Baudelaire, Poe ("let's spit in passing on Edgar Poe"), Rimbaud, and Sade (though he was shortly to be returned to grace). Among the Dadaist progenitors of Surrealism who were treated unkindly were Duchamp (whose endless chess playing was treated derisively), Ribemont-Dessaignes (dismissed as a movie-magazine hack), and Picabia (criticized for having succumbed to the role of being "merely" a painter). Only Tzara seemed to have remained pure, and, despite their former antagonism, Breton asked him to accept a place in the ranks of Surrealism.

From among the Surrealists themselves, the "purification" required the heads not only of Artaud and Soupault (already excommunicated) but of others, including Masson (once "si près de nous"). All of the expelled were described in an offensive manner. Robert Desnos, "who played a necessary and unforgettable role in Surrealism," was regretfully dismissed for wanting to pursue his destiny as a poet and, what was worse, for supporting himself in the meantime by journalism.

The vilification heaped on various personalities at the Bar du Château and in the second manifesto did not go unanswered. Early in 1930, a broadside violently attacking Breton appeared. Containing brief texts by Leiris, Raymond Queneau, Desnos, Ribemont-Dessaignes, Prévert, and Bataille, it described Breton variously as a "cop," "false curé," and "false revolutionary." On the cover was a faked photograph of Breton with a crown of thorns and the expression of a chromo Jesus (fig. D-134). The title of the pamphlet, Un Cadavre, was one that Breton had previously used for an attack on Anatole France, and the pamphlet ended with the same proclamation: "Il ne faut plus que mort cet homme fasse de la poussière." Breton's riposte to this came in the formal edition of the second manifesto (1930), where he printed side by side texts from Un Cadavre and admiring remarks about him written earlier by the same authors.

The ranks of Surrealism were much thinned by all these excommunications and defections, but Breton was heartened by the joining around 1930 of many new members, including Georges Hugnet, René Char, Luis Buñuel, and Georges Sadoul, while Tanguy and Man Ray, previously suspect, once again returned to favor. Ernst remained in the group; Miró began to drift away ("to navigate alone," as Breton put it) but did not break openly. Masson, however, was out, though he continued to paint with no immediate change in style (he would later call himself a "dissident Surrealist").

The new organ of the movement was Le Surréalisme au service de la révolution. This title indicated, as already pointed out, that there was no longer any question of an independent Surrealist revolution. The new magazine's pages were soon to carry Alberto Giacometti's sketches for his relatively little-known but extraordinary Surrealist sculptures. The artist whose appearance in the ranks of Surrealism seemed at the time the capital event in the movement was, however, Salvador Dali. "For three or four years," according to Breton, "Dali incarnated the Surrealist spirit, and his genius made it shine as that could only have been done by one who had in no way participated in the often ungrateful episodes of its birth."[151]

SALVADOR DALI

Salvador Dali's best pictures—like Illumined Pleasures and Accommodations of Desire (coloplates 30, 31)—have a hallucinatory power as images which they owe to the immediacy and naïveté of an inspiration born of his first contacts with Surrealism. And though this freshness of conception began to fade under the weight of self-consciousness and theorizing, Dali's impact on the movement can hardly be evaluated in terms of painting alone. For some years Dali

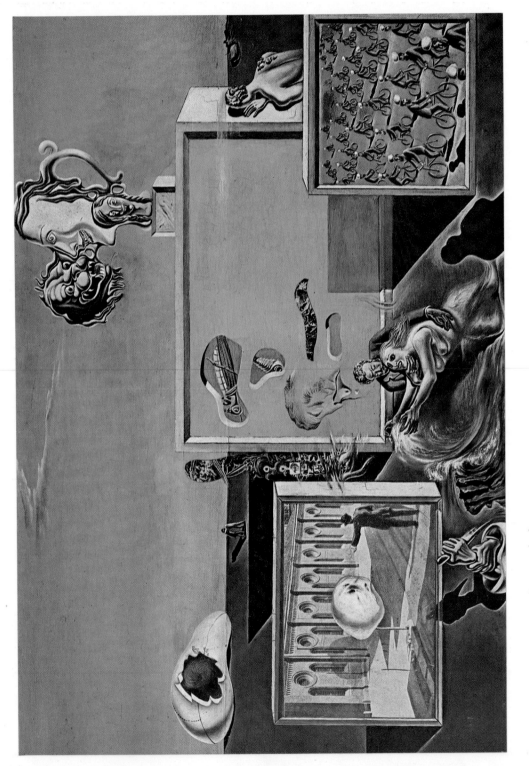

XXX SALVADOR DALI *Illumined Pleasures*. 1929

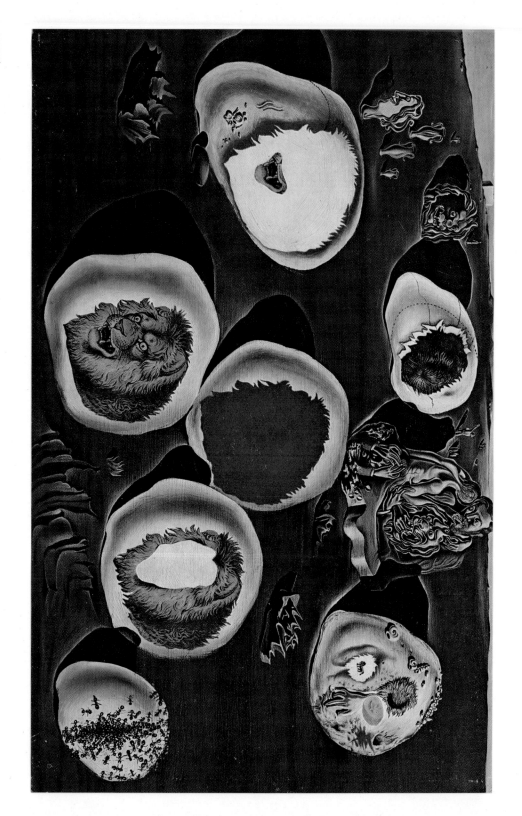

kept Surrealist circles in constant effervescence with his "critical" writing, his *gestes* (comparable to the best of Dada in their anarchic humor), his objects, and his poetry. "It is perhaps with Dali," wrote Breton, "that all the great mental windows are opening."

All these activities issued from what Dali called his "paranoiac-critical method," which he defined as "a spontaneous method of irrational knowledge based upon the critical and systematic objectification of delirious associations and interpretations"; alternatively, he described it as based upon "the interpretative-critical association of delirious phenomena." Behind this lay the methods described in the first Surrealist manifesto and the techniques of association which Max Ernst, inspired by that text, had derived from Leonardo in his earliest *frottages*. But Dali, in arguing for the assumption of a state of paranoiac delirium, seemed to be going further. He stressed "the speed and inconceivable subtlety of mind" frequent in paranoiacs and considered himself "supremely gifted with the paranoiac faculty." "I believe," he wrote in "L'Âne pourri" (1930), "that the moment is near when by a procedure of active paranoiac thought, it will be possible . . . to systematize confusion and contribute to the total discrediting of the world of reality."

Paranoia is a mental derangement characterized by chronic delusions and hallucinations, especially of grandeur, persecution, and castration. It had been the particular subject of research of Dr. Jacques Lacan, an acquaintance of some of the Surrealists, who found his work of special interest at the time of Dali's contact with them. (Dr. Lacan summarized his findings in *De la psychose paranoïaque dans ses rapports avec la personalité*, published in 1932). Dali, who had already been reading widely in Freud and Krafft-Ebing, made it clear that he was not claiming to be a true paranoid but rather that he could induce a paranoiac state in much the same ways that Surrealists had induced trances during the *époque des sommeils*. "The only difference between me and a madman," Dali observed, "is that I am not mad."

Visually the "paranoiac-critical method" referred to the hallucinatory power to look at any object and "see" another. Thus in Dali's pictures a woman's head becomes a pitcher, an egg, the head of a lion, a man's arm, a woman's torso. This, of course, goes beyond *hineinsehen* ("overreading"), the process involved in Ernst's *frottages* and in Masson's and Miró's automatism. In these latter cases the *Gestalt* was formed from disparate and often "abstract" visual cues. For Dali the second image (and the third, and so on, into "an infinity of multiple images") was derived from a visual field already discrete, well-defined, and logical in its components;

or, alternatively, such images were produced by intense concentration on an absolutely blank field. "I spent the whole day," wrote Dali in his *Secret Life*, "seated before my easel, my eyes staring fixedly, trying to *see*, like a medium. . . . Often I saw images exactly situated in the painting. Then I would paint them—with a hot taste in my mouth—at that very spot. . . . At times I would wait hours without such images imposing themselves."

In his very first Surrealist paintings Dali seems to have drawn some of his image components spontaneously from such deeply personal sources as his own childhood memories and dreams; in unexpected and poetic ways, they relate to one another and to the context of the picture as a whole. But from 1931 on, his image components were increasingly taken from an a priori vocabulary of symbols. Dali's visions became functions of his readings in psychiatry, suggestions from which began displacing experiences drawn from his own psyche. Whereas the imagery of de Chirico, Ernst, and Magritte focused primarily on the familiar, common denominators of human psychology, Dali's iconography dealt with more abnormal, exacerbated states as, for example, his obsessions with castration, putrefaction, voyeurism, onanism, coprophilia, and impotence. James Thrall Soby long ago observed that Dali's Surrealist pictures "swarm with fetishes direct from Krafft-Ebing's case histories—slippers, keys, hair and so on." Of all the Surrealist painters, Soby added, Dali "was the most directly indebted to Freud."[152] In differentiating himself from a madman, Dali was saying more than he knew, for this madness-by-the-book explained the mechanical and stereotyped character his imagery so soon acquired. The true paranoid, like the dreamer, is not in control of his hallucinations. He does not need to force them, or to read Freud and Krafft-Ebing to know how to embody them. Dali's induced "paranoia" was essentially a posture, and it was inevitable, therefore, that he should turn to texts on abnormal psychology for his ideas, just as he turned to pictures by de Chirico, Ernst, and others for symbols for them. In a sense, Dali's method, professedly based as it was on *totally* circumventing conscious concerns, including artistic ones, was doomed from the start, for as Breton was to remark in his "Art of Madmen" (in *La Clé des champs*), only insanity guarantees *total* authenticity.

Dali visited Freud in London in 1939, shortly before the latter's death, and Freud, who had seen reproductions of his work, gently reproached him:

It is not the unconscious that I seek in your pictures, but the conscious. While in the pictures of the Masters—Leonardo or Ingres—that which

interests me, that which seems mysterious and troubling to me, is precisely the search for unconscious ideas, of an enigmatic order, hidden in the picture. Your mystery is manifested outright. The picture is but a mechanism to reveal it.[153]

Salvador Dali was born in 1904 in the town of Figueras near Barcelona. His childhood, as he recounts it in *The Secret Life of Salvador Dali*, was punctuated with fits of rage against his family and schoolmates, cruel practical jokes, and adventures in voyeurism that proved prophetic for his painting. The Catalan love of fantasy was to appear in his work only when his art had matured, but the Catalan landscape, particularly the almost boundless plain of Ampurdan, the beach at Rosas, and the rocks of the Costa Brava, supplied material for his pictures from his student days on; and these nostalgic motifs of his childhood environment continued to appear in virtually all his Surrealist works, whether painted in France or in Spain.

At the age of twelve, Dali was already drawing very competently and had even begun more abstract experiments (for example, *Pianque*, 1916) with heavy impasto handled in a brushy manner. The following year, he began searching out catalogues of exhibitions of modern art. One devoted to Futurist reproductions led him to imitate that style convincingly in a group of paintings, including a *Self-Portrait*, which he completed before leaving for the Madrid School of Fine Arts in 1921 (fig. D-135). There the professors were relatively liberal: they advocated color divisionism and various other practices derived from Impressionism. Dali's characteristic contrariness took the form of espousing the kind of academicism from which the professors had just emerged. His two favorite artists became Modesto Urgell y Inglada ("the Catalan Böcklin"), who had had a passing influence on Miró, and Mariano Fortuny ("the Meissonier of our country").

Two years later, Dali was following the Scuola Metafisica (more particularly Carrà than de Chirico) and deriving his motifs from reproductions in books published by Valori Plastici; thus the Neo-Classical simplifications of late *pittura metafisica* are evident in pictures like his *Venus of Port Lligat* (1925). At about the same time that this painting was executed, Dali was also dabbling, under the influence of reproductions of Picasso, in Cubism and collage (*Harlequin, Pierrot with Guitar,* and *Pure Still Life*; fig. D-137), which he continued to do through 1928. Still at the same time, he had begun working in the tight, realist style (akin to Dutch seventeenth-century still-life painting) that we see in *The Basket of Bread* (1926; fig. 191). The exceedingly painstaking execution in the latter picture is akin to that of Meissonier, whose detailed realism Dali has since preserved as his ideal. In *The Basket of Bread,* however, the trick of enlarging the area devoted to the highlights, rendering the transitions of shading abruptly, and surrounding shadows with halos of light gives the subject an unreal, apparitional luminousness, a visionary quality foreign to Meissonier. And Dali was later to use these same devices in the depiction of fantastic objects.

Among the disparate styles evident in Dali's art of 1925–28 that of *Senicitas* (1928; fig. 192) emerged as crucial for his subsequent development. It is clear from this work that Dali had by this time seen paintings by Ernst and Miró; but the pervasive influence here is that of Tanguy. Tanguy's influence had already appeared in two Dalis executed later in 1927: *Apparatus and Hand* (fig. 193) and *Blood Is Sweeter than Honey.* The first contains orthogonal devices and the diminutive horizon vistas that were to be characteristic of Dali's perspective after 1928. The "apparatus" is an adaptation of scaffoldings on the order of de Chirico's *Jewish Angel* (fig. 117), and the "hand," surrounded by seemingly electrified antennae borrowed from Tanguy—in juxtaposition with a female torso that floats in the air at the left—hints at the onanistic motif explicit in the 1929–30 pictures.

The blue landscape ground of *Senicitas* is dominated by a large biomorphic torso balanced on one extrusion. In the center of this form, which is surrounded by hairlike motifs of a kind Tanguy was already using in the transitional pictures of 1926 reproduced in *La Révolution surréaliste,* Dali has tentatively modeled a navel and the musculature of an abdomen. In the upper-left corner of the picture is an elongated pyramid with cryptic letters at its base, an image resembling those in a number of Tanguys of 1926 and 1927. At the side of the pyramid are meandering, transparent linear ribbons lifted virtually intact from a central motif in Tanguy's *Storm* (fig. 171). Along with miniature torsos, heads, and curious fossilized forms distributed helter-skelter over the surface, *Senicitas* also contains birds and birds' heads of the type used by Ernst in his paintings of 1926–27 and, in a section on the left, guitar shapes in flat color à la Miró.

But even as Dali was executing these works, he continued his Cubist experiments, some of which, like *Head of a Woman* (1927), derive from Picasso's "curvilinear" Cubism of the late twenties and contain the profile within a full face which marked that style. Early in 1928, while at work on *Beigneuse* (sic; fig. 194), the most Tanguyesque of all his paintings, Dali visited Paris, where he met

Picasso; under the latter's influence his development was once again diverted, and upon his return home he executed some twenty collage-reliefs on white grounds, most of which were subsequently thrown away because his parents "saw absolutely nothing in them except a few stones, a few pieces of rope, and some tiny ideographic signs." Some months later, Dali revisited Paris, met Miró and, through him, Desnos, Eluard, and other members of the Surrealist group. Returning to Spain, he resumed the style of *Blood Is Sweeter than Honey* and began some of the pictures that were completed in the first months of 1929, like *The Lugubrious Game* (colorplate 32). In the fall of that year, these and other paintings were exhibited in Paris at the Surrealist-oriented Galerie Goemans, and Breton, who, like Eluard, had begun buying Dalis, wrote the catalogue essay.

The paintings of 1929 are unquestionably Dali's best. In them his style is completely consistent and assured, and their complex iconography contains virtually the entire repertory of motifs that he would soon be stringing out more and more programmatically. The technique is a fastidious, realistic illusionism that Dali identified with Meissonier. He understood his adaptation of this "retrograde technique" (his own term) as a defiance of art in the esthetic sense, in effect, as a kind of anti-art. Though he would later proclaim such realism a suitable vehicle for great painting (when he "became Classic" and saw himself as the perpetuator of the traditions of the old masters), Dali in his Surrealist days viewed this technique as a way of bypassing "plastic considerations and other *conneries*" and creating supraesthetic images which would be "a functional form of thought" whose "mortal purpose . . along with other Surrealist activities" was to "contribute to the ruin of reality." In the *Conquest of the Irrational* he wrote:

My whole ambition in the pictorial domain is to materialize the images of concrete irrationality with the most imperialist fury of precision.—In order that the world of the imagination and of concrete irrationality may be as objectively evident, of the same consistency, of the same durability, of the same persuasive, cognoscitive and communicable thickness as that of the exterior world of phenomenal reality. . . The illusionism of the most *arriviste* . . art, the usual paralyzing tricks of *trompe-l'oeil*, the most . . . discredited academicism, can all transmute into sublime hierarchies of thought. . . .

The facture of Dali's Surrealist paintings is even tighter than Meissonier's ("Dali has had the courage," he wrote of himself—characteristically in the third person—"to strive to emulate Meissonier, and he has nevertheless succeeded in painting like Dali"); many passages could have been executed only with the help of a magnifying glass. The cumulative effect resembles more than anything else that of Pre-Raphaelites like Holman Hunt and John Everett Millais, whose pictures Dali profoundly admired and about whom he later published an article in *Minotaure*. This tightly detailed realism made possible a phenomenal concentration of imagery in a small space. Dali called the results "hand-painted dream photographs." Nor is it accidental that most of Dali's best pictures are practically miniatures (*Illumined Pleasures* is 9⅜ by 13¾ inches, *Accommodations of Desire* 85⅝ by 13¾ inches, *The Specter of Sex Appeal*, fig. 202, 7 by 5½ inches). In the larger paintings the unarticulated expanses of shiny surface are visually oppressive—for some of the same reasons that photography remains a small-format art—while in the small ones, where concentration is obligatory, the image takes on the quality of an opalescent, jeweled object. At the same time, this diminutive size seems particularly suited to such an "interior image," for the screen of the mind's eye is felt to be small.

Partly as a mirror to measure his extreme realism, Dali affixed to many of his early paintings bits of photographs (men's hats—a nod to Ernst—in *The Lugubrious Game*, a lion's head in *Accommodations of Desire*), of whose presence most observers are unaware, since the photographic realism is perfectly matched by the painted realism. These "invisible" materials constitute a kind of "anti-collage," a complete reversal of the role and meaning of the original Cubist invention.

The larger pictures make us particularly aware of the dullness of Dali's color; his kind of modeling, built up by successive films of glazes, inevitably promotes a graying-out of whatever color it is applied to. (He himself considers color the least impressive element of his art.) On rare occasions, when called for by the iconography (as in the red silhouette of a lion's head in *Accommodations of Desire*), Dali will use a patch of flat color, but his exact choice of color seems arbitrary at best. His characteristic alternation between diluted large areas and high color accents in saccharine tones has a cosmetic effect, and his drawing is so purely illustrative that it can achieve no independent vitality or expressiveness. "Seen in separation now from their objects," Donald Sutherland notes, "[Dali's lines] seem flaccid and irresolute when curved, brittle or dispirited when straight, and timid when played against each other. On the other hand they are infallibly *graceful*, with a chic and a sort of svelteness that have made his adventures in the world of fashion and decoration perfectly secure."[154]

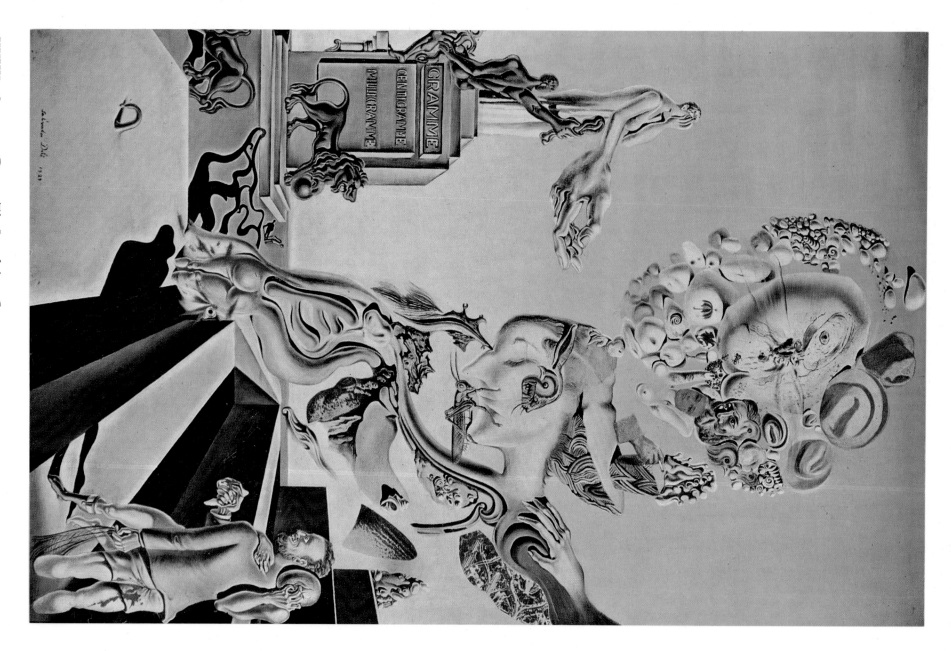

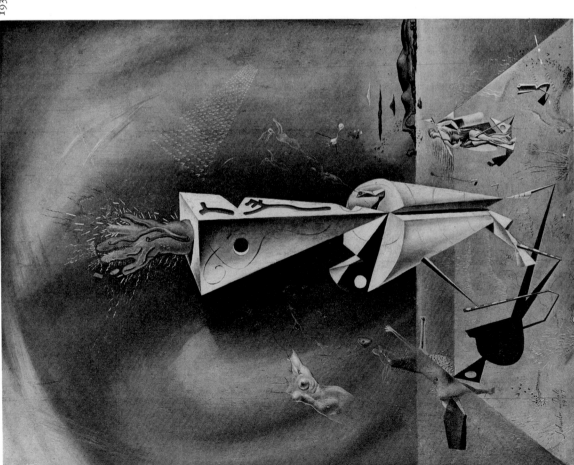

193 SALVADOR DALI *Apparatus and Hand.* 1927

194 SALVADOR DALI *Beignense* [*sic*]. 1928

195

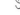

195 SALVADOR DALI *Imperial Monument to the Child-Woman. c. 1929*

196 SALVADOR DALI *Profanation of the Host. 1929*

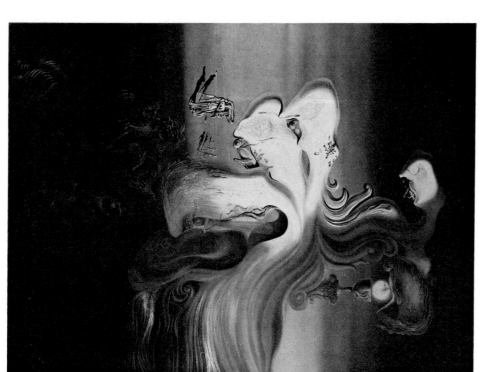

196

197 SALVADOR DALI *The Invisible Man.* 1929–33

198 SALVADOR DALI *The Persistence of Memory.* 1931

199 SALVADOR DALI *The Birth of Liquid Desires.* 1932

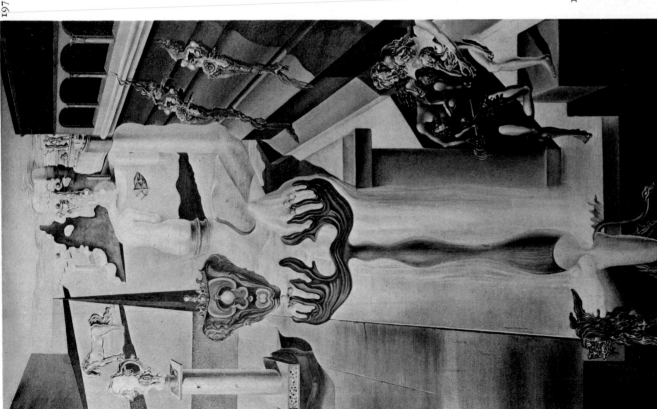

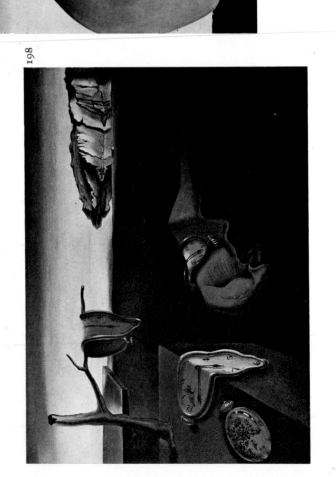

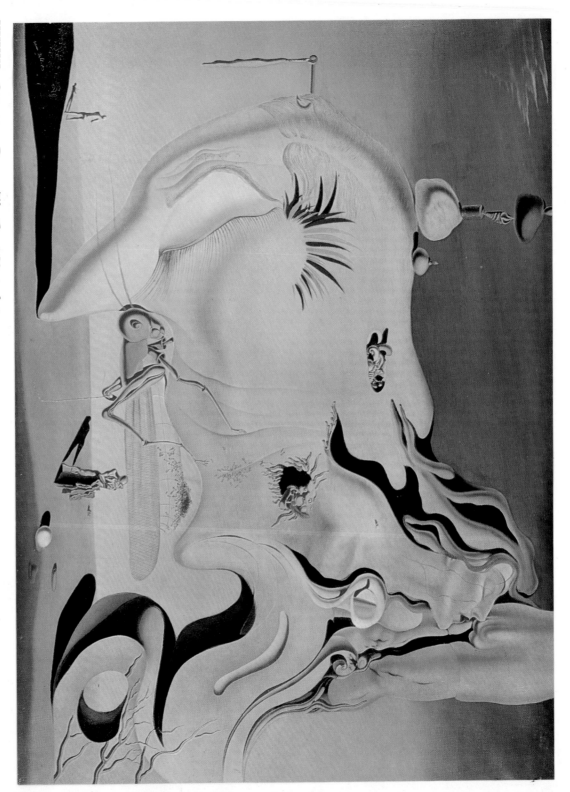

statue on a pedestal in *The Lugubrious Game*, where his right hand is enlarged—by virtue of its special function—to half the size of his body. (Segmented hands are familiar properties in these early Dalis, having already been specifically celebrated in the transitional *Apparatus and Hand.*) In *The Lugubrious Game* a muscular Negro supplies the Dalian youth with the missing phallus in the form of a large bone that Dali calls a "sex fossil" and which he holds before him later in *The Specter of Sex Appeal* (1934), where he represents himself as a child in a sailor suit "observing the Eternal Feminine."

The motif of the young man turning away in shame is identified with castration as well as onanism, as in Dali's various versions of the William Tell story, which he interprets strictly as a castration threat. In *William Tell* (1929) the bearded, leering father, his own sex boldly displayed, reaches out with a pair of scissors as his son turns away in anguish, his sex replaced by a leaf. In certain paintings, notably *Accommodations of Desire*, the nude young man hides his head in shame on the shoulder or chest of this same bearded father.

The interpretation of this bearded man as a father figure emerges self-evidently from a context like that of *William Tell*, but this can also be confirmed by tracing the motif back to the images in de Chirico and Ernst from which Dali took it. The prototypal image is the looming figure in de Chirico's *The Child's Brain* (fig. 106). This massive, bare-chested, mustached personage is generally interpreted as a fantasy of the artist's father.[156] In Ernst's *Pietà* (subtitled *Revolution by Night*; fig. 126) this same figure, slightly altered, is depicted holding a son in his arms—the origin of Dali's young man. To the right in the Ernst, drawn on a wall, is an enigmatic standing figure with full beard and mustache and bandaged head. It is this auxiliary figure, who in Dali's mind became associated with the father holding his son in the same picture, that is the *exact model* of the father figure in the Dalis of 1929–30. At the same time, the motif of the head turned in shame is derived from de Chirico's *The Return of the Prodigal* (fig. 121), which is re-enacted by tiny figures in the distant landscape of *Illumined Pleasures.*

Like the son, the father, too, is represented in *Illumined Pleasures* in two different forms, the second of which is a bulging-eyed, grinning lion's head put next to a woman's leering face at the top of the picture. (This same lion's head is the main subject of *Accommodations of Desire*, where it is a pasted-in cutout from a color gravure, parts of which are repeated verbatim—in paint—on big amorphic "stones"; colorplate 31.) Dali himself has identified the lion's head as a symbol of his father, though its constant sexual association with female figures would make that clear in any case. The origin of the image seems to have been the childhood hallucination of a cat's head. At the top left of *Imperial Monument to the Child-Woman* (c.1929; fig. 195) a cat is shown smiling hideously as part of a "family portrait"; in the upper right of the same picture the cat changes into a lion.

The female face that touches the lion's head in *Illumined Pleasures* is a double image, taking also the form of a jug with a handle, a fusion based on the Freudian commonplace of women as symbolic receptacles. We see such vases side by side with the same woman's head, in minuscule, in the upper left of *Accommodations of Desire*, and a similar jug-headed woman confronts a leering lion in *Portrait of Paul Eluard* (1929), where she is depicted in a cross section revealing a hollow interior containing a piece of putrescent fruit.

On the horizon, at the left of *Illumined Pleasures*, is a "cephalic biomorph" inspired, to judge from the "seams" on its surface, by the heads of the de Chirico mannequins. It has been partly torn open to reveal a toupee—exactly the same as the one at the top center of *Accommodations of Desire*. Though not as frequent a symbol as some others in Dali's art, the toupee also appears in such paintings as *The Great Masturbator*, where it is placed on the Dalian head in a form that points to its source in the mannequins' toupees in such de Chiricos as *I'll Be There . . . The Glass Dog* and *The Fatal Light* (figs. 111, 115).

The influence of de Chirico on *Illumined Pleasures* goes still further. There is not only the familiar elongated shadow—of a hand holding a knife at the bottom of the picture—but, in the lower right, the disembodied shadow of a mysterious presence akin to the shadow in de Chirico's *The Mystery and Melancholy of a Street* (fig. 109). Finally, there are the three "boxes"; those on the left and right are precisely the type of boxed picture-within-a-picture invented by de Chirico for *Grand Metaphysical Interior* (colorplate 12) and other works. The pictures inside the boxes in *Illumined Pleasures* are, however, handled more in the manner of Magritte than of de Chirico. (It is not without significance that Magritte was one of Dali's first friends among the Surrealists, and had visited him in Spain at the time *Illumined Pleasures* was painted.) The boxed picture on the left shows a man conjuring a biomorph (counterpart of those in *Accommodations of Desire*); while the one on the right shows numberless gentlemen on bicycles balancing on their heads what Dali identified as "the sugared almonds of the Playa Confitera which tantalize onanism." These also appear, not surprisingly, on the Dalian head in *The Great Masturbator.*

I have already touched on the influence of the proto-Surrealist,

1921–24 Ernsts in tracing the antecedents of the bearded father figure in the lower center of Illumined Pleasures. The 1925–27 Ernsts, too, make themselves felt in the totem composed of very colorful birds' heads that runs up the center of this same painting (and which was anticipated in the transitional Senicitas). It is also probable that the pasted-in photograph, which is the basis of the image in the left box of Illumined Pleasures, was suggested by Ernst's photomontage and collage techniques.

The remaining motif in Illumined Pleasures is the distracted woman who is trying to wash the blood off her hands in a miniature tidal wave while being held by the bearded father figure. The tinness of the wave and of the cliff on which it abuts—like the disparities of scale in dreams—wrenches perspective in a way similar in technique to, but more pronounced than, that in de Chirico and Ernst. To the left of the woman with bloody hands, isolated and enlarged—as if synopting another phase of her narrative—her hand holds a bloody knife and is being restrained by another hand gripping it at the wrist. The interpretation of this motif must needs be very speculative since it is the only motif in the picture that is not repeated in some other context in Dali's art.[157]

One of the most unusual and prophetic of Dali's Surrealist paintings is Imperial Monument to the Child-Woman, which he abandoned when it was just short of completion. The picture celebrates Dali's beloved Art Nouveau, from which come the unwinding arabesques and convoluted forms that decorate the strange "monument," in which various heads, segmented anatomies, and private icons (for example, Meissonier's head of Napoleon or the Gioconda) are imbedded. The incrustations of surface so common in Art Nouveau seem to have suggested this kind of texture, as is particularly noticeable at the top of the picture. Alternately gemlike and putrescent, the effect harks back to the "Byzantinism" of Moreau at the same time that it anticipates the decalcomania effects achieved by Ernst in such of his later works as Napoleon in the Wilderness (fig. 388), where, as in this Dali, the theme is voyeurism.

The meandering and organic character of Art Nouveau decor (especially in Gaudi, whose works were part of the Catalan environment of the painter's childhood) lent itself well to imaginative "overreading," or hineinsehen; in many others of Dali's pictures of this period various aspects of that style are transformed into Dalian icons by the "paranoiac-critical technique." This is especially true in The Invisible Man (1929–33; fig. 197), where a characteristic Art Nouveau terminal is converted into a "vaginal head." "No collective effort," Dali has observed, has succeeded in

creating so pure and disturbing a dream-world as these Art Nouveau buildings which, on the fringe of architecture, constitute in themselves alone absolutely valid realizations of desires made concrete, in which the cruellest and most violent automatism painfully betrays a hatred of reality and a need for refuge in an ideal world, as in the typical structure of childhood neurosis . . . the ornamental objects of Art Nouveau reveal to us in the most material way the persistence of dreams in the face of reality.[158]

The recent revival of interest in Art Nouveau—as witnessed in part by the large amount of scholarship being devoted to it—should not obscure the minimum of validity in Dali's claim that he "was the first—in 1929, at the beginning of La Femme visible—to consider, without a trace of unseriousness, the delirious architecture of Art Nouveau to be the most original and extraordinary phenomenon in the history of art."[159] Cahiers d'Art, in the very year Dali wrote the above, had described Gaudí as the architect who ruined the city of Barcelona.[160]

Imperial Monument to the Child-Woman is especially noteworthy for its inclusion, as tiny figures in the distant landscape, of the peasant couple from Jean-François Millet's Angelus. From this same painting Dali, three years later, was to derive a host of variant images by means of "paranoiac-critical" interpretation. (A. Reynolds Morse[161] mistakenly identifies the Meditation on the Harp of 1932, fig. D-139, as the "initial recreation of the figures derived from Millet's Angelus.") In the first issue of Minotaure Dali published the introduction to a projected study of The Angelus, a reproduction of which had hung in his grade school. But this introduction is merely a general elaboration of his "paranoiac-critical method" and says nothing about The Angelus itself. On the basis of the pictures themselves it is clear that, for Dali, the significance of the Millet painting did not lie in its kitschig religious sentiment but in what he considered its masked sexual implications. One of Dali's etchings for Les Chants de Maldoror in which he develops the Millet image has Millet's peasant holding his cap before him to hide an immense erection; a pitchfork, thrust into the "feminine" earth in The Angelus, is here thrust into the woman's vitals. (An ink-drawing variant of this etching shows the peasant woman pointing a butcher's knife at the erection and recalls the bloody-handed woman in Illumined Pleasures.)

One of the most curious among the other Dali works that take their point of departure from The Angelus is the 1933 painting Atavism of Twilight (fig. 200). Here the male peasant, though standing, is depicted as dead ("as in the praying mantis couple," said Dali), with a skull for a head and a cutout hole over his heart.

in some more poetically titled works of 1929–30. The bureaucrat in question is shown seated on the steps of Dali's home at Port Lligat, wearing a chemise and socks held up by garters (fetishistic accouterments in which Dali clothed figures as different as William Tell and Millet's peasant). The back of his head bulges far out (though not as much as in the "hydrocephalic" of *The Average True and Invisible Harp*, 1932, where a crutch is required to support the bulge), and the highlights of its modeling match the clouds and sky above (making him "atmospherocephalic"). He is "milking" a giant skull whose "soft constructions" hang down like cows' udders. The metaphor of a bureaucrat "milking" the minds of his subordinates is a simple Freudian metaphor-*cum*-dream image, and the notion of "milking," particularly when the milking is done with a bureaucrat's virtuoso skill, leads, on the dream level of metaphoric fusion, to the idea of harping, thus the "cranial harp." (Obliquely referred to in the title is the onanistic implication of harp playing, which becomes clear when we remember Dali's use of elongated "phallic skulls" projecting from the body and supported by crutches in such other pictures on the "harper" theme as the *Meditation on the Harp*, 1932.)

Other titles of this period, like *The Specter of Sex Appeal*, are less complicated, but equally unconcerned with poetry. In this striking little picture (which is reproduced here in its original size; fig. 202) Dali depicts himself as a child in a sailor suit, holding a hoop and a "sex fossil" and contemplating a giant putrescent female anatomy supported by crutches. In *Minotaure*[162] Dali had postulated that the difference between a *phantom* and a *specter* lay in the former's being stable and volumetric (his examples included Garbo, Meissonier's *Napoleon*, Freud), while the latter was unstable and decomposing (among the examples were his wife, Gala, Harpo Marx, and Marcel Duchamp). *The Specter of Sex Appeal* has legs and arms of rotting bones (suggested by Picasso's earlier "bone" figures but entirely different in character), a stone for a stomach, a back of rotten wood, and potato sacks for breasts, all held together by old rags. The head is missing, but the landscape background at that point is depicted in such a way as to suggest the head as a double image. This picture amounts to the visual realization of Dali's proclamation (in the above-mentioned article) that "the new sexual attraction of women shall come from the possible utilization of their spectral capacities and resources, that is to say, their possible dissociation, their luminous charnel decomposition . . . the spectral woman will be demountable . . . permitting each part to be shown separately, isolating them to be offered to be eaten separately."

Salvador Dali. *Homage to Millet*

The wheelbarrow of the original is attached to the man's head at the tip of one of its handles and floats in the air like the text balloons in comic strips. Dali has recorded that the "two sacks in the wheelbarrow are two sugared almonds of the Playa Confitera" which, as we have learned elsewhere, "tantalize onanism."

The obviousness of *Atavism of Twilight* is characteristic of the more labored, self-conscious associational schemes that dominate the iconography of Dali's pictures of 1932–34. A concomitant literalness is reflected in many of the titles of that period, even those that appear at first to be very arcane. The seemingly cryptic *An Average Atmospherocephalic Bureaucrat in the Act of Milking a Cranial Harp* (fig. 201) turns out to be a straightforward, if whimsical, description of the action in the picture rather than an enigmatic extension of it, as

228

Salvador Dali. *Cavalier of Death*

The putrefaction in the *Specter* is a familiar theme in Dali's art of the early thirties. What he called the "land of treasures" was supposed to lie "hidden" behind "the three great simulacra: excrement, blood, and putrefaction." The putrefying bones in *The Specter of Sex Appeal* share with the limp watches and gelatinous anatomies familiar elsewhere in his painting the need to be supported by crutches. The crutches are ubiquitous symbols of a special problem of Dali's which Marcel Jean cautiously characterizes as "always being haunted by ideas of deficiency." (Jean devotes a large section in his discussion of Dali to a highly imaginative yet convincing analysis of the limp watch as the symbol of a soft penis.[163])

Though constituting the first of "the three great simulacra," images of excrement are not nearly as frequent in Dali's art as those of putrescence, though they do appear (and allude even to coprophagy) more often in his poetry. The most obvious scatological illustration Dali produced as a painter is the man shown defecating in the lower right of *The Lugubrious Game*. (According to Dali, Breton was at first exceedingly distressed by this motif, but was finally won over to it.)

Coprophagy, the edibility of women, the comestibility of paintings and even of the Surrealists themselves ("we are food of the best quality, decadent, stimulating, extravagant . . . we are caviar") form a constellation of themes among which the holy wafer of Dali's Catholic childhood could hardly fail to appear. The Host, which, according to Dali, was offered by the Church "to appease the cannibal frenzy of moral and irrational hungers," enters a number of his paintings of 1929–30. It is the central subject in the large *Profanation of the Host* (1929; fig. 196), the protagonist of which is a biomorphic monstrosity of meandering Art Nouveau contours; from this monster there protrude several Dalian heads of the type of *The Great Masturbator*, one of which is eating the luminous wafer that floats just above a goblet of eucharistic wine. The same impulse to desecration led later to Dali's picture of Jesus with a flaming heart inscribed "Sometimes I spit on the portrait of my mother for sheer pleasure," and to many scenes in *L'Age d'or* (figs. D-142, D-143), a film made by Dali and Buñuel in 1930, in which the final image is a crucifix ornamented with women's scalps. (A riot broke out at the first performance of this film at the point when it showed a chauffeur emerging from a limousine and setting a monstrance on the ground while a pair of sexy woman's legs followed him from the car.)

Donald Sutherland locates the sources of Dali's sacrilegious imagery in Spanish tradition:

> There is an extreme but stable kind of Spanish cynicism which has been defined as the compulsion to crap on the tidiest places. The common Spanish oath, *me cago en Dios*, and its variant, *en la Virgen*, are scarcely possible in English, either verbally or in feeling. They are scandalous in Spain but readily felt. In much the same way Dali's . . . remark, "I spit on my mother!" (*sic*) may scandalize us but does not correspond, I think, to any common feeling, matriarchic though we be. Perhaps because nothing is quite so sacred with us as it can be in Spain, desecration is irritating or amusing but not really exciting, and Dali's . . . horsing around with sacred persons and objects seems to us a lighter comedy than it is.[164]

However much Dali's desecrations may have to do with his Spanish heritage, they fitted comfortably into the anti-Catholicism not only of Surrealism but of the whole literary tradition from which Surrealism sprang (for example, the Black Mass in the early Huysmans and the sexual profanation of Christianity in Sade). But Surrealism's antagonism toward the Catholic Church was heightened also by a definite feeling of competition. Breton speaks frequently of "a certain extrareligious *sacredness*" to be "disengaged from the degenerating ritualisms (i.e., organized religion) which cover it"[165] as one of the main contributions of Surrealism. A Surrealist manifesto addressed to the Vatican began: "It is not you, O Pope, but we, who are the confessional." (In *Un Cadavre* Breton was called a "pope" by the dissident Surrealists.) Surrealist circles were stirred by a special excitement when a defrocked priest named Jean Gengenbach, who happened on a copy of *La Révolution surréaliste* while contemplating suicide, was converted to Surrealism. Gengenbach continued to wear his cassock as a provocation and could be seen wearing it in cafés like the Dôme and the Rotonde, where he would sit with a pretty girl on his knees. (One of the quaintest photographs in *La Révolution surréaliste* shows "our contributor, Benjamin Péret, insulting a priest.") Gengenbach later tried to reconcile Surrealism and Christianity and, failing in that, returned to "the faith of [his] childhood," while denouncing Breton as the incarnation of Lucifer and the Surrealists as demons. Such reconversions are familiar sequels to earlier apostasies: Dali's return to Catholicism during the Spanish Civil War, commemorated by his meretricious Madonnas and epicene Jesuses, is in the tradition of the returns of Huysmans and Verlaine. "For an ex-Surrealist to become a Catholic mystic," Dali was to proclaim in retrospect, "was an ineluctable evolution."

Dali was by no means the only Surrealist painter to mock Christianity. Masson's skeletonic and animalistic priests of the late thirties were familiar anticlerical propaganda inspired by the Spanish Civil War,

Almost every one of the Surrealist painters had been born and baptized a Catholic, and blasphemy, as T. S. Eliot remarks, is closer to belief than indifference. It was in the work of a minor painter named Clovis Trouille that the Church was most blatantly insulted. The December, 1931, number of *Le Surréalisme A.S.D.L.R.* reproduced his *Remembrance* (fig. D-145), in which a priest is shown

Clovis Trouille

raising his cassock to expose frilly drawers, garters, and stockings. Dali and Aragon had come across Trouille in a 1930 Exhibition of Revolutionary Artists, and though he never regularly participated in the activities of the Surrealist group, a number of his pictures were reproduced in *Le Surréalisme A.S.D.L.R.* Trouille had studied drawing and worked as an advertising artist, but he painted somewhat like a *naïf*, just as his violent brand of anticlericalism had sources in popular tradition. It remains that his stylized realism was completely lacking in esthetic value, so that his pictures have only documentary interest.

but such monsters as Ernst's *Remembrance of God* (1923; fig. 127) were properly Surrealist in character, and the event depicted in his *Virgin Spanking the Child Jesus Before Three Witnesses: André Breton, Paul Eluard, and the Painter* (fig. D-144) was a typical example of Surrealist "scandal."

Dali had always leaned toward visual tricks, but around 1934 such gimmicks as double and anamorphic images became more common than ever in his art as a result of his study of Mannerist and Baroque fantasists. The double image—in which one set of contours may be read in two different and exclusive ways—had appeared in Dali's work as early as *The Invisible Man* (fig. 197; begun in 1929 but not finished until 1933, owing to the difficulty of jig-sawing still-life objects so that they would also reveal the spectral man of the title). In early paintings like this one Dali intended to offer two images whose meanings would interlock and reinforce one another poetically and psychologically. But this was hard to accomplish, and Dali soon became satisfied to make double images that were simple visual freaks, in which relations of meaning were either crassly obvious or, more frequently, nonexistent.

One of the most typical pictures in this respect is *Paranoiac Face* (1934–35; fig. D-148), a biaxial double image based on a photograph of Africans sitting outside a hut. Dali happened on the photograph in 1931, just after having looked at reproductions of Picassos of the "Negroid" period. The photograph, which is horizontal, was oriented vertically on the table where Dali first saw it, and he thought he was looking at a woman's head of a Picassoid type. In *Le Surréalisme A.S.D.L.R.*, along with the original photograph in both vertical and horizontal positions, he published a simplified sketch which made his "hallucinatory" reading clear (fig. D-147). Three years later, he "equalized" the two readings in the oil titled *Paranoiac Face*. In *Paranoia* (1936) and *Spain* (1938; fig. 205) he used arrangements of figures and horsemen in battle, which, when generalized by the eye, coalesced into women's heads. His drawing had by then changed into a mannered parody of Leonardo's, and the battle motif was inspired by the background of the latter's unfinished *Adoration of the Magi*. Dali wrongly interpreted his double images as illustrations of Leonardo's text on provoking the imagination, which he now proclaimed to be the source of his practice.

Salvador Dali. *Metamorphosis of a Page
from a Children's Book*

Even in the more successful instances, Dali's double images could not but serve to delimit rather than to enrich the pictorial experience. The less realistic, less specific morphology of Arp and Miró, for example, allowed and even provoked myriad readings, since its forms connoted much but denoted little. Such associational overtones were automatically eliminated by Dali's realism, and the double image simply compounded the inherent limitations of his realism, each of the two aspects of the image becoming necessarily less free and imaginative in its arrangement than either would have been alone.

The anamorphic image, which looks like a distorted reflection in a mirror, and was used occasionally by the old masters for cryptic details of illustration, inspired Dali in a group of pictures the most characteristic of which is *Soft Self-Portrait with Fried Bacon* (fig. 206). From Bracelli and Larmessin (figs. D-5, D-6) he derived a variety of ideas, most notably those embodied in his female figures of 1936, whose upper torsos are chests of drawers (for example,

City of Drawers). He even made a *Venus de Milo of the Drawers* (fig. 203) in which sections of a full-sized plaster cast of the statue could be drawn out of the stomach.

Such images as drawer torsos, flaming giraffes, and lobster telephones had become universally recognized as Dali's private clichés by the end of the thirties, but by then he had ceased to belong to

200 SALVADOR DALI *Atavism of Twilight*. 1933

201 SALVADOR DALI *An Average Atmospherocephalic Bureaucrat in the Act of Milking a Cranial Harp*. 1933

202 SALVADOR DALI *The Specter of Sex Appeal*. 1934

233

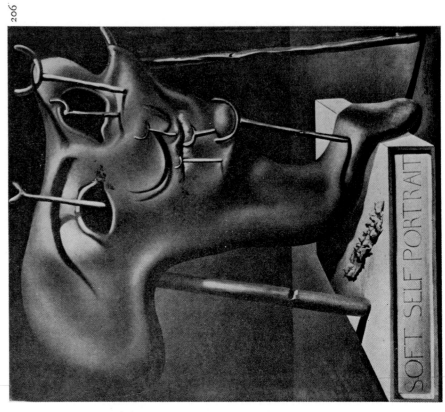

203 SALVADOR DALI *The Venus de Milo of the Drawers.* 1936

204 SALVADOR DALI *A Tray of Objects.* 1936. Exhibited at the first international exhibition of Surrealist objects, Charles Ratton Gallery, Paris, 1936

205 SALVADOR DALI *Spain.* 1938

206 SALVADOR DALI *Soft Self-Portrait with Fried Bacon.* 1941

203
204
205
206

209

207

208

210

207 ALBERTO GIACOMETTI *The Couple*. 1926

208 ALBERTO GIACOMETTI *The Spoon Woman*. 1926

209 ALBERTO GIACOMETTI *Woman*. 1927–28

210 ALBERTO GIACOMETTI *Head*. 1927–28

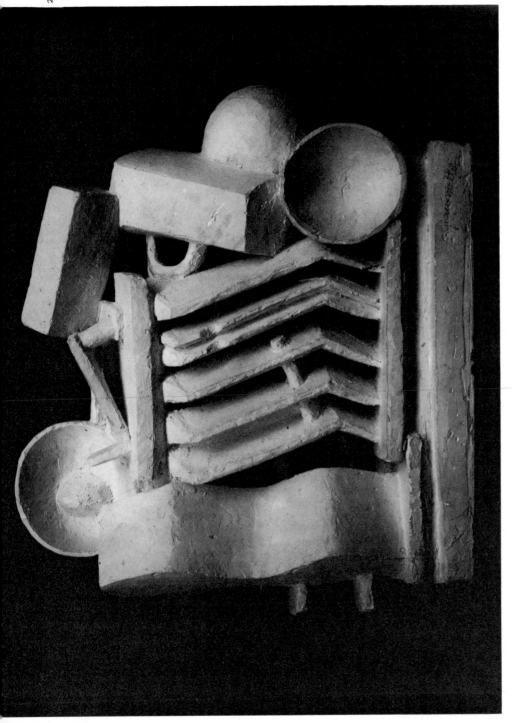

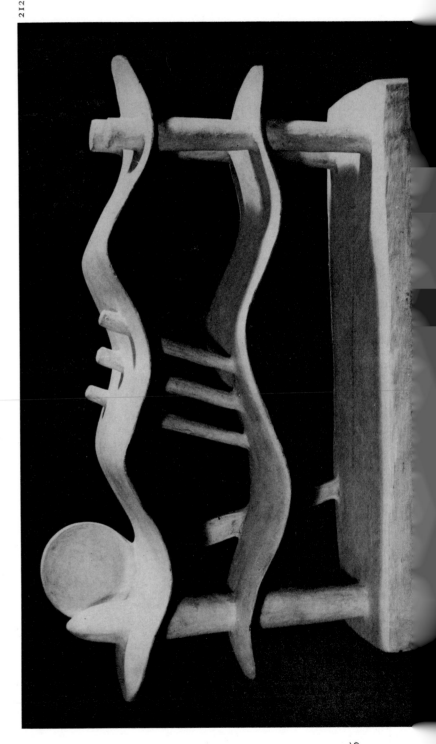

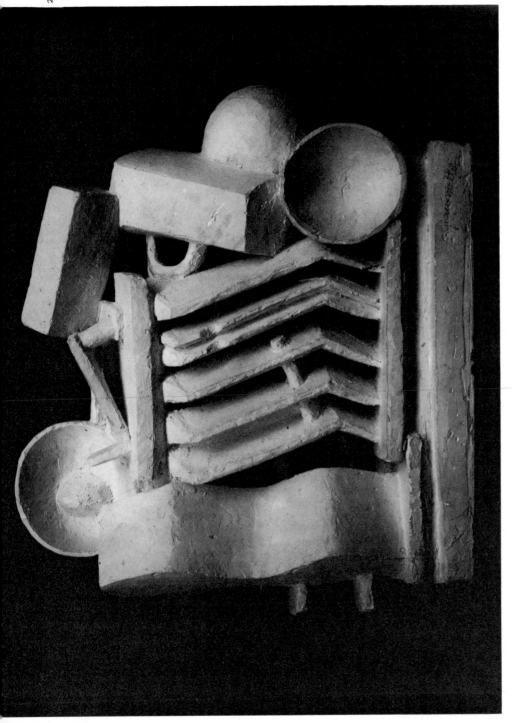

211 ALBERTO GIACOMETTI *Composition.* 1927–28

212 ALBERTO GIACOMETTI *Reclining Woman Who Dreams.* 1929

213 ALBERTO GIACOMETTI *Three Personages Outdoors.* 1929

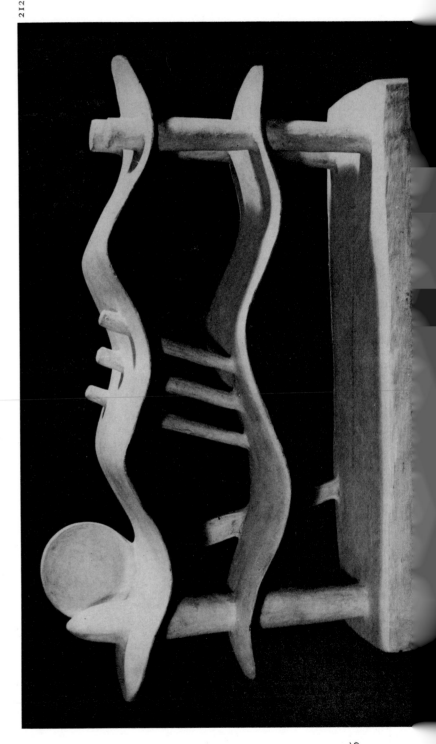

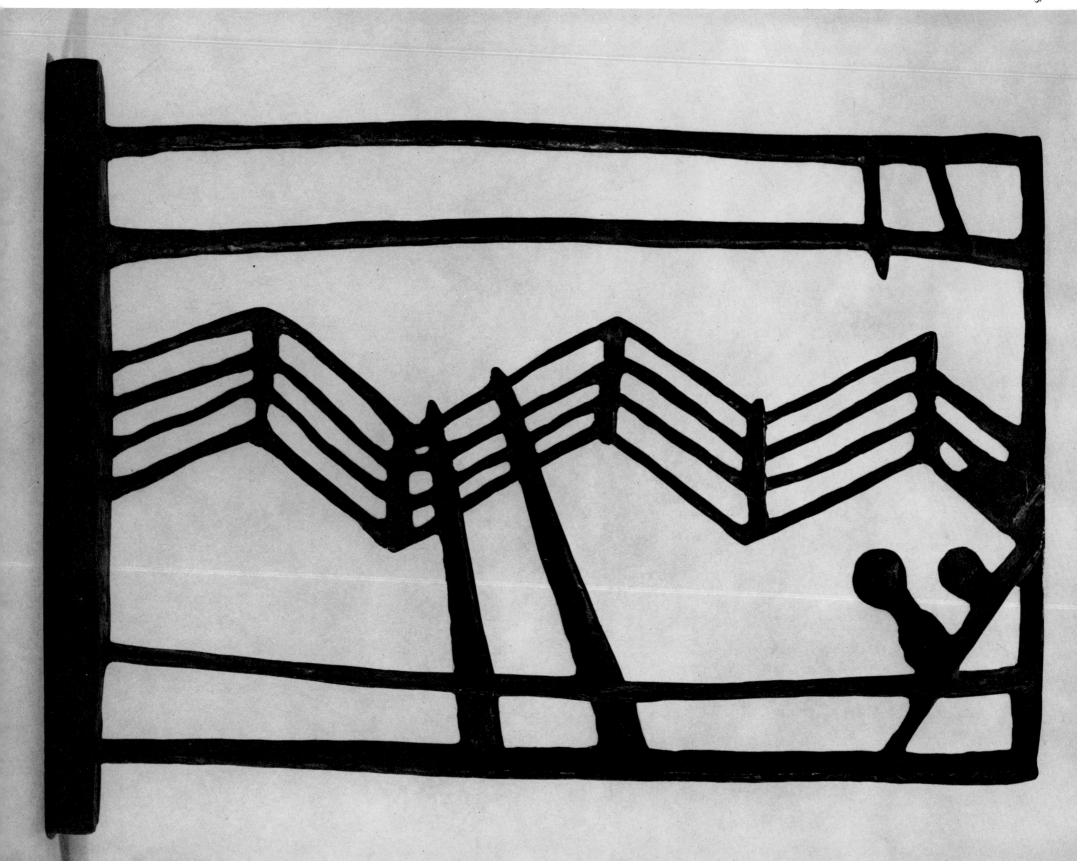

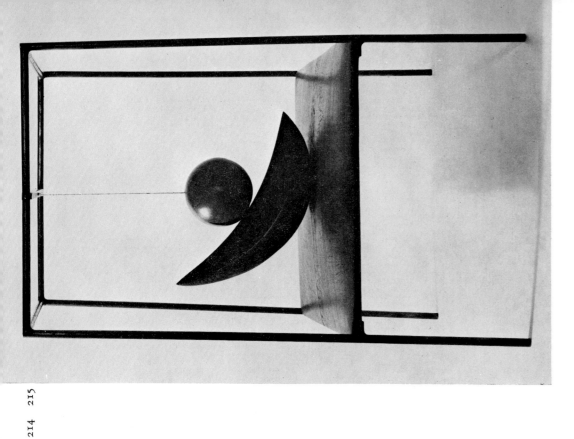

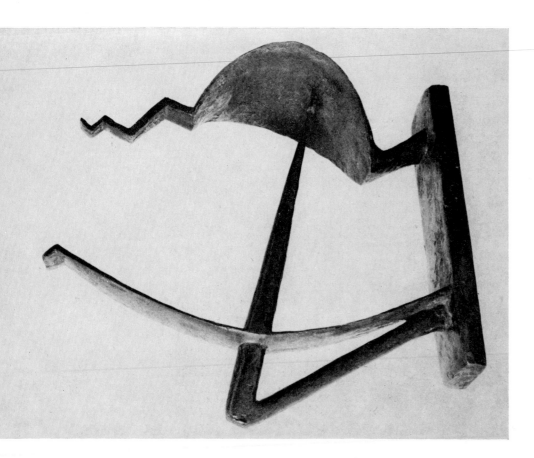

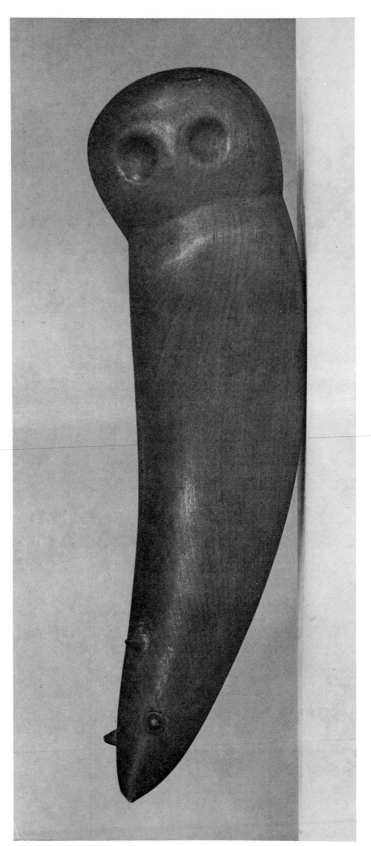

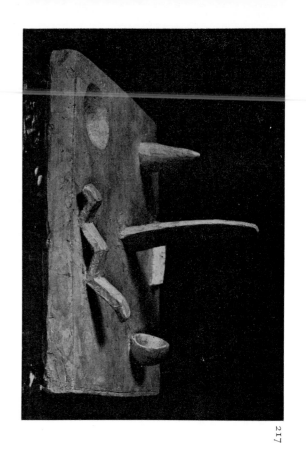

217

239

219

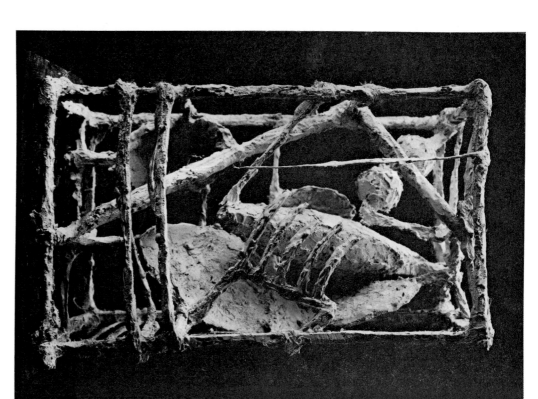

218

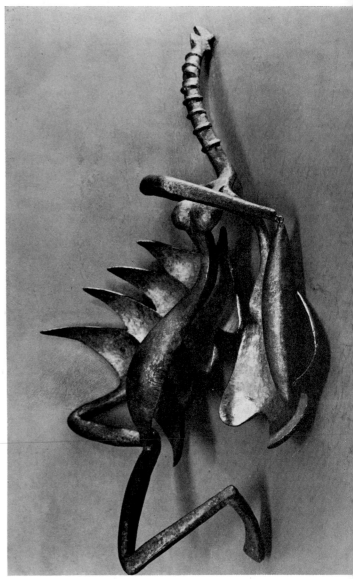

220 ALBERTO GIACOMETTI *Man, Woman, Child*. 1931

221 ALBERTO GIACOMETTI *No More Play*. 1932

222 ALBERTO GIACOMETTI *Woman with Her Throat Cut*. 1932

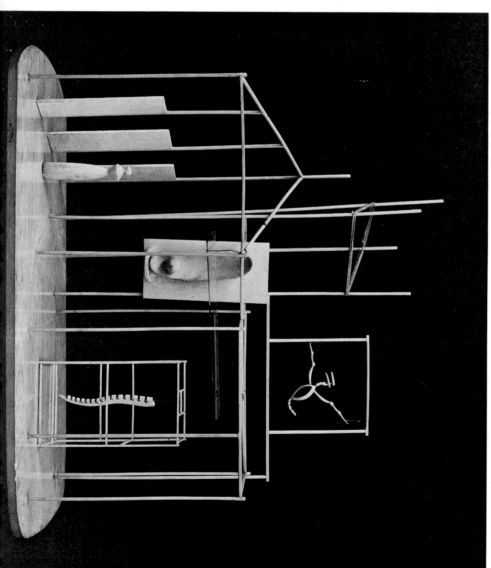

225

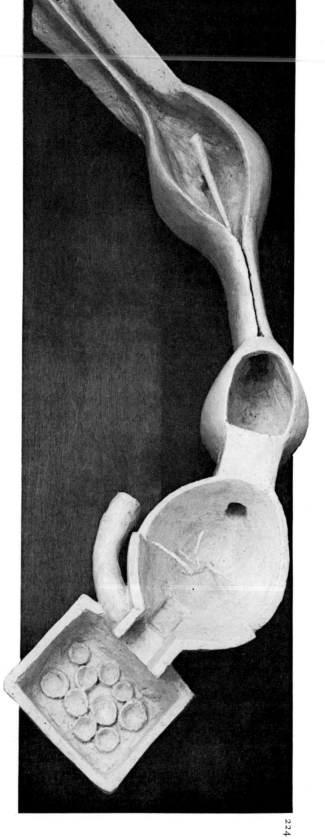

224

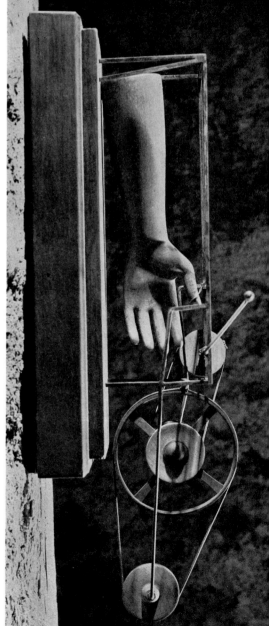

223

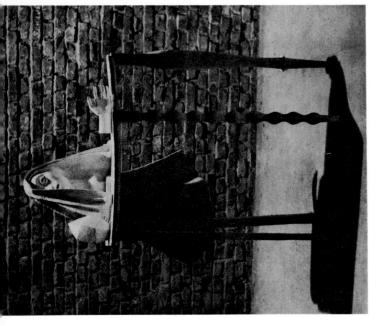

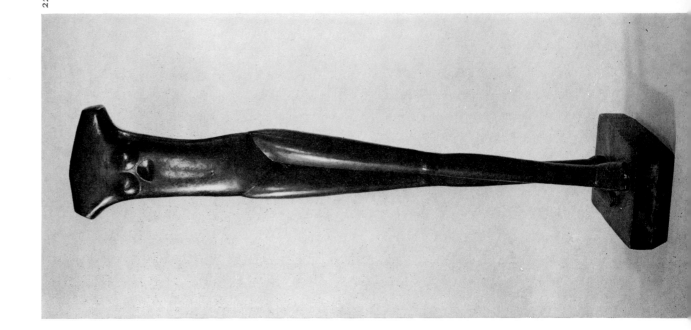

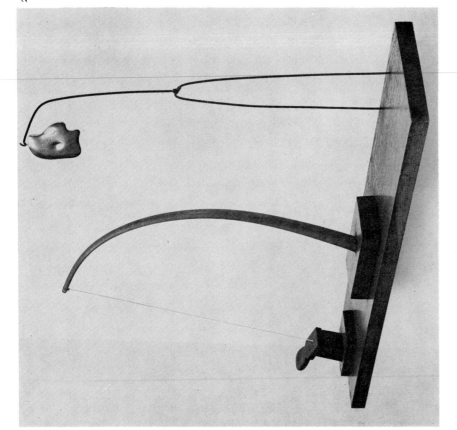

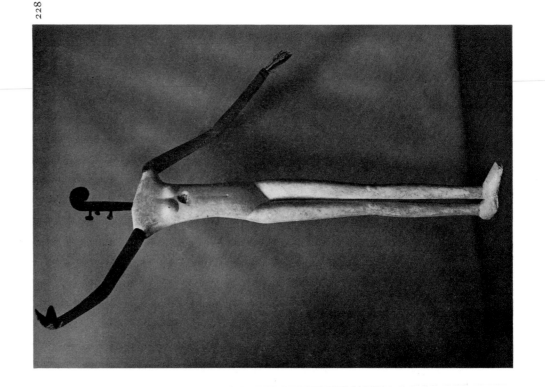

242

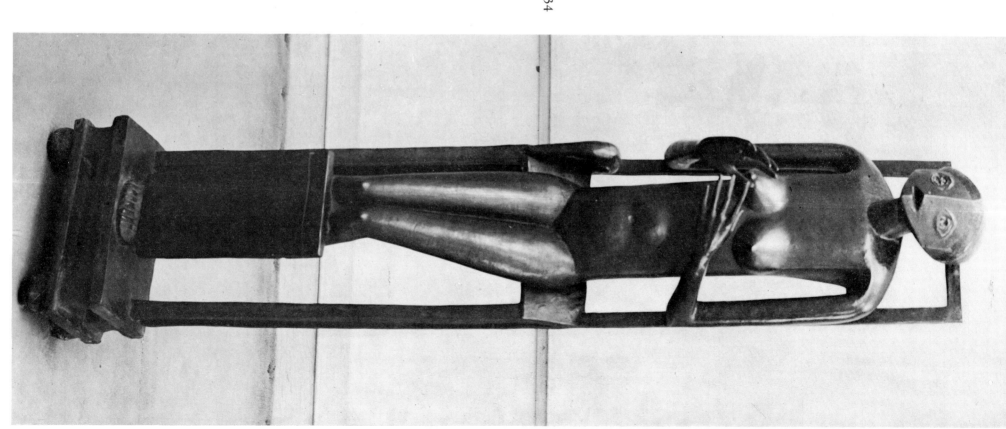

232

231

244

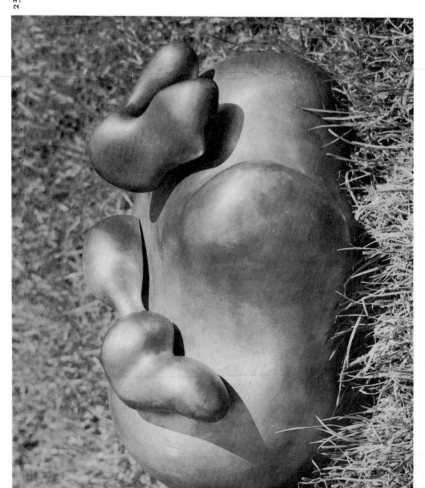

237 Jean Arp *Hand Fruit.* 1930

238 Jean Arp *Head with Annoying Objects.* 1930

239 Jean Arp *Torso.* 1930

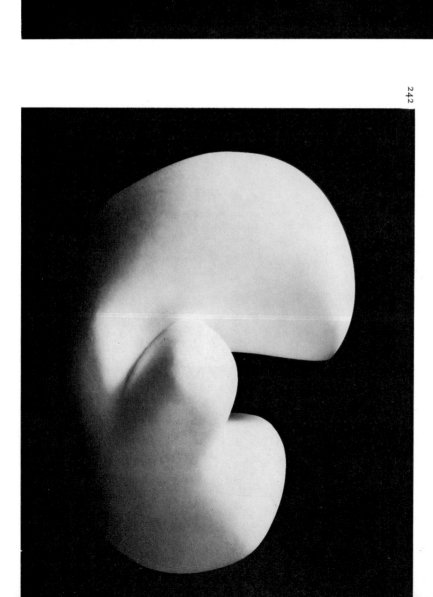

241

242

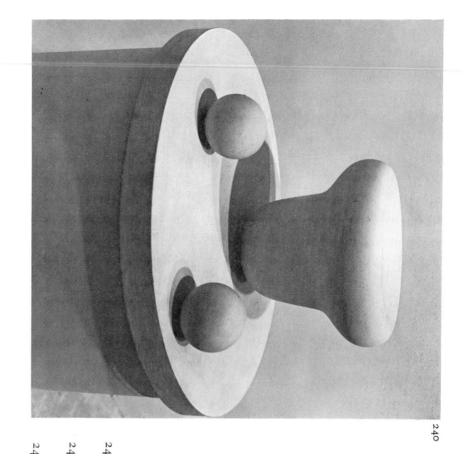

240

240 JEAN ARP *Bell and Navels, 1931*

241 JEAN ARP *Torso, 1931*

242 JEAN ARP *Human Concretion, 1935*

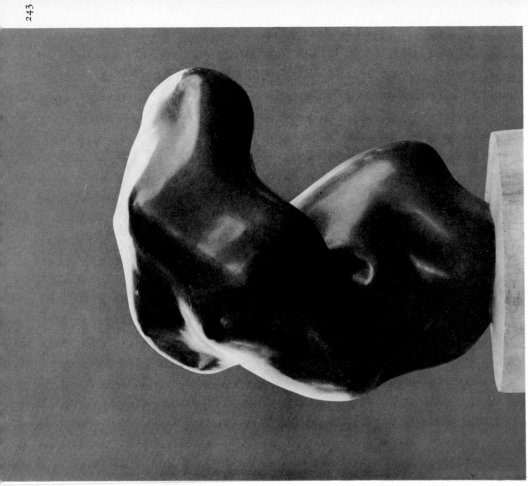

243 JEAN ARP *Human Lunar Spectral.* 1950

244 JEAN ARP *Ptolemy.* 1953

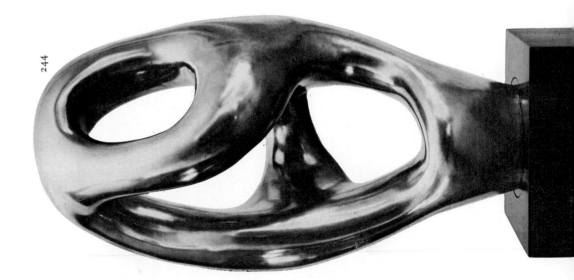

the Surrealist group. In fact, he was officially censured by the movement in 1934, although he continued to be included in its exhibitions for four more years. While his art was felt to be increasingly insincere, what finally brought matters to a head was his failure to act with the other Surrealists in support of left-wing causes (for example, joining the Association of Revolutionary Writers and Artists), an obligation that seemed more pressing than ever in view of Hitler's rise to power in Germany. Dali, moreover, had begun to show signs of a morbid fascination with Hitler. "It was charitably considered to be humor—which it was, no doubt, though of a dubious kind—when themes such as the 'Hitlerian Nurse' began appearing in his pictures," writes Marcel Jean,[166] who has given an extended account of the meeting at which Breton confronted Dali (and for which the latter "had invented a number of gags which would have made his fortune in a vaudeville theater"). Dali defended his Hitlerian imagery by observing that he could not help it if he dreamed about Hitler, and he reminded Breton of the first manifesto, which called for the expression of the unconscious free from moral censorship. In the face of political exigencies, however, Breton was not disposed to take his own manifesto so literally, and shortly afterward pledged himself in writing, along with other Surrealists, to "fight Dali by every possible means." In 1939, Dali proposed—without a trace of humor—that the *malaise* of the world was essentially *racial* and that the best solution would be a concerted effort on the part of all white peoples to reduce the colored peoples to slavery. "I do not see, after that," wrote Breton, "how independent milieux can take any more account of him."[167] And three years later, in his "Genesis and Perspective of Surrealism," Breton noted that Dali's "enterprise" (he dubbed him anagrammatically "Avida Dollars") "has for a long time been giving signs of panic, and has only been momentarily saved by the façade of its own vulgarization. . . . Since 1936 it has ceased to interest Surrealism in any way."

SURREALIST SCULPTURE: GIACOMETTI, ARP, AND ERNST

The pioneer years between the two Surrealist manifestoes saw nothing in the way of Surrealist sculpture. The medium did not especially lend itself to the practice of automatism or to the delineation of the irrational perspectives of a fantasy world; its very concreteness, its displacement of finite space, seemed alien to the imagination. Yet the illusionism heralded by Tanguy and Magritte and consum-

mated by Dali had made an aim of concreteness, of endowing the imagined with the same materiality, "the same persuasive, cognoscitive and communicable thickness" as the real. As a logical extension of this principle into three dimensions, Dali created "dream objects," which were soon at the center of the phenomenal proliferation of objects that characterized Surrealist activities throughout the 1930s. In this context, sculpture began to come to the fore as an art capable of endowing fantasy with a material actuality.

The principle that informed Surrealist objects was a poetic one. Although the artists and poets who fabricated the objects undoubtedly made certain decisions that were prompted esthetically, it was officially understood that the adjustment of components in these assemblages was determined—as in Lautréamont's famous image—only by the efficacy of metaphoric rapports. This, of course, could hardly be maintained for sculpture. Though a combination of found objects could be construed as non-art, the practice of modeling and carving immediately enforced the operation of an esthetic whose underpinning had to come from somewhere. Just as pioneer Surrealist painting depended on Cubism for its point of departure, so Surrealist sculpture presupposed the art of Picasso, Brancusi, and Lipchitz. Out of these sources, and out of the morphologies and technical devices they themselves had used earlier, Arp, Giacometti, and Ernst produced a body of sculpture that may be defined as Surrealist. Arp's sculpture was predominantly a matter of three-dimensional biomorphism; Giacometti's, a transference of illusionist space into miniature para-illusionist fields of actual space; and Ernst's, a translation and modification of collage to the purpose of sculpture. Common to the work of all three was the same type of fantasy that had governed the subject matter of Surrealist painting.

Giacometti

Partly because they are few in number, and hence rarely seen, and partly because the art public has generally accepted Giacometti's own preference for his more familiar later work (shortly after leaving Surrealism he characterized his earlier sculpture as "worthless, fit for the junk heap"), the pieces he made prior to 1935 are relatively little known or appreciated. Yet they are among the freshest and most moving works of art nurtured by Surrealism, and they contain, as we shall see, the germ of much that is prized in Giacometti's later work—though the latter has been mistakenly considered by both the artist and most of his critics to be diametrically opposed in nature. Alberto Giacometti was born in 1901 in Stampa in the Ticino,

the Italian-speaking part of Switzerland. His father, Giovanni, was a painter, as was his uncle Augusto, whose activities had brought him in contact with Dada (see pp. 74–75). At eighteen, after some years in the local *lycée*, Alberto decided to devote himself to art and enrolled in the Académie des Beaux-Arts in Geneva. Dissatisfied there, he almost immediately transferred to the Ecole des Arts-et-Métiers, where he studied sculpture for about six months. In 1920, he traveled to Italy, stopping in Venice, Padua, and Assisi, followed by a long stay in Rome. An avid student of the past, he became particularly interested in Giotto, Tintoretto, and the work of the Byzantine mosaicists. In Rome the museum in the Villa Giulia fascinated him; the archaic and Etruscan sculptures he saw there were to be echoed in the postures and proportions of his later work. David Sylvester remarks on his interest in Egyptian art in this regard. At that time, he was modeling from life (largely portraits), and painting in a Cézannesque style that had evolved from the Pointillist efforts of his student days. Many of his early narrative sketches and paintings were inspired by Sophocles and Aeschylus, in whose works he was then engrossed, and the subjects he chose from them (*The Sacrifice of Iphigenia, The Death of Cassandra, The Sack of Troy*) anticipated the erotic and violent themes of his later, Surrealist phase.

In 1922, Giacometti went to Paris. He entered the Académie de la Grande-Chaumière, where he stayed for three years in Bourdelle's class, drawing and painting from the model. In 1925, when he took his first studio, he settled in Paris permanently, though he returned often to Stampa. From then on and throughout his Surrealist period, he stopped painting entirely, to resume only in 1935, in an attempt to extricate himself from the impasse into which he felt his Surrealist sculpture had brought him. Subsequently, he painted and sculpted concurrently, and drawing has very much to do with his later, painterly style of sculpture.

Actually, Giacometti's first original sculptures antedate by about three years his active participation in Surrealism. What changed with that participation was the inflection rather than the nature of his style; working from memory, as David Sylvester observes, gave way increasingly to working from the imagination (though visual imagination depends upon visual memory). The Cubism ("one necessarily had to touch on it") evident in his work of 1926–28 provided the formal basis for the elaboration of his art during its specifically Surrealist phase. Of the sources of Cubist style closest to him—Brancusi, Laurens, and Lipchitz—it was Brancusi's influence that was at first dominant. In *The Couple* (1926; fig. 207) the head, breasts, arms, and vulva of the woman are pinched in low relief

or shallowly dug out from a flat oval in such a way as not to alter the abstract absoluteness of that form; the effect reminds us immediately of the raised surface "drawing" on the rectangular block of Brancusi's *Kiss*. Giacometti's reduction of the breasts to simple hemispheres, the arms to quadriglyphic ciphers, and the vulva to a virtual oval (repeated on a larger scale as the eye of the male figure) are reminiscent of the stylizations of primitive art, but probably came to Giacometti by way of Brancusi. Also influenced by Brancusi, but remarkably original nonetheless, is *The Spoon Woman* (1926; fig. 208), whose torso is an immense, exquisitely articulated concave ovoid.

In their plaquelike narrowness (foreshadowing in this respect his post-Surrealist figures), *Woman* (fig. 209), *Man*, and *Head* (fig. 210), all begun in 1927 and finished in the spring of the following year, come even closer to Brancusi and to the Cycladic sculpture that influenced him. (The various versions of Brancusi's *Fish* had just been completed.) By the end of 1925, Giacometti had given up working from the model and now worked from memory.

I worked at forcing myself to reconstitute from memory what I had seen at Bourdelle's in the presence of the model; and that reduced itself to very little ... to a plaque disposed in a certain way in space in which there were just two hollows. ... I had begun by wishing to recreate from memory the most possible of what I had seen. I began by making a figure with legs, arms, a head ... but all that seemed false to me, I could not believe in it. In order to realize it, I was obliged little by little to sacrifice, to reduce, to drop the head, arms, everything. Of the figure, there remained only the plaque. And that was never voluntary, nor satisfying, quite the contrary. ... I began two or three different sculptures, and they all arrived at the same point.[168]

In the same year (1927) that he began the plaques Giacometti executed a group of sculptures closer in spirit to Lipchitz than to Brancusi. *Construction* (fig. D-152) is a piling up of blocklike and cylindrical forms in the manner of those early Cubist pieces of Lipchitz that resemble three-dimensional realizations of Juan Gris' and Léger's paintings. (The full-blown Analytic Cubism of Picasso and Braque, being more inherently pictorial, lent itself little to this transformation.) But *Composition* (fig. 211), begun at the end of the year and completed in 1928, reflects, in its departure from the monolith, the influence of Lipchitz' extraordinary "Transparencies" (1926). It also contains, incipiently, the bell forms and parallel struts that Giacometti was to multiply a few years later.

cies," the morphology of his sculpture was entirely personal. And he already went beyond the openness of his more typical pieces of 1928 (like *Reclining Woman Who Dreams*, fig. 212, with its spoon head and undulating body of parallel planes) in the strutlike *Three Personages Outdoors* (fig. 213; finished in 1929)—perhaps influenced by Picasso's steel-wire sculptures of 1928 (fig. 294)—which is further from the monolith than anything in Lipchitz, and anticipates the "cage" sculptures Giacometti was to make during the next few years. From then on, Giacometti remarked, "Figures were never for me a compact mass but like a transparent construction."

The possibility of working in an open, linear manner seems to have liberated in Giacometti a latent sexual violence that was not well served by the more solid, Cubist-inspired forms of 1926–27. We need only compare the *Man and Woman* (1928–29; fig. 214) with the static *Couple* of 1926 already described. Now the man is a taut linear cipher, arched like a bow, from which springs a long, pointed, spike-like sex aimed at a tiny hole in the smooth, concave torso of the woman. "There is, or at least there was," Jacques Dupin observes, "an instinct of cruelty in Giacometti, a need for destruction which closely conditioned his creative activity. From earliest childhood, the obsession with a sexual murder provoked [him].... Formerly, with chance acquaintances or friends, especially women, he could not refrain from imagining how he might kill them."[169] Giacometti's familiarity with Surrealist literature, beginning with his friendship with many of the Surrealists, particularly Masson and Leiris in 1928, and his subsequent formal adherence to the movement in the winter of 1929–30, could only have encouraged him in the unfettered expression of such feelings, and they dominate in the works of 1930–34.

Sexuality—only slightly masked—is the theme of the strange *Suspended Ball* of c.1930–31 (fig. 215), a sculpture that caused a tremendous stir among the Surrealists. (Bought by Breton, it is now sometimes called *The Hour of Traces*, a title previously given to another work of the period.) With *Suspended Ball* a number of new ideas entered Giacometti's work. Having previously perforated the Cubist monolith and then advanced to the very fragile linear structures of *Three Personages Outdoors*, Giacometti now wanted the empty space not only to outweigh the solids, not only to function in and immediately around his "figures," but to constitute an a priori world whose coordinates would be demarcated by the linear frame of the cage.

The suspended ball of the title and its accompanying crescent are located within a space framed by this metal cage. The crescent, asym-

metrically tilted, is attached to the "floor" of the cage, and the ball, hanging down on a string, just touches it. The spectator is invited to slide the ball along the surface of the crescent. "Despite all my efforts," Giacometti recalled, "it was impossible for me then to endure a sculpture that gave an illusion of movement, a leg advancing, a raised arm, a head looking sideways. I could only create such movement if it was real and actual. I also wanted to give the sensation of motion that could be induced."[170] In this case the provocation was to rub the complementary components together. The ball is cloven, and the angular inner edge of the crescent fits into its fissure—but not quite: the string was purposely made a bit too short to allow the forms to dovetail perfectly. "Everyone who saw this object functioning," reports Maurice Nadeau, "experienced a strong but indefinable sexual emotion relating to unconscious desires. This emotion was in no sense one of satisfaction, but one of disturbance, like that imparted by the irritating awareness of failure."[171]

The idea of having the spectator participate in the movement—as when he moves the ball—is wholly different from the chance motion of Calder's mobiles, which, in any event, came only years later. It shortly appeared, however, that Giacometti would not find in movement an important opening for his art—even though he incorporated the general idea of spectator participation in a group of sculptures (like *Disagreeable Object*, 1931; fig. 216) which the spectator was invited to handle and to set down in any position, as well as in *Project for a Square* (1931; fig. 217). ("I wanted one to be able to sit, walk, and lean on the sculpture.")

Cage (c.1930–31; fig. 218) not only defines a spatial box, as in *Suspended Ball*, but crowds it with aggressive, anatomically allusive forms that obstruct, squeeze, and claw one another. Like the other sculptures of this period, it was executed in wood by a cabinetmaker working from Giacometti's full-scale plaster model. Whatever traces of handling are present in the plasters (*Cage* is unusually rough in execution) disappear in the smooth finish of the final versions. This is precisely the effect Giacometti wanted: the feeling that the sculptures had come into existence without any trace of the improvisational, such as the marks left by spatula, hand, or chisel would imply. During those years, says Giacometti, "the sculptures presented themselves to my mind entirely accomplished." As for the execution, "it was almost irritating. It was essential that the sketch having been made in plaster, they would be realized by a cabinetmaker (I retouched them afterward where necessary) so I could see them all done, like a projection."[172]

Because the works of the early thirties were executed in this way, because they sometimes contained moving parts, and above all because they so little resembled what traditionally passed for sculpture, Giacometti tended at the time to refer to them as "objects." (This pleased the Surrealists, for whom the term "sculpture" was freighted with too many esthetic implications.) Yet there is no reason at all why *Cage, Suspended Ball,* and *Disagreeable Object* (a tusklike form with thorny extrusions near its tip) should not be called sculpture. In so doing we distinguish them from the characteristic Surrealist objects made by Dali and others; these were three-dimensional collages whose components had had, individually, previous real identities as objects and did not derive their shapes, as in Giacometti, from the imagination.

The concept of spatial definition heralded by *Cage* received a new and more specifically illusionist orientation in 1931–32 with a series of pieces in which the main component was a flat plane that, tabletoplike, served as a measured and articulated space—a simulacrum of perspective—on which figures and abstract forms could play out their drama. The most remarkable of these works is *Point to the Eye* (fig. 219), in which a series of lines incised in the panel define and measure its space like the markings of a tennis court. At one end, raised on a skeletonic armature of metal, is a tiny, simplified wooden head, the eye of which is almost pierced by the point of a long, abstract wooden form projecting from the other side of the field, where it, too, is raised on a metal support. The exaggerated diminution of that form as it traverses the field acts as perspective foreshortening that at once intensifies the illusion of space and enhances the aggressive movement toward the eye. (The phenomenally elongated *Nose* of 1947 is not unrelated to this 1931 piece in character.) Another form of aggression, this time against the hand, was achieved in the "machine" with the *Caught Hand* (fig. 223). Here the implicit masochism of the situation, in which the spectator turns the wheels, suggests that the onanistic undertones—already present in the *Suspended Ball*—lead to a guilt demanding violent expiation.

Man, Woman, Child (1931; fig. 220) isolates its three movable figures (represented as a triangle, a simplified torso, and a small metal ball) by confining them within respective circular, arcuate, and straight tracks which do not intersect. The isolation of the figures is even more pronounced in *No More Play* (1932; fig. 221), where tiny male and female figures are placed far apart on a surface pock-marked with circular (lunar) pits and divided by three "graves," one of which contains a miniature "skeleton." This existential isolation of figures on a desolate field foreshadows Giacometti's postwar city squares just as the "cages" foreshadow the *Closed-in Figure, Cage,* and similar sculptures of around 1950.

No More Play was also revolutionary in that it *demanded* being viewed from above, thus challenging the traditional orientation of spectator and sculpture as two vertical monoliths in confrontation. Degas had introduced the idea of sculpture seen from above in certain of his small bathers, an advance which, like many others in modern sculpture, represented a translation of new pictorial devices into the sister art. But Degas' bathers, while inviting viewing from above, do not necessarily require it, as they still provide some sort of profile when seen from the side; this possibility virtually disappears in Giacometti's *No More Play.*

Nonetheless, Giacometti's table-top sculptures, though seen from above, were seen obliquely, since they were meant to be raised to a position intermediate between the floor and the spectator's eye by their supports, which thus constituted modified forms of the traditional base or socle. Giacometti saw the issue through to its logical conclusion in the remarkable *Woman with Her Throat Cut* (1932; fig. 222). Here the elements of a vaguely crustacean female anatomy are splayed out horizontally so that profiles and relations can be apprehended *only* from above. This free-lying sculpture literally has to be set on the floor, which is precisely the way Giacometti displayed it and photographed it in his studio (fig. D-151).

Having demarcated quasi-illusionistic space laterally on a horizontal plaque in *Point to the Eye* and related works, it was logical that Giacometti should now want to raise a three-dimensional vertical architecture on it. The wood scaffolding of *The Palace at 4 A.M.* (1932–33; fig. 225) is an extension of the original cage idea to the level of more highly articulated and illusionist table-top sculpture. Here we have the final triumph of the artist's aim of achieving a "transparent construction," which had been signaled by *Three Personages Outdoors*; at the same time, it is the work which best expresses the poetic side of his Surrealism. Here is Giacometti's own account of its creation:

> This object took form little by little (in my mind) towards the end of summer, 1932; it clarified slowly for me, various parts taking their exact form and their particular place in the ensemble. By the time autumn came, it had attained such reality that its actual execution did not take me more than one day.
>
> Without any doubt it relates to the period in my life which had come to a close one year previously, the period of six months passed hour by hour in the company of a woman who, concentrating all life in her, transported

Alberto Giacometti. Project for *The Palace at 4 A.M.*

my every moment into a state of enchantment. We constructed a fantastical palace in the night . . . a very fragile palace of matches: at the least false movement a whole section of this diminutive construction would collapse; we always began it all over again. I do not know why it became populated with the spinal column in a cage—the spinal column the woman sold me one of the very first nights I met her in the street—and with one of the skeletal birds which she saw the very night that preceded the morning our life together collapsed—the skeletal birds hovering very high over the basin of clear, green water, where the very delicate and very white skeletons of fishes were floating, in the great open hall amongst exclamations of enchantment at four o'clock in the morning. In the middle rises the scaffolding of a tower possibly unfinished or whose upper part has collapsed, broken to pieces. On the other side came to be placed the statue of a woman in which I discover my mother the way she impressed herself on my earliest memories. The long black dress that touched the ground disturbed me with its mystery; it seemed to be part of her body and this caused in me a feeling of fear and confusion. . . . I cannot say anything about the object in the center, lying on a small board. It is red; I identify myself with it.[173]

A comparison of the relatively literal figures in *The Palace at 4 A.M.* and *No More Play* with the more abstract symbols of *Man, Woman, and Child* of 1928–30, reveals that the spatial illusionism which had developed in the course of those years tended to foster representational realism as its concomitant. This aspect of Giacometti's development culminated in 1933 with *The Table* and *Mannequin* (figs. 227, 228), particularly the former. In its realism, *The Table* is closer to the typical Surrealist objects of the thirties than anything of his we have discussed so far. Executed in plaster, it is made up of a facsimile table of normal height (the variously styled legs are in the spirit of the lamps and other furniture Giacometti designed for the interior decorator Jean-Michel Frank, beginning in 1930), the top of which serves not as a field for forms reduced in scale (as in the works of 1931–32) but as a locus for objects—a severed left hand, a bottle, an abstract sculpture, and the bust of a woman—reproduced in more or less actual size. The woman's hood veils her right eye, its folds continuing below the table top about halfway to the ground; her position here and, indeed, the whole layout and conception of this sculpture anticipate Ernst's *The Table Is Set* (1944; fig. 250) and *The King Playing with the Queen* (1944; fig. 252). (Ernst was to begin making sculpture in the round the year following *The Table*, on the occasion of a summer visit with Giacometti.)

Except for its head (provisionally added for a single exhibition), which resembles the scrolled neck of a stringed instrument even to the pegs, *Mannequin* of 1933 is realistic, if simplified, in its forms. Jacques Dupin observes that *Mannequin's* proportions, and the proportions of the *Nude*, executed contemporaneously, "announce the future elongated figures." Yet their prophetic character does not stop at this, for in these figures Giacometti discovered for himself a secret that has always animated great figure sculpture and that above all else gives charisma to his later gaunt sculptures: the epiphanous gesture. His *Mannequin's* arms reach out in a way that seems strangely revelatory; it anticipates the effect of the great standing *Man Pointing* (1947; fig. D-153). Sartre has stressed Giacometti's sensitivity to "the magic of . . . gestures," which "he regards . . . with a passionate desire, as if he were from another realm."[174]

In the armless *Nude* (*Femme qui marche*, 1933–34, fig. 229)—a similar archaicizing truncation of limbs occurs later on, in works like *Figurine* (1957, fig. D-157)—the "gesture" is reduced simply to the articulation of the forward step the figure takes. Though the rear heel is raised, the general effect is flat-footed, for, as in archaic striding figures, the weight is not shifted forward. There is much the same articulation in the walking figures of the later "piazzas," where frequently the rear heel still touches the ground. In all such cases this detail of posture makes the movement enigmatic and gives the figure an air of introversion which enhances the atmosphere of isolation.

The literalness that prevailed in Giacometti's sculpture of 1933 occasionally inspired a reaction in the direction of the nonfigurative, as in the solid planar *Sculpture* of 1934. In fact, in 1934, he vacillated considerably between the two contrary impulses of the literal surreal and the purely abstract, which he found increasingly difficult to reconcile. But though in the following year he found himself in what he took to be a cul-de-sac, he was still able, in 1934, to bring together his divergent impulses in one work, *The Invisible Object* (fig. 230), which is unquestionably the greatest figure sculpture of his Surrealist period.

The Invisible Object shows a schematic female figure whose hands gesture as though she were holding something—whence a variant title, *Mains tenant le vide* (*Hands Holding the Void*). Breton interpreted this arcane gesture in a typically subjective way as "an emanation of the desire to love and be loved, in quest of its true human object and in all the agony of this quest."[175] The figure is contained in a cagelike scaffolding resembling what might be a high-backed chair in *The Palace at 4 A.M.*, and her lower legs are immobilized by a panel in front. To her right, at waist height, is the head

of a bird, sister to the primordial one that flies above the palace and cousin to Max Ernst's Loplop. The peculiar, totemistic immobility of this female figure, the ritual-like gesture, and above all the play of the figure against the abstract cage elements especially appealed to Matta, who bought the original plaster. Echoes of *The Invisible Object* emerge in *Le Vitreur* (fig. D-207) and other personages of Matta's private mythology of 1945–50.

Early in 1935, Giacometti abandoned his Surrealist style and shortly thereafter the Surrealists themselves. While his break with Surrealism did not involve quite as much acrimony as Masson's or Dalí's, it was not friendly. The shift in Giacometti's way of working had occurred while he was trying to resolve the problem of a conically shaped female figure titled $1 + 1 = 3$ (1934). "I had to make (quickly, I thought—in passing) one or two studies from nature," Giacometti recalls, "and in 1935 I took a model. This study should take (I thought) two weeks, and then I could realize my compositions. I worked with the model all day from 1935 to 1940."[176]

The major principle of Giacometti's familiar later style, which began to be integrated in the late thirties and matured fully in 1946, was its dependence upon nature rather than upon the imagination. ("What interests me is resemblance; what makes me discover a little of the exterior world.") While there is room for disagreement over the quality of Giacometti's work since the war, Marcel Jean's dismissal of it[177] typifies the objections which the Surrealists would have had to it in any case. Likening the change in Giacometti's art to that in de Chirico's around 1920 insofar as it betrayed a disdain for the imaginative, a "preoccupation with materials and techniques," and the choice of a "sketchy and Impressionistic" style, Jean criticizes Giacometti's later sculptures as "practically identical" and equates them with "those vague human silhouettes that architectural draftsmen include in their *maquettes*."

Giacometti's continuous exploration of just a few models (actually, mostly two—his wife and brother) in his later works particularly confused Surrealist critics, who could not appreciate that it was not the model—that is, the nominal subject—but what was produced in the course of Giacometti's attempt to plumb it which constituted the work of art. "Resemblance" to the model, in the deepest sense, is something Giacometti felt he had never achieved; thus he considered all his later sculptures as "work in progress." He characterized this later approach as "open" and "searching" (as opposed to his Surrealist works, which were "closed" and "found"), Cézannesque in character, and described his situation with Cézanne's plaint, "*le contour me fuit.*"

Arp

During the four years following the summer of 1921—when Jean Arp vacationed in the Tyrol with Ernst, Tzara, and, briefly, Breton, collaborating on *Dada Intirol Augrandair*—he lived a restless life, traveling mostly in Germany and France, with long sojourns, one particularly long one being in 1923, with Kurt Schwitters in Hanover. Only in 1925, on the occasion of the first Surrealist exhibition at the Galerie Pierre, in which he participated, did he move to Paris, taking a studio not far from Ernst's at 22 rue Tourlaque, where Miró had moved from the rue Blomet. Arp remained there for only about a year, however, after which he settled in the Parisian suburb of Meudon, buying the house he lived in until his death. Much of his energy in the years of the *époque floue* had been devoted to writing (he collaborated with Schwitters on the first issues of *Merz*, contributed to Hans Richter's review *G* and to *De Stijl*, and published a collection of poems titled *Die Pyramidenrock*) and to such ephemeral activities as the "Merz matinees" improvised with Hausmann and Schwitters in Hanover.

Just as his development as an artist was not defected by Dada, so there was no discernible shift in Arp's style when Dada was dissolving, nor any change that marks the beginning of his active participation in Surrealism in 1925. The course of Arp's art has evinced little or no stylistic evolution. His development has been hermetic, as it were, motivated by the single-minded search for the perfect plastic realization of a poetic formal language—what he has called his "essential forms"—that was already clearly established in 1916. This search has led him to adventures in mediums rather than in styles, his biomorphic forms achieving their most robust embodiment in free-standing sculpture, to which he did not turn until he was past forty. But though his enduring commitment to the biomorphology he had invented sharpened Arp's profile as an artist, it became a restriction at the same time: while it gave a distinctive stamp and character to his work, it narrowed its formal and expressive range (as comparison with Brancusi's makes clear).

In the years immediately before his move to Paris, Arp worked relatively little, and with the exception of the introduction of string into a few reliefs of 1924 (this technique was further explored in an extensive series in 1928), his work continued stylistically as before, the reliefs in the Galerie Pierre exhibition being indistinguishable from those of the Dada years. In Paris, Arp took part in most of the activities of the Surrealist group; his work was reproduced in *La Révolution surréaliste* accompanied by a laudatory text by

Breton. "Surrealism supported me, but did not change me," Arp recalled, "it perhaps emphasized the poetic, associational side of my work." In 1929, partly as a response to the changed ideals of the movement, Arp ceased being active in it but, like Miró, did not break with Breton, and remained nominally a member in good standing. This did not deter him from active participation in the Abstraction-Création group which he joined in 1932, and in the thirties he exhibited with both groups, now with the Surrealists, now in the company of Mondrian and Kandinsky.

The majority of Arp's reliefs of the 1920s are pictorial in the sense that they are contained within a predetermined rectangular field. Such a limit was probably felt by him to be necessary in order to contain the more molecular distribution of small forms he first introduced in a series for which he resurrected his Dada title *Arranged According to the Laws of Chance* (fig. 235). This framing device also enhanced by contrast the forms that were simply painted on the flat ground; these were compositionally fused with the raised wooden elements in *Infinite Amphora* (1929; fig. 236) and comparable works. But the most interesting reliefs of that period (for example, *Shirt Front and Fork*, 1922, fig. 231; and *Torso with Navel*, 1925, fig. 234) continued to be those which tended more toward the sculptural than the pictorial, by virtue of their meandering outer silhouettes as made possible by the elimination of the rectangular ground and frame. Removed from the wall, enlarged, and set upon bases, these arrangements made the bridge to Arp's free-standing sculptures of 1930.

This transition to sculpture in the round was provoked by a crisis in his work in the winter of 1929–30. To this crisis the first of his *papier-déchiré* collages (1930) bear witness. In their irregularly torn edges and hasty and rough execution, these constitute the sole exception to that insistence upon smooth finish which elsewhere characterizes Arp's collages, reliefs, and sculptures. He had been inspired to make these collages by the discovery that many of his earlier collages had fallen apart. Profoundly disturbed by the physical ephemerality of so much of what he had done, he fell into a depression from which he emerged only when he became able to accept the fact and try to make a virtue of it by tearing the remains of the collages to pieces and regluing them as new and much less precisely ordered works.

It was at this moment of concern with durability that Arp turned again to sculpture in the round, which he had not touched since his student days. The first few essays he made in this direction, early in 1929, appear in retrospect to have been false starts. Unlisted in the

Hagenbach catalogue, and apparently lost, two plaster heads from this group of works survive in photographic reproductions in a special issue of *Variétés*, titled "Le Surréalisme en 1929," that was published in the June of that year (fig. D-158). These reproductions reveal that Arp was not yet able to handle his personal form-language with the consistency and purity in three dimensions that he had shown in two. The chaotic effect of seemingly malleable facial features twisted in fantastical ways is Expressionist to a degree that would not obtain later; Expressionist imagery, however much distorted, is rooted in a realism foreign to Arp's imagination. While these heads recall some aspects of Arp's work in the period 1912–13, it is probable that the Picasso sketches of 1927 (see p. 283) were an immediate influence.

The failure of the works illustrated in *Variétés* indicates that the process of successfully converting Arp's form-language into sculpture in the round did not prove simple; he found he had to proceed through the intermediate step of free-standing reliefs. There was, of course, already a model for such biomorphic sculpture, at least in illusionistic form, in the painting of Tanguy. But Arp rejected this version unequivocally: "Illusionist art is a substitute for nature," he wrote. "I love nature, but not its substitutes. . . . [I] do not want to reproduce but to produce . . . like a plant that produces a fruit."[178] For three years by then, Tanguy had been peopling his landscapes with Arplike biomorphs modeled in the round, a kind of *trompe-l'oeil* anticipation of what Arp himself was now to do. But Arp still proceeded by stages; he went back to pick up the threads of the free-standing reliefs which had occupied him infrequently through the later twenties. This culminated in such wood sculptures of early 1930 as *Hand Fruit* (fig. 237). That piece is composed of a large organic form sawn by a carpenter from a template (as all Arp's wood reliefs were), to which a smaller simple form is attached; though the panels are considerably thicker than those used for the reliefs, there is no attempt to model them at the edges or otherwise articulate their flat surfaces, so that the ensemble remains entirely planar. It is set free-standing on a base formed of two repetitions of the sculpture's smaller form.

Then, in the last months of 1930, Arp made some small sculptures that were entirely modeled in the round and at the same time free of the Expressionist naturalism of the year before. From that point on, he did few wood sculptures; he was not basically a carver, and wood is not amenable to easy modeling. (One of the few exceptions is the uncharacteristic *Bell and Navels* of 1931, fig. 240, reminiscent of Giacometti's sculpture of the same period. Arp was

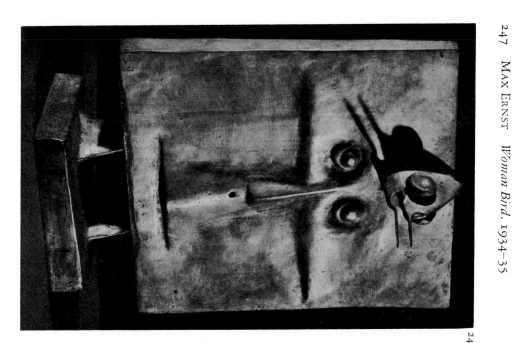

245 MAX ERNST *Stones Carved in Low Relief.* 1934

246 MAX ERNST *Lunar Asparagus.* 1935

247 MAX ERNST *Woman Bird.* 1934–35

247

245

257

246

248 MAX ERNST *Chimeras, Snakes, and Bottle.* 1935

249 MAX ERNST *Moon Mad.* 1944

250 MAX ERNST *The Table Is Set.* 1944

251 MAX ERNST *An Anxious Friend.* 1944

250

251

249

252 MAX ERNST *The King Playing with the Queen.* 1944

in close contact with Giacometti for a while, and always kept the *Man, Woman, Child* he bought from him then.)

Among the most interesting of Arp's first modeled sculptures is *Head with Annoying Objects* (1930; fig. 238). The "head" is an amorphic form slightly over a foot in length, and it sits directly on the ground, being the first of many sculptures Arp was to make without bases. The "annoying objects," which are stylized biomorphs identified by Arp as a mustache, a diminutive mandolin, and a fly, are not attached to the head but may be placed on it in any manner, a freedom from fixed orientation which we have seen in contemporaneous pieces by Giacometti like *Disagreeable Object*. Arp was later to fashion many of his "Human Concretions" (fig. 242) so that they could be placed in landscapes in a variety of positions.

Until 1960, *Head with Annoying Objects* existed only in plaster. *To Be Lost in the Woods* (1932), another small sculpture in three separate parts, is more familiar in its polished bronze casts, as is the *Torso* of 1930 (fig. 239) in its marble and terracotta versions. The material in which Arp works is generally a matter of indifference to him as long as it is attractive and capable of being smoothly finished. His sculpture does not result from a "dialogue" between the hand and the material, as do the forms of Brancusi's work. Arp's formal language has an autonomous, predetermined character that was established long before being adapted to sculpture. Only infrequently does he carve stone directly. (Of the 147 sculptures listed in the Hagenbach catalogue, almost all of which exist in at least one stone version—as well as varying editions of bronzes—only twenty, and these quite small, were carved by the artist himself.) Most of his pieces are conceived in clay and plaster, relatively characterless materials that encourage the metamorphosis and improvisation which Arp's fundamentally additive way of composing demands. The particular material, whether stone, terracotta, or high-tension bronze, is chosen afterwards for its felicity of surface, but is neither carved nor cast by Arp himself.

Some of Arp's torsos of the early thirties (as that of 1931, fig. 241, for example) demand that the spectator place himself primarily at right angles to their essentially planar disposition of forms; this reflects their origin in flat relief (the *Torso* of 1931 was derived from the *Torso* relief of 1925, in the estate of the artist). In 1934, however, Arp began a series called "Human Concretions," the shapes in which were vaguely anthropomorphic in character. Here he confirmed his sense of the sculptural by breaking through, for the first time, the classical, frontal, planar arrangement persisting from his more pictorial reliefs, to configurations that turn and twist in space

like Mannerist sculptures and refuse to give themselves up more completely from one angle than from another. "Concretion," wrote Arp in reference to their generic title, "designates curdling, the curdling of the earth and the heavenly bodies. Concretion designates solidification, the mass of the stone, the plant, the animal, the man. Concretion is something that has grown.'"119 This last remark evokes the gulf separating Arp and Brancusi, despite the superficial resemblances of their work. Brancusi's ascetic sculptures are true abstractions, purified and distilled to the absolute essence of the motif; Arp is less interested in condensing the motif than in multiplying its poetic associations by means of formal ambiguities. Brancusi's sculptural process is centripetal, demanding reduction to the simplest and most economical forms; Arp's is centrifugal, the work growing outward, seemingly organically, from a nucleus.

As Arp's concretions expand, they often surround and shape open space. These "holes" give the finished sculpture a more organic character and at the same time intensify its mass. There is no linear contouring or cagelike containment of three-dimensional space as in Giacometti, but rather a classical alternation of solid and void. Only once—late in his career—did Arp try to surround a three-dimensional spatial core: the forms of *Ptolemy* (1953; fig. 244) wind smoothly around its center rather than grow out of it.

As Giacometti had done in his later work, but in a different way, Arp created one of the last sculptural styles in the tradition leading back through Brancusi to the Greeks. In contrast to many forms of modern sculpture introduced by painters (Degas, Boccioni) or translated by sculptors from previously established painting styles (Lipchitz' early Cubism), it is inherently "sculptural." Like the style of Brancusi, it is removed from the new directions that sculpture has taken after World War II, in which the essential process is not carving or modeling but *manipulating*. The antecedents of that sculpture are not to be found in the classical tradition of Brancusi and the post-1930 Arp but in Picasso's relief constructions of 1912–14 and open sculptures of 1928, Arp's own early wood reliefs, Giacometti's early sculptures and objects, and Surrealist *objets trouvés-aidés*.

Ernst

During the summer of 1934, Giacometti was working at a studio he had rented at Maloja, not far from Stampa, in the Ticino. Max Ernst spent the summer there at his invitation, and, inspired by

Giacometti's example, turned to sculpture in the round for the first time since his youth. In the beds of the mountain streams Ernst found rounded and polished stones of beautiful shape which reminded him of the heads of the anthropomorphic birds and other denizens of his forests of the late twenties. These needed but slight modification to reveal their "hidden content," and Ernst cut only very delicate low-relief contours in their surfaces so as not to alter their original shape (fig. 245). In some cases he reinforced the relief with color, and in one or two instances did not carve at all but satisfied himself with merely painting on the stone.

For all that Ernst did to them, those stones constituted little more than natural *objets trouvés-aidés*. But on his return to Paris, Ernst began making a series of plaster models for bronzes that are sculptures in the fullest sense. The imagery of these works corresponds to that of his painting, but the visual impact of his familiar bestiary is often much greater in three dimensions. At the same time—that is, from 1934 on—Ernst's paintings themselves became not only more markedly descriptive but frequently precious and finicky. Indeed, in view of the quality of his sculpture, it is regrettable that he did not devote himself primarily to that rather than to painting after 1934.

Since Ernst's primary impulse as a sculptor is poetic—that is, image-oriented—he was not interested in Cubist conceptions and hence was freer to arrive, if only unintentionally, at unexpectedly fresh formal configurations. We must bear in mind that by 1934 the vitality of modern sculpture had reached a very low point; the original creative impetus of Cubism had degenerated into its own academicism. Lipchitz' best work was behind him; he had already embarked on the heavyhanded, self-consciously "monumental" compositions that are the despair of his later years. Brancusi had ceased working nearly a decade before, and although he began again in 1935, he was to create only a half dozen sculptures before his death in 1957. Even more than Giacometti, Ernst came to sculpture uninhibited by preconceptions about its particular plasticity. Nor, on the other hand, was he committed, as were Surrealists like Dali, to a relentlessly anti-esthetic posture; he merely regarded the plastic as secondary to the poetic, allowing it to inform his art as it might.

The results were remarkably varied and might have played some role in reviving the lagging art of sculpture had Ernst's plasters not remained uncast and largely unseen. The Museum of Modern Art in New York did acquire the plaster *Lunar Asparagus* (fig. 246)—it has not yet been cast—for its omnibus Surrealist exhibit of 1936; this is composed of two narrow, stalklike forms rising at a slight angle to a height of almost six feet and terminating in strange heads.

Oedipus is made up of two vaguely cephalic forms, the simpler one resting precariously on top of the horned one. As in other of his sculptures, Ernst here adopted the practices of automatism by casting real objects in plaster and then "collaging" them in disconcerting juxtapositions. Lucy Lippard observes that the ultimate bronze casting of *Oedipus* disguises the provenance of the precariously perched forms which derive from casts of wooden pails (*sabliers*).[180] *Woman Bird* (fig. 247) is a vertical rectangular plaque, mounted a few inches above its base, on which a disturbing visage has impressed itself in low relief like a Surrealist Veronica's handkerchief. Like a sudden irrational thought, an aggressively beaked bird extrudes from the forehead to contrast with the transfixed anxiety of the face below.

In 1938, Ernst decorated the wall outside his house at St.-Martin-d'Ardèche with massive bas-reliefs and elaborated his *Oedipus* into a striking three-part sculpture, *Chimeras, Snakes, and Bottle* (fig. 248). However, it was not until the summer of 1944, when he transformed the garage of a house he and Julien Levy had rented at Great River, Long Island, into a studio that he returned to sculpture in earnest, if only briefly. *Moon Mad* (fig. 249) and *An Anxious Friend* (fig. 251) are among the more successful works of that time, but the most impressive by far is *The King Playing with the Queen* (fig. 252). This sculpture, inspired by a projected exhibition at the Julien Levy Gallery on the theme of chess, shows the upper torso of a horned monster rising from a table top, on which Ernst's chess queen is located beside equally imaginative pawns, a rook, a knight, and a bishop. The conception here—particularly that of the horned king—is derived from one of Ernst's paintings of 1927, *One Night of Love* (colorplate 26), and also reflects his familiarity with Giacometti's *Table* of 1933. When we compare such sculptures with Ernst's pictorial art of the same years (to which I shall turn later), we realize that Surrealism might have produced as crucial an art in the thirties as it had earlier if only it had understood the sculptural implications of its new illusionism.

SURREALIST OBJECTS

The Surrealist object was essentially a three-dimensional collage of "found" articles that were chosen for their poetic meaning rather than their possible visual value. Its entirely literary character opened the possibility of its fabrication—or, better, its confection—to poets, critics, and others who stood professionally outside, or on the mar-

gins of, the plastic arts. This partially explains the tremendous vogue object making enjoyed in Surrealist circles during the 1930s.

In view of the change in direction of the movement which we have already described, the fact of the Surrealist interest in objects during the 1930s is no surprise. The principle behind them was not new, to be sure. Duchamp had provided one prototype in the "assisted" Readymades of 1920–21. And, in 1924, Breton had suggested "the concrete realization and subsequent circulation of numbers of copies of objects perceived only in dreams."[181] At that time, however, Breton's call went unheeded, and it was only when interest in automatism flagged at the end of the decade, and when the "occultation" of Surrealism, proclaimed in the second manifesto, prompted renewed search into the mystery of objects, that the stage was set for the efflorescence of object art. The rise at the same time of Surrealist illusionist styles—those of Magritte and Dali revolving very much around a *trompe-l'oeil* of real objects—provided an immediate pictorial prototype.

The Surrealist object was essentially a three-dimensional collage in the literary sense in which Max Ernst defined collage (see pp. 95–96) rather than in the sense of the Cubist *papier collé*. But if in Ernst's Dada collages the plastic aspect was secondary to the poetic, it was nevertheless present. Even if Ernst had wished to suppress his plastic instincts entirely, it would have hardly been possible, so much does the arrangement of forms in a flat, rectangular field ineluctably involve the arranger in the essential esthetic process of picture making. While the sense of the sculptural can—and to some extent inevitably did—inform that grouping of real articles in space which constituted the Surrealist object, the manipulations involved did not necessarily force the manipulators into the conditions of sculptural activity to the degree that working on the delimited flat surface forces one into the pictorial. A household object such as those Duchamp used as Readymades—or a combination of them—does not necessarily constitute a sculpture in the way that any contouring of a flat regular field produces a picture. An image of such an object, as Magritte observed, is not the same thing as the object; it is a picture. The object, on the other hand, is not a sculpture. However much the painter considers himself to be bypassing "plastic considerations and other *conneries*," to use Dali's words, the very conditions of his activity force him to make numerous decisions of a purely pictorial order. It was precisely this inevitability that earlier prompted Duchamp to move from two-dimensional images of objects (*Chocolate Grinder*) to the objects themselves (Readymades). And it is therefore not surprising that Dali, who alone

among Surrealist painters totally rejected the plastic—at least programmatically—should have been led by similar considerations to the creation of the first Surrealist objects.

Dali's "Objects of Symbolic Function," the earliest of which date from 1930 (fig. 253), depend upon the collage-displacement principle, which goes back to Lautréamont's classic image of 1868. In "L'Objet fantôme" Breton upheld Lautréamont's importance in this regard against the suggestion that the antecedents of Surrealist objects were to be found in the collage-fetishes of primitive peoples. He also provided the classic psychosexual interpretation of the Lautréamont image,

the force of which depends upon the fact that the umbrella cannot here but represent man, the sewing machine woman (this is true in most cases of machines, except that here we deal with a machine frequently used by women, as we know, for onanistic purposes) and the dissection table the bed. . . . The contrast between the immediate sexual act and the extremely dispersed components of Lautréamont's image of it is what alone provokes the response of the spectator.[182]

In his article "Objets surréalistes," Dali describes them as

representations susceptible of being provoked as fulfillments of unconscious actions. . . . The incarnation of desires whose manner of being objectified is by substitution and metaphor, their symbolic realization constitutes a process based on the *perversion of the sexual*, which resembles in all aspects the process of poetry-making.[183]

The original—as opposed to the later "assisted," or "*aidé*"—Readymades of Duchamp anticipated the Surrealist object only insofar as they were tactile, three-dimensional things that had been wrenched from their ordinary contexts. Because they did not involve collaging more than one object, or parts of objects, they fell short of the process suggested by Lautréamont. Moreover, such Readymades as *Bicycle Wheel* (1913; fig. 11), *Bottlerack* (1914; fig. 16), and *Comb* (1916) were not intended, as were Surrealist objects, to embody dreams or fantasies; they were spare in nature, intellectual in character, and ironic in spirit. Surrealist objects are more exotic, are poetically rather than intellectually challenging, and are complicated—frequently overcomplicated—in their combination of elements. Dali describes as follows an object of his (fig. 253) illustrated in the article mentioned above:

A woman's shoe, inside of which has been placed a cup of lukewarm milk [resting] in the middle of paste of ductile form and excremental color. The mechanism consists of lowering a piece of sugar, on which has been painted the image of a shoe, in order to observe its dissolution—and consequently [that of] the image of the shoe—[during its immersion] in the milk. Many accessories (pubic hairs glued to a sugar cube, a small erotic photo) complete the object, which is accompanied by a reserve box of sugar and a special spoon that serves to stir the lead pellets inside the shoe.

He also describes an object by Breton (fig. 254).

On a small bicycle seat is a small terra cotta receptacle filled with tobacco on the surface of which lie two long, rose-colored, sugared almonds. A sphere of polished wood, capable of being turned on the axis of the seat, forces contact, through that movement, between the point of the seat and two antennae of orange celluloid. The sphere is attached by two extensions ... to an hourglass lying horizontally (in order to block the flow of sand) and a bicycle bell which is supposed to become active when a green almond is shot along the axis by means of a catapult placed behind the [bicycle] seat. The whole is mounted on a board covered with sylvan vegetation, revealing here and there a pavement of percussion caps, one corner of which, more thickly wooded than the others, is occupied by a little book which is decorated with a glass-covered photograph of the tower of Pisa, near which one discovers, by parting the foliage, a percussion cap—the only one already exploded—under a doe's foot.

The principle of Lautréamont's verbal collage, though first realized pictorially within the framework of illusionistic theater by de Chirico, was only fully isolated and given its pure visual definition in 1919 in the collages of Max Ernst. He conceived these "as a chance encounter of two distant realities on a level foreign to them both, so to say, as a paraphrase and generalization of the celebrated passage in Lautréamont." It was not until the following year, after his stay in Paris, that Duchamp began combining the Readymade and collage principles in hybrid three-dimensional objects called "assisted" Readymades, like *Fresh Widow* (1920; fig. 21), a small French window with "panes" of waxed black leather, and *Why Not Sneeze?* (1921; fig. 22), a birdcage filled with cubes of "sugar" into which a thermometer and a cuttlebone are thrust. This last confection goes beyond the Surrealist object, since, as I have already indicated, the sugar cubes were actually white-marble facsimiles, thus constituting the prototype of the *trompe-l'oeil* object. Inasmuch as Duchamp

was concerned with these objects only as illustrations of ideas, it was not necessary to multiply them once their principle was established. Consequently, he never again made objects comparable to either *Fresh Widow* or *Why Not Sneeze?*, or, for that matter, to the original simple Readymades. The Surrealists were less interested in the principle than in the varied uses to which it could be put; the manufacture of objects had to fill "lyric needs," said Dali, and contain "the maximum of the strange and bizarre," hence their remarkable proliferation in the thirties.

While the bulk of the Surrealist objects were stationary, the first group—including the two described in detail by Dali above—incorporated a movable part, the motion being, of course, enigmatic rather than practical: hence their appellation, "Objects of Symbolic Function." It was universally agreed that the immediate prototype of the motor feature of the Surrealist object was Giacometti's *Suspended Ball* (fig. 215), the cryptosexual functioning of which has already been described. This caused *Suspended Ball* and Giacometti's other sculptures with movable parts to be regarded by critics like Breton and Jean as objects rather than sculptures. (Indeed, Giacometti at one point gave the generic title *Objets mobiles et muets* to sketches of some of these sculptures.) The result was a failure to distinguish these works in character and principle from the mass of later Surrealist objects. Dali, however, had the clarity of mind to perceive the distinction, for while praising *Suspended Ball* as a point of departure, he insisted that "it still held itself to the means proper to sculpture. [On the contrary,] the Objects of Symbolic Function leave no possibility for formal preoccupations. They depend only on our amorous imagination and are extra-plastic."[184]

In the same issue (No. 3, 1931) of *Le Surréalisme au service de la révolution* that contained Dali's pioneering article "The Surrealist Object" and Giacometti's sketches of *Objets mobiles et muets*, Yves Tanguy was represented by drawings for five projected objects accompanied by texts describing their proposed materials. Looking simply at the drawings, we see no more than the familiar Tanguy biomorphs isolated from their customary landscape so that they appear to be, not surprisingly, images of Arp sculptures. It is only their materials that are unexpected; of the two reproduced here, the one on the left was to be made of "wax in imitation of skin," its round forms in the center "of a hard material in matte white," while the one on the right was to be made of blue chalk so that it could be used for writing on a blackboard, wearing down and ultimately leaving "only the little tuft of hair at the top." The substitution of new materials, however, would not have deprived these projected

works of their character as sculpture, since Tanguy's plastic morphology remained constant, and this is probably one reason why Tanguy neglected to execute them. Only years later did he fabricate a real Surrealist object, *From the Other Side of the Bridge* (fig. 255), in which the tapered fingers of an elongated hand (stuffed pink linen) disappear into the holes of a fantastical solitaire board.

Le Surréalisme A.S.D.L.R., No. 3, also contained a reproduction of Miró's *Personage* (fig. 256), which may be described as a hybrid sculpture-object. A life-size personage was carefully carpentered from wooden boards and stylized to about the degree of Miró's "Imaginary Portraits" of 1929, though symmetrical in form and without the meandering contours familiar in his painting. From this flat frontal figure only two wooden forms protruded, a circular nose and a whimsically oversized and horizontally rigid phallus (about a yard long) fashioned from a heavy dowel stick. To this wood structure the artist had added a sprig of real leaves that rose above the head of the figure like a cavalier's plumes, and a real opened umbrella that hung diagonally across the upper torso.

While Miró frequently used real materials, such as rope, as collage elements in his work, he employed them only rarely outside a pictorial context. Of the few truly Surrealist objects he made in the thirties, the most interesting one (fig. 257; recent catalogues have called it *Poetic Object*) consists of a wooden block hollowed out to hold a doll's leg, above which perches a stuffed parrot and to which are attached a map and a pendulum.

Oscar Dominguez, a painter from Tenerife, who joined the Surrealists in 1934 and whose decalcomanias and oils will be discussed elsewhere, was perhaps the most typical and most popular fabricator of Surrealist objects. His pieces have neither the *déchainé* eroticism of Dali's nor the sparseness and irony of those by Man Ray (who had resumed the series of objects he had begun under Duchamp's influ-

Yves Tanguy

ence during the Dada period), but they are unfailingly pleasing. Dominguez' paintings of 1935 derive essentially from the proto-Surrealist Ernsts in their fusion of *collage-en-trompe-l'oeil* and semi-organic morphology. But in such pictures as *The Hunter* (fig. 261) the impulse to affirm the tactility of the represented objects led Dominguez to a type of relief collage which culminated in *The Peregrinations of Georges Hugnet* (1935; fig. 258), where, except for a simple rectangle painted on the ground, the entire image is an object-relief, a little painted rubber toy horse threaded through a minuscule bicycle. (The idea had been suggested by the fact that Hugnet once made his living by delivering toy slot-machine prizes on a bicycle.)

In pictures like *The Peregrinations of Georges Hugnet* the pictorial field is largely vestigial, and shortly afterward Dominguez eliminated it altogether in favor of pure objects like the *Conversion of Energy* (1935; fig. 259) and *The Coming of the Belle Epoque* (1936; fig. 260). Both were illustrated in an article on Dominguez by Hugnet,[185] in which he described Surrealist objects as a form of "poetry that has transcended metaphor" by objectifying the imagination.) The work of 1935 was originally titled *Le Tireur*. It is a cheap plaster reproduction of the familiar Hellenistic statue of a boy removing a thorn from his foot (*The Thorn-Puller*, known in French as *Le Tireur d'Epine*), which has been sliced, seemingly by the vertical pane of glass in front, so that we see only the cross sections—that is, the stumps where the head, hands, and legs had previously been. *The Coming of the Belle Epoque* is a small, typically academic, allegorical statuette, divided at the waist to permit the insertion of a wooden frame inside which are attached two narrow cones; the raised hand of the statuette is lost in a cloud of absorbent cotton.

In 1937, Dominguez created an "armchair" out of a wheelbarrow, the inside of which he upholstered in red satin. A photograph by Man Ray showing a model in a Lucien Lelong gown reclining in the "armchair" was published in *Minotaure*, No. 10. According to Marcel Jean, "this object was particularly admired by some connoisseurs, for whom Dominguez executed several replicas of his wheelbarrow."[186]

Jean, a close friend of Dominguez, created objects himself, and one of them, the *Specter of the Gardenia* (1936; fig. 262), was among the popular successes of the omnibus exhibition *Fantastic Art, Dada, Surrealism* held at The Museum of Modern Art in New York in 1936. It was a plaster woman's head the surface of which, except for zipper eyes, was shrouded in a chic black fabric drawn skintight, and had a collar of camera film.

Breton's most important personal contribution to the new vogue was the "Poem-Object" (fig. 264), which was not intended, as were the typical Surrealist objects, to transcend entirely the esthetic. Indeed, that would have been impossible, as the text and the objects of which they consisted were distributed in a closed and regular pictorial field. Breton conceived of them as "compositions which tend to combine the resources of poetry and plasticity and to speculate on their power of reciprocal exaltation."[187]

The Poem-Object was hardly a wholly new idea. The words and phrases introduced as fragments into the surface patterning of Cubist pictures had been extended and endowed with autonomous legible connotations in Futurist as well as Dadaist pictures, and whole poems had been woven into illusionist representations of real objects in Ernst's Picture-Poems of 1924 (and into more abstractly imaged iconographies in the Picture-Poems of Miró shortly afterwards). But it was not these sources so much as certain canvases by Magritte, such as *Key of Dreams* (1930; fig. 183), where images of single objects had been isolated and their "resonance" explored with particular words, that Breton considered his starting point. "I departed from the poetic," he observed, "in the same way Magritte did from the plastic."

Breton was less successful with another type of construction he labeled the "Dream Object" (fig. 263). This was less an object than a scale-model re-creation of a dream situation. The development followed naturally from Breton's assertion—characteristic of the thirties and admittedly contradicting his earlier position—that dream representation "seems to gain considerably in clarity in such [literal] three-dimensional figuration."[188] Breton's prototype of the Dream Object is largely a cardboard re-creation of a hotel corridor whose walls tilt back from the red carpeting at a vertiginous angle. The doors, when opened, reveal a tuft of green cotton, the large letter *O* placed above fragments of text from Lautréamont, and other collaged elements.

Though he never officially joined the Surrealist movement, Joseph Cornell was the first American to fall within the orbit of its art. He participated in the earliest American exhibition of Surrealism at The Wadsworth Atheneum in 1931, and the maturation of his art—though it took place in self-enforced isolation—paralleled the exploitation of the object among the Surrealists in Europe in that decade. Though he belongs, as Alexandra Cortesi observes, to the American tradition of the recluse—like Charles Ives, for instance—and though his iconography of personal mementos and household trivia relate him to Harnett and Peto, Cornell's point of departure was neverthe-

less European, more particularly, the Surrealist conception of collage. In fact, his collages of engravings of 1931–32 are immediately derived from those of Ernst. One of the most interesting joins, among other elements, a woman and a sewing machine on a table top (fig. 270) in a manner that carries the famous image of Lautréamont one step closer to the literal sexual interpretation given it by the Surrealists.

Despite his never having been to France, Cornell has always evinced a profound interest in Symbolist poetry, which is, of course, at the root of the Surrealist poetic tradition. His collaging of poetic words and lines in different contexts within his objects often produces passages comparable to those in Breton's Poem-Objects, though the continuity and syntax of the latter are never admitted. In the *Unpublished Memoirs of the Countess de G.* (fig. 271), Cornell enclosed within a circular box a series of lines cut from printed texts of French poetry (each one mounted rigidly in a plastic container) so that the lines can be taken out and assembled into virtually infinite series of accidental poems in a manner recalling the recipe of Tzara.

In his interest in nostalgic trivia Cornell at first suggests Schwitters, but only at first. Apart from the formal differences—Cornell shares with the Ernst of the 1930s an eschewal of the Cubist underpinning which Schwitters accepts—the iconography of Cornell is more a household one, derived from the attic rather than from the streets. It is also often infected by an almost morbid nostalgia, as in the works dedicated to defunct opera stars and silent-screen queens.

Apart from his objects proper, such as *Taglioni Jewel Casket* or *L'Egypte de Mlle Cléo de Mérode* (fig. 272), Cornell developed a formulation that became uniquely associated with him in the boxes which he treated as a kind of stage space. Sometimes, as in the marvelous *A Pantry Ballet for Jacques Offenbach* (fig. 273), where a corps de ballet of red plastic fish is posed against a drop scene of shelf-lining and silverware props, the image of the miniature theatre is carried out with a proscenium (here fringed with paper-doily "curtains"). While such boxes obviously recall the toy stages with which Cornell played as a child, it is probable that an immediate catalyst to their development are the "boxes" in such Dalis as *Illumined Pleasures*, which themselves were suggested by those in de Chirico. In effect, Cornell was re-creating in a literal manner precisely that deep-space illusionistic "theater" which had originated in de Chirico, been kept alive by Ernst, and flourished again at the time of the second Surrealist manifesto.

By 1936, the proliferation of Surrealist objects had reached a point where a special exhibition of them was called for in Paris. In May of that year, such an exhibition was installed at the establish-

ment of Charles Ratton, an expert and dealer in primitive art. These were congenial auspices, not so much because the show included a few fetish-objects—as we have seen, Breton discounted their role as forerunners—but because primitive art in general belonged to the pre-esthetic, magical order of creation, and therefore held a certain interest for Surrealism. Most of the Surrealist objects I have already described were exhibited, as well as many others. Among Man Ray's contributions was *What We All Need* (fig. 267), a clay pipe from whose bowl rose a glass bubble; Dali offered the *Aphrodisiac*

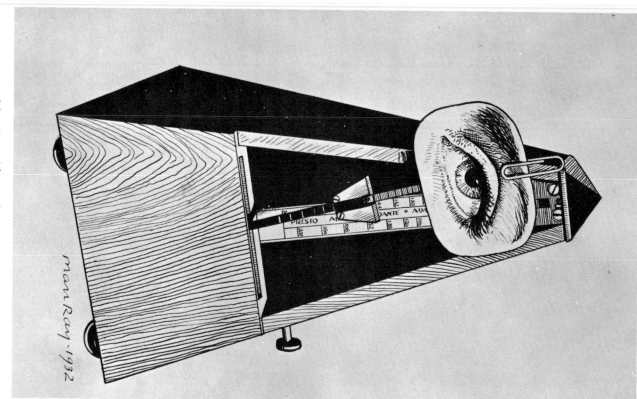

Man Ray. *Object of Destruction*. 1932

Jacket (fig. 268), a tuxedo decorated with multitudinous shot glasses filled with crème de menthe above a hanger to which a brassiere ad was appended; Maurice Henry's bandaged violin was titled *Homage to Paganini*. But the great hit of the exhibition—no doubt because it presented the essential principle of the Surrealist object with the classic simplicity of Lautréamont's evocation—was Méret Oppenheim's *Fur-Covered Cup, Saucer, and Spoon* (1936; fig. 269). This provocative conjunction of tactile and oral associations enjoyed an even greater success at the *Fantastic Art, Dada, Surrealism* exhibition at The Museum of Modern Art in New York in 1936. Dali paid this work oblique tribute, if he also diluted its idea, when he created a fur-lined bathtub for a window display at Bonwit Teller's in New York in 1939. (The display so disturbed the public that the store decided to remove it, whereupon Dali expressed feigned anger by diving headfirst through the plate glass window—after first assuring the presence of reporters and news photographers.)

Picasso was represented in the exhibition by Cubist works such as the small collage-sculpture of 1914, *Glass of Absinthe*, a bronze painted in decorative patterns typical of Synthetic Cubism, to which a real silver spoon was attached (fig. D-171). But this sculpture in no way exceeded the limits of Cubist construction or shared the characteristics of the Surrealist object. It was a curious choice, for, under the influence of Surrealism, Picasso had indeed made, in 1930, two object-sculptures; the first (fig. 274) was an abstract, rather linear "personage" in iron, with an oversized foot (a cobbler's last) separate from the body, to which all kinds of children's toys and knickknacks, including ribbons, birds, and a model airplane, were attached; the second (fig. 275) was made from a fig-tree root decorated with a horn and a feather.

The Charles Ratton exhibition also contained varieties of objects only tangentially related to those that were, strictly speaking, Surrealist. Among the "Natural Objects" were samples of agates, carnivorous plants, and a stuffed ant-bear (*Tamanoir*, fig. D-167). "Perturbed Objects" included the wineglass found in the detritus of an eruption of Mount Pelée in Martinique (fig. D-166). "Mathematical Objects" were three-dimensional realizations of geometrical formulas, of a type related to Pevsner's and Gabo's sculptures, which Ernst had come across in the Poincaré Institute. Also exhibited were "Found Objects" (*Objets trouvés*), such as a waterlogged and shell-encrusted book, a pipe whose bowl had been carved into a menacing head, gnarled roots, and peculiarly shaped rock formations.

In the same year as the Ratton exhibition, a Berliner named Hans

Hans Bellmer

Bellmer visited Paris and joined the Surrealists. His strange "dolls" were conceived before his visit but paralleled the development of Surrealist objects—particularly those that included clothes dummies and other kinds of mannequins—such as were to play a central role in the Surrealist exhibition of 1938. Bellmer's work was known to the Paris artists from photographs that appeared in the December, 1934, issue of *Minotaure* under the title "Variations on the Assembling of an Articulated Minor." These showed one of his female mannequins in various stages of construction, from the wood-and-metal skeleton to the realistic plaster-and-papier-mâché shell. A system of ball joints permitted the body to be dismantled and reassembled in all sorts of hallucinatorily confused combinations (figs. 276a–d). All the photographs show the doll in truncated, fragmentary form—as though torn apart violently—and the wigs, garments, and glass eyes made it an ideal fetish-object in the Freudian sense. Though this *poupée* has been his lifetime obsession, Bellmer has developed his theme of the hallucinatory confusion of limbs in some extraordinary, if mostly unpublishable, drawings and paintings of pubescent girls (fig. 278).

The multiplication of objects transformed the studios of some of the artists and poets into Surrealist grottoes; Dominguez' atelier in particular, with a wheelbarrow chair and a table cut in the form of a grand piano, surrounded by numerous objects, constituted a truly Surrealist "environment." These experiences were incorporated in the *Exposition Internationale du Surréalisme* held January-February, 1938, at the Galerie Beaux-Arts in the Faubourg St.-Honoré. Though many of the walls of the gallery were hung with paintings, what distinguished this event were the "environments." These began in the lobby, where, amid a confusion of flora, Dali's *Rainy Taxi*[189] (fig. 282), a disused vehicle in which a complicated system of tubing produced a localized rainstorm, was set. Inside the ivy-covered carriage were two drenched clothes dummies, a driver with a shark's head, and a distracted female passenger seated among heads of lettuce and live crawling snails.

The lobby led into a "Surrealist Street" lined with female dummies "composed" and "dressed" by Duchamp, Man Ray, Ernst, Arp, Dali, Miró, Matta, and others. The most admired of these, according to Marcel Jean, who himself dressed one as a water nymph enmeshed

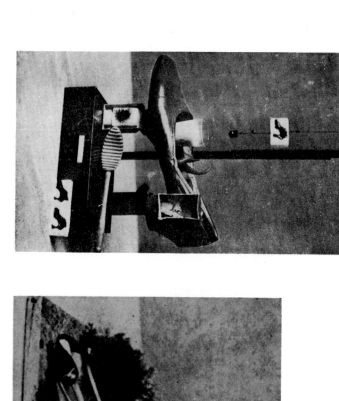

253

253 SALVADOR DALI *Object of Symbolic Function.* 1931

254 ANDRÉ BRETON *Object of Symbolic Function.* 1931

255 YVES TANGUY *From the Other Side of the Bridge.* 1936

256 JOAN MIRÓ *Personage.* 1931

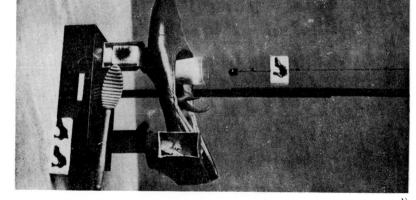

255

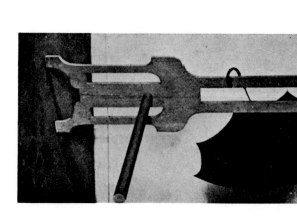

256

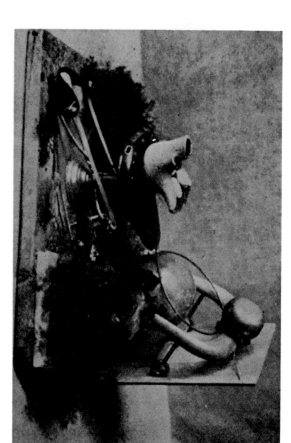

254

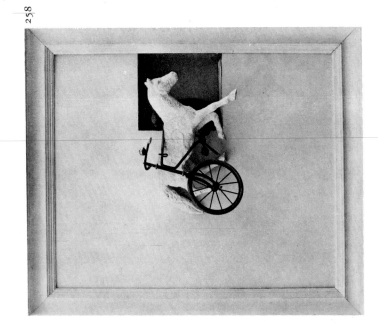

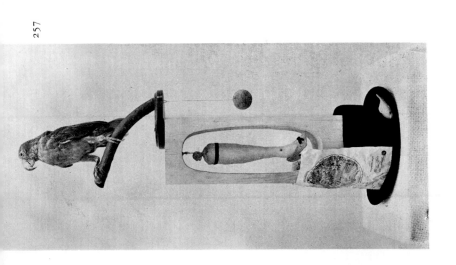

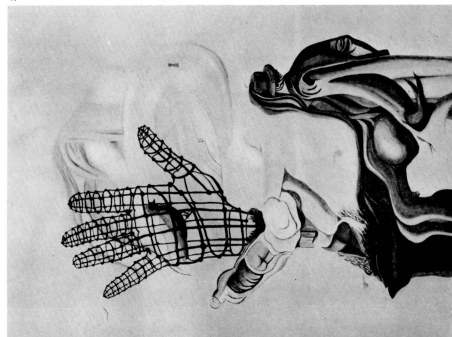

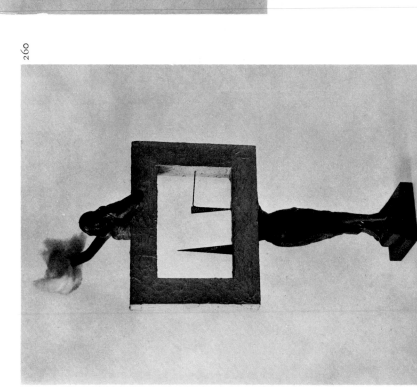

257 JOAN MIRÓ *Poetic Object.* 1936

258 OSCAR DOMINGUEZ *The Peregrinations of Georges Hugnet.*
1935

259 OSCAR DOMINGUEZ *Conversion of Energy (Le Tireur).* 1935.
Exhibited at the first international exhibition of Surrealist objects,
Charles Ratton Gallery, Paris, 1936

260 OSCAR DOMINGUEZ *The Coming of the Belle Epoque.* 1936

261 OSCAR DOMINGUEZ *The Hunter*

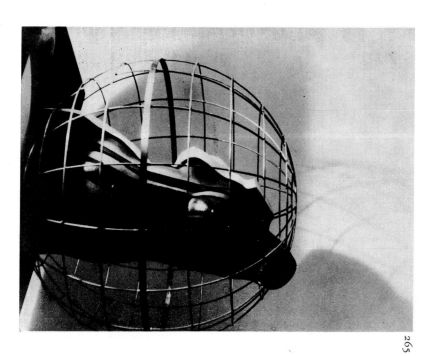

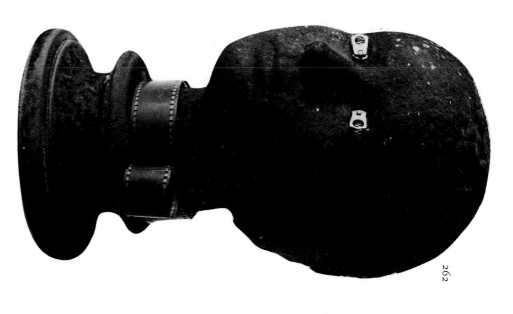

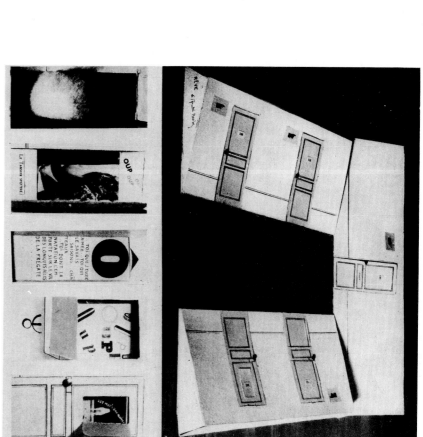

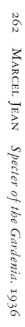

262 MARCEL JEAN *Specter of the Gardenia.* 1936

263 ANDRÉ BRETON *Dream Object.* 1935

264 ANDRÉ BRETON *Poem-Object.* 1937

265 ROLAND PENROSE *The Last Voyage of Captain Cook.* 1936–67

271

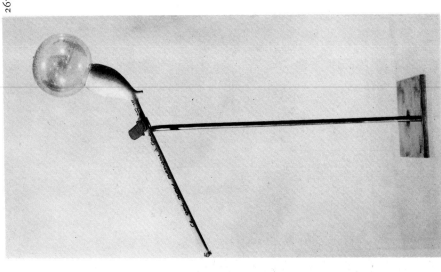

266

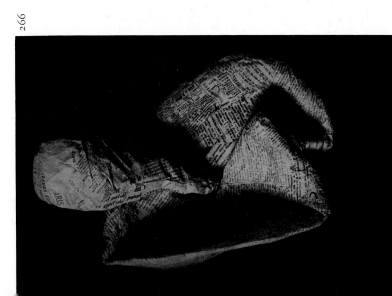

266 JEAN ARP *Mutilated and Stateless.* 1936

267 MAN RAY *What We All Need.* 1935.
Exhibited at the first international exhibition
of Surrealist objects, Charles Ratton Gallery,
Paris, 1936

268 SALVADOR DALI *Aphrodisiac Jacket. c.* 1936

269 MÉRET OPPENHEIM *Fur-Covered Cup,
Saucer, and Spoon.* 1936

269

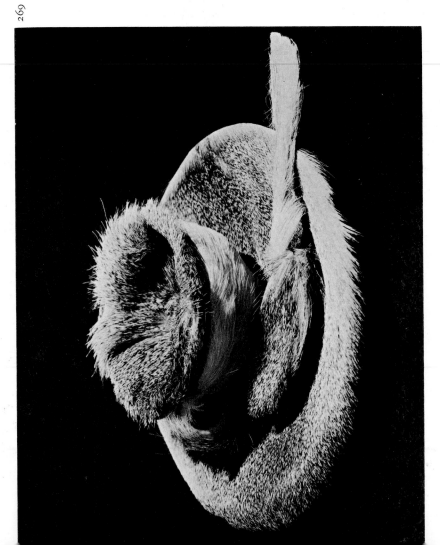

272

270 JOSEPH CORNELL *Woman and Sewing Machine*. 1932

271 JOSEPH CORNELL *Unpublished Memoirs of the Countess de G. c.* 1940

272 JOSEPH CORNELL *L'Egypte de Mlle Cléo de Mérode.* 1940

273 JOSEPH CORNELL *A Pantry Ballet for Jacques Offenbach.* 1942

271

270

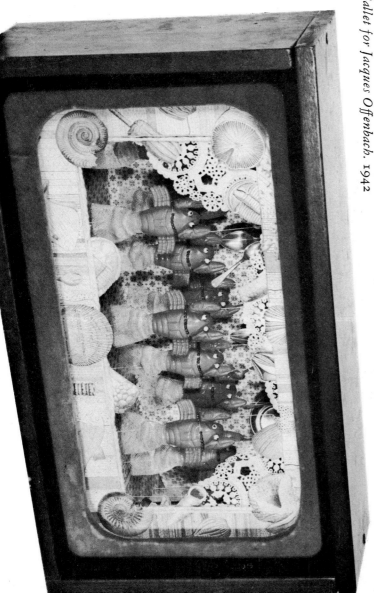

273

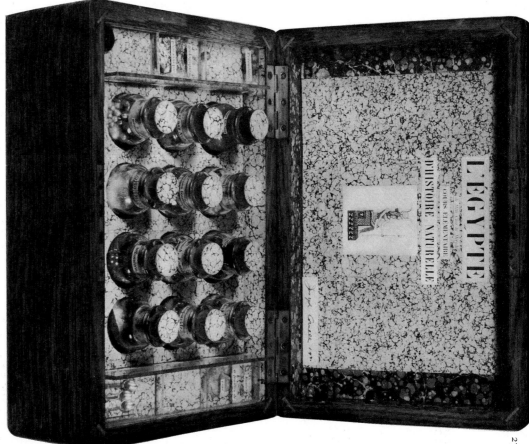

272

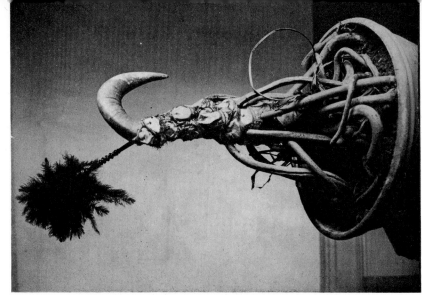

274 PABLO PICASSO *Woman.* 1930–32

275 PABLO PICASSO *Object.* 1930

276a, b, c, d HANS BELLMER
Four views of *La Poupée*, as arranged
by the artist in 1936

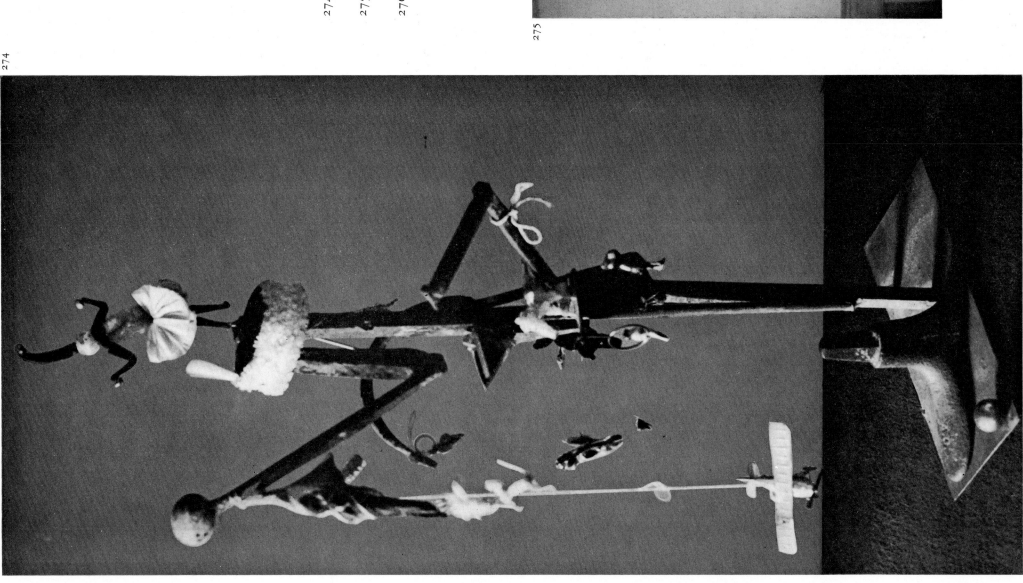

276c

276a

276d

276b

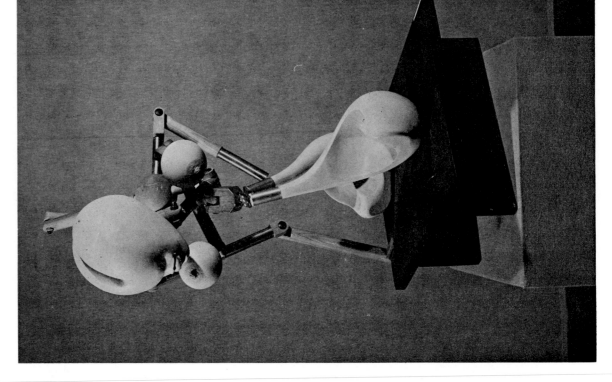

277

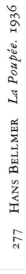

277 HANS BELLMER *La Poupée.* 1936

278 HANS BELLMER *Peppermint Tower in Honor of Greedy Little Girls.* 1936

279 HANS BELLMER *The Machine-Gunneress.* 1937

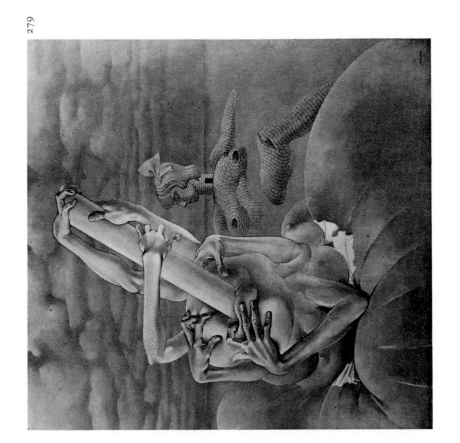

279

276

in a lead-weighted net, was that of Masson (fig. 283), "who had placed his mannequin's head in a cage, gagged her with a black velvet band, putting a flower—a pansy—where the mouth would have been. . . . The figure was otherwise unadorned, except for a 'G-string' covered with glass eyes."[190]

The large central hall was designed by Duchamp, who had accepted the task of overseeing the entire operation, and who characteristically departed for England a few hours before the opening. He hung 1,200 coal sacks from the ceiling (fig. D-188) and covered the floor with dead leaves and moss, which gave way at one point to a lily pond surrounded by ferns and reeds. Near it stood one of four sumptuous double beds, above which hung Masson's *Death of Ophelia*, echoing the implications of the pond and empty bed (fig. 284).

At the opening of the exhibition, a hidden coffee roaster permeated the atmosphere with "Perfumes of Brazil," and German marching songs came over the loudspeaker. A *tout Paris* crowd in evening dress heard Paul Eluard's welcoming speech and watched a dancer, Hélène Vanel, interpret *The Unconsummated Act* around the pond of the central hall. The opening was, as a "programed" event, closer to post-World War II Happenings than to the more anarchic manifestations of Dada.

Architecture, much more than sculpture, was an art alien to the aims and practices of Surrealism. To be sure, Breton was fascinated by the fantastic "palace" that had been constructed by the postman Ferdinand Cheval in southern France between 1879 and 1912 (fig. D-22). But this involved none of the collective and materialistic implications of architecture, which are so far from the spirit of Surrealism. Nevertheless, the Environment at the Galerie Beaux-Arts did lead Matta Echaurren to speculate on the possibility of a Surrealist architecture. A few months after the opening, Matta, formerly a student in the atelier of Le Corbusier and a recent adherent to Surrealism, published in *Minotaure* a project for a hallucinatory apartment (fig. D-197). An "iconic-psychologic" column passed through the different floors, which were decorated with soft, inflated-rubber furniture in the biomorphic shapes that Matta had just begun to employ in paintings. The vertiginous intersecting spaces were separated by pliable walls that would theoretically alter to reflect the inhabitant's anxieties. Later Frederick Kiesler, who designed Peggy Guggenheim's Art of This Century gallery in 1942 with curving walls and wooden biomorphic furniture (fig. D-199), and who installed much of the 1947 Surrealist exhibition at the Galerie Maeght,

brought Surrealist architecture closer to possible realization with the more advanced projects for The Endless House (fig. D-198). This conception, some aspects of which dated from the twenties, emerged in fully developed form as a succession of biomorphic shell-walls articulating a space that could flow continuously or be sectioned off for privacy. By way of this essentially sculpturesque concept, the beamless, columnless, concrete structure suggested in a more thorough-going manner than Matta's project a translation of the fundamental Surrealist morphology into architecture.

The "occultation" called for by Breton in the second manifesto produced other byproducts, among them associational-response games and experiments, not unrelated to those published in *Littérature* during the *époque floue*. These games and experiments were designed to reveal the mysterious character of objects. In the sixth number of *Le Surréalisme A.S.D.L.R.* (1933), Breton published their results under the title "Experimental Researches on the Irrational Knowledge of the Object." On different occasions, various people in the Surrealist milieu (including, among the artists, Dali, Tanguy, and Giacometti) had been confronted with a certain object (for example, a crystal ball, a piece of pink velvet, de Chirico's *Enigma of a Day*) and asked to write their responses to a series of questions about it. The responses were later tabulated, and an attempt—not very successful—was made to draw possible conclusions about the unconscious "signals" the object might be giving off.

In the case of the medium's crystal ball, for example, the twenty-six questions posed to a gathering of a dozen people included: "Is it favorable to love?" ("Yes," thirteen to two.) "Does it lend itself to metamorphosis?" (Dali: "No"; Giacometti: "Only to slight deformations"; Tanguy: "Yes, to every kind of metamorphosis.") "To what philosophical system does it belong?" (Despite three responses favoring Hegel, most chose ancient philosophers.) "What is its sex?" (Feminine mostly, but also sexless and hermaphroditic.) "What must it meet on a dissection table in order to be beautiful?" (The Lautréamontian nature of the question led to responses in which surgery, anatomy, and death predominated.) "To what crime does it correspond?" (Dali: "Theft, incurable kleptomania"; Giacometti: "Cruelties and violence"; Tanguy: "None.") Questions regarding *The Enigma of a Day* (fig. 107) included: "Who would be the first person to arrive in the piazza?" "Whom does the statue represent?" "Where [in the scene depicted] would you go to make love? To masturbate?" Responses here were so varied as to preclude any conclusions whatsoever.

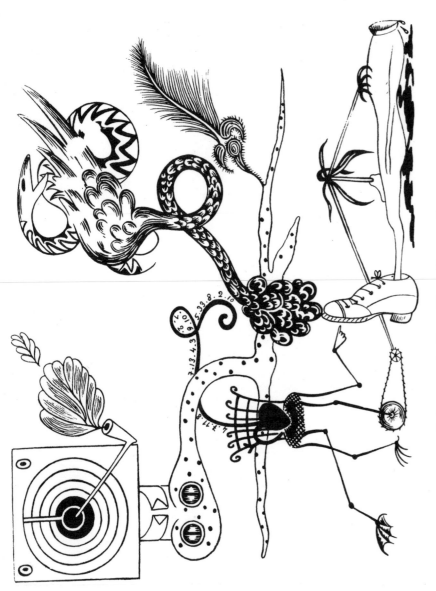

Cadavre exquis. Tzara, Hugo, Knutsen, Breton

Among Surrealist techniques exploiting the mystique of accident was a kind of collective collage of words or images called the *cadavre exquis* (exquisite corpse). Based on an old parlor game, it was played by several people, each of whom would write a phrase on a sheet of paper, fold the paper to conceal part of it, and pass it on to the next player for his contribution. The technique got its name from results obtained in an initial playing, "Le cadavre exquis boira le vin nouveau" (The exquisite corpse will drink the young wine). Other examples are: "The dormitory of friable little girls puts the odious box right" and "The Senegal oyster will eat the tricolor bread." These poetic fragments were felt to reveal what Nicolas Calas characterized as the "unconscious reality in the personality of the group" resulting from a process of what Ernst called "mental contagion." At the same time, they represented the transposition of Lautréamont's classic verbal collage to a collective level, in effect fulfilling his injunction—frequently cited in Surrealist texts—that "poetry must be made by all and not by one." It was natural that such oracular truths should be similarly sought through images, and the game was immediately adapted to drawing, producing a series of hybrids the first reproductions of which are to be found in No. 9–10 of *La Révolution surréaliste* (October, 1927) without identification of their creators. The game was adapted to the possibilities of drawing, and even collage, by assigning a section of a body to each player, though the Surrealist principle of metaphoric displacement led to images that only vaguely resembled the human form. One, by three hands, begins with a spider, which gives way to a man's torso the feet of which are formed by two jugs. Other, more interesting *cadavres exquis* were reproduced in a special issue of *Variétés* titled "Le Suréalisme en 1929" (fig. 288). One of these begins with a woman's head by Tanguy, which dissolves into a jungle scene by Max Morise, returning to a female anatomy schematically indicated by Miró, and terminating in "legs" in the form of a fishtail and an engineer's triangle by Man Ray.

The rise of Surrealist sculpture, the vogue of the object, and the wide variety of new techniques that proliferated as the pioneer Surrealist painters continued their endeavors—and were joined by new and younger artists—gave the 1930s an air of tremendous ferment and accomplishment. If in retrospect this epoch of Surrealism seems to have produced, in comparison with the movement's first years, more variety than profundity, it nevertheless reflects the leading role that Surrealism had assumed in the avant-garde not only in France but elsewhere. It was inconceivable that Picasso, whose oeuvre constitutes a kind of microcosm of this century's art, should not have become involved with Surrealism. As it was, the variety and nature of his own work, as well as his personal relations with leading Surrealists, made him particularly susceptible to contacts with the movement, and neither his own work of that time nor that of the Surrealist painters themselves can be properly understood except in relation to one another.

PICASSO AND SURREALISM

Between 1926 and 1939 Picasso's art shared a number of features with the work of the Surrealists, but his relation to the movement was equivocal. He was very much a part of the Surrealist scene in Paris, enjoying frequent contact with the painters and close friendship with poets of the movement, particularly Paul Eluard. Never formally a member of the movement—despite Breton's attempts to annex him—he nevertheless participated in most of its exhibitions and lent support to many of its activities. There is some truth in Yves Duplessis'[191] contention that in Picasso's work lies the "reconciliation" of the main divergent tendencies of Surrealism. And if it is true, as some critics have argued, that the Surrealists, particularly Breton, appropriated Picasso's name for the sake of its prestige, this was not intrinsically unfitting. But his affinity with certain aspects of Surrealist fantasy, his involvement with automatic poetry, and his sympathy with the

social aims of the movement notwithstanding, Picasso's art was ultimately antagonistic to Surrealism since it was almost always set in motion by a motif seen in the real world; the Surrealist vision was discovered, as Breton said, "with the eyes closed."

Matisse and Bonnard were among those artists who pursued the fulfillment of their visions in relative isolation, after a time, from the successive and frequently contradictory tendencies that animated the avant-garde during their lives. When, after a long period of supposed eclipse, Matisse—and to a lesser extent Bonnard—emerged after World War II as the embodiment of advanced taste, it was not because he had returned to the vanguard but because it—or at least its values and aims—had returned to him. Picasso is quite different in nature. The dialectical processes of his development demanded—at least until 1940—a constant dialogue with the new in art and with the painters and poets who, at any given moment, constituted the avant-garde. This, in turn, implied concern for the world of

Pablo Picasso

spiritual, social, psychological, and finally even political values of less influential meaning to more purely "inner-directed" artists. We cannot imagine a *Guernica* from the brush of Matisse or Bonnard, not because their styles precluded it—as in the case of Mondrian, for example—but because they never conceived of their art as *engagé* in the world in so literal a sense.

This dialogue with the world, as it were, was a source of great strength for Picasso's art; it endowed it with an extraordinary range of expression, however little it may have contributed to its purely plastic quality. The importance of Picasso's symbiotic relationship with the vanguard in all its phases—especially in his social intercourse with its members on the scene in Paris—can be judged from the doldrums into which his art has fallen since World War II, when, partly by choice and partly out of necessity (the practical difficulty a "living historical monument"[192] had in simply moving about Paris), he elected to lead the kind of semiretired Riviera life that had been so congenial to Bonnard and Matisse.

The most extreme claims in favor of Picasso's role in Surrealism are argued by Wallace Fowlie in his book on the movement. Reviewing the period of the Surrealist-dominated avant-garde, Fowlie characterizes Picasso as its artist par excellence—the one who gave Surrealism its art in the same sense that Breton gave it its manifestos and Lautréamont its "temperament." "Picasso's art," he writes,

in its abundance as well as in the methods it illustrates, is the greatest testimonial to the energies and the forces which underlay surrealism. All the various articles of surrealist faith may be exemplified in Picasso: paranoiac-criticism, usually associated with Dali; the art of dislocation wherein a suprahuman meaning may be found in the work; a psychological intuition which involves both eroticism and violence. But more than any other aspect of surrealism, Picasso uses a sense or a vision which is magical. . . . [He] is much more than a painter, and is constantly breaking through the bounds of painting. He is a prophet, interpretive historian, magician and necromancer. He is perhaps the greatest psychologist of the century, the Spanish doctor who replaced the Viennese. By the recklessness with which he views art and by the lyric frenzy in which he works, he exemplifies the surrealist precept that art is not so much the production of an object—a poem or a painting—as it is the expression of an attitude, of a revolution, of a metaphysics.[193]

Breton's appraisal is somewhat more temperate—or at least it was during his last years. He first mentions Picasso during the *époque floue*, in "Distances," where, along with Moreau, Gauguin, Seurat,

and Redon, Picasso is seen as a possible source of the "interesting revelations that I persist in believing one can [still] expect from painting." Picasso is mentioned again in the list of "precursors" in the first Surrealist manifesto, where he is described as "by far the purest" of the avatars. Later, in *La Révolution surréaliste*, where Breton published his answer (subsequently included in *Le Surréalisme et la peinture*) to Naville's denial of the possibility of Surrealist painting, he waxed characteristically poetic:

It has been said that there cannot be such a thing as Surrealist painting. Painting, literature, what is all that, O Picasso, you who carried the spirit, not simply of contradiction, but of evasion, to the supreme point! . . . A single failure of will power on his [Picasso's] part would have sufficed to set back, if not wholly defeat, everything with which we are concerned . . . we claim him as one of ours, even though it is impossible—and would be impudent, furthermore—to apply to his means the rigorous critique that elsewhere we propose to institute. Surrealism, if one must assign it a line of moral conduct, has but to pass where Picasso has already passed, and where he will pass in the future.

This text was accompanied by reproductions, mostly of Synthetic Cubist pictures, which seem to have been chosen, as Marcel Jean points out, because of the *distance* that separated title from image.

By 1930, enough affinities between Picasso's painting and that of the Surrealists had emerged to cause the emphasis to be shifted from Cubism (except with regard to collage, about which Aragon wrote in "La Peinture au défi" in 1930) to Picasso's more psychologically and poetically influenced post-Cubist work. In 1933, Breton hailed Picasso's collage objects in the first issue of *Minotaure*; he was especially taken by an unfinished work that was supposedly going to represent a defecation, "as, indeed, would have been quite obvious once Picasso had placed the relevant flies in position." The remainder of Breton's text suggests that he was the naïve victim of a little leg-pulling on Picasso's part. The artist is represented as deploring "the need to use paint for lack of a satisfactorily durable piece of real, dry excrement," the "*inimitable* turds that he sometimes noticed in the countryside where children had been eating cherries pit and all." In an unintentionally humorous digression, Breton describes this image of pit-ridden coproliths as "the most objective proof possible" of the special interest aroused by "the relationship between the unassimilated and the assimilated," a microcosm representing "the essential motivating force of artistic creation."[194]

By the end of the 1930s, it was clear to Breton that Picasso had

evolved into something other than a Surrealist. The "Dictionnaire abrégé du surréalisme," by Breton, Eluard, and others, contained in the catalog for the 1938 Paris exhibition, refers to Picasso simply as an artist "whose work since 1926 has objective qualities in common with Surrealism." By the time of his exile in America, Breton's enthusiasm for Picasso had completely cooled, and the Spanish painter's work is mentioned only in connection with Cubism in the preface "Genesis and Perspective of Surrealism" to *Art of This Century*. The text is most condescending toward Picasso, and his Cubist works are described as being rescued from their *géométrie jalouse* only by their lyric inscriptions. (Breton tells of a purported visit to Picasso's studio not long before, where he saw the painter standing before an unfinished Analytic Cubist picture, from 1911 or 1912, doing mathematical calculations on sheets of paper. He claims that Picasso confided to him that in order to clarify the picture for himself it was necessary to make all sorts of measurements. If this story has any truth to it, it must be another example of Picasso's whimsey that Breton swallowed whole. In any case, it provides an insight into Breton's astonishing lack of awareness of the processes of painting.)

Most Picasso criticism accords Surrealism less of a role in his work than—at their most eloquent—Breton or Fowlie claim, and this, I believe, is correct. Surrealism promoted an attitude toward art that was essentially alien to Picasso, and he could hardly have created the paradigmatic examples of its painting (even though his influence on Miró, Masson, and even Ernst between 1924 and 1929 was, as I have tried to show, far more pervasive than writers on Surrealist art have realized). Picasso's role in Cubism and in the Neo-Classicism of the early twenties was central, but his participation in Surrealism was not. True, between 1926 and 1935 he produced a few works that are of an out-and-out Surrealist character, and many more which in one or another of their aspects borrow from—or have affinities with—Surrealist art. But these works are only part of an extremely varied oeuvre whose dominant spirit is foreign to Surrealism.

Picasso was certainly influenced by Surrealist art, but the main importance of the movement to him was of a more general nature, a matter of personal friendship with some of its poets, and of the special ambiance the movement created within the Parisian avant-garde. Certainly the tendency toward the poetic, and sometimes the outright literary, that becomes evident in Picasso's art after 1925 reflects this. There are critics who see in Picasso's association with the Surrealists a cause of the stylistic equivocation and decline that his art suffered during the late twenties and thirties by comparison

Pablo Picasso. *Portrait of André Breton*

with what it had been in the two decades preceding 1926. But the notion advanced by Cesare Brandi,[195] that Surrealism "produced a grave deviation" in Picasso's art, misses the point. Picasso's relation to the cultural, social, and psychological *Zeitgeist* compelled him to participate in Surrealism to some extent; at the same time, Surrealism itself was less a cause than a symptom of the concerns that animated the cultural scene during the *entreguerre*.

Picasso first met Breton in the summer of 1923, and two etched portraits testify to the immediate interest he took in him. Picasso had always been remarkably responsive to young men with new ideas; this was an important factor in the constant self-renewal of his art before 1940. Breton, for his part, was mesmerized by Picasso and his work, and though he failed to grasp the essential nature of Picasso's more "formalistic" paintings, he praised them at a time when Cubism was still relatively little known and, as a result of

Pablo Picasso

the Neo-Classical reaction of the early twenties, somewhat in eclipse. It was due to the personal intervention of Breton that *Les Demoiselles d'Avignon* was disinterred from Picasso's studio, where it had lain rolled up since it was finished, and given place of honor in the collection of Jacques Doucet, whom Breton was advising. This pivotal masterpiece of Cubism was reproduced for the first time in France by Breton in *La Révolution surréaliste* of July, 1925, eighteen years after its execution. In that same year, Picasso overcame, for the first time, his aversion to group exhibitions and consented to Breton's including a number of his Cubist works in the first Surrealist exhibition at the Galerie Pierre. Though Picasso continued to maintain amicable if sporadic relations with Breton until the late thirties, he drew closer to other members of the movement, particularly Eluard, and also saw a number of the "dissident Surrealists" (among them

Limbour, Leiris, Desnos, and Masson), who had broken with Breton in the crisis of 1929–30.

The convulsive *Three Dancers* of 1925 is sometimes identified (see Brandi, *Carmine*) as the beginning of Picasso's Surrealist-oriented painting, and indeed this important picture does mark an abrupt departure in his art. However, despite the new psychological dimensions of this work, such deviations as it presents from earlier patterns of flat Cubism are more in the direction of Expressionist distortion than Surrealist metamorphosis.

Guitar (fig. 290), a large collage of 1926, is entirely Cubist in "syntax," but the nails hammered through the cloth from behind (Miró had already used them in collage objects) so that their points project menacingly from the picture surface "go beyond," as Alfred Barr observes, "the cubist esthetics of 'texture': they are psycho-

282

logically, almost physically, disquieting."[196] Roland Penrose describes the *Guitar* as an example of Picasso's "malicious art" and reports that the painter told him he considered "embedding razor blades in the edges of the picture so that whoever went to lift it would cut their hands."[197] The aggressiveness involved here not only anticipates works like Giacometti's thorny *Disagreeable Object* (fig. 216) but in a general sense is an echo of the sadistic strain that runs throughout Surrealist art and literature.

The curvilinear *Seated Woman* of 1927 bore witness to an incipient shift in the direction of Surrealist biomorphism, and, as in other pictures where Picasso appropriated this form-language in a flat manner, the influence of Miró comes to mind. Picasso had been very interested in Miró's work from 1924 onward and, as Breton observes, Picasso's decision to participate in Surrealist undertakings in the late twenties was largely the result of Miró's influence.[198]

It was at Cannes, in the summer of 1927, when Picasso suddenly started shading his drawings to give them an illusion of sculptural roundness, that his forms moved far enough away from simple curvilinear abstraction to be considered truly biomorphic. In the series of "Bathers" executed at that time, all the particulars (facial features, fingers, and toes) still present in the earlier "Seated Women" have been dissolved into smooth, generalized organic contours (fig. 291). Many of the drawings of this period, though more anthropomorphic than Tanguy's paintings, suggest that Picasso had been looking at the latter's work of 1927 out of the corner of his eye. Picasso's alteration of anatomy here goes beyond Cubist dislocation and Expressionist exaggeration toward a truly hallucinatory "confusion," a surreal metamorphosis which Picasso translated into sculpture in the round the following winter in a small group of fantastic bronze figures (fig. 293).

These sculptures, like the steel-wire constructions of 1928 (fig. 294), number only three or four. Their extraordinary inventiveness and quality make us regret that Picasso did not turn wholeheartedly to sculpture until 1932, when he worked in the less daring and less intense style exemplified by the Marie-Thérèse Walter portraits done at Boisgeloup. From 1927 through 1931, Picasso was frequently inspired with ideas for extraordinarily original sculpture, but he seemed to lack the patience—or will—to execute them. The ideas exist for us largely in the form of illusionistic drawings that, unfortunately, possess neither the virtues of real sculpture nor those of his best drawings.

In the summer of 1928, Picasso vacationed at Dinard and made a series of drawings for sculptural "monuments," an idea which

had occurred to him the summer before when he imagined the Croisette at Cannes lined with huge sculptures (fig. 295). The forms of the anatomies in these drawings are more open in character than those of 1927, the single rubbery biomorphs giving way to harder and somewhat less descriptive "bone" components stacked and piled against one another. Less whimsical than the "Bather" drawings, these "bone" constructions have an awkward, Stonehengelike grandeur.

In the next few years, Picasso returned now and then to the vocabulary of the Dinard "monuments," usually envisioning the results in the round, as in the *Project for a Monument* (*Metamorphosis*) of 1930 (fig. 298) and the drawings of 1932 after Grünewald's Isenheim Crucifixion (figs. 300, 301; cf. D-1). In 1933, these "metamorphoses" reached a new climax in a series of drawings of imaginary sculptures titled *An Anatomy* (fig. 302) that are even more like Surrealist sculptures than the Cannes or Dinard drawings. Fused with the biomorphs and "bone" structures are shapes, vaguely resembling primordial furniture, which come right out of Giacometti's *Objets mobiles et muets*, as comparison with the Giacometti drawings published in the December, 1931, issue of *Le Surréalisme A.S.D.L.R.* makes evident. The forms suspended on strings and the ball, prong, tusk, and cup shapes of *An Anatomy* recall the Giacometti drawings, while the slackened furniture elements, resembling chair backs and table tops, are familiar in other Giacometti works of the period 1926–33. Of course, such influences did not go entirely one way. I have already mentioned the importance of Picasso's openwork steel-wire constructions of 1928 for Giacometti's cages. It is also possible that the Cannes and Dinard drawings had some influence on Giacometti in such works as *Suspended Ball* (fig. 215) and *Cage* (fig. 218). But the affinities between Picasso and Giacometti through 1930 —aside from the former's *Anatomy*—are probably a matter of both artists responding to a form-language that was increasingly in the air.

The personages of *An Anatomy* constitute projects for sculptures rather than for Surrealist objects—in the same way as did Giacometti's sketches of *Objets mobiles et muets*. At the same time, Picasso did make a few excursions into the collaging of real objects (the principal result has already been described, on p. 267). Here again, his impulses rarely overcame his resistance to going beyond a sketch; the most interesting of these potential hybrids was realized only as an etching in the series celebrating "The Sculptor's Studio." Here a nude model, drawn in Neo-Classical style, ponders a Surrealist object representing a figure composed of chair legs and back, upholstery, cushions, sticks, balls, and what appear to be simple carpentered forms or found wood. Two little balls denoting the nipples of the

Pablo Picasso

chest are suspended from a colonic stick by strings, and the arms appear to be composed of a cloth "skin" clumsily stuffed. These awkward limbs are related in character to those—seemingly made of plaster—of *Two Figures on the Beach* (fig. 303), a drawing executed a few months later at Cannes, in which the personages are composed of doors, the slats of venetian blinds, chairs, cushions, sticks, and gloves. The compound object-personages depicted in the linear works of 1933 (figs. 303, 304) with their "stuffed" limbs and torsos of furniture and studio detritus, and the dreamlike confrontation of realistic but rationally unrelated figures exemplified by *Minotauromachy* (fig. 306), show Picasso at his closest approach to the Surrealism of the early thirties.

It is regrettable that the fantasies Picasso envisioned in the drawings just mentioned and in *An Anatomy* were never realized three-dimensionally. His nearest approach to this was a group of sand-covered reliefs made in the summer of 1930, in the best of which a

stuffed glove is enigmatically juxtaposed with a "head" of contoured felt covered with "hair" (ravelings from cloth) in a way that makes the whole work look like something washed up by the sea (fig. 299). Whereas Picasso had formerly mixed sand with pigment to create texture in his Cubist works, the sand here functions in the more poetic and descriptive manner of Masson's sand paintings—that is, as a reference to the locus of the images.

While not specifically Surrealist, the many works containing symbolic iconographies that Picasso executed in the late twenties and the thirties reflect the literary atmosphere of Surrealism, and especially its concern in later years with Classical myth in Freudianized form. And though the myths to which Picasso turned for his symbols were largely not those favored by the Surrealists, his treatment of them was akin to theirs insofar as it involved hallucinatory juxtapositions and metamorphoses. The importance of these iconographic explorations in defining Picasso's relation to Surrealism,

280 E. L. T. MESENS *Mask to Insult Esthetes.* 1929

281 E. L. T. MESENS *Les Caves du Vatican.* 1936

282 SALVADOR DALI *Rainy Taxi.* 1938

283 ANDRÉ MASSON *Mannequin.* 1938

MASQUE SERVANT A INJURIER LES ESTHÊTES

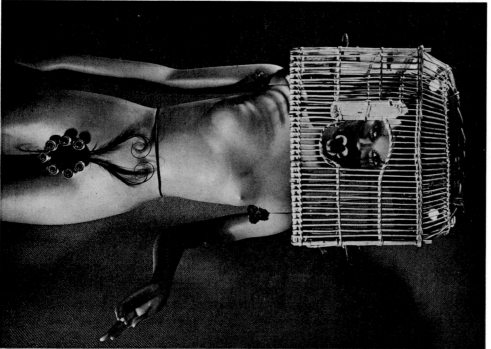

284 The pond at the *Exposition Internationale du Surréalisme*, Galerie Beaux-Arts, Paris, 1938. Works of art, from left to right: Paalen, title unknown; Roland Penrose, *The Real Woman*; André Masson, *The Death of Ophelia*; Marcel Jean, *Horoscope*

285 KURT SELIGMANN *Ultra-Furniture.* 1938

286 287

288

287

286 VICTOR BRAUNER Wolf-Table. 1937

287 ANDRÉ BRETON Poem-Object. 1941

288 MAN RAY, YVES TANGUY,
JOAN MIRÓ, and MAX MORISE
Cadavre exquis. 1928

290

289 PABLO PICASSO *Dying Horse.* 1917

290 PABLO PICASSO *Guitar.* 1926

291 PABLO PICASSO *Bather.* 1927

292 PABLO PICASSO *Minotaure.* 1928

289

291

292

combined with Picasso's crucial role in twentieth-century painting as a whole, requires that we analyze this phase of his work in particular detail.

Picasso's interest in Surrealist poetry, and his association with Eluard, prompted him to write some poetry of his own. He had long thought about experimenting with the substitution of one art for another, of "writing pictures and painting poems,"[199] and in some poems written at Boisgeloup blobs of paint represent objects. This idea proved unworkable, however, and in 1935 he turned to poetry in the strict sense, evoking fragments of visual experience by means of phrases separated at first by dashes of varying length but which were later suppressed in favor of run-on constructions not unlike Joyce's stream of consciousness:

. . . I make my way set alight and burn caress and lick embrace and watch I ring at full peal the bells until they bleed terrify the pigeons and make them fly about the dovecote until they fall to the ground already dead from fatigue I shall block up all the windows and doors with earth and with your hair I shall catch all the birds that sing. . . .

Pablo Picasso

Picasso's poems were written in Spanish—his friend Jaime Sabartés helped in preparing them for publication—and printed in a special number of *Cahiers d'Art* with an enthusiastic preface by Breton. They represent Picasso's closest approximation of Surrealist literature before his play *Desire Caught by the Tail*, written in 1941. But despite the associational Surrealist aspect of their technique (automatism), these poems remain apart from Surrealism to the extent that their raw material is not the rare, the marvelous, the esoteric, or even the oneiric. As Breton himself admitted, they find their "point of departure in immediate reality."[200]

Pablo Picasso

At the time Breton wrote this preface, he still had high hopes that Picasso would become a truly Surrealist artist. But he might have taken his own observation regarding Picasso's poetry as an augury—if not proof—that this was not to happen. If Picasso drew so much of his poetry from immediate, concrete reality, he was hardly likely to do otherwise in his painting, and by the end of the thirties, Breton had come to realize this clearly. No matter how extreme the metamorphosis in Picasso's paintings, the thing metamorphosed—with very rare exceptions—is not fantastical or oneiric but immediate and commonplace. In fact, Picasso's commitment to reality as a starting point has kept him not only from making truly Surrealist paintings but also from making integrally abstract ones, and even today he seems neither to understand nor sympathize with non-figurative art.

Precisely because he avoided the oneiric, Picasso could neither deal with the dream in the immediately given manner of Surrealist illusionism nor conjure an esoteric replacement of reality by the inductive means of Surrealist automatism. Whereas Masson, for example, starts with a void and lets the image—the thing represented—emerge associationally from initially inchoate marks, Picasso begins with an object—a thing—and the process of its metamorphosis, whether toward Cubism, Expressionism, or biomorphism, comes afterward.

While there are universal or archetypal symbols in dreams, the kind of Surrealist poetry and painting that deals with dreams does not stress these symbols to nearly the extent it does rare and personal images. For Picasso, however, it is the myth—the collective arche-typal dream symbols in narrative form—rather than dreaming itself that is of interest.

The three "myths" which predominate in Picasso's symbolic pic-tures are those of the Minotaur, the Crucifixion,[201] and the bullfight: these represent respectively the Classical Mediterranean heritage, the Christian heritage, and the Spanish national heritage, in which the first two are fused. All three involve violence and death and man's attempt to triumph over them by means of mind or spirit. The earliest of these motifs to appear in Picasso's art was the bullfight, which was closest to his immediate experience. His first *Crucifixion* dates from 1915, his earliest allusion to the Minotaur from 1928 (fig. 292). The bullfight and the Minotaur have evident points of contact, and Picasso's unconscious fusion of the two can be easily traced. The relationship of the Crucifixion to the bullfight, and hence by associ-ation to the Minotaur, is less direct but nevertheless demonstrable. The myth of the Minotaur was of interest to Surrealism in the thirties

and forties; the bullfight and the Crucifixion were not. But if the latter two motifs are not in themselves Surrealist, the techniques, both ideational and stylistic, that Picasso used to associate and fuse them were.

The bullfight, or *corrida*, is the national myth of Spain; its ritual is one which Picasso has always loved to watch, and one he has drawn and painted at various times throughout his career. As a young boy, the man whom Gomez de la Serna called "the torcador of painting" earned money to attend *corridas* by hawking his bull-fight sketches in the street.

Rites connected with the sacrifice of bulls go back to the Minoan and Mycenaean roots of civilization. Generally, the animal was sacrificed, his meat eaten and his blood drunk as a totemistic way of procuring the strength and virility of the animal. Sometimes the rite took on the form of an agon, or contest, in which man as a symbol of mind or intelligence struggled against brute force and compulsive instinct. It was not always necessary to kill the animal; in the famous frescoes of the palace at Knossos, in Crete, the human protagonists triumph by cleverly catching the bull's horns and somer-saulting over him. This is the antecedent of the refined choreography of the matador's drama, which insures that the final dispatch of the animal will be a sacrament and not butchery.

The denouement of the bullfight includes, however, one element—the picador's horse—that had no place in the ancient rituals but that "enriches" the Spanish drama, especially for Picasso. Though only an accessory to the agon, the horse is gored or, in these days of padding, violently butted by the bull, and his death, or punish-ment, is that of the *suffering innocent*. This role, as we shall see, permits his assimilation, in Picasso's iconography, to the crucified Christ (where it invests *Guernica* with a secondary and subtle level of meaning).

The place of the Crucifixion in Picasso's art and its relation to the bullfight can be approached through a study of the implied presence of both themes in the culminating work of Picasso's sym-bolic period, *Guernica* (fig. 308). (Only rarely in the considerable literature on *Guernica* has its iconography been shown to include the *corrida*, and never the Crucifixion.) The symbols in *Guernica* resist the highly specific interpretations given them by Juan Larrea,[202] Jerome Seckler,[203] and others. It is the very ambiguity of these sym-bols that accounts for their richness and that enables them to func-tion simultaneously as the elements of more than one theme.

That the bullfight belongs to the symbolic scaffolding of *Guernica* is attested by the prominence given the three actors of that ritual

drama. The agonized horse—prepared for in drawings of twenty years earlier—is central; the bull, unconquered, surveys the scene of destruction; and the dead man on the ground holding a broken sword (explained on the realistic narrative level as a dead soldier) is the matador. (That it is a sword he holds, and not a gun, was no doubt motivated, as Meyer Schapiro observes, by the desire to endow the picture with a certain timelessness and universality as far as its imagery was concerned, but the sword also serves to support the bullfighting motif.)

Less discernible in *Guernica* is the contribution made by the many drawings, and the painting of the Crucifixion, that Picasso did in the years just preceding. The horse, the guiltless sufferer with the spear in its side, is the main vehicle of the Crucifixion theme, but we can appreciate its full meaning only by tracing the previous development of the motif. Like the *corrida*, the Crucifixion belongs to collective experience, but the treatment Picasso gives it in the present context is highly personal and Surrealist-influenced, even down to the very morphology of his forms.

Picasso's *Crucifixion* (1915), a drawing in Neo-Classical style with "Mannerist" elongations, was followed by a pair of sketches in 1926 which treated the subject in the spirit of fantasy with extraordinary distortions and metamorphoses (fig. D-172). I shall discuss these and two other drawings of 1929, which are usually identified—wrongly, I believe—as Crucifixions, at length elsewhere.[204] In any event, the climax of Picasso's development of the Crucifixion image, and perhaps the best illustration of the Surrealist influences in his style, is the acidly colored oil he executed in February, 1930 (colorplate 34). Though small—20 by 26 inches—its relatively precise execution permitted Picasso to pack it with an exceptionally large number of motifs, some of them derived from the earlier studies. At first glance, the motifs seem hopelessly entangled; if, however, we bring to the picture an eye accustomed to the stylistic modalities of Picasso's other paintings of the period, it begins to clarify itself, and what it reveals is a work unique not only in Picasso's production for its subject, composition, and coloring (as Alfred Barr has pointed out)[205] but also unique in the iconography of modern painting and of Christianity. It is one of the most crucial of Picasso's images, although it is not one of his most successful paintings.

The space of this *Crucifixion* has been squeezed exceedingly flat; only bits of low-relief modeling are visible here and there. The aim of this flattening is not—as so frequently elsewhere in Picasso's images—to realize a decorative and patterned layout but to create an oppressive

atmosphere such as would reinforce the theme. The sense of space being so largely schematic, it depends for its reading on decipherable cues. Thus, as a result of their diminutive size, the tiny T-shaped crosses of the thieves in the lower left and middle right margins are *understood* to be, though not *illusionistically* seen to be, in deep space, far behind the plane of Christ's cross. The two small crosses themselves are bare: the broken bodies of the thieves are easily identified in the lower-left corner of the picture. Picasso contradicts our usual experience of pictorial space by a hallucinatory wrenching of the iconographic cues from their logical perspective context. The sponge, isolated in the upper left, is huge (its isolation may reflect Picasso's recollection of images of the Man of Sorrows), while the centurion, though located closer to the picture plane than Christ, is no bigger than the latter's head. Picasso has represented the centurion on horseback, and Roland Penrose[206] rightly assimilates him to the earlier images of picadors. He is executed in a loosely painted, quasi-realistic manner wholly at odds with the other stylistic impulses in the picture, all of which belong to surreal and expressionist types

of metamorphoses and distortions familiar in his paintings of the late twenties. While Picasso has usually, since 1917 or so, worked in a variety of styles at almost any given moment, he has rarely mixed them in the same work as he does here. Except in images like *Nude and Sculpture* from "The Sculptor's Studio," where the stylistic range between the female model and the Surrealist sculpture is "rationalized" by the narrative situation, and the manner of drawing in both figures—as opposed to the conception of them—is, in any case, the same, I cannot recall anything approaching the abrupt change of style displayed in the drawing of the centurion.

The legs, midsection, and what may possibly represent the open mouth of the man who previously (in the sketches of 1926 and 1929) held a ladder are visible in the 1930 *Crucifixion* in roughly the same place as before. But it is unclear whether he still holds the ladder, which is now shown as leaning on the left arm of the Cross. On one of the ladder's upper rungs stands a monstrous little red figure—perhaps the most surreal thing in all Picasso—who is hammering a nail into Christ's right hand. His anatomy is difficult to read, not only because it has a freedom of disposition comparable to the phenomenal yawning *Woman in an Armchair* (fig. 296) but because of the fantastic morphology. As we study the legs and arms, we begin to see that the figure has itself been metamorphosed into the shapes of nails, the *role* here being hallucinatorily confused with the *actor*.

The simplified and schematic figure of Christ, with his oversized

arms and Classical girdle, is easily distinguished as a white pattern against the white cross. And as part of the same cluster of white forms we see the weeping Magdalene, her head realized in the "bone" style of the Dinard "monuments," both dramatically and stylistically anticipating the Weeping Women of the *Guernica* period. To the right of the axis, in the middle ground, we can make out St. John, whose head contains a curious tomato-red shape and whose extended hand compassionately grasps the right arm of the Virgin, whose hands are clasped far above her head in a gesture of despair.

The grotesque yet whimsical group in the center right foreground completes the dramatis personae of the *Crucifixion*. Here, on the head of a military drum, two soldiers cast dice for Christ's garments. The soldier on the left, one of whose feet is immense, the other tiny, wears a plumed Roman helmet and holds an otherwise undecipherable article of Christ's clothing in his hand. The other, shown rolling the dice, has a monstrously distorted head, the top of which seems to have been cut off and sewn back in place. The intensity of the scene is relieved by a certain whimsy in the head of an onlooker, quoted almost literally from that of the skeletal "bone" *Seated Bather* of 1930 (fig. 297).

The long process of integration that prepared the *Crucifixion* and the completeness with which it is executed in spite of its small size appear to support Penrose's belief that it was intended as the *maquette* of a larger work. Even as it stands, it represents a moment of such unique importance in Picasso's art that it brings us up against the question why Picasso, an avowed atheist, went to such trouble with this subject, and why, if a larger work was envisioned, he did not carry it out.

Every writer who has considered the *Crucifixion* has agreed, in substance, that the picture "seems entirely devoid of religious significance."[207] Though there is, prima facie, nothing iconographically blasphemous in it, its distortions and metamorphoses would be regarded as that by Vatican standards. What strikes the viewer very sharply is the atmosphere of pain and anguish, communicated as much by the surreal morphology as by the hot clashing colors (both suggestive of the famous Beatus of St. Sever, the Spanish Romanesque manuscript which would also influence *Guernica*) and agonized attitudes of the protagonists. In this context, the picture takes its place among the other Picassos of the late twenties and the thirties, where themes of suffering and violence manifest themselves. It serves as anchor picture in a development that leads through *Guernica* to the latter's pendant, *The Charnel House* (1945; fig. D-177).

In the main, this Calvary furnishes Picasso with an excellent

vehicle for a descant on the theme of suffering. The picture is not in the "vertical"—that is, historical—line of treatment of the Crucifixion image, which reaches back into older art, but belongs to the "horizontal," or contemporary, order of images of violent anguish. These play a poignant role in Picasso's art. In any case, after World War II, it was not uncommon for nonreligious artists—Germaine Richier and Graham Sutherland, for example—to employ the Crucifixion as the epitomizing image of suffering. In the work of painters like Rico Lebrun and Bernard Buffet the crucified Christ became (as the Man of Dachau) a kind of pseudo-Expressionist cliché.

The irreligious character of Picasso's *Crucifixion* goes to an extreme insofar as it is literally anti-sacramental; this can be fully measured only by returning to certain enigmas of the composition. Is there any rationale for the presence in the same picture of the oversized sponge and the undersized centurion—to choose a most extreme instance? Let us for a moment imagine the scene portrayed not in the traditional manner, from the vantage point of the beholder, but from that of the Man on the Cross. In those moments of agony a hallucinatory state would have seemed natural: the sponge held up to Jesus' face might very well have seemed immense, and the centurion at the far end of the stabbing spear may indeed have appeared quite small. I do not mean to suggest that Picasso was painting a realistic picture of Christ's hallucinatory experience, but rather that in a general sense the assumptions of the picture can be understood if the artist is held to have abandoned his traditional position as observer and put himself in the place of the protagonist, with pictorial structure and iconography being revised accordingly. Since the spectator's point of view is the same as the artist's, man, in effect, is substituted for God in what could be described as a secularization of the image. All the transcendent implications of the Crucifixion are stripped away, leaving only that part of the experience which mortal man can know—the agony.

If we accept this reading of the *Crucifixion*—that it was conceived more from the point of view of the crucified than of the onlooker—we must concede at the same time that the work is inherently less Surrealist than we had supposed. To the extent that the hallucinatory mode ceases to be a precondition of Picasso's picture making at that moment and begins to belong to the subject of the picture—the agonized man—the artist who depicts the hallucinatory state as part of his identification with the subject is acting within his familiar mode of imaging.

The narrowing of traditional meanings in the *Crucifixion* is consistent with Picasso's approach to Grünewald's *Isenheim Altarpiece*

filled in with contrasting fields of black ink and white paper. Most of them, however, build upon the agonized nature of the image, translating it into a kind of nightmare peopled with "bone" figures. What interests one here, particularly in relation to the structure of *Guernica*, is the development of the figure of Christ (one of the least interesting in Picasso's own earlier *Crucifixion*) into an open "bone" formation which widens gradually from top to bottom, providing a striking prototype for the pattern of the dying horse in *Guernica*—the center of its composition, as Christ is of that of the *Crucifixion*. In this connection it is important to note that some of Picasso's Grünewald variations twist and reverse Christ's head in precisely the manner of the later *Guernica* horse, and that from the Grünewald itself, where Christ's tongue is beginning to emerge from his mouth (Meyer Schapiro has noted the horror suggested by this "externalization of the body"), Picasso got the idea for the protruding tongue of the horse in *Guernica*. In fact, the metamorphosis in some of Picasso's variations on Grünewald is so extreme that Christ's head resembles an animal's head far more than a man's. One variant in particular (fig. 301) turns the nose into a kind of horse's muzzle and comes very close to one of the studies Picasso was to make for the dying horse in *Guernica* five years later (fig. D-176).

Awareness of the specific relations that exist between the 1932 variations on Grünewald and the horse in *Guernica* reinforces the feeling that the Crucifixion is one of the "mythological" implications which, though not immediately evident, nevertheless indirectly adds to the iconographic overtones of *Guernica*. Under this aspect, the "suffering innocent" of the *corrida* functions as a surrogate for Christ. This reading also renders more logical a motif in *Guernica* that has never been satisfactorily explained (and one that is not consistent with the *corrida* level of interpretation): the spear in the horse's side—which now can be understood as the spear of Longinus.

If the reader thinks that my direct assimilation of the central icon of Christianity with the central protagonist of *Guernica* is forced, he need only recall the traditional, historical association of Christianity with the bullfight and the many indications of Picasso's awareness of it. For centuries, the bullfight has been part of Spanish popular Christianity; its imagery permeates the *villancicos*, traditional nonliturgical church songs. A notable instance of a ceremonial relation between the two is the Jesuit petition to the Chapter in Seville Cathedral to celebrate a bullfight immediately following the liturgical ceremonies at the canonization of St. Ignatius. The fusion of Christianity and the bullfight is also common in the modern Spanish

Pablo Picasso (after Grünewald)

(fig. D-1) two years later (figs. 300, 301). The Grünewald work contains, in addition to an agonized Crucifixion, a number of scenes of a wholly transcendent religious order that include a wide range of both experience and dogma. Of all this the Crucifixion is, to be sure, a crucial part—but only a part. It was characteristic of Picasso, and to that extent typical of his role as epitome of the twentieth-century artist, that he should select only the Crucifixion panel for his variations, isolating it from its original context.[208]

The series of variations on the Grünewald Crucifixion, executed at Boisgeloup in 1932, consists of nine full-sheet drawings and numerous notebook fragments. The best of these were published the following year in the first number of *Minotaure*; others are reproduced in Zervos' catalogue. Some are essentially decorative, abstracting the patterning of the Grünewald into a series of arabesques

literary tradition, as in Lorca's *Elegy for the Death of Blanchas Mejas*. Vincente Marrero[209] has gathered a number of other pertinent examples.

In *Guernica* and the works leading to it, the fusion of the two "myths" is only implicit. But its presence is attested explicitly in a series of drawings with which Picasso filled his notebook on March 2 and 3, 1959, even though here Christ tends to be identified more with the matador than with the picador's horse. The first two drawings in this series (far from impressive pictorially) show incidents from bullfights in which the matador, his arm outstretched and holding the *muleta*, curiously resembles the crucified Christ. The fifth drawing raises this combination, the matador above a dying horse; in the ninth drawing, which restates this combination, the matador has definitely become a Christ image, but though he hangs on the Cross, his right hand still grips the *muleta*. Drawings fourteen through sixteen make the identification even clearer by detailing Christ's beard and the crown of thorns (fig. D-179).

Though the fusion of the Crucifixion and the *corrida* become fully explicit only in drawings of a much later date, the two "myths" meet much earlier in the third, and most dominant, "myth" in Picasso's symbolic pictures, the literally mythological Minotaur.

Picasso's earliest image of the Minotaur appears to be a collage executed on New Year's Day, 1928 (fig. 292). Already the main characteristics of his treatment are evident: the Minotaur is separated from the other figures of the Theseus legend, and, delivered from the encumbrances of the old tale, becomes free to function entirely according to Picasso's fantasy—as a violent or pathetic, romantic or even comic personage, with attributes that have no connection with his original mythological role.

Though invented in 1928, Picasso's Minotaur seemed not to interest him much until 1933. Among the few representations dating from the intervening period is a large oil of 1928, *Running Minotaur*, which is essentially a variant of the earlier collage. When the artist made a series of etchings in 1930 for the Skira edition of Ovid's *Metamorphoses*, one of the main literary sources of the Thesean legend, not one of the thirty illustrations was devoted to the Minotaur. The renewal of Picasso's interest in this subject in 1933 is associated with his collaboration on the magazine *Minotaure*, founded in that year, and with his close contact at that time with the Surrealists.

Minotaure was published by Skira with the assistance of E. Tériade, and, true to the blazon in its masthead, it was devoted to "The plastic arts—poetry—music—architecture—ethnography and mythology—theater—psychoanalytical studies and observations."

Though it was not a Surrealist review, most of its contributors were Surrealists or close to their circle. The magazine brought Surrealist art together with Picasso, Brancusi, Laurens, Matisse, and others (including occasional old masters), as well as with "dissident" Surrealists like Masson. Duchamp, Miró, and Dalí (fig. D-191) designed covers for three of the first nine issues. With No. 10, published in the winter of 1937 with a cover by Magritte, Breton, who had been very active on the magazine not only as a contributor but as an editor behind the scenes, formally took over its direction, assisted primarily by Eluard. Max Ernst did the next cover, and André Masson the last (No. 12-13), which was published in May, 1939 (after which the political situation prevented the magazine's continuance).

The title *Minotaure*, suggested by Masson and Georges Bataille, was in accord with the growing interest in French intellectual circles in the psychoanalytical interpretation of myth. The labyrinth—the recesses of the mind—contains at its center the Minotaur, symbol of irrational impulses. Theseus, slayer of the beast, thus symbolizes the conscious mind threading its way into its unknown regions and emerging again by virtue of intelligence, that is, self-knowledge—a paradigmatic schema for the Surrealist drama, as indeed for the process of psychoanalysis.

Picasso, having been invited to design the cover of the first issue, produced a Minotaur, dagger in hand, rampant on a field of collaged paper doilies, tin foil, leaves, ribbons, and corrugated board (fig. 305). He also made four etchings of the Minotaur with the dagger in different positions; these were reproduced as a frontispiece. The issue contained, in addition, his Grünewald variations, *An Anatomy*, and an extensive article by Breton, "Picasso dans son élément."

The etchings and drawings of 1933 are the true introduction to Picasso's Minotaur. In the one dated May 17 the Minotaur lounges with a beautiful naked woman, raising his champagne glass in a toast; an etching made the following day shows him caressing the woman to the accompaniment of a flute. The etching of May 29 is of special interest because of its implicit fusion of the Minotaur with the bullfight: before a classically costumed audience in a stadium, a nude male athlete is about to administer the *coup de grâce* to the Minotaur with a dagger. The Minotaur is not consistently vanquished in this struggle, however, and in a powerful drawing of December 5 we see him wringing the neck of a picador's writhing horse.

During the next two years, Picasso varied and elaborated the personality of his Minotaur, adding to his characteristics that of pathos in particular. In the etchings, drawings, and mixed-media images of the blind Minotaur, all of 1934, the monster is shown with

his head tilted upward in a suffering way, walking with the aid of a staff, and led either by a young girl holding flowers or by a dove. In a May, 1936, watercolor (fig. D-175) he is dying, with a sword through his heart, as he begs help from a maiden in a boat (Ariadne?), while a female picador rides in the background. That this watercolor suggests the original myth somewhat more closely than the other images is not surprising when we consider that it was made just a few days after another watercolor in which the ancient legend is more fundamental to the picture than anywhere else in Picasso's treatment of the theme (fig. 307). Here the Minotaur emerges from the cave of the labyrinth, while in the distance Ariadne, looking on, hides herself with a veil. This is a remarkable example of the Picasso's mythological syncretism, for the dead victim the Minotaur holds in his arms is not one of the Athenian youths or maidens sacrificed to him but *the broken body of a picador's horse.* Thus the two are related in a way that recalls the *corrida* and dying horse of *Guernica.*

The Minotaur is shown in so many varied and contradictory guises and situations that it is clear that Picasso did not attribute any single, consistent meaning to him. We can intuit his symbolism only by assimilating the many contexts in which we see him, and even then the meaning remains elusive. As if to insist upon this, Picasso etched, sometime in 1934, an extraordinary image of a Sphinx-Minotaur (the enigmatic Greek Sphinx of the Oedipus legend, which has no connection with the Egyptian one). Basing his conception on familiar images of the Sphinx, perhaps that of Ingres in particular, he shows a synthetic monster with a lion's hind parts, an eagle's talons and wings, a woman's breasts, and a bull's head.

All the images discussed thus far must be kept in mind to grasp the symbolic meanings of the outsize etching of 1935 titled *Minotauromachy* (fig. 306), which is, iconographically at least, the climax of Picasso's symbolic pictures. Here a bison-headed Minotaur walks in from the right, his right hand extended before him to block the light from a candle held by a young girl facing him (in her other hand she holds a bouquet of flowers). Between them a gored horse neighs with fear and staggers under a naked-breasted female matador collapsed on his back. In the left margin is a bearded Christlike figure who looks back anxiously as he climbs a ladder; in the window of a building in the middle ground, on the ledge of which stand a pair of doves, two young girls look on.

Of special prophetic importance to this etching are two of the previous year that expand the earlier bullfight images in a way approaching that of *Minotauromachy.* The one executed on June

7, 1934, *Tauromachy,* shows a bull goring a horse, across whose back, as in *Minotauromachy,* the body of a naked-breasted female matador is draped. The July 24 etching depicts the bull, with sword planted in his back, disemboweling the horse, while a maiden holding a candle shields her eyes from the sight. The title *Tauromachy* is appropriate to these images derived from the *corrida* in a way that *Minotauromachy* is not (the Greek word *machy* means "battle"). There is no literal battle going on in *Minotauromachy,* though there is an agon. The Minotaur is not fighting but is presented as a symbol of potential violence and brute force undirected by knowledge or mind—for which the maiden's candle, which frightens him, stands. His relation to the gored horse is equivocal; if he did the goring, he did so before the scene Picasso depicts. To this extent perhaps he prefigures the enigmatic bull in *Guernica.* In *Minotauromachy,* with its hallucinatory confrontation of force and idealism, the primitive or primordial and the human, the hybrid and the pure, darkness and light, the one reference to Christian iconography is equivocal if not condescending, for the Christlike figure on the ladder is fleeing the struggle. Alfred Barr is no doubt correct in asserting that Picasso himself probably could not explain in words this "moral melodramatic charade of the soul."[210] What I have tried to do here is not so much interpret it as put before the reader such associational insights as are given elsewhere by Picasso himself in the form of images, not words.

The leap from *Minotauromachy* to *Guernica* is not as great as might at first appear. The two works have many dramatis personae in common, although, as befits a large public mural, the iconography of *Guernica* is less manifestly sophisticated. This is one of its poetic strengths, as Sir Herbert Read eloquently argued, for if "Picasso's symbols are banal, like the symbols of Homer, Dante, Cervantes . . . it is only when the widest commonplace is infused with the intensest passion that a great work of art, transcending all schools and categories, is born."[211]

This does not mean that the symbolism of *Guernica* is not open to as many levels of interpretation as that in *Minotauromachy;* on the contrary, we have already seen how rich in implications its iconography is. It is only on the level of the explicitly given that *Minotauromachy* is more complex and esoteric, more private than public. To that extent it is more in the Surrealist mood, but precisely for this reason Picasso's monumental commitment to a public statement in *Guernica* required that he transcend the forms and characteristics typical of his symbolic images in the previous decade. To transcend is not, however, to erase: just as the great pedimental composition

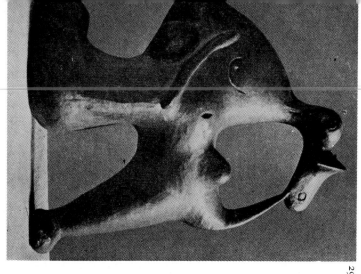

293

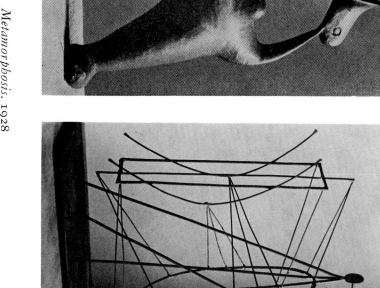

294

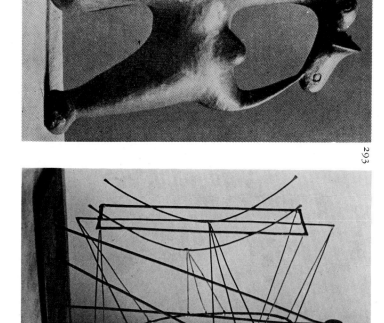

295

296

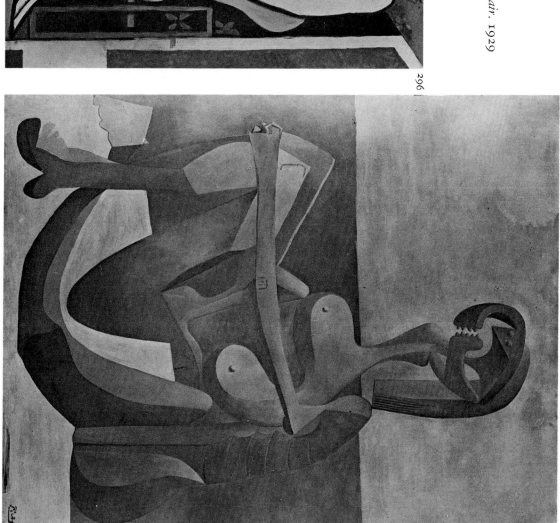

297

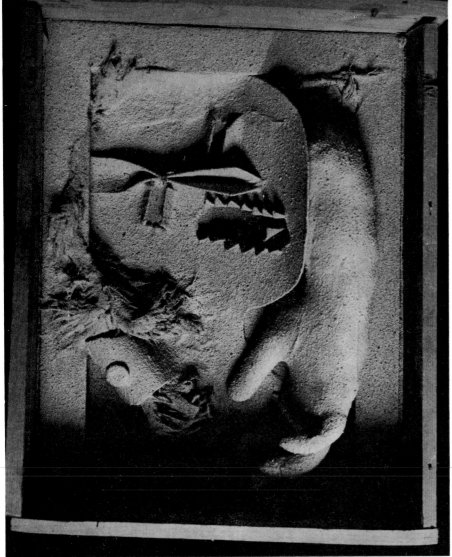

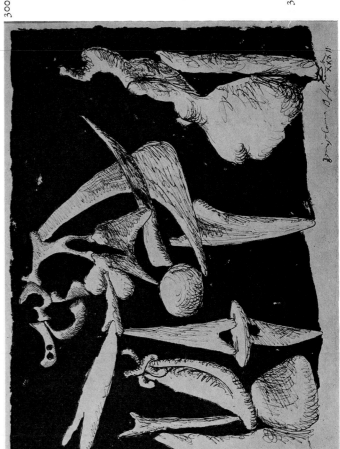

298 PABLO PICASSO *Project for a Monument (Metamorphosis)*. 1930

299 PABLO PICASSO *Construction with Glove (By the Sea)*. 1930

300 PABLO PICASSO *Crucifixion* (after Grünewald). 1932

301 PABLO PICASSO *Agonized Crucifixion* (after Grünewald). 1932

302 PABLO PICASSO *An Anatomy*. 1933

299

298

300

301

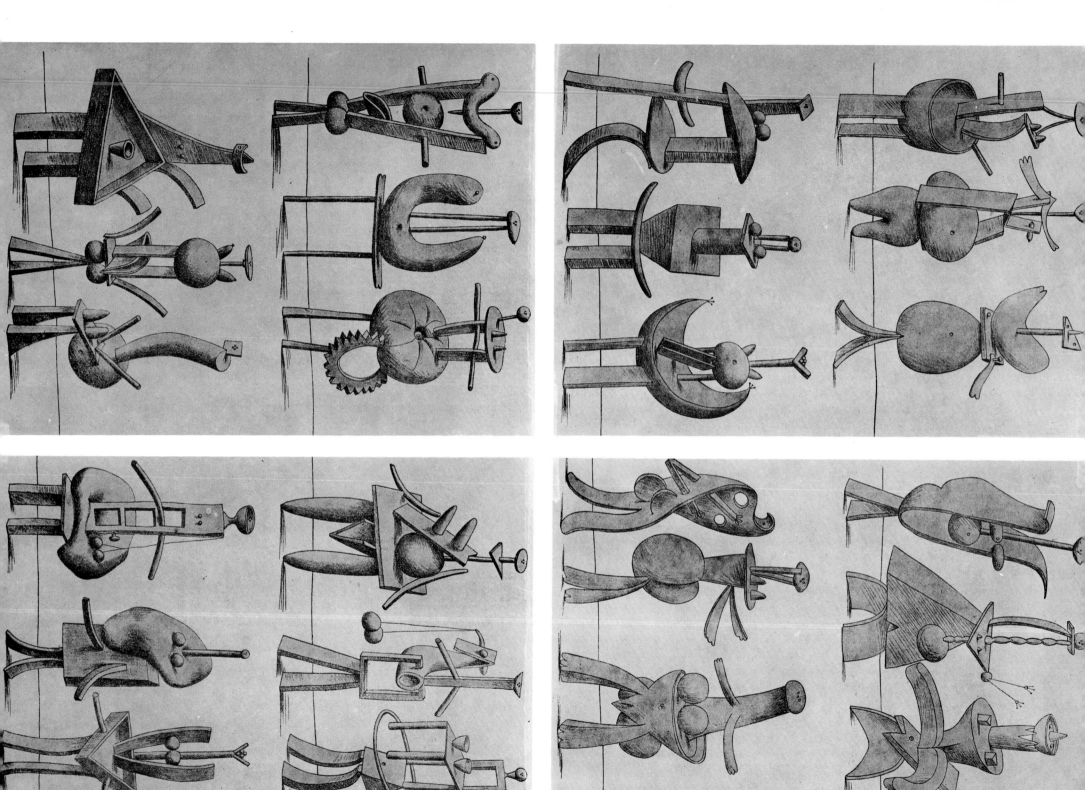

302

304

303

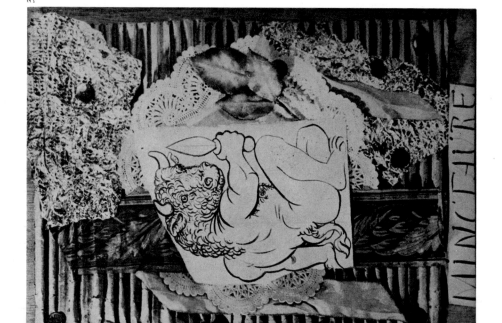

305 306

303 PABLO PICASSO *Two Figures on the Beach.* 1933

304 PABLO PICASSO *Composition.* 1933

305 PABLO PICASSO Cover of first issue of *Minotaure* (Paris), 1933

306 PABLO PICASSO *Minotauromachy.* 1935

309

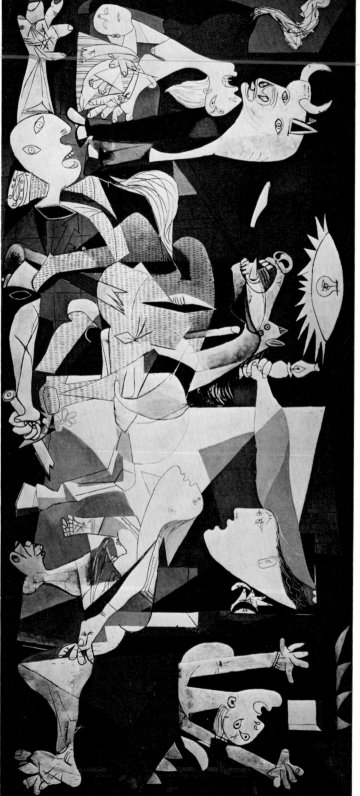

308

307

311

310 VICTOR BRAUNER *The Door.* 1932

311 VICTOR BRAUNER *Conspiracy.* 1934

312 VICTOR BRAUNER *The Strange Case of Mr. K.* 1934

312a VICTOR BRAUNER *The Strange Case of Mr. K.* (Detail)

313 VICTOR BRAUNER *Pivot de la soif.* 1934

314 VICTOR BRAUNER *Totentot or the Great Metamorphosis.* 1942

315 VICTOR BRAUNER *Talisman.* 1943

313

314

315

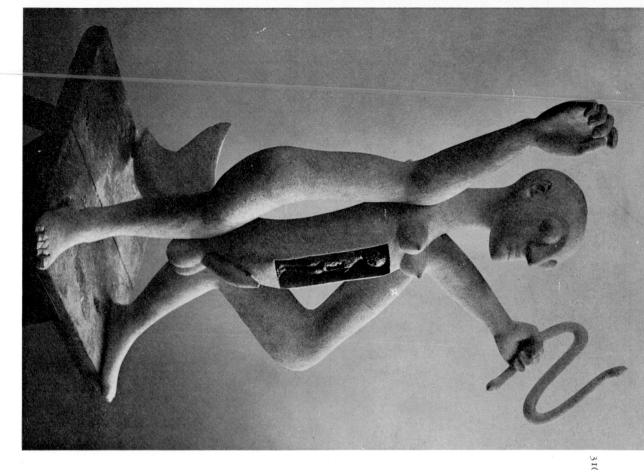

316

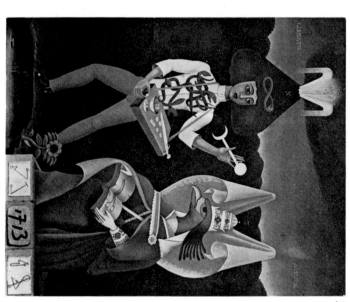

318

317

305

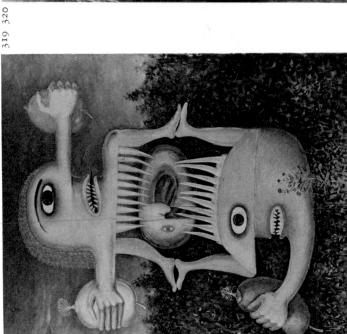

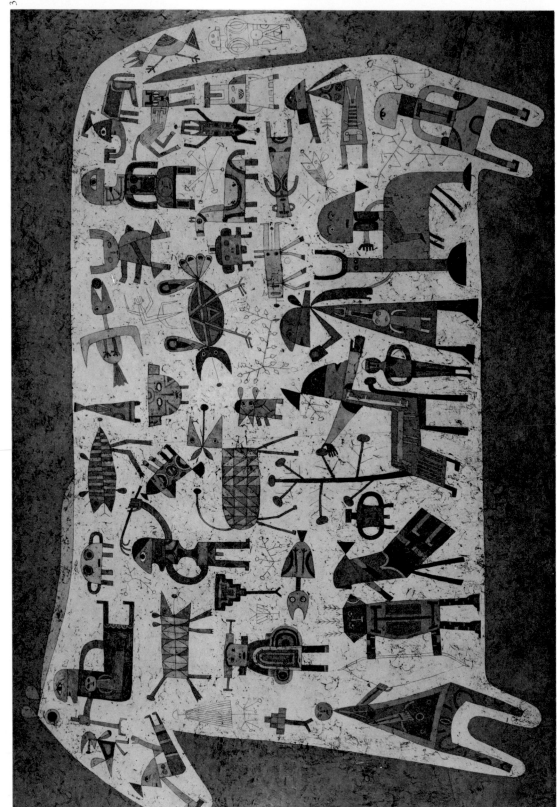

319 VICTOR BRAUNER
Totem of Blessed Subjectivity.
1948

320 VICTOR BRAUNER
Tout Terriblement. 1952

321 VICTOR BRAUNER
Prelude to a Civilization. 1954

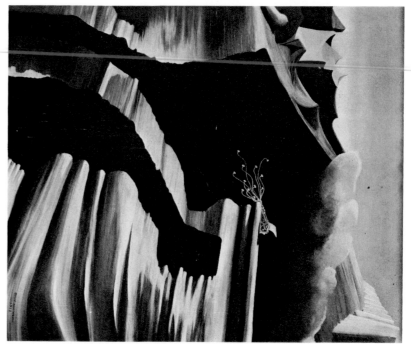

322 OSCAR DOMINGUEZ *Memory of the Future.* 1938

323 OSCAR DOMINGUEZ *Nostalgia of Space.* 1939

324 OSCAR DOMINGUEZ *Decalcomania.* 1936

325 OSCAR DOMINGUEZ *Decalcomania.* 1937

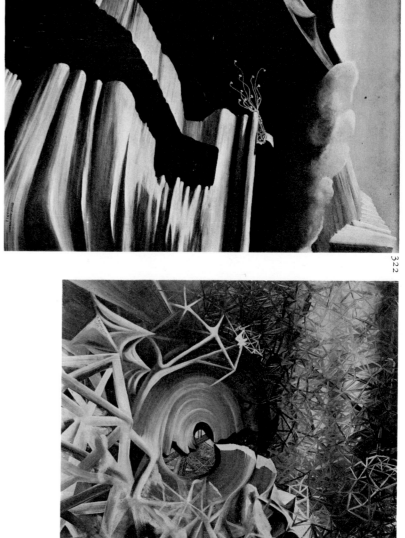

326 ANDRÉ BRETON *Decalcomania.* 1936

327 YVES TANGUY *Decalcomania.* 1936

328 MARCEL JEAN *Decalcomania.* 1937

329 MAN RAY *Painting Based on Mathematical Object.* 1948

ot *Guernica* synthesizes aspects of Cubism, collage, and Expressionism, while its morphology inflects these with the Surrealist biomorphism of the later twenties, so in its iconography the reverberations of the three "myths" that preoccupied Picasso throughout the period when he was close to Surrealism are resolved into a single harmonious triad.

THE NEW ADHERENTS AND PIONEERS DURING THE THIRTIES

From the point of view of the plastic arts, the years separating Giacometti's adherence to Surrealism (winter of 1929–30) and Matta's (1937) were the driest the movement was to experience. Not that there was a dearth of new painters. On the contrary, Surrealism could count such new recruits as Victor Brauner and Oscar Dominguez, and the internationalization of the movement brought a phenomenal number of additional members, though their careers as Surrealists were generally ephemeral.[212] But while they made modest contributions to the range and iconography of Surrealist art, the new painters of the thirties produced nothing comparable in invention or quality with what had gone before or with what was to appear in the work of Matta and Gorky during the 1940s in America.

Victor Brauner settled in Paris in 1930 at the age of twenty-seven. Born in Piatra Neamt, Romania, he had already had a one-man show in Bucharest (1925), published a *Manifesto of Picture-Poetry*, and made an exploratory visit to Paris. His first important friendship in Paris was with his compatriot, Brancusi, but more crucial for his development was an acquaintance with his neighbor Tanguy, who introduced him into the Surrealist circle in 1933. By that time Victor Brauner's art had been oriented toward the oneiric for some years; the stylistic influences he reflected had been diverse—Dada, Klee, Expressionism—and even as his work took on its personal stamp, the unfolding of an organically developed and unified poetic idea continued to be informed by stylistic eclecticism.

The Door (1932; fig. 310) opens onto an enigmatic, funerary city whose receding perspectives and landscape vista support a curious second stratum of architecture of diverse times and places. Descriptive realism is pressed to the point of caricature in the anti-chauvinist satire embodied in the picture's central figure (reminiscent of George Grosz), while subordinate motifs are devoted to themes of aggression, especially sexual sadism. (An isolated eye, a disembodied arm, and a wheel which mysteriously casts an unexpected shadow all suggest

Victor Brauner

the Redonesque and Chiricoesque roots of the *peinture-poésie* tradition.)

It is not surprising that Victor Brauner's first contacts with that tradition should have led him to de Chirico's art and the proto-Surrealist works of Ernst in particular. In *Conspiracy* (1934; fig. 311) the suggestion of a disturbing event is seen through the window of a house, whose orthogonals recede with Chiricoesque rapidity, while in the foreground three personages composed of de Chirico's mannequins and Ernst's silhouetting of 1920–23 whisper to each other. These figures, according to Victor Brauner, are the avatars of a "subversive reality," a hidden and secret world" existing underneath apparent reality. The same variety of head becomes more biomorphic in *Pivot de la soif* (1934; fig. 313), where its "soft construction"—recalling Dali's malleable bones—spills out onto the frame of the picture. The cross section of the head reveals a literal landscape of the mind.

The year 1934 was extremely productive for Victor Brauner. In addition to works of the type just described, he realized a series of

canvases in which the surface was divided into a grid of rectangles where a single figure was shown in diverse metamorphoses. In *The Morphology of Man* (1934; colorplate 35) we see sixty-four variations—both stylistic and iconographic—on the subject. Man is syncretized, as in ancient Egyptian art, with birds, cats, and other animals; he develops extra genitals, becomes female. Here he is modeled in the round, there loosely drawn or reduced to a stick figure. A few of the pictures of this series are devoted to "Mr. K," a pot-bellied, mustachioed symbol of the repugnant bourgeois (identified in a drawing of 1934 with Jarry's *Ubu*). *The Strange Case of Mr. K* (1934; fig. 312) was purchased by Breton, who also wrote the preface for Victor Brauner's one-man show at the Galerie Pierre. The picture divides so that the twenty indifferently realized panels on the right (devoted to Mr. K's varieties of love-making) form a composition of their own, or rather leave the twenty panels on the left to function independently. These are devoted to an imaginative metamorphosis of "K." In the upper left corner we see him nude. To the right, his nudity gradually becomes adorned with medals, insignia, and sashes of various national orders; elsewhere "K" becomes a fortress, a city, a contour map. In their multiplication, the medals finally cover his skin (a kind of prophetic image of Goering), turn into scales, and "K" becomes a prehistoric beast.

The results of his exhibition at the Galerie Pierre were disappointing, and Victor Brauner returned to Bucharest, where he remained until 1938. His return to Paris in that year was marred by the loss of an eye during a fight between friends in which he had interceded as peacemaker. He seemed to have had a strange prescience of the accident for, as early as his *Self-Portrait* of 1931 (fig. D-190), he had shown himself with one eye gouged out, a condition that not infrequently afflicted figures in his subsequent paintings; Pierre Mabille discussed these strange circumstances in "L'Oeil du peintre" in *Minotaure*, No. 12–13, 1939. Neither his departure from Paris nor his reappearance there after having stirred up some interest in Surrealism in Romanian intellectual circles coincided with any marked redirection in Victor Brauner's art. That continued to be marked by a heterogeneity of manners the common denominator of which was intimacy of scale and facture. For the most part, the images were structured in an illusionist space that relied on the linear devices. Increasingly toward the late thirties, these were combined with the atmospheric perspective generated by a soft-focus execution, as in *Psychological Space* (1939).

Many of Victor Brauner's hybrid conceptions (like most of Ernst's of the later thirties) look as though they would function well as sculptures. He certainly was aware of this, for in the forties he made a number of sculptures, some of which were versions of earlier pictorial ideas (the wolf-table of *Psychological Space* was itself fashioned into an object). In *Totentot or the Great Metamorphosis* (1942; fig. 314) the bronze statuette of a woman whose second Janus-type face is that of an animal is repeated, along with the sleeping man balanced on her head, as a painted figure in the canvas before which the sculpture is set. In style it is closely related to the extraordinary *Number* (1943; fig. 316), one of two large plasters by Brauner which have not yet been cast. Here we have a figure with a fishtail, the breasts of a woman, and genitals of a man. In the hollow of its stomach is a child whose own stomach, in turn, contains an even smaller figure. The somnambulistic head of this beautiful figure is utterly abstracted from the narrative activity that animates its arms. A similar enigmatic contrast pervades *Totentot*, where the pair of figures echoing the bronze seem utterly unaware of the menacing activities of the hybrid figure to the right. We sense the strange narrative relation between the elements of the iconography, but it is not a story we could repeat in words.

The variety of methods and manners in Victor Brauner's art can be understood only by keeping constantly in mind that the unity of this art lay not in its plastic but in its poetic conception. In his monograph on Victor Brauner, Sarane Alexandrian asserts that his painting is but a pretext for storytelling.

The least touch of his brush liberates the flow of anecdote. In effect, Brauner paints only according to the story he invents; he even confided to me that if he did not feel at the start the necessity of elaborating a fiction and recounting it with a plethora of picturesque details, he would never be tempted to make a single picture.[213]

However, the priority of the poetic did not turn Victor Brauner, as it did others, into an academic *imagier*. His work frequently revealed extremely nuanced brushwork and subtly inflected surface textures and, during the last two decades of his life, increasingly sophisticated color. Whether or not Victor Brauner attributed importance to formal values—and we must never forget how much sheer cant is involved in Surrealist statements about art—his pictures testify to his appreciation of them.

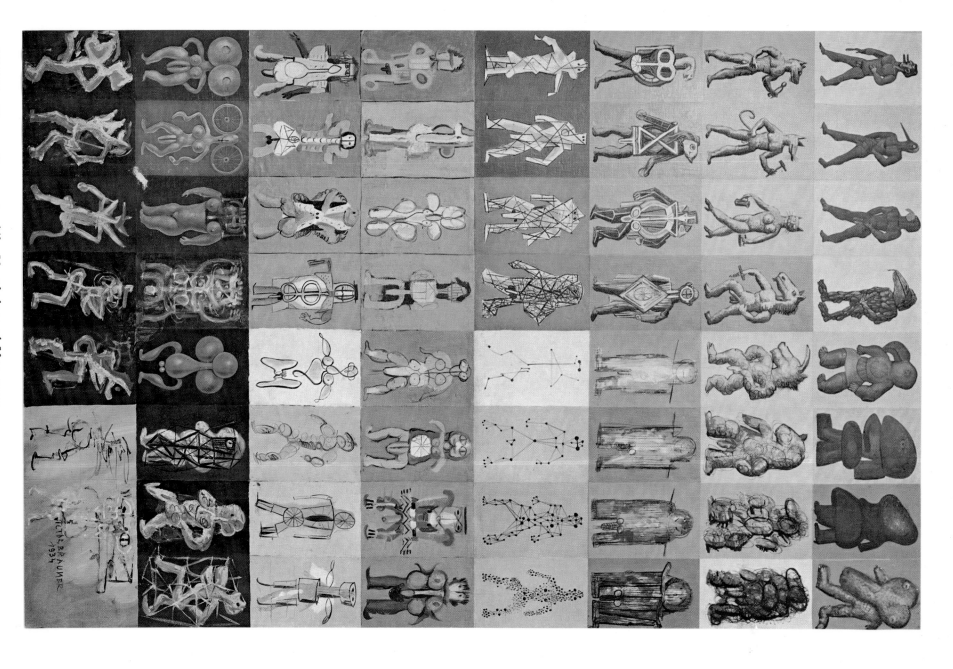

XXXVI VICTOR BRAUNER *Gemini.* 1938

challenge he devised an encaustic method that proved enormously successful. After covering his surface (usually wood panel or cardboard) with a layer of candle wax, he could draw into it with a stylus. As in *The Mechanical Fiancée* (1945; fig. 317), the resistance of the material made for a wiry, unfacile kind of notation that was frequently inflected by *pentimenti* and sympathetically awkward changes of direction. In other cases, he would model the tallow into graffito-like figures (e.g. *Talisman*, 1943; fig. 315) that somewhat anticipate the Dubuffets of the years just following the war. Color is used sparingly in them, the incised lines are usually heightened with lampblack, and sometimes shapes are tinted, though the strongest of these pictures are distinguished by their smoky monochromy.

While art produced after the Surrealist exhibition of 1947 is not, strictly speaking, within the scope of this book, a few words must be said about Victor Brauner's painting since then. The dissolution of Surrealism after World War II and the rise of the new American painting and its counterparts in Europe left the artists of the Surrealist generations in a peculiar historical position. Many of them, Miró and Ernst for example, continued to work largely within the framework of their earlier form-language and iconography, seeking, however, to introduce in their handling, scale, and in certain other aspects of their art some features of the new painting. One thing remains clear, nevertheless: none of the great pioneers of Surrealist painting, nor, for that matter, any of the artists of the second Surrealist generation like Matta and Wifredo Lam, have since 1947 produced work that equals in quality the very best things they did before that date. Victor Brauner forms perhaps the single exception. Though his wartime encaustic paintings may be, singly, his very best works, his art grew in range and deepened in content thereafter, so that, taken as a whole, it stood higher at the time of his recent death than it did before the war, when Surrealism was in the ascendancy.

Victor Brauner seemed better able than the other Surrealist painters of his generation to work in the absence of the milieu provided by a major movement. Though he was occasionally led astray (as in his Matta-influenced machine-monsters of 1951–52, exemplified in *Tout Terriblement*; fig. 320), the highly but tenderly colored decorative images, frequently in encaustic, which dominated his late production seem to me to realize Victor Brauner's inspiration most fully of all (fig. 321). The iconography of his postwar paintings is exceedingly cryptic, as in the religious symbolism pervading *Les Amoureux Messagers du nombre* (1947; fig. 318). Elsewhere it leans to such symbols as Tarot cards (which became popular following the "occultation" of Surrealism promised by Breton in the second Surrealist manifesto), Egyptian hieroglyphics (as preserved in astrology), and, particularly in his last years, the antique codices of Mexico (some of which were reproduced in the penultimate issue of *Minotaure*)—beautifully employed in *Prelude to a Civilization* (1954; fig. 321).

Oscar Dominguez was Victor Brauner's opposite insofar as he was fully dependent on his milieu. An artist without genius, but with a modicum of talent and a fertile imagination, Dominguez was able to ride the tide of Surrealism during the middle and late thirties and produce some interesting work. At that time also, he was inspired to experiment in the development of new techniques. Separated from the Surrealist milieu during World War II and finding it in rapid dissolution after, he was unable to fall back on his own resources and discover new artistic directives within himself. His art underwent abortive and meaningless changes in style, without evolving, until his suicide in 1957.

Dominguez was twenty-eight when he joined the Surrealist group in 1934. Born, as we have seen, on Tenerife in the Canary Islands, of a well-to-do family, he had visited Paris a few times before and had already, in 1933, called his one-man show in Tenerife a "Surrealist Exhibition." He did his best work in Surrealist objects and hybrid reliefs like *The Peregrinations of Georges Hugnet*. But Dominguez seems to have had very little feeling for organization of a limited, two-dimensional surface, and even when, as in his "cosmic" landscapes of 1939 (for example, *Nostalgia of Space*, fig. 323), he eschewed real relief, his insistent illusionism seems to be trying to identify the canvas itself with the objects represented on it.

The year after he joined the Surrealists, Dominguez came upon the technique of decalcomania (figs. 324, 325), which was the development of a process sometimes used by children and earlier exploited in ink by Victor Hugo for some of his drawings. Spreading gouache rather than ink on a sheet of paper, laying another sheet on top of it, pressing here and there, and then peeling the second sheet off, he produced effects suggesting exotic flora, mineral deposits, spongy growths—a veritable spelunker's dream. The telluric fantasies that this technique encouraged recommended it immediately to the Surrealists, and being a way of image making that required no technical ability, it was immediately adopted by the Surrealist poets. In *Minotaure*, No. 8 (1936), Breton presented a number of "decalcomanias-without-preconceived-object"—that is, with no initial figurative intention—including those of Marcel Jean (fig. 328) and Georges Hugnet.

Paul Delvaux

Yet despite the exoticism of the results obtained through it, decalcomania was not so much an end as a means, a chance method of image making not unrelated to *frottage*. "What you have before you," conceded Breton, "may be nothing but the paranoiac 'old wall' of Da Vinci, but it is that wall *carried to its perfection*." The perfection of a means has never, in itself, produced visual results of lasting interest, and it is not surprising that once their novelty had been digested the decalcomanias of Dominguez and others began to pall.

Pure decalcomania, as Dominguez practiced it, was composed entirely of chance effects. It is true that he made some selection from among its results, but he exercised no control over the process itself. In an attempt to put the technique at the service of more particularized images, Dominguez and Jean experimented with stencils (fig. 325), to some extent anticipating paintings done at the end of the decade by Ernst (fig. 386), who was the only artist to turn decalcomania to serious artistic profit.

Dominguez' last works of any interest are his "cosmic" landscapes of 1938–39. Unlike those of Matta begun a year earlier, which are called generically "psychological morphologies" or "Inscapes," but which seem to equate a fantasy of cosmic actualities with the boundless reaches of the unconscious, Dominguez' landscapes are wholly external in character. Painted in cool colors tending toward gray, they suggest wasteland and tundra. "Mountains" are stylized so that they

appear to be as much ice as earth. Man himself is absent from these spaces, but he is recalled by the symbolic objects occasionally isolated in them—the awkwardly metaphorical "sprouting" typewriter of *Memory of the Future* (1938; fig. 322), for example. As Dominguez continued to work on this series, his forms became increasingly crowded and fragmentary; their geometrical drawing was probably inspired, as Jean suggests, by the mathematical objects at the Poincaré Institute, which Man Ray had photographed and used as motifs for paintings (fig. 329).

Although he never in any way participated formally in the Surrealist movement, the art of the Belgian painter Paul Delvaux was nevertheless a direct outgrowth of it and should receive passing mention in an account of its situation in the late thirties. Delvaux was born in 1897 and attended the Brussels Academy. After graduation, his work, though slightly influenced in the direction of Expressionism by his compatriot James Ensor, otherwise remained entirely cut off from modern art, which he considered to be more of a hoax than anything else. Then, in 1936, Claude Spaak, at that time an official in Brussels' Palais des Beaux-Arts, and E. L. T. Mesens, whom Delvaux met through Spaak, interested him in some of the Surrealist works in their private collections as well as in those owned by the museum. He was immediately moved by the enigmatic character of de Chirico's paint-

ings and by Dali. Though at first somewhat disconcerted by Magritte, it was the latter's influence that soon became the most pervasive in his art.

Since the revolutionary effect of these confrontations was felt in the sphere of imagery rather than in that of style, there was no need thereafter for a lengthy evolution on the part of Delvaux's art. The manner for which he is known was born virtually whole in 1936. In *The Mirror* of that year, a woman in a gown sits in a tattered wall-papered interior contemplating herself in a mirror that shows her nude in a landscape. The mood of solipsistic isolation and the concern with voyeurism (here depicted as narcissism) are here clearly established, as they will remain through all his subsequent work. Woman is the center of Delvaux's world, woman in a sexual context that is wistful and passive. In *The Village of the Sirens* (1942; fig. 332), ladies in high-necked turn-of-the-century dresses populate

a brothel quarter yet seem condemned to a virginity both oppressive and eternal. Delvaux's women sit silently and wait endlessly: they are never in dialogue with men, who enter their world only as old doctors (frequently examining their bodies with magnifying glasses) or effete, epicene young boys like the nude youth of *The Visit* (1939; fig. 331). Here the woman, holding her full breasts, sits alone in a room which the boy, in what seems the recollection of a disturbing childhood experience, chances to enter. Sometimes the male principle is suppressed in a literal sense to emerge only symbolically, as, for example, the train which disturbs the repose of the ladies in *Le Train Bleu* (colorplate 37). The environment in which these ladies sit seems a Flemish counterpart of a Chiricoesque piazza; elsewhere the ambiance suggests a Surrealist equivalent of the antique Hellenism of Puvis de Chavannes.

Despite the influence of de Chirico in his perspective (James Thrall

Soby[214] has outlined this in connection with *Woman with a Rose*, 1936; fig. 330) and the smooth, literal style he adopted in part from Magritte, Delvaux remains at some distance from both these artists. He never really juggles the perspective in a truly Chiricoesque manner, and he rarely uses the incongruities inspired by the "collaging" of image elements which is so central in Magritte. His frequently dry drawing and limited sense of color weaken his pictures, and finickiness of detail (Delvaux loves to detail pubic hairs, nipples, drapery, etc.) prevents him from attaining the bold sense of projection and handsomeness of design Magritte achieved.

A technique for "forcing inspiration"—though in this case not a very promising one—was introduced by Wolfgang Paalen, who joined the Surrealists in 1935 (fig. 333), turning to illusionism after some years as an abstract painter. It took the form of depositing and elaborating smoke trails left on a picture surface by manipulating a candle, and was called *fumage* (fig. 334). Esteban Francés, who had been friendly with Dominguez in Barcelona, came to Paris in 1937 and turned the technique of *grattage*—previously used by Ernst—to his own purposes. After randomly distributing paint on a wood block, he scraped it off arbitrarily with a razor, and, pondering the results of the "print" obtained with this, disengaged from them the hallucinatory figures which constituted his iconography. In his painting these took on a look comparable to the morphologies of Matta's earliest pictures, though with linear and planar passages reminiscent of Matta's English friend, Gordon Onslow-Ford.

Matta and Onslow-Ford were the youngest adherents to Surrealism in the late thirties. The latter's paintings were quite abstract, containing prophetic experimental devices which he deployed essentially for the iconographic possibilities of their effects. Foremost among these was *coulage* (pouring commercial enamel), which was also being explored at that time by Brauner. As in *Without Bounds* (1939; colorplate 38) the enamel, partly controlled by the artist's guiding hand, finds its own silhouettes. The puddles, organic in contour, create an illusion of continuous metamorphosis (approximating the effects of Thomas Wilfred's Clavilux) and are rich in Rohrschach-like suggestions. To give order to what seemed almost "formless" arrangements, Onslow-Ford superimposed geometrical linear designs on them, but these failed to fuse adequately with the poured patterns. Though Hans Hofmann and Ernst used pouring some years later in a few paintings, it remained little more than a pictorial gimmick until Pollock found in it a means to a genuine style. Other Onslow-Ford paintings (fig.

335) made on the eve of World War II contain large panels of color before which were suspended modeled biomorphic forms and other shapes, unmodeled and in bright colors à la Miró. Concentric circles and crisscrossing lines, suggesting the patterns of a contour map gone mad, drew on the mathematical objects of the Poincaré Institute and provided an opening in a direction Matta would later explore more fully; but since Matta's evolution is largely associated with the war years in America, he will be discussed later in that context.

The 1930s saw the waning of invention among the pioneer Surrealists. This was marked in Max Ernst, the variety of whose imagery—particularly in the latter half of the decade—was sustained only by frequent re-exploration of forms and methods he had invented during the 1920s. Plastically his pictures alternated between flat patterning and modeling in illusionist space, with the alternations depending not on the development of pictorial ideas but on the implementation of poetic ones—which always have primacy in Ernst.

Among his more successful works of the thirties are a series begun in 1930 around the theme of his alter ego, Loplop, Superior of the Birds. Here the central image is a painting on plaster, begun in 1930 and worked on intermittently over the next few years, titled *Loplop Introduces a Young Girl* (fig. 336). Loplop, a kind of anthropomorphic bird, holds a rectangular frame within which metallic, string, and stone collage-objects, some of them dangling free, surround the medallion of a young girl's profile. The figure of Loplop was originally a simple line drawing but was subsequently heightened with some accents of low-relief modeling.

The title "Loplop Introduces" applies to a series of excellent collages begun in the winter of 1929–30 and continued over the next four years. In these Ernst frequently juxtaposed flat decorative materials like marbleized paper with academic illustrations from textbooks and drawing manuals in a delicate balance that anticipated, in its alternation of the flat and the recessional, his *Vox Angelica* of 1943 (colorplate 55). In the collage reproduced in figure 337, the line drawing of Loplop, which extends over the work as a whole, "mediates" between the perspective effects and the modeling of the nude woman and child in the collaged page from a drawing book, and the flat surface of the ink blotter and marbleized paper. Inasmuch as the drawing of Loplop is devoid of shading, its flatness is continuous with that of the marbleized paper and blotter, but since it suggests schematic space through linear perspective (these lines being drawn by Ernst over the art-manual page as well), it provides a spatial cradle through which the academically modeled nudes are easily resolved into the visual

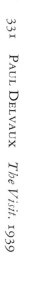

330

331

330 PAUL DELVAUX *Woman with a Rose.* 1936

331 PAUL DELVAUX *The Visit.* 1939

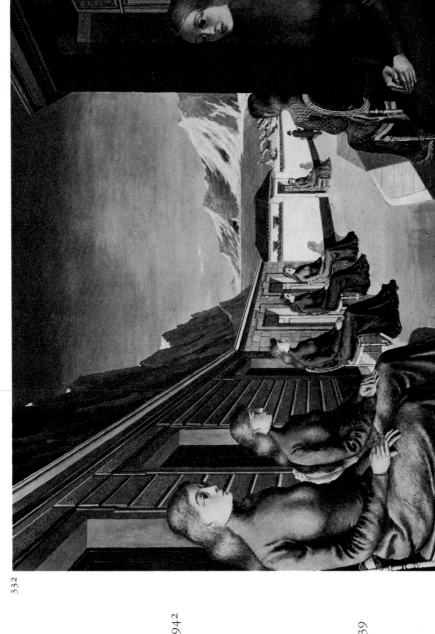

332 Paul Delvaux
 The Village of the Sirens. 1942

333 Wolfgang Paalen
 *Totemic Landscape of
 My Childhood.* 1937

334 Wolfgang Paalen
 Fumage. 1939

335 Gordon Onslow-Ford
 Man on a Green Island. 1939

336 MAX ERNST *Loplop Introduces a Young Girl.* 1930–36

337 MAX ERNST *Loplop Introduces.* 1931

338 MAX ERNST *Zoomorphic Couple.* 1933

337

336

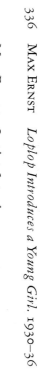

338

319

339 MAX ERNST *The Blind Swimmer.* 1934

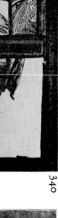

340

341

343

342

344

321

345

349

347

348

323

350 351

352

350 ANDRÉ MASSON *The Spring.* 1938

351 ANDRÉ MASSON *The Labyrinth.* 1938

352 ANDRÉ MASSON *The Thread of Ariadne.*
 1939

324

Max Ernst. *Two Young Ladies Promenading through the Sky*

scheme of the picture as a whole. As elsewhere in this series, Ernst added his own motifs to the conventional illustrations, which cast on the everyday world an atmosphere of mystery and foreboding.

Representing the poetic extreme of Ernst's richness, though less interesting plastically, are the "collage novels," *La Femme 100 Têtes* and *Rêve d'une petite fille qui voulut entrer au Carmel*, which appeared in 1929 and 1930 respectively, and *Une Semaine de bonté* of 1934. Many of these are composed entirely of bits and pieces of old engravings cut and glued so precisely that the resulting pictures seem not like collages but like things limned on a single support, except that the original engraved images have given way to a universe of fantastic disturbing juxtapositions (figs. 340–42).

A few of Ernst's strongest pictures of the early thirties hark back directly to the late twenties: *Zoomorphic Couple* (fig. 338), for example, in the morphology of its monsters and in the light-dark patterning of the whole, reminds us immediately of the "Hordes" series of 1927. In *Zoomorphic Couple*, however, *frottage* over string has been replaced by patterns of a string dipped in paint and dropped directly on the canvas, and by a stippled pattern—as well as drip marks—created by spraying the surface with the flexed bristles of a

brush dipped in liquid pigment. The two original versions of *The Blind Swimmer* (both 1934; colorplate 39, fig. 339), however, provide an entirely new image, and mark the high point of Ernst's painting in the 1930s. The version in figure 339 (of which Ernst was to make a somewhat weaker variant in 1948) has a centered emblematic design on which parallel lines—like the contour lines of a map of hidden regions of the mind or body—lead to a medallion containing a fantastic biological symbol.

Shortly afterward, however, Ernst embarked on an extensive series of "Garden Airplane Traps," in which, in a framework of perspective panels, carnivorous flowers devour fantastic airplanes (fig. 343). In their mostly descriptive modeling, conventional space, and poetic obviousness these works represent a low point for Ernst. The academic means he employed here continued to dominate much of his work of the later thirties, like the overcomplicated and fussy "Jungles"—for example, *The Joy of Living* (1936; fig. 344)—and the dry *Angel of Hearth and Home* (1937). It was only with his adaptation of the decalcomania technique at the beginning of the war that Ernst's imagery took a new direction; but since most of his decalcomania paintings were completed in America, these will be discussed later.

326

André Masson

André Masson. *Massacre*

For André Masson the 1930s were a period of constant unresolved crisis. In 1928, as we have seen, he had already retreated from the daringness of his best work into a more decorative curvilinear Cubism (*Wounded Animal*), which he revived occasionally later on (as in *Tormented Woman*, 1932; fig. 345). While the themes of germination and the struggles of nature in sea and earth were continued sporadically (for instance, in *Interior of a Field of Gran*, 1934; fig. 347), in the "Combats" and "Massacres" that prevailed in the first half of the decade Masson's subject matter tended toward the more literally realistic and anthropomorphic. But in pictures like *Massacre* (1932; fig. 346) there is nothing in the design or the constricted execution (as compared with the *élan* of the paintings of 1927) that sufficiently reinforces the ostensible violence in the theme of the work.

In Spain, in 1935, under the momentary influence of Miró's fantastic landscapes of the late twenties, Masson's pictures become bolder and flatter in design, as in *The Watch of Don Quixote* (fig. 348). But the bright, saturated reds and yellows of that year and the next—reds and yellows that Miró had handled with extraordinary

pictorial coherence—do not work for Masson, whose composition functions better when he remains within the light-dark armatures he inherited from Analytic Cubism. *Landscape of Wonders* (1935; fig. 349), whose chasms, serpents, comets, and lightning reflect the mood of the Spanish Civil War, is a case in point. Masson also did some propagandistic war drawings (one shows a bull-headed priest, bloody dagger in hand) in which he went over into descriptive literalness. This led him, on his return to France, first into a sculptural style based on Picasso's bone bathers (*Suntrap*, 1938; fig. D-185) and then into

literarily forced and exaggeratedly sadistic, as well as plastically confused, academic pictures like *In the Tower of Sleep* (1938; fig. D-186) and *The Rape* (1939). These pictures represent the lowest point of Masson's art, and the evolutionary process that led to them reveals Masson's flaw as a painter: his failure to sense the limits of the medium and his own personal limits and advantages as a painter. It

was precisely the rightness of Miró's instinct in these matters that assured the continuity of his art even in periods of crisis.

Yet even Miró experienced a certain relaxation in the thirties. The twenties had been the period of his most intense development; every year saw the creation of new compositional types. The thirties brought

André Masson

fewer discoveries; Miró's work of that time represents rather an extension, in the direction of a more monumental art, of previously established values. There are gaps at the beginning and in the middle of the decade, periods of six months to a year or so, when Miró's imagination seemed somnolent. Nevertheless, throughout the decade he made advances, principally in the direction of a more saturated and more luminous color.

The years 1930 and 1931 were equivocal for Miró. Though they

saw some handsome constructions (like that in wood and metal in The Museum of Modern Art, New York; fig. 353) and the "painting-object" in chain and wood in the Breton Collection, the focus that had previously characterized his development seemed lost. The year 1930 produced the most remarkably simple and abstract of all Miró's work (the large *Painting* consisting of just three different-sized circular shapes of color against a plain ground; frontispiece), as well as some disparate scrawls (like the painting subtitled *Mediterranean Land-*

Joan Miró. *Daphnis and Chloe*

scape; fig. D-181) which may be regarded as marking a low point in his art. The impulse toward abstraction led, in 1931, to such pictures as *Head of a Man, I* (fig. D-182), where panels of bright flat colors are surrounded by black lines in a manner more relaxed and freer than the comparable effects in Picasso's still lifes of the same year in the "stained-glass" style. At the same time, Miró began a series of paintings on Ingres paper in which the patches of color—now counterpointing rather than contained by the black lines—tend to take on the shape of bars. Though some familiar iconographic motifs, such as birds, moons, and eyes, can be discerned in them, these pictures are, in the almost rectilinear character of their abstraction, unique in his oeuvre (they seem to have had some influence on such younger School of Paris painters as Hans Hartung).

The very title *Painting*, which Miró began using frequently in 1930, suggests his renunciation of much of the anecdotal and narrative iconography he had used during the twenties. The *Painting* executed in 1933 is a characteristic example of this (fig. 355). Not that this picture and others like it are free of references to natural forms. Highly schematized animals—a dog and horned cattle—can be discerned suspended against luminous grounds (the horned forms are metamorphoses of the machine armatures used in the collage on which the picture is based). This kind of image owes a debt to Klee, whose work Miró knew from the earliest Surrealist days. But if Klee's spirit pervades the general structure of the 1933 *Painting*, the biomorphic figures themselves are even more indebted to Arp (in their larger, unbroken, more ascetic silhouettes) than had been those used by Miró in the twenties.

Painting (1933) is considered by many critics to rank with Miró's very finest works. But I find Miró stronger when he works in terms of decoration and fantasy than in the architectural terms he employs here. The shapes in *Painting* are less inventive, have less of Miró's unique personality, than is usual with him, and they are set against a background that is somewhat arbitrarily divided into soft-edged rectangles of color. Perhaps the difficulty lies in the presence of two distinct systems—the flat biomorphic figures on the one hand and the luminous geometrically divided ground (a rather old-fashioned compositional device) on the other—that never quite fuse. The divided luminous ground, suggesting an illusionistic atmospheric space much like Klee's and adumbrating certain of Matta's effects in 1944, tends to destroy that flat decorative unity of the surface which is Miró's forte. In a picture built on a single system (*Portrait of Mrs. Mills in 1750*, colorplate 20, for example), the shapes of the ground are endowed with as much profile and surface entity as

the forms of the figures. But the background of *Painting* (1933) remains behind the picture plane and neither is shaped by, nor interacts with, the biomorphic forms of the animals.

Many of the limitations inherent in these large pictures of 1933, which are based on collages, were resolved the following year in a group of paintings intended to serve as tapestry cartoons (though in creating them Miró made no concessions to the techniques of the weaver). These show Miró at the point of his greatest mastery of the big flat picture. In the ecstatic *L'Hirondelle d'amour* (colorplate 41), for instance, the illusionist space of the previous year is squeezed out by renouncing the combination of independent luminous ground and overlapping figures. The design elements, no longer isolated in static suspension but galvanized by continuous rhythms, are now completely locked in the picture plane in reciprocal patterns. Though not "automatic" in the sense of some of the 1925-27 paintings, *L'Hirondelle d'amour* surely recaptures the spontaneity of that era within a context of greater pictorial authority. Miró has never since handled the big picture with greater breadth and abandon.

Simultaneously with the large paintings we have been discussing, and no doubt somewhat as a relief from them, Miró made a series of amusing collages (fig. 356) that are very different from his formalist essays of the late twenties in that medium and that were unquestionably inspired by the collage handling in Ernst's "Loplop Introduces" series. Taking quaint nineteenth-century postcards and hats, butterflies, and other materials cut from illustrated children's books, he spotted them piquantly on very large sheets of drawing paper, and then drew his familiar personages around them in charcoal. Though the general conception of these collages is borrowed from Ernst, the morphology of the forms and the whimsey are entirely Miró's.

The years 1935-37 saw mostly small works, in particular a series of landscapes peopled with biomorphic figures (fig. 357). These have affinities with Picasso's bone figures. And if they lack the monumental presence of the Picassos, Miró's images are nevertheless more convincing as painting. Picasso's conventionally modeled bone figures would have been more successful as sculpture; Miró transforms Picasso's chiaroscuro modeling into a decorative play of flat contrasting colors.

Two unique works also date from the same epoch: *Self-Portrait* (1937-38; fig. D-183) and *Still Life with Old Shoe* (1937; fig. D-184). Both stand apart from the main body of Miró's mature work through their unexpected and disconcerting realism. It is, however, a hallucinatory realism, which rapidly dissolves itself into Miróesque

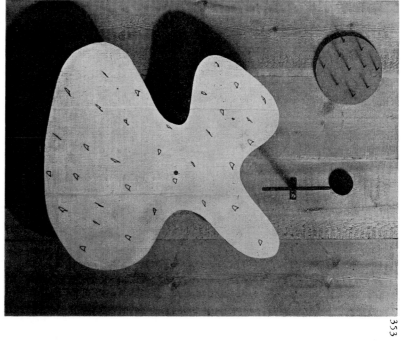

353

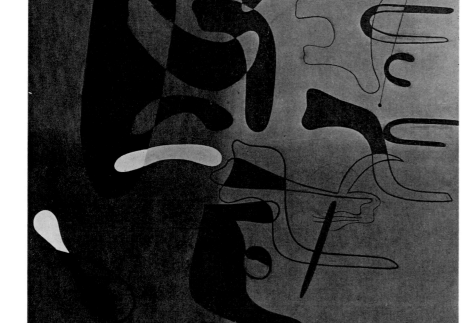

355

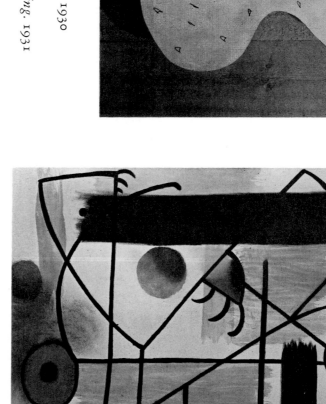

354

353 Joan Miró *Construction.* 1930

354 Joan Miró *Woman Walking.* 1931

355 Joan Miró *Painting.* 1933

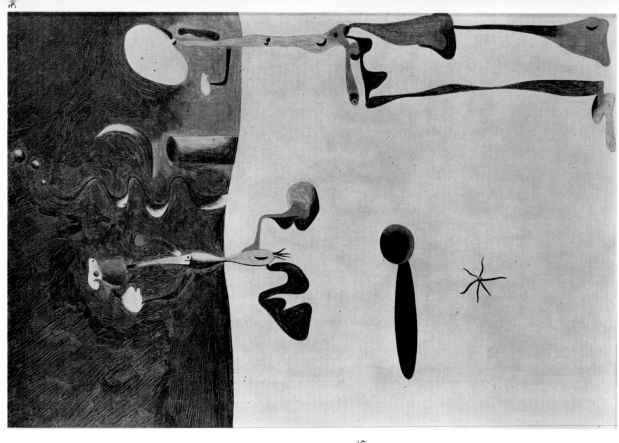

358

356 JOAN MIRÓ *Collage.* 1933

357 JOAN MIRÓ *Nocturne.* 1935

358 JOAN MIRÓ *Seated Woman.* 1938

356

334

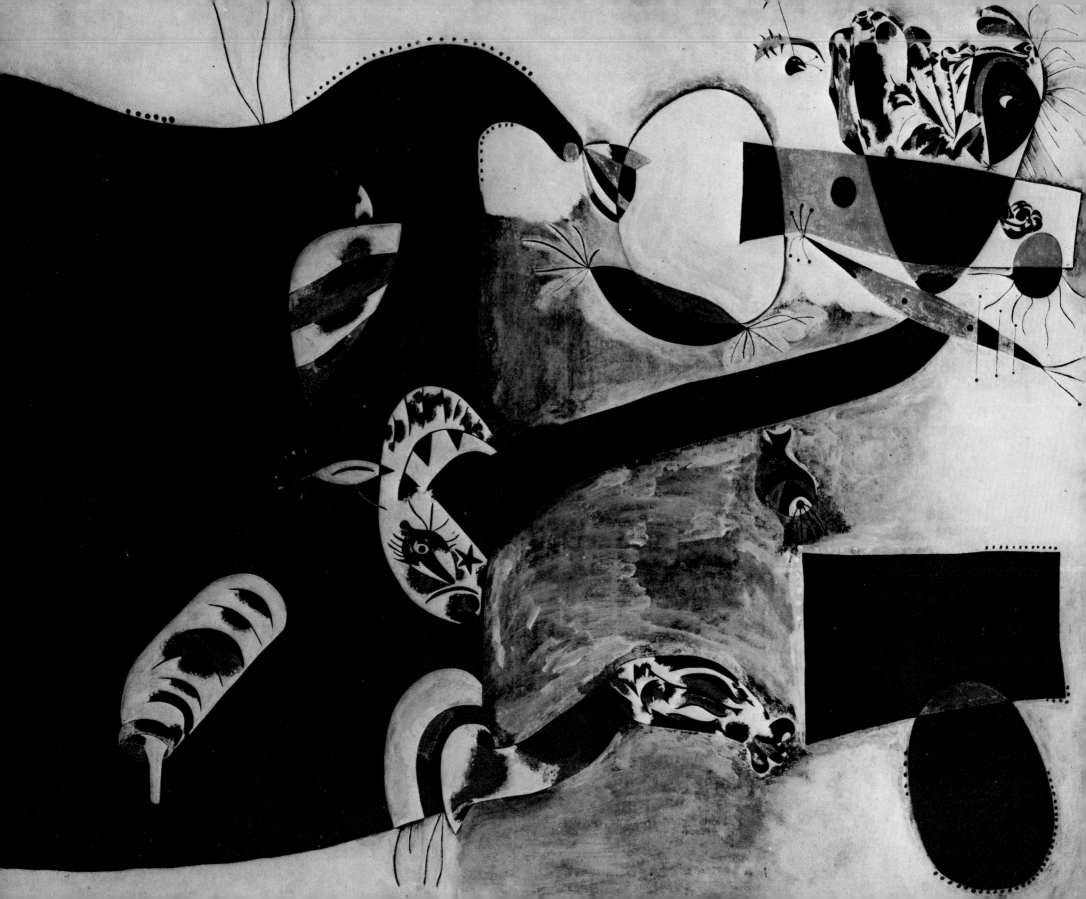

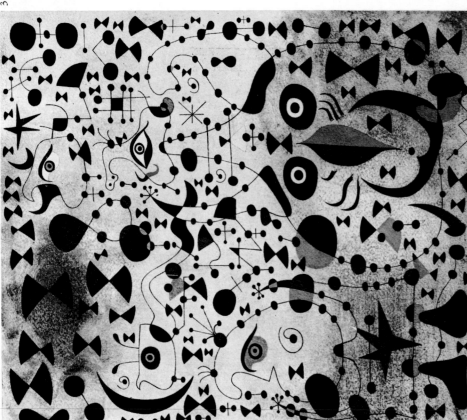

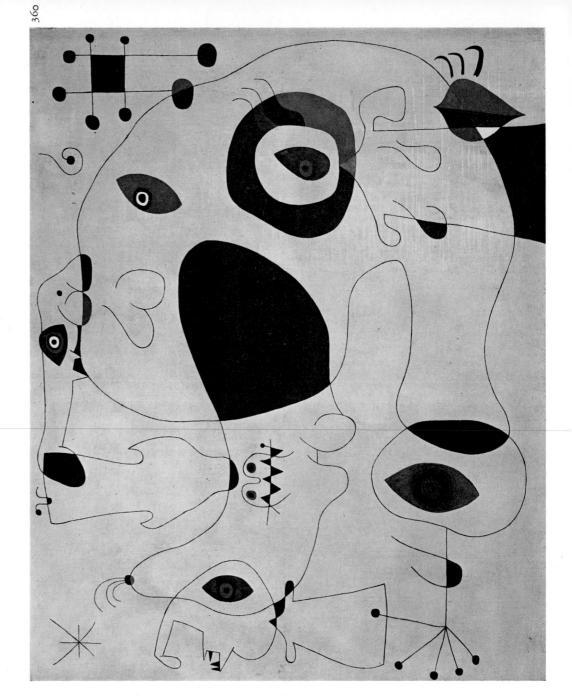

359 JOAN MIRÓ *The Beautiful Bird Revealing the Unknown to a Pair of Lovers*. 1941

360 JOAN MIRÓ *The Harbor*. 1945

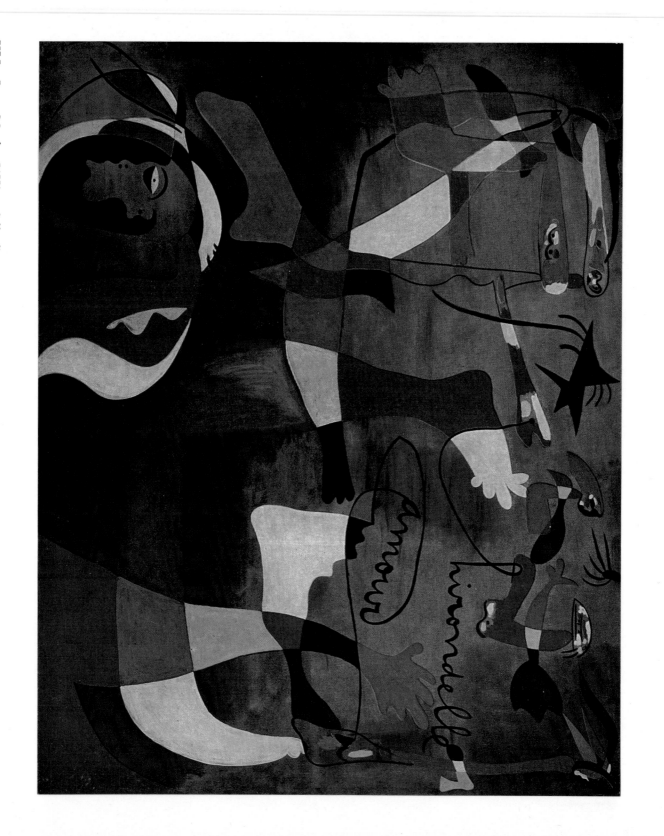

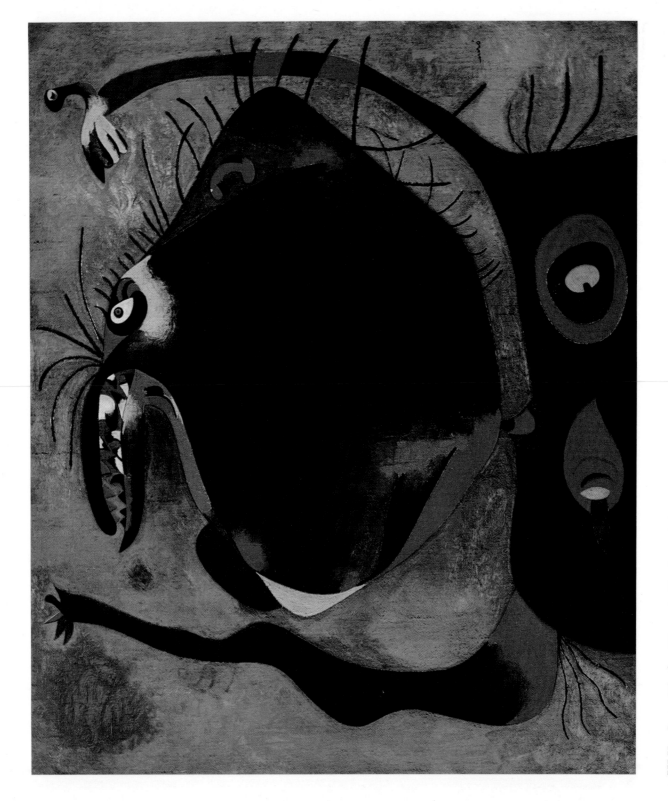

XLII JOAN MIRÓ *Woman's Head.* 1938

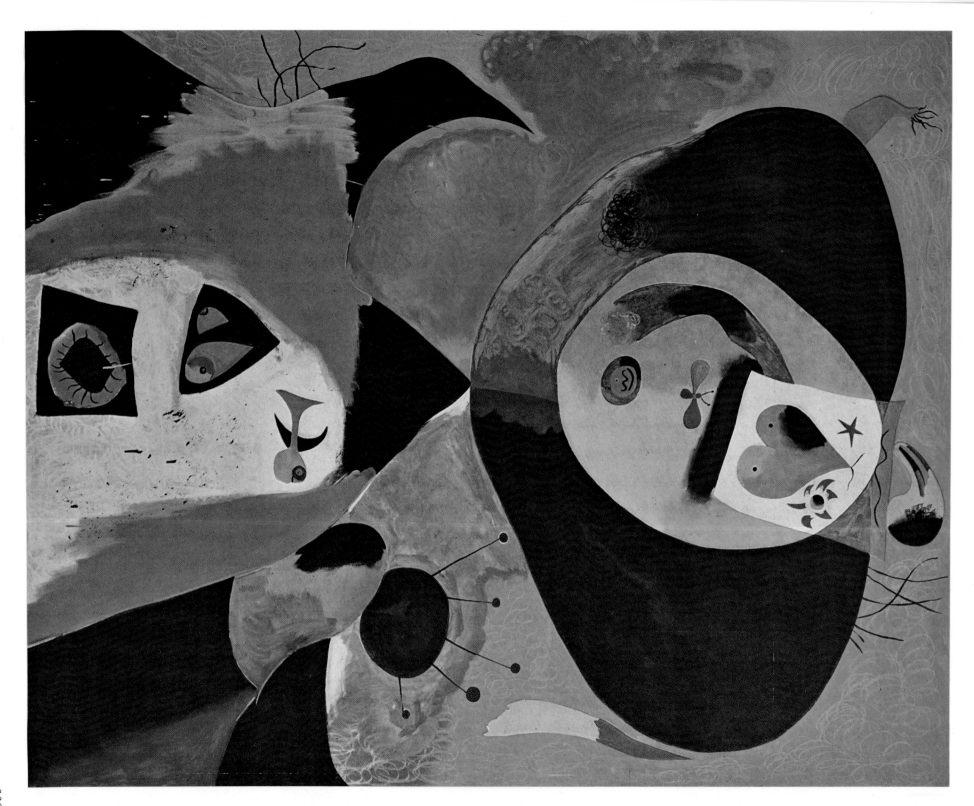

XLIII JOAN MIRÓ *Portrait I.* 1938

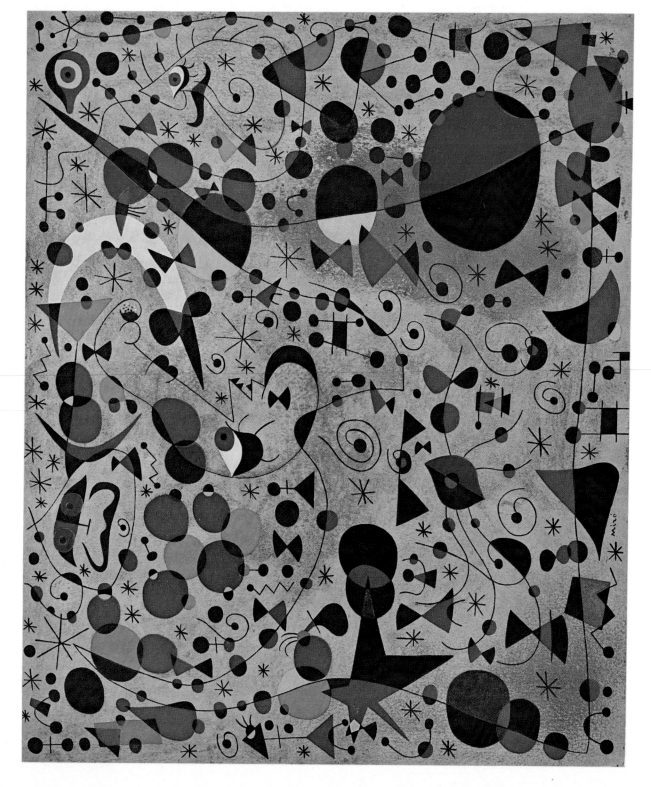

XLIV JOAN MIRÓ *The Poetess.* 1940

shapes that are wholly independent of the physiognomies of the objects represented. This is not a revival of the Cubist-inspired realism of Miró's early work but a momentary attempt—perhaps influenced by the war in Spain—to reaffirm and intensify the forms of external experience through the plastic language of internal fantasy. *Self-Portrait*, more a tinted drawing than a painting, has qualities of psychological insight somewhat unexpected in Miró, and is as well a brilliant exercise in draftsmanship.

Portraiture, even though of a less literal kind than that of *Self-Portrait*, must have been very much on Miró's mind in the years just before the outbreak of World War II, and his best paintings of 1938–39 are in this vein, especially *Portrait I* (1938; colorplate 43), in which the loose but highly assured brushwork and the bold design recall the high points of his art in 1934. Somewhat tighter in conception and marked by an unusual and aggressive physiognomic element is the small *Woman's Head* (colorplate 42), which predicts aspects of the magnificent *Seated Woman* (completed in December, 1938; fig. 358) in Peggy Guggenheim's collection. The latter is surely Miró's most important work just prior to the war.

After the fall of France, Miró returned to Spain, where, during the next two years, he completed a group of twenty-two small gouaches begun at Varengeville-sur-Mer. These "Constellations" constitute Miró's last historically important plastic invention. Against a modulated ground of diluted tones he placed a labyrinth of tiny flat shapes linked by tenuous webs of lines. The compactness and complexity of these diaphanous compositions are astonishing. It is not hard to believe Miró's assertion that the most quickly executed of them occupied him for more than a month. "I would set out with no preconceived idea," he recalls. "A few forms suggested here would call for other forms elsewhere to balance them. These in turn demanded others . . . I would take it [each gouache] up day after day to paint in other tiny spots, stars, washes, infinitesimal dots of color in order to achieve a full and complex equilibrium."215

The originality of the "Constellations" does not lie in the variety of their forms, which are not particularly inventive. Beyond circles, stars, triangles, and other simple geometrical items, we find few of the meandering, biomorphic shapes which gave character to Miró's

most interesting earlier work. In the best of the "Constellations"—*The Poetess* (colorplate 44), for example—the evenness in the spotting of colors and shapes and the proximity of the many small forms tend, however, to destroy traditional compositional focus and hierarchy, anticipating in this the "allover" style of painting that developed in New York during 1947–51 among artists whose debt to Miró was openly avowed. Remarkable in these works are the piquant variations in density within the allover dispersal of the forms that produce an animated flicker punctuated here and there by brief flashes of pure bright color. As an optical experience the "Constellations" (fig. 359) are entirely unprecedented, having no forerunners even in Miró's own work, except perhaps *The Harlequin's Carnival* (colorplate 15), where the more diluted coloring and less dense distribution minimize the effect.

At the end of World War II, Miró produced a series of rather large pictures in which his familiar vocabulary of flat forms is distributed across a blue-gray ground (fig. 360). Though these pictures introduce nothing new, they show the painter working with great economy and complete assurance. Not long afterward, however, Miró's work slipped into a prolonged crisis, his failures at that time no doubt contributing to his abandonment of painting in oil for five years, beginning in 1954.

By shifting his interest to ceramic sculpture in the later fifties, Miró was able to revitalize himself somewhat, but on a lower level. There are no new plastic ideas in the often interesting work executed in collaboration with the potter José Lloréns Artigas, but the change in medium gives the old forms a fresh look. The *Large Standing Figure* (1956) might have come right out of one of the landscapes of 1935–37, yet the work has a presence possible only to sculpture, and a new range of color is suggested by the ceramic glazes. In 1959, Miró began painting in oil again and produced a series of loosely executed and—for him—highly abstract canvases somewhat in the mood of the informal *tachiste* and Abstract Expressionist art that dominated the postwar years. With the partial exception of Masson, no other Surrealist has ventured into this realm of painting, and if Miró looks, relatively speaking, at home in it, it is because he was one of the main influences in its creation.

PART V: SURREALISM IN EXILE

AN IMMIGRANT MOVEMENT

The outbreak of World War II in September, 1939, hardly took the Surrealists in France by surprise. They had seen the Civil War in Spain as the prologue to a larger drama and had made "Fight Hitler" their most urgent slogan. While those Surrealists who were French citizens prepared for mobilization, the others began to look for more congenial places in which to carry on their work. The beginning of hostilities found Breton, Matta, Tanguy, and Esteban Francés living in a château in Chemillieu (Ain) that Gordon Onslow-Ford had rented. Onslow-Ford and Matta left for New York as soon as they could arrange their affairs; Tanguy, who was shortly declared medically unfit by the army, joined them there in November.

Max Ernst, on the other hand, faced special problems because of his German citizenship, which he had retained during all his years in France. He was interned as an enemy alien, first at Largentière and then near Aix-en-Provence, but by Christmas, 1939, the persistent efforts of Paul Eluard led to his release. Ernst resumed painting at St.-Martin-d'Ardèche, only to find himself re-interned during the German offensive in the late spring of 1940. But with the Armistice he once again was at liberty.

After the fall of France, many Surrealists fled into the unoccupied zone, whence they hoped to make their way to America. Sympathetic Americans set up an emergency rescue committee under the direction of Varian Fry (fig. D-195) that offered them refuge in a château near Marseilles while efforts were being made to arrange transportation to the United States. Breton, Wifredo Lam, Masson, and Claude Lévi-Strauss went to Martinique in the spring of 1941. Lam went on to Santo Domingo, and the others went to New York. Ernst managed to get to New York City in July, 1941, as did Kurt Seligmann, who remained there until his death. Man Ray had already returned to the United States in August, 1940, and he soon settled in California.

By 1942, New York and its environs had become the center of new Surrealist activity. The Surrealist painters found themselves part of an historically unique situation that included, besides themselves, such other exiled masters as Chagall, Léger, Lipchitz, and Mondrian (fig. D-200). Yet the world of Paris could not be re-created in New York. The exiled artists found it difficult to maintain contact with each other. "The café life was lacking," Ernst recalls. "As a result we had artists in New York but no art. Art is not produced by one artist but by several. It is to a great degree a product of their exchange of ideas with one another." For the Surrealists the Julien Levy and Pierre Matisse galleries became important meeting places in lieu of cafés. The Museum of Modern Art played its own substantial part; its directors (unlike museum directors in Paris) had always shown great interest in Surrealism, maintaining close contact with the members of the movement and buying many Surrealist works for the museum's permanent collection. Peggy Guggenheim's gallery, Art of This Century, was another important focal point—aside from its role as the scene of one-man shows that presented many of the pioneers of the new American painting. Miss Guggenheim's collection spanned the whole of twentieth-century abstract painting but was especially strong in Surrealism. (The catalogue of her collection, published in 1942, includes works by Arp, Ernst, Miró, Masson, Tanguy, Magritte, Dali, Giacometti, Paalen, Dominguez, Brauner, and Matta. The first of three prefaces of the catalogue was Breton's essay "Genesis and Perspective of Surrealism.") The interior of Art of This Century was designed by Frederick Kiesler (fig. D-199), and the room in which the Surrealist works were shown had curved plywood walls and biomorphic wooden furniture.

The suspension or inaccessibility of literary and art reviews published in Paris was partly compensated for by the founding in 1940 of View by Charles Henri Ford (fig. D-160). First issued in unbound sheets and later in increasingly larger magazine formats, View, from the special Surrealist issue of October-November, 1941, edited by

Nicolas Calas, was almost entirely in the service of the movement, devoting special numbers to Ernst, Duchamp, and Tanguy.

More specifically Surrealist in tone and consciously modeled on the defunct *Minotaure* was the review *VVV*, put out by David Hare, with André Breton and Max Ernst as editorial advisers. No. 1, appearing in June, 1942, had a cover by Ernst and numbered among its contributors Claude Lévi-Strauss, Roger Caillois, Breton ("Prolegomena to a Third Manifesto of Surrealism or Else"), and a group of Americans—Robert Motherwell (on Mondrian and de Chirico), Harold Rosenberg (on Lautréamont), Lionel Abel, and William Carlos Williams. The first two of these Americans were to form an

important liaison between the Surrealists and the community of younger New York painters. No. 2–3 of *VVV*, subtitled *Almanac for 1943*, had a cover by Duchamp, who, having made his way back to the United States (where he had spent most of the interwar years), had joined Breton and Ernst as the magazine's editorial advisers. This number was also notable for drawings by Matta, Kurt Seligmann, and Masson, and for Breton's essay "Situation of Surrealism between Two Wars," which was illustrated by Ernst. Matta did the cover for the third and last issue (No. 4; fig. D-202), whose exceptionally large number of reproductions of drawings and paintings attested to the continued vitality of Surrealist art.

André Masson. *Rape*

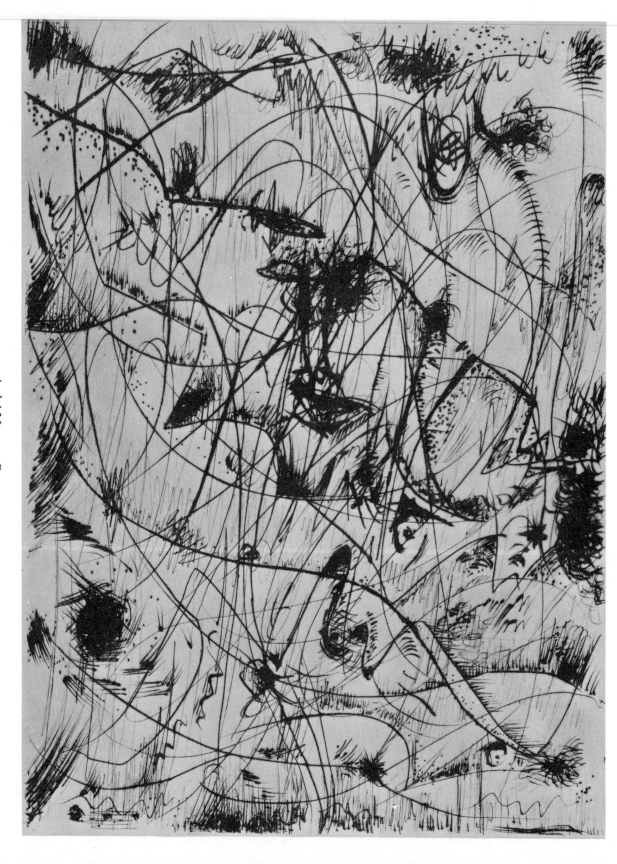

Matta. *Cataglyph the Great*

The Surrealists put on only one major group exhibition during their exile in New York. It was held at the old Whitelaw Reid mansion on Madison Avenue in October, 1942, and, aside from the expected European painters, included works by Calder, Motherwell, Baziotes, and Hare. Duchamp designed the installation (fig. b-201), which consisted of a maze of string, an Ariadne's thread beyond which the pictures hung like secrets at the heart of the labyrinth. The catalogue of this show was also designed by Duchamp, and was called *First Papers of Surrealism*, an allusion to the "first papers" of immigrants to the United States. In addition to a foreword by Sidney Janis, it contained a discussion by Breton of "myths" (including Orpheus, Icarus, the Messiah, Rimbaud, Superman, and the Great Invisible Ones).

MATTA

That Matta was asked to design one of the three covers for *VVV*, and that a considerable number of reproductions of his work appeared

throughout the magazine, testify to the significant role this painter played in the wartime phase of Surrealism. In 1939, Breton had already hailed him in *Minotaure* ("Les Tendances les plus récentes de la peinture surréaliste"), reproducing a work in color. Now Matta entered upon his period of fulfillment—and not as a painter alone. Twenty-seven years old at the time of his arrival in New York, he was better able to adapt himself to the possibilities and limitations of art life in New York than Breton and many of the older Surrealists. His conversation, as well as his art, generated considerable interest in the movement among Americans—particularly his contemporary Robert Motherwell, and later Arshile Gorky—for whom he acted as a kind of culture bringer from Europe. With the exception of Gorky, who participated directly in Surrealism only in the last years of its exile, and with due consideration given to the fine pictures Wifredo Lam executed during World War II, Matta's paintings constituted the only major artistic statement made by a new adherent to Surrealism during its final phase.

It was, moreover, the last major statement entirely definable within the coordinates of Surrealism. Though Gorky became a Surrealist

344

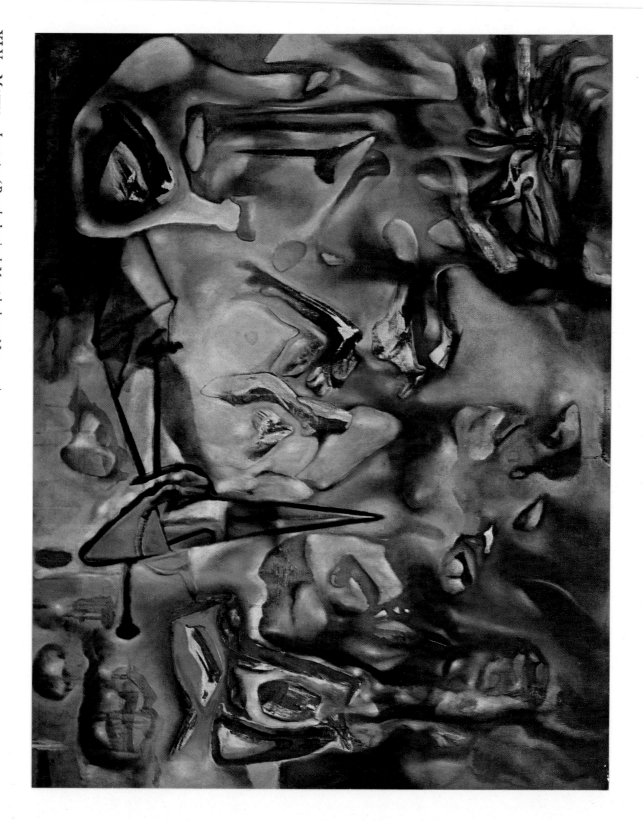

painter in many ways—catapulted in that direction by Miró and Matta —his mature style can be fully comprehended only in the light of his long apprenticeship to Picasso and the later influence on him of Kandinsky, in addition to that of Surrealism. This is not true of Matta. His art developed rapidly; within a year after he began to paint in oil, the essentials of his style were established, and the sources of that style—Tanguy and, later, to some extent, Duchamp— were entirely within the Surrealist tradition.

Roberto Sebastian Matta Echaurren did not begin painting until 1938. He was born in 1912 in Santiago, Chile, of mixed Spanish and French parentage. In 1934, he went to Paris, where he became an apprentice in Le Corbusier's office at the insistence of his parents, to whom the study of architecture seemed more practical than that of painting. But architecture did not give adequate scope to Matta's restless imagination, and, as the years passed, he spent less and less time in Le Corbusier's office and more and more in the company of Surrealist friends, whose group he joined officially in 1937. That same year, he did a series of colored drawings, some of which, in their morphology and illusionist perspective, came close to Dali, who admired them and encouraged him.

Later, in the following year, Matta began working in oil, and promptly gave up the deep perspective and the tight handling of his first colored drawings. In paintings like *The Morphology of Desire* (fig. 361) the shapes are irregular and frequently vague in contour; part of the surface is brushed in, but the thinner veils of paint that dominate the work were spread on with rags. The amorphous forms are engulfed in endless metamorphoses, passing through what appears to be a succession of vaporous, liquid, and crystalline states. Here thicker jewels of pigment cluster to form a highlight; there they eddy away and melt into open spaces as the painter "discovers" his vision improvisationally amongst the blots and spots.

This metaphor, as it were, of the genesis of the cosmos dominated Matta's art in the next five years. It comes into clearer focus in *Inscape* (1939; colorplate 45). There the tenuous horizon line clearly suggests a fantastic landscape—a kind of soft-focus Tanguy— which, as the title implies, is discovered within the self. As a projection into pictorial form of impulses, feelings, and fantasies, it constitutes what Matta called a "psychological morphology"—that is, a shape-language for psychological experience. The shapes of *Inscape*, though still quite unliteral, are more defined than in the pictures of 1938. Now, in Matta's mind, they would begin to "stand for," trees, birds, hills, and other components of a primordial world.

The vaporous washes of *Inscape* create the illusion of membranous "walls" dissolving into receding space, while the highlights of the pigment clusters suggest, as a form of modeling, projection forward. Yet the spatial definitions of this and the other pictures of 1939-41 remain indeterminate. In the shallow space the forms press forward over most of the surface toward the picture plane, interrupted only occasionally by pockets of depth.

Matta began these pictures by spilling washes of color on his canvas, then spreading them with rags into the broader constituents of his landscape image, after which he used the brush to detail smaller forms. The process was inductive and improvisational; accidents of spilling provoked some of the larger contours, which in turn suggested the smaller and more elaborate biomorphic shapes. Frequently, as in *Prescience* (fig. 362), which Matta painted in New York late in 1939, the accidental dripping and running of the first spillings were left visible in a manner anticipating the more automatic Gorkys of 1944. *Prescience* also contains passages of fragile linear webbing as well as a few more sculpturally modeled biomorphs reminiscent of Tanguy. While Matta was to retain the linear webbing and, in fact, develop it later into complex perspective systems, the few highly modeled forms of *Prescience* had subsequently to be rejected as inconsistent with the illusion of continual metamorphosis that constituted what Meyer Schapiro characterized as Matta's "futurism of the organic." They would return only in the later forties.

In 1941, Matta traveled to Mexico, where he was impressed by the volcanic landscape, burning sunlight, and bright colors. Subsequently, his "Inscapes" became charged with flaming paroxysmal yellows, oranges, and greens. This is the color scheme of *The Earth Is a Man* (colorplate 46), which is his first large picture and a brilliant synthesis of all his early imagery. The execution of this picture is tighter and the shading more smoothly graduated than before; as a result, the image seems more sharply focused, the forms more crisp. All this had to do no doubt with the very large size of *The Earth Is a Man*, which required that its layout be less improvised and more carefully planned in advance than had been Matta's habit previously; and it had also to do with the fact that the planning of the picture comprehended a more detailed and highly elaborated iconography than heretofore. The sun, partly eclipsed by a disintegrating red planet, illuminates a primordial landscape of apocalyptic splendor. It is the beginning of the universe; it is also the end. The high horizon line tilts the terrain toward the picture plane— flattening the space and allowing the entire composition to fuse more easily on the surface—and gives us a diving perspective on a landscape of amorphous hills and exploding volcanoes against whose melting

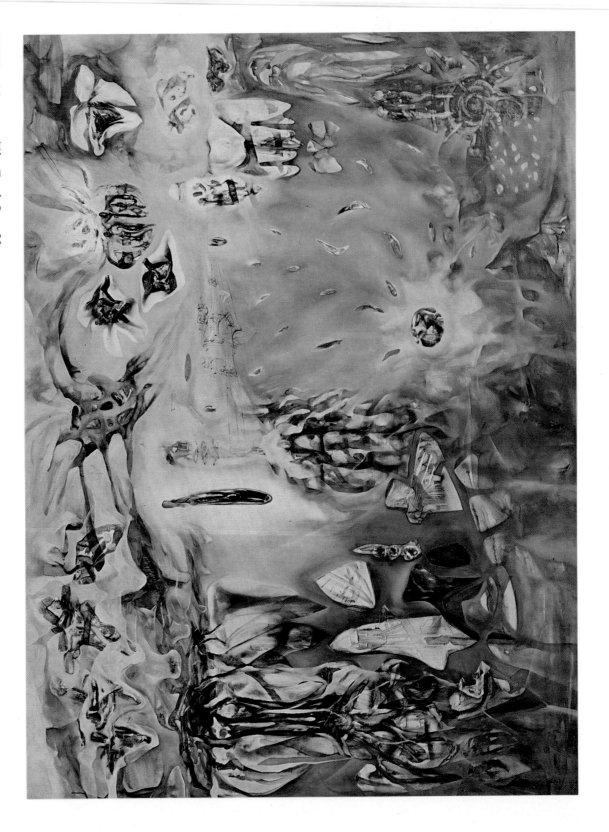

surfaces are silhouetted exotic and frequently highly inventive shapes that denote, in Matta's iconography, primeval birds and flowers. The title, *The Earth Is a Man*, draws our attention to the poetic metaphor of the landscape as a projection of the psyche. The rationalist Greeks had used the image of man (the microcosm) to represent the *finite* order and mechanical perfection they attributed to the universe (the macrocosm), but Matta conjures up a galactic vision of the earth to insist upon the infinity and mystery *within* man.

The year 1942 was important for him. In addition to *The Earth Is a Man*, he painted *Here Sir Fire, Eat* (fig. 364) and *The Disasters of Mysticism*, a brooding and particularly violent work distinguished by his richest handling of impasto in those years. The first picture is especially inventive and has a highly consistent spatial definition made possible by the elimination of the horizon line. The problem for the landscape painter is always how to articulate the sky as interestingly as the ground and, above all, how to make deep space unfold in continuity with the foreground (the latter was less of a problem for the old masters, who presumptively accepted the illusion of infinitely receding space). Despite the fantastic character of Matta's metaphoric landscape, he had to cope with these same difficulties. In pictures like *The Earth Is a Man* the interesting articulation of the "sky" was not a paramount problem, since the nature of Matta's galactic fantasy admitted a great variety of forms, which gave his "sky" the same compositional density as the lower part of the picture. The diving perspective did not, however, adequately solve the spatial problem engendered by the horizon line; and the remaining ambiguities disappeared only in *Here Sir Fire, Eat*, where Matta simply eliminated the horizon line and thus the implication of landscape space. As a result, the picture, though retaining shallow illusionistic space, has an approximately even depth throughout.

Matta's 1943 pictures explore a number of directions, but their general sense is equivocal. Not until the following year did the last vestiges of the "Inscapes"—the colorful mountains, volcanic explosions, and congealed lava flows—give place to an "a priori" continuum of dimly lit space, in which float a galaxy of smaller and very tenuously linked forms. The eye is now suspended in interstellar space, with its smaller galactic elements all more distant, more silent, more unchanging, and in their morphology more enigmatic than in the inscapes. As in *The Vertigo of Eros* (1944; colorplate 47), the only large picture and certainly the crucial one of this phase, the stability previously given by the horizon line is renounced in favor of an effect of suspension. Matta, paraphrasing Freud, declares that the life spirit, Eros, constantly challenged by the death instinct,

Thanatos, produces a state of vertigo, and the problem is one of remaining erect in this situation, of achieving physical and psychological equilibrium. Equilibrium in Matta's art, like equilibrium in life, is a continuing dramatic factor. It is constantly being lost and must be regained. Each picture—simply as a plastic problem—repeats the challenge. The delicately equilibrated composition of *The Vertigo of Eros* is a solution bound to the alignment of psychic forces in the moment of the creation of the painting; it would not be viable for the next picture.

The central metaphor of *The Vertigo of Eros* is that of infinite space which suggests simultaneously the cosmos and the recesses of the mind. Afloat in a mystical world of half-light that seems to emerge from unfathomable depths, a nameless morphology of shapes suggesting liquid, fire, roots, and sexual organs stimulates the awareness of our inner consciousness as it is when we trap it in reverie and dreams. Unlike Dali and Magritte, whose imagery accepts the prosaic and realistic appearance of objects seen in dreams, Matta invents new symbolic shapes. These constitute a morphology that reaches back beyond dream activity to the more latent sources of psychic life: an iconography of consciousness as it exists before being hatched into the recognizable coordinates of everyday experience.

The Vertigo of Eros breaks with Matta's work of the previous years by adhering uncompromisingly to a very deep—in fact, infinite —illusion of space that is in some ways like that of the old masters. De Chirico's illusionist space was achieved by linear perspective, which still allowed his planes to be flat and his pictures to look therefore relatively abstract. Matta's space is constructed primarily by atmospheric or aerial perspective, which precludes this flatness. He achieved this perspective by first laying down a ground of large alternating areas of wine and yellow; over this, when dry, he applied a black wash, which he then partly rubbed away with rags to allow color to emerge from the ground. The more black he rubbed away, the lighter became the final color (as in the lower right corner) and the more gradations were left by the rag to create the shaded passages which give the illusion of atmospheric space. Since the black was never entirely removed (this would have destroyed the tonal unity of the picture), the color is never pure but always "modeled." Within this atmospheric illusion of deep space, many lines—superimposed after the black had dried—crisscross or revolve to form a web of linear perspective that particularizes the co-ordinates of the more vague atmospheric perspective.

That Matta availed himself here of the two fundamental techniques

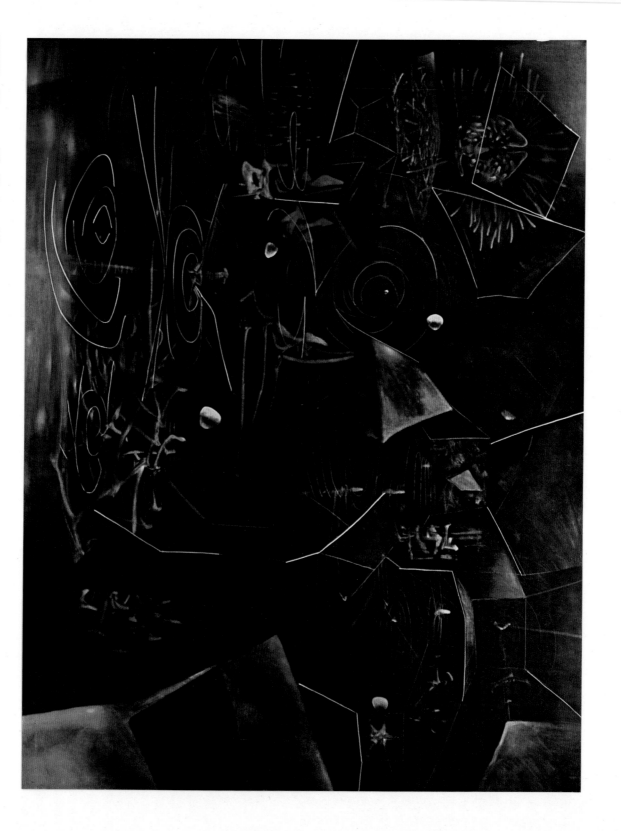

of old-master, illusionism—perspective space, and modeling in the round (which he used for the astral-genital eggs and other solid forms floating in his spatial continuum)—gives *The Vertigo of Eros* an old-fashioned look. It stands apart from the main tendency of modern painting, which has been toward greater flatness (that is, anti-illusionism) regardless of the degree of figuration. (Matisse is the epitome of the non-illusionist yet representational painter.) However, the test of any artistic convention is not its place in an historical development but its meaningfulness and viability in terms of feeling. Matta succeeds in moving us with his space because it conveys the mysterious and contradictory nature of consciousness in a revelatory way. Though he had to go back to illusionism for the plastic underpinning of his metaphor, his poetry still has an unexpected quality, and the shapes that carry it link exquisitely in the composition. His exteriorization of interior "space" reveals a new way of using the materials of illusionism; it constitutes the only spatial system of importance since de Chirico's.

Whereas the perspective system of old-master space is ordered by a single unified, governing idea (the perfect convergence of orthogonals in systematic focus perspective), Matta—taking a cue from de Chirico—articulates his deep space not with a single vanishing point but with multiple and frequently conflicting focuses. Like thought, which slips into unexpected byways, drops into maelstroms, and is suddenly frustrated by blockages, Matta's concentric circles suck the eye here and there into whirlpools of space, while at other points opaque planes suddenly materialize to obstruct its passage.

Toward the end of 1944, the deep space of *The Vertigo of Eros*, *To Escape the Absolute* (fig. 366), and other pictures of Matta's "dark" series gives way to a shallower and more consistently measured spatial illusion that tends to be based on linear rather than atmospheric techniques. The taut and intricately wired *Onyx of Electra* (colorplate 48) represents the culmination of this tendency. Here gray, white, and lemon prevail over a surface brushed in with comparative contempt for the medium. Gemlike clusters of pigment appear only as sparse accents articulating the perspective system and acting as nodes or terminals for the nervelike linear circuits (which is the reverse of what they do in the inscapes). The linear webs, which had multiplied in complexity after their tentative reintroduction in the works of 1942, reflected the continued influence of Tanguy and the influence too of the patterns of the mathematical objects Matta had seen at the Poincaré Institute and in the 1936 exhibition in Paris of Surrealist objects; some of the webs, resembling the concentric patterns in contour maps, recall the pictures of Onslow-Ford. James

Thrall Soby has pointed out, moreover, their affinity with Duchamp's fantastic network of white cord in the main gallery—which was organized around *The Palace of Windowed Rocks* (fig. 396), Tanguy's largest painting—of the 1942 Surrealist exhibition in New York.

Metaphorically *Onyx of Electra* seems to deal not so much with the deep recesses of the psyche as with a more intimate area, closer to the surface of the self, in which the life force is transformed into mental and nervous energy. In this "electrical" system of the mind all the tensions, ambiguities, contradictions, and frustrations of reality are felt. The space is fraught with pitfalls and sudden obstructions; perspective convergences pull us in opposite directions through planes whose surfaces bend under our impact and past pairs of icons suspended in sympathetic vibration. "It is the *space* created by contradictions," said Matta, "which interests me as the best picture of our real condition. The fault with most pictures today is that they show an a priori freedom from which they have eliminated all contradiction, all resemblance to reality."

There had been vaguely anthropomorphic suggestions in a number of Matta's paintings before 1944, but in that year these began to be more frequent and more legible. For the most part, they suggested only fragments of anatomies, as in *The Vertigo of Eros* (colorplate 47). *To Escape the Absolute* (fig. 366), however, contains an abstract, hard—almost bony-structure which, as it materializes in space, seems almost to imply a total anatomy. The following year, these adumbrations led to Matta's fantastic "portrait" of Breton, titled *A Poet* (fig. 367), the first of the "creatures," or "personages" that have populated his painting ever since. Breton had always looked to Matta like "a sort of lion with horns on his head . . . fixed in a position to carry a mirror," and the gun in Breton's hand, which is also his navel in the shape of a keyhole ("through which we unlock his enigma"), refers to the passage in the second Surrealist manifesto that recommends shooting at random into a crowd as the ideal Surrealist act.

Anthropomorphic personages had always been common in Matta's drawings, but like much else in his early iconography, they had not before found their way onto canvas. Unlike the paintings, the drawings had been frequently novelistic. The "adventures of a pair of biomorphs" which Matta drew in Chinese scroll form for his twin sons is three inches high and fourteen and a half feet long (divided into twelve panels; fig. D-204). That Breton should have occasioned the first personage in Matta's actual painting reflects the importance, in this transitional phase of his art, of the "beings" that Breton had

XLIX MATTA *The Spherical Roof around Our Tribe (Revolvers)*. 1952

362

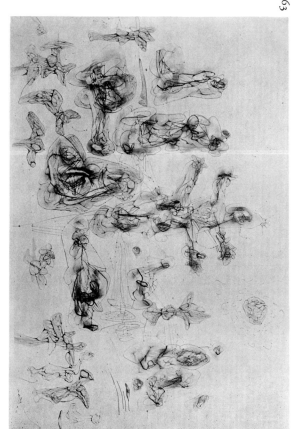

363

361

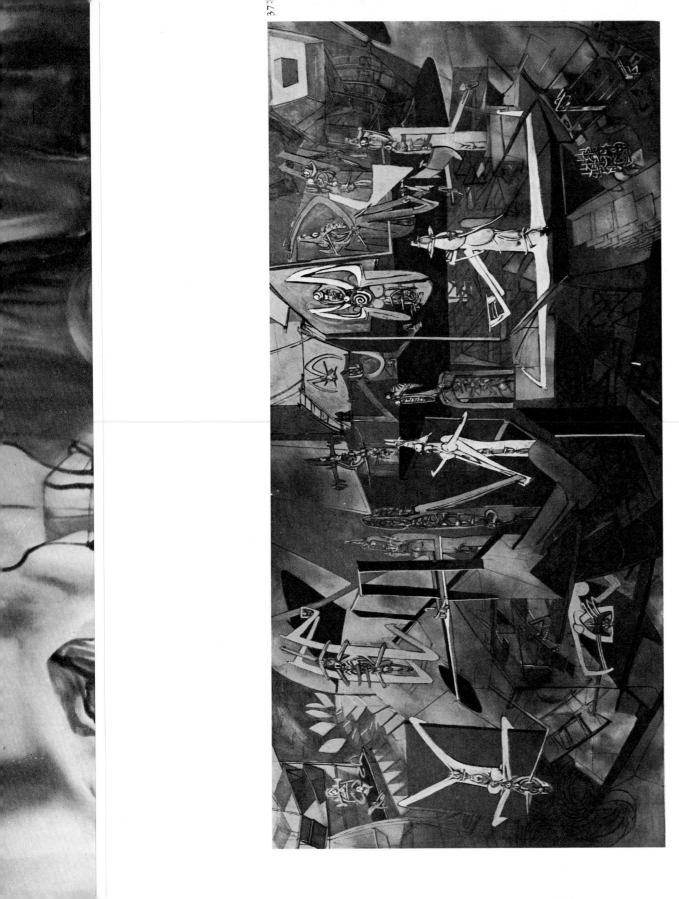

371

372

371 MATTA *Being With.* 1946

372 MATTA Untitled. 1949

373 MATTA *Against You, Dove Assassins.* 1949

374 MATTA *To Cover the Earth with a New Dew.*
 1953

375 WIFREDO LAM *Astral Harp.* 1943

called *Les Grands Transparents* (the Great Invisible Ones) in his "Prolegomena to a Third Surrealist Manifesto or Else," which had been published in 1942, illustrated with drawings by Matta. Breton wrote:

Man is perhaps not the center, the focus of the universe. One may go so far as to believe that there exist above him ... beings whose behavior is alien to him ... completely escaping his sensory frame of reference. ... This idea surely affords a wide field for speculation, though it tends to reduce man as an interpreter of the universe to a condition as humble as the child conceives the ant's to be when he overturns the anthill with his foot. Considering perturbations like the cyclone—or like war—on the subject of which notoriously inadequate views have been advanced, it would not be impossible ... even to succeed in making plausible the complexion and structure of such hypothetical beings, which obscurely manifest themselves to us in fear and the feelings of chance.[216]

The two personages in *The Heart Players* (1945; fig. 368) seem incarnations of these Great Invisible Ones. They manipulate the universe as they play a game of three-dimensional chess in which the pieces are the astral eggs and planes of the previous year's cosmic iconography. These syntactical constituents of Matta's language of the psyche are thus suddenly discovered to be pawns in the hands of previously invisible crystallizations of causality.

As Matta developed a variety of new and increasingly monstrous personages, he became more interested in Duchamp—to whom he now paid homage with an article and a painting (fig. D-203). From Duchamp's cinematic effects he derived the spun, splayed, and shuffled planes of *Splitting the Ergo* (1946; fig. 369), which were soon synchronized, as a kind of fantastic environment in motion, with one of the personages in *A Grave Situation* (1946; fig. 370). All this—the personages (now so varied and so monstrous as to constitute a private bestiary), the Duchampesque passages, in fact everything new in Matta's art after *The Vertigo of Eros*—was summarized in 1946 in an outsize (fifteen feet wide) canvas titled *Being With* (fig. 371). In this and related pictures Matta's handling becomes particularly broad; with their summarily modeled monsters and opaque planes they lack entirely the airy, delicately graduated atmospheric effects and intricate brushwork of his earlier pictures. Since very large canvases would be as frequent as previously they had been rare, this more summary manner became inevitable. Matta was the first painter in New York to make such big pictures standard for himself; it was not until a few years later that Pollock, Mark

Rothko, and Clyfford Still were to do so. But when they did, it was in different ways, in ways more related to that of the late Monet than to Matta's; his illusionist scale, whatever the size of his canvas, is always determined by the presence of anthropomorphic figures that act more or less as modules, and to that extent the prototype of his

wall-size pictures is the *Guernica*.

In *Being With*, the tendency toward literary specificity that had increasingly characterized Matta's iconography reached a peak from which it has never since then appreciably receded. The monsters are all in easily decipherable "anecdotal" situations; with their semaphoric gestures, their half-insect, half-machine forms, they are intended as cybernetic embodiments of "the hidden forces that seek to control our lives." The specific anthropomorphic character of these creatures, as I have already observed, was influenced by Giacometti's *The Invisible Object* (fig. 230), by Duchamp's anthropomorphic machines, as well as by certain drawings of Masson (1940–43), and the monsters of Ernst. The characters alter with the experience the creatures undergo, and the space around them bends sympathetically in response to their action.

The solidly modeled figures and hard, opaque surrounding surfaces in the pictures of 1946 continue until the end of the decade, just before which their morphologies become increasingly spike-like and thorny (fig. 372), endowing them with an Expressionist violence not unrelated in spirit to certain developments in American painting at that time. Matta's evolution as an inventor of forms has now slowed down; the novelty of these years is largely literary: the invention of new situations for the personages. Having moved from a pictorial, or (in a Wölfflinian sense) painterly, style to a more sculptural one, Matta may well have considered turning those personages into sculpture in the round (as Ernst had earlier done with his). But though the personages might have become more effective as works of art, they could not then have been so easily arranged in the narrative situations in which they resided, as far as Matta was concerned, their main meaning. Matta did turn to sculpture (fig. D-210) much later, but by then he had reverted to a more loosely brushed, anti-sculptural style of painting.

By 1950, when Matta's work underwent a new inflection, the last major Surrealist group show had taken place in Paris (1947; figs. D-218–220), and the sense of Surrealism's having run its course was widespread, even among those who held no brief for the emergent new American painting or its European counterparts. In 1948 Matta had been forcibly separated from the Surrealist group because of personal matters. Most of the Surrealists had gone back to France

in 1946 and 1947, and even though Ernst remained in America (he would return to France temporarily in 1949, permanently in 1953), and Tanguy stayed behind, there was for Matta little sense of a congenial milieu in New York after 1947. To be sure, the situation in Paris was not much better, for Surrealism had not been able, particularly after the 1947 exhibition, to reimpose itself or restore what in the thirties had been its virtual cultural hegemony. Too many new things were going on, too many new personalities who had gone through the critical years of their development during the absence of the Surrealists were making themselves felt, for Breton's role to be central.

Surrealism nevertheless persisted in many ways as a state of mind, and Matta, committed to the ideal of *peinture-poésie*, now suffered from a feeling of rootlessness. Responding with the courage of his cosmopolitanism, he began to roam: first to England, then to Italy, but finally he returned to France, where he still lives. Matta's art in the fifties—particularly late in the decade—reflected the breakup of Surrealism. With its frequent thinness and in its relative failure to evolve, to create new forms and images, it constitutes a marked contrast to what it was in its early years.

If sculptural illusionism dominated Matta's painting in the late forties, the two revisions of style notable in his subsequent work were both in the direction of the painterly. Beginning in 1949, there was a loosening of the handling; surfaces were increasingly accented by staccato strokes until by 1952 proliferated into effects akin to those in early Futurist Boccionis. *The Spherical Roof around Our Tribe* (colorplate 49) of that year is like an electromagnetic field in which the charged activity of the white strokes counterpoints the vibrations of a composite creature and a swarm of buzzing insectile heads.

An increasing concern with the more fantastic possibilities of science—versions of the universe as it might be seen through the "poet's" microscope or telescope—produced a number of pictures in the fifties that led to Matta's being criticized somewhat unjustly as a "painter of science fiction." This interest in science led him, at the end of 1952, to the theme of biological growth, the poetry of germination as conceived in terms of a botanical fantasy the germ of which goes back to Redon. The burgeoning forms of *To Cover the Earth with a New Dew* (1953; fig. 374) suggest a sun rising behind a landscape in which a flurry of activity animates the flora: roots spread and pistils discharge clouds of seeds; on the left, huge blossoms of color joyously burst forth. It is as if one speck of soil in the vast cosmic landscape of *The Earth Is a Man* (1942; colorplate 46) had been isolated under an enlarging lens. These botanical landscapes have

continued to alternate since 1952 with the "novelistic" pictures of personages. The further loosening of the paint handling that they show reflects the feelings of relaxation and *détente* inherent in the theme itself. Airily and thinly painted as they are, these pictures recapture certain aspects of Matta's earliest work and are more universal in their poetry than the novelistic pictures whose iconographies have become excessively journalistic, centering on politics more than on Eros (which had dominated his art in the forties).

OTHER SURREALIST PAINTERS IN EXILE

Though Wifredo Lam spent most of the war in Cuba, paintings of his were shown at the Pierre Matisse Gallery in 1942 and 1943, as well as reproduced in *VVV*. They made a significant new contribution to the imagery of Surrealist art. Lam was born in Cuba in 1902. His mother was of mixed African, Indian, and European origin, his father Chinese. At twenty-two, after attending the Academy of San Alejandro in Havana, he went to study in Madrid until, with the end of the Spanish Civil War, he settled in Paris. There he got encouragement from Picasso, and an exhibition he had at the Galerie Pierre in 1939 was well received. Breton took no notice of Lam at that time, however, and it was not until late in the year that he entered the Surrealist orbit.

Though there are traces of primitive and ethnic art in the imagery of a painter like Ernst—in his sculpture in particular—these magically intended forms of artistic creation counted for surprisingly little as far as most of the Surrealist painters were concerned. This is all the more curious in view of the importance given to magic in the second Surrealist manifesto and the avid collecting of primitive art by Surrealists themselves. (Breton, for example, possessed an outstanding collection; fig. D-164.) It is only with Lam that primitive sources come to the fore. Fused in a personal image that achieved its fullest expression in 1943 are traces of such divergent influences as Haitian voodoo figures and Congolese masks. This is by no means "footnote" painting; the borrowings are so blended by Lam's personal fantasy that there are no inner contradictions. Unlike Picasso's art, where the primitive imparts a rude energy to the forms and elicits (in the works of 1907) a rough and slashing execution, Lam's deals with the primitive in a way that is largely iconographic. He is concerned, as Nicolas Calas has observed,[217] with "spilling fresh blood on primitive altars, reinterpreting their basic rites." The large Lams of 1943, for example *The Jungle* (colorplate 50) and *Astral Harp* (fig.

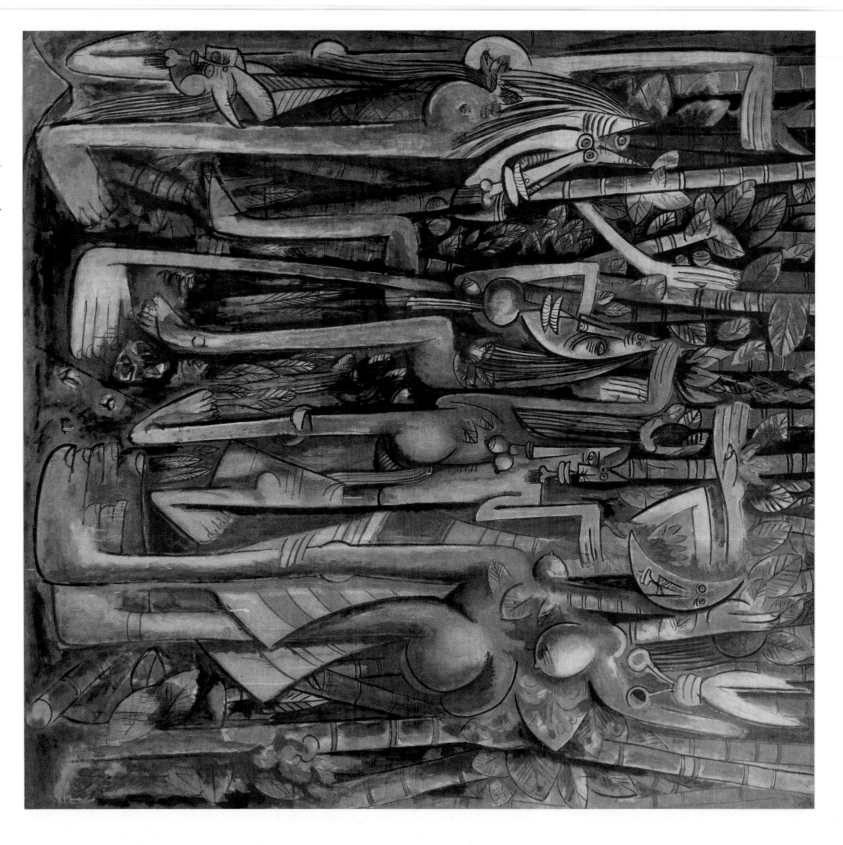

pictorial beauty. Here, as often in Cézanne's watercolors, large areas are left unpainted or only vaguely indicated. Touches of pure color, almost Neo-Impressionist at times in their staccato application, cluster to define the wings of exotic birds and horned totemic heads. These works come as close as anything in late Surrealist painting to *belle peinture*. But Lam did not persist in this vein for long; gradually he developed out of it into the flat, boldly contrasting style (fig. 378) he still uses today as the vehicle for his iconography, which remains unchanging.

Of the pioneer Surrealist painters who came to the United States during the war, only Masson experienced a major change in his art. It was one that was very much for the better. His paintings of 1942–43, and the drawings he produced the following year, have a force comparable with that of his work of 1927; they represent, qualitatively, the high point of Surrealist painting in exile. We have already seen how far Masson was deflected from his best possibilities as a painter during the 1930s; and the doldrums into which his art fell late in that decade were in no way relieved by his reconciliation with Breton after the Spanish Civil War, as his subsequent Surrealist-Mythological pictures (like *Labyrinth*, 1938) show. These fussily modeled, overelaborated paintings, some of them—such as *In the Tower of Sleep* (1938; fig. D-186)—stuffed with unconvincing and exaggerated sadistic matter, represented Masson's submission to a purely literary idea of painting. Nonetheless, amid the literalness there emerge suggestions of a new form-language, a mutation of biomorphism with convoluted, meandering silhouettes. These suggestions developed greater clarity in 1942, in the first oil paintings Masson did after his arrival in the United States from Martinique (figs. 379, 380).

To disengage this form-language, Masson had to effect two major changes in his art, both of them in the direction of simplification. First: the great number and variety of shapes that characterized his paintings just before World War II—the formal patterns of which could hardly be assimilated visually—were reduced. The remaining forms were more closely related to one another by analogy. This process was facilitated by a shift from an intricate literary iconography to a less specific one, based on themes of germination—related to those of Masson's earliest Surrealist works—suggested by the Connecticut countryside in which he spent his war exile. (Titles like *Indian Spring*, *Grain and the Star*, and *Meditation on an Oak Leaf*—all 1942 —reflect this renewed pastoral interest.) Second: the deep space and sculpturesque modeling which had led in the late thirties to a certain

Wifredo Lam. *I Am Leaving*

375), have sometimes been compared with Picasso's *Demoiselles d'Avignon*, but unlike that seminal work, they are not new with respect to formal structure (their shallow space and low-relief modeling come right out of Picasso) but only in their iconography. In a landscape filled with palm fronds, bamboo stems, and sugar cane, vaguely anthropomorphic personages appear: aggressive horned male figures, hard and rigid in shape, and females with immense breasts dissolving into the voluptuous landscape. Lam's figures seem "collaged" from different levels of actuality; a woman whose torso is little more than an immense biomorphic breast, and whose head is like an African mask, wears a fetishlike, flowering high-heeled shoe.

The execution of the large pictures of 1943, such as *The Jungle*, is never tight, though Lam is concerned to model his forms in definite relief. The picture area is crowded and luxuriant, the artist giving almost equal emphasis to the whole canvas, while the color is generally muted. In 1944, under what seems clearly to be the impetus of Cézanne's watercolors, Lam did a series of thinly painted and brightly colored canvases (*The Spirit Watching*, fig. 376, is typical) in which he sacrificed iconographic clarity and complexity to a more purely

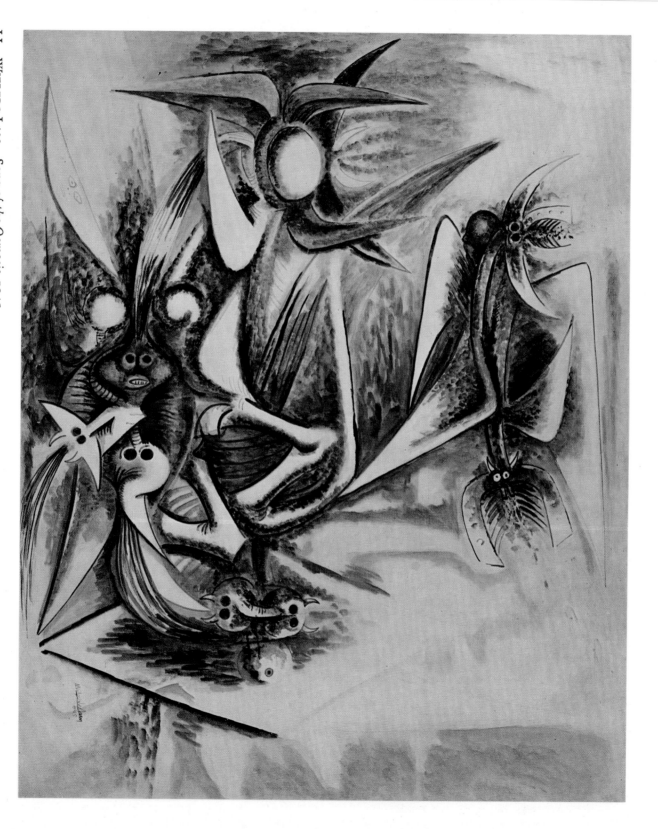

Martinique experience (*The Sorcerer, Martinique Fisherwomen*), and others (like *Pasiphaë*) demonstrate his continued interest in the Freudianized myth (likewise a common subject with such American painters as Pollock, Gottlieb, and Rothko at that time).[218] the bulk of his pictures of those years has to do with a fantasy of nature. Of these, *Meditation on an Oak Leaf* (colorplate 52) is Masson's masterpiece. Despite its complex layout, this painting is wholly without the cluttered look of his works of the late thirties. The perfect jig-sawing of flattened shapes allows the eye to pass easily from one to the other. A blue silhouette of the oak leaf in the upper left of the picture forms the starting point of the painter's reverie. As the eye moves on, various elements of the leaf—its veins, its outer contours—disengage themselves as autonomous shapes and gradually metamorphose into suggestions of eyes, animal heads, insects, and other inhabitants of a landscape world. These same things act as symbols of procreation. The process of psychological association—the imagery that suggests the way the artist's mind wanders as he ponders on the leaf—is perfectly married to a wholly self-sufficient formal design.

The dark, brooding color of *Meditation on an Oak Leaf*—in which glowing blues and wines are stressed—is characteristic of Masson's painting throughout 1942–43; so is his use of sand to enrich the texture and enhance the telluric association. The allusively anthropomorphic arrangement in *Meditation*, with a cat's head at the top, a body in two convoluted sections, and the unbalanced placement of the "feet," was vividly echoed in Pollock's *Totem I* (1944; fig. D-251), as I have shown elsewhere,[219] and, as Clement Greenberg observes,[220] in Hans Hofmann's *Fairy Tale* (1944; fig. D-252). When we compare the Pollock and Masson pictures, we see not only evidence of the attention—even if inadvertent—paid to Masson by an important American painter but also the gulf that separated the two. In the Masson the application is subtle, the tonal nuances refined, the drawing searching; the picture embodies all the pictorial culture of European tradition. The Pollock work is ruder and more vigorous in its execution, more vigorous even than it is in the Picassos that also influenced *Totem I*.

Pollock's surface is strewn with energetic motifs that do not so much participate in iconography as stand independent as expressive marks. To the extent, however, that Pollock drew on an iconography of Freudianized mythology, his symbolism is very close to Masson, just as his later "drip" pictures represent a fulfillment, on a heroic scale, of ideas of linear automatism introduced by Masson in the twenties. Masson's automatist pictures and the dark paintings of his

André Masson. *Sybille*

pictorial incoherence had to be squeezed out; and when Masson's forms were flattened, their value as shapes became more evident. How much Masson's new environment had to do with these changes in his art is a matter of conjecture. It is certain, however, that though these changes meant a return, in a sense, to notions of picture making by which he had been guided in the period 1925–28, they also reflected, more generally, the taste that prevailed among the American avant-garde of the war years, especially insofar as they brought Masson closer to Picasso (as in the former's *Pasiphaë*, 1943, fig. 381, for example). By the same token, as we shall see shortly, the new direction of his art was much appreciated by certain sections of advanced American art opinion.

While some of Masson's themes of 1942–43 are drawn from his

André Masson. *Invention of the Labyrinth*

American period played a significant role for American art. "André Masson's presence on this side of the Atlantic during the War," wrote Clement Greenberg, pioneer critic of the new American painting, in 1953, "was of inestimable benefit to us. Unfulfilled though he is, and tragically so, he is still the most seminal of all painters, not excepting Miró, in the generation after Picasso's. He, more than anyone else, anticipated the new abstract painting, and I don't believe he has received enough credit for it."[221]

Masson awoke one night in 1943 intensely stirred by a dream he could not recall. In the effort to recapture it, he rapidly began to draw images that came to his mind by free association.[222] Strange birds, exotic flora and fauna, breasts and sexual organs were all put down on successive pages until finally the central image of the dream returned: the torso of a voluptuous Negro woman Masson had seen during his stay in the Antilles. All these images were synthesized in his major picture of 1943, *Antille* (colorplate 53), where the subordinate motifs are disposed in relation to the twisting body of a nude in accordance with the same principles of free association as

LIII ANDRÉ MASSON *Antille.* 1943

had operated in *Meditation on an Oak Leaf*. The convulsive, erotic sense of movement in *Antille* is provoked by the rush of exclusively curvilinear rhythms, enhanced by sand mixed in the pigment, which gives to the purple-brown body of the Negress the illusion of glistening with perspiration; the total effect is reinforced by explosive bursts of saturated bright colors against a predominantly dark blue, brown, and red ground—this kind of fireworks unique in Masson's coloring at that time.

Antille is the last peak of his art. The years 1944–45 saw some of Masson's finest drawings and an occasional prophetic painting like *Elk Attacked by Wild Hounds* (1945; colorplate 54), where the curvilinear rhythms form virtually an "allover" design; yet the compositional density of his paintings diminished, and the emphasis given in them to calligraphic drawing accompanied by a shift to light and frequently pastel shades of color produced a more decorative, less affective, less mordant art. This *détente* was further evidence of Masson's short-windedness, and it settled in with full force on his return to France after the end of the war. There his decorative calligraphy gradually gave way to an Impressionistic handling reminiscent of Turner and Monet. This return to "pure painting" as defined by French tradition, surprising as it was in Masson, was accompanied by the complete disappearance from his art of the oneiric, erotic, and mythological. There came, with this, a new break with Breton. Later, Masson repudiated the direction his art had taken in the immediate postwar years and returned to a style more like that of his American period, partly under the influence of the Pollocks he saw only some years after his departure from America.

As I have observed, Max Ernst's supreme achievement during his years in the United States lay in his sculpture. But if the quality of his wartime painting comes off badly in comparison with the quality of many things he did before, the variety of his imagery still remains impressive. Most of his paintings of 1940–43 betray an academic fussiness that was inherent in their decalcomania technique (which Ernst had borrowed from Dominguez). By thinning his pigment, he was able to adapt to oil a technique which Dominguez had used exclusively in gouache. From the illusion of highly detailed mineral and organic deposits that this technique created for him, Ernst, by selection and elaboration with the brush, conjured hidden figures and monsters. The effect has an affinity with Moreau's "Byzantinism" and with that of the more encrusted Dalis like *Imperial Monument to the Child-Woman* (fig. 195).

Ernst's first paintings in this manner—*Europe after the Rain* (fig.

386) and *Day and Night* (fig. 387), for example—were completed from decalcomania bases laid down while he was at St.-Martin-d'Ardèche, shortly before his flight to America. In such pictures as *Napoleon in the Wilderness* (1941; fig. 388), only a small part of the surface is decalcomania; the sea, sky, and parts of the figures are brushed on in a conventional descriptive way. From the decalcomania suggestions emerge three vertical elements silhouetted against the sky: Napoleon, a totem, and a female nude holding a fantastic musical instrument. Ernst recalls the iconography here as summarizing his flight from Europe ("Napoleon—the dictator; wilderness—St. Helena; exile—defeat, and so forth"), but, as suggested above (p. 124), the theme is also quite clearly one of voyeurism.

In landscapes like *Europe after the Rain* and *The Eye of Silence* (1943–44; fig. 391) Ernst is at his most illustrative, the decalcomania technique being wholly absorbed into *trompe-l'oeil* and the iconography seething with extrapictorial allusions. If these works seem in general to be Ernst's most Germanic ones, *The Temptation of St. Anthony* (fig. D-213) specifically confirms this impression, reminding one as it does of Grünewald's version of the same subject in the Isenheim Altar. A comparison of these pictures points up the main problem of Ernst's hallucinatory iconography in this period: the Grünewald convinces us, and the Ernst does not. Some time ago, Nicolas Calas wrote of Ernst: "If monsters exist it is for them to convince us of the reality of their presence."[223] The horned monster of Ernst's *One Night of Love* (1927; colorplate 26) and the apparitions of his "Hordes" are deeply felt; those he evoked at the time of World War II are merely seductive.

Far more successful than the pure decalcomania landscapes is a group of pictures in which Ernst divided his surface into rectangular panels which he then filled with passages in many different styles. In *Vox Angelica* (1943; colorplate 55), the major work of this group, some of the panels contain decalcomania landscapes, others *frottage* "Forests" in the vein of 1927–28; still others are filled with the brightly striated "geological sections" of the early thirties; there is a "Jungle" of the later thirties, flat *frottage* patterns of wood panels, *trompe-l'oeil* of sculptures, and so on. What brings off the whole work is the precarious balance Ernst achieves between panels that are alternately deep (illusionistically) and flat, simple and complex, dark and light. There is nothing mechanical in the way this is worked out, yet it is doubtful whether this tour de force of stylistic synthesis could have been accomplished without an a priori geometrical framework.

One panel of *Vox Angelica* is filled with a series of linear patterns

LIV ANDRÉ MASSON *Elk Attacked by Wild Hounds.* 1945

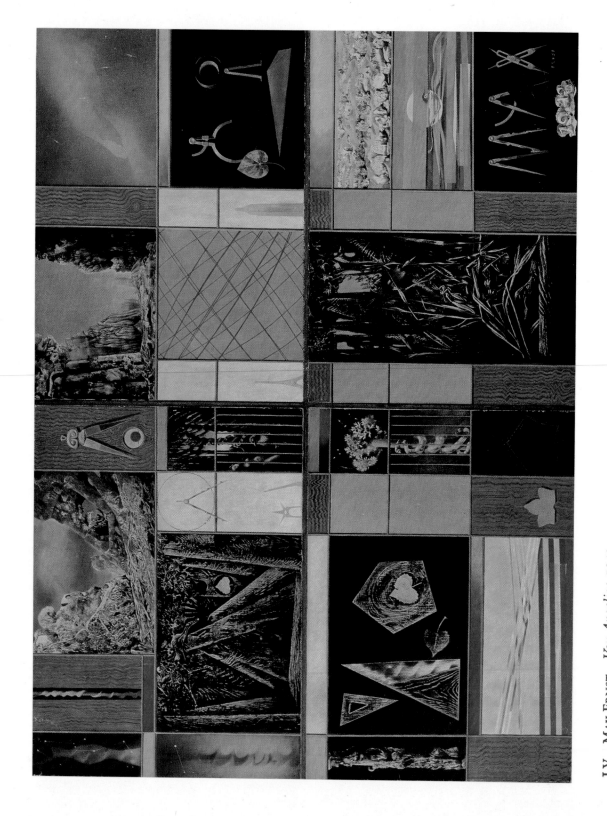

LV MAX ERNST *Vox Angelica.* 1943

372

of a type being executed by the surreal monster-artist in *Surrealism and Painting* (fig. 389). Since they form the basis of two pictures begun in 1942, *The Mad Planet* (fig. 390) and *Young Man Intrigued by the Flight of a Non-Euclidean Fly* (finished 1947; fig. 392), they have become the springboard for an effort by writers on Ernst to make him the originator of Pollock's drip style. Ernst began these pictures with webs of more or less symmetrical elliptical lines that he got on canvas by swinging a paint can with a pinhole in it at the end of a string. Patrick Waldberg, author of a pioneer monograph on Ernst, says the following:

The Mad Planet and the *Non-Euclidean Fly* had, historically, unexpected repercussions.... When these canvases were exhibited late in 1942, the painters Motherwell and Jackson Pollock were astounded by the delicacy of their structures and begged Max Ernst to tell them his secret. It was a simple one [the string-and-can mechanism], and Jackson Pollock subsequently used this technique, called "dripping," most systematically. Later he was credited with its invention.[224]

Marcel Jean describes Pollock's drip style as "nothing more than Max Ernst's process of *oscillation* done by hand." But his familiarity with Pollock's art can be measured by his assertion that Pollock would cut up the canvases thus covered and sell them by the foot.[225] The claim that Ernst invented Pollock's drip method is repeated frequently in European writing on the former. One look at the pictures in question tells us immediately and clearly that Ernst's regular patterns as formed by a gyrating can have little in common with the poured, meandering textures of Pollock's pictures of five years later. Pollock's method was an outgrowth of and a solution to problems developing out of his own brush and palette-knife paintings of 1946. His dripping implemented a *style*, Ernst's was merely a technique for "forcing inspiration."

The influence of Ernst and of Surrealism in general on the young American painters was of a much less specific kind. As examples of disdain for conventional ways of painting, all the Surrealist techniques were significant models. It was the Surrealist notion of linear automatism that was germinal—for Pollock in particular. But even

Max Ernst

Max Ernst

Pollock was impressed more with the idea than with the specific use that any of the Surrealist painters had made of it.

Of the major Surrealist artists who spent the war years in the United States, Yves Tanguy, who married the American Surrealist painter Kay Sage and settled in Woodbury, Connecticut, where he died in 1955, remains to be dealt with. His move to America occasioned no break in the steady elaboration of his own interior image—and of its stylistic vehicle—which has been discussed in detail above (pp. 194–98). We have already mentioned the tendency toward brighter color Tanguy showed in the 1930s. During World War II, this brightness continued to increase in Tanguy's description of "solid" forms. But his landscape grounds, which during the previous decade had often been colored, sometimes with almost rainbowlike striations, now tended to gray or whiten out. As a result, the more saturated color of the "solids" became brilliant and gemlike by contrast.

At the same time, these composites of biomorphs became both more monumental and more implicitly anthropomorphic, as in *Through Birds, Through Fire, but Not Through Glass* (colorplate 56). The stately sculptural presences in the foreground space of *Slowly Toward the North* (1942; fig. 394) and *Indefinite Divisibility* (1942; fig. 395) evoke a world more static and stable than the melting metamorphoses of *The Armoire of Proteus* (fig. 176) or the primordial germinations of *The Storm* (fig. 171). The superimposition on atmospheric space of increasingly complex linear perspective webs—like those of *Slowly Toward the North; The Palace of Windowed Rocks* (fig. 396); and other pictures of 1942—had an influence, as we have seen, on the devices introduced by Matta during the next two years, just as the aggressive, bony figure that dominates Tanguy's *My Life, White and Black* (1944; fig. 397) suggests the osseous forms that began emerging in Matta's *To Escape the Absolute* of the same year.

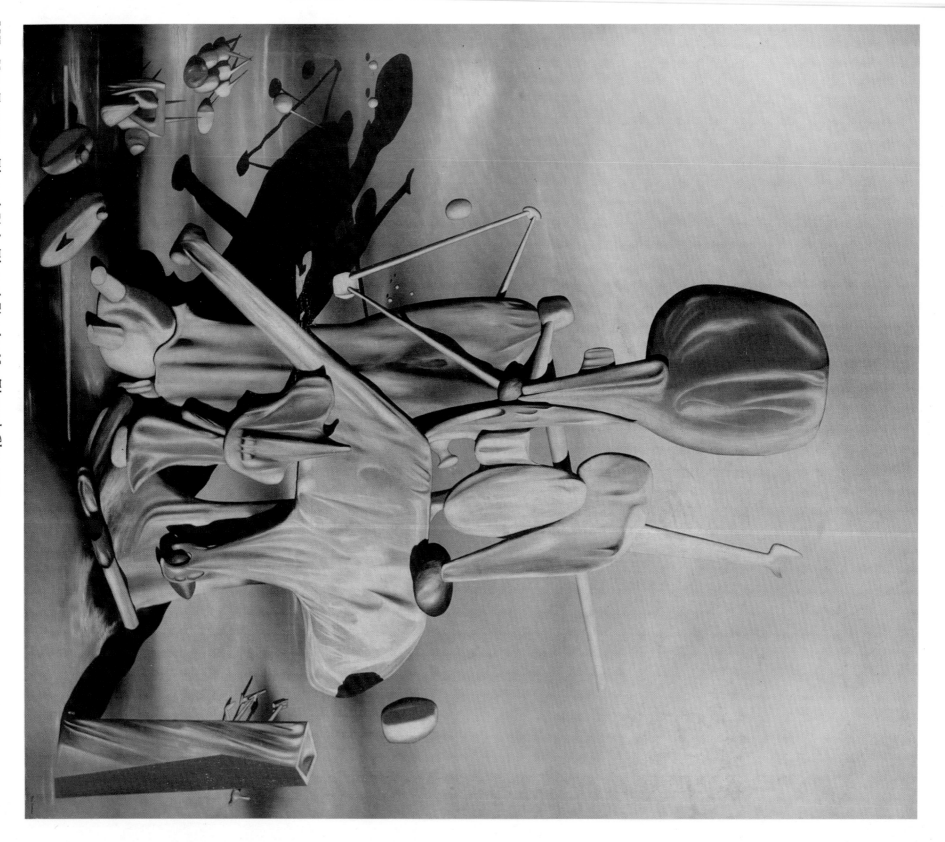

Yves Tanguy

The concluding phase in the evolution of Tanguy's image begins to become evident in 1949 in *Fear* (fig. 398), where the two large devices packing the left and right margins of the picture and framing the stage space in the center are made up no longer of a few salient sculptural elements as during the war years but of a coalescing of myriad tiny forms which now begin to crowd the surface obsessively. In *Rose of the Four Winds* (1950; fig. 399) and *The Hunted Sky* (1951) the crowding dominates the foreground, and though this tendency did not continue unabated, or in a mechanical way, in the next years, the whole evolution of Tanguy's style seems in retrospect to have led ineluctably to the hallucinatory *Multiplication of Arcs* (1954; fig. 400), which he completed not long before his death. Here the once virtually empty landscape is covered with a mass of biomorphs, all individuated in shape despite their phenomenal number and their limited range of size. The result conjures up certain aspects of the coast of Brittany, where Tanguy spent much of his childhood. "I saw Tanguy several times in Woodbury when the

Multiplication was in progress," wrote James Thrall Soby.[226] "He worked on the picture like one possessed. . . . Clearly he sensed that [it] was to be the summary of lifelong aims and preoccupations; he would arrive at the end of the day exhausted by the long hours of unrelenting concentration. And what a cosmic image he achieved! The picture is a sort of boneyard of the world."

Besides being a "boneyard of the world," *Multiplication of Arcs* was also the graveyard of illusionistic biomorphism. And by 1955, even flat or abstract biomorphism had ceased evolving. Though it was still the language of Arp's reliefs and free-standing sculpture, his version of it had become fixed and frozen early in his career. And the same is true of Tanguy's version. From the point of view of the historical development of biomorphism, the sole new impetus after Matta came from Arshile Gorky, with whom its vital development comes to a close. It is indeed with Gorky that one epoch of art history ends and another is heralded, a transition which has been the focal point of much dispute and polemic.

376

377

376 WIFREDO LAM *The Spirit Watching*. 1944

377 WIFREDO LAM *Tree of Mirrors*. 1945

377

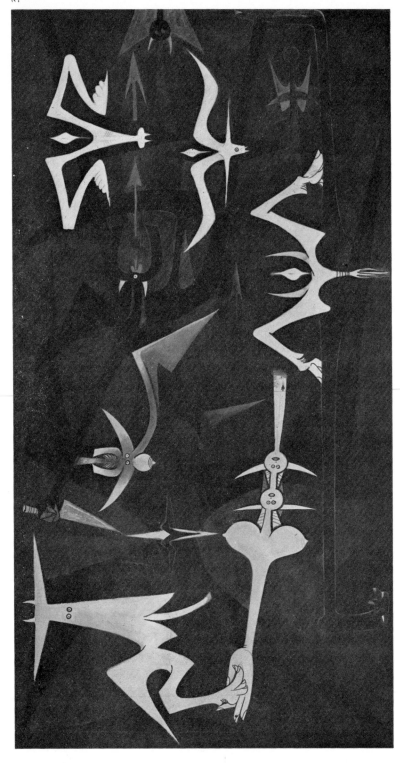

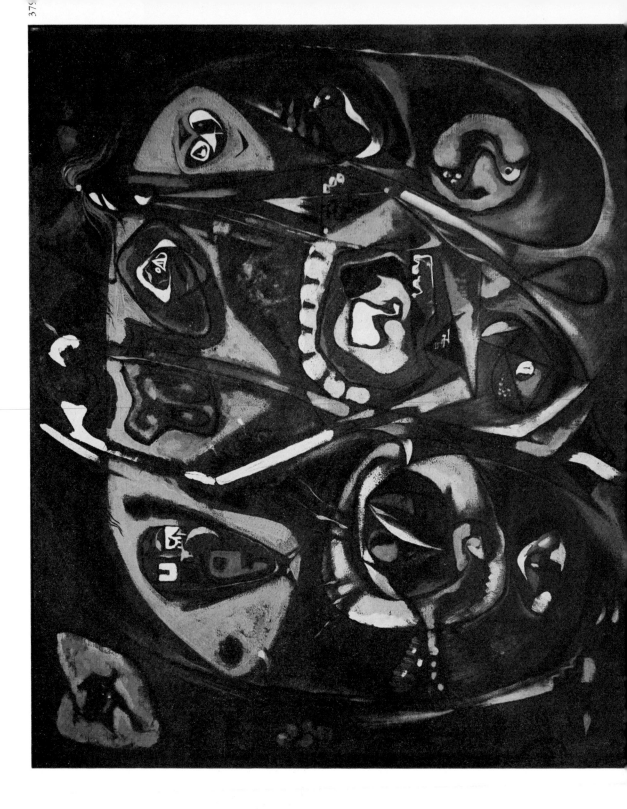

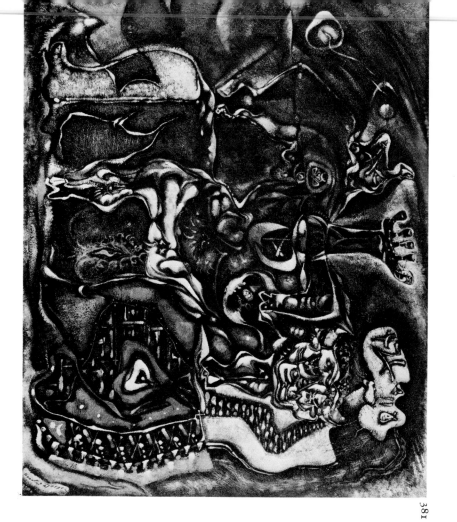

381

379

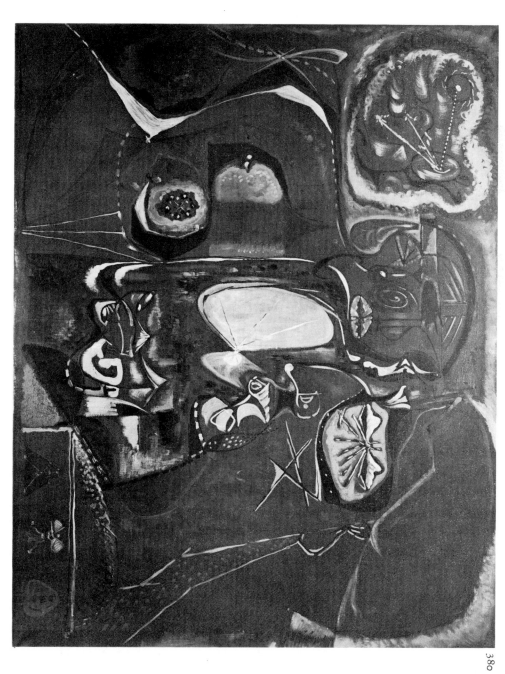

380

382

386 MAX ERNST *Europe after the Rain.* 1940–42

387 MAX ERNST *Day and Night.* 1941–42

388 MAX ERNST *Napoleon in the Wilderness.* 1941

389

390

392

389 MAX ERNST *Surrealism and Painting.* 1942

390 MAX ERNST *The Mad Planet.* 1942

391 MAX ERNST *The Eye of Silence.* 1943–44

392 MAX ERNST *Young Man Intrigued by the Flight of a Non-Euclidean Fly.* 1942–47

393 KURT SELIGMANN *The Offering.* 1946

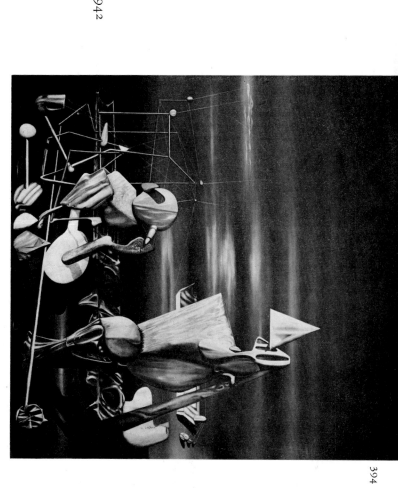

394

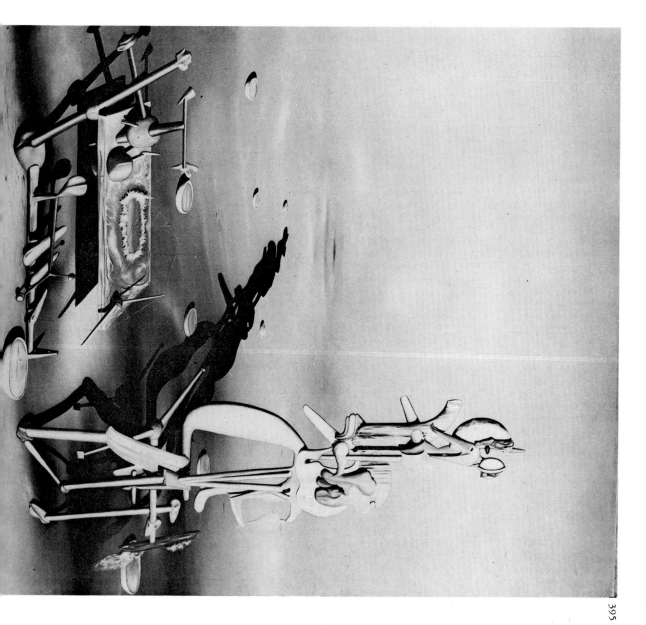

395

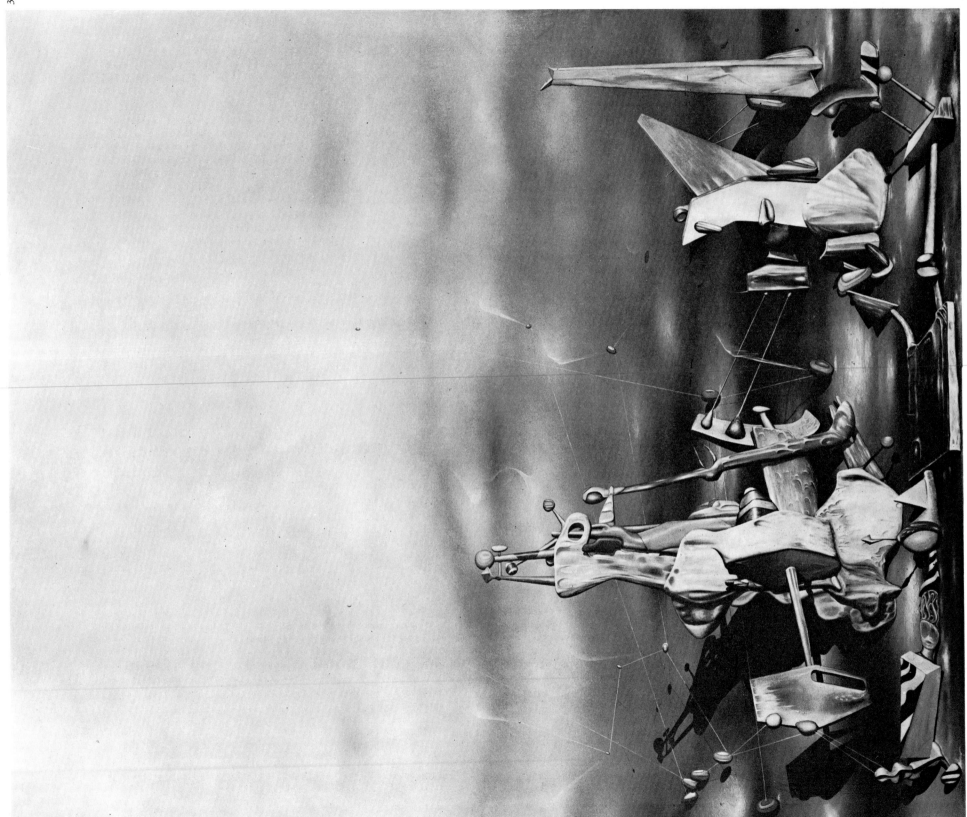

396 YVES TANGUY *The Palace of Windowed Rocks.* 1942

397 YVES TANGUY *My Life, White and Black.* 1944

398 YVES TANGUY *Fear.* 1949

397

398

401

400

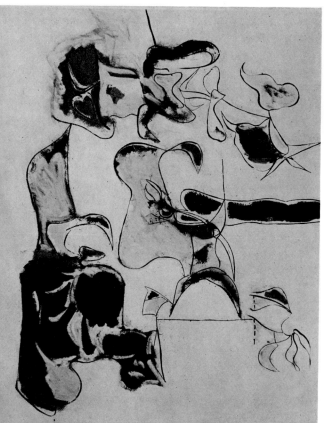

404

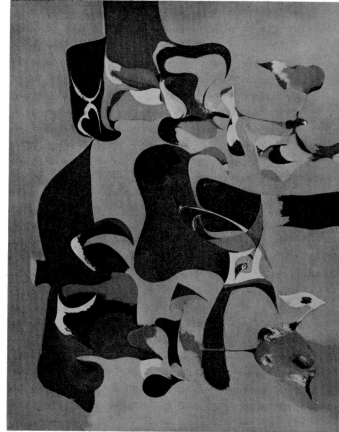

402

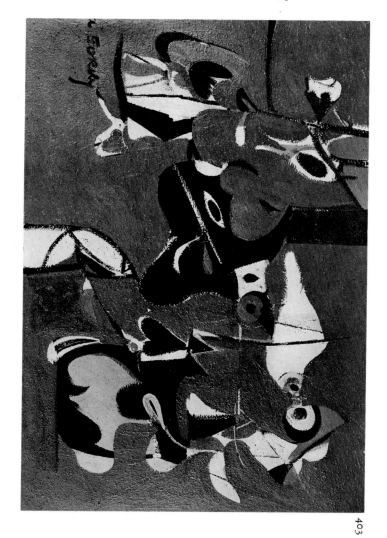

403

399 YVES TANGUY *Rose of the Four Winds.* 1950

400 YVES TANGUY *Multiplication of Arcs.* 1954

401 ARSHILE GORKY *Image in Xhorkom.* c. 1936

402 ARSHILE GORKY *Garden in Sochi I.* 1941

403 ARSHILE GORKY *Garden in Sochi II.* 1941

404 ARSHILE GORKY *Garden in Sochi III.* 1943

405 ARSHILE GORKY *The Pirate I.* 1942

406 ARSHILE GORKY *Landscape.* 1943

407 ARSHILE GORKY *Drawing.* 1943

408 ARSHILE GORKY *Waterfall.* 1943

406

407

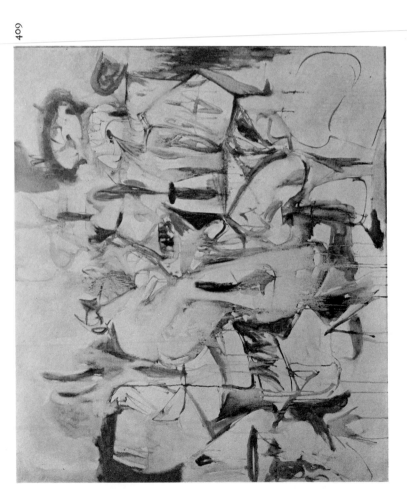

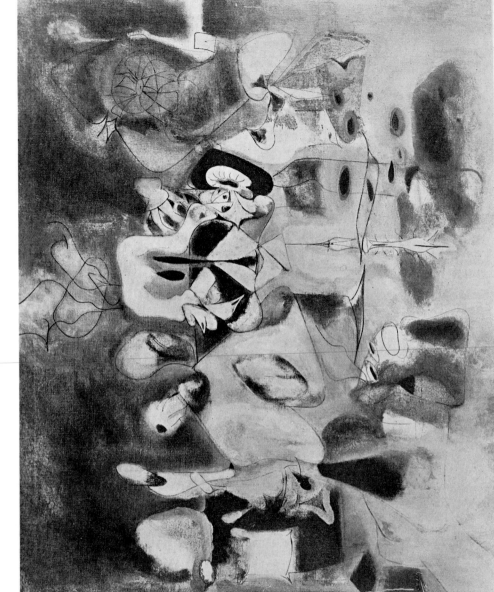

409 ARSHILE GORKY *How My Mother's Embroidered Apron Unfolds in My Life.* 1944

410 ARSHILE GORKY *The Unattainable.* 1945

411 ARSHILE GORKY *The Diary of a Seducer.* 1945

ARSHILE GORKY: SURREALISM AND THE NEW AMERICAN PAINTING

The general unanimity of critics and historians on the high quality of Gorky's art is in marked contrast to the divergence of opinion on the nature of his style and its historical position during the critical 1940s, or, more specifically, Gorky's possible role either as the last Surrealist or as a pioneer of the new American painting.

The Surrealists treat Gorky as a significant ornament of their movement, and he was, indeed, the last important painter accepted into their circle. His work attracted the attention of Breton in 1943; two years later, when Gorky exhibited at the Julien Levy Gallery, he was treated as a fullfledged member of the Surrealist group. The final section of Breton's 1945 edition of *Le Surréalisme et la peinture* is devoted to Gorky; he is also the last Surrealist to be dealt with in the quite different histories of Surrealist painting written by Patrick Waldberg and Marcel Jean. Robert Motherwell asserts that there is nothing in Gorky's work that cannot be understood within the context of Surrealism.

But there is also a considerable body of opinion that views Gorky as a pioneer of the new American painting. His inclusion in the exhibition of that title that The Museum of Modern Art, New York, circulated through Europe is symptomatic in this regard, as was the earlier exhibition of examples of his work in the American

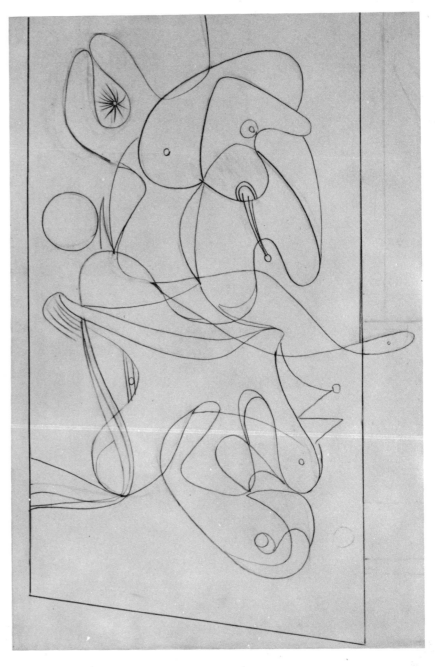

Arshile Gorky

Pavilion at the Venice Biennale of 1950 along with examples by Pollock and de Kooning. In a recent monograph Harold Rosenberg[227] minimizes Gorky's relation to Surrealism and speaks of him as "a typical hero of Abstract Expressionism."

It is the coincidence in Gorky's art of elements usually associated with either Surrealism or recent American abstraction (far fewer of the latter, I believe) that provokes the divergence of opinion, and this dualism itself stems, to a large extent, from Gorky's unique historical position in a decade that saw both the end of Surrealism and the rise of the new American painting. To view Gorky simply as the last Surrealist is to overlook certain qualities that differentiate his painting from that of all other Surrealists, qualities that are in fact contrary to the theory and practice of Surrealism. Yet to conceive of him primarily as a pioneer of the new American painting necessitates gerrymandering one's image of his art so as to suppress not only its morphology but also its particular poetic sensibility and psychological disposition. Sufficient time has now elapsed for art historians to approach the decade of the forties and the problem of Gorky's place in it independently of the *partis pris*, both geographical and personal, which have converted much recent discussion of this period into polemic.

Surrealism's reflowering in exile was brought to a conclusion by the celebration of Gorky as a Surrealist in the last year of the war, the end of which was the signal for the hasty return of the Surrealist

exiles to France. But the vacuum left in New York by their departure —most were gone by 1947—was already being filled by a group of American painters, many of whom had had contacts with the Surrealists and had exhibited with them in Peggy Guggenheim's Art of This Century. The end of the decade saw these artists established as painters of great force and originality. And by then Gorky's art was being looked at no longer in terms of what had gone before but of what had come after.

In attempting to bring into focus the historical picture of the remarkable transition that took place in the 1940s, we might start with the year 1947. If we accept Willem de Kooning's generous statement that it was "Jackson Pollock [who] broke the ice," the breakthrough surely dates from the winter of 1946–47, when Pollock did his first canvases with "allover" webs of poured paint. Pollock had already painted some magnificent pictures in the earlier forties, but, unlike his later work, they are not "world-historical" in the Hegelian sense. Despite their originality, they do not possess his full identity; they contain perhaps too much of Picasso, Masson, and Miró to allow this. De Kooning, Still, Motherwell, and Rothko, among others, also painted fine pictures in the early forties, but it was only during the period 1947–50 that they realized their more personal styles and did what in some cases remain their best work.

The major single influence on these American painters in the early forties was Picasso; but the most diffused and pervasive one was Surrealism, through Picasso himself, but mostly through Miró, secondarily through Masson and Matta, and marginally through Ernst and Arp. (The illusionistic side of Surrealist painting, as exemplified by Dali and Magritte, had no influence at all on these particular Americans). In fact, the Surrealist painters' works were transcended by the Surrealist ideas of relating picture making to unconscious impulses and fantasies through the methods of automatism; these ideas were very much in the air in the early and middle forties. Gorky was by no means the first to come in contact with them; as early as 1941, Motherwell was exploring them in discussions with Matta, with whom he was then quite friendly, and they also came early to the attention of Pollock. Within one or two years, such diverse painters as Still, Rothko, Gottlieb, Baziotes, and Barnett Newman were working in a manner that might well be termed *surréalisant*. None became formal members of the Surrealist group (although Motherwell and Baziotes, as we have seen, participated in the 1942 Surrealist exhibition). But the morphology of their work, its Freudianized mythological symbolism, and its flirtation with

automatism—all this was related to Surrealism. And these precisely were the features (with the exception of automatism) of the new American painting that tended to be purged by the end of the decade.

The year 1947, which signaled the ripening of the new American painting, also heralded the end of Surrealism. We know that historical movements do not instantly crystalize or dissolve and that there is always overlapping. Nevertheless, there are significant events which clarify history by summarizing lengthy processes in their own brief moments. If the emergence of Pollock's drip style in 1947 was one such event, another was the *Exposition Internationale du Surréalisme* held in Paris at the Galerie Maeght that same year. Whereas the earlier and livelier Surrealist exhibition which had been held in the Whitelaw Reid mansion in 1942 had an air of "work in progress," the one in Paris was clearly post-mortem. Only one first-rate painter —Gorky—had been added to the Surrealist roster in the interim, among many mediocrities, and despite the subtitle of the exhibition— *Le Surréalisme en 1947*—not one of the better pictures in the show had been executed after 1945.

The years 1942–46 embrace the crucial period in which the conclusions of 1947 were being prepared. This, it seems to me, is essential to the understanding of Gorky's historical role; for his career as an independent painter, *and bis alone*, exactly spans this critical period. Despite some vagueness and possible misrepresentation in the dates of his paintings through 1942, there is no question that he was working in his personal style by the end of that year, that he was creating extraordinary pictures by the following year, and that he continued to produce them, if somewhat erratically, through 1947, the year before his death. Gorky's peculiar historical position sustains the impression that his style is hybrid and identifies him as what we may truly call a *transitional* painter. The idea that he is thus a link between the European tradition and present-day American abstraction finds favor with many critics, but, Harold Rosenberg rightly cautions,

the "link" idea slips . . . when it is applied to suggest that Gorky represents nothing more than a transition to a body of painting more "advanced" and more "authentically American." . . . Those to whom Gorky represents a link to something newer and better should be reminded that in art, as elsewhere, a chain is nothing but *links*, and that there is no particular virtue in being the one at the end.[228]

We can sympathize with Rosenberg's reaction to the general tendency to confuse novelty and quality, to attribute to the word

394

"advanced" the implications it would have if we were talking about technological progress. But the word "newer," which Rosenberg paired with the word "better," need not go down the drain with it, for American painting after Gorky is manifestly newer, and it is new in ways that differentiate it collectively from Gorky.

The nature of Gorky's unique and ambiguous relationship with Surrealism was unalterably conditioned by his earlier apprenticeship to pre-Surrealist European abstraction. This began in the late twenties with some very handsome pictures in the style of Cézanne—whom Gorky, significantly, considered the greatest painter of all time—and continued into the early and middle thirties with paraphrases of

Picasso in his Neo-Classic and Synthetic Cubist phases. Subsequent influences—Miró, Masson, and Matta—were all drawn from Surrealism, except for Kandinsky, whose earliest abstract painting became important for Gorky in 1943 and 1944.

Two things have consistently struck critics about Gorky's Cézannesque and Picassoid pictures: first, the frankness and lack of embarrassment with which Gorky imitated these masters; second, the surprisingly excellent quality of the results, given this fact of imitation. For Gorky, who had never had any formal art-school education, the recapitulation of various stages of European painting was not simply a series of identifications, subsequently rejected, which

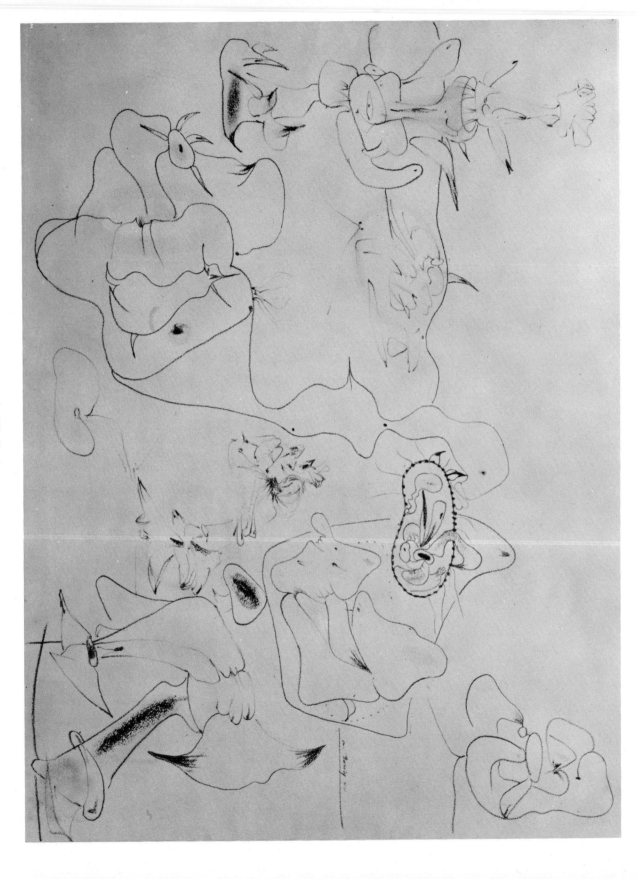

allowed him to discover who he was by discovering who he was not; it was a series of lessons about the possibilities of painting. These possibilities were to remain part of his vocabulary long after the vehicles of their assimilation had disappeared. Rosenberg has advanced the theory that Gorky's work in the twenties and thirties was premised on the *deliberate rejection of originality*. If this is so, then his rejection of originality at the very time when Dada and Surrealism had consciously made it a goal of avant-garde painting constituted a kind of originality in reverse.

From the time of the Impressionists until World War I, neither artists nor critics placed a premium on originality *for its own sake*. Manet had set the tone with the statement that he "presumed neither to overthrow earlier painting nor to make it new," but "merely tried to be himself and not someone else." In the work of those pioneer generations, originality seemed a natural byproduct—though by no means an inevitable concomitant—of making communicative, affective paintings. Bonnard, for example, was a painter with great prestige on the eve of World War I, despite the fact that his form of late Impressionism was much less "advanced" than the avant-garde art of the previous decade. The greatness of his painting was in no way diminished by the fact that its premises were hardly revolutionary.

It was with the Dada and Surrealist generations of the interwar period (and *not* recently in America, as some believe) that the situation changed. For the first time, originality—which was to become indistinguishable from novelty—was itself a goal. "Before all else," said Picabia, "we wanted to make something new. Something that nobody had even seen before." Precisely at that moment, the quality of avant-garde painting fell off. Genuine esthetic invention tended to give way in large measure to an *illusory* originality in which the novelty depended on an increasing load of extraplastic, often frankly literary, effects.

A not unrelated notion of originality held sway in America at that time; many painters believed that they could create a new and peculiarly American art by drawing their subjects from the American scene. There was, however, during the thirties, a small group of Americans, including Gorky, de Kooning, Gottlieb, Rothko, and Pollock, who resisted the chauvinism of the painters of the American scene and embraced the essentially international pre-Surrealist tradition of modern painting. None was more resolute in this position than Gorky; in his commitment to Cézanne and Picasso he was much closer to the fountainhead of modern art than the painters of his own generation in Paris. This is what Meyer Schapiro meant when he wrote that Gorky "belonged then to the School of Paris more

surely than many painters living in France."229 An inveterate museum goer, his attachment to the art in museums, rather than to the "scene" outside them (taken literally or figuratively), not only distinguished him from most of his European and American coevals but *set him apart fundamentally from Surrealism*, even when he later accepted much from it and was in turn accepted by its leaders.

The first fragmentary traces of Surrealist influence in Gorky's art date from the middle and late thirties, when they were assimilated into the Picassoid type of Cubism he was imitating. We see the mark of Miró and Masson in a group of pictures that begin around 1936, such as *Image in Xhorkom* (fig. 401) and *Enigmatic Combat* (fig. D-227). The general organization of the picture surface here is Cubist, and the touch, pigment texture, and contouring are still Picasso's; but the biomorphic forms, particularly in *Image in Xhorkom*, belong to Surrealism and especially to Miró.

Gorky's assimilation of biomorphism into the context of firmly brushed, heavily impastoed Synthetic Cubism had already been partly anticipated by Picasso in such paintings as *Girl before a Mirror* (fig. D-173). In this picture, which was shown at Valentine Dudensing's gallery in 1936 (four years after its execution) and which became part of the permanent collection of The Museum of Modern Art, New York, in 1938, Gorky had the model for the synthesis he was now to explore. In fact, we can see the specific influence of this painting in Gorky's *Enigmatic Combat*, which probably dates from 1936. As Rosenberg has pointed out, some general aspects of the design as well as the title of this picture derive from the "Combats" painted by Masson from 1932 to 1935 and exhibited shortly afterward in New York by Pierre Matisse. But the facture here is nevertheless Picasso's, and the circular "breast" on the lower left and the head on the lower right are quite clearly quotations from *Girl before a Mirror*, while the kidney shape just left of center derives from Picasso's earlier *Artist and Model*. It was as if the dislocations of Masson's "Combats" had helped Gorky break up the integrity of figuration still obtaining in Picasso's *Girl before a Mirror*, leaving the elements strewn about the surface.

Gorky's metamorphosis from an imitative painter, albeit an extraordinary one, into an independent painter began around 1940 and extended through 1942. This transformation, which took place under the sign of Surrealism in general and Miró in particular, can be traced in three pictures titled *Garden in Sochi* (figs. 402-404). The iconography is common to all three versions. *Garden in Sochi* (Sochi is a Russian Black Sea resort) is the title Gorky gave to a vision actually derived from recollections of his father's farm on the shores

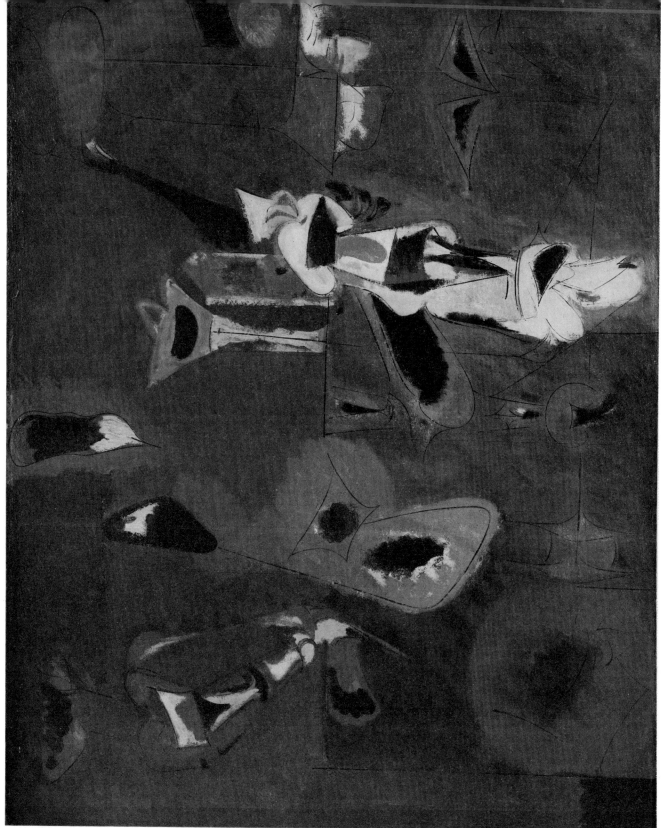

412 ARSHILE GORKY *Study for Agony.* 1946–47

413 ARSHILE GORKY *Agony.* 1947

414

414 ARSHILE GORKY *Study for The Betrothal.* 1947

415 ARSHILE GORKY *The Betrothal II.* 1947

416 ARSHILE GORKY *The Plough and the Song II.* 1947

417 ARSHILE GORKY Untitled.

of Lake Van in Armenia, where he grew up. In 1942, he recorded the following memories:

... my father had a little garden with a few apple trees which had retired from bearing fruit. There was a ground constantly in shade where grew incalculable amounts of wild carrots and porcupines had made their nests. There was a blue rock half buried in the black earth with a few patches of moss placed here and there like fallen clouds. But from where came all the shadows in constant battle like the lancers in Paolo Uccello's painting? This garden was identified as the Garden of Wish Fulfillment and often I had seen my mother and other village women opening their bosoms and taking their soft and dependable breasts in their hands to rub them on the rock. Above all this stood an enormous tree completely bleached under the sun the rain the cold and deprived of leaves. This was the Holy Tree. I myself do not know why this tree was holy but I have witnessed many people whoever did pass by that would tear voluntarily a strip of their clothes and attach this to the tree. Thus through many years of the same act like a veritable parade of banners under the pressure of the wind all these personal inscriptions of signatures very softly to my innocent ear used to give echo to the sh-h-h of silver leaves of the poplars.[230]

It would be idle to try to decipher literally the various *Gardens in Sochi* on the basis of this description, for the process of abstraction and the cross-fertilization of images from different sources produced hybrids that defy such limited readings. However, we can speculate whether the large vertical in the top center is not the trunk of the Holy Tree, with strips of tattered cloth waving around it in the breeze and a bird flying past on the right. Ethel Schwabacher,[231] Gorky's friend and biographer, sees the shape of a crouching animal, probably one of Gorky's porcupines, on the lower right and, with more certainty, the blue rock and black earth on the lower left. This textual analysis, however, provides no clue to the image's most prominent form, occupying the center of all three versions, which has been referred to variously as a boot, a shoe, and a slipper. (William Seitz[232] observes that pointed slippers, birds, and similar paraphernalia can be found in Armenian manuscripts from Gorky's native region of Lake Van.) Whatever its original source, this is among the first of certain persistent shapes, indefinable but charged with evocative power, that illuminate Gorky's fantasy world and endow his biomorphism with a specifically personal character. The three versions of *Garden in Sochi* show Gorky disengaging

himself from the picture-making attitudes of Picasso's Cubism in favor of conceptions closer to Surrealism. The process involved a substitution of landscape for still life and a transformation of abstraction springing from immediate confrontation of the subject—that is, from visual perception—into a more subjective imagery pervaded with memories and fantasies. The temporal and geographical distance from the subject (his father's garden as against his studio props) permitted the esthetic structure to fuse myriad associations from different levels of psychic experience into a hybrid image.

After this crucial transitional moment in his art, Gorky turned to nature, not to imitate her but to stimulate inspiration. Some weeks in the Connecticut countryside in the summer of 1942 were followed a year later by a stay at the Virginia farm of his wife's father. The drawings made during these and the following summers served as the bases of paintings executed during the winters between. William Seitz relates how the conjunction of a new and happy marriage, the prospect of a family, and "the return to the bucolic environment he looked back to so nostalgically" seemed to realize the promise of the Garden of Wish Fulfillment.

Taking a worshiper's delight in the sun, Gorky produced some [of his] most original and sophisticated drawings.... he drew the life he saw "in the grass." But Gorky, as he once remarked, "never put a face on an image." While he scrutinized botanical and biological organisms at close range, another vision was directed inward and backward, bringing into focus passages from the works of artists he admired, moments of past emotional experience or points of pain, fear or sexual desire. All these diverse levels and kinds of images joined in his mind with the phenomena before him.[233]

What Gorky had in fact done was to re-create the landscape as a theater in which to project his own psychological drama. In so doing he was following in the footsteps of Kandinsky (now to become the only important non-Surrealist influence on Gorky), Masson, and Matta (in this period one of Gorky's closest friends). But though Matta provided the more immediate model for Gorky's "psychological landscapes," the latter surpass Matta's "Inscapes" (colorplate 45) in their range of feeling and in their richness as paintings. This is partly because Gorky was able to create a personal form of biomorphism that was less literal, less specific in its evocation, and hence more universal than Matta's.

It is in Gorky's pencil and wax-crayon drawings of 1943 (fig. 407) that Matta's influence is most evident; he provided Gorky with a model of a more disjointed, loosely articulated surface than can be

found in the "Improvisations" of Kandinsky, whose influence soon became dominant. In comparing these Gorky drawings with Matta's work in the same medium in previous years we find, common to both groups, networks of lines that spread tenuously across the surface, completely obviating, through radiating patterns and other shorthand schemata of spatial notation, the flatness to which Gorky had previously subscribed. Here and there, too, in this implicitly deep space both artists summarily model little biomorphic animals or personages.

Kandinsky and Matta also furnished general precedents for the adoption of a painterly (*malerisch*) style, which emerges in Gorky's work at the end of 1942. However, with the exception of a few of Gorky's pictures from the winter of 1944–45, Matta's influence in this respect is clearly secondary, despite his more immediate presence in Gorky's world as both friend and painter. To the extent that his style was abstract, Matta's paintings represented a significant break with the flat, linear abstraction of Synthetic Cubist inspiration that had dominated the avant-garde in New York throughout the thirties. Matta's paintings pointed the way to a more informal, spontaneous, and lyrical abstraction, in which three-dimensional, illusionist space was again proposed as viable. But despite the looseness of his painterly fabric, an innate commitment to illustration tended to transform Matta's pigment into an illusion of something other than itself, whereas Gorky never lost his delight in the *matière* as such.

When, during the winter of 1942–43, Gorky went over into his loose, painterly manner, he did not resort to the paraphernalia of deep space as had Matta (though he employed it for some drawings), preferring only hints of modeling and atmospheric effects. His shallow frontalized space, ultimately derived from the Cézannesque illusion of bas-relief taken over by Analytic Cubism, did not retreat from the picture plane to deep vanishing points but was measured by half-modeled forms that seemed to project toward the spectator from a space-closing back plane. This was similar to the shallow space—also inspired by landscape painting—that we find in the Kandinskys of 1910–14, and partly explains the affinity of such Gorky pictures as *Waterfall* (fig. 408) with Kandinskys like *Sunday* (fig. D-26).

The synthesis, in an entirely personal form, of the painterly language inspired by Kandinsky, the biomorphism of Miró, and the automatist surreal "Inscape" of Matta was reached early in 1944 with one of Gorky's most stunning canvases, *The Liver Is the Cock's Comb* (colorplate 57). Though confused and overcrowded in spots, and lacking the distilled perfection of later works like *The Diary of a Seducer* (1945; fig. 411) and *Agony* (1947; fig. 413), *The Liver Is*

the Cock's Comb contains some remarkable passages and recommends itself by its ambitiousness. The great plumes of color, probably inspired by Kandinsky's paintings on the order of *Black Lines* (1913; fig. D-27), are potently seductive even though as a group their registration does not finally cohere. The general design, which subsequently was to be a favorite of Gorky's, involves a clustering of the slightly modeled forms above and below an implied horizontal that bisects the surface. These clusters thin out and disappear as we move to the top or the bottom of the field, where the ground color, which seems somewhat deeper in space than the plumes, shows through.

The poetry of *The Liver Is the Cock's Comb* is more comprehensive, but also more self-conscious, than that of the *Gardens in Sochi*, and this must certainly be attributed to Gorky's new contact with the Surrealists. One has only to compare the awkward but straightforward recollections of the Garden of Wish Fulfillment quoted earlier with the pretentious text with which he "describes" *The Liver Is the Cock's Comb*: "The song of a cardinal, liver, mirrors that have not caught reflection, the aggressively heraldic branches, the saliva of the hungry man whose face is painted with white chalk." As with the Surrealists (who suggested many of Gorky's titles), neither Gorky's title nor his description should be taken literally. One critic, misled in this respect, interpreted the picture as "the successfully deceptive dismemberment of a rooster."

Another aspect of Surrealism synthesized in *The Liver Is the Cock's Comb* is the erotic—a concern already quite clear in Gorky's drawings of 1943 and one that later formed, as Ethel Schwabacher has observed, the core of his myth. Surrealism had been the first movement in art to make sexuality central, a perfectly understandable development in view of its general commitment to Freud. Each painter, as we have seen, handled the theme consistently with the character of his art as a whole. In Miró, for example, sex is always playful and whimsical; in Dali it is associated with voyeurism and impotence. But the artists who gave the erotic the crucial role of catalyst to the imagination were Masson and Matta. Both understood the sexual paroxysm as the moment of the fusion of contraries—the conscious and unconscious, mind and body, the self and the "other"—and, hence, the moment of the liberation of the imagination. In Masson sex has a robust quality that galvanizes the automatism of the method and binds all sorts of hybrid themes with its energy; in Matta, on the other hand, it acquired, after lyric beginnings, an exceedingly aggressive and self-conscious character. In *The Liver Is the Cock's Comb* male and female genitalia (center left of the picture) are the only literal forms to emerge from the otherwise ambiguous context of shapes. But the sumptuous

LVII Arshile Gorky *The Liver Is the Cock's Comb.* 1944

403

affirmation of the sexual in this picture was to give way soon to the more characteristically Gorkyjan context of nervous tension, suffering, and masochism in *The Diary of a Seducer* and, more notably, *Agony*.

It was during the winter of 1944–45 that Gorky's interest in spontaneousness carried him beyond the "Improvisations" of Kandinsky to the technique of automatism. This essay brought him nearer to Surrealism than he had yet been—or was ever to be afterward—and marks precisely the time of his greatest personal closeness to Breton and to Matta. Such pictures as *The Leaf of the Artichoke Is an Owl* and *One Year the Milkweed* (both 1944; colorplates 58, 59) were executed with a spontaneity far greater than anything we find in Kandinsky. The rapid drawing, the loose brushwork that encouraged the spilling and dripping of the liquid paint, departed from Matta's automatism of 1938–42 and went beyond it. It was only natural that Breton should have encouraged Gorky in this excursion. Julien Levy, Gorky's dealer at the time, speaks of this as "liberation." For Gorky, "automatism was a redemption." Surrealism, he continues, helped Gorky "both to bring himself to the surface and dig himself deep in his work," so that "his most secret doodling could be very central."[234] But there is an essential difference between Gorky's automatism and that of the Surrealists, and it was to this that Breton alluded when he singled out Gorky as the "only Surrealist" who kept "in direct contact with nature, placing himself *before her to paint*."[235]

Despite the beauty of a few of these automatist Gorkys (*One Year the Milkweed*, in particular), most of them are confused and over-complicated—*How My Mother's Embroidered Apron Unfolds in My Life*, for example (fig. 409). Others, like *The Unattainable* (fig. 410), contain excessively suave drawing that degenerates into emotionally shallow linear figure skating. By the end of 1945, however, Gorky returned to his more personal style, with a new delicacy and transparency in the backgrounds (anticipating Baziotes) for which his automatist wash pictures were very likely responsible. By then, he had been an independent painter for three years, though during that time he had still found it necessary to explore the ideas of others. Now he had literally experienced everything, and he was ready to produce his most individual works. One of them, *The Diary of a Seducer* (late 1945; fig. 411)—its debt to Masson (fig. 380) notwithstanding—is probably his masterpiece. The most sorrowful aspect of the fire that destroyed Gorky's studio in January, 1946, is that the greater number of the twenty-seven pictures destroyed, as well as numerous drawings, came from this perfect moment of his art.

In 1947, the tragedies that were to lead to Gorky's suicide the following year—the fire, cancer, sexual impotence, a broken neck—

Arshile Gorky

LVIII ARSHILE GORKY *The Leaf of the Artichoke Is an Owl.* 1944

LIX ARSHILE GORKY *One Year the Milkweed*. 1944

were taking their toll, and his work reflects this. For a year, his biomorphism had already been marked by extremes of pathos and aggression. The new profiles of his shapes suggested emotions that were being exacerbated, literally drawn out almost beyond the point of endurance. In the center right of *The Betrothal II* (fig. 415) we see one of these new biomorphic shapes. Its contour is pinched together and drawn upward in a more and more fragile line—like a nerve that is being stretched tight—until, just before it snaps, it is resolved into another plane. The four corners of this plane are in turn tortuously pulled outward so that its sides appear scalloped, a painful distortion that is set off boldly by the more regular rectangular plane on which it is superimposed. Precedent for this type of transmutation of the entire contour of a plane into an independent line may be found in Mirós like *Fratellini* (1927; fig. 138). But there the drawing is relaxed; Miró's line never attains the tautness and ductility of Gorky's.

In the drawings of 1946–47, cruel and monstrous personages, of a type that had entered Matta's art in 1945, manifested themselves through a kind of hard and summary modeling that Gorky had never used before. But, as we observe in comparing the drawing for *Agony* (fig. 412) with the finished work (fig. 413), these specters were rendered less descriptive when converted into painting, where Gorky's gentle, deeply poignant touch dissolved them into the surface design. With the pictures of 1947 Gorky's contribution to modern painting ends. The few canvases of the last tormented months of his life are understandably overwrought and add nothing.

EPILOGUE*

You will understand, when you see America, that one day they will have painters, because it is not possible that such a country, which offers such stunning visual spectacles, should not have painters one day.
—Henri Matisse to André Masson

The year of Gorky's *Agony*—1947—was, as we have seen, the year when Pollock "broke the ice"; from then until the end of the decade, a large number of New York painters integrated their own highly original styles. Nobody in 1947—least of all Gorky, in view of his attachment to European art and culture—could have grasped the full measure of the movement that was emerging in New York. But Gorky had been very close to at least one major painter of that movement, de Kooning, through whom a few aspects of Gorky's art found their way into the new American painting. In his works of the early forties de Kooning had created a highly personal amalgam out of elements of Miró and Picasso, and such pictures as *Pink Angels* (about 1945), with its incipiently organic forms tied together by a tangle of mordant angular lines, show his extraordinary draftsmanship already fully developed. In 1948, his form-language was temporarily infected by Gorky's biomorphism. *Painting* of that year (The Museum of Modern Art) presents a cluster of such forms slightly in front of the vestiges of a rectilinear ground, like a still life seen against architecture. It is in such black paintings of 1948–49 that Gorky was painted into de Kooning's pictures. But in the Expressionist attack upon these forms (*Night Square*) he was painted right out again, Gorky's symbolic morphology being reduced to signs and finally to marks.

Gorky's influence was felt in New York painting during the late forties and afterward largely by way of de Kooning, but to some extent directly.[236] Yet, though Gorky is usually considered a part of the new American painting, the character of the movement as a whole was clearly in reaction against the kind of art that he had in large part embraced. The mature styles of such artists as Pollock, Rothko, Newman, Still, and even Gottlieb involved a conversion of their own earlier painting *away* from a Surrealizing ambiance. We have discussed the affinities between the pre-1946 Pollock and Surrealism; with the purging of his totemic subject matter, only automatism—carried to a point and in a direction never envisioned by Surrealism—remained.

The Rothkos of the early and middle forties have iconographies dealing with magic, totemism, and myth. Through a haze of exquisitely nuanced tonal veils, the elegant drawing suggests anthropomorphic personages and metamorphoses of organic forms sometimes reminiscent of Redon. In the later forties, this imagery and its morphology dissolved into spots and shapes of color which, by the end of the decade, resolved into the deceptively simple color architecture of Rothko's familiar work. The Newmans of the later forties deal with "cosmic" themes favored by Surrealism; the surfaces of many of them suggest the effects of wood veining seen in Ernst's *frottage* and are sometimes accompanied by haloed suns or moons recalling the latter's *Forests* (colorplate 25). By 1949, however, these image elements had been purged in favor of a pure abstraction which, nonetheless, continued to retain, as pure painting, the mystery and poetry earlier

*Except for those specifically indicated, all illustrations relevant to this section will be found in "An Album of Post-Surrealism" in the rear of the documentation section (D-232-302).

invested in part in iconographic suggestions. The Stills of the early forties contain dark and lowering totemic presences reminiscent of Surrealist monsters, and it may be true that, as Clement Greenberg says, "Still's art as a whole owes an immense debt to Miró's 'string' or monolinear painting of the later 1920s" (fig. 138). Nevertheless, Still's art is in spirit, and in its willfully heavyhanded and awkward facture, further from Surrealism—and from European modernism as a whole—than the work of the other painters mentioned. In Still, too, however, the evolution toward abstraction remains similar: in the later forties, the shapes of his "presences" become progressively less literal, defining themselves more and more in terms of the jagged, Gothicizing drawing of his mature style.

With Gottlieb the evolution from symbol to sign to mark did not go as far. Gottlieb's pictographs of the forties, which reflect Surrealist ideas of image association in their poetic and "irrational" juxtaposition of motifs, and are much influenced by Miró in their detail (as by Klee in their layout), gave way in the fifties to a variety of more open images in which—as in the "Fantastic Landscapes" and "Bursts"—the now simplified abstract shapes always retain some relation to a poetic iconography, usually of a "cosmic" kind. Motherwell, despite his personal closeness to the Surrealists and his interest (as a critic) in their art, produced painting more in the line of Picasso and, later, Matisse than that of the Surrealists, though he did—and still does—make considerable use of automatic techniques and explores possibilities of decalcomania in a basically abstract context. William Baziotes, more than any other American painter except Gorky, accepted the biomorphic form-language—mainly through Miró—which he handled with increasing tonal delicacy and transparency. After 1950, the flat designs of his biological and animal fantasies are hung, or float, in a pastel-hued indeterminate atmospheric space not unlike that of certain early Mattas and later Gorkys. But this "intimist" painter, who might be called the Redon of the new American painting, never made the transition to more marked abstraction that his colleagues did; until his death in 1963, Baziotes' art remained suspended in the transitional surréalisant state that characterized so much of American abstract painting in the mid-forties.

The reaction of the pioneers of the new American painting against their own earlier work and against the ambiance of Surrealism, which influenced it, appeared by 1950 to be complete. The mature styles of Pollock, Rothko, and others seemed to reject out of hand almost everything Surrealism had stood for. Impelled in part by the need to impose themselves and their new art on "the scene," these painters, along with many critics and other inhabitants of the "art world,"

substituted sharp criticism for their earlier approval of Surrealism. The American painters, some of whom had no doubt been overimpressed by the Surrealists as representatives of the great European avant-garde at the time of their arrival in New York, now regarded them as idols with clay feet. Only Miró, who had not been in America during the war, and, to some extent, Masson were excepted from the general rejection.

In the past decade, however, as the American painters and the movement they formed have become internationally appreciated, the once natural and expedient reaction against Surrealism has dissolved, and it has been possible to judge the movement more dispassionately and from a position more removed. Today it is clear that despite what appeared to be the expunging of Surrealist influences in the late 1940s, the American painters produced a type of abstraction markedly different from that to which Cubism and Fauvism alone would have led. These movements had already lost their momentum in Europe in the 1930s, and the American practitioners of flat decorative Cubism in those same years found themselves at a dead end. Only a new spirit could have freed them.

Certainly the mature styles of the "first generation" American painters descend lineally from Gubism and Fauvism. Their art depends much more on such sources (thus the infrastructure of the "all-over" Pollocks derives from Analytic Cubism and the 1913–14 Mondrians; figs. D-31, D-32) than most critics and art historians realize. But it was precisely because these American painters had passed through the experience of Surrealism that it was possible for them to challenge and open up the sclerotic traditions of Cubism and Fauvism, and thus preserve what was viable in them. In France, where, as a result of the war, painters who came of age around 1950 were deprived of the experience of Surrealism, the impulse toward "informal" abstraction was much weaker; painters like Jean Bazaine and Alfred Manessier produced only effete forms of late Cubism, and even Nicolas de Stael's painting led into a blind alley.

Surrealist notions of automatism did more than anything else in the Surrealist arsenal to help American painters open up Cubism. This does not mean, however, that such other Surrealist techniques as decalcomania and frottage, favoring as these did the provocation of accident in the picture-making process, did not interest them. But whereas these latter techniques were employed by the Surrealists "in favor of the image," to use Breton's formulation, the American painters exploited them—when they did—for the possibilities they suggested in pure painting.

While it is true that the Americans had by 1950 purged their paint-

ing of the specific imagery that had earlier related it to Surrealism, the spirit of their wholly abstract art retained much of Surrealism's concern with poetry, albeit in a less obvious form. The poetic dimension and visionary nature of the mature art of a Pollock, Rothko, Still, Newman, or Motherwell does as much as differences in technique or structure to set them apart from Picasso, Mondrian, and Matisse.

In the late 1950s, the dialectic of modern painting led, in the work of younger Americans like Jasper Johns and Robert Rauschenberg, to a reaction against the extreme abstraction of the first generation of new American painters. This reaction took the form of a return to specific iconographies that reached back through Surrealist Object-Art to Dada: to Duchamp and Schwitters in particular. But just as the first generation had incorporated Surrealist elements in a new form, Johns and Rauschenberg, in their turn, depended greatly on their predecessors—de Kooning, Pollock, and others—for handling and compositional devices. It is precisely this esthetic relationship that distinguishes Johns—even when he is supposedly most Dada—from Duchamp.

The transition in New York from the para-Dada of Rauschenberg and Johns to Pop art involved a movement away from Dada (though not entirely) and an assimilation (in Warhol, Indiana, Lichtenstein, and others) of aspects of the flat hard-edge and color abstraction which in the late 1950s was succeeding the "painterly" style of the first-generation abstractionists (to which style Rauschenberg and Johns still adhered). The shift from Abstract Expressionist brushwork on modeled clay to plastic surfaces, as in Claes Oldenburg, is a case in point.

Kinetic sculpture also has roots in Dada, as the sculptors themselves have always observed. If Duchamp's *Rotary Glass Plate* (fig. D-60) is the classic antecedent work of this sort, it was accompanied by other experiments in the enigma of motion, both as illusion (the "machine" paintings of Picabia, Duchamp, Schamberg, and others) and in actuality (Dali's "Objects of Symbolic Function" and Giacometti's moving sculptures, and the since-lost machine made from clock parts during the Dada period by the latter's uncle, Augusto Giacometti). As antecedents not only in their character but in the much greater emphasis they place on esthetic—as opposed to ideational—aspects of the work.

From Dada ideas of action and engagement there emerged, during the crisis period of American art in the forties, a theory which became crystallized in an essay titled "The American Action Painters" pub-

lished by the critic Harold Rosenberg in 1952. Suggested by the "automatic" character in much New York painting in the forties, and deriving ideas from Dada and Surrealist texts as well as notions of Existentialism and Zen, which were very much in the air, the Rosenberg theory postulated an "Action" art which in retrospect seems to have little to do with the actual paintings of the Abstract Expressionist artists, on which it was supposedly based. Rosenberg's suggestion that the artists were making something other than pictures ("the canvas was not a picture, but an event . . . [they have] broken down every distinction between art and life . . . its value must be found apart from art") is ultimately untenable. But as a metaphor of the crisis mentality of American painting—a crisis which began with the Dadaism of World War I and had not dissipated in avant-garde circles right through to the late forties—the Action Painting theory is of interest.

It was by applying the Action theory to Pollock that Allan Kaprow arrived at the theoretical basis for "Happenings," which had existed as Dada and Surrealist "manifestations" and were described—though never realized—in more evolved form by Schwitters (see p. 110). This is not to say that Happenings lack original content, any more than that the Action theory is just a rehash of Dadaist and Surrealist ideas. Both are new impulses in the same line of thought.

In France, the myth of Action Painting, fused with the heritage of automatism, led to Mathieu's "enactments" of paintings. In Europe, as we have seen, the war effected a break in artistic continuity, making the situation of painting in France, already somewhat in crisis in the late 1930s, more difficult than it had been for a century. *Tachisme* and other varieties of "informal" abstraction produced few works of real consequence. Though Wols went through an evolution somewhat like that of the American painters—beginning with an automatic-image art closer to Klee than to Surrealism and arriving at a pure "informal" abstraction—his painting, little known until after his death, had no long-term effect on younger artists. Dubuffet, in my estimation the only major painter to emerge in Europe after World War II, stood outside the main trends of French art and, for many years, was far more appreciated in America than in Europe. Curiously, in the 1920s—at the time of his first essay at painting—Dubuffet was involved with some of the Surrealists, and though the semi-automatic drawing and other techniques for "forcing" the possibilities of his material in his mature art owe more to Klee than to Surrealism, his interest in the art of children, *naïfs*, and the insane paralleled that of the Surrealists, and of Breton in particular—who, shortly after World

War II, collaborated with Dubuffet in the formation of an exhibition of *art brut*.

On their return to France after the war, the Surrealists tried to regain their former position of leadership in the avant-garde. But their 1947 exhibition at the Galerie Maeght had—in contrast to the Surrealist exhibitions of the 1920s and 1930s, as well as to that of 1942 in New York—something of the atmosphere of a historical retrospective. It got enormous attention in Paris and enjoyed great publicity, but this interest was inspired more by curiosity than by any real urge to participate in or support Surrealism. Current French art was left untouched by the show. This is not surprising; Surrealism appeared clearly beside the point to such new leaders of the French literary, philosophical, and even political scene as Sartre and Camus. Their positions enjoyed the sense of pertinence that stemmed from their involvement with the Resistance while the Surrealists were in exile.

Breton planned to focus the 1947 exhibition on the theme of the myth, a concern which was to engage French artistic and intellectual circles—like the same circles in America—less and less in the late forties and fifties. (Georges Bataille's essay at that time, "The Absence of Myth," observed that "myth and the possibility of myth are vanishing.") The premises of the Galerie Maeght (figs. D-217–220) were remodeled in the spirit of the arrangements that had marked the Surrealist exhibition at the Galerie Beaux-Arts in 1938: a Hall of Superstitions led through a "baptismal chamber," in which it rained continuously, to a "labyrinth" in whose recesses altars (patterned on those of the voodoo cults) were located—the most impressive were those of Lam and Brauner (figs. D-218, D-219). It

had also been planned to include works by Surrealist precursors as well as by artists who, in Breton's words, had at the time "ceased to gravitate in the movement's orbit" (among them Dali, Masson, Magritte, Dominguez, and Picasso), but this plan was not carried out.

In his efforts to revive Surrealism in Paris, Breton attempted to re-create the old *centrale* (the Bureau of Surrealist Research; see p.110) on the premises of the Galerie Nina Dausset in the rue du Dragon, giving it a new name, "Solution Surréaliste." But after sponsoring a few exhibitions, the organization collapsed. Breton also put out two magazines: *Médium*, twelve numbers of which appeared from 1952 to 1955, and *Le Surréalisme, Même*, a few numbers of which have appeared irregularly since 1956. But these reviews, far from testifying to the vitality of Surrealism, offered perhaps the best evidence that the movement was no longer historically viable, no longer capable of inspiring or even attracting men of genius. Except for an occasional contribution by one of the earlier Surrealists, generally something from the pre-1939 period, the writing and the art reproduced in these magazines are of unrelieved mediocrity.

After 1947, Breton occasionally arranged large exhibitions of Surrealist painting, but these were of interest only to the extent that they were retrospective. In a show he organized in December, 1959, at the Galerie Daniel Cordier (fig. D-232) he was reduced to includ-ing a Jasper Johns *Target with Plaster Casts* in order to create a sense of up-to-dateness. The best of Surrealism had long since been absorbed into the mainstream of modern art and literature, where it enjoys an immortality far more substantial than that which Breton's admirable but pathetic attempts to keep the movement alive by fiat could ever have conferred on it.

NOTES

The reader will find that in the case of translated material there may be differences between the version presented in the text and the English source to which he is directed. The author has taken the liberty of modifying translations in the interest of clarity and greater accuracy, but prefers, for the convenience of students, to indicate where material is readily available in English.

1 Tristan Tzara, "Lecture on Dada," in Robert Motherwell (ed.), *The Dada Painters and Poets: An Anthology* (New York, 1951), p. 250. Originally published "Conference sur dada," *Merz* (Hanover), January 1924. First delivered at the Weimar Congress of 1922.

2 Hans Kreitler, "The Psychology of Dadaism," in Willy Verkauf (ed.), *Dada, Monograph of a Movement* (New York, 1957), pp. 74–86.

3 Tristan Tzara, *An Introduction to Dada* (New York, 1951). Originally planned for Motherwell (ed.), *op. cit.*, but issued as a separate pamphlet.

4 Tristan Tzara, "Dada Manifesto 1918," in Motherwell (ed.), *op. cit.*, p. 81. Originally published "Manifest Dada 1918," *Dada* (Zurich), December 1918.

5 Jean Arp, "De plus en plus je m'éloignais de l'esthétique," reprinted in *On My Way: Poetry and Essays, 1912–1947* (New York, 1948), pp. 47–48.

6 Tristan Tzara, introduction to Georges Hugnet, *L'Aventure dada* (Paris, 1957), p. 9.

7 Richard Huelsenbeck, "En Avant Dada," in Motherwell (ed.), *op. cit.*, p. 28. Originally published *En Avant Dada: Die Geschichte des Dadaismus* (Hanover, 1920).

8 Georges Hugnet, *L'Aventure dada*, *op. cit.*, p. 63.

9 *Lettres de Guerre de Jacques Vaché* (Paris, 1919); new edition with four prefaces by André Breton (Paris, 1949).

10 André Breton, "Jacques Vaché: 1896–1919," a preface to *Lettres de Guerre*, *op. cit.* [p. 13].

11 Tristan Tzara, quoted in André Breton, "For Dada," in Motherwell (ed.), *op. cit.*, p. 200. Originally published "Pour Dada," *Nouvelle Revue Française* (Paris), August 1920.

12 Charles Baudelaire, "Le Peintre de la vie moderne," *Oeuvres* (Paris, 1948), vol. 3, p. 256.

13 Edouard Roditi, "Interview with Hannah Höch," *Arts* (New York), December 1959, p. 29.

14 *Ibid.*

15 Georges Hugnet, "The Dada Spirit in Painting," in Motherwell (ed.), *op. cit.*, p. 186. Originally published "L'Esprit dada dans la peinture," *Cahiers d'Art* (Paris), vol. 11, no. 8–10, 1936. See bibl. 121 for publication details of this series of articles.

16 André Breton, "La Confession dédaigneuse," in *Les Pas perdus* (Paris, 1924), pp. 20–21.

17 André Breton, *Seconde Manifeste du surréalisme* (Paris, 1930), p. 12. Hereafter referred to as the second Surrealist manifesto.

18 André Breton, "La Confession dédaigneuse," *op. cit.*, p. 24.

19 "Le Suicide est-il une solution?" *La Révolution surréaliste* (Paris), January 1925.

20 Tristan Tzara, introduction to Hugnet, *L'Aventure dada, op. cit.*, p. 7.

21 James Johnson Sweeney (ed.), "Eleven Europeans in America: Marcel Duchamp," *Bulletin of The Museum of Modern Art* (New York), September 1946, pp. 20–21.

22 Richard Huelsenbeck, "En Avant Dada," in Motherwell (ed.), *op. cit.*, p. 43.

23 André Breton, "Lighthouse of the Bride," in Robert Lebel, *Marcel Duchamp*, translated by George Heard Hamilton (New York, 1959), p. 88. Originally published "Phare de La Mariée," *Minotaure* (Paris), Winter 1935.

24 Robert Motherwell, introduction to Motherwell (ed.), *op. cit.*, p. xvii. (Italics mine.)

25 Gabrielle Buffet-Picabia, *Aires abstraites* (Geneva, 1957), p. 35.

26 See Katherine Dreier and Matta Echaurren, *Duchamp's Glass: An Analytical Reflection* (New York, 1944).

27 F. T. Marinetti, *Premier Manifeste du Futurisme* (Paris, 1909). Translated in Joshua C. Taylor, *Futurism* (New York, 1961).

28 This attitude, along with the concept of "automatism," introduced by Dada and fully developed by Surrealism, provides the source of the theory of "action painting" developed by Harold Rosenberg. See my "Jackson Pollock and the Modern Tradition: The Myths and the Paintings," *Artforum* (New York), February 1967.

29 André Breton, "Distances," in *Les Pas perdus*, *op. cit.*, p. 174 and his *Manifeste du surréalisme* (Paris, 1924). Hereafter referred to as the first Surrealist manifesto.

30 Robert Lebel, *op. cit.*, p. 40.

31 Richard Huelsenbeck, "En Avant Dada," in Motherwell (ed.), *op. cit.*, p. 33.

32 Kurt Schwitters, "Merz," in Motherwell (ed.), *op. cit.*, pp. 57–65. Originally published *Der Ararat* (Munich), no. 2, 1921.

33 Salvador Dali, "De la Beauté terrifiante et comestible, de l'architecture Modern style," *Minotaure* (Paris), vol. I, no. 3–4, 1933, pp. 69–76.

34 Robert Lebel, *op. cit.*, p. 3.

35 James Johnson Sweeney (ed.), *op. cit.*, p. 20.

36 *Ibid.*

37 Guillaume Apollinaire, *Les Peintures cubistes* (Paris, 1913), p. 74.

38 James Johnson Sweeney (ed.), *op. cit.*, p. 20.

39 Robert Lebel, *op. cit.*, p. 11.

40 James Johnson Sweeney (ed.), *op. cit.*, p. 20.

41 Gabrielle Buffet-Picabia, "Some Memories of Pre-Dada: Picabia and Duchamp," in Motherwell (ed.), *op. cit.*, p. 257.

42 André Breton, "Lighthouse of the Bride," *op. cit.*, p. 90.

43 Michel Sanouillet, introduction to Marcel Duchamp, *Marchand du sel: écrits* (Paris, 1959). p. 14.

44 Statement made at a round-table discussion," The Art of Assemblage," at The Museum of Modern Art, New York, October 19, 1961. Other participants were William C. Seitz (moderator), Lawrence Alloway, Richard Huelsenbeck, Robert Rauschenberg, and Roger Shattuck.

45 Gino Severini, *Du Cubisme au classicisme* (Paris, 1921).

46 James Johnson Sweeney (ed.), *op. cit.*, p. 21.

47 Meyer Schapiro, lecture on Leonardo commemorating the five-hundredth anniversary of his birth, at The Cooper Union, New York, April 15, 1952.

48 "Marcel Duchamp," in James Nelson (ed.), *Wisdom: Conversations with the Elder Wise Men of Our Day* (New York, 1958), p. 92.

49 Charles Baudelaire, *Oeuvres* (Paris, 1954), p. 1381. Cited by Sanouillet in introduction to Duchamp, *Marchand du sel*, *op. cit.*, p. 21.

50 Jean Reboul, "Machines célibataires, schizophrénie et lune noire," *Journal intérieur du Cercle d'Etudes Métaphysiques* (Toulon), May 1954, and Lebel, *op. cit.* James Thrall Soby has indicated to me that he now believes de Chirico began his mannequins in 1913, though there is no firm evidence for this. The earliest such picture in Soby's *Giorgio de Chirico* (New York, 1955) is dated 1914.

51 In producing a commissioned picture, the size of which was predetermined by the structure of Mrs. Dreier's library, Duchamp was making an ironic comment on the notion of freedom of inspiration (and freedom from the patronage system) which has always been central to the tradition of modern painting, and against which Duchamp was reacting.

52 Cited in Georges Ribemont-Dessaignes, *Déjà Jadis: ou, du mouvement dada à l'espace abstrait* (Paris, 1958), p. 54.

53 Philip Pearlstein, "The Symbolic Language of Francis Picabia," *Arts* (New York), January 1956, and "The Paintings of Francis Picabia,"

1908–1930," unpublished Master's thesis, Institute of Fine Arts, New York University, 1955.

54 Gabrielle Buffet-Picabia, *Aires abstraites, op. cit.*, p. 33.

55 John I. H. Baur, "The Machine and the Subconscious: Dada in America," *The Magazine of Art* (New York), October 1951.

56 Richard Huelsenbeck, "Dada Lives!" in Motherwell (ed.), *op. cit.*, p. 279. Originally published *Transition* (Paris), Fall 1936.

57 Marcel Janco, "Creative Dada," in Verkauf (ed.), *op. cit.*, p. 28.

58 "Dadaland," in Arp, *op. cit.*, p. 45.

59 Hugo Ball, *Die Flucht aus der Zeit* (Munich and Leipzig, 1927).

60 Georges Hugnet, "Dada," in Alfred H. Barr, Jr. (ed.), *Fantastic Art, Dada, Surrealism* (New York, 1937), p. 15.

61 Georges Ribemont-Dessaignes, *op. cit.*, pp. 12, 15.

62 Jean Cassou, "Tristan Tzara et l'humanisme poétique," *Labyrinthe* (Paris), November 15, 1945, pp. 1–2.

63 Georges Ribemont-Dessaignes, *op. cit.*, p. 12.

64 Robert Motherwell, introduction, in Motherwell (ed.), *op. cit.*, p. xxxi.

65 Richard Huelsenbeck, "Dada Lives!" in Motherwell (ed.), *op. cit.*, p. 278.

66 Tristan Tzara, "Seven Dada Manifestoes," in Motherwell (ed.), *op. cit.*, p. 92. Originally published *Sept Manifestes dada* (Paris, 1924).

67 *Ibid.*, p. 82.

68 Richard Huelsenbeck, "En Avant Dada," in Motherwell (ed.), *op. cit.*, p. 33.

69 Jean Arp, *op. cit.*, p. 47.

70 "And so the circle closed," in Arp, *op. cit.*, p. 76.

71 Robert Melville, "On Some of Arp's Reliefs," in James Thrall Soby (ed.), *Arp* (New York, 1958), p. 30.

72 "See Reproduction," in Arp, *op. cit.*, p. 52.

73 Georges Hugnet, "The Dada Spirit in Painting," *op. cit.*, p. 134.

(Italics mine.) Originally published *Cahiers d'Art* (Paris), vol. 7, no. 1–2, 1932.

74 Richard Huelsenbeck, "En Avant Dada," in Motherwell (ed.), *op. cit.*, p. 44.

75 Edouard Roditi, *op. cit.*, p. 26.

76 *Ibid.*, p. 27.

77 Matta, "Hallucinations," in Max Ernst, *Beyond Painting and Other Writings by the Artist and His Friends* (New York, 1948), p. 194.

78 Max Ernst, "An Informal Life of M. E. (as told by himself to a young friend)," in William S. Lieberman (ed.), *Max Ernst* (New York, 1961), p. 7.

79 *Ibid.*, pp. 11–12.

80 Though some writers record the collages themselves as made collaboratively, it appears that, in fact, the two artists simply alternated the making and titling of them. Baargeld also collaborated with Ernst in "Fatagaga" collages on the same basis.

81 Werner Schmalenbach, "Kurt Schwitters," *Art International* (Zurich), September 1960, p. 58.

82 Robert Motherwell, introduction, in Motherwell (ed.), *op. cit.*, p. xxi.

83 Kurt Schwitters, *op. cit.*, p. 60.

84 Richard Huelsenbeck, "Dada and Existentialism," in Verkauf (ed.), *op. cit.*, p. 58.

85 Cited in Schmalenbach, *op. cit.*, p. 58.

86 Kurt Schwitters, *op. cit.*, p. 62.

87 Raoul Hausmann, *Courrier dada* (Paris, 1958) p. 116.

88 Kate Steinitz, "The Merzbau of Kurt Schwitters," unpublished manuscript quoted in William C. Seitz, *The Art of Assemblage* (New York, 1961), p. 50.

89 Kurt Schwitters, *op. cit.*, pp. 62–63.

90 Annette Michelson, "But Eros Sulks," *Arts* (New York), March 1960.

91 Cited in Ribemont-Dessaignes, *op. cit.*, pp. 77–78.

92 Cited in Hugnet, "The Dada Spirit in Painting," in Motherwell (ed.), *op. cit.*, p. 190. Originally published in *Cahiers d'Art* (Paris), vol. 9, no. 1–4, 1934.

93 Ibid., p. 168.

94 William S. Lieberman, "Apollinaire and the New Spirit," Dance Index (New York), November-December, 1946.

95 Wallace Fowlie, Age of Surrealism (New York, 1950), p. 160.

96 Guillaume Apollinaire, program for "Parade," 1917, reprinted in Chroniques d'art (Paris, 1960), pp. 426-27.

97 Georges Ribemont-Dessaignes, op. cit., p. 90.

98 André Breton, "Entrée des mediums," Les Pas perdus, op. cit., p. 149.

99 André Breton, Le Surréalisme et la peinture, (2nd ed., New York and Paris, 1945), pp. 21-22.

100 Claude Roy, Arts fantastiques (Paris, 1960).

101 Marcel Brion, Art fantastique (Paris, 1961).

102 Dore Ashton, "Gustave Moreau," in Odilon Redon, Gustave Moreau, Rodolphe Bresdin (New York, 1962), p. 109.

103 Ibid., p. 132.

104 Ragnar von Holten, L'Art fantastique de Gustave Moreau (Paris, 1960), pp. 48-53.

105 André Breton, "Genesis and Perspective of Surrealism," in Peggy Guggenheim (ed.), Art of This Century (New York, 1942), p. 17.

106 Daniel Catton Rich, Henri Rousseau (New York, 1946), p. 31.

107 André Breton, L'Art magique (Paris, 1959), p. 37.

108 Tristan Tzara, "Henri Rousseau," Transition, Forty-Eight (Paris), no. 3, 1948, p. 36. (Italics mine.)

109 Philippe Soupault, Henri Rousseau le douanier (Paris, 1927), p. 9 et passim.

110 Guillaume Apollinaire, "Le Douanier," Les Soirées de Paris (Paris), January 15, 1913.

111 Letter to André Dupont, April 1, 1910, quoted in Soupault, op. cit., pp. 24-25.

112 Robert Melville, "Rousseau and de Chirico," Scottish Arts and Letters (Glasgow), no. 1, 1944.

113 Herbert Read, "Henri Rousseau," A Coat of Many Colours: Occasional Essays (London, 1945), pp. 99-103.

114 Cf. Clement Greenberg, "Surrealist Painting," The Nation (New York), August 12-19, 1944.

115 André Breton, L'Art magique, op. cit., p. 216.

116 James Thrall Soby, Giorgio de Chirico (New York, 1955), pp. 38-42, 79.

117 André Breton, "Giorgio de Chirico," Les Pas perdus, op. cit., p. 111.

118 Giorgio de Chirico, "Sull'arte metafisica," Valori Plastici (Rome), April-May 1919, p. 16. Cited in Soby, op. cit., p. 67.

119 André Breton, L'Art magique, op. cit., p. 42.

120 André Breton, Le Surréalisme et la peinture, op. cit., p. 38.

121 This was pointed out by Meyer Schapiro in a lecture on Leonardo in 1952. See n. 47.

122 Miss Lippard is preparing a study of Ernst's techniques in which the chronology of this period will be analyzed more extensively.

123 This was pointed out by Meyer Schapiro in his lectures on Romanesque painting at Columbia University, New York, 1951.

124 Cited in James Johnson Sweeney, "Joan Miró: Comment and Interview," Partisan Review (New York), February 1948, p. 209.

125 Hilton Kramer, "Miró," Arts (New York), May 1959.

126 Jacques Dupin, Joan Miró: His Life and Work (New York, 1962), p. 99.

127 André Breton, "Genesis and Perspective of Surrealism," op. cit., p. 22.

128 James Thrall Soby, Joan Miró (New York, 1959), p. 37.

129 Joan Miró untitled article on Harlequin's Carnival, Verve (Paris), January-March, 1939, p. 85.

130 Robert Motherwell, "The Significance of Miró," Art News (New York), May 1959, p. 65.

131 Cited in Sweeney, "Joan Miro," op. cit., p. 212.

132 André Breton, Le Surréalisme et la peinture, op. cit., p. 68.

133 Jacques Dupin, op. cit., p. 191.

134 James Thrall Soby, Joan Miró, op. cit., p. 60. A recent dismounting of the backing of this picture revealed that its correct title is Portrait of

Mistress Mills in 1750 and not *Mrs. Mills* as it has been traditionally identified. Helen Franc devised the method of research which unearthed the British prototype of this painting.

135 Clement Greenberg, *Joan Miró* (New York, 1948), p. 31.

136 *Entretiens avec Georges Charbonnier* (Paris, 1958), pp. 54, 58.

137 Michel Leiris, in Jean-Louis Barrault, Georges Bataille, and others, *André Masson* (Rouen, 1940), p. 10.

138 Conversation between Miró and Masson in 1924; recounted to the author by Masson.

139 Daniel-Henry Kahnweiler, preface to *André Masson*, catalogue of an exhibition, Buchholz Gallery and Willard Gallery, New York, February 17–March 14, 1942 [p. 3].

140 This picture has been reproduced and listed in catalogues both as *Painting* and as *Figure* (which, indeed, it represents).

141 Max Ernst, "Comment on force l'inspiration," *Le Surréalisme au service de la révolution* (Paris), May 1933. English translation, "Inspiration to Order," in *Beyond Painting, op. cit.*, p. 24.

142 *Ibid.* Max Ernst, "Au delà de la peinture," *Cahiers d'Art* (Paris), vol. 11, no. 6–7, 1936; English translation, in *Beyond Painting, op. cit.*, p. 7.

143 Patrick Waldberg, *Max Ernst* (Paris, 1958), p. 222.

144 Max Ernst, in *Beyond Painting, op. cit.*, pp. 28–29.

145 James Thrall Soby, *Yves Tanguy* (New York, 1955), pp. 9–10.

146 *Ibid.*, p. 15.

147 Herbert Read, "Magritte," *London Bulletin* (London), April 1938, p. 2. (Italics mine.)

148 Cited in Suzi Gablik, "René Magritte: Mystery Painter," *Harper's Bazaar* (New York), November 1963.

149 *Entretiens avec Georges Charbonnier, op. cit.*, p. 127.

150 Georges Ribemont-Dessaignes, *op. cit.*, p. 131.

151 André Breton, *Entretiens 1913–1952* (Paris, 1952), p. 159.

152 James Thrall Soby, *Paintings, Drawings, Prints: Salvador Dali* (New York, 1941), p. 16.

153 Amended account given in conversation with the author, February 1967. Originally recounted in Salvador Dali, *The Secret Life of Salvador Dali*, translated by Haakon M. Chevalier (New York, 1942), p. 267.

154 Donald Sutherland, "The Ecumenical Playboy," *Arts* (New York), February 1963, p. 69.

155 Roger Caillois, "La Mante religieuse," *Minotaure* (Paris), vol. 1, no. 5, 1933, p. 25.

156 James Thrall Soby, *Salvador Dali, op. cit.*, p. 14.

157 It is possible that this motif represents a direct quotation from one of Dali's dreams. I know of no source for it in earlier Surrealist painting; among literary sources, the first to spring to mind is Lady Macbeth. Yet, quite apart from the fact that Dali exhibits little interest in Shakespeare, the patricidal, psychological implications of Lady Macbeth's crime are inconsistent with the iconographic program of *Illumined Pleasures*. We have noted that the woman in *Illumined Pleasures* is not only associated with the castrating father (familiar from *William Tell* and elsewhere) but that in this case she seems to have done the bloody deed herself. An alternative, more compatible literary reading may be found in the story of Moses' circumcision. Dali has always felt an affinity for Moses. One of his favorite photographs, taken in his art-school days, shows him with his long hair held up in two "horns" as what he called "a phantasm of deification as Moses," and he has always credited his wife, Gala, with having saved him from the plague of locusts (one of the ten plagues of Egypt in the Mosaic story). The pertinence of the Moses story to the image of a castrating woman hangs on the extraordinary passage in the Bible in which it is said that God was wroth with Moses and wished to slay him because he had neglected the rite of circumcision (which Freud identifies clearly as "the symbolic substitute for castration"). In the Biblical story, the operation is performed on Moses by his wife.

158 Salvador Dali, "De la Beauté terrifiante et comestible, de l'architecture Modern style," *op. cit.*, p. 72.

159 *Ibid.*, p. 70.

160 Marcel Jean, *History of Surrealist Painting*, translated by Simon Watson Taylor (New York, 1960), p. 209.

161 A. Reynolds Morse, *Dali: A Study of His Life and Work* (Greenwich, Conn., 1958), p. 29.

162 Salvador Dali, "Les Nouvelles Couleurs du 'Sex-Appeal spectral,'" *Minotaure* (Paris), vol. 1, no. 5, 1933.

163 Marcel Jean, *op. cit.*, p. 218.

164 Donald Sutherland, *op. cit.*, p. 92.

165 André Breton, *Entretiens 1913–1952, op. cit.*, pp. 236, 281.

166 Marcel Jean, *op. cit.*, p. 220.

167 André Breton, "Des Tendances les plus récentes de le peinture sur-réaliste," *Minotaure* (Paris), vol. 3, no. 12–13, 1939, p. 17.

168 "Entretien avec Alberto Giacometti," Georges Charbonnier (ed.), *Le Monologue du peintre* (Paris, 1959), pp. 162–63.

169 Jacques Dupin, *Alberto Giacometti* (Paris, 1962), Section 4. French edition contains an English translation by John Ashbery.

170 "A Letter from Alberto Giacometti to Pierre Matisse, 1947," published in *Exhibition of Sculptures, Paintings, Drawings*, Pierre Matisse Gallery, New York, January 19–February 14, 1948; reproduced in facsimile, with translation, in Peter Selz (ed.) *Alberto Giacometti* (New York, 1965), p. 20.

171 Maurice Nadeau, *Histoire du surréalisme* (2nd ed., Paris, 1958), p. 176.

172 "Entretien avec Alberto Giacometti," Georges Charbonnier (ed.), *op. cit.*

173 Alberto Giacometti [Notes on *The Palace at 4 A.M.*], *Minotaure* (Paris), vol. 1, no. 3–4, 1933, p. 46. English translation, "1 + 1 = 3," *Transformation* (New York), 1952, pp. 165–66.

174 Jean-Paul Sartre, "Le Recherche de l'absolu," *Les Temps Modernes* (Paris), January 1948, p. 1154.

175 André Breton, "Equation de l'objet trouvé," *Documents* (Paris), June 1934, p. 18.

176 "A Letter from Alberto Giacometti to Pierre Matisse, 1947," *op. cit.*, p. 26.

177 Marcel Jean, *op. cit.*, pp. 228–29.

178 Jean Arp, "Art is a Fruit" and "Concrete Art," in *On My Way*, *op. cit.*, pp. 51, 70.

179 Cited in Carola Giedion-Welcker, *Jean Arp* (New York, 1957), p. xxvii.

180 Lucy Lippard, "The Sculpture," in Sam Hunter (ed.), *Max Ernst: Sculpture and Recent Painting*, catalogue of an exhibition at The Jewish Museum, New York, March 3–April 17, 1966.

181 André Breton, *Introduction au discours sur le peau de réalité* (Paris, 1927), p. 33.

182 André Breton, "L'Objet fantôme," *Le Surréalisme au service de la révolution* (Paris), December 1931, p. 21.

183 Salvador Dali, "Objets surréalistes," *Le Surréalisme au service de la révolution* (Paris), December 1931, p. 16.

184 *Ibid.*

185 Georges Hugnet, "L'Objet utile," *Cahiers d'Art* (Paris), vol. 10, no. 5–6, 1935.

186 Marcel Jean, *op. cit.*, p. 247.

187 André Breton, *Entretiens, op. cit.*, p. 162; "Du Poème-objet," *Le Surréalisme et la peinture, op. cit.*, p. 178.

188 André Breton, "Rêve-objet," *Cahiers d'Art* (Paris), vol. 10, no. 5–6, 1935, p. 125.

189 Dali created a variant of the *Rainy Taxi* for the 1939 New York World's Fair. In 1968 he made a second version of the *Rainy Taxi* for the exhibition *Dada, Surrealism, and Their Heritage*, shown at The Museum of Modern Art, New York.

190 Marcel Jean, *op. cit.*, p. 281.

191 Yves Duplessis, *Surrealism*, translated by Paul Capon (New York, 1962), p. 79. Originally published Paris, 1950.

192 This phrase has been attributed to Françoise Gilot at the time of her break-up with Picasso. She has since disclaimed its authorship. Cf. Gilot, *My Life with Picasso* (New York, 1964), p. 358.

193 Wallace Fowlie, *op. cit.*, pp. 170, 161.

194 André Breton, "Picasso dans son élément," *Minotaure* (Paris), vol. 1, no. 1, 1933, p. 22.

195 Cesare Brandi, *Carmine: o, della pittura, con due saggi su Duccio e Picasso* (Florence, 1947), p. 305.

196 Alfred H. Barr, Jr., *Picasso: Fifty Years of His Art* (New York, 1946), p. 143.

197 Roland Penrose, *Picasso: His Life and Work* (New York, 1958), p. 232.

198 André Breton, "Genesis and Perspective of Surrealism," *op. cit.*, p. 22.

199 Roland Penrose, op. cit., p. 250.

200 André Breton, "Picasso poète," Cabiers d'Art (Paris), vol. 10, no. 7–10, 1935, p. 187.

201 The Crucifixion is understood here in its non-sacramental sense, Christ and his imagery being a cultural myth of the West independent of questions of religious confession.

202 Juan Larrea, Guernica (New York, 1947).

203 Jerome Seckler, in "Symposium of 'Guernica'... November 25, 1947" (typescript in the library, The Museum of Modern Art, New York).

204 William S. Rubin, "Picasso and Religious Imagery," to be published in The Art Journal (New York).

205 Alfred H. Barr, Jr., op. cit., p. 167.

206 Roland Penrose, op. cit., p. 236.

207 Alfred H. Barr, Jr., op. cit., p. 167.

208 This point was made by Meyer Schapiro in a lecture comparing the Guernica with the Isenheim Altarpiece, Columbia University, New York, 1951.

209 Vincente Marrero, Picasso and the Bull, translated by Anthony Kerrigan (Chicago, 1956).

210 Alfred H. Barr, Jr., op. cit., p. 193.

211 Herbert Read, "Picasso's Guernica," in A Coat of Many Colours, op. cit.

212 This is particularly true of the Central European and English painters. See Herbert Read (ed.), Surrealism (London, 1936), in passim.

213 Sarane Alexandrian, Victor Brauner, l'illuminateur (Paris, 1954), p. 66.

214 James Thrall Soby, De Chirico, op. cit., p. 150.

215 James Johnson Sweeney, "Joan Miró," op. cit., p. 211.

216 André Breton, "Prolegomena to a Third Manifesto of Surrealism or Else," VVV (New York), June 1942, pp. 25–26.

217 Nicolas Calas, "Lam," in Bloodflames 1947 (New York, 1947), p. 3.

218 See the discussion of "globalism" in the chapter "Surrealism: Automatism and the Early Iconography," in my monograph on Jackson Pollock to be published by Harry N. Abrams, Inc., New York.

219 William S. Rubin, "Notes on Masson and Pollock," Arts (New York), November 1959.

220 Clement Greenberg, Hans Hofmann (Paris and New York, 1961).

221 Clement Greenberg, "Contribution to a Symposium," in Art and Culture (Boston, 1961), p. 126.

222 This procedure was comparable to, but not identical with, that which produced Masson's Nocturnal Notebook (New York, 1944).

223 Nicolas Calas, "Max Ernst," in Ernst, Beyond Painting, op. cit., p. 192.

224 Patrick Waldberg, op. cit., p. 388.

225 Marcel Jean, op. cit., p. 347n.

226 James Thrall Soby, De Chirico, op. cit., p. 22.

227 Harold Rosenberg, Arshile Gorky: The Man, the Time, the Idea (New York, 1962).

228 Ibid., p. 24.

229 Meyer Schapiro, introduction to Ethel K. Schwabacher, Arshile Gorky (New York, 1957), p. 12.

230 Written by Gorky, June 26, 1942, at the request of Dorothy C. Miller, curator of the Museum Collections, The Museum of Modern Art, New York.

231 Ethel K. Schwabacher, op. cit., p. 67.

232 William C. Seitz, Arshile Gorky: Paintings, Drawings, Studies (New York, 1962), p. 27.

233 Ibid., p. 29.

234 Julien Levy, foreword to ibid., p. 8.

235 André Breton, "The Eye-Spring: Arshile Gorky," in Arshile Gorky, catalogue of an exhibition at the Julien Levy Gallery, New York, 1945, p. 3. Originally published "Arshile Gorky, Le Surréalisme et la peinture, op. cit.

236 Cf. William Rubin, "Arshile Gorky, Surrealism, and the New American Painting," Art International (Zurich), February 1963.

DOCUMENTARY ILLUSTRATIONS

D-1 MATTHIAS GRÜNEWALD The Crucifixion, Panel of Isenheim Altarpiece. c. 1510-15

D-2 GIUSEPPE ARCIMBOLDO (c. 1530-1591). Bust Composed of Animals

D-3 GIUSEPPE ARCIMBOLDO The Librarian

D-4 JOSSE DE MOMPER Winter. (c. 1625)

D-5 GIOVANNI BATTISTA BRACELLI (active 1624-49). Furniture Figures. 1624

D-6 NICOLAS I DE LARMESSIN (d. 1694). Habit de Layettier

D-7 GEORGE ENGLEHEART (1752-1829). Portrait of Mrs. Mills

D-8 RODOLPHE BRESDIN Aqueduct and Waterfalls

D-9 GUSTAVE MOREAU Salome Dancing before Herod. 1876

D-10 GUSTAVE MOREAU Sketch D

D-11 ODILON REDON The Eye Like a Strange Balloon Moves toward Infinity. 1882

D-12 ODILON REDON Germination. 1885

D-13 ODILON REDON The Spider. 1887

D-14 ODILON REDON Light. 1893

421

D-17 ART NOUVEAU
column base

D-20 HECTOR GUIMARD
Métropolitain Station, Place
de l'Etoile, Paris. 1900
(Demolished)

D-24 HENRI ROUSSEAU
Portrait of Pierre Loti.
c. 1910

D-28 UMBERTO BOCCIONI The
Forces of a Street. 1911

D-16 ANTONI GAUDÍ
Palau Güell. 1885–89

D-19 HENRY VAN DE VELDE
Composition.
1890

D-23 HENRI ROUSSEAU
The Dream. 1910

D-27 WASSILY KANDINSKY
Black Lines. 1913

D-15 GEORGES SEURAT Sunday Afternoon on the Island of
La Grande Jatte. 1884–86

D-18 PHILIPPE WOLFERS
Inkstand. c. 1889

D-22 THE POSTMAN CHEVAL. The
Ideal Palace. Facade. Finished
1912. Hautrives (Drôme), France

D-26 WASSILY KANDINSKY
Sunday. 1911

D-21 HENRY VAN DE VELDE
Candelabrum. c. 1902

D-25 L. (E. V.) and M. (G.)
What a Life. Page 45.
Novel with collage
illustrations. 1911

D-29 PABLO PICASSO
*Bottle of "Vieux Marc,"
Glass, Newspaper*, 1912

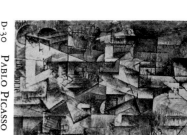

D-30 PABLO PICASSO
Ma Jolie, 1911-12

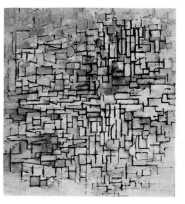

D-31 PIET MONDRIAN
Composition 7, 1913

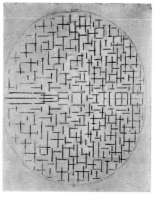

D-32 PIET MONDRIAN
Pier and Ocean, 1914

D-33 MARC CHAGALL
*Dedicated to
My Fiancée*, 1911

D-34 PAUL KLEE *An Artist
(Self-Portrait)*, 1919

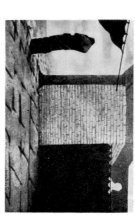

D-35 GIORGIO DE CHIRICO
The Enigma of the Oracle,
1910

D-36 ARNOLD BÖCKLIN *Odysseus
and Calypso*, 1883

D-37 ARNOLD BÖCKLIN *Battle of
the Centaurs*, 1873

D-38 MAX ERNST *The Last
Judgment*, c. 1919

D-39 GIORGIO DE CHIRICO
*The Departure of the Knight
Errant*, 1923

D-40 MAX KLINGER
*Paraphrase on the Finding
of a Glove, Plate II*,
Published 1881

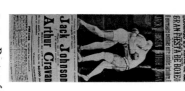

D-41 Poster for
Johnson-Cravan
fight, Madrid,
April 23, 1916

D-42 FRANCIS PICABIA
Arthur Cravan

D-43 JACQUES VACHÉ
Self-Portrait

D-44 Jacques Vaché
in uniform, 1918

D-48 Marcel Duchamp as Rose Sélavy. Photograph by Man Ray. 1920

D-47 Alfred Jarry

D-46 Baroness Elsa von Freytag-Loringhoven. 1921

D-45 André Breton in uniform. 1917–18

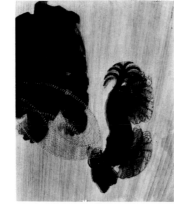

D-52 GIACOMO BALLA *Leash in Motion.* 1912

D-51 MARCEL DUCHAMP *Portrait (Dulcinea).* 1911

D-50 MARCEL DUCHAMP *L.H.O.O.Q.* 1919

D-49 FRANCIS PICABIA *Portrait of Cézanne....* 1920

D-54 Marcel Duchamp descending a staircase. Stroboscopic photograph by Eliot Elisofon

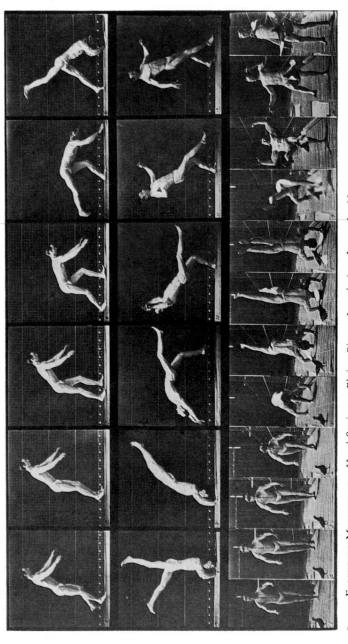

D-53 EADWEARD MUYBRIDGE *Head-Spring, a Flying Pigeon Interfering.* June 26, 1885

424

D-55 MARCEL DUCHAMP
Virgin I, 1912

D-56 Marcel Duchamp's studio, 33 West 67th Street, New York, 1917–18

D-57 RUBE GOLDBERG Cartoon. From *New York Dada* (New York), April, 1921

D-58 Katherine Dreier's library with Duchamp's *Tu'm* and the *Large Glass,* 1937

D-59 MAN RAY *Portrait of Marcel Duchamp,* 1923

D-60 MARCEL DUCHAMP *Rotary Glass Plate (Precision Optics) (in motion),* 1920

D-61 Gabrielle Buffet and Francis Picabia in their Mercer, 1917

D-62 Francis Picabia, Gabrielle Buffet, Guillaume Apollinaire at Luna Park, Paris, 1914

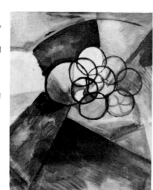

D-63 FRANCIS PICABIA *Rubber,* 1909

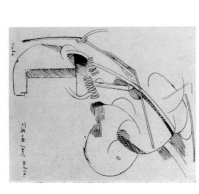

D-64 FRANCIS PICABIA *Girl Born Without a Mother,* 1913

425

D-68 The Spiegelgasse, Zurich. The Cabaret Voltaire was at No. 1, lower right

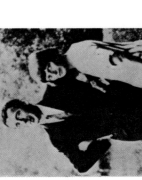

D-75 JEAN ARP *Static Composition.* 1915

D-67 MAN RAY *By Itself.* 1918

D-74 Emmy and Hugo Ball, Zurich. 1918

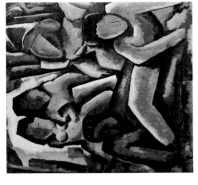

D-66 MAN RAY *Five Figures.* 1914

D-73 MARCEL JANCO *Dada Construction.* 1917

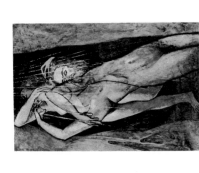

D-65 FRANCIS PICABIA *Judith.* 1932

D-69 Tristan Tzara, Zurich. 1916

D-70 Hugo Ball reciting the Sound Poem *Karawane.* 1916

D-71 *Admiral Seeks a House for Rent* (Simultaneous Poem), from *Cabaret Voltaire*, 1916

D-72 At "Die Neue Kunst," Galerie Wolfsberg, Zurich, 1918. Left to right: Marcel Janco, Sterling, Jean Arp

L'amiral cherche une maison à louer

Poème simultan par R. Huelsenbeck, M. Janko, Tr. Tzara

TRISTAN TZARA

D-76 JEAN ARP AND SOPHIE
TÄUBER-ARP
Duo Collage, 1918

D-77 Jean Arp and Sophie
Täuber-Arp, Zurich, 1918

D-78 SOPHIE TÄUBER-ARP
Untitled, 1920

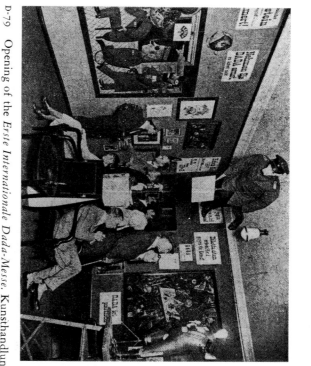

D-79 Opening of the *Erste Internationale Dada-Messe*, Kunsthandlung
Dr. Otto Burchard, Berlin, June, 1920. From left to right: Raoul
Hausmann, Hannah Höch, Dr. Burchard, Johannes Baader,
Wieland Herzfelde, Mrs. Herzfelde, Otto Schmalhausen,
George Grosz, John Heartfield

D-80 Hannah Höch and Raoul
Hausmann at the *Erste
Internationale Dada-Messe*

D-81 Catalogue-announcement of the
Erste Internationale Dada-Messe

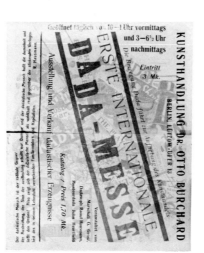

D-82 GEORGE GROSZ AND JOHN HEARTFIELD
*Henri Rousseau Self-Portrait.
Montage.* From catalogue-
announcement of the *Erste
Internationale Dada-Messe*

D-83 List of names from catalogue-announcement
of the *Erste Internationale Dada-Messe*

D-84 RICHARD HUELSENBECK
Cover of *Dada Almanach*, 1920

D-85 Richard Huelsenbeck
c. 1916

427

D-89 RICHARD HUELSENBECK *Jean Arp.* 1949

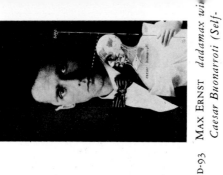

D-93 MAX ERNST *dadamax wi... Caesar Buonarroti (Self-Portrait).* 1920

D-97 KURT SCHWITTERS *Aerated Painting.* 1917

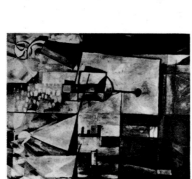

D-88 RICHARD HUELSENBECK *The Lion Hunt.* 1945

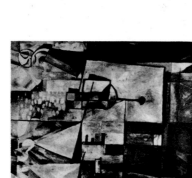

D-92 MAX ERNST *Still Life in Cubist Style.* c. 1913

D-96 Cover of *Merz,* No. 20, showing Kurt Schwitters

D-101 Dada Festival at the Salle Gaveau, Paris, May 26, 1920

D-87 LUDWIG MEIDNER *Richard Huelsenbeck.* 1918

D-91 BAARGELD (ALFRED GRÜNWALD) *Self-Portrait.* 1920

D-95 Opening of the Max Ernst exhibition at the Galerie au Sans Pareil, Paris, May, 1921. Left to right: Hilsum, Péret, Charchoune, Soupault, Rigout, Breton

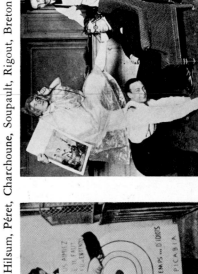

D-100 Performance of *Vous m'oublierez* at the Salle Gaveau, Paris, 1920. Left to right: Eluard, Soupault, Breton, and Fraenkel

D-86 Richard Huelsenbeck (left) and Raoul Hausmann, Prague. 1920

D-90 HANS RICHTER Frames from *Rhythmus 21.* 1921

D-94 MAX ERNST Cover of *Die Schammade* (Cologne), February, 1920

D-99 André Breton reading the "Festival Manifeste Presbyte" by Francis Picabia, at the Salle Gaveau, Paris, 1920

D-98 PABLO PICASSO *The Manager from New York.* Costume designed for *Parade.* 1917

D-102 The Barrès Trial at the Salle des Sociétés Savantes, Paris, May, 1921

D-103 Francis Picabia *Relâche* (ballet). Marcel Duchamp as Adam. Paris. 1924

D-104 *Entr'acte* Film by René Clair. 1924. Still of Marcel Duchamp and Man Ray playing chess

D-105 Left to right, Tzara, Arp, and Ernst in the Tyrol, Summer, 1921

D-108 Bottom row: Simone Breton, Louis Aragon, Colette Jéramec-Tual; top row: André Breton, Max Morise, Roland Tual

D-106 Max Ernst *The Meeting of Friends*. 1922. First row, left to right: Réné Crevel (at invisible piano), Max Ernst (on lap of Dostoevski), Dr. Fraenkel, Jean Paulhan, Benjamin Péret, Baargeld, Robert Desnos. Second row: Philippe Soupault, Jean Arp, Max Morise, Raphaël, Paul Eluard, Louis Aragon, André Breton, Giorgio de Chirico, Gala Eluard

D-109 Left to right: Georges Malkine, André Masson, André Breton, Max Morise, Georges Neveux in Nice. 1924

D-110 Left to right: Robert Desnos, André Breton, Malkine, Max Morise, Simone Breton Collinet in Florence. 1924

D-107 André Breton (with makeup), in front of a de Chirico painting. 1926

D-113 Dada "Happening" at the church of Saint Julien le Pauvre, 1921. Left to right: unidentified journalist, Soupault, Tzara, Breton (reading)

D-111 The Surrealist *centrale*, 1924. Left to right: François Baron, Raymond Queneau, André Breton, Jacques Boiffard, Giorgio de Chirico, Roger Vitrac, Paul Eluard, Philippe Soupault, Robert Desnos, Louis Aragon; front row: Pierre Naville, Simone Breton Collinet, Max Morise, Pauline Soupault

D-112 The Surrealist *centrale*, 1924. Left to right: Morise, Vitrac, Boiffard, Breton, Eluard, Naville, de Chirico, Soupault; bottom: Desnos, Baron; at the typewriter: Simone Breton Collinet

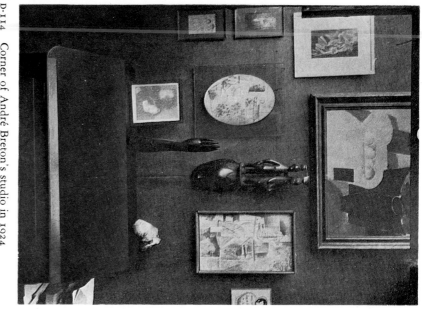

D-114 Corner of André Breton's studio in 1924

D-117 PIERRE ROY *Daylight Saving Time.* 1929

D-118 JOAN MIRO *The Path, Ciurana.* 1917

D-121 JOAN MIRÓ *Standing Nude.* 1918

D-122 JOAN MIRÓ *The Table (Still Life with Rabbit).* 1920

D-123 On the beach at Juan Les Pins, 1925. Left to right: André Masson, Daniel-Henri Kahnweiler, Pablo Picasso, Olga Picasso, Mme Lascaux, Louise Leiris, Michel Leiris

D-119 JOAN MIRÓ *Village and Street, Ciurana.* 1917

D-124 ANDRÉ MASSON *Feather Collage.* 1927

D-120 JOAN MIRÓ *Nord-Sud.* 1917

D-116 DÉDÉ SUNBEAM *Collage*

D-115 ROBERT DESNOS and PIERRE NAVILLE *Painting.* 1924

431

D-128 YVES TANGUY *The Certitude of the Never Seen.* 1933

D-131 The Belgian Surrealist group. Left to right: E. L. T. Mesens, René Magritte, Louis Scutenaire, André Souris, Paul Nougé; seated: Irène Hamoir, Marthe Nougé, Georgette Magritte

D-135 Salvador Dali when he attended the School of Fine Arts, Madrid

D-127 YVES TANGUY *Girl with Red Hair.* 1926

UN CADAVRE

Il ne faut plus que mort cet homme fasse de la poussière.
André BRETON (*Un Cadavre, 1924.*)

MORT
D'UN MONSIEUR

PAPOLOGIE
D'ANDRÉ BRETON

AUTO-PROPHÉTIE

D-134 *Un Cadavre* (broadside). 1930

D-126 MAX ERNST *The Idol* (Plate XIX from *Histoire Naturelle*). 1926

D-130 RENÉ MAGRITTE *Memory.* 1948

D-125 MAX ERNST *System of Solar Money* (Plate XXXI from *Histoire Naturelle*). 1926

D-129 RENÉ MAGRITTE *Man at the Window.* 1920

D-132 RENÉ MAGRITTE *Delusion of Grandeur.* 1962

D-133 RENÉ MAGRITTE *The Ocean.* 1942

D-140 SALVADOR DALI Hysterical and Aerodynamic Feminine Nude. 1934

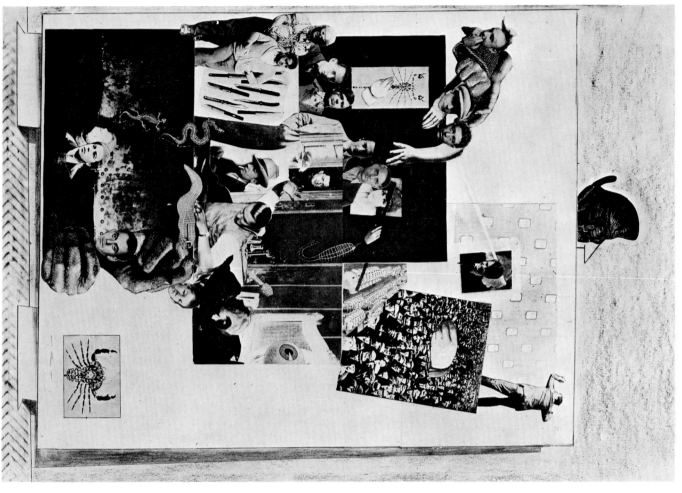

D-136 MAX ERNST Surrealist Personages. 1931

Salvador Dali and Luis Buñuel Still from the film An Andalusian Dog

D-142 Salvador Dali and Luis Buñuel Still from the film L'Age d'or

D-143 Salvador Dali and Luis Buñuel in still from L'Age d'or "Are you cold?"

D-139 SALVADOR DALI Meditation on the Harp. 1932

D-138 The Rock of Slumber. Photo of a rock taken by Dali on Cape Creus, Spain

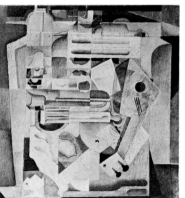

D-137 SALVADOR DALI Pure Still Life. 1924

D-146 CLOVIS TROUILLE *Lust.* 1959

D-148 SALVADOR DALI *Paranoiac Face.* 1934-35

D-149 Surrealist exhibition at the Pierre Colle Gallery, Paris, 1933. Objects by Breton, Dali, Duchamp, Ernst, and Man Ray

D-145 CLOVIS TROUILLE *Remembrance.* 1931

D-144 MAX ERNST *The Virgin Spanking the Child Jesus....* 1923(?)

D-147 SALVADOR DALI *Paranoiac Face.* Sketch with postcard that suggested it

434

D-150 MAN RAY Montage of photographs which were taken previously. 1934. Left to right, top row: Breton, Ernst, Dali, Arp; second row: Tanguy, Char, Crevel, Eluard; third row: de Chirico, Giacometti, Tzara, Picasso; fourth row: Magritte, Brauner, Péret, Rosey; bottom row: Miró, Mesens, Hugnet, Man Ray

ALBERTO GIACOMETTI
Construction. 1927

D-152

ALBERTO GIACOMETTI
Man Pointing. 1947

D-153

ALBERTO GIACOMETTI
City Square. c. 1948

D-154

ALBERTO GIACOMETTI
Closed-in Figure. 1950

D-155

JOSEPH CORNELL *Soap Bubble Set.* 1936

D-159

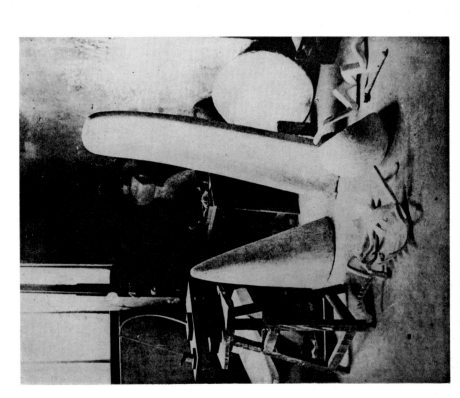

D-151 Studio of Alberto Giacometti

D-156 ALBERTO GIACOMETTI
Cage. 1950–51

D-157 ALBERTO GIACOMETTI
Figurine. 1957

D-158 JEAN ARP *Head.* 1929

436

D-160 JOSEPH CORNELL *America Fantastica.* Cover of *View*, January, 1943

D-161 JOSEPH CORNELL *Apothecary.* 1950

D-162 Marcel Jean and Oscar Dominguez, with the latter's object *Ouverture*, in Marcel Jean's studio, Paris, 1936

D-163 View of the *Exposition Surréaliste d'Objets.* Charles Ratton Gallery, Paris, 1936

D-164 View of the private collection of André Breton in his studio, rue Fontaine, Paris

D-165 GEORGES HUGNET *Poème-Découpage.* 1936

D-166 Wineglass found at Saint-Pierre, Martinique, after the eruption of Mount Pelée, 1902

437

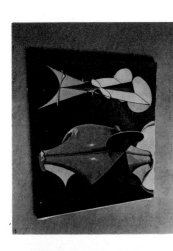

MAN RAY *Anthony and Cleopatra* ("Shakespearean Equations"). 1948 D-170

PABLO PICASSO *Bull, Horse and Woman.* 1934 D-174

PABLO PICASSO Notebook drawing of a bullfight. 1959 D-178

JOAN MIRÓ *Head of a Man, I.* 1931 D-182

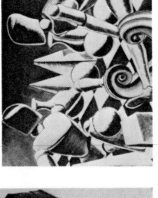

MAN RAY *End Game.* 1946 D-169

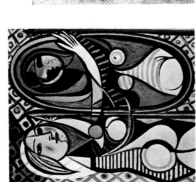

PABLO PICASSO *Girl before a Mirror.* 1932 D-173

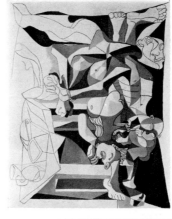

PABLO PICASSO *The Charnel House.* 1945 D-177

JOAN MIRÓ *Mediterranean Landscape.* 1930 D-181

MAN RAY Photograph of a mathematical object. 1948 D-168

PABLO PICASSO *Crucifixion.* 1926 D-172

PABLO PICASSO *Horse's Head* (Study for *Guernica*). 1937 D-176

JOAN MIRÓ *Painting.* 1930 D-180

Tamanoir. 1936. Collage-object D-167

PABLO PICASSO *Glass of Absinthe.* 1914 D-171

PABLO PICASSO *Dying Minotaur.* 1936 D-175

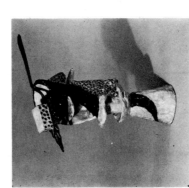

PABLO PICASSO Notebook drawing of a bullfight. 1959 D-179

D-183 JOAN MIRÓ
Self-Portrait. 1937–38

D-184 JOAN MIRÓ *Still Life with
Old Shoe*. 1937

D-185 ANDRÉ MASSON
Suntrap. 1938

D-186 ANDRÉ MASSON *In the
Tower of Sleep*. 1938

D-187 International Surrealist exhibition, Galerie Beaux-Arts, Paris, 1938.
The main room of the exhibition, showing one of the revolving doors,
with paintings by Yves Tanguy, Oscar Dominguez, Marcel Jean, and
Wolfgang Paalen; on the left: *Mannequin* by Marcel Jean

D-188 The main room of the international Surrealist exhibition,
Galerie Beaux-Arts, Paris, 1938. Hanging from the
ceiling, Marcel Duchamp's coal bags; in the front, *Jamais*
by Oscar Dominguez; on the left, painting by Tanguy; on
the right, painting by Dali

D-189 Victor Brauner in his studio, seated before
a sculpture entitled *Number*. 1953

D-190 VICTOR BRAUNER
Self-Portrait. 1931

D-191 SALVADOR DALI
Cover for *Minotaure*
(Paris), No. 8, 1936

D-194 Tanguy, Breton, Onslow-Ford, Matta, Francés, Anne Pajarito, Jacqueline Breton at Gertrude Stein's country home near Belley, France, Summer, 1939

D-197 Matta *Project for an Apartment.* 1938

D-198 Frederick Kiesler Model for The Endless House, 1958–59

D-193 Esteban Francés *The Labyrinth of the Minotaur.* 1939

D-196 André Masson *Portrait of André Breton.* 1941

D-192 Matta Untitled drawing. 1937

D-195 Jacqueline Breton, André Masson, André Breton, and Varian Fry, Director of the emergency rescue committee, Marseilles. 1941

D-200 Artists in Exile. Photograph taken on the occasion of an exhibition at Pierre Matisse Gallery, March, 1942. Left to right, first row: Matta, Ossip Zadkine, Yves Tanguy, Max Ernst, Marc Chagall, Fernand Léger; second row: André Breton, Piet Mondrian, André Masson, Amédée Ozenfant, Jacques Lipchitz, Pavel Tchelitchew, Kurt Seligmann, Eugene Berman

D-199 Art of This Century, New York, October, 1942. Surrealist gallery designed by Frederick Kiesler

440

D-201 Installation view of the exhibition *First Papers of Surrealism*, New York. 1942. Twine by Marcel Duchamp

D-204 MATTA *Babes in Mattaland* (detail) 1943

D-202 MATTA Cover for *VVV* magazine, No. 4, 1944

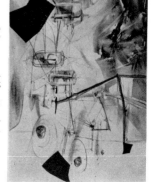

D-203 MATTA *The Bachelors Twenty Years After*, 1943

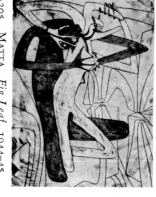

D-205 MATTA *Fig Leaf*, 1944–45

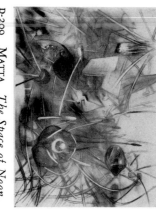

D-206 MATTA in his studio, Winter, 1945–46

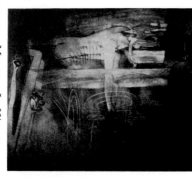

D-207 MATTA *Le Vitreur* (fragment of a destroyed painting), 1945

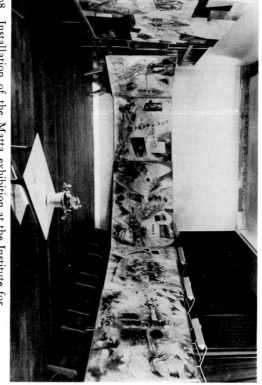

D-208 Installation of the Matta exhibition at the Institute for Contemporary Art, London, January, 1951

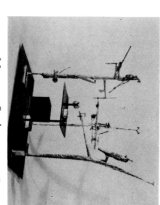

D-209 MATTA *The Space of Noon*, 1956

D-210 MATTA *Sculpture*, 1958

D-211 Wifredo Lam in his studio

D-215 DOROTHEA TANNING *Birthday*. 1942

D-214 Hans Richter Shipwreck scene from *Dreams that Money Can Buy*: Max Ernst, left; Julien Levy, right

D-219 WIFREDO LAM *La Chevalure de Falmer*. Altar at the Exposition Internationale du Surréalisme, Paris. 1947

D-218 VICTOR BRAUNER *Le Serpentaire*. Altar at the Exposition Internationale du Surréalisme, Paris. 1947

D-213 MAX ERNST *The Temptation of Saint Anthony*. 1945

D-217 MARCEL DUCHAMP and FREDERICK KIESLER *Le Rayon Vert*. At the Exposition Internationale du Surréalisme. Galerie Maeght, Paris. 1947

D-212 Max Ernst in New York. c. 1942

D-216 LEONORA CARRINGTON *Where the Treasure Is*. c. 1956

D-220 At the *Exposition Internationale du Surréalisme*, 1947: 1) Baskine; 2) Demarne; 3) Henry; 4) Kujavski; 5) Tarnaud; 6) Jean; 7) Delanglade; 8) Brauner; 9) Alexandrian; 10) Toyen; 11) Rodanski; 12) Mme Jean; 13) Nora Mitrani; 14) Bellmer; 15) Breton; 16) Pastourau; 17) Harfaux; 18) Matta; 19) Heisler; 20) Kiesler; 21) Hérold; 22) Goetz; 23) Serpan

D-221 KAY SAGE *Hypben.* 1954

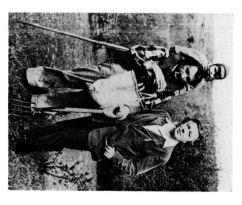

D-228 Arshile Gorky, Maro Gorky, and André Breton. c. 1946

D-230 ENRICO DONATI *Le Philtre.* 1943

D-225 ANDRÉ MASSON *La Chevauchée du poisson.* 1955

D-222 JOAN MIRÓ *Hope Returns to Us through the Flight of Constellations.* 1954

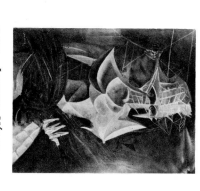

D-231 JACQUES HÉROLD *La Liseuse d'Aigle.* 1942

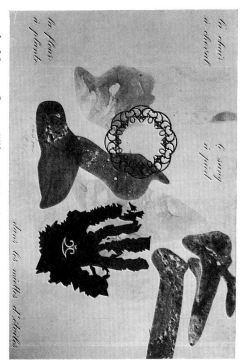

D-229 Max Ernst and Robert Motherwell playing chess, Amagansett, Long Island. 1944

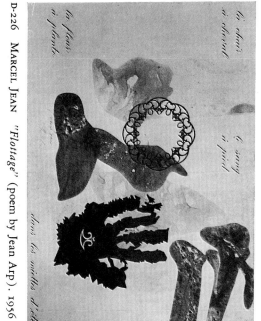

D-226 MARCEL JEAN *"Flotage"* (poem by Jean Arp). 1956

D-223 MATTA *La Banale de Venise.* 1956

D-224 ANDRÉ MASSON *Nocturnal City.* 1956

D-227 ARSHILE GORKY *Enigmatic Combat.* c. 1936

D-232 Installation of *Exposition Internationale du Surréalisme,* Galerie Daniel Cordier, Paris, Winter, 1959–60

D-233 JEAN DUBUFFET. *The Magician.*
1954

D-237 WOLS *Memory of a Town.* 1950

D-241 HENRI MICHAUX *Personage.*
c. 1955–56

AN ALBUM OF
POST-SURREALISM

D-234 WOLS (WOLFGANG SCHULZ) *German*
Music. 1939

D-238 WOLS *Trees.* C. 1950

D-235 WOLS *Whales in Water Flowers.* 1937

D-239 GEORGES MATHIEU
Montjoie Saint Denis!
1954

D-236 WOLS *Electric Contact.* 1938

D-240 Georges Mathieu as
"Action Painter"

D-242 JEAN TINGUELY
Metamechanic Relief. 1954

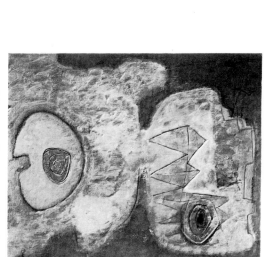

D-243 WILLIAM BAZIOTES *Dwarf.* 1947

D-244 THEODOROS STAMOS *Echo.* 1948

445

D-245 Painters of the New York School, 1951. Seated, left to right: Theodoros Stamos, Jimmy Ernst, Jackson Pollock, Barnett Newman, James Brooks, Mark Rothko; standing, left to right: Richard Pousette-Dart, William Baziotes, Willem de Kooning, Adolph Gottlieb, Ad Reinhardt, Hedda Sterne, Clyfford Still, Robert Motherwell, Bradley Walker Tomlin

D-248 WILLEM DE KOONING Night Square. c. 1949

D-247 WILLEM DE KOONING Painting. 1948

D-246 WILLEM DE KOONING Pink Angels. c. 1945

D-255 JACKSON POLLOCK *Number 27.* 1951

D-252 HANS HOFMANN
Fairy Tale. 1944

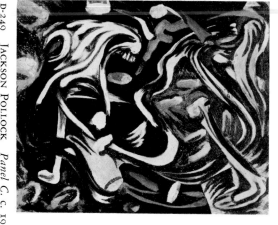

D-249 JACKSON POLLOCK *Panel C. c.* 1936

D-256 JACKSON POLLOCK *Echo.* 1951

D-253 JACKSON POLLOCK
Untitled drawing. 1945

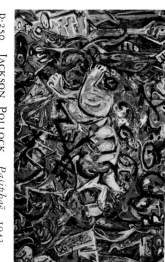

D-250 JACKSON POLLOCK *Pasiphaë.* 1943

D-257 MARK ROTHKO
Baptismal Scene. 1945

D-254 JACKSON POLLOCK
Mural on Indian Red Ground. 1950

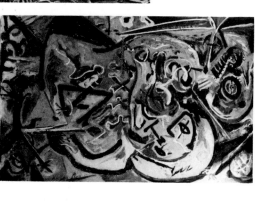

D-251 JACKSON POLLOCK
Totem I. 1944

447

D-258 MARK ROTHKO Untitled.
c. 1945

D-259 MARK ROTHKO Slow Swirl by the Edge of
the Sea. 1944

D-260 MARK ROTHKO Tentacles
of Memory. c. 1945

D-262 ADOLPH GOTTLIEB Man Looking at
Woman. 1949

D-263 ADOLPH GOTTLIEB Hot Horizon. 1956

D-261 ADOLPH GOTTLIEB The Rape of
Persephone. 1940

D-265 ROBERT MOTHERWELL Mallarmé's
Swan. 1944–47

D-264 ADOLPH GOTTLIEB Burst. 1957

D-266 ROBERT MOTHERWELL Black on White.
1961

D-267 CLYFFORD STILL
Jamais. 1944

D-270 CLYFFORD STILL Untitled.
c. 1955

D-273 BARNETT NEWMAN *Two Edges.* 1948

D-268 CLYFFORD STILL *1944–A*

D-271 BARNETT NEWMAN *Pagan Void.* 1946

D-274 BARNETT NEWMAN
Onement No. 3. 1949

D-269 CLYFFORD STILL *1947–G*

D-272 BARNETT NEWMAN *Death of Euclid.* 1947

D-275 ALEXANDER CALDER *Steel Fish.* 1934

449

ISAMU NOGUCHI *The Self.* 1956
D-277

ISAMU NOGUCHI
Kouros. 1946
D-276

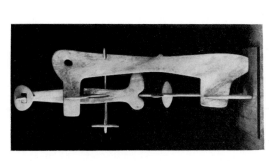

DAVID HARE *Man with Drums.*
1947
D-278

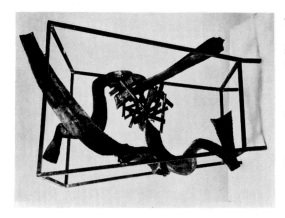

DAVID SMITH *The Timeless Clock.* 1957
D-281

DAVID SMITH *Interior for Exterior.*
1939
D-280

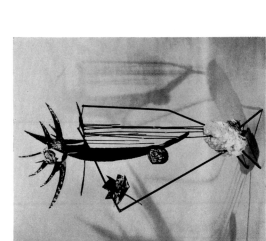

DAVID HARE *Sunrise.* 1954–55
D-279

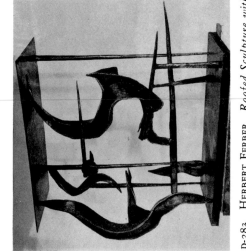

HERBERT FERBER *Calligraph
in Cage with Cluster II.*
1962
D-284

HERBERT FERBER *Roofed Sculpture with
S Curve II.* 1954
D-283

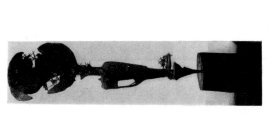

HERBERT FERBER
He Is Not a Man.
1950
D-282

450

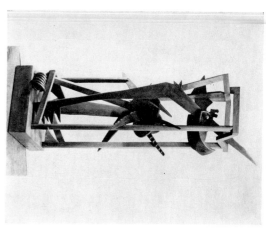

D-285 SEYMOUR LIPTON
Imprisoned Figure.
1948

D-286 SEYMOUR LIPTON
The Defender. 1962

D-287 ALFONSO OSSORIO
To You the Glory. 1950

D-288 GEORGE COHEN
Anybody's Self-Portrait.
1953

D-289 WILLIAM COPLEY
The Birth of Jules Verne.
1951–53

D-290 ROBERT RAUSCHENBERG *Bed.* 1955

D-291 ROBERT RAUSCHENBERG
Interview. 1955

D-292 ROBERT RAUSCHENBERG
Monogram. 1959

D-293 JASPER JOHNS *Target with Plaster Casts.* 1955

D-296 CLAES OLDENBURG *Giant Hamburger.* 1963

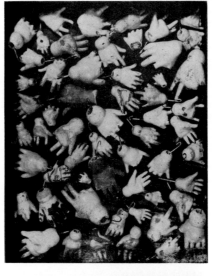

D-299 ARMAN (ARMAN FERNANDEZ) *Little Hands.* 1960

D-302 ALLAN KAPROW *Eat.* 1964. Environment

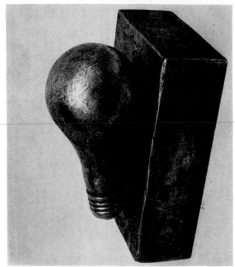

D-295 JASPER JOHNS *Light Bulb.* 1960

D-298 EDWARD KIENHOLZ *Roxy's House.* 1963

D-301 ALLAN KAPROW *A Service for the Dead* (1). 1962. Happening

D-294 JASPER JOHNS *Flashlight III.* 1958

D-297 GEORGE SEGAL *The Gas Station.* 1963

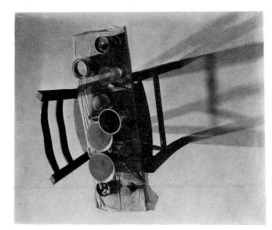

D-300 DANIEL SPOERRI *Kichka's Breakfast.* 1960

CHRONOLOGY

Compiled by Irene Gordon

1913

NEW YORK

January. Francis Picabia arrives in New York in connection with the Armory Show.

February 17–March 15. Armory of the Sixty-Ninth Infantry. *International Exhibition of Modern Art.* Duchamp's *Portrait of Chess Players* (1911), *The King and Queen Surrounded by Swift Nudes* (1912), and *Nude Descending a Staircase, No. 2* (1912) attract much attention and controversy. Picabia exhibits Cubist-inspired works, *Dances at the Spring and Procession, Seville* (both 1912).

March 17–April 5. Little Gallery of the Photo-Secession (291 Fifth Avenue). *Picabia Exhibition.* Picabia shows a series of watercolors at Alfred Stieglitz's gallery "291," where Matisse, Picasso, Cézanne, Rousseau, Marin, Weber, Dove, and Hartley had already been introduced to America. The preface Picabia writes for his exhibition appears in *Camera Work* (April–July), a magazine published by Stieglitz from 1903 to 1917 in which much avant-garde work is reproduced. Soon after the exhibition closes Picabia returns to Paris.

NEW JERSEY

Spring. Man Ray joins artists' and intellectuals' colony in Ridgefield. Meets Alfred Kreymborg and Max Eastman.

PARIS

On his return to Paris, Picabia paints large canvases—*Edtaonisl, Udnie,* and (probably the following year) *Je revois en souvenir ma chère Udnie* (*I See Again in Memory My Dear Udnie*).

Duchamp paints *Chocolate Grinder I* which marks the break with the canvases of 1912 and establishes the basis of the *Large Glass.* Renounces oil painting, secures a minor post in the Bibliothèque Ste.-Geneviève, makes his first Readymade, *Bicycle Wheel.*

The "American" boxer-poet Arthur Cravan (Fabian Avena-

rius Lloyd) continues to publish his polemical review *Maintenant,* the first issue of which appeared in April 1912.

De Chirico continues series of metaphysical Italian piazzas; exhibits three paintings in the Salon des Indépendants, four in the Salon d'Automne.

August. Max Ernst, who lives in Cologne, visits Paris. September. Apollinaire publishes "L'Antitradizione futurista," in *Lacerba* (Florence); *Alcools* and *Les Peintres cubistes* also published this year.

November. Picasso's earliest Cubist constructions are reproduced for the first time, in *Les Soirées de Paris.*

SWITZERLAND

Hans (Jean) Arp, living in Weggis, has drawings reproduced in *Der Sturm* (Berlin); is also co-author with L. H. Neitzel of a book on new French painting (*Neue französische Malerei*) published in Leipzig.

BERLIN

September–November. Der Sturm. *Erster deutscher Herbstsalon.* Exhibition includes, among others, Picabia, Arp, Ernst, Klee, Chagall, and the Futurists. Marinetti gives two lectures during the course of the exhibition.

1914

NEW YORK

November 3–December 8. Little Gallery of the Photo-Secession (291). *Negro Art.* An exhibition of African wood carvings, reported in *Camera Work* as "the first time in the history of exhibitions, either in this country or elsewhere, that Negro statuary was shown solely from the point of view of art."

PARIS

Cravan's review of the Salon des Indépendants, which he publishes as an issue of *Maintenant* (March–April), constitutes

1914–1916

an attack on modern art and some of its practitioners. He is challenged to a duel by Apollinaire and is taken to court by Sonia Delaunay, which results in a sentence of eight days in jail and a fine of one franc.

Picabia, though a Cuban national, allows himself to be drafted into the French army.

Arp arrives for a stay, during which he meets Cravan, Apollinaire, Delaunay, Modigliani, and Picasso; his style changes under the impact of Cubism.

André Breton "discovers" the Gustave Moreau museum.

ZURICH

Hugo Ball, German poet and pacifist, and his wife Emmy Hennings arrive from Germany.

COLOGNE

Arp and Max Ernst meet at the Deutscher Werkbund exhibition (May–October).

1915

NEW YORK

March. The periodical 291, edited by Paul Haviland and Marius de Zayas, begins to appear, under Stieglitz's auspices.

June. Picabia, on his way to an army mission, arrives in New York and stays for several months; publishes in 291 a series of "object portraits" which present Stieglitz as a camera, Picabia himself as an auto horn, and the young American girl in a state of nudity as a spark plug. He also executes a series of "machine pictures."

Duchamp arrives in New York. Visits artists' colony in Ridgefield, New Jersey, where he meets Man Ray. Begins The Bride Stripped Bare by Her Bachelors, Even (the Large Glass), which he will leave incomplete in 1923.

De Zayas publishes African Negro Art: Its Influence on Modern Art.

September. Picabia leaves New York for Panama.

PARIS

March. The fifth, and last, number of Cravan's Maintenant appears.

ZURICH

Arp, Tristan Tzara, Marcel Janco settle in Zurich. Arp begins collaboration with his future wife, Sophie Täuber. November. Galerie Tanner. Joint exhibition of Arp, Otto van Rees, and Mme van Rees. Arp shows precisely executed rectilinear collages and writes a preface to the catalogue.

FERRARA

July. De Chirico returns to Italy from Paris. He does military service at Ferrara, where he meets Carlo Carrà.

1916

NEW YORK

Man Ray makes collages called "Revolving Doors" (1916–1917); paints The Rope Dancer Accompanies Herself with Her Shadows.

The home of the poet Walter C. Arensberg is a meeting place for avant-garde artists and intellectuals such as Duchamp, Man Ray, Marius de Zayas.

PARIS

January. Pierre Albert-Birot begins to publish the review Sic, which soon shows Dadaist tendencies.

NANTES

Jacques Vaché and André Breton meet. Breton is an orderly in an army mental clinic, where he becomes interested in psychiatry.

ZURICH

February 5. Opening of the Cabaret Voltaire, founded by Hugo Ball.

February 26. Richard Huelsenbeck arrives from Berlin.

March 30. Gala night at Cabaret Voltaire during which Huelsenbeck, Janco, and Tzara (aided by the researches of the Futurists, and Henri Martin Barzun and Fernand Divoire) recite a simultaneous poem of their own creation.

April. The word "Dada" discovered.

June. Publication of the first, and only, issue of Cabaret Voltaire. The preface, written by Ball in May, uses the word "Dada" publicly for the first time. Contributors include,

among others, Apollinaire, Arp, Cendrars, Marinetti, Modigliani, Picasso, Tzara, Huelsenbeck, Kandinsky.

July. First publication under the Dada imprint: Tzara's *La première Aventure céleste de M. Antipyrine* (The First Celestial Adventure of Mr. Fire Extinguisher), with color woodcuts by Janco.

July 14. Salle zur Waag. First Dada Soirée. An evening of music, dances, manifestations, poetry readings, costumes, masks, paintings. Tzara reads the first Dada manifesto. Hugo Ball composes "Lautgedichte" (sound poems).

September. Huelsenbeck's *Phantastische Gebete* (Fantastic Prayers) published under the Dada imprint, with woodcuts by Arp.

October. Huelsenbeck's *Schalaben Schalomai Schalamezomai* published under the Dada imprint, with drawings by Arp.

Arp confirms his biomorphic style, begun the previous year, in wood reliefs (*Forest, Portrait of Tzara*) and "automatic" drawings. Begins collages "arranged according to the laws of chance."

[COLOGNE]

Max Ernst, serving as an artillery engineer in the German army, makes occasional small paintings.

BERLIN

January. Der Sturm. Max Ernst's first exhibition.

1917

BARCELONA

August. Picabia settles in Barcelona where he finds Marie Laurencin, Albert Gleizes, Arthur Cravan.

MADRID

April 23. Arthur Cravan knocked out by Jack Johnson in a boxing match.

NEW YORK

April. Picabia arrives from Barcelona where, in the first months of the year, he had published nos. 1–4 of his review *391*.

April 10–May 6. Grand Central Palace. *First Annual Exhibition of the Society of Independent Artists*. Picabia exhibits *Physical Culture* and *Music Is Like Painting*. Duchamp sends a urinal (Readymade) titled *Fountain* and signed "R. Mutt"; its rejection leads to his resignation from the jury. His Readymades are shown in the lobby of the Bourgeois Gallery.

Arthur Cravan arrives drunk at the Independents exhibition where he is to deliver a lecture. He curses the smartly dressed audience and begins to undress, but is stopped by police.

April–May. Beatrice Wood publishes, Man Ray and Duchamp edit, and H. P. Roché and Arensberg contribute to the two issues of *The Blind Man* (dealing mainly with the Independents controversy) and the one issue of *Rongwrong*.

June–August. Picabia publishes nos. 5, 6, 7 of *391*.

PARIS

May. Théâtre du Châtelet. First performance of Erik Satie's ballet, *Parade*, with scenario by Cocteau, choreography by Massine, décor and costumes by Picasso. The program contains an article by Apollinaire in which the earliest reference to "sur-réalisme" appears.

June 24. Première of Apollinaire's *Mamelles de Tirésias* (The Breasts of Tiresias), subtitled "a surrealist drama." Jacques Vaché, dressed as an English officer, brandishes a gun during the intermission and causes a riot.

Friendship of Breton, Philippe Soupault, and Louis Aragon. Breton sees a copy of *Dada 1* at the home of Apollinaire, although the Zurich magazines remain virtually unknown in Paris until 1919.

October. Picabia arrives from New York via Barcelona.

ZURICH

January–February. Galerie Corray. Dada Exhibition. Includes Arp, Janco, Hans Richter, Negro art; Tzara delivers three lectures: on Cubism, on the old and new art, and on the art of the present.

March 17. Galerie Dada (formerly the Galerie Corray) opens, with exhibition of Campendonk, Kandinsky, Klee, and others.

March 23. Galerie Dada. Grand opening ceremonies. Dance, music, and poetry program, dances by Sophie Täuber, costumes by Arp.

July. Publication of *Dada 1*, which succeeds the review *Cabaret Voltaire*. *Dada 1* and *Dada 2* (December) include contributions by Arp, de Chirico (*The Evil Genius of a King*), Janco, Kandinsky, and Klee.

Marcel Janco makes painted reliefs, masks, constructions; does an oil painting of the Cabaret Voltaire.

Augusto Giacometti joins the Dadaists, makes abstract paintings and a Dada machine from clockparts.

BERLIN

January. Huelsenbeck returns to Berlin from Zurich. In May he publishes "Der neue Mensch" in the magazine *Die Neue Jugend*, preparing the way for Dada.

BARCELONA

Miró meets Picabia, Laurencin, and Max Jacob.

1918

NEW YORK

Duchamp paints his last picture, *Tu m'*, a frieze-shaped canvas slightly over ten feet wide, for Katherine Dreier's library. Man Ray begins his "Aerographs," executed with an air gun.

MEXICO

Arthur Cravan is seen for the last time in a small town on the Mexican coast.

PARIS

November 9. Apollinaire dies. Memorial statements by Tzara and Picabia published in *Dada 3* (December).

Friendship of Breton, Paul Eluard, and Jean Paulhan is formed. They, as well as Aragon, Soupault, and Georges Ribemont-Dessaignes, see Dada periodicals in Paris and become interested in the movement.

Breton begins correspondence with de Chirico.

ZURICH

July 23. Salle zur Meise. *Soirée Tristan Tzara*.
December. Tzara's "Manifeste Dada 1918" is published in *Dada 3*.

BASEL

An artists' club, Das Neue Leben, is founded. Arp, Augusto Giacometti, and Janco are among its charter members.

LAUSANNE

February. Picabia arrives, stays in Gstaad. He meets Tzara and Arp, participates in *Dada 3*.

BERLIN

Huelsenbeck founds a new branch of Dada.

April. Club Dada is founded. First meeting April 12, at which Huelsenbeck reads a manifesto signed by Tzara, Franz Jung, George Grosz, Janco, Huelsenbeck, Gerhard Preiss, Raoul Hausmann, and Walter Mehring. One issue of a revue, *Club Dada*, published, edited by Mehring, Huelsenbeck, Jung, and Hausmann.

June. Kurt Schwitters seeks out Herwarth Walden to examine the possibility of exhibiting at Der Sturm gallery. Meets Arp, which leads to a close association with the Zurich Dadaists.

Hausmann and others develop new typography on the basis of Futurist compositions; makes "letterist" sound poems (working with individual letters instead of inventing words as had Ball and others); invents a form of photo-montage that is actually photo-collage.

COLOGNE

Max Ernst is discharged from the army; meets Baargeld (Alfred Grünewald).

1919

PARIS

March. First issue of *Littérature*, edited by Aragon, Breton, and Soupault.

April. *Littérature* publishes (continuing in the May issue) Breton's "discovery" of the *Poésies* of the nineteenth-century poet Isidore Ducasse (the "comte de Lautréamont"), the sole copy of which belongs to the Bibliothèque Nationale. Paul Valéry and André Gide are among *Littérature*'s heroes.

July. Duchamp arrives, stays with Picabia. They establish contact with the Dada group then meeting at the Café Certà. Duchamp adds a beard and mustache to a reproduction of the *Mona Lisa*, titles it *L.H.O.O.Q.*

Littérature publishes (continuing in the August and September issues) the letters of Jacques Vaché.

October. *Littérature* publishes (continuing in the November and December issues) "Les Champs magnétiques," by Breton and Soupault, later described by Breton as "incontestably the first Surrealist work (in no way Dada) since it is the fruit of the first systematic applications of automatic writing."

NANTES

January. Jacques Vaché commits suicide.

ZURICH

January. Kunsthaus. *Das neue Leben.* Exhibition includes Arp, Augusto Giacometti, Janco, Picabia, and others. Tzara delivers lecture, *L'Art abstrait* (Abstract Art); Janco, *Sur l'Art abstrait et ses buts* (Abstract Art and Its Aims).

February. Picabia publishes no. 8 of *391.*

April 9. Saal zur Kaufleuten. 8. *Dada-Soirée.* Program promises manifestoes, lectures, compositions, dance, simultaneous poems; lists, among others, Tristan Tzara's *Le Fièvre du mâle,* described as a simultaneous poem performed by 20 persons; Hans Arp's *Wolkenpumpe;* Suzanne Perottet playing compositions of Arnold Schönberg.

May. *Dada 4–5* appears with cover title *Anthologie Dada;* contains drawings by Picabia, woodcuts by Arp, reproductions of paintings by Augusto Giacometti, Kandinsky, Klee, and Richter.

Sophie Tauber makes "Dada heads" from hat molds.

November. Publication of *Der Zeltweg,* magazine edited by Tzara, Otto Flake, and Walter Serner, cover design by Arp.

BERLIN

January. Der Sturm. Schwitters shares group exhibition with Paul Klee and Johannes Molzahn.

February 6. Manifesto *Dadaisten gegen Weimar* appears, signed by Baader, Hausmann, Tzara, George Grosz, Janco, Arp, Huelsenbeck, and others.

June. Hausmann founds review *Der Dada* (three issues, 1919–1920).

COLOGNE

Ernst and Baargeld found the Dada conspiracy of the Rhineland, whose address is W/3 West Stupidia.

Ernst publishes a portfolio of eight lithographs influenced by Carrà and de Chirico entitled *Fiat Modes: Pereat Ars* (Let There Be Fashion: Down with Art).

HANOVER

Kurt Schwitters makes his first *Merz* collages, books, and poems; publishes *Anna Blume,* a poem formed by "collaging" the clichés of bourgeois sentimental language.

1920

NEW YORK

Duchamp, who has returned from Paris, Katherine Dreier, and Man Ray found the Société Anonyme, which is in effect the first museum of modern art in New York. Duchamp decides to change from "anti-artist" to "engineer," a shift in identity that is signaled by the adoption of the pseudonym Rrose Sélavy and photographs of Duchamp as a woman by Man Ray. His first machine is the *Rotary Glass Plate,* made, with the aid of Man Ray, of glass plates turned by a motor.

PARIS

January. Tzara, "awaited like a Messiah," arrives in Paris.

January 23. Palais des Fêtes. *Premier Vendredi de Littérature.* The first Friday soirée organized by *Littérature,* which serves as an introduction of the Dada manifestation into Paris. The program lists a talk by André Salmon, poems by or read by Max Jacob, Aragon, Breton, Eluard, Cocteau, Tzara, among others; a display of paintings by de Chirico, Juan Gris, Léger, sculpture by Jacques Lipchitz. Under the title "Poème," Tzara reads a newspaper article while Eluard and a friend of Breton's hammer on bells; Breton presents a Picabia drawing in chalk on a blackboard which he erases as the drawing appears.

February. Dada manifestations are held at the Salon des Indépendants, Club du Faubourg, and the Université Populaire du Faubourg St.-Antoine.

Dada 6 appears as *Bulletin Dada,* declares itself anti-pictorial and anti-literary; includes poems by Picabia, Tzara,

Breton, Aragon, and others, which had been recited at the January soirée.

March. *Dada 7* is published as *Dadaphone*; cover by Picabia, texts by Tzara, Picabia, Soupault, Eluard, Ribemont-Dessaignes, Breton, Aragon, and others.

March 27. Maison de l'Œuvre. *Manifestation Dada*. Comprised of manifestoes read by 38 lecturers, farces, music, and short plays, among them Tzara's *La première Aventure céleste de M. Antipyrine*, and Breton reading in total darkness Picabia's "Manifeste cannibale."

April. Picabia publishes the first of two issues of a new review, *Cannibale*, which includes his collage-picture *Portrait of Cézanne*, in which the artist is represented by a stuffed monkey.

May. *Littérature* publishes the 23 Dada manifestoes that were read at the February manifestations. The magazine now puts itself completely in the service of Dada.

May 26. Salle Gaveau. *Festival Dada*. Program lists *Le Célèbre illusioniste* by Ribemont-Dessaignes, during which colored balloons with the names of famous people are released; and Tzara's *La deuxième Aventure de monsieur Aa l'antipyrine*. The program also announces that "all the Dadaists will have their hair cut on stage."

August. *Nouvelle Revue Française* contains Breton's "Pour Dada."

BERLIN

With Raoul Hausmann, the brothers Herzfelde, Johannes Baader, and Hannah Höch, Huelsenbeck guides Berlin Dada toward a more radical political consciousness than it has elsewhere. George Grosz contributes to antibourgeois, antireligious, antipatriotic Dada magazines.

February. Huelsenbeck, Hausmann, and Baader organize a Dada tour that begins in Leipzig (Zentraltheater, February 24), and includes Teplitz-Schönau (February 26), Prague (Commodities Exchange, March 1; Mozarteum, March 2), and Karlsbad (March 5). In Prague—where the Czechs are opposed to them because they are Germans, the Germans consider them Bolsheviks, and the Socialists denounce them as reactionaries—the atmosphere of violence built up against

them by weeks of publicity causes Baader to desert the tour.

April. Der Sturm. First one-man show of Schwitters.

June. Kunsthandlung Dr. Otto Burchard. *Erste Internationale Dada-Messe*. First international Dada fair brings together 174 Dada objects and works of art.

Dada Almanach, the last important German Dada publication, appears, edited by Huelsenbeck.

Arp visits Berlin, meets El Lissitzky, Schwitters, and the Dadaists.

COLOGNE

February. Publication of *Die Schammade* (*Dadameter*), edited by Ernst, cover by Arp, contributions by Aragon, Baargeld, Breton, Huelsenbeck, and others.

April. Brauhaus Winter. *Dada-Vorfrühling: Gemälde, Skulpturen, Zeichnungen, Fluidoskeptrik, Vulgärdilettantismus.* Participants are Arp, Baargeld, and Ernst. Entrance to exhibition is through a public urinal; Ernst supplies a hatchet with one object so that the public may destroy it; a young girl in first communion dress recites obscene poetry. Police close the exhibition, but it reopens in May when it appears that the work judged most shocking by the police is Dürer's engraving *Adam and Eve*.

Ernst collaborates with Arp, and also with Baargeld, on a series of collages that they call "Fatagaga" (FAbrication de TAbleaux GArantis GAzométriques [Manufacture of Pictures Guaranteed To Be Gasometric]).

BRUSSELS

René Magritte has his first exhibition, which he shares with P. Flouquet, at the Centre de l'Art. Meets E.L.T. Mesens.

1921

NEW YORK

Man Ray invents his "Rayographs"; makes Dada objects, such as *Gift*.

April. Publication of *New York Dada*, edited by Duchamp and Man Ray.

July. Man Ray leaves for Paris.

April 14. *Excursions & Visites Dada. 1ère Visite: Eglise Saint Julien le Pauvre*. The first, and only, of a series of derisive Dada visits to various places "to remedy the incompetence of suspect guides and cicerones."

May 3–June 3. Au Sans Pareil. *Exposition Dada Max Ernst*. First Paris exhibition of Ernst's collages, opening is staged as a Dada demonstration.

May 13. Salle des Société Savantes. *Mise en Accusation et Jugement de M. Maurice Barrès par Dada* (Trial and Sentencing of M. Maurice Barrès by Dada). Breton is presiding judge at the "trial" of the writer Maurice Barrès, indicted by the Dadaists for "crimes against the security of the spirit." Picabia disapproves and does not take part; Tzara, too, is critical but participates as one of the "witnesses" against Barrès, who is represented by a life-size mannequin.

June 6–30. Galerie Montaigne. *Salon Dada, Exposition Internationale*. End of season Dada exhibition and series of demonstrations. Catalogue, which lists 81 works, contains contributions from poets and artists including, among others, Arp, Aragon, Eluard, Péret, Man Ray, Tzara. Soupault's entry in the exhibition is a mirror entitled *Portrait of an Unknown*; slips of paper with numbers (28–31) take the place of the works Duchamp refused to send. Tzara's *Le Cœur à gaz* (The Gas-Operated Heart) given for the first time. The last major Dada show.

July. Having renounced Dada in published statements, Picabia turns violently against his former colleagues; publishes a special number of *391—Le Pilhaou-Thibaou*—in which he denies that Tzara invented the word "Dada."

Man Ray arrives; Duchamp introduces him to the Dadaists.

August. Last issue of series 1 of *Littérature* is devoted to the Barrès trial held in May.

December 3–31. Librairie Six. *Exposition Dada, Man Ray*. A retrospective exhibition of 35 works dating 1914–1921. Catalogue notes by Aragon, Arp, Eluard, Ernst, Man Ray, Ribemont-Dessaignes, Soupault, and Tzara.

Ernst makes proto-Surrealist paintings (*The Elephant Celebes*)

that merge collage imagery of the previous years with elements of Chiricoesque style. Makes his first entirely illusionistic collage of old engravings.

September 1. Commodities Exchange. Anti-Dada and *Merz* soirée organized by Schwitters and Hausmann which consists of poetry readings by both men. Schwitters hears Hausmann's phonetic poem *fmsbw* for the first time, which has a profound effect on him.

September. Arp, Ernst, and Tzara vacationing together in Tarrenz-bei-Imst publish *Dada Intirol Augrandair*, the last important Dada publication; includes Arp's fantasy on the origin of the word "Dada," which is later seriously used to support Tzara's claim to the discovery of the word.

Breton, on his honeymoon, joins the Dadaists and, except for a brief excursion to Vienna to have an interview with Freud, remains through October when he and Eluard return to Paris by way of Cologne where they visit Ernst.

January–April. During the winter months Breton attempts to organize a Congrès de Paris (Congress of Paris), a Congrès International pour la Détermination des Directives et la Défense de l'Esprit Moderne (International Congress for the Determination of Directives and for the Defense of the Modern Spirit). The Organizing Committee includes Georges Auric, Delaunay, Léger, Ozenfant, Paulhan, and Roger Vitrac. Tzara refuses to participate, for which he is attacked by Breton who declares that Tzara is not the father of Dada and accuses him of having usurped credit for the Dada manifesto of 1918 from Serner, whom he alleges to be the author. In a meeting at the Closerie des Lilas (February 17) Breton is called to account for the character of his attacks on Tzara, and the forty-five persons present pass a resolution withdrawing their confidence from the Organizing Committee. In April Tzara edits a pamphlet, *Le Cœur à barbe* (The Bearded Heart). These last events virtually mark the end of the Dada movement.

1922–1923

March. Publication of the first issue of the new series of *Littérature*, now edited by Breton, which moves away from Dadaism toward what will become Surrealism.

Man Ray publishes *Les Champs délicieux*, an album of 12 Rayographs, preface by Tzara.

Masson in Paris; signs contract with Kahnweiler. Friendship with Miró, the poets Armand Salacrou, Georges Limbour, Michel Leiris. Miró and Masson have adjoining studios at 45 Rue Blomet.

ST.-RAPHAEL
Picabia publishes sole issue of review, *La Pomme de Pins* (The Pine Cone), dated February 25, in which he attacks the Congress of Paris and most of the Dadaists.

COLOGNE
Arp and Sophie Täuber marry.

HANOVER
Schwitters organizes lectures for Tzara in Hanover, Jena, and Weimar.

BERLIN
Grosz breaks with the Dadaists.

WEIMAR
October. *Kongress der Konstruktivisten* (Congress of the Constructivists). Led by Theo van Doesburg, includes Tzara and Arp against the will of more purist members. Among others participating are El Lissitzky, Richter, Moholy-Nagy.

BARCELONA
November 18–December 8. Galeries Dalmau. *Exposition Francis Picabia*. Breton and Picabia journey to Barcelona for the opening of the exhibition; catalogue preface by Breton. Breton also delivers a lecture on modern art.

BRUSSELS
Magritte is introduced to the work of de Chirico through a reproduction of *The Song of Love*.

1923
NEW YORK
Duchamp definitively "incompletes" *The Bride Stripped Bare by Her Bachelors, Even* (the *Large Glass*).

PARIS
July 7. Théâtre Michel. *Soirée du "Cœur à barbe"* (Soirée of the Bearded Heart). Among the performances scheduled are films by Richter and Man Ray, music by Satie, Auric, Stravinsky, and Milhaud, and a performance of Tzara's *Cœur à gaz*. Breton, Aragon, Péret, and Eluard provoke a full-scale riot. Breton later accuses Tzara of being responsible for the police action brought against them.

Breton and his circle dispute the use of the term "surrealism" with Ivan Goll and Paul Dermée, who had also adopted it from Apollinaire.

Summer. Breton and Picasso meet.

Eluard visits the de Chirico exhibition at the second Rome Biennale, purchases a number of new pictures which, on Eluard's return to Paris, are severely criticized by Breton. Rapid disenchantment of the Surrealists with de Chirico ensues.

Tanguy's accidental discovery of an early de Chirico painting in the window of Paul Guillaume's gallery crystallizes his desire to become a painter.

Masson meets Breton and makes first automatic drawings (winter 1923/1924), and semi-Cubist paintings influenced by Picasso, Gris, and Derain.

Toward the end of the year Miró begins his transition from Cubism to Surrealism.

HANOVER
Schwitters publishes the first issues of the review *Merz*: first number (January) is subtitled *Holland-Dada*; second (April) contains "Manifest Proletkunst" signed by Theo van Doesburg, Schwitters, Arp, Tzara; third consists of a portfolio of 6 lithographs by Schwitters; fourth (July) is subtitled *Banalitäten*; fifth is another portfolio, 7 *Arpaden*, containing 7 lithographs by Arp; sixth (October) is subtitled *Imitatoren*.

December 30. Hausmann and Schwitters give a *Merzmatinee* during which one of the presentations consists of Hausmann and Schwitters standing on a darkened stage, Hausmann holding the switch to an electric light while Schwitters recites

one of his poems. After every other line Hausmann turns on the light, revealing himself in a grotesque pose. Thus, during the 20 lines of the poem there is an alternation between noisy darkness and silent light.

1924
PARIS

The Café Cyrano in the Place Blanche, near the home of Breton in the Rue Fontaine, is an important meeting place for the Surrealists. Evening gatherings take place at Breton's home, and at the studios of Miró and Masson in the Rue Blomet.

Aragon's *Une Vague de rêves* summarizes the experiments in hypnosis begun two years earlier.

Miró joins the Surrealists and is introduced to Arp's work.

February. Galerie Simon. First one-man exhibition of Masson. Fantasy elements are breaking through Cubist structures. Meets Eluard, Aragon; joins the Surrealists.

July. Ernst sails for the Far East, meets Paul and Gala Eluard in Saigon; returns to Paris in the fall.

October. Ivan Goll publishes the only issue of the review *Surréalisme.*

Breton publishes *Manifeste du surréalisme* in which Surrealism is defined primarily in terms of automatism.

Anatole France dies and the Surrealists publish a pamphlet entitled *Un Cadavre* attacking him. They are in turn viciously attacked in the newspapers.

Bureau de Recherches Surréalistes (Bureau of Surrealist Research) is opened in the Rue de Grenelle; distributes the *papillons surréalistes.*

Picabia now turns against the Surrealist group and lampoons them in the final issue of *391.*

Duchamp makes *Rotating Demisphere,* which anticipates the "Rotoreliefs" of 1934.

December. Rolf de Maré's Ballets Suédois stages Picabia's Dada ballet *Relâche,* with music by Satie. During the intermission, *Entr'acte,* a film made by Picabia and René Clair, is shown; Satie's score is first music written especially for a film.

Founding of the review *La Révolution Surréaliste;* editors, Pierre Naville and Benjamin Péret; motto, "We must work toward a new declaration of the rights of man." First issue includes accounts of dreams by de Chirico and Breton, auto-

matic texts, illustrations by Ernst, Masson, Man Ray, and Picasso.

1925
PARIS

January 15. The second issue of *La Révolution Surréaliste* publishes responses to the question posed in the December issue: "Le Suicide est-il une solution?" (Is suicide a solution?)

April 15. Third issue of *La Révolution Surréaliste* contains collective addresses to the Pope ("The confessional, O Pope, is not you but us"), the Dalai Lama, Buddhist schools, rectors of European universities, and directors of insane asylums. It is in this issue that Naville declares "there is no such thing as Surrealist painting."

June 12–27. Galerie Pierre. *Exposition Joan Miró.* First exhibition of Miró's Surrealist painting, catalogue text by Péret.

Tanguy and Prévert join the Surrealists, having been introduced into the Breton circle late in the previous year. Marcel Duhamel shares a house in the Rue du Château with them, which becomes a center of Surrealist activity.

Beginning of the collective drawing and poem on folded paper called *cadavre exquis* (exquisite corpse).

Arp returns to Paris, takes studio near Miró and Ernst in the Rue Tourlaque in Montmartre; he begins to participate in the Surrealist group.

Duchamp begins to devote himself increasingly to chess.

August. Ernst begins to develop *frottage* (rubbing), an automatic technique first used in drawing, then adapted to painting.

October 21–November 14. Galerie Vavin-Raspail. *39 Aquarelles de Paul Klee.* First one-man show of Klee in Paris; catalogue includes introduction by Aragon, poem by Eluard.

November 14–25. Galerie Pierre. *Exposition, La Peinture Surréaliste.* First group exhibition of Surrealist painting includes Arp, de Chirico, Ernst, Klee, Masson, Miró, Picasso, Man Ray, Pierre Roy; catalogue text by Breton and Desnos. Though Klee's name is mentioned in the Surrealist manifesto, he never actively participates in the movement. He is subsequently championed by the Surrealists but arouses little interest otherwise in France.

1925–1927

BERLIN

Schwitters exhibits at Der Sturm gallery.

HANOVER

Merz no. 13 consists of a phonograph record, "Lausonate." The "Golden Grotto" section of *Merzbau* is completed.

BRUSSELS

March. Magritte and Mesens publish the sole issue of *Oesophage*, which includes contributions by many leading Dadaists. Magritte begins to paint his first mature works.

1926

NEW YORK

Duchamp's *Large Glass* is broken on its return from an exhibition of modern art at The Brooklyn Museum.

PARIS

March 26–April 10. Galerie Surréaliste. *Tableaux de Man Ray et Objets des Iles*. Opening exhibition of the Surrealist gallery in the Rue Jacques-Callot is a retrospective of paintings and objects by Man Ray, and primitive sculptures of the Pacific Islands from the collections of Breton, Eluard, Aragon, and others.

Miró and Ernst are attacked by certain Surrealists for collaborating on the décor of Constant Lambert's *Roméo et Juliette* for Diaghilev's Ballets Russes. Collaborating with such an organization is viewed as inimical to the subversive ideal of Surrealism. The opening of the ballet (May 4) is broken up by a Surrealist demonstration, but Miró and Ernst return to grace shortly afterward.

Naville writes "La Révolution et les intellectuels. Que peuvent faire les surréalistes?" (Revolution and the Intellectuals. What Can the Surrealists Do?); in September, Breton replies in a pamphlet, *Légitime Défense*. Naville crisis ensues; he leaves the Surrealist group to become coeditor of the Communist magazine *Clarté*. In November, Artaud and Soupault are expelled from the Surrealist group for "recognizing value in purely literary activity."

Arp settles in the Parisian suburb of Meudon. *La Révolution Surréaliste* (June) reproduces his new work.

Tanguy paints pictures that combine landscapes and figures with collage-in-*trompe l'oeil* elements suggested by Ernst's paintings of 1921–1924.

Picasso reflects first influence of Surrealism.

Man Ray publishes *Revolving Doors, 1916–1917*, a series of abstract collages he had made in New York. He, Duchamp, and Marc Allégret make the film *Anemic Cinema*.

BRUSSELS

October. Aragon acts as intermediary in bringing about official contact between the Paris Surrealists and the Surrealist group founded by Magritte and Mesens, which also includes Louis Scutenaire, Paul Nougé, and Camille Goemans.

MADRID

Dali paints *The Basket of Bread* in detailed but visionary realism. Begins to exhibit in Madrid and Barcelona; is permanently expelled from the Madrid School of Fine Arts.

1927

PARIS

January. Ernst visits Megève, where he begins series of "Hordes." Returns to Paris in February. Continues the "Forests"; other new series are "Shell Flowers" and "Monuments to the Birds."

Breton publishes *Introduction au discours sur le peu de réalité*, probably written in 1924, in which he raises the question of "Surrealist objects."

Aragon, Breton, and Eluard publish *Lautréamont envers et contre tout*.

Masson makes his first sand paintings; by "automatically" spreading glue on the raw canvas and pouring sand on the glue areas, he counterpoints the patterns that result by drawing directly with paint squeezed from a specially constructed tube.

Man Ray makes the film *Emak Bakia*.

Tanguy paints pictures that establish the biomorphism which remains characteristic of his art.

May 26–June 15. Galerie Surréaliste. *Yves Tanguy et Objets*

d'Amérique. First one-man exhibition of Tanguy, catalogue preface by Breton.

Alberto Giacometti moves to studio on the Rue Hippolyte-Maindron, where he will live until his death in 1966.

August. Magritte moves to Perreux-sur-Marne, near Paris (where he remains until 1930) and joins the Surrealist milieu.

October. The only issue of *La Révolution Surréaliste* published during the year contains the French translation of "Hands Off Love," a defense of Charlie Chaplin that had appeared in the September issue of *Transition*; protests official recognition of Rimbaud; reproduces for the first time *cadavre exquis* drawings. The issue also contains the conclusion of Breton's study, "Le Surréalisme et la peinture."

CANNES

Picasso begins sculpturally shading his biomorphic forms; first use of the Minotaur motif.

[COLOGNE]

Baargeld is killed in an avalanche while climbing in the Alps.

MUNICH

Hugo Ball publishes *Die Flucht aus der Zeit*, his diary of the Dada period.

BRUSSELS

April 23–May 3. Galerie Le Centaur. *Exposition Magritte.* First one-man show of Magritte, who had been able to devote himself entirely to painting the previous year thanks to the gallery's aid.

MADRID

Dali, having become interested in Surrealism largely through its publications, begins to work in a new and Surrealist-influenced manner.

LONDON

Two "Sound Poems" by Schwitters published in *Ray* no. 2.

1928

PARIS

February 15–March 1. Galerie Surréaliste. *Œuvres Anciennes de Georges de Chirico.* Retrospective exhibition, catalogue preface by Aragon.

March. Sole issue of *La Révolution Surréaliste* published during the year contains the questionnaire-discussion of researches in sexuality.

Breton publishes his Surrealist "anti-novel" *Nadja*.

Publication of Breton's *Le Surréalisme et la peinture*, composed of the essays on Picasso, Miró, Braque, de Chirico, Ernst, Man Ray, and Masson which had appeared in successive issues of *La Révolution Surréaliste*, augmented by texts on Tanguy and Arp. The de Chirico text testifies to a final break with the artist.

April 2–15. Au Sacre du Printemps. *Exposition Surréaliste.* Group exhibition includes Arp, de Chirico, Ernst, Georges Malkine, Masson, Miró, Picabia, Roy, Tanguy.

May 1–15. Galerie Georges Bernheim. Miró exhibition.

Desnos and Man Ray make the film *L'Etoile de Mer.*

Masson, abandoning sand painting, reverts to a more Cubist style.

Ernst continues monumental pictures on the theme of Birds, Flowers, and Forests.

Giacometti sculpts from memory, influenced by Brancusi and Lipchitz; friendship with Masson, Leiris, and the "dissident" Surrealists (Queneau, Limbour, Desnos, Prévert) knows Miró.

On various trips to Paris, Dali meets Picasso, Miró, and the Surrealists. He and Luis Buñuel make the film *Un Chien Andalou*, which is shown privately at the Cinéma au Vieux-Columbier.

December 1–15. Galerie Georges Bernheim. *Max Ernst, Ses Oiseaux, Ses Fleurs Nouvelles, Ses Forêts Volantes, Ses Malédictions, Son Satanas.* Catalogue text by Crevel.

1929

PARIS

April. Georges Bataille founds the review *Documents*; Desnos, Leiris, and Prévert collaborate. Concerned with painting of

HOLLAND

Spring. Miró visits Holland, paints three "Dutch Interiors."

all epochs, ethnography and archaeology, it anticipates the character of the later *Minotaure*. Picasso, Léger, Miró, Arp, Masson, Braque, Brancusi, Klee, Giacometti, and Lipchitz are among the contemporary artists whose work is represented.

Man Ray makes film *Les Mystères du Château de Dé* at the home of the vicomte de Noailles.

Miró drifts from the Surrealist milieu but does not break with Breton; makes "imaginary" portraits, highly abstract collages with sandpaper.

Giacometti officially joins the Surrealist circle.

Picasso makes his "bone" paintings.

Masson disengages from the Surrealist movement, dubs himself "dissident" Surrealist.

Ernst's collage-novel, *La Femme 100 Têtes*, published.

Autumn. Dali moves to Paris; he, Buñuel, and René Char join the Surrealists.

October 1–December 23. Studio 28. First public showing of *Un Chien Andalou.*

November 20–December 5. Galerie Goemans. *Dali.* First one-man exhibition in Paris, catalogue essay by Breton.

December. In the last issue of *La Révolution Surréaliste*, Breton publishes the "Second Manifeste du surréalisme," calling it a "recall to principles," a "purification of Surrealism." The list of Surrealist "precursors" is drastically revised: Baudelaire, Rimbaud, Poe, and de Sade are rejected; fourteenth-century alchemists such as Nicolas Flamel are celebrated. Automatism is not mentioned. Former Surrealists Artaud, Vitrac, Limbour, Masson, and Soupault are castigated.

BRUSSELS
June. Special issue of the Belgian magazine *Variétés* is subtitled "Le Surréalisme en 1929," contains articles by leading Belgian and Parisian Surrealists, photographs by Man Ray, exquisite corpses made in collaboration by Miró, Max Morise, Man Ray, and Tanguy, reproductions of work by Magritte, Picabia, Arp, Ernst, and Tanguy.

1930
PARIS
Under the title *Un Cadavre* (which had earlier served for the Surrealist attack on Anatole France), dissident Surrealists violently attack Breton; Leiris, Queneau, Desnos, and Prévert are joined by independents Bataille and Ribemont-Dessaignes. Breton is described as a "flic" (cop), "false curé," "false friend," "false Revolutionary," "false Communist." In a new publication of the second manifesto, Breton interpolates a reply to these attacks.

Breton finds activity in a Communist cell (Gasworks) incompatible with Surrealism, searches for a formula of co-operation between the two movements.

March. Galerie Goemans. *Exposition de Collages.* Catalogue contains important preface by Aragon, "La Peinture au défi."

Ernst begins new collage and painting series, "Loplop présente"; second collage-novel published, *Rêve d'une petite fille qui voulut entrer au Carmel.*

After false starts in 1929, Arp makes first small sculptures in the round; begins "torn papers." Joins Seuphor's Circle and Square group, as does Schwitters.

July. First issue of *Le Surréalisme au Service de la Révolution,* a new review succeeding *La Révolution Surréaliste,* which is founded under the direction of Breton; includes a statement of solidarity with Breton signed by, among others, Aragon, Buñuel, Dali, Eluard, Ernst, Péret, Tanguy, and Tzara.

November 28–December 3. *L'Age d'Or,* film made by Buñuel and Dali, is shown at Studio 28. After a few showings it provokes a violent rightist riot, ink is thrown at the screen, seats are destroyed, and the Surrealist paintings exhibited in the entrance hall (Dali, Ernst, Miró, Tanguy) are damaged and destroyed. The film is banned by the police.

Victor Brauner arrives from Bucharest.

KHARKOV
Aragon attends the Second International Congress of Revolutionary Writers; delivers a *mea culpa* denouncing many Surrealist views, signs a letter to the International Writers' Union which attacks the second Surrealist manifesto, idealism, and Freudianism and Trotskyism as forms of idealism, and pro-

claims acceptance of Communist discipline. Writes the poem *Front rouge* (Red Front), returns to France a Communist convert but does not break with Surrealism.

Picasso makes drawings after Grünewald's Isenheim *Crucifixion*.

HANOVER
Schwitters publishes last issue of *Merz* (no. 24), which contains "Ursonate"; joins "abstraction-création" group.

1931
HARTFORD, CONNECTICUT
November. Wadsworth Atheneum. *Newer Super-Realism*. First important Surrealist exhibition in the United States; 50 works, including de Chirico, Dali, Ernst, Masson, Miró, Picasso.

PARIS
Arp and Giacometti are in close contact.
December. *Le Surréalisme au Service de la Révolution* publishes Dali's "Objets à fonctionnement symbolique," and his "Visage paranoïaque," the first of a series of "double images" he will produce through the 1930s. Issue also reproduces one of Clovis Trouille's anticlerical pictures.

1932
NEW YORK
January 9-29. Julien Levy Gallery. *Surrealist Group Show*. Exhibition previously shown at the Wadsworth Atheneum.

PARIS
January. As a result of the publication of his *Front rouge* (Red Front), Aragon is charged by the government with provoking military disobedience and inciting to murder. Breton and others circulate a petition that is signed by some 300 intellectuals; Gide and Romain Rolland are among those who refuse to sign, maintaining that true revolutionaries bear the responsibility for their work, whatever the risks. Breton publishes a tract intended to be a defense of Aragon, which Aragon, however, disavows. In March, Aragon formally breaks with the Surrealists, who publish a pamphlet criticizing him.
Breton publishes *Les Vases communicants*, in which he attempts to prove that there is no contradiction between Marx and Freud.
Giacometti has first one-man show at the Galerie Pierre Colle.
Arp joins "abstraction-création" group.

1933
PARIS
May. The last issue of *Le Surréalisme au Service de la Révolution* marks the temporary end of official Surrealist reviews. The review *Minotaure* is founded under the direction of Albert Skira and E. Tériade. With no. 3-4 (December) it becomes a preponderantly Surrealist-oriented publication. The main collaborators are Breton, Dali, Eluard, Maurice Heine, Pierre Mabille, and Péret.
For refusing to condemn a letter he had published in *Le Surréalisme au Service de la Révolution* in which Ferdinand Alquié criticized the Russian film *The Road to Life*, Breton is expelled from the newly-founded Association des Écrivains et Artistes Révolutionnaires.
Publication of Marcel Raymond's *De Baudelaire au surréalisme*.
Victor Brauner is introduced to the Surrealists by Tanguy.
June 7-18. Galerie Pierre Colle. *Exposition Surréaliste*. Works by Duchamp, Ernst, Eluard, Giacometti, Marcel Jean, Dali, Magritte, Miró, Picasso, Man Ray, Tanguy, and others. Dali proposes a catalogue preface (used immediately afterward for his one-man show at the same gallery, June 19-29) which contemptuously dismisses Cézanne as "un peintre très sale" and praises Meissonier.
Mason paints the décor for *Les Présages* (Ballets Russes de Monte Carlo), his first work for the theater.
Surrealist group show at the Salon des Surindépendants includes Arp, Brauner, Dali, Ernst, Giacometti, Valentine Hugo, Magritte, Miró, Oppenheim, Man Ray, Tanguy, Trouille. Kandinsky, recently arrived in Paris, participates as guest of honor.
December. Trial of Violette Nozières, who murdered her parents, is commemorated by the Surrealists in a booklet of

1933–1935

poems and drawings by Arp, Brauner, Breton, Dali, Eluard, etc., cover by Man Ray, published by Editions Nicolas Flamel.

NORWAY

Schwitters moves temporarily to Norway, where he spends increasing amounts of time.

1934

NEW YORK

November. Dali makes first trip to the United States.

November 21–December 10. Julien Levy Gallery. *Paintings by Salvador Dali.*

December. Julien Levy Gallery. *Abstract Sculpture by Alberto Giacometti.* First one-man show of Giacometti in the United States.

PITTSBURGH

Dali's painting *Enigmatic Elements in a Landscape* awarded honorable mention at the Carnegie International.

PARIS

January. Dali is officially censured by the Surrealists for his interest in Nazism and his Hitlerian fantasies, but continues to participate in the Surrealists' exhibitions.

Breton publishes (in Brussels) *Qu'est-ce que le surréalisme?*, illustrated by Magritte.

Publication of *Petite Anthologie poétique du surréalisme,* with important critical introduction by Georges Hugnet.

Ernst spends summer with Giacometti in Maloja (Switzerland), begins relief sculpture on stones; returns to Paris and during the winter months makes plasters of major pieces. Publishes his third collage novel, *Une Semaine de bonté.*

Matta begins to study architecture in the office of Le Corbusier.

Toward the end of the year Oscar Dominguez joins the Surrealists.

December. Galerie Pierre. First exhibition of Victor Brauner in Paris, catalogue preface by Breton. Shortly afterward Brauner returns to his native Bucharest.

Minotaure (no. 6) publishes photographs of Hans Bellmer's first *poupée* in various arrangements.

SPAIN

Masson lives in Catalonian fishing village.

1935

NEW YORK

January 10–February 9. Pierre Matisse Gallery. *Joan Miró 1933–1934.*

January 11. The Museum of Modern Art. Salvador Dali gives an illustrated lecture, *Surrealist Painting: Paranoiac Images,* translated from the French by Julien Levy.

Masson has exhibition at Pierre Matisse Gallery.

Arshile Gorky joins the WPA Federal Art Project and begins work on murals for Newark Airport.

Dali's *Conquest of the Irrational* published by Julien Levy.

Publication of James Thrall Soby, *After Picasso,* first American book primarily devoted to Surrealism.

PARIS

June. A week before the opening of the Congrès des Ecrivains pour la Défense de la Culture, an international congress of writers that aims at furthering Franco-Soviet cultural relations, Breton slaps Ilya Ehrenburg for having published remarks hostile to Surrealism. As a result Breton is not permitted to address the congress, which leads to Crevel's suicide. In the *Bulletin International du Surréalisme* published in August in Brussels the Surrealists denounce both the congress and the Soviet Union.

Breton creates first "poem-objects," compositions in which he combines poetry and the plastic arts.

Picasso abandons himself to writing poetry; his first poems are Surrealist in character and derive from the technique of automatic writing.

Giacometti returns to painting and to working from the model. He is officially expelled from the Surrealist group; later he disowns his early work.

Duchamp's Rotoreliefs are published; he presents them at the Concours Lépine, an annual show for inventors.

Wolfgang Paalen joins the Surrealists.

Dominguez discovers the technique of decalcomania.

LONDON

David Gascoyne publishes *A Short Survey of Surrealism*, the first book in English devoted entirely to Surrealism.

1936

NEW YORK

Duchamp repairs the *Large Glass*.

Julien Levy publishes *Surrealism*, an anthology.

December 9, 1936–January 17, 1937. The Museum of Modern Art. *Fantastic Art, Dada, Surrealism*. Exhibition directed by Alfred H. Barr, Jr., accompanied by an extensively illustrated catalogue, provokes popular controversy.

PARIS

May 22–29, Galerie Charles Ratton. *Exposition Surréaliste d'Objets*. In addition to Surrealist objects, exhibition includes natural objects, interpreted natural objects, perturbed objects, found objects, mathematical objects, Readymades, etc. Special issue of *Cahiers d'Art* on the object includes an essay by Breton, "Crise de l'objet" (The Crisis of the Object).

June. *Minotaure* (no. 8) publishes decalcomanias by Breton, Dominguez, Hugnet, Marcel Jean, and Yves Tanguy.

Surrealists attack the Moscow trials.

BRUSSELS

Paul Delvaux is introduced to the work of de Chirico, Dali, and Magritte by E. L. T. Mesens and Claude Spaak; associates with Belgian Surrealists; evolves mature style.

LONDON

June 11–July 4. New Burlington Galleries. *International Surrealist Exhibition*. Catalogue text by Breton, introduction by Herbert Read, exhibition includes some 60 artists from 14 nations; in addition to the official Surrealist artists, exhibition also includes works by Brancusi, Klee, Picasso, Henry Moore; in addition to Surrealist objects, there are Oceanic objects, African and American objects, photographs of objects from the British Museum, familiar objects, found objects, natural objects interpreted; children's drawings.

Publication of *Surrealism*, edited and with an introduction by Herbert Read, with contributions by Breton, Eluard, Hugnet.

1937

PARIS

Masson returns from Spain, reconciles with Breton, and participates in Surrealist reviews.

Breton opens Galerie Gradiva, a Surrealist gallery on the Rue de Seine, named after the heroine in a story by the German writer Wilhelm Jensen, which had been analyzed by Freud. The glass door, cut out in the silhouette of a couple, is by Duchamp.

Breton publishes *L'Amour fou*.

Miró briefly returns to painting in a realistic vein.

September 22–26. Performance of Alfred Jarry's *Ubu enchaîné* by the company of Sylvain Itkine at the Comédie des Champs-Elysées. Sets by Max Ernst; program pays homage to Jarry with a series of Surrealist texts and illustrations by Magritte, Miró, Paalen, Picasso.

Paalen invents the technique of *fumage*, in which patterns are achieved by passing a candle flame swiftly across a freshly painted surface.

Esteban Francés and Kurt Seligmann join the Surrealist circle.

Matta makes first drawings; joins the Surrealists. Meets Gordon Onslow-Ford who is so impressed with Matta's drawings that he decides to become a painter.

Antonin Artaud institutionalized.

December. Breton takes over editorial direction of *Minotaure*.

NORWAY

Schwitters settles outside Oslo; begins work on second *Merzbau* (destroyed February 1951).

1938

MEXICO

February. Breton, on a lecture tour, stays at the house of Diego Rivera where he meets Rivera's other guest, Leon Trotsky.

1938–1939

July. Breton and Trotsky collaborate on the manifesto *Pour un art révolutionnaire indépendant* (Toward an Independent Revolutionary Art), although at Trotsky's request Rivera's signature replaces his own.

PARIS

January-February. Galerie Beaux-Arts. *Exposition Internationale du Surréalisme.* Organized by Breton and Eluard, general supervision by Duchamp, technical advisers Dali and Ernst, lighting by Man Ray, "waters and brushwood" by Paalen. Catalogue, accompanied by a *Dictionnaire abrégé du surréalisme* compiled by Breton, Eluard, and others, lists 60 artists from 14 countries exhibiting 229 entries, announces: "Ceiling covered with 1,200 sacks of coal, revolving doors, Mazda lamps, echoes, odors from Brazil, and the rest in keeping."

Publication of the complete works of Lautréamont, illustrated by Brauner, Dominguez, Ernst, Magritte, Man Ray, Masson, Matta, Miró, Paalen, Seligmann, Tanguy.

Gordon Onslow-Ford joins the Surrealists.

Matta begins his first oils, a series of "psychological morphologies," or "Inscapes."

Bellmer arrives from Berlin; forms friendship with Eluard and Tanguy, in contact with Arp, Breton, Duchamp, Ernst, Man Ray.

Cuban-born Wifredo Lam arrives after living in Spain for 14 years, becomes close friends with Picasso and Dominguez, has exhibition at the Galerie Pierre.

August. Breton returns from Mexico, breaks permanently with Eluard over Stalinism. Ernst leaves the Surrealist group on behalf of Eluard, Hugnet is expelled.

LONDON

April. First issue of the Surrealist-oriented *London Bulletin* (published by the London Gallery), under the direction of Mesens.

1939
NEW YORK

Wifredo Lam paintings shown at the Perls Gallery.

March 15–16. Dali creates two display windows for Bonwit Teller called *Day (Narcissus)* and *Night (Sleep).* The store alters one, and in the agitation that follows as Dali struggles with a fur-lined bathtub, he crashes through the plate-glass window.

June. Opening at the World's Fair of Dali's *Dream of Venus,* a Surrealist exhibit in which "liquid ladies" float through the water against a background of ruined Pompeii among an undulating piano, an exploding giraffe, botanical typewriters, etc., occasionally milking a cow, while Venus lies on a couch thirty-six feet long dreaming the dreams of all mankind. The "Rainy Taxi" of the 1938 Paris exhibition is re-created.

Matta arrives.

November. Tanguy arrives, joins Kay Sage.

December 6–31. Julien Levy Gallery. *Exhibition of Objects by Joseph Cornell.* Catalogue text by Parker Tyler.

MEXICO

September. Paalen arrives.

FRANCE

Breton and Péret drafted as war breaks out. Breton assumes a medical post with a pilots school at Poitiers.

Onslow-Ford invents *coulage.*

September. Still a German citizen, Ernst is interned as an enemy alien. At a concentration camp in Les Milles (near Aix-en-Provence), with Bellmer, he experiments with decalcomania. He is liberated at Christmas as a result of Eluard's efforts. At his studio in St.-Martin-d'Ardeche he uses the technique of decalcomania to begin some large canvases.

LONDON

July 19. Dali, brought to visit Freud by Stefan Zweig, makes a sketch of Freud and maintains that Freud's cranium is reminiscent of a snail. The next day Freud writes to Zweig: "...until now I have been inclined to regard the Surrealists, who have apparently adopted me as their patron saint, as complete fools.... That young Spaniard, with his candid fanatical eyes and his undeniable technical mastery, has changed my estimate. It would indeed be very interesting to investigate analytically how he came to create that picture."

1940

NEW YORK

April 16–May 7. Julien Levy Gallery. *Matta.* First exhibition in New York; "catalogue," in form of a newssheet, contains article by Nicolas Calas, quote by André Breton, and a "news story" concerning Julien Levy, Parker Tyler, Calas, and Matta himself.

August. Man Ray arrives, then drives crosscountry to settle in California.

September. Publication of the first issue of the magazine *View*, founded by Charles Henri Ford.

MEXICO CITY

January–February. Galería de Arte Mexicano. *Exposición Internacional del Surrealismo.* Exhibition organized by Breton, Paalen, and the poet César Moro.

FRANCE

January. Miró at Varengeville-sur-Mer; begins a series of gouaches known collectively as "Constellations." At the fall of France returns to Spain, settles in Palma (Majorca). Arp flees to Grasse.

August. Breton, demobilized, proceeds to Marseilles where he, among many others, is given refuge by the American Committee of Aid to Intellectuals, directed by Varian Fry. Daily meetings of numerous Surrealists, among them Masson, Lam, and Ernst who arrives after having been released from reinternment.

SWITZERLAND

Brauner takes refuge in an Alpine village, where he remains till the end of the war; devises a new encaustic method to compensate for shortage of painting material.

NORWAY

April. Schwitters flees north after German invasion.

SCOTLAND

June. Schwitters arrives with his son, is interned in various camps for the next 17 months but continues to work intensively.

Tanguy and Kay Sage marry.

1941

MARTINIQUE

Breton, Lam, Masson, and Claude Lévi-Strauss arrive on a refugee ship. Lam goes on to Santo Domingo, the others to New York.

NEW YORK

July. Ernst arrives in New York via Lisbon. At the end of the year marries Peggy Guggenheim.

Breton breaks again with Dalí, dubs him "Avida Dollars." Publication of George Lemaître, *From Cubism to Surrealism in French Literature.*

Robert Motherwell meets the Surrealists in exile, studies engraving briefly with Kurt Seligmann, is particularly friendly with Matta.

October–November. *View* devotes a special number to the Surrealist movement.

November 19–January 11, 1942. The Museum of Modern Art. *2 Exhibitions: Paintings, Drawings, Prints—Joan Miró, Salvador Dalí.* Dalí catalogue by James Thrall Soby is the first comprehensive study of the artist in English; Miró catalogue by James Johnson Sweeney.

PARIS

Picasso writes Surrealist play, *Desire Caught by the Tail.*

LONDON

Schwitters is released from internment, settles in London, earns his living painting portraits.

1942

NEW YORK

March 3–28. Pierre Matisse Gallery. *Artists in Exile.* Exhibition of fourteen artists who have come to America to live and work includes Eugene Berman, Breton, Chagall, Ernst, Léger, Lipchitz, Masson, Matta, Mondrian, Ozenfant, Seligmann, Tanguy, Tchelitchew, and Zadkine. Catalogue essays by James Thrall Soby and Nicolas Calas.

April. Special issue of *View* dedicated to Max Ernst. Ernst develops technique of "oscillation."

May. Special issue of *View* dedicated to Yves Tanguy.

June. Publication of first issue of *VVV*, a Surrealist-oriented review founded and edited by David Hare, with Breton and Ernst as editorial advisers. Cover by Ernst, introductory note by Lionel Abel, "It is Time To Pick the Iron Rose"; articles by Breton ("Prolegomena to a Third Manifesto of Surrealism or Else"), Kiesler, Lévi-Strauss, Motherwell, Harold Rosenberg.

Dali publishes his autobiography, *The Secret Life of Salvador Dali.*

The Motherwells, Baziotes, and Pollocks make "automatic" poems.

October 14–November 7. 451 Madison Avenue. *First Papers of Surrealism.* Exhibition sponsored by the Coordinating Council of French Relief Societies. Twine webbing installation by Duchamp; participants include Arp, Bellmer, Brauner, Calder, Chagall, Duchamp, Ernst, Francés, Giacometti, Frida Kahlo, Kiesler, Klee, Lam, Matta, Magritte, Miró, Masson, Moore, Richard Oelze, Onslow-Ford, Picasso, Seligmann, and Tanguy. Motherwell, Hare, Baziotes, Jimmy Ernst are among the young Americans shown.

October. Peggy Guggenheim opens her gallery Art of This Century, designed by Frederick Kiesler, which serves as a museum for her private collection and a gallery for temporary exhibitions.

NEW HAVEN
December 10. Breton gives a lecture, *Situation du surréalisme entre les deux guerres,* to the students at Yale University (published in *VVV,* March 1943).

SWITZERLAND
Arp and his wife Sophie Täuber take refuge from the war.

1943
NEW YORK
March. Publication of *VVV: Almanac for 1943.* Cover by Duchamp.

Baziotes, Motherwell, and Pollock invited to participate in a collage exhibition at Art of This Century.

November 9–27. Art of This Century. *Jackson Pollock: Paintings and Drawings.* First one-man exhibition; catalogue note by James Johnson Sweeney.

ZURICH
January. Sophie Täuber-Arp dies.

HANOVER
Schwitters' house containing the first *Merzbau* destroyed in an air raid.

1944
NEW YORK
February. Last issue of *VVV.* Cover by Matta; also includes reproduction of Duchamp's *George Washington,* a collage of painted gauze, gold stars, and blue paper, which was commissioned by *Vogue* for a July 4 cover but not used.

Arshile Gorky meets Breton, with whom he forms a warm friendship despite the fact that neither man speaks the other's language.

Hans Richter begins to make the film *Dreams That Money Can Buy,* to which Alexander Calder, Duchamp, Ernst, Fernand Léger, and Man Ray contribute.

Ernst spends summer on Long Island working primarily on sculpture.

October 3–21. Art of This Century. *Paintings and Drawings by Baziotes.* First one-man exhibition.

October 24–November 11. Art of this Century. *Robert Motherwell: Paintings, Papiers Collés, Drawings.* First one-man exhibition; catalogue preface by James Johnson Sweeney.

November. Publication of Sidney Janis, *Abstract & Surrealist Art in America.*

1945
NEW YORK
January 9–February 4. Art of This Century. *Mark Rothko: Paintings.*

March. Julien Levy Gallery. *Arshile Gorky.* Catalogue foreword by Breton, "The Eye-Spring: Arshile Gorky."

March. Special issue of *View* devoted to Duchamp, includes

articles by Breton, James Thrall Soby, Harriet and Sidney Janis, Robert Desnos, Gabrielle Buffet.

Publication of second, enlarged edition of Breton's *Le Surréalisme et la peinture*.

UNITED STATES

Summer. Breton makes a long journey through the West where he visits ghost cities of the Gold Rush period, observes rites on Hopi and Zuni Indian reservations in New Mexico and Arizona.

HAITI

December. Breton arrives for a lecture tour during which he meets Wifredo Lam. Through Mabille, now the French cultural attaché, he witnesses voodoo ceremonies.

PARIS

Brauner returns; accidentally settles in the same building in which Henri Rousseau had had his studio.

November. Masson returns.

Publication of first volume of Maurice Nadeau, *Histoire du surréalisme*.

ENGLAND

Schwitters settles in the Lake District, near Ambleside (Westmorland), where, helped by a grant from The Museum of Modern Art, New York, he begins his third *Merzbau*, at Cylinders Farm, Little Langdale.

1946

NEW YORK

January 2–19. Kootz Gallery. *Robert Motherwell: Paintings, Collages, Drawings*. First exhibition at the gallery with which he will have a long association.

January. A fire in Gorky's studio in an old barn in Sherman, Connecticut, destroys about 27 paintings, including 15 canvases painted during the previous year, which were to have been exhibited in April.

February. Gorky undergoes operation for cancer.

February 2–March 12. Art of This Century. *Clyfford Still*. First one-man show in New York.

February 12–March 2. Samuel M. Kootz Gallery. *William Baziotes*. First exhibition at gallery with which he will have a long association.

April 1–20. Mortimer Brandt Gallery (Contemporary Section directed by Betty Parsons). *Paintings by Stamos*.

April 22–May 4. Mortimer Brandt Gallery (Contemporary Section). *Mark Rothko: Exhibition of Watercolors*.

Late in the year Pollock begins to paint his all-over "drip" canvases.

HAITI

January. Breton's first lecture on Surrealism leads to a general strike and four days of rioting, which oblige the dictator-president to flee the country.

PARIS

Spring. Breton returns; finds an atmosphere hostile to Surrealism, in which men of the Resistance are the heroes and leaders.

Artaud is released from sanatorium. His return is celebrated at the Théâtre Sarah Bernhardt; speech by Breton.

Arp returns to Meudon from Basel. Publication of first complete collection of his poems in French, *Le Siège de l'air: Poèmes 1915–1945*.

Publication by Galerie Louise Leiris (and Curt Valentin in New York) of *Bestiaire*, introductory text by Georges Duthuit, 12 lithographs and 10 drawings by Masson.

November. Théâtre Marigny. Opening of Jean-Louis Barrault's production of *Hamlet*, translation by André Gide, costumes and settings by Masson.

1947

NEW YORK

February. Miró arrives in the United States to paint a mural commissioned for the Gourmet Restaurant of the Terrace Hilton Hotel in Cincinnati; works on the mural in a studio on East 119th Street.

April 14–26. Betty Parsons Gallery. *Clyfford Still: Recent Paintings*.

1947

Spring. Peggy Guggenheim closes Art of This Century and returns to Europe.

October. Miró's finished mural exhibited at The Museum of Modern Art.

Publication of Anna Balakian, *Literary Origins of Surrealism*.

CHICAGO

November 6–January 11, 1948. The Art Institute of Chicago. *The Fifty-Eighth Annual Exhibition of American Painting and Sculpture: Abstract and Surrealist American Art*.

PARIS

April. In a lecture at the Sorbonne entitled *Le Surréalisme et l'après-guerre*, Tzara condemns Surrealism in the name of *art engagé* and rallies his audience to Communism. The lecture is violently interrupted by Breton who leads members of the audience out of the hall.

May. In an article in *Les Temps Modernes*, Jean-Paul Sartre declares that Surrealist revolt is basically abstract, metaphysical, and ineffective, and that the Surrealists were incapable of action when the moment came.

June. Publication of *Rupture inaugurale*, a collective declaration in which the Surrealists answer Sartre's charges.

July–August. Galerie Maeght. *Exposition Internationale du Surréalisme*. Last major group show of the movement, organized by Breton and Duchamp, installation supervised by Kiesler. Catalogue, *Le Surréalisme en 1947*, lists 87 artists representing 24 countries, among whom are Arp, Bellmer, Brauner, Calder, Enrico Donati, Duchamp, Ernst, Giacometti, Gorky, Jacques Hérold, Kiesler, Lam, Matta, Miró, Isamu Noguchi, Penrose, Picabia, Man Ray, Richier, Riopelle, Kay Sage, Serpan, Tanguy. Among the unrealized plans: the exhibition of "surrealists despite themselves," which would have included work by Arcimboldo, Blake, Bosch, Henri Rousseau, and of "those who have ceased to gravitate in the movement's orbit," such as Dali, Dominguez, Masson, Picasso.

LISTS OF ILLUSTRATIONS

COLORPLATES

Frontispiece Joan Miró. *Painting.* 1930. Oil on canvas, 59 x 88⅝". Collection D. and J. de Menil, Houston

1 Marcel Duchamp. *The Passage from Virgin to Bride.* 1912. Oil on canvas, 23⅜ x 21¼". The Museum of Modern Art, New York

2 Marcel Duchamp. *Tu m'.* 1918. Oil and graphite on canvas, with bottle-washing brush, safety pins, nut and bolt, 27½ x 122¾". Yale University Art Gallery, New Haven, Connecticut (Bequest of Katherine S. Dreier)

3 Francis Picabia. *Edtaonisl.* 1913. Oil on canvas, 118¼ x 118⅜". The Art Institute of Chicago (Gift of Mr. and Mrs. Armand Phillip Bartos)

4 Francis Picabia. *Very Rare Picture on the Earth.* 1915. Gilt and silver paint with collage of wood and cardboard forms, 44¾ x 34". Collection Peggy Guggenheim, Venice

5 Man Ray. *The Rope Dancer Accompanies Herself with Her Shadows.* 1916. Oil on canvas, 52 x 73⅜". The Museum of Modern Art, New York (Gift of G. David Thompson)

6 Jean Arp. *Enak's Tears (Terrestrial Forms).* 1917. Painted wood, 33½ x 23⅜". Collection F. C. Graindorge, Liège, Belgium

7 Jean Arp. *Plant Hammer.* 1917. Oil on wood, 24¾ x 19⅝". Collection François Arp, Paris

8 Max Ernst. *Two Ambiguous Figures.* 1919. Collage with gouache, 9½ x 6½". Collection Mme Marguerite Arp-Hagenbach, Meudon, France

9 Kurt Schwitters. *The "Worker" Picture (Das Arbeiterbild).* 1919. Collage of wood and pasted papers, 49¼ x 35⅝". Moderna Museet, Stockholm

10 Kurt Schwitters. *Blue Bird.* 1922. Oil on canvas, 8 x 7". Collection Mr. and Mrs. Solomon Ethe, New York

11 Giorgio de Chirico. *The Song of Love.* 1914. Oil on canvas, 28⅜ x 23½". Private collection, New York

12 Giorgio de Chirico. *Grand Metaphysical Interior.* 1917. Oil on canvas, 37¾ x 27¾". Collection James Thrall Soby, New Canaan, Connecticut

13 Max Ernst. *Oedipus Rex.* 1922. Oil on canvas, 35 x 46". Private collection, Paris

14 Joan Miró. *Tilled Field.* 1923–24. Oil on canvas, 26 x 37". Collection Mr. and Mrs. Henry Clifford, Radnor, Pennsylvania

15 Joan Miró. *The Harlequin's Carnival.* 1924–25. Oil on canvas, 26 x 35⅜". Albright-Knox Art Gallery, Buffalo, New York

16 Joan Miró. *The Birth of the World.* 1925. Oil on canvas, 96½ x 76¾". Collection René Gaffé, Cagnes-sur-Mer (Alpes-Maritime), France

17 Joan Miró. *Amour.* 1926. Oil on canvas, 57½ x 45". Galerie Rosengart, Lucerne, Switzerland

18 Joan Miró. *Le Fond Bleu.* 1927. Oil on canvas, 45⅝ x 35⅜". Private collection, Paris

19 Joan Miró. *Dutch Interior III.* 1928. Oil on canvas, 50¾ x 37⅛". Florene M. Schoenborn—Samuel A. Marx Collection, New York

20 Joan Miró. *Portrait of Mrs. Mills in 1750.* 1929. Oil on canvas, 45⅝ x 35". Collection James Thrall Soby, New Canaan, Connecticut

21 André Masson. *Woman.* 1925. Oil on canvas, 28¾ x 23½". Collection Dr. and Mrs. Paul Larivière, Montreal

22 André Masson. *Painting (Figure).* 1927. Oil and sand on canvas, 18 x 10½". Private collection, New York

23 Max Ernst. *To 100,000 Doves.* 1925. Oil on canvas, 32 x 39½". Collection Mme Simone Collinet, Paris

24 Max Ernst. *Snow Flowers.* 1927. Oil on canvas, 51⅝ x 51⅝". F. C. Graindorge, Liège, Belgium

25 Max Ernst. *The Great Forest.* 1927. Oil on canvas, 45 x 57½". Kunstmuseum, Basel

26 Max Ernst. *One Night of Love.* 1927. Oil on canvas, 63¾ x 51⅛". Private collection, Paris

27 Yves Tanguy. *A Large Painting Which Is a Landscape.* 1927. Oil on canvas, 46 x 35¾". Collection Mr. and Mrs. William Mazer, New York

28 René Magritte. *On the Threshold of Liberty.* 1929. Oil on canvas, 44 x 57⅝". Museum Boymans-van Beuningen, Rotterdam

29 René Magritte. *Personal Values.* 1952. Oil on canvas, 31⅛ x 39½". Collection Jan-Albert Goris, Brussels

30 Salvador Dali. *Illumined Pleasures.* 1929. Oil on composition board with collage, 9⅜ x 13¾". The Museum of Modern Art, New York (the Sidney and Harriet Janis Collection)

31 Salvador Dali. *Accommodations of Desire.* 1929. Oil on wood, 8⅝ x 13¾". Julien Levy Gallery, Bridgewater, Connecticut

32 Salvador Dali. *The Lugubrious Game.* 1929. Oil and collage on panel, 18⅛ x 15". Private collection, Paris

33 Salvador Dali. *The Great Masturbator.* 1929. Oil on canvas, 43¼ x 59⅛". Collection Mme Gala Dali, Paris

34 Pablo Picasso. *Crucifixion.* 1930. Oil on wood, 20 x 26". Collection the artist

35 Victor Brauner. *The Morphology of Man.* 1934. Oil on canvas (two panels), 70½ x 45⅝". Private collection, New York

36 Victor Brauner. *Gemini.* 1938. Oil on canvas, 18 x 21⅜". Collection Mr. and Mrs. Julien Levy, Bridgewater, Connecticut

37 Paul Delvaux. *Le Train Bleu.* 1946. Oil on wood, 48 x 96⅛". Collection Joachim Jean Aberbach, Sands Point, New York

38 Gordon Onslow-Ford. *Without Bounds.* 1939. Enamel paint on canvas, 28¾ x 36¼". Collection the artist

39 Max Ernst. *The Blind Swimmer.* 1934. Oil on canvas, 36 x 28⅞". Collection Mr. and Mrs. Julien Levy, Bridgewater, Connecticut

40 André Masson. *Summer Divertissement.* 1934.

Oil on canvas, 92 x 73". Collection Kahnweiler, Paris

41 Joan Miró. *L'Hirondelle d'amour*. 1934. Oil on canvas, 78½ x 97½". Private collection, New York

42 Joan Miró. *Woman's Head*. 1938. Oil on canvas, 18⅛ x 21⅝". Collection Mr. and Mrs. Donald Winston and Minneapolis Institute of Arts

43 Joan Miró. *Portrait I*. 1938. Oil on canvas, 63¾ x 51¼". The Baltimore Museum of Art (Saidie A. May Collection)

44 Joan Miró. *The Poetess*. 1940. Gouache on paper, 15 x 18". Collection Mr. and Mrs. Ralph F. Colin, New York

45 Matta. *Inscape (Psychological Morphology No. 104)*. 1939. Oil on canvas, 28⅞ x 36⅜". Collection Gordon Onslow-Ford, Inverness, California

46 Matta. *The Earth Is a Man*. 1942. Oil on canvas, 72¼ x 96½". Collection Mr. and Mrs. Joseph Shapiro, Oak Park, Illinois

47 Matta. *The Vertigo of Eros*. 1944. Oil on canvas, 6'5" x 8'3". The Museum of Modern Art, New York

48 Matta. *The Onyx of Electra*. 1944. Oil on canvas, 50⅛ x 72". Collection Mr. and Mrs. E. A. Bergman, Chicago

49 Matta. *The Spherical Roof around Our Tribe (Revolvers)*. 1952. Tempera and pastel on canvas, 6'6⅝" x 9'7⅞". The Museum of Modern Art, New York (Gift of Dominique and John de Menil)

50 Wifredo Lam. *The Jungle*. 1943. Gouache on paper mounted on canvas, 7'10¼" x 7'6½". The Museum of Modern Art, New York (Inter-American Fund)

51 Wifredo Lam. *Song of the Osmosis*. 1945. Oil on canvas, 49½ x 60⅜". Collection Joseph Cantor, Carmel, Indiana

52 André Masson. *Meditation on an Oak Leaf*. 1942. Tempera, pastel, and sand on canvas, 40 x 33". The Museum of Modern Art, New York

53 André Masson. *Antille*. 1943. Oil and tempera on canvas, 53 x 33". Collection Peter B. Bensinger, Chicago

54 André Masson. *Elk Attacked by Wild Hounds*. 1945. Oil on canvas, 20 x 25". Collection Joseph H. Hirshhorn

55 Max Ernst. *Vox Angelica*. 1943. Oil on canvas, 60⅛ x 80⅛". Collection Mr. and Mrs. Julien Levy, Bridgewater, Connecticut

56 Yves Tanguy. *Through Birds, Through Fire, but Not Through Glass*. 1943. Oil on canvas, 40 x 35". Collection Mr. and Mrs. Donald Winston, Los Angeles

57 Arshile Gorky. *The Liver Is the Cock's Comb*. 1944. Oil on canvas, 73 x 98½". Albright-Knox Art Gallery, Buffalo, New York (Gift of Seymour H. Knox)

58 Arshile Gorky. *The Leaf of the Artichoke Is an Owl*. 1944. Oil on canvas, 28 x 36". Collection Ethel K. Schwabacher, New York

59 Arshile Gorky. *One Year the Milkweed*. 1944. Oil on canvas, 37 x 47". Collection Mrs. Agnes Gorky Phillips, London

BLACK-AND-WHITE PLATES

1 Marcel Duchamp. *The Sonata*. 1911. Oil on canvas, 57 x 44½". Philadelphia Museum of Art (Louise and Walter Arensberg Collection)

2 Marcel Duchamp. *Portrait of Chess Players*. 1911. Oil on canvas, 39¾ x 39¾". Philadelphia Museum of Art (Louise and Walter Arensberg Collection)

3 Marcel Duchamp. *Sad Young Man in a Train*. 1911. Oil on canvas on board, 39 x 29". Collection Peggy Guggenheim, Venice

4 Marcel Duchamp. *Nude Descending a Staircase, No. 1*. 1911. Oil on cardboard, 37¾ x 23½". Philadelphia Museum of Art (Louise and Walter Arensberg Collection)

5 Marcel Duchamp. *Nude Descending a Staircase, No. 2*. 1912. Oil on canvas, 58 x 35". Philadelphia Museum of Art (Louise and Walter Arensberg Collection)

6 Marcel Duchamp. *The King and Queen Surrounded by Swift Nudes*. 1912. Oil on canvas, 45¼ x 50½". Philadelphia Museum of Art (Louise and Walter Arensberg Collection)

7 Marcel Duchamp. *The Bride*. 1912. Oil on canvas, 35½ x 21¾". Philadelphia Museum of Art (Louise and Walter Arensberg Collection)

8 Marcel Duchamp. *Study for The King and Queen Surrounded by Swift Nudes*. 1912. Watercolor, pencil, and gouache, 19⅜ x 23¼". Philadelphia Museum of Art (Louise and Walter Arensberg Collection)

9 Marcel Duchamp. *The Bride Stripped Bare by Her Bachelors*. 1912. Pencil, 9 x 13". Cordier & Ekstrom, Inc., New York

10 Marcel Duchamp. *Chocolate Grinder, No. I*. 1913. Oil on canvas, 24⅜ x 25⅝". Philadelphia Museum of Art (Louise and Walter Arensberg Collection)

11 Marcel Duchamp. *Bicycle Wheel*. Readymade. 3rd version, 1951 (original, 1913, and 2nd version, 1916, lost). Bicycle wheel on wood stool, height 52". The Museum of Modern Art, New York (the Sidney and Harriet Janis Collection)

12 Marcel Duchamp. *Three Standard Stoppages*. 1913-14. Three threads fixed on canvas strips pasted on glass, accompanied by wooden "yardsticks" 44¼" long, shaped according to the outlines of the threads, the whole enclosed in a croquet case. The Museum of Modern Art, New York (Katherine S. Dreier Bequest)

13 Marcel Duchamp. *Water Mill Within Glider (in Neighboring Metals)*. 1913-15. Oil and lead wire on glass, 60¼ x 33". Philadelphia Museum of Art (Louise and Walter Arensberg Collection)

14 Marcel Duchamp. *Chocolate Grinder, No. II*. 1914. Oil, pencil, and thread on canvas, 25½ x 21¼". Philadelphia Museum of Art (Louise and Walter Arensberg Collection)

15 Marcel Duchamp. *Network of Stoppages*. 1914. Oil on canvas, damaged, 58 x 78½". Private collection, New York

16 Marcel Duchamp. *Bottlerack*. Readymade. 2nd version, 1961 (original, 1914, lost). Galvanized iron, 25 x 17". Collection Man Ray, Paris

17 Marcel Duchamp. *Cemetery of Uniforms and Liveries*. 1913. Pencil heightened with watercolor, 25½ x 39". Philadelphia Museum of Art (Louise and Walter Arensberg Collection)

18 Marcel Duchamp. *Nine Malic Molds*. 1914-15. Oil, lead wire, and foil on glass, 26 x 41". Collection Mrs. Marcel Duchamp, New York

19 Marcel Duchamp. *The Bride Stripped Bare by Her Bachelors, Even (the Large Glass)*. 1915–23. Oil, lead wire, and foil, dust and varnish on glass, 107 x 67". Philadelphia Museum of Art (Bequest of Katherine S. Dreier)

20 Marcel Duchamp. *Fountain (by R. Mutt)*. Readymade. 3rd version, 1964 (original, 1917, lost). Urinal turned on its back, height 24". Galleria Schwarz, Milan

21 Marcel Duchamp. *Fresh Widow*. 1920. Miniature French window; wood frame and eight panes of glass covered with leather, 30½ x 17⅝". The Museum of Modern Art, New York (Katherine S. Dreier Bequest)

22 Marcel Duchamp. *Why Not Sneeze Rose Sélavy?* 1921. Birdcage, cuttlebone, wood, thermometer, and marble, 4½ x 8⅝ x 6⅜". Philadelphia Museum of Art (Louise and Walter Arensberg Collection)

23 Raymond Duchamp-Villon. *Horse*. 1914. Bronze, height 40". The Museum of Modern Art, New York (Van Gogh Purchase Fund)

24 Francis Picabia. *Landscape at Creuse*. 1912. Oil on canvas, 29 x 36½". Collection Mrs. Barnett Malbin, Birmingham, Michigan (the Lydia and Harry Winston Collection)

25 Francis Picabia. *Dances at the Spring*. 1912. Oil on canvas, 47½ x 47½". Philadelphia Museum of Art (Louise and Walter Arensberg Collection)

26 Francis Picabia. *Procession, Seville*. 1912. Oil on canvas, 48 x 48". Private collection, New York

27 Francis Picabia. *Negro Song*. 1913. Watercolor, 26 x 22". The Metropolitan Museum of Art, New York (The Alfred Stieglitz Collection, 1949)

28 Francis Picabia. *Udnie*. 1913. Oil on canvas, 118⅛ x 118⅛". Musée National d'Art Moderne, Paris

29 Francis Picabia. *I See Again in Memory My Dear Udnie*. 1914. Oil on canvas, 8½" x 66¼". The Museum of Modern Art, New York (Hillman Periodicals Fund)

30 Francis Picabia. *Beware of Wet Paint*. 1916. Oil, enamel, and metallic paint on canvas, 36 x 28¾". Moderna Museet, Stockholm

31 Francis Picabia. *Picture Painted to Relate, Not to Prove*. 1915. Pen and ink and gouache on tracing paper, 8 x 6". Private collection, Sweden

32 Francis Picabia. *Novia*. 1917. Watercolor, used as cover of *391*, No. 1

33 Francis Picabia. *Amorous Parade*. 1917. Oil on board, 37½ x 28½". Collection Mr. and Mrs. Morton G. Neumann, Chicago

34 Francis Picabia. *Match-Woman II*. 1920. Oil on canvas, with pasted matchsticks, hair pins, zippers, and coins, 35½ x 28⅜". Collection Mme Simone Collinet, Paris

35 Francis Picabia. *Conversation II*. 1921. Oil on board, 18 x 24". Private collection

36 Francis Picabia. *The Spanish Night*. 1922. Commercial enamel on canvas, 63 x 51¼". Private collection, New York

37 Francis Picabia. *Culotte Tournante*. 1922. Watercolor, 28⅜ x 23⅜". Collection Mme Simone Collinet, Paris

38 Man Ray. *Revolving Doors: Dragonfly*. 1916–17. Collage, 21½ x 15⅝". Collection J. Daniel Weitzman, New York

39 Man Ray. *Legend*. 1916. Oil on canvas, 25¾ x 18¼". Collection Mr. and Mrs. J. B. Urvater, Brussels

40 Man Ray. *Boardwalk*. 1917. Oil on wood with furniture knobs and wire, 25½ x 28". Collection Mlle Gloria de Herrera, Paris

41 Man Ray. *Untitled Aerograph*. 1919. (Based on a template later considered an Object and titled *By Itself*; see fig. D-67.) Airbrush, 29½ x 23½". Cordier & Ekstrom, Inc., New York

42 Man Ray. *Preconception of Violetta*. 1919. Airbrush, 19⅝ x 23⅜". Private collection, New York

43 Man Ray. *The Impossibility*. 1920. Glass, airbrush and oil, 24 x 16". Collection Mme André Breton, Paris

44 Man Ray. *The Enigma of Isidore Ducasse*. 1920. Cloth and rope over sewing machine. (Destroyed)

45 Man Ray. *Coat Stand*. 1920. As reproduced in *New York Dada*

46 Man Ray. *Gift*. Replica of lost original of 1921. Flatiron with nails, height 6½". Collection Mr. and Mrs. Morton G. Neumann, Chicago

47 Man Ray. *Rayograph*. 1922. From *Les Champs Délicieux* (Paris), 1922. The Museum of Modern Art, New York

48 Man Ray. *Observation Time—The Lovers*. 1932–34. Oil on canvas, 39⅜ x 98⅜". Private collection Tristan Tzara, Paris

49 Christian Schad. *Schadograph*. 1918. Formerly collection Tristan Tzara, Paris

50 Morton L. Schamberg. *Machine*. 1916. Oil on canvas, 30⅛ x 22¾". Yale University Art Gallery, New Haven, Connecticut (Collection of the Société Anonyme)

51 Joseph Stella. *Machine*. c. 1918. Oil on glass, 13¼ x 8½". Private collection

52 Marcel Janco. *Cabaret Voltaire*. 1916. Oil on canvas. On the podium, from left to right: Hugo Ball (at piano), Tristan Tzara (wringing hands), Jean Arp, Richard Huelsenbeck (below Arp), Marcel Janco

53 Marcel Janco. *White on White*. 1917. Wood relief, 29¾ x 22¾". Collection François Arp, Paris

54 Marcel Janco. *Mask*. c. 1916. Mask of cardboard with a mustache of twine. Collection the artist

55 Augusto Giacometti. *Chromatic Fantasy*. 1914. Oil on canvas, 39 x 39". Kunsthaus, Zurich

56 Jean Arp. *The Stag*. 1914. Painted wood relief, 44 x 30⅞". Collection François Arp, Paris

57 Jean Arp. *Portrait of Tzara*. 1916. Painted wood relief, 19½ x 18½". Estate of the artist

58 Jean Arp. *Automatic Drawing*. 1916. Brush and ink on gray paper, 16¾ x 21¼". The Museum of Modern Art, New York (given anonymously)

59 Jean Arp. *Squares Arranged According to the Laws of Chance*. 1916–17. Collage of colored papers, 19⅛ x 13⅝". The Museum of Modern Art, New York

60 Jean Arp. *Madame Torso with Wavy Hat*. 1916. Wood, 15⅞ x 10⅜". Kunstmuseum (Hermann and Margrit Rupf Foundation), Bern

61 Jean Arp. *Forest*. 1916. Painted wood relief, 12⅝ x 7½". Penrose Collection, London

62 Jean Arp. *Bird Mask*. 1918. Wood relief, 12¼ x 13". Private collection, Paris

63 Hans Richter. *Orchestra.* 1915. Oil on cardboard, 18⅞ x 25⅝". Collection the artist

64 Hans Richter. Portion of *Rhythmus 23.* Oil on canvas, scroll, 50" long. Collection the artist

65 Viking Eggeling. Portion (No. 8) of *Diagonal Symphonie.* 1921–23

66 Raoul Hausmann. *The Spirit of Our Time.* 1919. Wood, metal, leather and cardboard, height 12¾". Collection the artist

67 Raoul Hausmann. *Optophonetic Poem and Manifesto.* 1919. 18⅞ x 26". Collection the artist

68 Raoul Hausmann. *Tatlin at Home.* 1920. Collage of pasted papers and gouache, 16⅛ x 11". Moderna Museet, Stockholm

69 Raoul Hausmann. *Head.* 1923. Collage of pasted papers, 16 x 11¼". Collection the artist

70 Hannah Höch. *Cut with the Kitchen Knife.* 1919. Collage of pasted papers, 44⅞ x 35⅜". Nationalgalerie, Staatliche Museen, Berlin

71 Hannah Höch. *He and His Milieu.* 1919. Watercolor, 19 x 15". Collection Mr. and Mrs. Barnet Hodes, Chicago

72 Johannes Baader. *The Author in His Home.* 1920. Collage of pasted photographs on book page, 8½ x 5¾". The Museum of Modern Art, New York (Abby Aldrich Rockefeller Fund)

73 Johannes Baader. *Collage a.* 1920–22. Collage of pasted papers. 13⅞ x 19⅞". Musée National d'Art Moderne, Paris

74 Paul Citroen. *Metropolis.* 1923. Collage of photographs, prints, and postcards, 30 x 23". Prentenkabinet, Rijksuniversiteit, Leiden

75 George Grosz. *The Lovesick One.* 1916. Oil on canvas, 39¼ x 30". Collection John L. Loeb, Jr., New York

76 George Grosz. *Student* (Study for Goll's *Methusalem*). 1916. Watercolor, 20½ x 14½". The Cleveland Museum of Art (Contemporary Collection)

77 George Grosz. *The Engineer Heartfield.* 1920. Collage and watercolor, 16½ x 12". The Museum of Modern Art, New York (Gift of A. Conger Goodyear)

78 Max Ernst. Untitled. 1920. Photomontage. Collection Mme Marguerite Arp-Hagenbach, Meudon, France

79 Max Ernst. *Flowers and Fish.* 1916. Oil on canvas, 30 x 24". Collection Mr. and Mrs. Chaim Gross, New York

80 Max Ernst. *Submarine Still Life.* 1917. Oil on canvas, 22 x 24½". Collection F. De Margouliès, New York

81 Max Ernst. *The Roaring of Ferocious Soldiers* (*You Who Pass—Pray for Dada*). 1919. Rough proof from assembled printers' plates, altered with pen and ink, 15½ x 11". Galleria Schwarz, Milan

82 Max Ernst. *Here Everything Is Still Floating.* 1920. Pasted photoengravings, 4⅛ x 4⅞". The Museum of Modern Art, New York

83 Max Ernst. *Self-Constructed Small Machine.* 1919. Pencil and rubbing from assembled printers' plates, altered with ink, 18 x 12". Collection Mr. and Mrs. E. A. Bergman, Chicago

84 Max Ernst. *Aquis Submersus.* 1919. Oil on canvas, 21¼ x 17¼". Penrose Collection, London

85 Max Ernst. *Fruit of a Long Experience.* 1919. Painted wood and metal, 18 x 15". Penrose Collection, London

86 Max Ernst. *Above the Clouds Midnight Passes.* 1920. Pasted photoengravings and pencil, 7¼ x 5⅝". Private collection, New York

87 Max Ernst. *The Hat Makes the Man.* 1920. Pasted papers, pencil, ink, watercolor, 14 x 18". The Museum of Modern Art, New York

88 Max Ernest. *The Gramineous Bicycle.* c. 1920–21. Botanical chart altered with gouache, 29¼ x 39¼". The Museum of Modern Art, New York

89 Max Ernst. *The Massacre of the Innocents.* 1920. Photomontage, watercolor, and pastel, 8¼ x 11½". Collection Mme Simone Collinet, Paris

90 Max Ernst *Undulating Catherine.* 1920. Wallpaper altered with gouache and pencil, 11¾ x 9⅞". Penrose Collection, London

91 John Heartfield. Cover for *Der Dada #3* (Berlin), 1920

92 Kurt Schwitters. *The "And" Picture* (*Das Undbild*). 1919. Collage of pasted papers, wood, and metal, 14 x 11". Marlborough-Gerson Gallery, Inc., New York

93 Kurt Schwitters. *Merz Picture 25 A. Das Sternenbild.* 1920. Collage, 41 x 31⅛". Kunstsammlung Nordrhein-Westfalen, Düsseldorf

94 Kurt Schwitters. *0–9.* 1920. Collage. Private collection

95 Kurt Schwitters. *Mirror Collage.* 1920. Collage sculpture. Formerly collection Tristan Tzara, Paris

96 Kurt Schwitters. *Unicos Importadores.* 1921. Collage. Collection Ileana Sonnabend, Paris

97 Kurt Schwitters. *"Breite Schnurchel."* 1923. Wood relief, 14⅛ x 21⅝". Collection Hannah Höch, Berlin

98 Kurt Schwitters. View of the *Merzbau.* Hannover, Germany. Detail of inner grotto, c. 1924 (pet guinea pig not part of construction)

99 Kurt Schwitters. View of the *Merzbau.* Hannover, Germany. Detail, c. 1933

100 Kurt Schwitters. Untitled. 1925. Collage, 6¼ x 5¼". Collection Rose Fried, New York

101 Kurt Schwitters. *Cathedral.* 1926. Wood relief, 15⅜ x 5⅞". Collection Hannah Höch, Berlin

102 Kurt Schwitters. *Merzbild.* 1930. Oil and collage on hardboard, 17½ x 14". Collection Peggy Guggenheim, Venice

103 Giorgio de Chirico. *The Enigma of the Hour.* 1911. Oil on canvas, 21⅛ x 27⅞". Private collection, Milan

104 Giorgio de Chirico. *Self-Portrait.* 1913. Oil on canvas, 32 x 21¼". Collection Mr. and Mrs. Alex Hillman, New York

105 Giorgio de Chirico. *The Anxious Journey.* 1913. Oil on canvas, 29½ x 42". The Museum of Modern Art, New York (Acquired through the Lillie P. Bliss Bequest)

106 Giorgio de Chirico. *The Child's Brain.* 1914. Oil on canvas, 32 x 25½". Nationalmuseum, Stockholm

107 Giorgio de Chirico. *The Enigma of a Day.* 1914. Oil on canvas, 72¾ x 55½". Collection James Thrall Soby, New Canaan, Connecticut

108 Giorgio de Chirico. *Gare Montparnasse* (*The Melancholy of Departure*). 1914. Oil on canvas, 55 x 72⅞". Collection James Thrall Soby, New Canaan, Connecticut

109 Giorgio de Chirico. *The Mystery and Melancholy of a Street.* 1914. Oil on canvas, 34¼ x 28⅛". Collection Mr. and Mrs. Stanley R. Resor, New Canaan, Connecticut

110 Giorgio de Chirico. *The Serenity of the Scholar*. 1914. Oil on canvas, 52 x 28⅜" (at base). Collection Mr. and Mrs. Joseph Slifka, New York

111 Giorgio de Chirico. *I'll Be There . . . The Glass Dog*. 1914. Oil on canvas, 27 x 22½". Collection Mr. and Mrs. Bernard Reis, New York

112 Giorgio de Chirico. *The Evil Genius of a King*. 1914–15. Oil on canvas, 24 x 19¾". The Museum of Modern Art, New York

113 Giorgio de Chirico. *The Double Dream of Spring*. 1915. Oil on canvas, 22 x 21". The Museum of Modern Art, New York (Gift of James Thrall Soby)

114 Giorgio de Chirico. *The Two Sisters*. 1915. Oil on canvas, 26 x 17". Kunstsammlung Nordrhein-Westfalen, Düsseldorf

115 Giorgio de Chirico. *The Fatal Light*. 1915. Oil on canvas, 21½ x 15". Collection Mr. and Mrs. Lee Ault, New York

116 Giorgio de Chirico. *The Astronomer*. 1915. Oil on canvas, 16⅛ x 13". Private collection, Houston

117 Giorgio de Chirico. *The Jewish Angel*. 1916. Oil on canvas, 26½ x 17¼". Penrose Collection, London

118 Giorgio de Chirico. *The Faithful Servitor*. 1916. Oil on canvas, 15⅛ x 13⅝". Collection James Thrall Soby, New Canaan, Connecticut

119 Giorgio de Chirico. *Evangelical Still Life*. 1916. Oil on canvas, 31½ x 28". The Museum of Modern Art, New York (the Sidney and Harriet Janis Collection)

120 Giorgio de Chirico. *The Disquieting Muses*. 1917. Oil on canvas, 38¼ x 26". Collection Gianni Mattioli, Milan

121 Giorgio de Chirico. *The Return of the Prodigal*. 1917. Pencil, 12⅜ x 8⅞". Private collection, New York

122 Giorgio de Chirico. *Roman Villa*. 1922. Tempera, 40 x 30". Collection Mr. and Mrs. Bruno Pagliai, Mexico City

123 Max Ernst. *The Horse, He's Sick*. c. 1920. Pasted papers, pencil, ink, 5¾ x 8½". The Museum of Modern Art, New York

124 Max Ernst. *Perturbation, My Sister*. 1921. Mixed media, 9⅞ x 6¾". Private collection, Switzerland

125 Max Ernst. *The Teetering Woman*. 1923. Oil on canvas, 51⅜ x 31⅛". Collection Mr. and Mrs. Joseph Slifka, New York

126 Max Ernst. *Pietà or Revolution by Night*. 1923. Oil on canvas, 45½ x 35". Penrose Collection, London

127 Max Ernst. *Remembrance of God*. 1923. Oil on canvas, 39⅜ x 31⅛". (Destroyed)

128 Max Ernst. *Woman, Old Man, and Flower*. 1923–24. Oil on canvas, 38 x 51¼". The Museum of Modern Art, New York

129 Max Ernst. *Two Children Are Threatened by a Nightingale*. 1924. Oil on wood with wood construction, 18 x 13". The Museum of Modern Art, New York

130 Max Ernst. *Picture-Poem*. 1924. Oil on canvas, 24 x 20". Collection Mr. and Mrs. J. B. Urvater, Brussels

131 Max Ernst. *La Belle Saison*. 1925. Oil on canvas, 22⅞ x 42½". Collection Mr. and Mrs. J. B. Urvater, Brussels

132 Joan Miró. *The Farm*. 1921–22. Oil on canvas, 48¼ x 55¼". Collection Mrs. Ernest Hemingway, New York

133 Joan Miró. *Catalan Landscape (The Hunter)*. 1923–24. Oil on canvas, 25½ x 39½". The Museum of Modern Art, New York

134 Joan Miró. *Le Corps de ma brune . . .* 1925. Oil on canvas, 51⅛ x 38¼". Collection Mr. and Mrs. Maxine Hermanos, New York

135 Joan Miró. *Amour*. 1925. Oil on canvas, 28¾ x 36". Private collection, Chicago

136 Joan Miró. *Animated Landscape*. 1927. Oil on canvas, 51 x 76". Collection Jacques Gelman, Mexico City

137 Joan Miró. *The Lasso*. 1927. Oil on canvas, 51⅛ x 37⅜". Fogg Art Museum, Harvard University (Gift of Louise and Joseph Pulitzer, Jr.)

138 Joan Miró. *Fratellini*. 1927. Oil on canvas, 51¼ x 38". Collection Mrs. Barnett Malbin, Birmingham, Michigan (the Lydia and Harry Winston Collection)

139 Joan Miró. *Spanish Dancer*. 1928. Collage of sandpaper, string, and nails, 42 x 26¾". Collection Mr. and Mrs. Morton G. Neumann, Chicago

140 Joan Miró. *Dutch Interior I*. 1928. Oil on canvas, 36¼ x 28¾". The Museum of Modern Art, New York (Mrs. Simon Guggenheim Fund)

141 Joan Miró. *Portrait of a Lady in 1820*. 1929. Oil on canvas, 45¾ x 35⅛". **The Museum of Modern Art, New York**

142 André Masson. *Card Players*. 1923. Oil on canvas, 31⅞ x 23⅝". Private collection, Paris

143 André Masson. *The Constellations*. 1925. Oil on canvas, 36¼ x 25⅝". Collection Mme Simone Collinet, Paris

144 André Masson. *Birth of Birds*. 1925. Automatic drawing, ink on paper, 16½ x 12⅜". The Museum of Modern Art, New York

145 André Masson. *The Dead Bird*. 1925. Oil on canvas, 28¾ x 21¼". Collection Mr. and Mrs. Joseph Slifka, New York

146 André Masson. *The Meteors*. 1925. Oil on canvas, 28¾ x 21½". Private collection, New York

147 André Masson. *Queen Marguerite*. 1926. Oil on canvas, 18 x 13¾". Private collection, New York

148 André Masson. *The Haunted Castle*. 1927. Oil on canvas, 18½ x 15⅜". Collection Mr. and Mrs. Claude Asch, Strasbourg

149 André Masson. *Battle of Fish*. 1927. Oil, sand, and pencil on canvas, 14¼ x 28¾". The Museum of Modern Art, New York

150 André Masson. *Two Death's-Heads*. 1927. Oil and sand on canvas, 5⅝ x 9⅝". Collection Mr. and Mrs. E. A. Bergman, Chicago

151 André Masson. *Fish Drawn on the Sand*. 1927. Oil and sand on canvas, 39⅜ x 28¾". Kunstmuseum (Herrmann and Margrit Rupf Foundation), Bern

152 André Masson. *Metamorphosis*. 1928. Plaster, length 9". Galerie Louise Leiris, Paris

153 André Masson. *Great Battle of Fish*. 1927. Oil on canvas, 38¼ x 51¼". Galerie Louise Leiris, Paris

154 André Masson. *La Poissonnière*. 1930. Oil on canvas, 37½ x 51". Collection Mr. and Mrs. William Mazer, New York

155 Max Ernst. *The Earthquake* (Plate V from *Histoire Naturelle*). 1926

156 Max Ernst. *The Repast of the Dead* (Plate XXVIII from *Histoire Naturelle*). 1926

157 Max Ernst. *When the Light Makes the Wheel* (Plate III from *Histoire Naturelle*, II). 1925

158 Max Ernst. *The Wheel of Light* (Plate XXIX from *Histoire Naturelle*). 1926

159 Max Ernst. *The Fugitive* (Plate XXX from *Histoire Naturelle*). 1926

160 Max Ernst. *The Ego and His Own*. 1925. Pencil frottage, 10¼ x 7⅞". Collection Arman, Nice

161 Max Ernst. *Blue and Rose Doves*. 1926. Oil on canvas, 31⅞ x 39⅜". Kunstmuseum, Düsseldorf

162 Max Ernst. *The Gulf Stream*. 1927. Oil on canvas, 28⅜ x 23¼". Collection F. C. Graindorge, Liège, Belgium

163 Max Ernst. *Forest*. 1927. Oil on canvas, 44⅞ x 57½". Collection Mr. and Mrs. Joseph Slifka, New York

164 Max Ernst. *Vision Provoked by a String Found on My Table*. 1927. Oil on canvas, 16⅛ x 13". Collection Mme Simone Collinet, Paris

165 Max Ernst. *The Horde*. 1927. Oil on canvas, 44⅞ x 57½". Stedelijk Museum, Amsterdam

166 Max Ernst. *Monument to Birds*. 1927. Oil on canvas, 64 x 51¼". Collection Vicomtesse de Noailles, Paris

167 Max Ernst. *Flower and Animal Head*. 1928. Oil on canvas, 39¼ x 31¾". Collection Mr. and Mrs. Arne Horlin Ekstrom, New York

168 Max Ernst. *Two Anthropomorphic Figures*. 1930. Oil on canvas, 26 x 21¼". Collection Mr. and Mrs. Pierre Matisse, New York

169 Yves Tanguy. *At the Fair*. 1926. Oil on canvas, 16 x 11¾". Collection Marcel Duhamel, Mouans-Sartoux, France

170 Yves Tanguy. *Genesis*. 1926. Oil on canvas, 39⅜ x 31⅞". Collection Mme Hélène Anavie, Pauillac, France

171 Yves Tanguy. *The Storm*. 1926. Oil on can-

172 Yves Tanguy. *He Did What He Wanted*. 1927. Oil on canvas, 31⅞ x 25⅝". Collection Richard S. Zeisler, New York

173 Yves Tanguy. *Mama, Papa Is Wounded!* 1927. Oil on canvas, 36¼ x 28¾". The Museum of Modern Art, New York

174 Yves Tanguy. *The Lovers*. 1929. Oil on canvas, 39⅜ x 32". Private collection, New York

175 Yves Tanguy. *Promontory Palace*. 1930. Oil on canvas, 28¾ x 23⅝". Collection Peggy Guggenheim, Venice

176 Yves Tanguy. *The Armoire of Proteus*. 1931. Oil on canvas, 24 x 19¾". Collection Mme André Breton, Paris

177 René Magritte. *The Conqueror*. 1925. Oil on canvas, 25½ x 29½". Grosvenor Gallery, London

178 René Magritte. *The Great Voyages*. 1926. Oil on canvas, 31½ x 55⅝". Collection E. L. T. Mesens, London

179 René Magritte. *The Acrobat's Ideas*. 1928. Oil on canvas, 116 x 81". Collection Mr. and Mrs. J. B. Urvater, Brussels

180 René Magritte. *The False Mirror*. 1928. Oil on canvas, 21¼ x 31⅞". The Museum of Modern Art, New York

181 René Magritte. *Surprises and the Ocean*. 1928. Oil on canvas, 39 x 29". Collection Mrs. Ruth Moskin Fineshriber, New York

182 René Magritte. *The Wind and the Song*. 1928–29. Oil on canvas, 23½ x 31½". Private collection, New York

183 René Magritte. *Key of Dreams*. 1930. Oil on canvas, 31⅞ x 23⅝". Private collection, Paris

184 René Magritte. *The Human Condition, I*. 1934. Oil on canvas, 39⅜ x 31½". Collection Claude Spaak, Choisel (Seine-et-Oise), France

185 René Magritte. *The Red Model*. 1935. Oil on canvas, 29 x 19¾". Moderna Museet, Stockholm

186 René Magritte. *Memory*. 1938. Oil on canvas, 29⅛ x 21¼". Collection Joachim Jean Aberbach, Sands Point, New York

187 René Magritte. *Delusion of Grandeur*. 1948.

188 René Magritte. *The Empire of Light, II*. 1950. Oil on canvas, 31 x 39". The Museum of Modern Art, New York (Gift of Dominique and John de Menil)

189 René Magritte. *The Explanation*. 1952. Oil on canvas, 18¼ x 14". Collection Mr. and Mrs. H. Glasgall, New York

190 René Magritte. *Hegel's Holiday*. 1958. Oil on canvas, 23½ x 19¼". Collection Mme Jean Krebs, Brussels

191 Salvador Dali. *The Basket of Bread*. 1926. Oil on wood panel, 12½ x 12½". The Salvador Dali Museum Collection, The Reynolds Morse Foundation, Cleveland

192 Salvador Dali. *Senicitas*. 1928. Oil on canvas, 25¼ x 18⅞". Collection Mme Gala Dali, Paris

193 Salvador Dali. *Apparatus and Hand*. 1927. Oil on wood, 24½ x 18¾". The Salvador Dali Museum Collection, The Reynolds Morse Foundation, Cleveland

194 Salvador Dali. *Beigneuse* [sic]. 1928. Oil and gravel collage on composition board, 25 x 29½". The Salvador Dali Museum Collection. The Reynolds Morse Foundation, Cleveland

195 Salvador Dali. *Imperial Monument to the Child-Woman*. c. 1929 (unfinished). Oil on canvas, 56 x 32". Collection Mme Gala Dali, Paris

196 Salvdor Dali. *Profanation of the Host*. 1929. Oil on canvas, 56 x 32". The Salvador Dali Museum Collection, The Reynolds Morse Foundation, Cleveland

197 Salvador Dali. *The Invisible Man*. 1929–33. Oil on canvas, 54⅞ x 31". Collection Vicomtesse de Noailles, Paris

198 Salvador Dali. *The Persistence of Memory*. 1931. Oil on canvas, 9½ x 13". The Museum of Modern Art, New York (given anonymously)

199 Salvador Dali. *The Birth of Liquid Desires*. 1932. Oil on canvas, 37⅜ x 44⅛". Collection Peggy Guggenheim, Venice

200 Salvador Dali. *Atavism of Twilight*. 1933. Oil on wood, 5¼ x 6¾". Private collection, Switzerland

Oil on canvas, 39 x 32". Collection Joseph H. Hirshhorn

vas, 32 x 25¾". Philadelphia Museum of Art (Louise and Walter Arensberg Collection)

201 Salvador Dalí. *An Average Atmospherocephalic Bureaucrat in the Act of Milking a Cranial Harp.* 1933. Oil on canvas, 8¾ x 6½". The Salvador Dalí Museum Collection, The Reynolds Morse Foundation, Cleveland

202 Salvador Dalí. *The Specter of Sex Appeal.* 1934. Oil on wood, 7 x 5½". Collection Gala Dalí, Paris

203 Salvador Dalí. *The Venus de Milo of the Drawers.* 1936. Painted bronze, height 39⅜". Galerie du Dragon, Paris

204 Salvador Dalí. *A Tray of Objects.* 1936. Exhibited at the first international exhibition of Surrealist objects, Charles Ratton Gallery, Paris, 1936. Collection Charles Ratton, Paris. Now dismantled

205 Salvador Dalí. *Spain.* 1938. Oil on canvas, 36 x 25⅝". Collection Edward James, London

206 Salvador Dalí. *Soft Self-Portrait with Fried Bacon.* 1941. Oil on canvas, 24 x 20". Collection Mme Gala Dalí, Paris

207 Alberto Giacometti. *The Couple.* 1926. Bronze, height 23½". Collection Mr. and Mrs. Arnold H. Maremont, Detroit

208 Alberto Giacometti. *The Spoon Woman.* 1926. Bronze, height 57¼". Collection Mr. and Mrs. Joseph Slifka, New York

209 Alberto Giacometti. *Woman.* 1927–28. Plaster, height 15¾". Galerie Maeght, Paris

210 Alberto Giacometti. *Head.* 1927–28. Bronze, height 15⅜". The Florene M. Schoenborn–Samuel A. Marx Collection, New York

211 Alberto Giacometti. *Composition.* 1927–28. Plaster, 12⅝ x 13¾". Galerie Maeght, Paris

212 Alberto Giacometti. *Reclining Woman Who Dreams.* 1929. Painted bronze, length 16⅝". Collection Joseph H. Hirshhorn

213 Alberto Giacometti. *Three Personages Outdoors.* 1929. Bronze, height 20¼". Collection Mrs. Rosalie Thorne McKenna, Stonington, Connecticut

214 Alberto Giacometti. *Man and Woman.* 1929. Bronze, height 18". Collection Mme Henriette Gomès, Paris

215 Alberto Giacometti. *Suspended Ball.* 1930–31. Wood and metal, height 23⅝". Collection Mme André Breton, Paris

216 Alberto Giacometti. *Disagreeable Object.* 1931. Wood, length 19". Private collection, New York

217 Alberto Giacometti. *Project for a Square.* 1931. Plaster, 10¼ x 6¼ x 7⅛". Galerie Maeght, Paris

218 Alberto Giacometti. *Cage.* 1930–31. Plaster, height 17⅜". Galerie Maeght, Paris

219 Alberto Giacometti. *Point to the Eye.* 1931. Wood and metal, 3⅝ x 13¾ x 9⅞". Collection Mme Marguerite Arp-Hagenbach, Meudon, France

220 Alberto Giacometti. *Man, Woman, Child.* 1931. Wood and metal, 3⅝ x 13¾ x 9⅞". Collection Mme Marcel Duchamp, New York

221 Alberto Giacometti. *No More Play.* 1932. Marble, wood, bronze, length 23¼". Collection Mr. and Mrs. Julien Levy, Bridgewater, Connecticut

222 Alberto Giacometti. *Woman with Her Throat Cut.* 1932. Bronze, length 34½". The Museum of Modern Art, New York

223 Alberto Giacometti. *Caught Hand.* 1932. Wood and metal, length 23". Kunsthaus, Zurich (Giacometti Foundation)

224 Alberto Giacometti. *Plan for a Tunnel.* 1932. Plaster, length 49½". Kunsthaus, Zurich (Giacometti Foundation)

225 Alberto Giacometti. *The Palace at 4 A.M.* 1932–33. Construction in wood, glass, wire, string, height 25". The Museum of Modern Art, New York

226 Alberto Giacometti. *Taut String.* 1933. Wood and metal with string, height 22½". Kunsthaus, Zurich (Giacometti Foundation)

227 Alberto Giacometti. *The Table.* 1933. Plaster, 57½ x 39⅜". Musée National d'Art Moderne, Paris

228 Alberto Giacometti. *Mannequin.* 1933. Plaster, height 67". Galerie Maeght, Paris

229 Alberto Giacometti. *Nude (Femme qui marche).* 1933–34. Bronze, height 59". Museum of Fine Arts, Boston (Henry Lee Higginson Fund, William Francis Warden Fund)

230 Alberto Giacometti. *The Invisible Object.* 1934. Bronze, height 61". Collection Aimé Maeght, Paris

231 Jean Arp. *Shirt Front and Fork.* 1922. Painted wood, 22 x 27½". Collection Mr. and Mrs. George Heard Hamilton, Williamstown, Massachusetts

232 Jean Arp. *Egg Board.* 1922. Painted wood relief, 29½ x 39". Collection F. C. Graindorge, Liège, Belgium

233 Jean Arp. *Dancer.* 1923–24. String and oil on canvas, 20 x 15¾". Private collection, New York

234 Jean Arp. *Torso with Navel.* 1925. Wood, 10¼ x 6¾". Private collection, Paris

235 Jean Arp. *Arranged According to the Laws of Chance.* 1929. Painted wood relief, 55⅛ x 42⅛". Private collection, Switzerland

236 Jean Arp. *Infinite Amphora.* 1929. Painted wood, 57⅛ x 44⅞". Collection Mme Carola Giedion-Welcker, Zurich

237 Jean Arp. *Hand Fruit.* 1930. Painted wood, 21⅝ x 34⅝". Private collection, Switzerland

238 Jean Arp. *Head with Annoying Objects.* 1930. Bronze, 14⅛ x 10¼ x 7½" (face). Private collection, Paris

239 Jean Arp. *Torso.* 1930. Plaster, height 12¼". Collection Claire Goll, Paris

240 Jean Arp. *Bell and Navels.* 1931. Painted wood, 10¼ x 19¼". The Museum of Modern Art, New York

241 Jean Arp. *Torso.* 1931. Marble, height 14⅛". Collection Mme A. Petzold-Mueller, Basel

242 Jean Arp. *Human Concretion.* 1935. Cast stone (1949, after original plaster); height 19½". The Museum of Modern Art, New York (Gift of the Advisory Committee)

243 Jean Arp. *Human Lunar Spectral.* 1950. Bronze, height 45". Collection Joseph H. Hirshhorn

244 Jean Arp. *Ptolemy.* 1953. Bronze, height 40½". Collection Mr. and Mrs. William Mazer, New York

245 Max Ernst. *Stones Carved in Low Relief.* 1934. Granite, height 36"; height of lower right stone, 5¾". Private collection, New York

246 Max Ernst. *Lunar Asparagus.* 1935. Plaster, height 6⅝". The Museum of Modern Art, New York

247 Max Ernst. *Woman Bird.* 1934–35. Bronze, height 20¾". Allan Frumkin Gallery, New York

248 Max Ernst. *Chimeras, Snakes, and Bottle.* 1935. Plaster, height 25⅝". (Destroyed)

249 Max Ernst. *Moon Mad.* 1944. Mahogany, height 36¼". Collection Mr. and Mrs. Julien Levy, Bridgewater, Connecticut

250 Max Ernst. *The Table Is Set.* 1944. Bronze, height 11", width 21½". Collection D. and J. de Menil, Houston

251 Max Ernst. *An Anxious Friend.* 1944 plaster; 1950 [?] bronze, height 26⅜". Collection Mr. and Mrs. Joseph Slifka, New York

252 Max Ernst. *The King Playing with the Queen.* 1944. Plaster; 1954 bronze, height 38½". The Museum of Modern Art, New York (Gift of Dominique and John de Menil)

253 Salvador Dali. *Object of Symbolic Function.* 1931.

254 André Breton. *Object of Symbolic Function.* 1931. Collection Mme André Breton, Paris

255 Yves Tanguy. *From the Other Side of the Bridge.* 1936. Painted wood and stuffed cloth, 19 x 8¾". Collection Mr. and Mrs. Morton G. Neumann, Chicago

256 Joan Miró. *Personage.* 1931. Wood, foliage, and umbrella, c. 72". (Destroyed)

257 Joan Miró. *Poetic Object.* 1936. Construction of hollowed wooden post, stuffed parrot on wooden stand, hat, and map, height 31⅞". The Museum of Modern Art, New York (Gift of Mr. and Mrs. Pierre Matisse)

258 Oscar Dominguez. *The Peregrinations of Georges Hugnet.* 1935. Painted wood with manufactured toys, 15⅜ x 12½". Collection Georges Hugnet, Paris

259 Oscar Dominguez. *Conversion of Energy (Le Tireur).* 1935. Painted plaster, objects, and glass, height 18⅞". Exhibited at the first international exhibition of Surrealist objects, Charles Ratton Gallery, Paris, 1936. Collection Charles Ratton, Paris

260 Oscar Dominguez. *The Coming of the Belle Epoque.* 1936. Cotton, wood, plaster, and metal, height 19¾". Collection Marcel Jean, Paris

261 Oscar Dominguez. *The Hunter.* Private collection

262 Marcel Jean. *Specter of the Gardenia.* 1936. Plaster covered with cloth, zippers, and a strip of film, height 10½". The Museum of Modern Art, New York

263 André Breton. *Dream Object.* 1935. Cardboard collage construction

264 André Breton. *Poem-Object.* 1937. 13 x 9½". Collection Mr. and Mrs. E. A. Bergman, Chicago

265 Roland Penrose. *The Last Voyage of Captain Cook.* 1936-67. Painted plaster, wood, and wire. Collection the artist

266 Jean Arp. *Mutilated and Stateless.* 1936. Newspaper construction, 14½ x 12⅝". Collection Peggy Guggenheim, Venice

267 Man Ray. *What We All Need.* 1935. Clay pipe and glass bubble, length 9". Exhibited at the first international exhibition of Surrealist objects, Charles Ratton Gallery, Paris, 1936. Collection Charles Ratton, Paris

268 Salvador Dali. *Aphrodisiac Jacket.* c. 1936

269 Méret Oppenheim. *Fur-Covered Cup, Saucer, and Spoon.* 1936. Fur, cup, saucer, and spoon; cup, 4⅜" diameter; saucer, 9⅜" diameter; spoon, 8" long. The Museum of Modern Art, New York

270 Joseph Cornell. *Woman and Sewing Machine.* 1932. Collage. (Lost)

271 Joseph Cornell. *Unpublished Memoirs of the Countess de G.* c. 1940. Mixed media construction, 5 x 2¾". Collection Mr. and Mrs. Richard L. Feigen, New York

272 Joseph Cornell. *L'Egypte de Mlle Cléo de Mérode.* 1940. Mixed media construction, 4¾ x 10¾ x 7". Collection Mr. and Mrs. Richard L. Feigen, New York

273 Joseph Cornell. *A Pantry Ballet for Jacques Offenbach.* 1942. Construction in paper, plastic, and wood, 10½ x 18 x 6". Collection Mr. and Mrs. Richard L. Feigen, New York

274 Pablo Picasso. *Woman.* 1930-32. Iron, with cobbler's last, model airplane, doll, and string, height 55⅛". Now dismantled

275 Pablo Picasso. *Object.* 1930. Fig-tree roots, feathers, and horn. No longer extant

276a, b, c, d. Hans Bellmer. Four views of *La Poupée,* as arranged by the artist in 1936

277 Hans Bellmer. *La Poupée.* 1936. Painted bronze, 16⅞ x 8⅝ x 5⅞". Collection the artist

278 Hans Bellmer. *Peppermint Tower in Honor of Greedy Little Girls.* 1936. Oil on canvas, 38⅛ x 35". Galerie A. F. Petit, Paris

279 Hans Bellmer. *The Machine-Gunneress.* 1937. Wood, metal, and papier-mâché, height 23⅜". The Museum of Modern Art, New York

280 E. L. T. Mesens. *Mask to Insult Esthetes.* 1929. Photo-collage, 10 x 8⅛". Collection the artist

281 E. L. T. Mesens. *Les Caves du Vatican.* 1936. Construction with tree trunk and silk banner. Collection Charles Ratton, Paris

282 Salvador Dali. *Rainy Taxi.* Created for *Exposition Internationale du Surréalisme,* Galerie Beaux-Arts, Paris, 1938

283 André Masson. *Mannequin.* Detail of "'Surrealist Street" at the international Surrealist exhibition, Galerie Beaux-Arts, Paris, 1938

284 The pond at the *Exposition Internationale du Surréalisme,* Galerie Beaux-Arts, Paris, 1938. Works of art, from left to right: Paalen, title unknown; Roland Penrose, *The Real Woman;* André Masson, *The Death of Ophelia;* Marcel Jean, *Horoscope*

285 Kurt Seligmann. *Ultra-Furniture.* Exhibited at the international Surrealist exhibition, Galerie Beaux-Arts, Paris, 1938. (Destroyed in a hurricane at Sugar Loaf, New York, 1949)

286 Victor Brauner. *Wolf-Table.* 1937. Wood with parts of stuffed animal, length 19¼", height 17¾", width 11". Collection Mme Victor Brauner, Paris

287 André Breton. *Poem-Object.* 1941. Assemblage, 18 x 21". The Museum of Modern Art, New York (Kay Sage Tanguy Bequest)

288 Man Ray, Yves Tanguy, Joan Miró, and Max Morise. *Cadavre exquis.* 1928. Pen and ink and crayon, 13½ x 8¾". Collection Mr. and Mrs. E. A. Bergman, Chicago

289 Pablo Picasso. *Dying Horse.* 1917. Drawing. Collection the artist

290 Pablo Picasso. *Guitar.* 1926. Cloth with string, pasted paper, paint, nails, 51¼ x 38¼". Collection the artist

291 Pablo Picasso. *Bather.* 1927. Charcoal. Collection the artist

292 Pablo Picasso. *Minotaure*. 1928. Collage, 54¾ x 89⅜". Collection Mme Marie Cuttoli, Paris

293 Pablo Picasso. *Metamorphosis*. 1928. Bronze, height 8⅝". Collection the artist

294 Pablo Picasso. *Construction*. 1928. Steel wire, height 11¾". Collection the artist

295 Pablo Picasso. Drawing for *Dinard Monument*. 1928. Collection the artist

296 Pablo Picasso. *Woman in an Armchair*. 1929. Oil on canvas, 76¾ x 51⅛". Collection the artist

297 Pablo Picasso. *Seated Bather*. 1930. Oil on canvas, 65 x 48". The Museum of Modern Art, New York (Mrs. Simon Guggenheim Fund)

298 Pablo Picasso. *Project for a Monument (Metamorphosis)*. 1930. Oil on wood, 26 x 19⅛". Private collection

299 Pablo Picasso. *Construction with Glove (By the Sea)*. 1930. Cardboard, plaster, and wood on canvas, covered with sand, 10⅝ x 13¾". Collection the artist

300 Pablo Picasso. *Crucifixion* (after Grünewald). 1932. Ink, 13¾ x 20". Private collection

301 Pablo Picasso. *Agonized Crucifixion* (after Grünewald). 1932. Ink, 13⅝ x 20⅜". Private collection

302 Pablo Picasso. *An Anatomy*. 1933. Pencil drawings from *Minotaure* (Paris), No. 1, 1933

303 Pablo Picasso. *Two Figures on the Beach*. 1933. Pen and ink, 15¾ x 20". The Museum of Modern Art, New York

304 Pablo Picasso. *Composition*. 1933. Watercolor, 15¾ x 20". Collection Dr. Allan Loos, New York

305 Pablo Picasso. Cover of first issue of *Minotaure* (Paris), 1933. Collage, 12 x 9"

306 Pablo Picasso. *Minotauromachy*. 1935. Etching, 19½ x 27¼". The Museum of Modern Art, New York (Abby Aldrich Rockefeller Purchase Fund)

307 Pablo Picasso. *Minotaur Emerging from Cave*. 1936. Watercolor, 19¾ x 25½". Private collection

308 Pablo Picasso. *Guernica*. 1937. Oil on canvas, 11'6" x 25'6". The Museum of Modern Art, New York (On extended loan from the artist)

309 Pablo Picasso. *Bull's Head*. 1943. Bronze, after bicycle seat and handle bar, height 16⅛". Collection the artist

310 Victor Brauner. *The Door*. 1932. Oil on wood, 16¾ x 27⅞". Richard L. Feigen Gallery, Chicago and New York

311 Victor Brauner. *Conspiracy*. 1934. Oil on canvas, 51⅛ x 38⅛". Collection Mme Victor Brauner, Paris

312 Victor Brauner. *The Strange Case of Mr. K*. 1934. Oil on canvas, 31⅞ x 39⅜". Collection Mme André Breton, Paris

312a Victor Brauner. *The Strange Case of Mr. K*. (Detail)

313 Victor Brauner. *Pivot de la soif*. 1934. Oil on wood, 20 x 23¼". Collection Mrs. Claire Zeisler, Chicago

314 Victor Brauner. *Totentot or the Great Metamorphosis*. 1942. Bronze, and oil on canvas. Private collection, Paris

315 Victor Brauner. *Talisman*. 1943. Tallow on wood, 6⅜ x 10⅞". The Museum of Modern Art, New York (the Sidney and Harriet Janis Collection)

316 Victor Brauner. *Number*. 1943. Plaster, height 39⅜". Collection the artist

317 Victor Brauner. *The Mechanical Fiancée*. 1945. Encaustic on paper, mounted on composition board, 25½ x 19½". Collection Mr. and Mrs. Julien Levy, Bridgewater, Connecticut

318 Victor Brauner. *Les Amoureux Messagers du nombre*. 1947. Oil on canvas, 36¼ x 28¾". Private collection

319 Victor Brauner. *Totem of Blessed Subjectivity*. 1948. Oil on canvas, 36¼ x 28¾". Collection Jean Lacade, Paris

320 Victor Brauner. *Tout Terriblement*. 1952. Oil on canvas, 36¼ x 28¾". Rose Art Museum, Brandeis University, Waltham, Massachusetts (Gift of Mrs. Ruth Moskin Fineshriber)

321 Victor Brauner. *Prelude to a Civilization*. 1954. Encaustic, 51¼ x 76¾". Collection Mr. and Mrs. Jacques Gelman, Mexico City

322 Oscar Dominguez. *Memory of the Future*. 1938. Oil on canvas, 24 x 19¾". Collection Marcel Jean, Paris

323 Oscar Dominguez. *Nostalgia of Space*. 1939. Oil on canvas, 28¾ x 36⅛". The Museum of Modern Art, New York (Gift of Peggy Guggenheim)

324 Oscar Dominguez. *Decalcomania*. 1937. 15 x 11". Collection Marcel Jean, Paris

325 Oscar Dominguez. *Decalcomania*. 1936. 10 x 13". Collection Marcel Jean, Paris

326 André Breton. *Decalcomania*. 1936. Gouache, 6⅛ x 8⅝". The Museum of Modern Art, New York (Anonymous gift)

327 Yves Tanguy. *Decalcomania*. 1936. Gouache, 12 x 19". Collection Marcel Jean, Paris

328 Marcel Jean. *Decalcomania*. 1937. 8 x 10". Collection the artist

329 Man Ray. *Painting Based on Mathematical Object*. 1948

330 Paul Delvaux. *Woman with a Rose*. 1936. Oil on canvas, 45 x 35". Private collection, New York

331 Paul Delvaux. *The Visit*. 1939. Oil on canvas, 38⅝ x 43¾". Collection Mr. and Mrs. J. B. Urvater, Brussels

332 Paul Delvaux. *The Village of the Sirens*. 1942. Oil on panel, 41 x 49". The Art Institute of Chicago (Gift of Mr. and Mrs. Maurice E. Culberg)

333 Wolfgang Paalen. *Totemic Landscape of My Childhood*. 1937. Oil on canvas, 19⅝ x 12¼". Private collection

334 Wolfgang Paalen. *Fumage*. 1939. Smoke and oil paint. Private collection, Paris

335 Gordon Onslow-Ford. *Man on a Green Island*. 1939. Oil on canvas, 29½ x 37". Collection the artist

336 Max Ernst. *Loplop Introduces a Young Girl*. 1930-36. Painted plaster on wood with dangling objects, 77 x 25⅜". Private collection

337 Max Ernst. *Loplop Introduces*. 1931. Pencil, pasted engraving, and blotter with ink, 25⅝ x 21¼". Collection Mr. and Mrs. Ernö Goldfinger, London

338 Max Ernst. *Zoomorphic Couple*. 1933. Oil on canvas, 36 x 28¾". Collection Peggy Guggenheim, Venice

339 Max Ernst. *The Blind Swimmer*. 1934. Oil

on canvas, 36¼ x 28¾". The Museum of Modern Art, New York

340 Max Ernst. Collage of engravings from *Une Semaine de bonté*: Element: Blood, Example: Oedipus. 1934

341 Max Ernst. Collage of engravings from *Une Semaine de bonté*: Element: Mud, Example: The Lion of Belfort. 1934

342 Max Ernst. Collage of engravings from *Une Semaine de bonté*: Third Visible Poem. 1934

343 Max Ernst. *Garden Airplane Trap*. 1935. Oil on canvas, 21¼ x 29". Collection the artist

344 Max Ernst. *The Joy of Living*. 1936. Oil on canvas, 28⅜ x 36". Penrose Collection, London

345 André Masson. *Tormented Woman*. 1932. Oil on canvas, 16⅛ x 13". Galerie Louise Leiris, Paris

346 André Masson. *Massacre*. 1932. Oil on canvas, 25⅝ x 43¼". Private collection

347 André Masson. *Interior of a Field of Grain*. 1934. Oil on canvas, 29⅞ x 25⅝". Galerie Louise Leiris, Paris

348 André Masson. *The Watch of Don Quixote*. 1935. Oil on canvas, 49⅝ x 38⅝". Galerie Louise Leiris, Paris

349 André Masson. *Landscape of Wonders*. 1935. Oil on canvas, 29⅞ x 25⅝". Galerie Louise Leiris, Paris

350 André Masson. *The Spring*. 1938. Oil on canvas, 18⅛ x 15". Richard Feigen Gallery, Chicago and New York

351 André Masson. *The Labyrinth*. 1938. Oil on canvas, 47¼ x 24". Galerie Louise Leiris, Paris

352 André Masson. *The Thread of Ariadne*. 1939. Oil on canvas, 8¾ x 10⅝". Galerie Louise Leiris, Paris

353 Joan Miró. *Construction*. 1930. Wood and metal, 35⅞ x 27⅝". The Museum of Modern Art, New York

354 Joan Miró. *Woman Walking*. 1931. Oil on canvas, 24⅜ x 18⅛". Collection Mr. and Mrs. J. B. Urvater, Brussels

355 Joan Miró. *Painting*. 1933. Oil on canvas, 68½ x 77¼". The Museum of Modern Art, New York (Gift of the Advisory Committee)

356 Joan Miró. *Collage*. 1933. Charcoal and pasted papers, 42 x 27½". Collection Mr. and Mrs. Morton G. Neumann, Chicago

357 Joan Miró. *Nocturne*. 1935. Oil on copper, 16½ x 11¾". Penrose Collection, London

358 Joan Miró. *Seated Woman*. 1938. Oil on canvas, 63 x 50¾". Collection Peggy Guggenheim, Venice

359 Joan Miró. *The Beautiful Bird Revealing the Unknown to a Pair of Lovers*. 1941. Gouache, 18 x 15". The Museum of Modern Art, New York (Acquired through the Lillie P. Bliss Bequest)

360 Joan Miró. *The Harbor*. 1945. Oil on canvas, 51⅛ x 63¾". Collection Mr. and Mrs. Armand P. Bartos, New York

361 Matta. *The Morphology of Desire*. 1938. Oil on canvas, 28¾ x 36¼". Collection Gordon Onslow-Ford, Inverness, California

362 Matta. *Prescience*. 1939. Oil on canvas, 36 x 52". The Wadsworth Atheneum, Hartford, Connecticut (Ella Gallup Sumner and Mary Catlin Sumner Collection)

363 Matta. *Landscape*. 1940. Pencil and crayon, 14¾ x 21½". Collection Mr. and Mrs. E. A. Bergman, Chicago

364 Matta. *Here Sir Fire, Eat*. 1942. Oil on canvas, 56 x 44". Collection James Thrall Soby, New Canaan, Connecticut

365 Matta. *The Great Transparent Ones*. 1942. Pencil and wax crayons. Collection the artist

366 Matta. *To Escape the Absolute*. 1944. Oil on canvas, 38 x 50". Collection Mr. and Mrs. Joseph Slifka, New York

367 Matta. *A Poet*. 1944-45. Oil on canvas, 37 x 30". Collection the artist

368 Matta. *The Heart Players*. 1945. Oil on canvas, 77 x 99". Collection Mr. and Mrs. Richard L. Feigen, New York

369 Matta. *Splitting the Ergo*. 1946. Oil on canvas, 77 x 99¼". Collection Mr. and Mrs. Burton Tremaine, Meriden, Connecticut

370 Matta. *A Grave Situation*. 1946. Oil on canvas, 55 x 77". Collection Mr. and Mrs. Earle Ludgin, Chicago

371 Matta. *Being With*. 1946. Oil on canvas, 7'4" x 15'. Collection the artist

372 Matta. *Untitled*. 1949. Oil on canvas, 37½ x 63". Collection Mr. and Mrs. Frederick Gash, New York

373 Matta. *Against You, Dove Assassins*. 1949. Oil on canvas, 6'6½" x 87¼". Alexander Iolas Gallery, New York

374 Matta. *To Cover the Earth with a New Dew*. 1953. Oil on canvas, 67½" x 9'6". City Art Museum of Saint Louis, Saint Louis, Missouri

375 Wifredo Lam. *Astral Harp*. 1943. Oil on canvas, 82⅝ x 78¾". Collection Mr. and Mrs. J. B. Urvater, Brussels

376 Wifredo Lam. *The Spirit Watching*. 1944. Oil on canvas, 60⅝ x 51⅛". Collection Mr. and Mrs. J. B. Urvater, Brussels

377 Wifredo Lam. *Tree of Mirrors*. 1945. Oil on canvas, 39½ x 49½". Collection Joseph Cantor, Carmel, Indiana

378 Wifredo Lam. *Rumblings of the Earth*. 1950. Oil on canvas, 59¾ x 112". The Solomon R. Guggenheim Museum, New York (Gift of Mr. and Mrs. Joseph Cantor)

379 André Masson. *Indian Spring*. 1942. Distemper on canvas, 33 x 39¾". Collection Mr. and Mrs. William Mazer, New York

380 André Masson. *Leonardo da Vinci and Isabella d'Este*. 1942. Oil on canvas, 39⅞ x 50". The Museum of Modern Art, New York

381 André Masson. *Pasiphaë*. 1943. Oil and tempera on canvas, 39¾ x 50". Private collection, Illinois

382 André Masson. *Interwoven Lovers*. 1943. Crayon and gouache, 10⅝ x 8¼". Galerie Louise Leiris, Paris

383 André Masson. *Meditation of the Painter*. 1943. Oil and tempera on canvas, 52 x 40". Collection Richard S. Zeisler, New York

384 André Masson. *The Auguring Sibyl*. 1944. Oil and sand on canvas, 31 x 38". Private collection, New York

385 André Masson. *The Burrow*. 1946. Oil and tempera on canvas, 33⅛ x 40⅛". Private collection, Paris

386 Max Ernst. *Europe after the Rain*. 1940-42. Oil on canvas, 21½ x 58½". The Wadsworth Atheneum, Hartford, Connecticut (Ella Gallup Sumner and Mary Catlin Sumner Collection)

387 Max Ernst. *Day and Night*. 1941-42. Oil on canvas, 44¼ x 57½". Private collection, California

388 Max Ernst. *Napoleon in the Wilderness*. 1941. Oil on canvas, 18¼ x 15". The Museum of Modern Art, New York

389 Max Ernst. *Surrealism and Painting*. 1942. Oil on canvas, 76¾ x 91¾". Private collection, New York

390 Max Ernst. *The Mad Planet*. 1942. Oil on canvas, 43 x 55½". Tel-Aviv Museum

391 Max Ernst. *The Eye of Silence*. 1943-44. Oil on canvas, 42½ x 55½". Washington University, Saint Louis, Missouri

392 Max Ernst. *Young Man Intrigued by the Flight of a Non-Euclidean Fly*. 1942-47. Oil on canvas, 32¼ x 26". Collection Dr. W. Löffler, Zurich

393 Kurt Seligmann. *The Offering*. 1946. Oil on canvas, 30½ x 27½". Washington County Museum of Fine Arts, Hagerstown, Maryland

394 Yves Tanguy. *Slowly Toward the North*. 1942. Oil on canvas, 42 x 36". The Museum of Modern Art, New York (Gift of Philip C. Johnson)

395 Yves Tanguy. *Indefinite Divisibility*. 1942. Oil on canvas, 40 x 35". Albright-Knox Art Gallery, Buffalo, New York (Room of Contemporary Art Fund)

396 Yves Tanguy. *The Palace of Windowed Rocks*. 1942. Oil on canvas, 64 x 52". Musée d'Art Moderne, Paris

397 Yves Tanguy. *My Life, White and Black*. 1944. Oil on canvas, 36 x 30". Collection Mr. and Mrs. Jacques Gelman, Mexico City

398 Yves Tanguy. *Fear*. 1949. Oil on canvas, 60 x 40". Whitney Museum of American Art, New York

399 Yves Tanguy. *Rose of the Four Winds*. 1950. Oil on canvas, 28 x 23". Pierre Matisse Gallery, New York

400 Yves Tanguy. *Multiplication of Arcs*. 1954. Oil on canvas, 40 x 60". The Museum of Modern Art, New York (Mrs. Simon Guggenheim Fund)

401 Arshile Gorky. *Image in Xhorkom*. c. 1936. Oil on canvas, 32⅞ x 43". Collection Jeanne Reynal, New York

402 Arshile Gorky. *Garden in Sochi I*. 1941. Oil on canvas, 44¼ x 62¼". The Museum of Modern Art, New York (Purchase Fund and gift of Mr. and Mrs. Wolfgang S. Schwabacher)

403 Arshile Gorky. *Garden in Sochi II*. 1941. Oil on canvas, 25 x 29". Estate of Arshile Gorky

404 Arshile Gorky. *Garden in Sochi III*. 1943. Oil on canvas, 31 x 39". Estate of Arshile Gorky

405 Arshile Gorky. *The Pirate I*. 1942. Oil on canvas, 29¼ x 40⅛". Collection Mr. and Mrs. Julien Levy, Bridgewater, Connecticut

406 Arshile Gorky. *Landscape*. 1943. Pencil and crayon, 20¼ x 27⅜". Collection Mr. and Mrs. Walter Bareiss, Munich

407 Arshile Gorky. *Drawing*. 1943. Pencil and wax crayon, 18½ x 23½". Collection Mr. and Mrs. Seymour Propp, New York

408 Arshile Gorky. *Waterfall*. 1943. Oil on canvas, 60½ x 44½". Estate of Arshile Gorky

409 Arshile Gorky. *How My Mother's Embroidered Apron Unfolds in My Life*. 1944. Oil on canvas, 40 x 45". Collection Mr. and Mrs. C. Bagley Wright, Jr., Seattle

410 Arshile Gorky. *The Unattainable*. 1945. Oil on canvas, 41⅛ x 29¼". The Baltimore Museum of Art (Museum Purchase)

411 Arshile Gorky. *The Diary of a Seducer*. 1945. Oil on canvas, 50 x 62". Collection Mr. and Mrs. William A. M. Burden, New York

412 Arshile Gorky. *Study for Agony*. 1946-47. Pencil, wax crayon, and gray wash, 22 x 30". Estate of Arshile Gorky

413 Arshile Gorky. *Agony*. 1947. Oil on canvas, 40 x 50½". The Museum of Modern Art, New York (A. Conger Goodyear Fund)

414 Arshile Gorky. *Study for The Betrothal*. 1947. Pencil, charcoal, pastel, and wax crayon, 49 x 39". Collection Jeanne Reynal, New York

415 Arshile Gorky. *The Betrothal II*. 1947. Oil on canvas, 50¾ x 38". Whitney Museum of American Art, New York

416 Arshile Gorky. *The Plough and the Song II*. 1947. Oil on canvas, 52 x 64". Collection Mr. and Mrs. Milton A. Gordon, New York

417 Arshile Gorky. *Untitled*. Oil on canvas, 20 x 25½". Private collection

DOCUMENTARY ILLUSTRATIONS

D-1 Matthias Grünewald. *The Crucifixion*, panel of *Isenheim Altarpiece*. c. 1510-15. Panel, 8'10" x 10'1". Musée Unterlinden, Colmar

D-2 Giuseppe Arcimboldo (c. 1530-1591). *Bust Composed of Animals*. Oil on canvas, 26⅝ x 19⅝". Kunsthistorisches Museum, Vienna

D-3 Giuseppe Arcimboldo. *The Librarian*. Oil on canvas, 38⅛ x 28". Private collection, Sweden

D-4 Josse de Momper. *Winter*. c. 1625. Oil on canvas, 20½ x 15⅜". Collection Robert Lebel, Paris

D-5 Giovanni Battista Bracelli (active 1624-49). *Furniture Figures*, 1624. Etching. Bibliothèque Nationale, Paris

D-6. Nicolas I de Larmessin (d. 1694). *Habit de Layettier*. Engraving, 10⅝ x 7½". Plate in *Habits et Métiers*

D-7 George Engleheart (1752-1829). *Portrait of Mrs. Mills* (After an engraving by J. R. Smith)

D-8 Rodolphe Bresdin. *Aqueduct and Waterfalls*. n.d. Pen and India ink, 4⅝ x 4¾". Collection Mr. and Mrs. Leonard Baskin, Northampton, Massachusetts

D-9 Gustave Moreau. *Salome Dancing before Herod*. 1876. Oil on canvas, 55½ x 41". The Gallery of Modern Art, Including the Huntington Hartford Collection, New York

D-10 Gustave Moreau. *Sketch D*. Oil on cardboard, 18½ x 12½". Musée Gustave Moreau, Paris

D-11 Odilon Redon. *The Eye Like a Strange Balloon Moves toward Infinity*. Plate I from *A Edgar Poë*. 1882. Lithograph, 10¼ x 7¾". The Museum of Modern Art, New York (Gift of Peter H. Deitsch)

D-12 Odilon Redon. *Germination*. 1885. Charcoal, 20½ x 15". Collection Henri Dorra, Philadelphia

D-13 Odilon Redon. *The Spider*. 1887. Lithograph, 11 x 8½". The Art Institute of Chicago (The Stickney Collection)

D-14 Odilon Redon. *Light*. 1893. Lithograph, 15½ x 10¾". The Museum of Modern Art, New York (Gift of Victor S. Riesenfeld)

D-15 Georges Seurat. *Sunday Afternoon on the Island of La Grande Jatte.* 1884–86. Oil on canvas, 81 x 120⅜". The Art Institute of Chicago (Helen Birch Bartlett Memorial Collection)

D-16 Antoni Gaudí. Palau Güell, Barcelona. 1885–89. Detail of wrought-iron decoration in upper-floor bedroom

D-17 Art Nouveau column base. From *Minotaure* (Paris), No. 3–4

D-18 Philippe Wolfers. *Inkstand.* c. 1889. Gilded bronze, 13¾ x 8½". Collection Baroness Horta, Brussels

D-19 Henry van de Velde. *Composition.* 1890. Pastel, 18½ x 20". Rijksmuseum Kröller-Müller, Otterlo, The Netherlands

D-20 Hector Guimard. Métropolitain Station, Place de l'Etoile, Paris. 1900. (Demolished)

D-21 Henry van de Velde. *Candelabrum.* c. 1902. Silver-plated bronze, height 21¾". Nordenfjeldske Kunstindustrimuseum, Trondheim

D-22 The Postman Cheval. The Ideal Palace. Façade. Finished 1912. Hautrives (Drôme), France

D-23 Henri Rousseau. *The Dream.* 1910. Oil on canvas, 6'8½" x 9'9½". The Museum of Modern Art, New York (Gift of Nelson A. Rockefeller)

D-24 Henri Rousseau. *Portrait of Pierre Loti.* c. 1910. Oil on canvas, 24 x 19⅝". Kunsthaus, Zurich

D-25 L. (E. V.) and M. (G.). *What a Life.* Page 45. Novel with collage illustrations. 1911. Methuen and Co., London

D-26 Wassily Kandinsky. *Sunday.* 1911. Oil on canvas, 42⅜ x 37⅜". Städtische Galerie, Munich (Gabriele Münter Foundation)

D-27 Wassily Kandinsky. *Black Lines.* 1913. Oil on canvas, 51¼ x 51⅜". The Solomon R. Guggenheim Museum, New York

D-28 Umberto Boccioni. *The Forces of a Street.* 1911. Oil on canvas, 39½ x 31½". Collection Mrs. Nell Urech-Walden, Schinznach, Switzerland

D-29 Pablo Picasso. *Bottle of "Vieux Marc," Glass, Newspaper.* 1912. Charcoal and pasted papers, 24⅜ x 18½". Collection Mme Marie Cuttoli, Paris

D-30 Pablo Picasso. *Ma Jolie (Woman with a Zither or Guitar).* 1911–12. Oil on canvas, 39⅜ x 25¾". The Museum of Modern Art, New York (Acquired through the Lillie P. Bliss Bequest)

D-31 Piet Mondrian. *Composition 7.* 1913. Oil on canvas, 41⅞ x 45". The Solomon R. Guggenheim Museum, New York

D-32 Piet Mondrian. *Pier and Ocean.* 1914. Charcoal, brush, and ink, heightened with white wash on buff paper, 34⅜ x 44". The Museum of Modern Art, New York (Mrs. Simon Guggenheim Fund)

D-33 Marc Chagall. *Dedicated to My Fiancée.* 1911. Oil on canvas, 77⅞ x 45". Berner Kunstmuseum, Bern

D-34 Paul Klee. *An Artist (Self-Portrait).* 1919. Pen drawing, 9 x 5¼". Private collection

D-35 Giorgio de Chirico. *The Enigma of the Oracle.* 1910. Oil on canvas, c. 14 x 18". Private collection, Italy

D-36 Arnold Böcklin. *Battle of the Centaurs.* 1873. Tempera on canvas, varnished, 41⅜ x 76¾". Kunstmuseum, Basel

D-37 Arnold Böcklin. *Odysseus and Calypso.* 1883. Tempera on mahogany, varnished, 41 x 59". Kunstmuseum, Basel

D-38 Max Ernst. *The Last Judgment.* c. 1919. (Lost) Oil on canvas. Formerly collection Frau Johanna Ey, Düsseldorf

D-39 Giorgio de Chirico. *The Departure of the Knight Errant.* 1923. Tempera, 38 x 50". Collection Marta Pallini, Milan

D-40 Max Klinger. *Paraphrase on the Finding of a Glove, Plate II.* Published 1881. Etching, 11¼ x 8¼". The Museum of Modern Art, New York

D-41 Poster for Johnson-Cravan fight, Madrid, April 23, 1916

D-42 Francis Picabia. *Arthur Cravan.* Pencil drawing. Private collection

D-43 Jacques Vaché. *Self-Portrait.* Etching. Private collection

D-44 Jacques Vaché in uniform. 1918

D-45 André Breton in uniform. 1917–18

D-46 Baroness Elsa von Freytag-Loringhoven. 1921

D-47 Alfred Jarry. From *Minotaure* (Paris), No. 10, 1937

D-48 Marcel Duchamp as Rose Sélavy. Photograph by Man Ray. 1920

D-49 Francis Picabia. *Portrait of Cézanne. . .* 1920. (No longer extant.) Reproduced from *Cannibale* (Paris), April 25, 1920

D-50 Marcel Duchamp. *L.H.O.O.Q.* 1919. Reproduction of the *Mona Lisa* altered with pencil, 7½ x 5". Private collection

D-51 Marcel Duchamp. *Portrait (Dulcinea).* 1911. Oil on canvas, 57¼ x 44⅞". Philadelphia Museum of Art (Louise and Walter Arensberg Collection)

D-52 Giacomo Balla. *Leash in Motion.* 1912. Oil on canvas, 35¾ x 43⅜". The Buffalo Fine Arts Academy (Gift of George F. Goodyear)

D-53 Eadweard Muybridge. *Head-Spring, a Flying Pigeon Interfering,* June 26, 1885 (Plate 365 from *Animal Locomotion,* 1887)

D-54 Marcel Duchamp descending a staircase. Stroboscopic photograph by Eliot Elisofon

D-55 Marcel Duchamp. *Virgin I.* 1912. Pencil, 13 x 10". Philadelphia Museum of Art (A. E. Gallatin Collection)

D-56 Marcel Duchamp's studio, 33 West 67th Street, New York. 1917–18

D-57 Rube Goldberg. Cartoon. From *New York Dada* (New York), April, 1921

D-58 Katherine Dreier's library with Duchamp's *Tu m'* and the *Large Glass.* 1937

D-59 Man Ray. *Portrait of Marcel Duchamp.* 1923. Private collection, New York

D-60 Marcel Duchamp. *Rotary Glass Plate (Precision Optics)* (in motion). 1920. Motorized construction, painted glass and metal, 73 x 48 x 40". Yale University Art Gallery, New Haven, Connecticut (Gift of the Société Anonyme)

D-61 Gabrielle Buffet and Francis Picabia in their Mercer. 1917

D-62 Francis Picabia, Gabrielle Buffet, Guillaume Apollinaire at Luna Park, Paris. 1914

D-63 Francis Picabia. *Rubber.* 1909. Oil on canvas, 17¾ x 24". Musée d'Art Moderne, Paris

D-64 Francis Picabia. *Girl Born Without a Mother*, 1913. Pencil. Private collection

D-65 Francis Picabia. *Judith*. 1932. Oil on canvas, 76 x 50⅜". Collection Mme Simone Collinet, Paris

D-66 Man Ray. *Five Figures*, 1914. Oil on canvas, 36 x 32". Whitney Museum of American Art, New York (Gift of Mrs. Katharine Kuh)

D-67 Man Ray. *By Itself*. 1918. Wood, height 22". Collection the artist

D-68 The Spiegelgasse, Zurich. The Cabaret Voltaire was at No. 1, lower right

D-69 Tristan Tzara, Zurich, 1916

D-70 Hugo Ball reciting the Sound Poem *Karavane*, 1916

D-71 *Admiral Seeks a House for Rent* (Simultaneous Poem), from *Cabaret Voltaire*, 1916

D-72 At "Die Neue Kunst," Galerie Wolfsberg, Zurich, 1918. Left to right, Marcel Janco, Jean Arp

D-73 Marcel Janco. *Dada Construction*. 1917

D-74 Emmy and Hugo Ball, Zurich, 1918

D-75 Jean Arp. *Static Composition*. 1915. Oil on cardboard, 35⅞ x 28". Collection R. Tillard Arp, Paris

D-76 Jean Arp and Sophie Täuber-Arp. *Duo Collage*. 1918. Paper on cardboard, 33⅞ x 26". Collection Mr. and Mrs. Burton Tremaine, Meriden, Connecticut

D-77 Jean Arp and Sophie Täuber-Arp, Zurich, 1918

D-78 Sophie Täuber-Arp. Untitled. 1920. Watercolor, 16⅛ x 11". Private collection, New York

D-79 Opening of the *Erste Internationale Dada-Messe*. Kunsthandlung Dr. Otto Burchard, Berlin, June, 1920. From left to right: Raoul Hausmann, Hannah Höch, Dr. Burchard, Johannes Baader, Wieland Herzfelde, Mrs. Herzfelde, Otto Schmalhausen (Dadaoz), George Grosz, John Heartfield, 1918

D-80 Hannah Höch and Raoul Hausmann at the *Erste Internationale Dada-Messe*

D-81 Catalogue-announcement of the *Erste Internationale Dada-Messe*

D-82 George Grosz and John Heartfield. *Henri Rousseau—Self-Portrait*. Montage. From cata-

logue-announcement of the *Erste Internationale Dada-Messe*

D-83 List of names from catalogue-announcement of the *Erste Internationale Dada-Messe*

D-84 Richard Huelsenbeck. Cover of *Dada Almanach*, 1920

D-85 Richard Huelsenbeck. c. 1916

D-86 Richard Huelsenbeck (left) and Raoul Hausmann, Prague. 1920

D-87 Ludwig Meidner. *Richard Huelsenbeck*. 1918. Drawing

D-88 Richard Huelsenbeck. *The Lion Hunt*. 1945. Oil on canvas, c. 48 x 54". Collection the artist

D-89 Richard Huelsenbeck. *Jean Arp*. 1949. Oil on canvas. Collection the artist

D-90 Hans Richter. Frames from *Rhythmus 21*.

D-91 Baargeld (Alfred Grünwald). *Self-Portrait*. 1920. Photographic collage

D-92 Max Ernst. *Still Life in Cubist Style*. c. 1913. Private collection, Paris

D-93 Max Ernst. *dadamax with Caesar Buonaroti* (*Self-Portrait*). 1920. Photographic collage, 7 x 4½". Formerly collection Tristan Tzara, Paris

D-94 Max Ernst. Cover of *Die Schammade* (Cologne), February, 1920

D-95 Opening of the Max Ernst exhibition at the Galerie au Sans Pareil, Paris, May, 1921. Left to right: Hilsum, Péret, Charchoune, Soupault, Rigout, Breton

D-96 Cover of *Merz*, No. 20, showing Kurt Schwitters

D-97 Kurt Schwitters. *Aerated Painting*. 1917. Oil and collage on canvas, 24½ x 18½". Collection Mr. and Mrs. Victor Leventritt, New York

D-98 Pablo Picasso. *The Manager from New York*. Costume designed for *Parade*, 1917. c. 10' high

D-99 André Breton reading the "Festival Manifeste Presbyte" by Francis Picabia, at the Salle Gaveau, Paris, May 26, 1920

D-100 Performance of *Vous m'oublierez* at the Salle Gaveau, Paris, May 26, 1920. Left to right: Paul Eluard (above), Philippe Soupault (below), André Breton, and Dr. Fraenkel

D-101 Dada Festival at the Salle Gaveau, Paris, May 26, 1920

D-102 The Barrès Trial at the Salle des Sociétés Savantes, Paris, May, 1921

D-103 Francis Picabia. *Relâche* (ballet). Marcel Duchamp as Adam. Paris, 1924

D-104 *Entr'acte*. Film by René Clair. 1924. Still of Marcel Duchamp and Man Ray playing chess

D-105 Left to right, Tristan Tzara, Jean Arp, and Max Ernst in the Tyrol, Summer, 1921. Period of *Dada Intirol Augrandair*

D-106 Max Ernst. *The Meeting of Friends*. 1922. 51¼ x 82⅝". First row, left to right: René Crevel (at invisible piano), Max Ernst (on lap of Dostoevski), Dr. Fraenkel, Jean Paulhan, Benjamin Péret, Baargeld, Robert Desnos. Second row: Philippe Soupault, Jean Arp, Max Morise, Raphaël, Paul Eluard, Louis Aragon, André Breton, Giorgio de Chirico, Gala Eluard. Collection Dr. Lydia Bau, Hamburg

D-107 André Breton (with make-up), in front of a de Chirico painting. 1926

D-108 Bottom row: Simone Breton, Louis Aragon, Colette Jéramec-Tual; top row: André Breton, Max Morise, Roland Tual

D-109 Left to right: Georges Malkine, André Masson, André Breton, Max Morise, Georges Neveux; in Nice, 1924

D-110 Left to right: Robert Desnos, André Breton, Malkine, Max Morise, Simone Breton Collinet; in Florence, 1924

D-111 The Surrealist *centrale*. 1924. Left to right: François Baron, Raymond Queneau, André Breton, Jacques Boiffard, Giorgio de Chirico, Roger Vitrac, Paul Eluard, Philippe Soupault, Robert Desnos, Louis Aragon; front row: Pierre Naville, Simone Breton Collinet, Max Morise, Pauline Soupault

D-112 The Surrealist *centrale*. 1924. Left to right: Max Morise, Roger Vitrac, Jacques Boiffard, André Breton, Paul Eluard, Pierre Naville, Giorgio de Chirico, Philippe Soupault; bottom: Robert Desnos, François Baron; at the typewriter: Simone Breton Collinet

D-113 Dada "Happening" at the church of Saint Julien le Pauvre, 1921. Left to right: unidentified

485

journalist, Philippe Soupault, Tristan Tzara, André Breton (reading)

D-114 Corner of André Breton's studio in 1924

D-115 Robert Desnos and Pierre Naville. *Painting.* 1924

D-116 Dédé Sunbeam. *Collage*

D-117 Pierre Roy. *Daylight Saving Time.* 1929. Oil on canvas, 21½ x 15". The Museum of Modern Art, New York (Gift of Mrs. Ray Slater Murphy)

D-118 Joan Miró. *The Path, Ciurana.* 1917. Oil on canvas, 23⅜ x 29½". Collection Ernest Tappenbeck, Paris

D-119 Joan Miró. *Village and Street, Ciurana.* 1917. Oil on canvas, 23⅝ x 28¾". Collection Mr. and Mrs. James W. Alsdorf, Winnetka, Illinois

D-120 Joan Miró. *Nord-Sud.* 1917. Oil on canvas, 24¾ x 28". Galerie Maeght, Paris

D-121 Joan Miró. *Standing Nude.* 1918. Oil on canvas, 60¼ x 47½". City Art Museum of Saint Louis, Missouri

D-122 Joan Miró. *The Table (Still Life with Rabbit).* 1920. Oil on canvas, 51¼ x 43¼". Collection Gustav M. Zumsteg, Zurich

D-123 On the beach at Juan Les Pins, 1925. Left to right: André Masson, Daniel-Henri Kahnweiler, Pablo Picasso, Olga Picasso, Mme Lascaux, Louise Leiris, Michel Leiris

D-124 André Masson. *Feather Collage.* 1927. Oil and feathers on canvas, 43¼ x 22½". Galerie Louise Leiris, Paris

D-125 Max Ernst. *System of Solar Money* (Plate XXXI from *Histoire Naturelle*). 1926

D-126 Max Ernst. *The Idol* (Plate XIX from *Histoire Naturelle*). 1926

D-127 Yves Tanguy. *Girl with Red Hair.* 1926. Oil on canvas, 24 x 18¼". Collection Mr. and Mrs. Pierre Matisse, New York

D-128 Yves Tanguy. *The Certitude of the Never Seen.* 1933. Oil on wood, with carved wood frame, 8⅝ x 9⅞ x 2½". Private collection

D-129 René Magritte. *Man at the Window.* 1920. Oil on canvas, 35⅞ x 25⅝". Collection Pierre Bourgeois, Brussels

D-130 René Magritte. *Memory.* 1948. Oil on canvas, 29⅞ x 21¼". Belgian State Collections, Brussels

D-131 The Belgian Surrealist group. Left to right: E. L. T. Mesens, René Magritte, Louis Scutenaire, André Souris, Paul Nougé; seated: Irène Hamoir, Marthe Nougé, Georgette Magritte

D-132 Réne Magritte. *Delusion of Grandeur.* 1962. Oil on canvas, 39½ x 32". Alexander Iolas Gallery, New York

D-133 René Magritte. *The Ocean.* 1942. Oil on canvas, 19⅝ x 25⅝". Private collection

D-134 *Un Cadavre* (broadside). 1930. Retouched photo of André Breton as Jesus

D-135 Salvador Dali when he attended the School of Fine Arts, Madrid

D-136 Max Ernst. *Surrealist Personages.* 1931. Photomontage, 19¾ x 13¼". The Museum of Modern Art, New York

D-137 Salvador Dali. *Pure Still Life.* 1924. Oil on canvas, 39⅓ x 39⅓". Private collection

D-138 *The Rock of Slumber.* Photo of a rock taken by Dali on Cape Creus, Spain

D-139 Salvador Dali. *Meditation on the Harp.* 1932. Oil on canvas, 26¼ x 18½". Private collection

D-140 Salvador Dali. *Hysterical and Aerodynamic Feminine Nude.* 1934. Plaster, length 30". Private collection

D-141 Salvador Dali and Luis Buñuel. Still from the film *An Andalusian Dog*

D-142 Salvador Dali and Luis Buñuel. Still from the film *L'Age d'or*

D-143 Salvador Dali and Luis Buñuel. Still from the film *L'Age d'or,* "Are you cold?"

D-144 Max Ernst. *The Virgin Spanking the Child Jesus . . .* 1923(?); Oil on canvas, 37¾ x 11¾". Collection Mme Jean Krebs, Brussels

D-145 Clovis Trouille. *Remembrance.* 1931. Oil on canvas, 29⅛ x 34⅝". Collection the artist

D-146 Clovis Trouille. *Lust.* 1959. Oil on canvas, 19⅝ x 24". Private collection, Paris

D-147 Salvador Dali. *Paranoiac Face.* Sketch with postcard that suggested it

D-148 Salvador Dali. *Paranoiac Face.* 1934-35. Oil on wood, 7½ x 9". Collection Edward James, London

D-149 Surrealist exhibition at the Pierre Colle Gallery, Paris, 1933. Objects by Breton, Dali, Duchamp, Ernst, and Man Ray

D-150 Man Ray. Montage of photographs which were taken previously. 1934. Left to right, top row: Breton, Ernst, Dali, Arp; second row: Tanguy, Char, Crevel, Eluard; third row: de Chirico, Giacometti, Tzara, Picasso; fourth row: Magritte, Brauner, Péret, Rosey; bottom row: Miró, Mesens, Hugnet, Man Ray

D-151 Studio of Alberto Giacometti

D-152 Alberto Giacometti. *Construction.* 1927. Plaster, height 20⅛". Private collection

D-153 Alberto Giacometti. *Man Pointing.* 1947. Bronze, height 69⅝". The Tate Gallery, London

D-154 Alberto Giacometti. *City Square.* c. 1948. Bronze, height 8½", length 25⅜". The Museum of Modern Art, New York (Purchase)

D-155 Alberto Giacometti. *Closed-in Figure.* 1950. Plaster, height 25⅝". Private collection

D-156 Alberto Giacometti. *Cage.* 1950-51. Bronze, height 67". Collection Aimé Maeght, Paris

D-157 Alberto Giacometti. *Figurine.* 1957. Bronze, height 12⅝". Private collection

D-158 Jean Arp. *Head.* 1929. Plaster. (Lost)

D-159 Joseph Cornell. *Soap Bubble Set.* 1936. Mixed media construction. The Wadsworth Atheneum, Hartford, Connecticut

D-160 Joseph Cornell. *America Fantastica.* Cover of *View,* January 1943

D-161 Joseph Cornell. *Apothecary.* 1950. Wooden cabinet with glass jars containing various objects and materials, in glass compartments, 15⅞ x 11⅞ x 4⅜". Private collection, Houston

D-162 Marcel Jean and Oscar Dominguez, with the latter's *Ouverture,* in Marcel Jean's studio, Paris. 1936

D-163 View of the *Exposition Surréaliste d'Objets,* Charles Ratton Gallery, Paris. 1936

D-164 View of the private collection of André Breton in his studio, rue Fontaine, Paris

D-165 Georges Hugnet. *Poème-Découpage.* 1936

D-166 Wineglass found at Saint-Pierre, Martinique, after the eruption of Mount Pelée, 1902. Formerly Permanent Museum of the Colonies, Paris

D-167 *Tamanoir*. 1936. Collage-object

D-168 Man Ray. Photo of a mathematical object.

D-169 Man Ray. *End Game*. 1946. Oil on canvas, 23½ x 29½". Cordier & Ekstrom, Inc., New York

D-170 Man Ray. *Anthony and Cleopatra* ("Shakespearean Equations"). 1948. Oil on canvas. Private collection

D-171 Pablo Picasso. *Glass of Absinthe*. 1914. Painted bronze with silver spoon, height 8½". The Museum of Modern Art, New York (Gift of Mrs. Bertram Smith)

D-172 Pablo Picasso. *Crucifixion*. 1926. Ink. Private collection

D-173 Pablo Picasso. *Girl before a Mirror*. 1932. Oil on canvas, 63¾ x 51¼". The Museum of Modern Art, New York (Gift of Mrs. Simon Guggenheim)

D-174 Pablo Picasso. *Bull, Horse and Woman*. 1934. Etching printed in black, 11¾ x 9¼". The Museum of Modern Art, New York (On extended loan from the artist)

D-175 Pablo Picasso. *Dying Minotaur*. 1936. Watercolor. Private collection

D-176 Pablo Picasso. *Horse's Head* (Study for *Guernica*). 1937. Oil on canvas, 25½ x 36¼". The Museum of Modern Art, New York (On extended loan from the artist)

D-177 Pablo Picasso. *The Charnel House*. 1945. Oil on canvas, 78⅝ x 98½". Collection Walter P. Chrysler, Jr., New York

D-178 Pablo Picasso. Notebook drawing of a bullfight. 2-3-59. IX. 1959. Chinese ink, 14½ x 10⅛". Private collection

D-179 Pablo Picasso. Notebook drawing of a bullfight. 2-3-59. XIV. 1959. Chinese ink, 14½ x 10⅝". Private collection

D-180 Joan Miró. *Painting*. 1930. Oil on canvas, 59 x 88⅝". Collection D. and J. de Menil, Houston

D-181 Joan Miró. *Mediterranean Landscape*. 1930. Oil on canvas, 92½ x 61". Collection Otto Preminger, New York

D-182 Joan Miró. *Head of a Man, I*. 1931. Oil on canvas, 25⅝ x 19⅝". Private collection, Paris

D-183 Joan Miró. *Self-Portrait*. 1937–38. Pencil, crayon, and oil on canvas, 57½ x 38½". Collection James Thrall Soby, New Canaan, Connecticut

D-184 Joan Miró. *Still Life with Old Shoe*. 1937. Oil on canvas, 32¼ x 46". Collection James Thrall Soby, New Canaan, Connecticut

D-185 André Masson. *Suntrap*. 1938. Oil on canvas, 39⅜ x 31⅞". Galerie Louise Leiris, Paris

D-186 André Masson. *In the Tower of Sleep*. 1938. Oil on canvas, 32 x 39½". The Baltimore Museum of Art (Saidie A. May Collection)

D-187 International Surrealist exhibition, Galerie Beaux-Arts, Paris. 1938. The main room of the exhibition, showing one of the *Revolving Doors*, with paintings by Yves Tanguy, Oscar Dominguez, Marcel Jean, and Wolfgang Paalen; on the left: *Mannequin* by Marcel Jean

D-188 The main room of the international Surrealist exhibition, Galerie Beaux-Arts, Paris. 1938. Hanging from the ceiling, Marcel Duchamp's coal bags; in the front, *Jamais* by Oscar Dominguez; on the left, painting by Dali; on the right, painting by Tanguy

D-189 Victor Brauner in his studio, seated before a sculpture entitled *Number*. 1953

D-190 Victor Brauner. *Self-Portrait*. 1931. Oil on wood, 8⅝ x 6¼". Collection Mme Victor Brauner, Paris

D-191 Salvador Dali. Cover for *Minotaure* (Paris), No. 8, 1936

D-192 Matta. Untitled drawing. 1937. Crayon and pencil, 12⅝ x 19⅜". Collection Ann Matta Alpert, New York

D-193 Esteban Francés. *The Labyrinth of the Minotaur*. 1939. Oil on canvas, 28½ x 36¼". Collection Gordon Onslow-Ford, Inverness, California

D-194 Tanguy, Breton, Onslow-Ford, Matta, Francés, Anne Pajarito, Jacqueline Breton at Gertrude Stein's country home near Belley, France, Summer, 1939

D-195 Jacqueline Breton, André Masson, André Breton, and Varian Fry, Director of the emergency rescue committee, Marseilles, 1941

D-196 André Masson. *Portrait of André Breton*. 1941. Ink, 18⅞ x 24¾". Galerie Louise Leiris, Paris

D-197 Matta. *Project for an Apartment*. 1938. Collage. Whereabouts unknown. Reproduced from *Minotaure* (Paris), No. 11, 1938

D-198 Frederick Kiesler. Model for The Endless House, 1958–59. Cement, 42 x 72". Collection Mrs. Frederick Kiesler, New York

D-199 Art of This Century, New York, October, 1942. Surrealist gallery designed by Frederick Kiesler. On chair at left, Giacometti's *Woman with Her Throat Cut*

D-200 Artists in Exile. Photograph taken on the occasion of an exhibition at Pierre Matisse Gallery, March, 1942. Left to right, first row: Matta, Ossip Zadkine, Yves Tanguy, Max Ernst, Marc Chagall, Fernand Léger; second row: André Breton, Piet Mondrian, André Masson, Amédée Ozenfant, Jacques Lipchitz, Pavel Tchelitchew, Kurt Seligmann, Eugene Berman

D-201 Installation view of the exhibition *First Papers of Surrealism*, New York, 1942. Twine by Marcel Duchamp

D-202 Matta. Cover for *VVV* magazine, No. 4, 1944

D-203 Matta. *The Bachelors Twenty Years After*. 1943. Oil on canvas, 38 x 50". Collection Mr. and Mrs. George Heard Hamilton, Williamstown, Massachusetts

D-204 Matta. *Babes in Mattaland*. 1943. Pencil and crayon, 3" x 146" (detail 3 x 14¼"). Collection Ann Matta Alpert, New York

D-205 Matta. *Fig Leaf*. 1944–45. Oil on canvas, 51¼ x 38¼". Private collection, New York

D-206 Matta in his studio, Winter, 1945–46

D-207 Matta. *Le Vitreur* (fragment of a destroyed painting). 1945. Oil on canvas

D-208 Installation of the Matta exhibition at the Institute for Contemporary Art, London, January, 1951

D-209 Matta. *The Space of Noon*. 1956. Oil on canvas, c. 48 x 72". Collection Mrs. Ruth Moskin Fineshriber, New York

D-210 Matta. *Sculpture*. 1958. Bronze, height 28", length 26". Collection Joseph H. Hirshhorn

D-211 Wifredo Lam in his studio

D-212 Max Ernst in New York. c. 1942

D-213 Max Ernst. *The Temptation of Saint Anthony.* 1945. Oil on canvas, 43⅜ x 50¾". Wilhelm-Lehmbruck Museum. Duisburg, Germany

D-214 Hans Richter. Shipwreck scene from *Dreams that Money Can Buy:* Max Ernst, left; Julien Levy, right

D-215 Dorothea Tanning. *Birthday.* 1942. Oil on canvas

D-216 Leonora Carrington. *Where the Treasure Is.* c. 1956. Oil on plywood, 35 x 19¼". Private collection, New York

D-217 Marcel Duchamp and Frederick Kiesler. *Le Rayon Vert.* At the *Exposition Internationale du Surréalisme,* Galerie Maeght, Paris. 1947

D-218 Victor Brauner. *Le Serpentaire.* Altar at the *Exposition Internationale du Surréalisme,* Paris. 1947

D-219 Wifredo Lam. *La Chevalure de Falmer.* Altar at the *Exposition Internationale du Surréalisme,* Paris. 1947

D-220 At the *Exposition Internationale du Surréalisme,* 1947: 1) Baskine; 2) Demarne; 3) Henry; 4) Kujavski; 5) Tarnaud; 6) Jean; 7) Delanglade; 8) Brauner; 9) Alexandrian; 10) Toyen; 11) Rodanski; 12) Mme Jean; 13) Nora Mitrani; 14) Bellmer; 15) Breton; 16) Pastourau; 17) Harfaux; 18) Matta; 19) Heisler; 20) Kiesler; 21) Hérold; 22) Goetz; 23) Serpan

D-221 Kay Sage. *Hyphen.* 1954. Oil on canvas, 30 x 20". The Museum of Modern Art, New York

D-222 Joan Miró. *Hope Returns to Us through the Flight of Constellations.* 1954. Oil on canvas, 44⅞ x 57½". Galerie Maeght, Paris

D-223 Matta. *La Banale de Venise.* 1956. Oil on canvas, 78¾ x 118⅛". Collection the artist

D-224 André Masson. *Nocturnal City.* 1956. Tempera, 39⅜ x 31⅞". Galerie Louise Leiris, Paris

D-225 André Masson. *La Chevauchée du poisson.* 1955. Sand and gouache, 25⅝ x 19⅝". Collection Mr. and Mrs. Joseph Slifka, New York

D-226 Marcel Jean. "*Flottage*" (with poem by Jean Arp). 1956. 19 x 25½". Collection the artist

D-227 Arshile Gorky. *Enigmatic Combat.* c. 1936.

Oil on canvas, 35¾ x 48". San Francisco Museum of Art (Gift of Jeanne Reynal)

D-228 Arshile Gorky, Maro Gorky, and André Breton. c. 1946

D-229 Max Ernst and Robert Motherwell playing chess, Amagansett, Long Island. 1944

D-230 Enrico Donati. *Le Philtre.* 1943. Oil on canvas, c. 40 x 50". Private collection, Paris

D-231 Jacques Hérold. *La Liseuse d'Aigle.* 1942. Watercolor, 24¾ x 18¾". Private collection, New York

D-232 Installation of *Exposition Internationale du Surréalisme,* Galerie Daniel Cordier, Paris. Winter, 1959–60

D-233 Jean Dubuffet. *The Magician.* 1954. Slag and roots, height 43¼". Collection N. Richard Miller, Philadelphia

D-234 Wols (Wolfgang Schulz). *German Music.* 1939. 9 x 12½". Galerie Europe, Paris

D-235 Wols. *Whales in Water Flowers.* 1937. Oil on paper, 10⅝ x 13¾". Galerie Europe, Paris

D-236 Wols. *Electric Contact.* 1938. Gouache, 12½ x 9¼". Galerie Europe, Paris

D-237 Wols. *Memory of a Town.* 1950. Gouache on paper, 8⅛ x 6¼". Galerie Europe, Paris

D-238 Wols. *Trees.* c. 1950. Oil on canvas, 32 x 26". Collection Mr. and Mrs. Joseph Shapiro, Oak Park, Illinois

D-239 Georges Mathieu. *Montjoie Saint Denis!* 1954. Oil on canvas, 12⅜" x 2'11½". The Museum of Modern Art, New York (Gift of Mr. and Mrs. Harold Kaye)

D-240 Georges Mathieu as "Action Painter"

D-241 Henri Michaux. *Personage.* c. 1955–56. Watercolor, 18 x 12". Collection Mrs. Ruth Moskin Fineshriber, New York

D-242 Jean Tinguely. *Metamechanic Relief.* 1954. 55⅛ x 33½"

D-243 William Baziotes. *Dwarf.* 1947. Oil on canvas, 42 x 36⅛". The Museum of Modern Art, New York (A. Conger Goodyear Fund)

D-244 Theodoros Stamos. *Echo.* 1948. Oil on composition board, 48 x 36". The Metropolitan Museum of Art, New York (Arthur H. Hearn Fund, 1950)

D-245 Painters of the New York School. 1951. Seated, left to right: Theodoros Stamos, Jimmy Ernst, Jackson Pollock, Barnett Newman, James Brooks, Mark Rothko; standing, left to right: Richard Pousette-Dart, William Baziotes, Willem de Kooning, Adolph Gottlieb, Ad Reinhardt, Hedda Sterne, Clyfford Still, Robert Motherwell, Bradley Walker Tomlin

D-246 Willem de Kooning. *Pink Angels.* c. 1945. Oil and charcoal on canvas, 52 x 40". Collection Mr. and Mrs. Frederick R. Weisman, Beverly Hills

D-247 Willem de Kooning. *Painting.* 1948. Commercial enamel and oil on canvas, 42⅛ x 56⅛". The Museum of Modern Art, New York

D-248 Willem de Kooning. *Night Square.* c. 1949. Enamel on cardboard, mounted on composition board, 30 x 40". Collection Martha Jackson, New York

D-249 Jackson Pollock. *Panel C.* c. 1936. Oil on hardboard, 7½ x 5½". Collection Lee Krasner Pollock, New York

D-250 Jackson Pollock. *Pasiphaë.* 1943. Oil on canvas, 4'8" x 8'. Marlborough-Gerson Gallery, New York

D-251 Jackson Pollock. *Totem I.* 1944. Oil on canvas, 70 x 44". Collection Mrs. Emily Walker, West Redding, Connecticut

D-252 Hans Hofmann. *Fairy Tale.* 1944. Oil on plywood, 60 x 36". Estate of Hans Hofmann

D-253 Jackson Pollock. Untitled drawing. 1945. Oil, gouache, pastel, pen and ink, 30⅝ x 22⅜". The Museum of Modern Art, New York (Blanchette Rockefeller Fund)

D-254 Jackson Pollock. *Mural on Indian Red Ground.* 1950. Oil on canvas, 6'1" x 8'1". Private collection, New York

D-255 Jackson Pollock. *Number 27.* 1951. Enamel on canvas, 55¾ x 75". Marlborough-Gerson Gallery, New York

D-256 Jackson Pollock. *Echo.* 1951. Enamel on canvas, 7'8" x 7'1¾". Collection Mr. and Mrs. Ben Heller, New York

D-257 Mark Rothko. *Baptismal Scene.* 1945. Watercolor, 19⅞ x 14". Whitney Museum of American Art, New York

D-258 Mark Rothko. Untitled. c. 1945. Watercolor, 18 x 24". Private collection

D-259 Mark Rothko. *Slow Swirl by the Edge of the Sea.* 1944. Oil on canvas, 6'3" x 7½". Collection the artist

D-260 Mark Rothko. *Tentacles of Memory.* c. 1945. Watercolor, 22 x 15". Collection the artist

D-261 Adolph Gottlieb. *The Rape of Persephone,* 1940. Oil on canvas, 32 x 25". Collection Mrs. Annalee Newman, New York

D-262 Adolph Gottlieb. *Man Looking at Woman,* 1949. Oil on canvas

D-263 Adolph Gottlieb. *Hot Horizon.* 1956. Oil on canvas, 50 x 72". Collection Mr. and Mrs. Charles B. Benenson, New York

D-264 Adolph Gottlieb. *Burst,* 1957. Oil on canvas, 96 x 40". Collection Mr. and Mrs. Ben Heller, New York

D-265 Robert Motherwell. *Mallarmé's Swan,* 1944–47. Collage, 43⅝ x 35⅜". The Cleveland Museum of Art (Contemporary Collection)

D-266 Robert Motherwell. *Black on White.* 1961. Oil on canvas, 78 x 163¼". The Museum of Fine Arts, Houston

D-267 Clyfford Still. *Jamais,* 1944. Oil on canvas, 65 x 31½". Collection Peggy Guggenheim, Venice

D-268 Clyfford Still. *1944–A.* Oil on canvas, 70 x 97". Private collection

D-269 Clyfford Still. *1947–G.* Oil on canvas, 63 x 39". Private collection

D-270 Clyfford Still. *Untitled.* c. 1955. Oil on canvas. Collection Mr. and Mrs. Joseph Slifka, New York

D-271 Barnett Newman. *Pagan Void.* 1946. Oil on canvas, 33 x 38". Collection Mrs. Annalee Newman, New York

D-272 Barnett Newman. *Death of Euclid.* 1947. Oil on canvas, 16 x 20". Collection Mrs. Betty Parsons, New York

D-273 Barnett Newman. *Two Edges.* 1948. Oil on canvas, 48 x 36". Collection Mrs. Annalee Newman, New York

D-274 Barnett Newman. *Onement No. 3.* 1949. Oil on canvas, 72 x 34". Collection Mr. and Mrs. Joseph Slifka, New York

D-275 Alexander Calder. *Steel Fish.* 1934. Iron, sheet steel, steel rod, and sheet aluminum, height

10'. The Virginia Museum of Fine Arts, Richmond, Virginia

D-276 Isamu Noguchi. *Kouros.* 1946. Pink Georgia marble, height 10'. The Metropolitan Museum of Art, New York

D-277 Isamu Noguchi. *The Self.* 1956. Cast iron. The Tate Gallery, London

D-278 David Hare. *Man with Drums.* 1947. Bronze, height 22". Collection Mrs. Alice Baber Jenkins, New York

D-279 David Hare. *Sunrise.* 1954–55. Bronze and steel, 71 x 42 x 27". Albright-Knox Art Gallery, Buffalo, New York (George Cary Fund)

D-280 David Smith. *Interior for Exterior,* 1939. Steel and bronze, 18 x 22 x 23¾". Collection Mr. and Mrs. Orin Raphael, Oakmont, Pennsylvania

D-281 David Smith. *The Timeless Clock.* 1957. Sterling silver, 21 x 27". Private collection, New York

D-282 Herbert Ferber. *He Is Not a Man.* 1950. Lead and brass, height 6'. Collection Mark Rothko, New York

D-283 Herbert Ferber. *Roofed Sculpture with S Curve II.* 1954. Bronze, 50½ x 60 x 22". Collection the artist

D-284 Herbert Ferber. *Calligraph in Cage with Cluster II.* 1962. Brass and copper, 46 x 32 x 36". Walker Art Center, Minneapolis, Minnesota

D-285 Seymour Lipton. *Imprisoned Figure.* 1948. Lead and wood, height 6'8". Marlborough-Gerson Gallery, Inc., New York

D-286 Seymour Lipton. *The Defender.* 1962. Nickel, silver on Monel metal, height 81". Collection the artist

D-287 Alfonso Ossorio. *To You the Glory.* 1950. Watercolor and wax, 30 x 22". Private collection

D-288 George Cohen. *Anybody's Self-Portrait.* 1953. Framed mirror mounted on painted masonite, 9⅝" diameter, with mirrors, plastic doll's torso, legs and arms, painted doll's eyes with fiber lashes in anchovy tin can, small metal hand, nail heads, screw eyes, hooks, string, and cloth. The Museum of Modern Art, New York (Larry Aldrich Foundation Fund)

D-289 William Copley. *The Birth of Jules Verne.* 1951–53. Oil on canvas, 63¾ x 51⅛". Private collection, Paris

D-290 Robert Rauschenberg. *Bed.* 1955. Combine with pillow and quilt, 74 x 31". Collection Mr. and Mrs. Leo Castelli, New York

D-291 Robert Rauschenberg. *Interview.* 1955. Construction, 66 x 49". Collection Count Panza di Biumo

D-292 Robert Rauschenberg. *Monogram.* 1959. Combine with angora ram, 48 x 72 x 72". Moderna Museet, Stockholm

D-293 Jasper Johns. *Target with Plaster Casts.* 1955. Encaustic and collage on canvas with plaster casts, 51 x 44". Collection Mr. and Mrs. Leo Castelli, New York

D-294 Jasper Johns. *Flashlight III.* 1958. Plaster, 5¼ x 3¾ x 8¼". Collection the artist

D-295 Jasper Johns. *Light Bulb.* 1960. Bronze, 4½ x 6 x 4". Collection Mr. and Mrs. Leo Castelli, New York

D-296 Claes Oldenburg. *Giant Hamburger.* 1962. Canvas and casein, 40 x 90". Art Gallery of Toronto, Canada

D-297 George Segal. *The Gas Station.* 1963. Plaster and mixed media, length 25'

D-298 Edward Kienholz. *Roxy's House.* 1963. Tableau construction. Dwan Gallery, Los Angeles

D-299 Arman (Arman Fernandez). *Little Hands.* 1960. Dolls' hands glued in wooden drawer, 14⅝ x 17⅞ x 2⅞". Collection Mr. and Mrs. Robert C. Scull, New York

D-300 Daniel Spoerri. *Kichka's Breakfast.* 1960. Wooden chair with board across seat, with coffee pot, tumbler, china, egg cups, eggshells, cigarette butts, spoons, tin cans, etc., 14⅜ x 27¼ x 25¾". The Museum of Modern Art, New York (Philip C. Johnson Fund)

D-301 Allan Kaprow. *A Service for the Dead* (1). 1962. Happening

D-302 Allan Kaprow. *Eat.* 1964. Environment

TEXT ILLUSTRATIONS

Page 13 Alfred Jarry. *Père Ubu.* From *VVV* (New York), No. 2–3, 1943

Page 14 Francis Picabia. *Guillaume Apollinaire,*

BIBLIOGRAPHY

The works cited below have been arranged in the following groupings:
I Bibliographies (nos. 1–5), II Precursors and Background (nos. 6–40), III General Works
on Dada and Surrealism (nos. 41–115), IV Dada Art (nos. 116–127), V Surrealist Art
(nos. 128–172), VI Individual Artists (nos. 173–405), VII Group Exhibitions
(nos. 406–451), VIII Manifestoes and Original Publications (nos. 452–484).

I BIBLIOGRAPHIES

1 THE ART INSTITUTE OF CHICAGO. *Surrealism and Its Affinities: The Mary Reynolds Collection.* 1956.

2 H. MATARASSO LIBRAIRIE. *Surréalisme: Poésie et art contemporains.* Paris, 1949.

3 MOTHERWELL, ROBERT, ED. *The Dada Painters and Poets: An Anthology.* New York: Wittenborn, Schultz, 1951. Contains a critical bibliography by Bernard Karpel. – Includes Arthur Cravan, "Exhibition at the Independents," pp. 3–13; Gabrielle Buffet-Picabia, "Arthur Cravan and American Dada," pp. 13–17; Erik Satie, "Memories of an Amnesic (fragments)," pp. 17–19; Richard Huelsenbeck, "En Avant Dada: A History of Dadaism," pp. 21–47; Hugo Ball, "Dada Fragments," pp. 49–54; Kurt Schwitters, "Merz," pp. 55–65; Jacques Vaché, Two Letters to André Breton, pp. 69–72; Tristan Tzara, "Seven Dada Manifestoes," pp. 73–98; Georges Ribemont-Dessaignes, "History of Dada," pp. 99–120; Georges Hugnet, "The Dada Spirit in Painting," pp. 123–196; André Breton, "Three Dada Manifestoes," pp. 197–206; André Breton, "Marcel Duchamp," pp. 207–211; Jean Arp, "Notes from a Dada Diary," pp. 221–225; Richard Huelsenbeck, "End of the World," p. 226; Paul Eluard, two poems, pp. 228–229; Louis Aragon, "Project for a History of Contemporary Literature," pp. 230–231; André Breton and Philippe Soupault, "The Magnetic Fields (fragment)," p. 232; Tristan Tzara, "Zurich Chronicle," pp. 235–242; Richard Huelsenbeck, "Collective Dada Manifesto," pp. 242–246; Tristan Tzara, "Lecture on Dada," pp. 246–251; Gabrielle Buffet-Picabia, "Some Memories of Pre-Dada: Picabia and Duchamp," pp. 253–267; Francis Picabia, ed., "La Pomme de Pins," pp. 268–271; Kurt Schwitters, "Theo van Doesburg and Dada," pp. 273–276; Richard Huelsenbeck, "Dada Lives!" pp. 277–281; Hans Richter, "Dada X Y Z . . ," pp. 283–289; Jean Arp, "Dada Was Not a Farce," pp. 293–295; Jean Arp,

"Sophie," p. 296; Albert Gleizes, "The Dada Case," pp. 298–303; Tristan Tzara, "A Letter on Hugnet's 'Dada Spirit in Painting,'" pp. 303–306; Harriet and Sidney Janis, "Marcel Duchamp: Anti-Artist," pp. 306–315; Raoul Hausmann, "Sound-Rel" and "Bird-like," p. 316.

4 LIBRAIRIE JOSÉ CORTI. *Livres et publications surréalistes.* Paris, 1932.

5 LIBRAIRIE NICAISE. *Cubism, futurism, dada, surréalisme.* Paris, 1960. Complemented by a further publication by Librairie Nicaise, *Poésie-prose, peintres, graveurs de notre temps, éditions rares, revues.* Paris, 1964.

II PRECURSORS AND BACKGROUND

6 ABEL, LIONEL. "A B and C on Lautréamont," *View* (New York), December 1944, pp. 117, 151–154.

7 APOLLINAIRE, GUILLAUME. *The Cubist Painters: Aesthetic Meditations.* New York: Wittenborn, Schultz, Inc., 1949. Translated from the French. Paris: E. Figuière, 1913.

8 ————. "Salon d'Automne," *Les Soirées de Paris* (Paris), November 15, 1913, pp. 6–10.

9 ————. "Le 30ᵉ Salon des 'Indépendants,'" *Les Soirées de Paris* (Paris), March 15, 1914, pp. 183–188. See also bibl. 477

ASHTON, DORE. See bibl. 29

10 BARR, ALFRED H., JR. *Cubism and Abstract Art.* New York: The Museum of Modern Art, 1936. See also bibl. 376, 413

11 BACOU, ROSELINE. *Odilon Redon*. 2 vols. Geneva: Pierre Cailler, 1956.

12 BEGUIN, ALBERT. *L'Âme romantique et la rêve: Essai sur le romantisme allemand et la poésie française*. Marseilles: Editions des Cahiers du Sud, 1937.

13 BRION, MARCEL. *Art fantastique*. Paris: Editions Albin Michel, 1961.

14 CARRÀ, CARLO. *Pittura Metafisica*. 2nd rev. ed. Milan: Casa Editrice "Il Balcone," 1945. First published 1919.

15 COLLINS, GEORGE R. *Antonio Gaudí*. New York: George Braziller, Inc., 1960.

CONSTANTINE, MILDRED. See bibl. 27

DANIEL, GRETA. See bibl. 27

FERN, ALAN M. See bibl. 27

HITCHCOCK, HENRY-RUSSELL. See bibl. 27

16 HOLTEN, RAGNAR VON. *L'Art fantastique de Gustave Moreau*. Paris: Jean-Jacques Pauvert Editeur, 1960.

17 HUYSMANS, JORIS KARL. *L'Art moderne*. Paris, 1883.

18 JARRY, ALFRED. *Gestes et opinions du Docteur Faustroll, pataphysicien, Roman néo-Scientifique, suivi de spéculations*. Paris: Bibliothèque Charpentier, 1911.

JOACHIM, HAROLD. See bibl. 29

19 ———. *Le Surmâle*. Paris: Editions de la Revue Blanche, 1902.

20 ———. *Ubu Enchaîné, précédé de Ubu Roi*. Paris: Editions de la Revue Blanche, 1900.

21 LAUTRÉAMONT, COMTE DE (ISIDORE DUCASSE). *Maldoror (Les Chants de Maldoror)*. Mount Vernon, N.Y.: Golden Eagle Press, 1944. Translated from the French by Guy Wernham. Paris, Brussels, 1874.

22 ———. *Poésies*. Paris: Au Sans Pareil, 1920. Preface by Philippe Soupault—Originally published in *Littérature* (Paris), April 1919, pp. 2–13; May 1919, pp. 8–24.

23 MASSOT, PIERRE DE. *De Mallarmé à 391*. Paris: Au Bel Exemplaire, 1922.

24 MASSON, ANDRÉ. "Redon: Mystic with a Method," *Art News* (New York), June 1957, pp. 40–43.

25 MELLERIO, ANDRÉ. *Odilon Redon, peintre, dessinateur et graveur*. Paris: H. Floury, 1923.

26 ———. *L'Oeuvre graphique complet d'Odilon Redon*. Paris, 1913.

27 NEW YORK, THE MUSEUM OF MODERN ART. *Art Nouveau: Art and Design at the Turn of the Century*. 1960. Edited by Peter Selz and Mildred Constantine. Contains essays by Alan M. Fern, Peter Selz, Greta Daniel, and Henry-Russell Hitchcock, and a bibliography by James Grady.—Exhibition shown: New York, June 6–Sept. 6, 1960; Pittsburgh, Carnegie Institute, Oct. 13–Dec. 12, 1960; Los Angeles County Museum of Art, Jan. 17–Mar. 5, 1961; The Baltimore Museum of Art, Apr. 1–May 15, 1961.

28 ———. *Henri Rousseau*. 1942. Text by Daniel Catton Rich. Bibl.—In collaboration with The Art Institute of Chicago.—2nd rev. ed. 1946.

29 ———. *Odilon Redon, Gustave Moreau, Rodolphe Bresdin*. 1961. Essays by John Rewald, Dore Ashton, and Harold Joachim. Bibl.—Exhibition shown: New York, Dec. 4, 1961–Feb. 4, 1962; The Art Institute of Chicago, March 2–April 15, 1962.

30 PARIS, MUSÉE GUSTAVE MOREAU. *Catalogue sommaire des peintures, dessins, cartons et aquarelles exposés dans les galeries du Musée Gustave Moreau*. 1904.

31 REY, ROBERT. "Rodolphe Bresdin," *L'Amour de l'Art* (Paris), October 1924, pp. 327–333.

REWALD, JOHN. See bibl. 29

RICH, DANIEL CATTON. See bibl. 28, 426

32 ROGER-MARX, CLAUDE. *Odilon Redon*. Paris: Nouvelle Revue Française, 1925.

33 ROUSSEL, RAYMOND. *Impressions d'Afrique*. Paris: Librairie Alphonse Lemerre, 1910.

34 ———. *Locus Solus*. Paris: Librairie Alphonse Lemerre, 1914.

35 ROY, CLAUDE. *Arts fantastiques*. Paris: Encyclopédie Essentielle, 1960.

36 SANDSTRÖM, SVEN. *Le Monde imaginaire d'Odilon Redon*. Lund: Gleerup, 1955.

SELZ, PETER. See bibl. 27, 270, 436

37 SWEENEY, JAMES JOHNSON. *Plastic Redirections in 20th Century Painting.* Chicago: The University of Chicago Press, 1934. See also bibl. 166, 186, 224, 292, 335, 351, 353

38 TZARA, TRISTAN. "Henri Rousseau," *Transition Forty-Eight* (Paris), no. 3, 1948, pp. 29-40. See also bibl. 3, 54, 108-114, 125, 126, 286, 314, 315, 352, 397, 429, 462, 480, 481, 484

39 VACHÉ, JACQUES. *Lettres de guerre de Jacques Vaché.* Paris: "K" Editeur, 1949. Edited and with four prefaces by André Breton. – Originally published Paris, 1919. – Two letters translated in bibl. 3.

40 WILSON, EDMUND. *Axel's Castle: A Study in the Imaginative Literature of 1870-1930.* New York: Charles Scribner's Sons, 1931.

III GENERAL WORKS ON DADA AND SURREALISM

41 ARAGON, LOUIS. *Une Vague de rêves.* Paris: S.N.E., 1924. See also bibl. 3, 54, 409, 466

42 ARTAUD, ANTONIN. *L'Art et la mort.* Paris: Robert Denoël, 1929.

43 ———. *Le Théâtre et son double.* Paris: Gallimard, 1938.

44 BALAKIAN, ANNA. *Surrealism: The Road to the Absolute.* New York: Noonday Press, 1959.

45 ———. "The Surrealist Image," *Romanic Review* (New York), December 1953, pp. 273-281. See also bibl. 130, 131

46 BALL, HUGO. *Briefe, 1911-1927.* Einsiedeln: Benzinger Verlag, 1957. Edited by Annemarie Schütt-Hennings.

47 ———. *Die Flucht aus der Zeit.* Munich and Leipzig: Duncker & Humbolt, 1927. See also bibl. 3, 459

48 BATAILLE, GEORGES. "Le Surréalisme et sa différence avec l'existentialisme," *Critique* (Paris), July 1946, pp. 99-110. See also bibl. 132, 205, 465

49 BEDOUIN, JEAN-LOUIS, ED. *La Poésie surréaliste.* Paris: P. Seghers, 1964.

50 ———. *Vingt Ans du surréalisme: 1939-1959.* Paris: Editions Denoël, 1961.

51 BENAYOUN, ROBERT. *Erotique du surréalisme.* Paris: Jean-Jacques Pauvert Editeur, 1965.

52 BLANCHOT, MAURICE. "Continuez autant qu'il vous plaira," *La Nouvelle NRF* (Paris), February 1953, pp. 308-314.

53 ———. "L'Ecriture automatique, l'inspiration," *La Nouvelle NRF* (Paris), March 1953, pp. 485-492.

54 BO, CARLO, ED. *Antologia del surrealismo.* Milan: Edizioni di Uomo, 1944. Includes theoretical writings and poetry by participants in the Surrealist movement such as Breton, Aragon, Eluard, René Crevel, Tzara, Dali, and Picabia.

55 BRETON, ANDRÉ, ED. *Anthologie de l'humour noir.* Paris: Editions du Sagittaire, 1940.

56 BRETON, ANDRÉ. "C'est à vous de parler, jeune voyant des choses...," *XXe Siècle* (Paris), June 1952, pp. 27-30.

57 ———. *La Clé des champs.* Paris: Editions du Sagittaire, 1953.

58 ———. *Entretiens 1913-1952.* Paris: Gallimard, 1952. With André Parinaud.

59 ———. *Flagrant Délit.* Paris: Editions Thésée, 1949.

60 ———. "Freud at Vienna," *London Bulletin* (London), May 1938, p. 2.

61 ———. *Au Grand Jour.* Paris: Editions Surréalistes, 1927.

62 ———. *Introduction au discours sur le peau de réalité.* Paris: Gallimard, 1927.

63 ———. *Légitime Défense.* Paris: Editions Surréalistes, 1926.

64 ———. *Nadja.* Paris: Nouvelle Revue Française, 1928.

65 ———. *Point du jour.* Paris: Gallimard, 1934.

66 ———. *Position politique du surréalisme.* Paris: Editions du Sagittaire, 1935.

67 ———. *Les Vases communicants.* Paris: Editions des Cahiers Libres, 1932. See also bibl. 3, 54, 133-140, 141, 142, 143, 151, 179, 183, 206, 220,

226, 227, 248, 271, 289, 294, 315, 320, 330, 333, 337, 338, 357, 364, 378, 401, 402, 408, 412, 417, 419, 420, 425, 427, 432, 438, 454–457, 466, 473, 478, 479

68 ——— and ELUARD, PAUL. *L'Immaculée Conception.* Paris: Editions Surréalistes, 1930.
See also bibl. 3, 54, 82, 141–143, 315, 417

69 ——— and PÉRET, BENJAMIN. *Almanach surréaliste du demi-siècle.* Paris: Editions du Sagittaire, 1950. Special number of *La Nef* (Paris), March–April 1950.
See also bibl. 102, 143, 356, 473

70 ——— and SOUPAULT, PHILIPPE. *Les Champs magnétiques.* Paris: Au Sans Pareil, 1921.
See also bibl. 3, 22, 466

71 BROWDER, CLIFFORD. *André Breton: Arbiter of Surrealism.* Geneva: Librarie Droz, 1967.

72 CALAS, NICOLAS. "Surrealist Intentions," *Trans/formation* (New York), 1950, pp. 48–52.
See also bibl. 129, 424

73 CARROUGES, MICHEL. *André Breton et les données fondamentales du surréalisme.* 6th ed. Paris: Gallimard, 1950.

74 ——— "L'Écriture automatique," *Cahiers G.L.M.* (Paris), May 1936, pp. 31–39.

75 ——— *Les Machines célibataires.* Paris: Arcanes, 1954.

76 ——— "Le Passé et l'avenir du surréalisme," *La Vie Intellectuelle* (Paris), November 1945, pp. 125–135.

77 ——— "Le Surréalisme mort ou vif?" *Monde Nouveau* (Paris), April 1952, pp. 61–66.

78 CHARBONNIER, GEORGES. *Le Monologue du peintre.* 2 vols. Paris: René Julliard, 1952, 1960. Conversations with artists: vol. 1 includes Max Ernst, Joan Miró, Francis Picabia, Alberto Giacometti, André Masson; vol. 2 includes Salvador Dali.

CREVEL, RENÉ. See bibl. 54, 207

79 DESNOS, ROBERT. *De l'Erotisme considéré dans ses manifestations écrites et du point de vue de l'esprit moderne.* Paris: Editions "Cercle des Arts," 1952.

80 DUPLESSIS, YVES. *Surrealism.* New York: Walker & Company, 1962.

Translated from the French by Paul Capon. Paris: Presses Universitaires de France, 1950.

81 EIGELDINGER, MARC, ED. *André Breton, essais et témoignages.* Neuchâtel: A la Baconnière, 1950.

82 ELUARD, PAUL. *Donner à voir.* 5th ed. Paris: Gallimard, 1939.
See also bibl. 3, 54, 68, 141–143, 315, 417

83 FOWLIE, WALLACE. *Age of Surrealism.* New York: The Swallow Press and William Morrow, 1950.

84 GAFFÉ, RENÉ. *Peinture à travers dada et le surréalisme.* Brussels: Editions des Artistes, 1952.
See also bibl. 190, 217

85 GAUSS, CHARLES. "Theoretical Backgrounds of Surrealism," *Journal of Aesthetics and Art Criticism* (New York), Fall 1943, pp. 37–44.

86 GENBACH, JEAN (ABBÉ ERNEST DE GENGENBACH). *Satan à Paris.* Paris: H. Meslin, 1927.

87 GIDE, ANDRÉ. "Dada," *Nouvelle Revue Française* (Paris), April 1, 1920, pp. 477–481.

88 GIEDION-WELCKER, CAROLA, ED. *Poètes à l'écart: Anthologie der Abseitigen.* Bern and Bumpliz: Benteli, 1946.
See also bibl. 175–177, 390

89 GLEIZES, ALBERT. "L'Affaire Dada," *Action* (Paris), April 1920, pp. 26–32. For English translation, see bibl. 3

90 GRACQ, JULIEN (LOUIS POIRIER). *André Breton.* Paris: José Corti, 1948.

91 HUELSENBECK, RICHARD. "Dada Lives," *Transition* (Paris), Fall 1936, pp. 77–80. Reprinted in bibl. 3.

92 HUGNET, GEORGES. *Petite Anthologie poétique du surréalisme.* Paris: Editions Jeanne Bucher, 1934.
See also bibl. 3, 120, 121, 142, 143, 161, 163, 342, 413, 418

93 JOLAS, EUGENE, ED. *Transition Workshop.* New York: Vanguard Press, Inc., 1949.

94 JOSEPHSON, MATTHEW. *Life Among the Surrealists: A Memoir.* New York: Holt, Rinehart and Winston, Inc., 1962.

95 KYROU, ADO. *Le Surréalisme au cinéma*. Paris: Le Terrain Vague, 1963.

96 LACÔTE, RENÉ, ED. *Tristan Tzara*. Paris: P. Seghers, 1952.

97 LHOTE, ANDRÉ. "Surréalisme et surindépendance," *Nouvelle Revue Française* (Paris), January 1, 1936, pp. 134–137.

98 MATTHEWS, J. H. *An Introduction to Surrealism*. University Park, Pa.: Pennsylvania State University Press, 1965.

99 ——. *Surrealism and the Novel*. Ann Arbor: University of Michigan Press, 1966.

100 MAURIAC, CLAUDE. *André Breton*. Paris: Editions de Flore, 1949.

101 NADEAU, MAURICE. *History of Surrealism*. New York: Macmillan, 1965. Introduction by Roger Shattuck. Translation from the French by Richard Howard. Paris: Club des Editeurs, 1958. – An abridgement and revision of *Histoire du surréalisme*. 2 vols. Paris: Editions du Seuil, 1945, 1948. The history of the movement, as well as documents and excerpts from original publications mentioned in the text, and a bibliography of Surrealist publications appear in vol. 1; vol. 2, *Documents surréalistes*, contains further material pertaining to vol. 1 as well as additional documents. – The 1958 and 1965 editions lack the documentary portions of vol. 1 and include only a selection of material from vol. 2.

102 PÉRET, BENJAMIN, ED. *Anthologie de l'amour sublime*. Paris: Editions Albin Michel, 1956. See also bibl. 69, 143, 356, 437

103 PEYRE, HENRI. "The Significance of Surrealism," *Yale French Studies* (New Haven), Fall-Winter 1948, pp. 34–49.

104 RAYMOND, MARCEL. *From Baudelaire to Surrealism*. New York: Wittenborn, Schultz, 1950. Translated from the French. Rev. ed., Paris: José Corti, 1947.

105 SANDLER, IRVING. "The Surrealist Emigrés in New York," *Artforum* (New York), May 1968, pp. 24–31. Extracted from his forthcoming study, *Abstract Expressionism*. New York: William Morrow & Co., Inc. [1969].

106 SANOUILLET, MICHEL. *Dada à Paris*. Paris: Jean-Jacques Pauvert Editeur, 1965. See also bibl. 223, 358

107 SHATTUCK, ROGER. *The Banquet Years, The Arts in France 1885–1918: Alfred Jarry, Henri Rousseau, Erik Satie, Guillaume Apol-linaire*. New York: Harcourt, Brace, and Company, 1958. See also bibl. 101, 129

108 TZARA, TRISTAN. *Cinéma calendrier du cœur abstrait*. Paris: Au Sans Pareil, 1920.

109 ——. *Le Cœur à gaz*. Paris: Editions G.L.M., 1946.

110 ——. *La Deuxième Aventure céleste de Monsieur Antipyrine*. Paris: Editions des Réverbères, 1938.

111 ——. *An Introduction to Dada*. New York: Wittenborn, Schultz, 1951.

112 ——. *Le Surréalisme et l'après-guerre*. Paris: Nagel, 1947.

113 ——. *Vingt-cinq-et-un Poèmes*. 2nd rev. ed. Paris: Editions de la Revue Fontaine, 1946.

114 ——. *Vingt-cinq Poèmes*. Zurich: J. Heuberger, 1918. See also bibl. 3, 38, 54, 125, 126, 286, 314, 315, 352, 397, 429, 462, 480, 481, 484

115 WYSS, DIETER. *Der Surrealismus: Eine Einführung und Deutung surrealistischer Literatur und Malerei*. Heidelberg: Lambert Schneider, 1950.

IV DADA ART

116 BAUR, JOHN I. H. "The Machine and the Subconscious: Dada in America," *Revolution and Tradition in American Art*, Cambridge, Mass.: Harvard University Press, 1951, pp. 23–33. Originally published in *Magazine of Art* (New York), October 1951. See also bibl. 282

BLAUKOPF, KURT. See bibl. 127

BOLLIGER, HANS. See bibl. 127, 400

BRETON, ANDRÉ. See bibl. 3, 54, 55–70, 133–140, 141, 142, 143, 151, 179, 183, 206, 220, 226, 227, 248, 271, 289, 294, 315, 320, 330, 333, 337, 338, 357, 364, 378, 401, 402, 408, 412, 417, 419, 420, 425, 427, 432, 438, 454–457, 466, 473, 479

117 BUFFET-PICABIA, GABRIELLE. *Aires abstraites*. Geneva: Pierre Cailler, 1957. See also bibl. 3, 142, 365, 366

118 HUELSENBECK, RICHARD. En Avant Dada: Die Geschichte des Dadaismus. Hanover: Paul Steegemann, 1920. For English translation, see bibl. 3

119 ———. Dada Siegt: Eine Bilanz des Dadaismus. Berlin: Malik Verlag, 1920. See also bibl. 3, 91, 125, 127, 180, 429, 435, 461, 464

120 HUGNET, GEORGES. L'Aventure dada (1916-1922). Paris: Galerie de l'Institut, 1957.

121 ———. "L'Esprit dada dans la peinture," Cahiers d'Art (Paris), 1932-1936.
"I. Zurich & New York," vol. 7, no. 1-2, 1932, pp. 57-65; "II. Berlin (1918-1922)," vol. 7, no. 6-7, 1932, pp. 281-285; "III. Cologne et Hanovre," vol. 7, no. 8-10, 1932, pp. 358-364; "IV. Dada à Paris," vol. 9, no. 1-4, 1934, pp. 109-114; "V. (Fin)," vol. 11, no. 8-10, 1936, pp. 267-272. – For English translation see bibl. 3
See also bibl. 3, 92, 142, 143, 161, 163, 342, 413, 418

KLEIN, RUDOLF. See bibl. 127

KREITLER, HANS. See bibl. 127

122 RAYNAL, MAURICE. "Dada' and Scepticism in Painting," in Modern French Painters. New York: Brentano's, Inc., 1928.

123 RIBEMONT-DESSAIGNES, GEORGES. Déjà Jadis: Ou du Mouvement dada à l'espace abstrait. Paris: René Juilliard, 1958.
See also bibl. 3, 349, 435

124 SALMON, ANDRÉ. "Dada," in L'Art vivant. Paris: G. Cres, 1920.

125 SCHIFFERLI, PETER, ED. Die Geburt des Dada: Dichtung und Chronik der Gründer. Zurich: Verlag der Arche, 1957. Includes contributions by Arp, Huelsenbeck, Tzara. – Documentary section reprinted in Peter Schifferli, ed., Als Dada Begann. Zurich: Verlag Sanssouci, 1957.

126 TZARA, TRISTAN. "Le Papier collé ou le proverbe en peinture," Cahiers d'Art (Paris), vol. 6, no. 2, 1931, pp. 61-64. See also bibl. 3, 38, 54, 108-114, 125, 286, 314, 315, 352, 397, 429, 462, 480, 481, 484

127 VERKAUF, WILLY, ED. Dada: Monograph of a Movement. New York: George Wittenborn, 1957. Texts in English, German, and French. – Includes Verkauf, "Dada —Cause and Effect," pp. 8-25; Marcel Janco, "Creative Dada," pp. 26-49; Richard Huelsenbeck, "Dada and Existentialism," pp. 50-63; Hans Richter, "Dada and the Film," pp. 64-73; Hans Kreitler, "The Psychology of Dadaism," pp. 74-87; Rudolf Klein and Kurt Blaukopf, "Dada and Music," pp. 88-97; Hans Bolliger and Willy Verkauf, "Dada Chronology," pp. 98-100, 109-114; Hans Bolliger and Willy Verkauf, "A Dada Dictionary," pp. 115-116, 141-174; Bolliger and Verkauf, "Dada-Bibliography," pp. 176-183.

V SURREALIST ART

128 ALQUIÉ, FERDINAND. The Philosophy of Surrealism. Ann Arbor: University of Michigan Press, 1965. Translated from the French by Bernard Waldrop. Paris: Flammarion, 1956.

129 Artforum (Los Angeles), September 1966. Special issue devoted to Surrealism: Max Kozloff, "Surrealist Painting Re-examined," pp. 5-9; Lucy R. Lippard, "Dada into Surrealism," pp. 10-15; Ronald Hunt, "The Picabia/Breton Axis," pp. 16-20; Robert Rosenblum, "Picasso as Surrealist," pp. 21-25; Toby Mussman, "The Surrealist Film," pp. 26-31; Roger Shattuck, "On René Magritte," pp. 32-35; William Rubin, "Toward a Critical Framework," pp. 36-55; Whitney Halstead, "The Hodes Collection," pp. 56-59; Kurt von Meier, "Surrealism and Architecture," pp. 60-65; Sidney Tillim, "Surrealism as Art," pp. 66-71; Annette Michelson, "Breton's Esthetics," pp. 72-77; Nicolas Calas, "A Perspective," pp. 78-79; Nicolas Sloninsky, "Music and Surrealism," pp. 80-85; Jerold Lanes, "Surrealist Theory and Practice in France and America," pp. 86-87.

130 BALAKIAN, ANNA. "Is Surrealism a Humanism?" Arts and Sciences (New York), June 14, 1965, pp. 1-7.

131 ———. Literary Origins of Surrealism: A New Mysticism in French Poetry. New York: King's Crown Press, 1947; New York University Press, 1966. See also bibl. 44, 45

132 BATAILLE, GEORGES. "Le Surréalisme," Critique (Paris), March 1948, pp. 273-275. See also bibl. 48, 205, 465

133 BRETON, ANDRÉ. L'Art magique. Paris: Club Français de l'Art, 1957. With the aid of Gérard Legrand.

134 ———. "Equation de l'objet trouvé," Documents (Brussels), June 1934, pp. 17-24.

135 ———. Les Pas perdus. Paris: Gallimard, 1924.

136 —— "Pour dada," *Nouvelle Revue Française* (Paris), August 1, 1920, pp. 208–215.

137 —— *La Situation du surréalisme entre les deux guerres*. Paris: Editions de la Revue Fontaine, 1945.

138 —— *Le Surréalisme et la peinture*. Paris: Gallimard, 1928; 2nd ed., New York and Paris: Brentano's, 1945; 3rd ed., additional essays, revised and corrected, Paris: Gallimard, 1966.

139 —— "Des Tendances les plus récentes de la peinture surréaliste," *Minotaure* (Paris), May 1939, pp. 16–17.

140 —— *What Is Surrealism?* London: Faber & Faber, 1936. Translated from the French by David Gascoyne. Brussels: René Henriquez, 1934.
See also bibl. 3, 54, 55–70, 141, 142, 143, 151, 179, 183, 206, 220, 226, 227, 248, 271, 289, 294, 315, 320, 330, 333, 337, 338, 357, 364, 378, 401, 402, 408, 412, 417, 419, 420, 427, 432, 438, 454–457, 466, 473, 478, 479

141 ELUARD, PAUL, *et al.* "Dictionnaire abrégé du surréalisme."
See bibl. 417
See also bibl. 3, 54, 82, 142, 143

142 *Cahiers d'Art* (Paris), no. 1–2, 1936.
Special issue devoted to the object, includes: André Breton, "Crise de l'objet," pp. 21–26; Georges Hugnet, "L'Oeil de l'aiguille," p. 27; Paul Eluard, "L'Habitude des tropiques," p. 29; Gabrielle Buffet, "Cœurs volants," pp. 34–43; Claude Cahun, "Prenez garde aux objets domestiques," pp. 45–48; Salvador Dali, "Honneur à l'objet!" pp. 53–56; Marcel Jean, "Arrivée de la belle époque," p. 60; Hans Bellmer, untitled, p. 66.

143 *Cahiers d'Art* (Paris), no. 5–6, 1935.
Special issue devoted to Surrealism, includes: André Breton, "Préface aux expositions surréalistes de Copenhague et de Tenerife," pp. 97–98; Paul Eluard, "La Nuit est à une dimension," pp. 99–100; David Gascoyne, "Premier Manifeste anglais du surréalisme (fragment)," p. 106; Benjamin Péret, "Yves Tanguy ou l'anatife torpille les jivaros," p. 109; Marcel Jean and Leo Malet, "Oui! Ce sont toujours les même méthodes!" p. 114; Maurice Henry, "Joan Miró," p. 115; Kandinsky, "Toile vide, etc.," p. 117; Man Ray, "Sur le Réalisme photographique," p. 120; Salvador Dali, "Les Eaux où nous nageons," p. 123; André Breton, "Rêve Objet," p. 125; Man Ray, "à l'heure de l'observatoire . . . les amoureux," p. 127; André Breton, "Automatisme de la variante," pp. 128–129; René Magritte, "Le Fil d'Ariane," p. 130; Charles Ratton, "Exposition d'Art Nègre au Museum of Modern Art de New York," pp. 133–134; Benjamin Péret, "Le Surréalisme international," p. 138; Georges Hugnet, "L'Objet utile à propos d'Oscar Dominguez," p. 139.

CAHUN, CLAUDE. See bibl. 142

144 CAZAUX, JEAN. "Endophanie et écriture automatique," *Surréalisme et Psychologie*. Paris: Librairie José Corti, 1938.

145 CIRLOT, JUAN EDUARDO. *La Pintura surrealista*. Barcelona: Seix Barral, 1955.

146 COMFORT, ALEX, and BAYLISS, JOHN, EDS. *New Road*. London: The Grey Walls Press, 1943.

147 CONNOLLY, CYRIL. "Surrealism," *Art News Annual* (New York), vol. 21, 1952, pp. 131–162, 164, 166, 168, 170.

DAVIES, HUGH SYKES. See bibl. 163

148 DUTHUIT, GEORGES. "Enquête," *Cahiers d'Art* (Paris), vol. 14, no. 1–4, 1939, pp. 65–73.

ELUARD, PAUL. See bibl. 3, 141–143, 417

149 GASCOYNE, DAVID. *A Short Survey of Surrealism*. London: Cobden-Sanderson, 1935.
See also bibl. 143, 412

150 GREENBERG, CLEMENT. "Surrealist Painting," *The Nation* (New York), August 12–19, 1944, pp. 192–193. Reprinted in *Horizon* (London), January 1945, pp. 49–56.
See also bibl. 341

151 GUGGENHEIM, PEGGY, ED. *Art of This Century: Objects, Drawings, Photographs, Painting, Sculpture, Collages, 1910 to 1942*. New York: Art of This Century, 1942.
Includes: André Breton, "Genesis and Perspective of Surrealism"; Arp, "Abstract Art, Concrete Art."

HALSTEAD, WHITNEY. See bibl. 129

HENRY, MAURICE. See bibl. 143

HUNT, RONALD. See bibl. 129

152 JANIS, SIDNEY. *Abstract & Surrealist Art in America*. New York: Reynal & Hitchcock, 1944.

153 —— "School of Paris Comes to U.S.," *Decision* (New York), Nov.–Dec. 1941, pp. 85–95.
See also bibl. 3, 241

—— and HARRIET. See bibl. 3, 241

154 JEAN, MARCEL. *The History of Surrealist Painting*. New York: Grove Press, 1960; reprinted 1967. With the collaboration of Arpad Mezei. Translated from the French by Simon Watson Taylor. Paris: Editions de Seuil, 1959. See also bibl. 142, 143

155 JOUFFREY, ALAIN. "La Collection André Breton," *L'Oeil* (Paris), October 1955, pp. 32–39. See also bibl. 181, 184, 185, 222, 331

156 JUIN, HUBERT. "Mythologies," *Cahiers du Musée de Poche* (Paris), December 1959, pp. 48–57. See also bibl. 323

KANDINSKY, WASSILY. See bibl. 143

KOZLOFF, MAX. See bibl. 129

LANES, JERROLD. See bibl. 129

157 LEVY, JULIEN. *Surréalism*. New York: The Black Sun Press, 1936. Excerpts from the writings of twentieth-century Surrealists and precursors of Surrealism; list of Surrealist exhibitions in the United States 1930–1936; bibliography. See also bibl. 212, 272, 276, 277, 431, 444

LIPPARD, LUCY R. See bibl. 129, 249, 259

MALET, LEO. See bibl. 143

MEIER, KURT VON. See bibl. 129

158 MICHELSON, ANNETTE. "But Eros Sulks: Surrealism's Recent International Exhibition in Paris," *Arts* (New York), March 1960, pp. 32–39. See also bibl. 129

MUSSMAN, TOBY. See bibl. 129

159 MOTHERWELL, ROBERT. "Painters' Objects," *Partisan Review* (New York), Winter 1944, pp. 93–97. See also bibl. 3, 194, 348

160 NASH, PAUL. "Surrealism and the Illustrated Book," *Signature* (London), March 1937, pp. 1–11. Includes "A Selected List of Books Illustrated by Contemporary Surrealists," pp. 10–11.

161 *Petite Mythologie poétique du surréalisme*. Paris: Jean Bucher, 1934. Introduction by Georges Hugnet.

162 PIERRE, JOSÉ. *Le Surréalisme*. Lausanne: Editions Rencontre, 1966. RATTON, CHARLES. See bibl. 143, 411

163 READ, HERBERT, ED. *Surréalism*. London: Faber & Faber, 1936. Herbert Read, Introduction, pp. 19–91; André Breton, "Limits not Frontiers of Surrealism," pp. 95–116; Hugh Sykes Davies, "Surrealism at This Time and Place," pp. 119–168; Paul Eluard, "Poetic Evidence," pp. 171–183; Georges Hugnet, "1870–1936," pp. 187–251. See also bibl. 299, 383, 412, 415, 431

RUBIN, WILLIAM. See bibl. 129, 237, 251, 274, 326, 334, 451

ROSENBLUM, ROBERT. See bibl. 129, 236, 384

164 SEUPHOR, MICHEL. "Histoire sommaire du tableau-poème," *XXe Siècle* (Paris), June 1952, pp. 21–25. See also bibl. 286

SLONIMSKY, NICOLAS. See bibl. 129

165 SOBY, JAMES THRALL. *After Picasso*. New York: Dodd, Mead, 1935. See also bibl. 198, 213, 304, 332, 354, 405

SOUPAULT, PHILIPPE. See bibl. 3, 22, 79, 466

166 SWEENEY, JAMES JOHNSON, ED. "Eleven Europeans in America," *Bulletin of The Museum of Modern Art* (New York), September 1946, pp. 1–39. Includes interviews with André Masson, Kurt Seligmann, Max Ernst, Marcel Duchamp, Yves Tanguy. See also bibl. 37, 186, 224, 292, 335, 351, 353

167 *This Quarter* (Paris), September 1932. Special Surrealist issue, guest editor André Breton.

TILLIM, SIDNEY. See bibl. 129

168 *Variétés* (Brussels), June 1929. Special issue entitled "Le Surréalisme en 1929."

169 WALDBERG, PATRICK. *Chemins de surréalisme*. Brussels: Editions de la Connaissance, 1965.

170 ——— *Mains et merveilles: Peintres et sculpteurs de notre temps*. Paris: Mercure de France, 1961.

171 ——— *Surrealism*. Lausanne: Skira, 1965. Translated from the French by Stuart Gilbert. Lausanne: Skira, 1962.

499

172 ———. *Surrealism.* New York: McGraw-Hill, 1965.
See also bibl. 254, 267, 284, 291, 301, 310, 441

VI INDIVIDUAL ARTISTS

Within the individual entries the items are arranged in the following order: artist's writings and interviews (arranged chronologically); works about the artist (arranged alphabetically); exhibition catalogues (arranged chronologically).

ARP, Jean (Hans)

173 *On My Way: Poetry and Essays, 1912–1947.* (The Documents of Modern Art.) New York: Wittenborn, Schultz, 1948. Contains bibliography.
See also bibl. 3, 125, 151, 180, 286, 429, 435

174 CATHELIN, JEAN. *Arp.* Paris: Le Musée de Poche, 1959.

175 GIEDION-WELCKER, CAROLA. "Jean Arp," *Horizon* (New York), October 1946, pp. 232–239.

176 ———. *Jean Arp.* New York: Harry N. Abrams, 1957. Translated from the German by Norbert Guterman.

177 ———. "Urelement und Gegenwart in der Kunst Hans Arp," *Werk* (Zurich), May 1952, pp. 164–172.

178 SEUPHOR, MICHEL. *Arp.* New York: Universe Books, 1961.

179 PARIS. GALERIE SURRÉALISTE. *Arp.* November 21–December 9, 1927. Foreword by André Breton.

180 NEW YORK. THE MUSEUM OF MODERN ART. *Arp.* October 6–November 30, 1958.
James Thrall Soby, ed. Articles by Jean (Hans) Arp, Richard Huelsenbeck, Robert Melville, and Carola Giedion-Welcker.

BELLMER, Hans

181 JOUFFROY, ALAIN. *Bellmer.* Chicago: William and Norma Copley Foundation, 1962.
Translated by Bernard Frechtman.
See also bibl. 142

BRAUNER, Victor

182 ALEXANDRIAN, SARANE. *Victor Brauner, l'illuminateur.* Paris: Editions Cahiers d'Art, 1954.

183 BRETON, ANDRÉ. "Victor Brauner," *Le Surréalisme et la peinture.* 3rd ed. Paris: Gallimard, 1966, pp. 121ff.

184 JOUFFROY, ALAIN. *Brauner.* Paris: Le Musée de Poche, 1959.

185 ———. "Suprématie poétique de Victor Brauner," *Cahiers d'Art* (Paris), 1951, pp. 162–170.

CALDER, Alexander

186 NEW YORK. THE MUSEUM OF MODERN ART. *Alexander Calder.* 1943.
Text by James Johnson Sweeney. Contains bibliography, chronology. Rev. ed. 1951.

de CHIRICO, Giorgio

187 *Hebdomeros.* New York: Four Seasons Book Society, 1966. Translated, with an introduction, by James A. Hodkinson. Originally published Paris: Editions du Carrefour, 1929.
See also bibl. 198

188 CARRIERI, RAFFAELE. *Giorgio de Chirico.* Milan: Garzanti, 1942.

189 FALDI, ITALO. *Il Primo de Chirico.* Venice: Alfieri, 1949.

190 GAFFÉ, RENÉ. *Giorgio de Chirico, le voyant.* Brussels: Editions "La Boétie," 1946.

191 LO DUCA, GIUSEPPE. *Dipinti di Giorgio de Chirico.* Milan: U. Hoepli, 1945.

192 MELVILLE, ROBERT. "Rousseau and de Chirico," *Scottish Arts and Letters* (Glasgow), no. 1, 1944, pp. 31–35.

193 ———. "The Visitation—1911–1917," *London Bulletin* (London), June 1940, pp. 7–9.

194 MOTHERWELL, ROBERT. "Notes on Mondrian & de Chirico," *VVV* (New York), June 1942, pp. 59–61.

195 RAGGHIANTI, CARLO L. "Il Primo de Chirico," *La Critica d'Arte* (Rome), November 1949, pp. 325–331.

196 RIBEMONT-DESSAIGNES, GEORGES. "Giorgio di Chirico," *Documents* (Paris), no. 6, 1930, pp. 336–345.

197 VITRAC, ROGER. *Georges de Chirico.* Paris: Gallimard, 1927.

198 NEW YORK. THE MUSEUM OF MODERN ART. *Giorgio de Chirico.* 1955.

Text by James Thrall Soby. Includes writings by the artist, bibliography. — Published on the occasion of an exhibition at the Museum, September 8–October 30, 1955. — Reprinted by Arno Press, New York, 1966.

CORNELL, Joseph

199 COPLANS, JOHN. "Notes on the Nature of Joseph Cornell," *Artforum* (New York), February 1963, pp. 27–29.

200 GOOSSEN, E. C. "The Plastic Poetry of Joseph Cornell," *Art International* (Zurich), vol. 3, no. 10, 1959–1960, pp. 37–40.

201 NEW YORK. SOLOMON R. GUGGENHEIM MUSEUM. *Joseph Cornell.* May 4–June 25, 1967. Text by Diane Waldman. Bibliography, list of exhibitions.

DALI, Salvador

202 *La Femme visible.* Paris: Editions Surréalistes, 1930. Includes "Le Grand Masterbateur."

203 "The Stinking Ass," *This Quarter* (Paris), Summer 1932, pp. 49–54. Translation of "L'Ane pourri," *Le Surréalisme au Service de la Révolution* (Paris), July 1930, pp. 9–12.

204 *Conquest of the Irrational.* New York: Julien Levy, 1935. Translated from the French by David Gascoyne. See also bibl. 54, 78, 142, 143

205 BATAILLE, GEORGES. "Le 'Jeu lugubre," *Documents* (Paris), no. 7, 1929, pp. 369–372.

206 BRETON, ANDRÉ. "Le 'Cas' Dali," *Le Surréalisme et la peinture.* 2nd ed. New York and Paris: Brentano's, 1945, pp. 144ff; 3rd ed. Paris: Gallimard, 1966, pp. 130ff.

207 CREVEL, RENÉ. *Dali; Ou, l'Anti-obscurantisme.* Paris: Editions Surréalistes, 1931.

208 DESCHARNES, ROBERT. *The World of Salvador Dali.* New York: Harper & Row, 1962.

209 MORSE, A. REYNOLDS. *Dali: A Study of His Life and Work.* Greenwich, Conn.: New York Graphic Society, 1958. With a special appreciation by Michel Tapié and descriptive captions for the colorplates written especially for this volume by Salvador Dali.

210 ———. *A New Introduction to Salvador Dali.* Cleveland: Reynolds Morse Foundation, Inc., 1960.

211 SUTHERLAND, DONALD. "The Ecumenical Playboy," *Arts* (New York), February 1963, pp. 69–73.

212 NEW YORK. JULIEN LEVY GALLERY. Exhibition catalogues, 1937–1941.

213 NEW YORK. THE MUSEUM OF MODERN ART. *Salvador Dali: Paintings, Drawings, Prints,* 1941. Text by James Thrall Soby. Includes chronology, list of exhibitions, lists of films and ballets on which Dali collaborated, jewelry, bibliography. — Published on the occasion of an exhibition at the Museum, November 19, 1941–January 11, 1942. Rev. ed. 1946; reprinted by Arno Press, New York, 1968.

214 KNOKKE. LE ZOUTE. ALBERT PLAGE. CASINO COMMUNAL. *Salvador Dali.* July 1–September 10, 1956. Exhibition organized by Felix Labisse and J. M. De Vlieger. Contains "Salvador Dali aujourd'hui-même," by Louis Pauwels. — Published by Editions de la Connaissance, 1956.

215 NEW YORK. GALLERY OF MODERN ART. *Salvador Dali, 1910–1965, with The Reynolds Morse Collection.* 1965. Published on the occasion of an exhibition at the Gallery, December 18, 1965–February 28, 1966. See also bibl. 417

DELVAUX, Paul

216 BARTSCH, WALTER FREDERICK. "Paul Delvaux," *Critique* (New York), January–February 1947, pp. 49–50, 59.

217 GAFFÉ, RENÉ. *Paul Delvaux; Ou, les Rêves éveillé.* Brussels: Editions "La Boétie," 1945.

218 SPAAK, CLAUDE. *Paul Delvaux.* Antwerp: De Sikkel, 1948.

219 NEW YORK. STAEMPFLI GALLERY. *Paul Delvaux.* October 20–November 7, 1959. Contains a letter to George W. Staempfli by Robert Giron and an essay by Em. Langui.

DOMINGUEZ, Oscar

220 BRETON, ANDRÉ. "Oscar Dominguez," *Le Surréalisme et la peinture.* 3rd ed. Paris: Gallimard, 1966, pp. 128ff. See also bibl. 143

DUCHAMP, Marcel

221 *Rrose Sélavy.* Paris: Editions G. L. M., 1939.

222 "Marcel Duchamp nous déclare: 'Il n'est pas certain que je revienne à la peinture," *Arts* (Paris), October 29–November 4, 1958, p. 12. Interview with Alain Jouffroy.

223 *Marchand du sel; Ecrits de Marcel Duchamp.* Michel Sanouillet, ed. Paris: Le Terrain Vague, 1958. Contains bibliography.

224 "Marcel Duchamp," in James Nelson, ed. *Wisdom: Conversations with the Elder Wise Men of Our Day.* New York: W. W. Norton, 1958, pp. 89–99. Transcription of a conversation between Duchamp and James Johnson Sweeney shown on NBC-TV, January 1956.

225 *The Bride Stripped Bare by Her Bachelors, Even: A Typographic Version by Richard Hamilton of Marcel Duchamp's Green Box.* (The Documents of Modern Art.) New York: George Wittenborn, 1960. First complete translation, by George Heard Hamilton, of Duchamp's *Boîte verte; Ou, la Mariée mise à nu par ses célibataires même.* Paris: Editions Rrose Sélavy, 1934.
See also bibl. 166, 315, 471, 474

226 Breton, André. "Marcel Duchamp," *Littérature* (Paris), October 1, 1922, pp. 7–10.

227 ———. "Phare de La Mariée," *Le Surréalisme et la peinture.* 2nd ed. New York and Paris: Brentano's, 1945, pp. 107ff.; 3rd ed. Paris: Gallimard, 1966, pp. 85ff.
English translation in bibl. 233. First published *Minotaure* (Paris), Winter 1935, pp. 45–49.

228 Carrouges, Michel. "La Machine célibataire selon Franz Kafka et Marcel Duchamp," *Les Machines célibataires.* Paris: Arcanes, 1954, pp. 27–59.

229 Desnos, Robert. "Rrose Sélavy," *Littérature* (Paris), December 1922, pp. 14–22.

230 Dreier, Katherine, and Matta Echaurren. *Duchamp's Glass . . . An Analytical Reflection.* New York: Société Anonyme, Inc., 1944.

231 Hamilton, Richard. "Duchamp," *Art International* (Zurich), January 1964, pp. 22–28.

232 Hopps, Walter; Linde, Ulf; and Schwarz, Arturo. *Marcel Duchamp, Ready-Mades, etc. (1913–1964).* Paris: Le Terrain Vague, 1964.

233 Lebel, Robert. *Marcel Duchamp.* New York: Grove Press, 1959. Translated from the French by George Heard Hamilton. Catalogue raisonné, bibliography.

234 Reboul, Jean. "Machines célibataires, schizophrénie et lune noir," *Journal Intérieur du Cercle d'Etudes Métaphysiques* (Toulon),

235 Roche, Henri-Pierre. "Duchamp," in *Dictionary of Modern Painting.* New York: Paris Book Center, Inc., 1955.

236 Rosenblum, Robert. "The Duchamp Family," *Arts* (New York), April 1957, pp. 20–23.

237 Rubin, William. "Reflections on Marcel Duchamp," *Art International* (Zurich), November 1960, pp. 49–53.

238 Schwarz, Arturo. *The Large Glass and Related Works.* Milan: Galleria Schwarz, 1967. Published in two separate volumes, *The Complete Works of Marcel Duchamp and Notes and Projects for the Large Glass,* by Harry N. Abrams, 1969.

239 Spector, Jack J. "Freud and Duchamp: The Mona Lisa 'Exposed,'" *Artforum* (New York), April 1968, pp. 54–56.

240 Steefel, Lawrence D., Jr. "The Position of *La Mariée mise à nu* . . . in the Stylistic and Iconographic Development of the Art of Marcel Duchamp." Unpublished Ph.D. dissertation, Princeton University, 1960.

240 a ———. "The Art of Marcel Duchamp," *Art Journal* (New York), vol. 21, no. 2, Winter 1962–63, pp. 72–80.

241 *View* (New York), March 1945. Special Marcel Duchamp number. – Includes Harriet and Sidney Janis, "Marcel Duchamp, Anti-Artist," pp. 18–19.

242 Pasadena Art Museum. *Marcel Duchamp.* October 8–November 3, 1963.
Largest comprehensive exhibition of Duchamp's lifework to date.

243 New York. Cordier & Ekstrom. *Not Seen and/or Less Seen of/by Marcel Duchamp/Rrose Sélavy: 1909–64.* January 14–February 13, 1965.
Foreword and catalogue by Richard Hamilton. Exhibition of the Mary Sisler collection.

244 London. Arts Council of Great Britain. *The Almost Complete Works of Marcel Duchamp.* At the Tate Gallery, June 18–July 31, 1966.
First major retrospective exhibition to be held in Europe.
See also bibl. 417, 420, 425, 429, 438, 453, 471, 474

Ernst, Max

245 *Beyond Painting and Other Writings by the Artist and His Friends.*

246 BOSQUET, ALAIN. "Le Bonheur de Max Ernst," *Quadrum* (Brussels), no. 5, 1958, pp. 11–22.

247 BOSSCHÈRE, JEAN DE. "Max Ernst," *Cahiers d'Art* (Paris), no. 2, 1928, pp. 70–73.

248 BRETON, ANDRÉ. "Vie légendaire de Max Ernst," *Le Surréalisme et la peinture.* 2nd ed. New York and Paris: Brentano's, 1945, pp. 159ff.; 3rd ed. Paris: Gallimard, 1966, pp. 155ff.

249 LIPPARD, LUCY R. *The Technical Innovations of Max Ernst.* Unpublished Master's thesis, Institute of Fine Arts, New York University, 1962.

250 MANDIARGUES, ANDRÉ PIEYRE DE. "Max Ernst," *Art International* (Zurich), vol. 4, no. 1, 1960, pp. 35–38.

251 RUBIN, WILLIAM. "Max Ernst," *Art International* (Zurich), May 1, 1961, pp. 31–37.

252 RUSSELL, JOHN. *Max Ernst.* New York: Harry N. Abrams, 1967.

253 *View* (New York) April 1942. Special Max Ernst number.

254 WALDBER, PATRICK. *Max Ernst.* Paris: Jean-Jacques Pauvert Editeur, 1958.

255 ZERVOS, CHRISTIAN, ED. *Max Ernst: Oeuvres de 1919 à 1936.* Paris: Editions Cahiers d'Art, 1937.

256 PARIS, GALERIE AU SANS PAREIL. *Max Ernst: Exposition dada.* May 3–June 3, 1920.

257 PARIS, MUSÉE NATIONAL D'ART MODERNE. *Max Ernst.* November 13–December 31, 1959. Bibliography and chronology edited by the artist. Preface by J. Cassou. Catalogue by G. Vienne.

258 NEW YORK, THE MUSEUM OF MODERN ART. *Max Ernst.* March 1–May 7, 1961. William S. Lieberman, ed. Includes "An Informal Life of M. E. (as told by himself to a young friend)"; a selection from Ernst's writings revised and augmented by the artist for this publication; bibliography.

(The Documents of Modern Art.) New York: Wittenborn, Schultz, 1948. Bibliography by Bernard Karpel. See also bibl. 78, 166, 356, 435, 475

259 NEW YORK, THE JEWISH MUSEUM. *Max Ernst: Sculpture and Recent Painting.* 1966. Sam Hunter, ed. Includes: Lucy R. Lippard, "The Sculpture," pp. 37–52; John Russell, "Recent Book Illustration," pp. 55–56. — Published on the occasion of an exhibition at the Museum, March 3–April 17, 1966. See also bibl. 417, 475

GIACOMETTI, Alberto

260 "1 + 1 = 3," *Trans/formation* (New York) 1952, pp. 165–167. Translated from the French. Originally published *Minotaure* (Paris), December 1933, p. 46.

261 *Alberto Giacometti, Schriften, Fotos, Zeichnungen / Essais, photos, dessins.* Ernst Scheidegger, ed. Zurich: Peter Schifferli, 1958. See also bibl. 78, 270

262 BUCARELLI, PALMA. *Giacometti.* Rome: Editalia, 1962.

263 DUPIN, JACQUES. *Alberto Giacometti.* Paris: Maeght, 1962. Published also in an edition with an interleaved English translation by John Ashbery.

264 KRAMER, HILTON. "Giacometti," *Arts* (New York), November 1963, pp. 52–59.

265 LEIRIS, MICHEL. "Alberto Giacometti," *Documents* (Paris), September 1929, pp. 209–214.

266 ———. "Pierres pour un Alberto Giacometti," *Derrière le Miroir* (Paris) June–July 1951. Served as catalogue to exhibition at the Galerie Maeght. — A preliminary draft of the text was translated into English by Douglas Cooper, "Thoughts Around Alberto Giacometti," *Horizon* (New York), June 1949, pp. 411–417.

267 WALDBERG, PATRICK. "Alberto Giacometti, l'espace et l'angoisse," *Critique* (Paris), April 1959, pp. 329–340.

268 ZERVOS, CHRISTIAN. "Quelques Notes sur les sculptures de Giacometti," *Cahiers d'Art* (Paris), no. 8–10, 1932, pp. 337–342.

269 NEW YORK, PIERRE MATISSE GALLERY. *Alberto Giacometti, Drawings.* November 17–December 12, 1964. Introduction by James Lord.

270 NEW YORK, THE MUSEUM OF MODERN ART. *Alberto Giacometti.* June 7–October 10, 1965. Introduction by Peter Selz. Includes chronology compiled by Irene Gordon; letter from the artist to Pierre Matisse, 1947; bibliography.

–Exhibition also shown: The Art Institute of Chicago, November 5–December 12, 1965; Los Angeles County Museum of Art, January 11–February 20, 1966; San Francisco Museum of Art, March 10–April 24.

GORKY, Arshile

271 BRETON, ANDRÉ. "Arshile Gorky," *Le Surréalisme et la peinture.* 2nd ed. New York and Paris: Brentano's, 1945, pp. 196ff.; 3rd ed. Paris: Gallimard, 1966, pp. 199ff.

272 LEVY, JULIEN. *Gorky.* New York: Harry N. Abrams, 1968.

273 ROSENBERG, HAROLD. *Arshile Gorky: The Man, the Time, the Idea.* New York: Horizon Press, 1962.

274 RUBIN, WILLIAM. "Arshile Gorky, Surrealism, and the New American Painting," *Art International* (Zurich), February 1963, pp. 27–38.

275 SCHWABACHER, ETHEL. *Arshile Gorky.* New York: Macmillan for the Whitney Museum of American Art, 1957. Preface by Lloyd Goodrich; Introduction by Meyer Schapiro.

276 NEW YORK. JULIEN LEVY GALLERY. *Arshile Gorky.* 1945. Contains André Breton, "The Eye-Spring: Arshile Gorky," which is English translation of bibl. 271

277 NEW YORK. THE MUSEUM OF MODERN ART. *Arshile Gorky: Paintings, Drawings, Studies.* 1962. By William C. Seitz; Foreword by Julien Levy.–Published on the occasion of an exhibition at the Museum, December 17, 1962–February 12, 1963. Also shown: The Washington Gallery of Modern Art, March 12–April 14, 1963.

GROSZ, George

278 *George Grosz Drawings.* New York: H. Bittner & Co., 1944.

279 *A Little Yes and a Big No, the Autobiography of George Grosz.* New York: The Dial Press, 1946.

280 BITTNER, HERBERT, ED. *George Grosz.* New York: Arts, Inc., 1960. Grosz, "On My Drawings" (1944); Introduction by Ruth Berenson and Norbert Muhlen; bibliography. See also bibl. 463

281 HIRSCHFELD, GEORG. "George Grosz im Spiegel der Kritik," *Der Ararat* (Munich), July 1920, pp. 84–86.

282 NEW YORK. THE WHITNEY MUSEUM OF AMERICAN ART. *George Grosz.* January 14–March 7, 1954.

Text by John I. H. Baur.–Contains chronology, bibliography. Exhibition also shown: Kansas City, William Rockhill Nelson Gallery of Art, May 1–May 30; The Pasadena Art Institute, June 25–July 25; San Francisco Museum of Art, August 17–September 19.

HAUSMANN, Raoul

283 *Courrier dada.* Paris: Le Terrain Vague, 1958. Includes a bio-bibliography. See also bibl. 3, 435, 461, 463

HEROLD, Jacques

284 WALDBERG, PATRICK. *Jacques Hérold.* London: Percy Lund, Humphries & Co., Ltd., n.d.

HÖCH, Hannah

285 RODITI, EDOUARD. "Interview with Hannah Höch on the Berlin Dadaist Group," *Arts* (New York), December 1959, pp. 24–29. See also bibl. 435

JANCO, Marcel

286 TEL AVIV MUSEUM. *Marcel Janco: Dada Documents et témoignages, 1916–1958.* 1959. Texts by Jean Arp, Michel Seuphor, and Hans Richter. Poems by Tristan Tzara and Jean Arp. Catalogue and bibliography in English. See also bibl. 127

JEAN, Marcel. See bibl. 142, 154

KIESLER, Frederick

287 "Design-Correlation," *VVV* (New York), March 1943, pp. 76–80.

288 *Inside the Endless House; Art, People, and Architecture: A Journal.* New York: Simon and Schuster, 1964.

LAM, Wifredo

289 BRETON, ANDRÉ. "Wifredo Lam," *Le Surréalisme et la peinture.* 2nd ed. New York and Paris: Brentano's, 1945, pp. 181ff.; 3rd ed. Paris: Gallimard, 1966, pp. 169ff.

290 *Derrière le Miroir* (Paris), February 1953. Accompanied an exhibition at the Galerie Maeght.

291 WALDBERG, PATRICK. "Wifredo Lam et les idoles crépusculaires," *Quadrum* (Brussels), no. 3, 1957, pp. 31–40.

292 Notre Dame, Indiana. University of Notre Dame Art Gallery. *Wifredo Lam.* January 8–29, 1961. Introduction by James Johnson Sweeney.

MAGRITTE, René

293 "Word vs Image," in New York. Sidney Janis Gallery. *René Magritte.* March 1–20, 1954. Translation from the French by E. L. T. Mesens of "Les Mots et les images," *La Révolution Surréaliste* (Paris), December 15, 1929, pp. 32–33.

294 Breton, André. "René Magritte," *Le Surréalisme et la peinture.* 3rd ed. Paris: Gallimard, 1966, pp. 269ff.

295 Gablik, Suzi. "Méta-Trompe-l'oeil." *Art News* (New York), March 1965, pp. 46–48.

296 ———. "René Magritte: Mystery Painter," *Harper's Bazaar* (New York), November 1963, pp. 146–149, 190–191.

297 Mesens, E. L. T. "René Magritte," in *Peintres belges contemporains.* Brussels: Les Editions Lumière, 1946, pp. 157–161.

298 Nougé, Paul. *René Magritte; Ou, les Images défendues.* Brussels: Les Auteurs Associés, 1943.

299 Read, Herbert. "Magritte," *London Bulletin* (London), April 1938, p. 2.

300 Scutenaire, Louis. *Magritte.* Brussels: Editions Libraire Sélection, 1947.

301 Waldberg, Patrick. *René Magritte.* Brussels: André De Rache, 1965.

302 Brussels. Palais des Beaux-Arts. *Exposition René Magritte.* May 27–June 7, 1933.

303 Dallas. The Museum for Contemporary Arts. *René Magritte in America.* December 8, 1960–January 8, 1961. Contains statement by Magritte in French and English and a biographical outline. Douglas MacAgy, "About the Art of Magritte."—Also shown: Houston Museum of Fine Arts, February 1961.

304 New York. The Museum of Modern Art. *René Magritte.* 1966. Text by James Thrall Soby, bibliography.–Published on the occasion of an exhibition at the Museum, December 13, 1965–February

305 "Photography Is not Art," *View* (New York), April 1943, p. 23; October 1943, pp. 77–78.

See also bibl. 129, 143, 416

MAN RAY

306 *Self-Portrait.* Boston: Little, Brown, 1963. See also bibl. 143, 314, 315, 435, 471

307 Belz, Carl. "Man Ray and New York Dada," *Art Journal* (New York), Spring 1964, pp. 207–213.

308 Copley, William. "Man Ray: The Dada of Us All," *Portfolio* (Cincinnati), Winter 1963, pp. 14–23.

309 Ribemont-Dessaignes, Georges. *Man Ray.* Paris: Gallimard, 1924.

310 Waldberg, Patrick. "Bonjour Monsieur Man Ray," *Quadrum* (Brussels), no. 7, 1959, pp. 91–102.

311 Wescher, Paul. "Man Ray as a Painter," *Magazine of Art* (New York), January 1953, pp. 31–37.

312 London. Institute of Contemporary Arts. *Works of Man Ray.* March 31–April 25, 1959.

313 Paris. Bibliothèque Nationale. *Man Ray, L'Oeuvre photographique.* 1962. Text by Jean Adhémar. Catalogue by Jean Adhémar and Evelyne Pasquet.

314 Milan. Galleria Schwarz. *Man Ray: Objects of My Affection.* March 14–April 3, 1964. Texts by Man Ray and Tristan Tzara.

315 Los Angeles County Museum of Art, Lytton Gallery. *Man Ray.* October 27–December 25, 1966. Texts by Jules Langsner and Man Ray; section titled "Man Ray's Friends on Man Ray" includes writings by Paul Eluard, Marcel Duchamp, André Breton, Tristan Tzara, Hans Richter; Carl I. Belz, "The Film Poetry of Man Ray." See also bibl. 416, 417, 453, 471

MASSON, André

316 *Anatomy of My Universe.* New York: Curt Valentin, 1943.

27, 1966. Also shown: Rose Art Museum Brandeis University, Waltham, Massachusetts, April 3–May 1; The Art Institute of Chicago, May 30–July 3; Pasadena Art Museum, August 1–September 4; University Art Museum, University of California, Berkeley, October 1–November 1, 1966.

317 *Entretiens avec Georges Charbonnier.* Paris: René Julliard, 1958.

318 "Le Surréalisme et après," *L'Oeil* (Paris), May 15, 1955, pp. 12–17. Conversation with Georges Bernier. See also bibl. 24, 78, 166

319 BECKETT, SAMUEL. "André Masson," *Transition Forty-Nine* (Paris), no. 5, 1949, pp. 98–100.

320 BRETON, ANDRÉ. "Prestige d'André Masson," *Le Surréalisme et la peinture.* 2nd ed. New York and Paris: Brentano's, 1945, pp. 155ff.; 3rd ed. Paris: Gallimard, 1966, pp. 151ff.

321 EINSTEIN, CARL. "André Masson, étude ethnologie," *Documents* (Paris), May 1929, pp. 93–102.

322 HAHN, OTTO. *Masson.* New York: Harry N. Abrams, 1965. Translation from the French by Robert Erich Wolf.

323 JUIN, HUBERT. *André Masson.* Paris: Le Musée de Poche, 1963.

324 KAHNWEILER, DANIEL-HENRY. "André Masson illustrateur," *Albert Skira: Vingt ans d'activité.* Geneva and Paris: Editions Albert Skira, 1948.

325 LEIRIS, MICHEL and LIMBOUR, GEORGES. *André Masson and His Universe.* Geneva and Paris: Editions des Trois Collines/London: Horizon, 1947.
 Includes texts in French, with some translated into English by Douglas Cooper.

326 RUBIN, WILLIAM. "Notes on Masson and Pollock," *Arts* (New York), November 1959, pp. 36–43.

327 BALTIMORE MUSEUM OF ART. *André Masson.* October 31–November 22, 1941.

328 HANOVER. KESTNER GESELLSCHAFT. *André Masson: Gemälde, Zeichnungen.* 1955.
 Text by Alfred Hentzen.

MATTA (Sebastian Antonio Matta Echaurren)

329 "Hellucinations," in Ernst, Max. *Beyond Painting . . .* (The Documents of Modern Art.) New York: Wittenborn, Schultz, 1948, pp. 193–194.
 See also bibl. 230

330 BRETON, ANDRÉ. "Matta," *Le Surréalisme et la peinture.* 2nd ed. New York and Paris: Brentano's, 1945, pp. 190ff.; 3rd ed. Paris: Gallimard, pp. 183ff.

331 JOUFFROY, ALAIN. "Le Réalisme ouvert de Matta," *Cahiers d'Art* (Paris), no. 1, 1953, pp. 112–116.

332 SOBY, JAMES THRALL. "Matta Echaurren," *Magazine of Art* (New York), March 1947, pp. 102–106.

333 PARIS. GALERIE RENÉ DROUIN. *Matta.* 1947. Contains essay by André Breton.

334 NEW YORK. THE MUSEUM OF MODERN ART. *Matta.* September 10–October 20, 1957.
 Text by William Rubin.

MIRÓ, Joan

335 SWEENEY, JAMES JOHNSON. "Joan Miró: Comment and Interview," *Partisan Review* (New York), February 1948, pp. 206–212.

336 *Joan Miró: Gesammelte Schriften.* Ernst Scheidegger, ed. Zurich: Verlag der Arche, 1957.
 See also bibl. 78, 143

337 BRETON, ANDRÉ. "Constellations de Joan Miró," *L'Oeil* (Paris), December 1958, pp. 50–55.

338 ——. "Joan Miró," *Le Surréalisme et la peinture.* 3rd ed. Paris: Gallimard, 1966, pp. 257ff.

339 DUPIN, JACQUES. *Miró.* New York: Harry N. Abrams, 1962. Translated from the French by Norbert Guterman. – Catalogue raisonné, bibliography.

340 DUTHUIT, GEORGES. "Fantasy in Catalonia," *Magazine of Art* (New York), July 1937, pp. 440–443.

341 GREENBERG, CLEMENT. *Joan Miró.* New York: Quadrangle Press, 1948.

342 HUGNET, GEORGES. "Joan Miró; Ou, L'Enfance de l'art," *Cahiers d'Art* (Paris), no. 7–8, 1931, pp. 335–340.

343 HUNTER, SAM. *Joan Miró: His Graphic Work.* New York: Harry N. Abrams, 1958.

344 KRAMER, HILTON. "Miró," *Arts* (New York), May 1959, pp. 48–50.

345 LASSAIGNE, JACQUES. *Miró: Biographical and Critical Study.* Geneva: Skira, 1963.

Translated from the French by Stuart Gilbert.

346 LEIRIS, MICHEL. "Joan Miró," *Documents* (Paris), October 15, 1929, pp. 263-269.

347 ———. *The Prints of Joan Miró.* New York: Curt Valentin, 1947. Translated from the French by Walter Pach.

348 MOTHERWELL, ROBERT. "The Significance of Miró," *Art News* (New York), May 1959, pp. 32-33.

349 PRÉVERT, JACQUES, and RIBEMONT-DESSAIGNES, GEORGES. *Joan Miró.* Paris: Maeght Editeur, 1956.

350 SCHNEIDER, PIERRE. "Miró," *Horizon* (New York), March 1959, pp. 70-81.

351 SWEENEY, JAMES JOHNSON. "Miró," *Art News Annual* (New York), vol. 23, 1954, pp. 58-81.

352 TZARA, TRISTAN. "A Propos de Joan Miró," *Cahiers d'Art* (Paris), no. 3-4, 1940, pp. 37-47. See also bibl. 143.

353 NEW YORK. THE MUSEUM OF MODERN ART. *Joan Miró.* 1941. Essay by James Johnson Sweeney. – Published on the occasion of an exhibition at the Museum, November 19, 1941-January 11, 1942.

354 NEW YORK. THE MUSEUM OF MODERN ART. *Joan Miró.* Mar. 18-May 10, 1959. Essay by James Thrall Soby; bibliography.

355 LONDON. ARTS COUNCIL OF GREAT BRITAIN. *Miró.* At the Tate Gallery, August 27-October 11, 1964. Text by Roland Penrose. – Also shown: Zurich, Kunsthaus, October 31-December 6.

OPPENHEIM, Meret

356 STOCKHOLM. MODERNA MUSEET. *Meret Oppenheim.* April 15-May 21, 1967.

PAALEN, Wolfgang

357 BRETON, ANDRÉ. "Wolfgang Paalen," *Le Surréalisme et la peinture.* 2nd ed. New York and Paris: Brentano's, 1945, pp. 136ff.; 3rd ed. Paris: Gallimard, 1966, pp. 136ff. See also bibl. 419

PICABIA, Francis

358 *391* (Barcelona, New York, Zurich, Paris), 1917-1923. Edited by Francis Picabia. Published in reduced facsimile, ed. Michel Sanouillet, Paris: Le Terrain Vague, 1960.

359 *Poèmes et dessins de la fille née sans mère.* Lausanne: Imprimeries Réunis, 1918.

360 "Francis Picabia et Dada," *L'Esprit Nouveau* (Paris), vol. 1, no. 9, 1920, pp. 1059-1060.

361 "Good Painting," *The Little Review* (New York), Autumn 1922, pp. 61-62.

362 *Dits. Aphorismes réunis par Poupard-Lieusson.* Paris: Le Terrain Vague, 1960. See also bibl. 3, 54, 78, 460

363 ALLOWAY, LAWRENCE. "Picabia," *Art International* (Zurich), vol. 3, no. 9, 1959, pp. 23-24.

364 BRETON, ANDRÉ. "Francis Picabia," *Le Surréalisme et la peinture.* 3rd ed. Paris: Gallimard, 1966, pp. 221ff.

365 BUFFET-PICABIA, GABRIELLE. "Picabia et l'anti-peinture," in *Prisme des Arts: Panorama de l'art présent.* Paris: 1957, 2 pp.

366 ———. "Picabia, l'inventeur," *L'Oeil* (Paris), June 1956, pp. 30-35, 46-47.

367 CAMFIELD, WILLIAM. "The Machinist Style of Francis Picabia," *Art Bulletin* (New York), September-December 1966, pp. 309-322.

368 PEARLSTEIN, PHILIP. "The Paintings of Francis Picabia, 1908-1930." Unpublished Master's thesis, Institute of Fine Arts, New York University, 1955.

369 ———. "The Symbolic Language of Francis Picabia," *Arts* (New York), January 1956, pp. 37-43.

370 PERRIN, MICHEL. "Picabia," *Art-Documents* (Geneva), April 1954, p. 3.

371 SANOUILLET, MICHEL. *Picabia.* Paris: Les Editions du Temps, 1964. Contains bibliography by M. Poupard-Lieussou; chronology. See also bibl. 3, 129

372 PARIS. GALERIE CRAVEN. *Hommage à Picabia.* October 1953.

373 MARSEILLES. MUSÉE CANTINI. *Picabia.* March 20-May 15, 1962. Bibliography by M. Poupard-Lieussou.

374 NEWCASTLE. UNIVERSITY OF NEWCASTLE UPON TYNE, HATTON GALLERY. *Francis Picabia*. March 1964. Introduction by Ronald Hunt.– Also shown: London, Institute of Contemporary Arts, April 1964.

PICASSO, Pablo

375 *Desire Caught by the Tail*. New York: Citadel Press, 1962. Translated from the French by Bernard Frechtman. Originally published Paris: Gallimard, 1945.

376 BARR, ALFRED H., JR. *Picasso: 50 Years of His Art*. New York: The Museum of Modern Art, 1946. Bibliography by Dorothy Simmons. Reprinted by the Museum, 1955; reprinted by Arno Press, New York, 1966.

377 BOECK, WILHELM, and SABARTES, JAIME. *Picasso*. New York: Harry N. Abrams, 1955.

378 BRETON, ANDRÉ. "Pablo Picasso," *Le Surréalisme et la peinture*. 3rd ed. Paris: Gallimard. 1966, pp. 101ff.

379 GILOT, FRANÇOISE, and LAKE, CARLTON. *Life with Picasso*. New York: McGraw-Hill, 1964.

380 LARREA, JUAN. *Guernica*. New York: The Museum of Modern Art, 1947.

381 MARRERO, VINCENTE. *Picasso and the Bull*. Chicago: Henry Regnery Co., 1956. Translated from the Spanish by Anthony Kerrigan. Madrid: Editorial Calamo, 1951.

382 PENROSE, ROLAND. *Picasso: His Life and Work*. London: Victor Gollancz Ltd., 1958.

383 READ, HERBERT. "Picasso's 'Guernica,'" *A Coat of Many Colours: Occasional Essays*. London: G. Routledge & Sons Ltd., 1945, pp. 317-319.

384 ROSENBLUM, ROBERT. "Picasso as a Surrealist," in ART GALLERY OF TORONTO. *Picasso and Man*. 1964. Reprinted in bibl. 129

385 PARIS. GALERIE PIERRE. *Picasso: Papiers collés 1912-1914*. February 20-March 20, 1935.

386 NEW YORK. THE MUSEUM OF MODERN ART. *The Sculpture of Picasso*. 1967. Essay by Roland Penrose; chronology by Alicia Legg; bibliography.

– Published on the occasion of an exhibition at the Museum, October 9, 1967-January 1, 1968.

RICHTER, Hans

387 *Dada, Art and Anti-Art*. New York: McGraw-Hill, 1965. See also bibl. 3, 127, 286, 315, 391, 435

SCHWITTERS, Kurt

388 *Memoiren Anna Blumes in Bleie*. Freiburg: Walter Heinrich, 1922. See also bibl. 3, 399, 469

389 ALLOWAY, LAWRENCE. "Schwitters and Dada," *Art International* (Zurich), November 1958, p. 21.

390 GIEDION-WELCKER, CAROLA. "Schwitters: or the Allusions of the Imagination," *Magazine of Art* (New York), October 1948, pp. 218-221.

391 RICHTER, HANS. "Kurt Schwitters," *G: Material zur elementaren Gestaltung* (Berlin), June 1924, n.p.

392 SCHMALENBACH, WERNER. "Kurt Schwitters," *Werk* (Zurich), May 1956, pp. 153-158.

393 ———. "Kurt Schwitters," *Art International* (Zurich), September 25, 1960, pp. 58-62.

394 ———. *Kurt Schwitters*. Cologne: Verlag DuMont Schauberg. 1967.

395 STEINITZ, KATE. *Kurt Schwitters: A Portrait from Life*. Berkeley and Los Angeles: University of California Press [1969].

396 THEMERSON, STEFAN. *Kurt Schwitters in England*. London: Gaberbocchus Press, 1958.

397 TZARA, TRISTAN. "Merz-master: Kurt Schwitters 1887-1948," *Portfolio* (Cincinnati), Spring 1964, pp. 66-75.

398 VAHLBRUCH, HEINZ. "Kurt Schwitters, Maler und Dichter," *Kunstwerk* (Baden-Baden), vol. 7, no. 3-4, 1953, pp. 27-30.

399 LONDON. MARLBOROUGH FINE ART LIMITED. *Schwitters*. March-April 1963. Includes Ernst Schwitters, "One Never Knows"; statements by the artist; biographical notes by Hans Bolliger.

400 NEW YORK. MARLBOROUGH-GERSON GALLERY, INC. *Kurt Schwitters*. May-June 1965.

Texts by Werner Schmalenbach and Kate Steinitz; biographical notes by Hans Bolliger.

SELIGMANN, Kurt. See bibl. 166

TANGUY, Yves

401 BRETON, ANDRÉ. "Ce que Tanguy voile et révèle," *Le Surréalisme et la peinture*. 2nd ed. New York and Paris: Brentano's, 1945, pp. 173ff.; 3rd ed. Paris: Gallimard, 1966, pp. 173ff.

402 ———. *Yves Tanguy*, New York: Pierre Matisse, 1946. Text in French and English; English translation by Bravig Imbs.

403 TANGUY, KAY SAGE, ED. *Yves Tanguy*. New York: Pierre Matisse, 1963. Includes an illustrated bibliography by M. Poupard-Lieussou and Bernard Karpel.

404 *View* (New York), May 1942. Tanguy-Tchelitchew special number.

405 NEW YORK. THE MUSEUM OF MODERN ART. *Yves Tanguy*. September 7–October 30, 1955. Text by James Thrall Soby; bibliography. See also bibl. 166, 416

VII GROUP EXHIBITIONS

406 COLOGNE. BRAUHAUS WINTER. *Dada-Vorführung: Gemälde, Skulpturen, Zeichnungen, Fluidoskeptrik, Vulgärdilettantismus.* April–May, 1920.

407 BERLIN. KUNSTHANDLUNG DR. OTTO BURCHARD. *Erste internationale Dada-Messe.* June 5–August 25, 1920.

408 PARIS. GALERIE PIERRE. *La Peinture surréaliste.* November 14–25, 1925. Preface by André Breton and Robert Desnos.

409 PARIS. GALERIE GOEMANS. *Exposition de collages.* 1930. Contains: Louis Aragon, "La Peinture au défi."

410 COPENHAGEN. INTERNATIONAL KUNSTUGSTILLING. *Kubisme—surréalisme.* January 15–28, 1935.

411 PARIS. GALERIE CHARLES RATTON. *Exposition surréaliste d'objets,* May 22–29, 1936.

412 LONDON. NEW BURLINGTON GALLERIES. *The International Surrealist Exhibition.* June 11–July 4, 1936. Preface by André Breton, translated by David Gascoyne. Introduction by Herbert Read.

413 NEW YORK. THE MUSEUM OF MODERN ART. *Fantastic Art, Dada, Surrealism.* December 7, 1936–January 17, 1937. Catalogue edited by Alfred H. Barr, Jr. 1st ed. 1936; 2nd ed., 1937 includes essays by Georges Hugnet, "Dada," pp. 15–34, and "In the Light of Surrealism," pp. 35–52; 3rd ed., 1947, contains additional plates. Reprinted by Arno Press, New York, 1968.

414 TOKYO. NIPPON SALON. *Album surréaliste.* June 1937. Special number of *Mizué*; edited by Tiroux Yamanaka. Artist and title list in English and Japanese.

415 LONDON GALLERY. *Surrealist Objects & Poems.* 1937. Foreword; David Gascoyne, "Three Poems."

416 BRUSSELS. PALAIS DES BEAUX-ARTS. *Trois Peintures surréalistes; René Magritte, Man Ray, Yves Tanguy.* December 11–22, 1937. Presented by E. L. T. Mesens.

417 PARIS. GALERIE BEAUX-ARTS. *Exposition internationale du surréalisme.* January–February 1938. Organized by André Breton and Paul Eluard, general supervision by Marcel Duchamp, technical advisers Salvador Dali and Max Ernst, lighting by Man Ray. Catalogue contains "Dictionnaire abrégé du surréalisme," compiled by Breton, Eluard, and others.

418 AMSTERDAM. GALERIE ROBERT. *Surréalistische Schilderkunst.* 1938. Introduction by Georges Hugnet.

419 MEXICO CITY. GALÉRIA DE ARTE MEXICANO. *Exposición Internacional del Surréalismo.* January–February 1940. Organized by André Breton, Wolfgang Paalen, and César Moro.

420 NEW YORK. [Coordinating Council of French Relief Societies.] *First Papers of Surrealism.* October 14–November 7, 1942. Exhibition held at the Reid Mansion, 451 Madison Avenue. Hanging by André Breton, webbing installation by Marcel Duchamp.

421 ZURICH. MUSEUM ALLERHEILIGEN SCHAFFHAUSEN. *Abstrakte und Surrealistische Kunst in der Schweiz.* January 24–February 17, 1943.

422 SAN FRANCISCO MUSEUM OF ART. *Abstract and Surrealist Art in the United States.* 1944. Works of art selected by Sidney Janis. Cincinnati Art Museum, February 8–March 12; Denver Art Museum, March 26–April 23; Seattle Art Museum, May 7–June 10; Santa Barbara Museum of Art, June–July; San Francisco Museum of Art, July.

423 BRUSSELS. GALERIE BOÉTIE. *Surréalisme.* December 15, 1945–January 15, 1946.

424 NEW YORK. HUGO GALLERY. *Bloodflames 1947.* 1947. By Nicolas Calas.

425 PARIS. GALERIE MAEGHT. *Exposition internationale du surréalisme: Le Surréalisme en 1947.* July–August 1947. Organized by André Breton and Marcel Duchamp.

426 THE ART INSTITUTE OF CHICAGO. *The Fifty-Eighth Annual Exhibition of American Painting and Sculpture: Abstract and Surrealist American Art.* November 6, 1947–January 11, 1948. Organized by Frederick A. Sweet and Katherine Kuh; catalogue texts: Daniel Catton Rich, Foreword; Frederick A. Sweet, "The First Forty Years"; Katherine Kuh, "The Present."

427 PARIS. GALERIE NINA DAUSSET. *Le Cadavre exquis, son exaltation.* October 7–30, 1948. Essay by André Breton.

428 BASEL. KUNSTHALLE. *Phantastische Kunst des XX. Jahrhunderts.* August 30–October 12, 1952.

429 NEW YORK. SIDNEY JANIS GALLERY. *Dada 1916–1923.* April 15–May 9, 1953. Catalogue (a large sheet, originally distributed as a crumpled ball of paper), designed by Marcel Duchamp, contains original statements by Tristan Tzara, Jean Arp, Richard Huelsenbeck, and Jacques-Henry Lévesque.

430 BRUSSELS. MINISTÈRE DE L'INSTRUCTION PUBLIQUE. *Collection Urvater.* 1957. Published by Editions de la Connaissance. – Introduction by E. Langui. Biographies. – Exhibition shown: Otterlo, Kröller-Müller Museum; Liège, Musée des Beaux-Arts.

431 HOUSTON. CONTEMPORARY ARTS MUSEUM. *The Disquieting Muse: Surrealism.* January 9–February 16, 1958. Contains excerpts from Herbert Read's *Surrealism and the Romantic Principle;* Jermayne MacAgy, "History Is Made at Night"; Julien Levy, "The Disquieting Muse."

432 PARIS. LE BATEAU-LAVOIR. *Dessins symbolistes.* March 7–April 12, 1958.

433 DÜSSELDORF. KUNSTHALLE. *Dada: Dokumente einer Bewegung.* September 5–October 19, 1958. Texts in German, French, Dutch, and English. – Exhibition also shown: Amsterdam, Stedelijk Museum, December 23, 1958–February 2, 1959.

434 THE ARTS CLUB OF CHICAGO. *Surrealism Then and Now.* October 1–30, 1958.

435 AMSTERDAM. STEDELIJK MUSEUM. *Dada . . .* December 23, 1958–February 2, 1959. Texts in German, French, Dutch, and English by Richard Huelsenbeck, Hans Richter, Jean Arp, Man Ray, Georges Ribemont-Dessaignes, Max Ernst, Raoul Hausmann, and Hannah Höch.

436 NEW YORK. THE MUSEUM OF MODERN ART. *New Images of Man.* 1959. Edited by Peter Selz. – Published on the occasion of an exhibition at the Museum, September 9–November 29, 1959. Also shown: Baltimore Museum of Art, January 9–February 7, 1960.

437 PARIS. GALERIE DANIEL CORDIER. *Exposition internationale du surréalisme.* December 15, 1959–February 29, 1960. On the theme of eroticism.

438 NEW YORK. D'ARCY GALLERIES. *Surrealist Intrusion in the Enchanters' Domain.* November 28, 1960–January 14, 1961. Directed by André Breton and Marcel Duchamp. – Includes "Surrealism, Jackson Pollock, and Lyric-Abstraction" by José Pierre.

439 NEW YORK. THE MUSEUM OF MODERN ART. *The Art of Assemblage.* 1961. By William C. Seitz. – Published on the occasion of an exhibition at the Museum, October 2–November 12, 1961. Also shown: Dallas Museum of Contemporary Arts, January 9–February 11, 1962; San Francisco Museum of Art, March 5–April 15.

440 PARIS. GALERIE D'ART L'OEIL. *Minotaure.* May–June 1962. Contains Jean-François Revel, "A Magazine Which After Thirty Years Is Still New." – Catalogue notes by Guy Habasque.

441 PARIS. GALERIE CHARPENTIER. *Le Surréalisme: Sources, histoire, affinités.* 1964. Texts by Raymond Nacenta and Patrick Waldberg.

442 SÃO PAULO. VIII BIENAL. *Surrealismo e Arte Fantástica.* 1965. Organized by Felix Labisse.

443 STOCKHOLM. MODERNA MUSEET. *Dada.* February 3–March 27, 1966. Organized by K. G. Pontus Hultén.

444 SANTA BARBARA. ART GALLERY OF THE UNIVERSITY OF CALIFORNIA. *Surrealism, a State of Mind, 1924–1965.* February 26–March 27, 1966. Note by Mrs. Ala Story; Introduction by Julien Levy.

445 SANTA BARBARA MUSEUM OF ART. *Harbingers of Surrealism*. February 26–March 27, 1966. Foreword by William J. Hesthal.

446 MILAN. GALLERIA SCHWARZ. *Cinquant'Anni a Dada: Dada in Italia 1916–1966*. June 24–September 30, 1966. Texts in Italian, French, and English. Essays by Lino Montagna, Arturo Schwarz, and Daniela Palazzoli.

447 ZURICH. KUNSTHAUS. *Dada. Ausstellung zum 50-jährigen Jubiläum*. October 8–November 17, 1966. Texts in German and French. Extensive chronology, biographies of the artists. Also shown: Paris, Musée National d'Art Moderne, November 30, 1966–January 30, 1967.

448 BERN. KUNSTHALLE. *Phantastische Kunst–Surrealismus*. October 21–December 4, 1966.

449 MILAN. GALLERIA SCHWARZ. *Hommage to André Breton*. January–February 1967. Published by Centro Francese di Studi (Milan), and Centro Culturale Francese (Rome).

450 TURIN. GALLERIA CIVICA D'ARTE MODERNA. *Le Muse inquietanti*. 1967. Organized by Luigi Carluccio.

451 NEW YORK. THE MUSEUM OF MODERN ART. *Dada, Surrealism, and Their Heritage*. March 27–June 9, 1968. Text by William S. Rubin. Includes chronology by Irene Gordon; bibl. – Exhibition also shown: Los Angeles County Museum of Art, July 16–September 8; The Art Institute of Chicago, October 19–December 8.

VIII MANIFESTOES AND ORIGINAL PUBLICATIONS

452 *Bleu* (Mantua), January 1921. Edited by J. Evola, Gina Cantarelli, and Aldo Fiozzi.

453 *The Blind Man* (New York), April, May 1917. Edited by Marcel Duchamp, with editorial participation by Man Ray.

454 BRETON, ANDRÉ. *Manifeste du surréalisme*. Paris: Editions du Sagittaire, 1924.

455 ——. *Second Manifeste du surréalisme*. Paris: Editions Kra, 1930. Originally published in *La Révolution Surréaliste* (Paris), December 15, 1929.

456 ——. *Les Manifestes du surréalisme, suivis de prolégomènes à un troisième manifeste du surréalisme ou non*. Paris: Editions du Sagittaire, 1946.

457 ——. *Les Manifestes du surréalisme, suivis de prolégomènes à un troisième manifeste du surréalisme ou non, du surréalisme en ses œuvres vives, et d'éphémérides surréalistes*. Paris: Edition du Sagittaire, 1955.

As the present volume went to press, publication was announced of André Breton, *Manifestoes of Surrealism*, translated from the French by Richard Seaver and Helen R. Lane. Ann Arbor: University of Michigan Press, 1969.

458 *Bulletin International du Surréalisme*. 1935–1936. Published irregularly by Surrealist groups in various countries, title and text in French and language of origin: (Prague), April 1935; (Santa Cruz de Tenerife), October 1935; (Brussels), August 20, 1935; (London), September 1936.

459 *Cabaret Voltaire* (Zurich), June 1916. Edited by Hugo Ball.

460 *Cannibale* (Paris), April 25, May 25, 1920. Edited by Francis Picabia.

461 *Club Dada* (Berlin), 1918. Edited by Richard Huelsenbeck, Franz Jung, and Raoul Hausmann.

462 *Dada* (Zurich and Paris), July 1917–March 1920. Edited by Tristan Tzara. *Dada 4–5* cover title is *Anthologie Dada*; *Dada 6* cover title is *Bulletin Dada*; *Dada 7* cover title is *Dadaphone*.

463 *Der Dada* (Berlin), 1919–1920. Edited by Raoul Hausmann, George Grosz, John Heartfield.

464 *Dada Almanach* (Berlin), 1920. Edited by Richard Huelsenbeck. Published in facsimile edition, New York: Something Else Press, 1966.

465 *Documents* (Paris), 1929–1930. Edited by Georges Bataille.

466 *Littérature* (Paris), March 1919–June 1924. Edited by Louis Aragon, André Breton, Philippe Soupault.

467 *London Bulletin* (London) April 1938–June 1940. Edited by E. L. T. Mesens. Includes catalogues of Surrealist one-man exhibitions at London Gallery.

468 *Maintenant* (Paris), April 1912–March–April 1915. Edited by Arthur Cravan. Published in facsimile edition, Paris: Erik C. Losfeld, 1957.

469 *Merz* (Hanover), 1923–1932. Edited by Kurt Schwitters.

470 *Minotaure* (Paris), 1933–1939. Edited by Albert Skira and E. Tériade.

471 *New York Dada* (New York), April 1921. Edited by Marcel Duchamp, with editorial participation by Man Ray.

472 *Nord-Sud* (Paris), March 1917–January 1918. Edited by Pierre Reverdy.

473 *La Révolution Surréaliste* (Paris), December 1, 1924–December 15, 1929. Edited by Pierre Naville, Benjamin Péret, André Breton.

474 *Rongwrong* (New York), 1917. Edited by Marcel Duchamp.

475 *Die Schammade* (Cologne), February 1920. Edited by Max Ernst.

476 *Sic* (Paris), January 1916–December 30, 1919. Director, Pierre Albert-Birot.

477 *Les Soirées de Paris* (Paris), 1912–1914. Edited by Guillaume Apollinaire and others.

478 *Le Surréalisme au Service de la Révolution* (Paris), 1930–1933. Edited by André Breton.

479 *Le Surréalisme, Même* (Paris), 1956–1959. Edited by André Breton.

480 TZARA, TRISTAN. "Conférence sur dada," *Merz* (Hanover), January 1924, pp. 68–70. English translation in bibl. 3.

481 ——. *Sept Manifestes dada*. Paris: Jean Budry, 1924. Republished in *Lampisteries, précédées des sept manifestes dada. Quelquesdessins de Francis Picabia*. Paris: Jean-Jacques Pauvert Editeur, 1963. – For English translation see bibl. 3.

482 *View* (New York), 1940–1947. October–November 1941 is a special Surrealist issue.

483 *VVV* (New York), June 1942–February 1944. Edited by David Hare.

484 *Der Zeltweg* (Zurich), November 1919. Edited by Otto Flake, Walter Serner, and Tristan Tzara.

INDEX

PHOTOGRAPHIC CREDITS

The publisher and author wish to thank the museums, galleries, and private collectors for granting permission to reproduce the artworks in their collections. Photographs have been supplied by the owners or custodians, except in the instances listed below. For supplying these photographs, we gratefully acknowledge the courtesy of: Berenice Abbott, New York: D-199, D-212; Ampliaciones y Reproducciones MAS, Barcelona: 16; ARTS Magazine, New York: D-232; Bacci Attilio, Milan: 20, 34; Oliver Baker, New York: 33, D-14, D-66, D-97, D-285, D-286; Ivan Bettex, Prilly, Switzerland: 81; Oliver Baker, New York: 33, D-14, D-66, D-97, D-285; Ivan Bettex, Prilly, Switzerland: Pierre Brassaï, Paris: 274, 294, 299; Bulloz, Paris: D-10; Rudolph Burckhardt: 191, 193, 194, 196, 201, D-276, D-284, D-293; Editions Cahiers d'Art, Paris: D-29, D-98; Leo Castelli, New York: D-291, D-292, D-294, D-295; Chevojon, Paris: 309; Geoffrey Clements, New York: 9,11, 398; Mme. Simone Collinet, Paris: D-45, D-107, D-108, D-109, D-110, D-111, D-112, D-114; Colton, New York: 266, 377, D-204, D-205; The Salvador Dali Archives, New York: 195, 200, D-139, D-140; Robert David, Paris: D-134, D-223; Robert Descharnes, Paris: D-135; Walter Dräyer, Zurich: 90, 392; Marcel Duchamp, New York: 16, D-50; Dwan Gallery, Los Angeles: D-97; George Eastman House, Rochester, New York: D-53; Eliot Elisofon, LIFE Magazine, © TIME INC., New York: D-54; Richard Feigen Gallery, Chicago: 75; Galerie Chalette, New York: 99; Galerie Louise Leiris, Paris: 142, 145, 146, 148, 149, 382, D-225; Galerie Maeght, Paris: 210, 230, D-118; The Gallery of Modern Art, Including the Huntington Hartford Collection, New York: 203, 206, D-9; Galerie A. F. Petit, Paris: 277; Grosvenor Gallery, London: 333; The Solomon R. Guggenheim Museum, New York: 213, 216, 219, 221, 224, 226, D-27, D-31; David Hare, New York: D-278; Ives Hervochon, Paris: 310; Dr. Charles Hulbeck, New York: D-85, D-86, D-87, D-88, D-89; Jacqueline Hyde, Paris: 184, D-213; Images & Textes, Denise Bellon, Paris: 282, 283, 284, D-146, D-218, D-219, D-220, D-301; Léni Iselin, Paris: 215; Sidney Janis Gallery, New York: 409, D-296, D-297; The Jewish Museum, New York: D-242; H. Josse, Paris: 101, 292, 300; Peter A. Juley & Son, New York: 77, D-117; Walter Klein, Dusseldorf: 114, 161; Joseph Klima, Jr., New York: 24; Lacoste, Paris: 143, D-65; Le Point Cardinal, Paris: 248; Nina Leen, LIFE Magazine, © TIME, INC., New York: D-245; N. Mandel, Paris: 164; Christian Manz, Zurich: 241; Gianni Mari, Milan: 120; Marlborough-Gerson Gallery, New York: D-249, D-263; Ann Matta Alpert, New York: 167; Adelaide de Menil, New York: D-132; New York: 367, 397; Edward Meneeley, New York: 167; Adelaide de Menil, New York: D-132; W. F. Miller & Co., Hartford, Connecticut: 362; Robert Motherwell, New York: D-229; The Museum of Modern Art, New York: 49, 73, 82, 86, 98, 107, 108, 109, 118, 132, 138, 139, 155, 163, 174, 179, 205, 231, 232, 233, 237, 240, 244, 257, 299, 296, 356, 360, 387, 401, 402, 404, 406, 407, 408, 410, 412, 413, D-6, D-28, D-35, D-45, D-52, D-100, D-122, D-127, D-133, D-148, D-150, D-184, D-200, D-264; Hans Namuth, New York: 4-256; Nationalmuseum, Stockholm: 3; O. E. Nelson, New York: 100, 134, 189, D-250, D-255; Piaget, St. Louis Missouri: 391; Olga Picabia, Paris: 61; Eric Pollitzer, New York: 62, 104, 110, 111, 115, 125, 154, 186, 207, 244, 251, 372, 379, 384, 399, D-183, D-251, D-252, D-259, D-260, D-270, 4-282, D-299; Puytorac, Bordeaux: 4; Nathan Rabin, New York: D-216; André de Rache, Brussels: 129; Charles Ratton, Paris: 204, 259, 267, 281, D-163; Man Ray, Paris: 39, 43, 44, 45, D-48, D-67; Hans Richter, Locarno, Switzerland: 63, 64, 65, D-44, D-90; Walter Rosenblum, New York: D-209; Ernst Scheidegger, Zurich: D-152, D-155, D-156, D-157; John D. Schiff, New York: 15, 51, 94, 96, D-88, D-248; Wilbur Seiders: 116, D-161; Service Photographique, Musées Nationaux, Versailles: 63; Service T.I.P., Liège, Belgium: 162; Gian Sinigaglia, Milan: 39; H. Stebler, Bern, Switzerland: 33; Dr. Franz Stödtner, Dusseldorf: D-20; Adolph Studly, New York: 172, 380, 381, 385; Taylor and Dull, New York: 247, 250; Michel Waldberg: 389; John Webb, London: 84, 85, 117, 337, 344, 357; Etienne Bertrand Weill, Paris: 238, D-75; Dietrich Widmer, Basel, Switzerland: 220; Hehnke Winterer, Dusseldorf: 127; A. J. Wyatt, Philadelphia: D-55; Marc Vaux, Paris: 209, 217, 218, 228, 346, D-208; Yale University Art Gallery, New Haven, Connecticut: 249; I. Zafrir, Tel Aviv: 390. Additional illustrations in the text are credited as follows: Serge Béguier, Paris: p. 59; Paul Bijtebier, Brussels: p. 169; H. Josse, Paris: p. 53; N. Mandel, Paris: p. 121; The Museum of Modern Art, New York: p. 228; John D. Schiff, New York: p. 289; Marc Vaux, Paris: p. 328.